APOLLO

REMASTERED

APOLLO
REMASTERED

This book is dedicated to my children, Ben and Luna:
Shoot for the stars without fear of failure—if you miss,
you may still reach the Moon . . .

Black Dog & Leventhal Publishers
Hachette Book Group
1290 Avenue of the Americas
New York, NY 10104

www.hachettebookgroup.com
www.blackdogandleventhal.com

First U.S. edition: October 2022
Published in the UK by Particular Books

Black Dog & Leventhal Publishers is an imprint of Perseus Books, LLC, a subsidiary of Hachette Book Group, Inc.
The Black Dog & Leventhal Publishers name and logo are trademarks of Hachette Book Group, Inc.

The publisher is not responsible for websites (or their content) that are not owned by the publisher.

The Hachette Speakers Bureau provides a wide range of authors for speaking events.
To find out more, go to www.HachetteSpeakersBureau.com or call (866) 376-6591.

Print book interior design by Jim Stoddart

LCCN: 2022930522

ISBNs: 978-0-7624-8024-1 (hardcover), 978-0-7624-8025-8 (ebook)

Printed in China

APS

10 9 8 7 6 5 4 3

CONTENTS

"The exploration of space will go ahead, whether we join in it or not, and it is one of the great adventures of all time, and no nation which expects to be the leader of other nations can expect to stay behind in the race for space . . . Its conquest deserves the best of all mankind, and its opportunity for peaceful cooperation may never come again. But why, some say, the Moon? Why choose this as our goal? And they may well ask why climb the highest mountain? Why, 35 years ago, fly the Atlantic? . . .

"We choose to go to the Moon. We choose to go to the Moon in this decade and do the other things, not because they are easy, but because they are hard, because that goal will serve to organize and measure the best of our energies and skills, because that challenge is one that we are willing to accept, one we are unwilling to postpone, and one which we intend to win . . .

"If I were to say, my fellow citizens, that we shall send to the Moon, 240,000 miles away from the control station in Houston, a giant rocket more than 300 feet tall . . . made of new metal alloys, some of which have not yet been invented, capable of standing heat and stresses several times more than have ever been experienced, fitted together with a precision better than the finest watch, carrying all the equipment needed for propulsion, guidance, control, communications, food and survival, on an untried mission, to an unknown celestial body, and then return it safely to Earth, re-entering the atmosphere at speeds of over 25,000 miles per hour, causing heat about half that of the temperature of the Sun . . . and do all this, and do it right, and do it first before this decade is out – then we must be bold . . .

"Many years ago the great British explorer George Mallory, who was to die on Mount Everest, was asked why did he want to climb it. He said, 'Because it is there.' Well, space is there, and we're going to climb it, and the Moon and the planets are there, and new hopes for knowledge and peace are there. And, therefore, as we set sail we ask God's blessing, on the most hazardous and dangerous and greatest adventure on which man has ever embarked."

JOHN F. KENNEDY

PREFACE

The original NASA photographic film from the Apollo missions is some of the most important and valuable film in existence. It is securely stored in a freezer, to help maintain its condition, in Building 8 at Johnson Space Center, Houston. It never leaves the building – in fact, the film rarely leaves the freezer. The images it contains include the most significant moments in our history, as humankind left the confines of our home planet for the first time.

While the astronauts' primary goal was to simply record their activities, they captured images that transcend documentation.

The photographs from the lunar surface are as close as we can get to standing on the Moon ourselves. The small cross-hairs on many of these images are synonymous with Apollo and an instant indicator that the photographs were taken in a scientific setting, where a documentary measuring tool of the utmost precision was required.

For the first time, we were able to look back at Earth from afar, experiencing the "overview effect," the cognitive shift that elicits an intense emotional experience and mental clarity upon seeing our home planet from space for the first time. The "Blue Marble" photograph, taken as Apollo 17 set course for the Moon, depicts the whole sunlit Earth, and is the most reproduced photograph of all time. Along with Apollo 8's "Earthrise," which depicts Earth above the lunar horizon, it was a catalyst for the environmental movement that continues today.

Many of these images from Apollo are so well known they are seared into our collective memory; they are visual artifacts produced by space explorers. The treasures they returned to Earth included 842lbs of Moon rock, and their film, exposed in the alien environment.

As the original flight film lay hermetically encapsulated in its frozen vault for half a century, almost all of the Apollo images made publicly available have been copies of master duplicates, or copies of copies, leading to the gradual degradation in the quality of the images we see. This process has only accelerated with the prevalence of digital representations of these images online.

In recent years, however, the original film for each mission has been removed from the freezer, thawed, cleaned, and digitally scanned to an unprecedented resolution. There is a huge treasure trove of around 35,000 photographs, the vast majority of which are rarely seen, in part due to the quality or exposure of the original film. It's easy to forget that they were taken in an era when photography was purely analog, requiring light-sensitive chemistry, film and paper. Since the film was designed for analog mediums, digital scans of the transparencies are often chronically underexposed and difficult to process. As a result, many of the photographs from early spaceflight, including some of the most important images in our history, are typically poorly represented.

The images in this book are derived from the new, high-resolution raw scans of the original flight film. I have painstakingly restored and remastered them utilizing image-enhancement technology and techniques to present them in unprecedented detail and clarity. Having inspected all 35,000 images in NASA's archive, I have selected those which most effectively represent the Apollo program, in addition to a select few from the preceding Mercury and Gemini missions, which helped pave the way.

The actual photographic content of alien landscapes and apparently complex, unfamiliar machinery and technology benefits hugely from the inclusion of familiar human forms to help us interpret and connect with the images. Rarely, however, do astronauts appear in mission photographs; NASA's objective was not the idolization of the select few humans doing the work, but the work itself. Project Gemini missions included the Hasselblad Superwide Camera (SWC). Its wide-angle capability was well suited to capturing the whole spacecraft from close quarters and a good coverage of Earth's surface, but equally the inside of the cramped capsule itself and its space-faring inhabitants.

Inexplicably, the Hasselblad SWC failed to make it onto the flight manifest of Apollo's Moon-bound missions. As such, the relatively few in-flight photographs documenting these explorers inside their spacecraft, embarking upon arguably the greatest ever human expedition, show little context and tend to be blurred, dark and out of focus.

Fortunately, a 16mm "movie" camera was included to supplement the medium-format 70mm still cameras. While the 16mm Data Acquisition Camera (DAC) was intended to record sequences of events, such as vehicle rendezvous and docking, for engineering assessment, its wider-angle lenses also captured brief moments inside the spacecraft. Despite capturing the internal space more successfully, however, the 16mm film suffers from comparatively more image noise and a lack of detail inherent in smaller-format film.

Trying to recreate a sense of intimacy, I have undertaken a rigorous and transformative process to enhance this film, and have included the results alongside the still photographs. I have applied an image-stacking principle, often employed in astrophotography, to the highest-quality, uncompressed HD digital transfers of the flight film. Over recent years I have evolved this process and developed the techniques to effectively apply this principle to more dynamic scenes, especially for this unique historical footage. As many as several hundred separate frames are stacked, aligned and processed to produce a more photo-like output, revealing detail that has been lost for half a century.

Only around ten hours of 16mm footage, spread across the whole Apollo program were captured. I have inspected the source film in its entirety, in places frame-by-frame, to identify key detail. The innate desire to see inside the spacecraft, to appreciate what our first Moon-bound vehicles of the 1960s looked like, and to observe life on board these journeys drove my selection. In this book you will find scenes well suited to the stacking technique, revealing significant historical moments, and conveying the human aspect, or the spacecraft interior with its myriad analog dials and switches.

During some of the more critical mission events, the crews were too engaged in the activity to record their actions with their still cameras. Since the 16mm DAC camera was often mounted to the spacecraft, running automatically at a low frame rate, it occasionally captured these moments that the still cameras did not – albeit on only a handful of frames. These fleeting moments, which include some of the most significant in the history of flight, have also undergone this stacking process, despite the lower frame count.

I have organized all the selected imagery from the 70mm still cameras and 16mm DAC footage by mission. This includes a selection from the "pre-Apollo" Mercury and Gemini programs, which contribute to the story of our efforts to

reach for the Moon. At the end of the "pre-Apollo" section I have also included some images from the uncrewed Apollo test flights, before Apollo 7 commenced with the first crewed mission in October, 1968. Every Apollo mission through to Apollo 17, which splashed down on the 19th December, 1972, is then covered.

Within each mission chapter, but for a few exceptions, I have made every effort to present the images chronologically. They feature every human who has made the journey from the Earth to the Moon. Mission transcripts – the records of in-flight communications (including with Mission Control) – are one source I studied to determine not only the order of events and when images were taken, but the photographer responsible, the content conveyed, and pertinent quotes from those who were there at the moment the images were captured. The aim is to add context and perspective to the scene and to help better comprehend what it would be like to witness the events first-hand. Following the images and captions in sequence tells not only the story of each mission, but also of the whole progression from our first-ever glimpses of the curvature of Earth, to taking one giant leap by setting foot upon the Moon.

The images from NASA's early space missions offer an intoxicating mix of the pioneering, pre-digital 1960s era, with analog film photography capturing stunning other-worldly vistas, pre-computer-designed spacecraft and technology. The technical proficiency in their taking, combined with the quality of the equipment used, produced images so crisp they border on the surreal. NASA was at the forefront of photographic technology, using some of the best cameras and photographic film stocks of the day, modified to their specification and meticulously processed in the most advanced photo lab available. That very film, literally frozen in time for half a century, is the source of the photographs in this book.

My aim here is to present the best of the many thousands that were captured, in the greatest detail and clarity attainable, so that we may try to gain an understanding of the endeavor and imagine making the incredible journey ourselves. To view the curvature of Earth from space and watch as it sinks away into the blackness. To peer down in wonder at the Moon from 60 miles and watch in awe as the colorful Earth rises above the lunar horizon, then enter a flying machine designed specifically to deliver us to its surface. To glimpse the hostile, desolate environment through its triangular windows, before opening the hatch and stepping out onto the Moon itself. To observe the fine lunar dust under our feet then take in the full vista of this eerily beautiful landscape. To make fresh footprints and tracks on a pristine celestial body, untouched for 4.5 billion years. To marvel at the grandeur and scale as we stand on the edge of huge craters and rilles and gaze up at towering mountains, absorbing the magnificent desolation of this alien world. Or, simply observe, as Neil Armstrong and his fellow space explorers descend the ladder, and peer through the lens of their cameras.

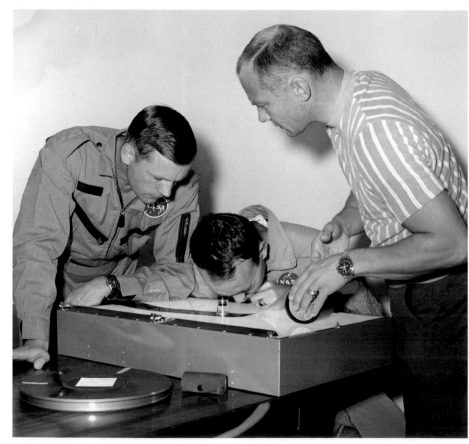

ABOVE: THE CREW OF APOLLO 11 INSPECT COPIES OF THEIR FILM AFTER RETURNING TO EARTH

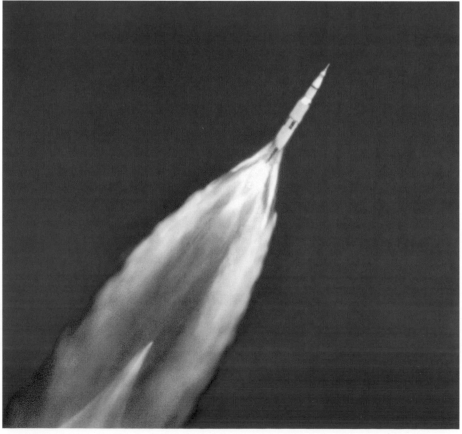

ABOVE: THE APOLLO 11 SATURN V ON A TOWER OF FLAME BEGINS ITS JOURNEY FROM THE EARTH TO THE MOON.

TO MAKE THE JOURNEY FROM THE EARTH TO THE MOON

From Earth orbit, Ken Mattingly was awestruck: "I can't get over the view of that Earth. None of the pictures just do it justice. Absolutely beautiful!" Upon escaping Earth's grasp, despite traveling at thousands of miles per hour, there was no atmosphere and no wind noise to give any impression of movement. Rather than speeding toward the Moon, the crews felt more that they were watching Earth simply sink away into the blackness. Apollo 17 Commander Gene Cernan confirmed that every astronaut that had ventured to lunar distance was amazed by the beauty of Earth and it was the single thing he most cherished from his missions. Apollo 13 Commander Jim Lovell was struck by the concept that he could completely cover Earth with just his outstretched thumb – everyone alive, everyone that's ever lived, everything we know and love, music, art, birth, death, joy; everything that has been or will ever be, blotted out in an instant. Without its presence there was nothing but the hostile, colorless, silent, lifeless blackness of space. Apollo 14's Stuart Roosa was impacted by this view in other ways too: "It's the abject smallness of the Earth that gets you . . . It's the feeling of knowing you're *that* far away from home."

On entering lunar orbit, having barely seen the Moon during the long journey, Apollo 8's Bill Anders, among others, described the impact of becoming aware of its presence. With the absence of the Sun, entering into the shadow of the Moon, the blackest of black skies imaginable became punctuated with millions of stars, more than can be seen from anywhere on Earth. The exception, as seen from the Command Module's window, was a large void, where the light from the stars was absent. The realization that this was the Moon was profound; they could almost feel the presence of this mass of rock that has orbited our Earth for billions of years. Anders would later recall: "That was the only time in the flight the hair kind of came up on the back of my neck."

When crossing into darkness on the near side, the Moonscape was bathed in a soft blue light reflected from Earth; Mattingly likened this to flying over a moonlit field of snow back home, telling author Andrew Chaikin: "You get this *magic* terrain." This Earthlight effect also left a lasting impression on Neil Armstrong during Apollo 11, when, during trans-lunar coast, the Moon crossed in front of the Sun: "It was the most beautiful sight I'd ever seen."

On the surface, upon donning their protective suits and helmets, the astronauts descended the ladder and stepped into the airless void to experience this alien world up close. Aldrin described the scene at the time as "magnificent desolation," while others were struck by its surreal beauty. From inside their helmets, with only a gentle breeze of oxygen on their face, beyond their own breathing there was silence, punctuated only by the crackled voice transmissions from Earth and their crewmates in their radio headsets. Even with their gold protective visor down, the crystal-clear view of the lunar landscapes in the airless environment was a shock to the senses. Yet many were still drawn to Earth.

The first American in space and renowned no-nonsense test pilot, Alan Shepard, was taken aback, explaining after his Apollo 14 mission: "If somebody'd said before the flight, 'Are you going to get carried away looking at the Earth from the Moon?' I would have said, 'No, no way.' Yet when I first looked back at the Earth, standing on the surface of the Moon, I cried." Crewmate Edgar Mitchell's feelings were more of frustration: "You develop an instant global consciousness, a people orientation, an intense dissatisfaction with the state of the world, and a compulsion to do something about it. From out there on the Moon, international politics look so petty. You want to grab a politician by the scruff of the neck and drag him a quarter of a million miles out and say, 'Look at *that*, you son of a bitch!'"

Sleeping on the Moon was easier for some than for others. Cernan used the time to contemplate: "There you were, a quarter of a million miles from Earth, laying in a hammock in a little tin can . . . [thinking], 'Here I am; I'm really on the Moon. What should I be doing that I'm not doing? How can I take advantage of this? Is it real? Is it a dream?'" For crewmate Jack Schmitt, waking to the humming sounds from the fans and pumps in the Lunar Module was a comfort, while to Armstrong they were an annoyance.

It was leaving the grasps of lunar orbit that afforded some of the most spectacular views of the Moon in its entirety. The incredible sight was also met with mixed emotions. The mission was almost complete, home beckoned, yet there was a realization they would almost certainly never return to this fascinating place. Most acutely felt on Apollo 17, as humans left the Moon for the last time.

Few Apollo astronauts have spoken more openly about the impact their experience and the sights they witnessed had on them than Apollo 9's Rusty Schweickart. During his spacewalk, as Dave Scott attempted to fix a jammed 16mm magazine, Schweickart was gifted a few minutes of relative peace. He released his right hand from the Lunar Module handrail, opening up his body to face toward Earth. Remaining motionless, his roomy pressurized suit effectively became an extended small spacecraft inside which his body floated freely. Feeling almost naked, and in a depth of silence he'd never experienced, floating above Earth, traveling at over 17,000mph, he was awestruck with the incredible view and what this moment represented.

In an interview during the XPrize Insights series, he explained this epiphany: "The view out the helmet is totally unobstructed . . . It was a time when I said, OK I'm just going to be a human being here and look at what's happening . . . How did I get here? Humanity has reached this point where we're moving out from the Earth, and I'm a small part of that but that's what's going on, and how does that happen in history, and what does it mean? . . . Am I me or am I us? – It's very clear that you're there as a representative of humankind." Schweickart described to me the visual experience during this moment: "The thing that really stands out, aside from just the sheer beauty of the Earth, was the brightness of the atmosphere at the horizon; you know that iridescent blue line, and the contrast with the black, and the contrast between the visual and the fact there is *no* noise – there's no air rushing by you and the radios were voice activated, so when nobody was talking it was totally silent; and you couldn't hear anything in the backpack, so the complete silence in contrast with that visual was something else . . . And that horizon line is very thin; it's a very, very impressive line, let me put it that way . . . when you realize what that beautiful blue line is and what it represents. I mean that's a powerful realization."

Schweickart recommends looking through the images in this book late at night; when all around is dark and totally silent, allowing us all to put ourselves in the position of the few who experienced these historic moments during our first journeys from the Earth to the Moon.

May 5, 1961–November 15, 1966

PRE-APOLLO

THE MISSIONS

When President Kennedy announced his plan to land a man on the Moon by the end of the decade, NASA required significantly more than its 15 minutes of spaceflight experience (Alan Shepard's suborbital mission). There was no known predetermined path to the Moon, so NASA would need to progress through an accelerated program of test flights and crewed missions. Each mission built upon the last, pushing the boundaries further, testing new hardware, launching increasingly larger payloads on bigger rockets which sent more astronauts for longer periods in space.

By the end of 1962, the basic fundamentals of Project Apollo had been determined. The remainder of Project Mercury and the whole of Project Gemini were focused on gaining experience to allow Project Apollo to complete the objective.

Project Mercury consisted of six crewed flights (in addition to many uncrewed test flights), each carrying a single astronaut. Alan Shepard, who would later walk on the Moon on Apollo 14, became the first American in space during his short suborbital flight in May 1961. Gus Grissom followed, before John Glenn became the first American to orbit Earth, in February 1962. Further orbital missions were accomplished by Scott Carpenter and Wally Schirra, who would later command Apollo 7. By the time Gordon Cooper splashed down, completing the final Mercury flight in May 1963, missions of up to 34 hours had been accomplished. An astronaut had slept in space, orbited Earth 22 times in one mission and could take hundreds of photographs of Earth through the capsule window.

Having reached the limit of the Atlas rocket and one-man Mercury capsule, Project Gemini would adopt an Intercontinental Ballistic Missile, the Titan II rocket, to launch the larger, two-man Gemini capsule.

Project Gemini consisted of ten crewed flights, each carrying two astronauts. The program was entirely focused on proving the techniques required to allow Project Apollo to carry out missions to the Moon. These included long-duration missions, beyond the eight days required for a round trip to the Moon, and EVAs (Extravehicular Activity) to demonstrate how humans could maneuver and work effectively outside the protective environment of their spacecraft, as well as orbital maneuvers (including rendezvous and docking) and atmospheric re-entry techniques.

The ten missions were completed at an incredible rate, all accomplished between March 1965 and November 1966, each mission building on the last, and they were crammed with objectives.

The program was not without serious incident and significant challenges. Two of the six Agena target rendezvous vehicles suffered launch failures. On Gemini VIII, Neil Armstrong and Dave Scott were fortunate to escape with their lives when their docked spacecraft started to tumble out of control. And Gene Cernan became dangerously overheated and exhausted in his cumbersome spacesuit while out on his two-hour spacewalk; only the third in history.

Project Gemini ultimately succeeded in building upon the pioneering Mercury missions, progressing spaceflight techniques and experience sufficiently to pave the way for the upcoming Apollo missions, and the first human voyages to the Moon.

THE PHOTOGRAPHY

The photographs taken during the Mercury and Gemini missions document some of the most important moments in the history of spaceflight. Although photography was not considered a priority by NASA in the early years, every mission carried photographic equipment.

Stunning photographs of our own planet were taken throughout Project Gemini. The Hasselblad SWC (Super Wide Camera) was perfectly suited to spaceflight, capturing some awe-inspiring images of the capsule in orbit, while Buzz Aldrin made use of its wide-angle capability to take the first selfie in space. Disappointingly, the SWC never made it onto Apollo's Moon-bound voyages.

Before the end of Project Gemini, uncrewed Apollo test flights were being undertaken in preparation for the first crewed missions. Automatic onboard cameras captured astonishing 16mm footage of the Saturn rocket's staging and offered a tantalizing indication of the spectacular images anticipated from the upcoming Apollo program.

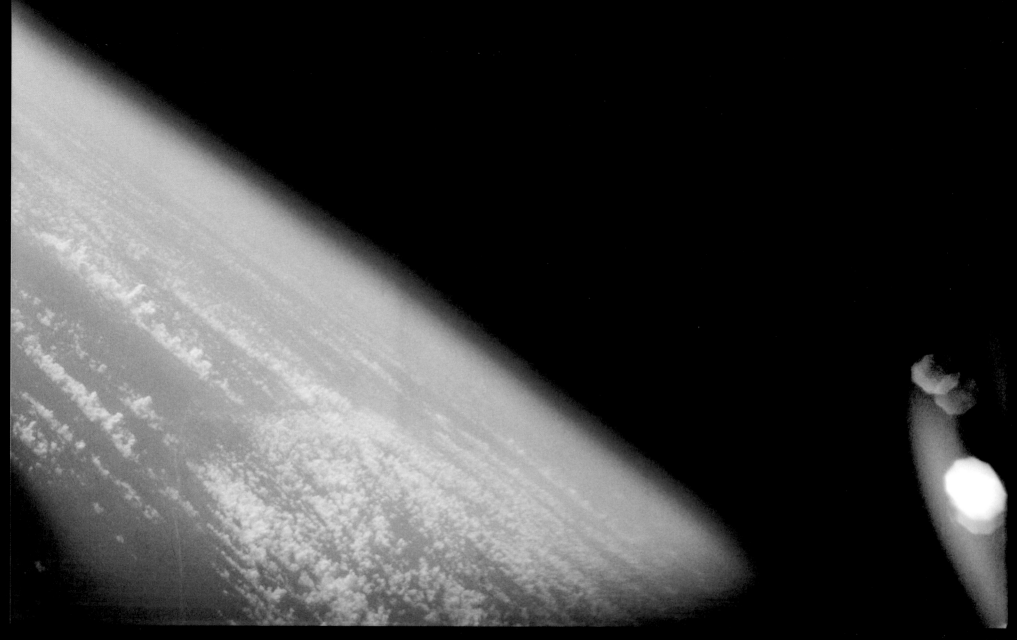

May 5, 1961

MAURER 220G 70MM. LENS 75MM F/2.8 | BY AUTO TIME-LAPSE

NASA ID: MR-3-13012-039

Mercury-Redstone 3. Alan Shepard became the first American in space on this short, suborbital mission. Yuri Gagarin's Vostok 1 flight a month earlier didn't carry a film camera. As such, the series of photographs on Shepard's flight, taken automatically by a time-lapse camera pointed through a porthole in the capsule, were the first to show the curvature of Earth on a human spaceflight. The mission timer can be seen, upper right. *(EL: 3/5)*

February 20, 1962 ANSCO AUTOSET 35MM. LENS 50MM F/2.8 | BY JOHN GLENN NASA ID: MA-6-40452-023

Mercury-Atlas 6. This was NASA's first orbital manned mission. John Glenn took it upon himself to purchase a $40 Ansco Autoset 35mm camera from a local drugstore. It was crudely adapted with a pistol grip to make it easier to use with gloved hands in the cramped capsule. Aiming the camera through the Mercury capsule window, he took the first photographs of sunrise/sunset from space. *(Rotated, EL: 4/5)*

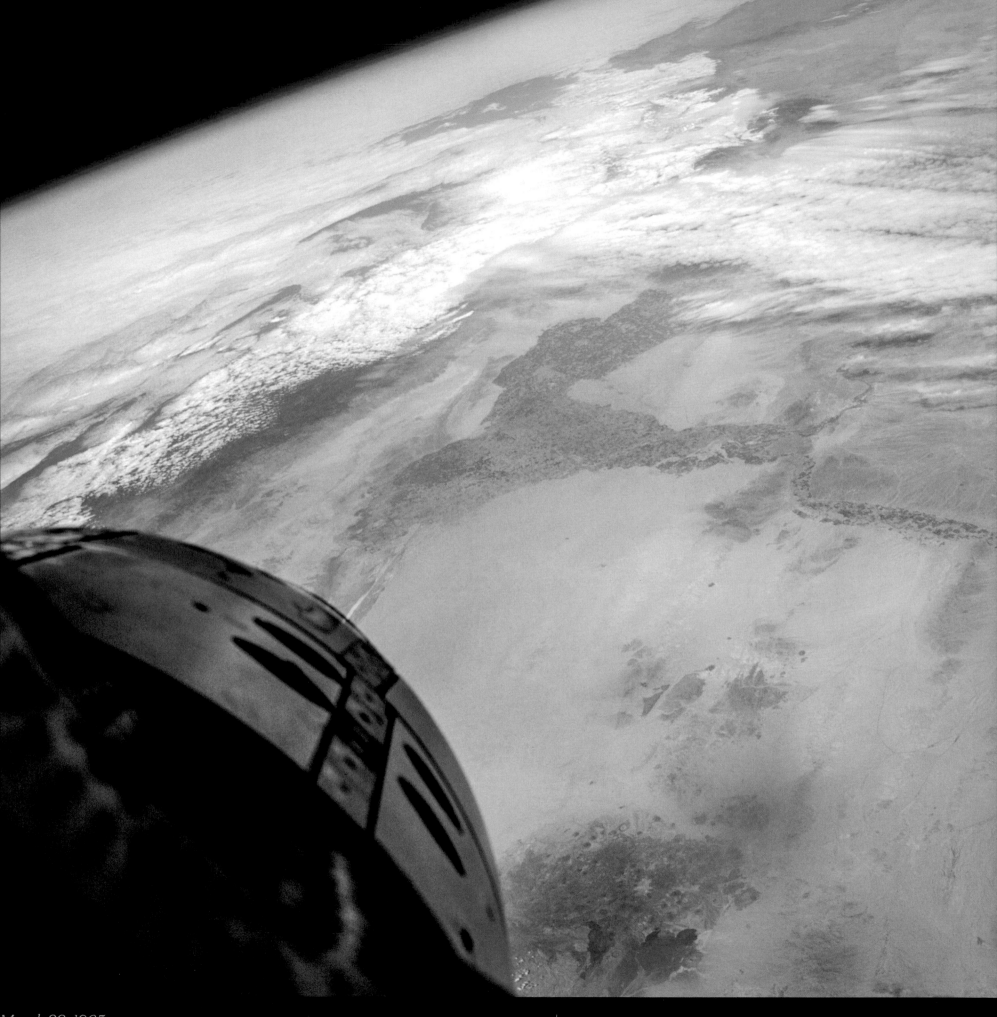

March 23, 1965 HASSELBLAD 70MM. LENS 80MM F/2.8 │ BY JOHN YOUNG NASA ID: S65-18743

Gemini III. NASA's first crewed Gemini mission and their first carrying two astronauts: Gus Grissom and John Young. Reaching the Moon would require long-duration spaceflight, involving multiple crewmembers. The mission performed the world's first orbital maneuver. Grissom would later be tragically killed in the Apollo 1 fire, Young would walk on the Moon as Commander of Apollo 16. *(EL: 3/5)*

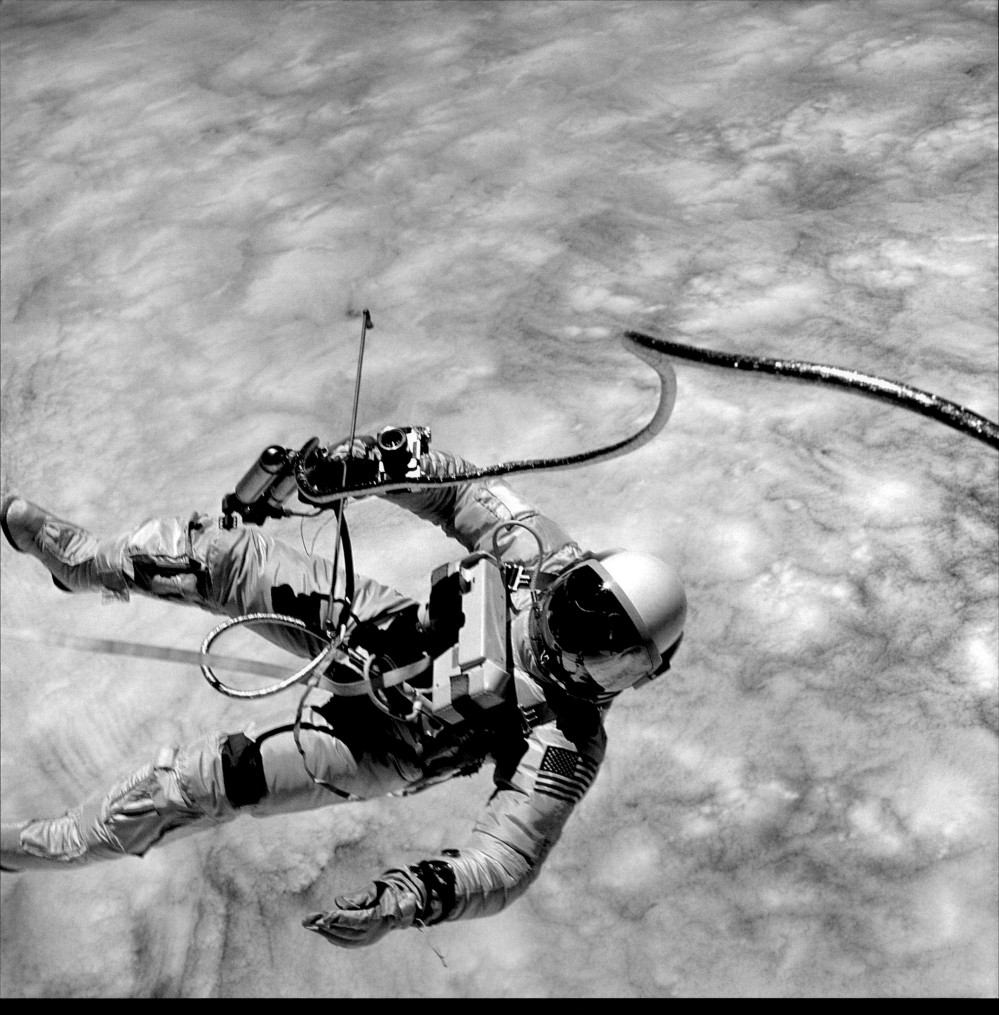

June 3–7, 1965 HASSELBLAD 70MM. LENS 80MM F/2.8 | BY JIM McDIVITT NASA ID: **S65-30427**

Gemini IV. Walking on the Moon would ultimately require humans to operate outside the protective environment of their spacecraft. Eleven weeks after Alexi Leonov performed the world's first spacewalk, the U.S. followed suit as Ed White floated out of the hatch into the void for a 23-minute EVA. This is the first portrait taken by another human in space, and the first photograph of a U.S. flag in space. Note the spacecraft reflected in White's visor. *(EL: 3/5)*

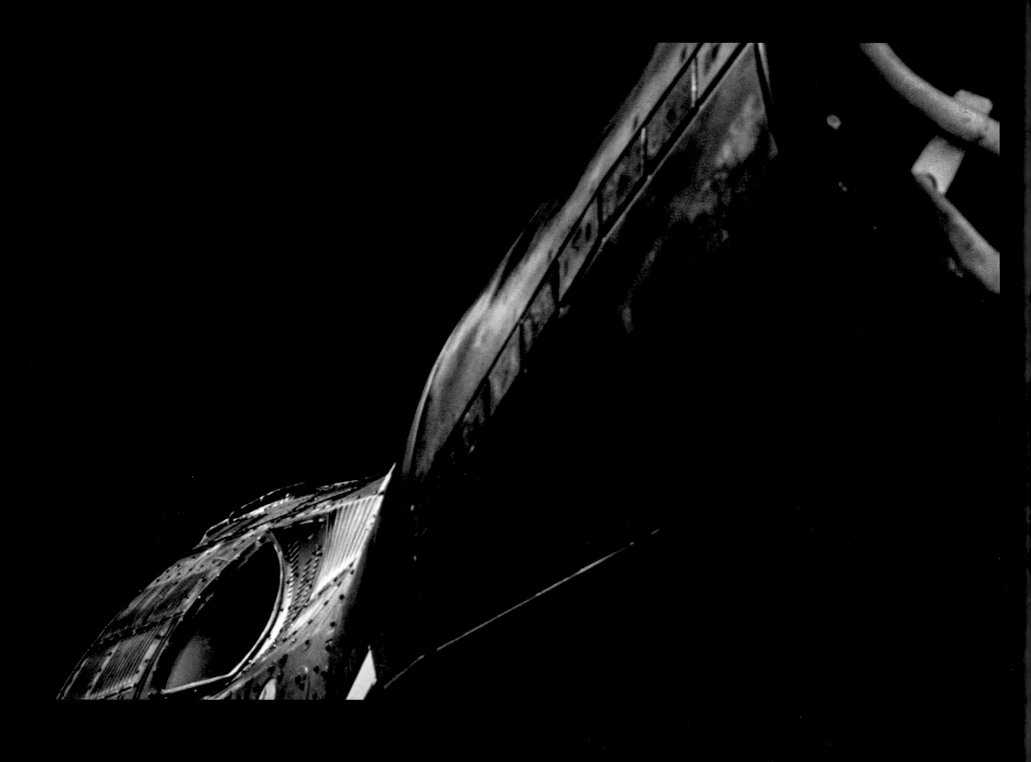

June 3–7, 1965　　　　　　　　　ZEISS IKON CONTAREX 35MM. LENS 50MM F/2 | BY ED WHITE　　　　　　　　NASA ID: GT4-37199-002

Gemini IV. NASA's first spacewalk was an opportunity to photograph the outside of the spacecraft, to assess any effects of launch before a fiery re-entry wiped away any evidence. White was equipped with a Zeiss Ikon Contarex 35mm camera fixed to his compressed gas, hand-held maneuvering unit. He took this atmospheric portrait of his Gemini spacecraft as he floated toward the top of the capsule, where the landing system was housed. *(EL: 5/5)*

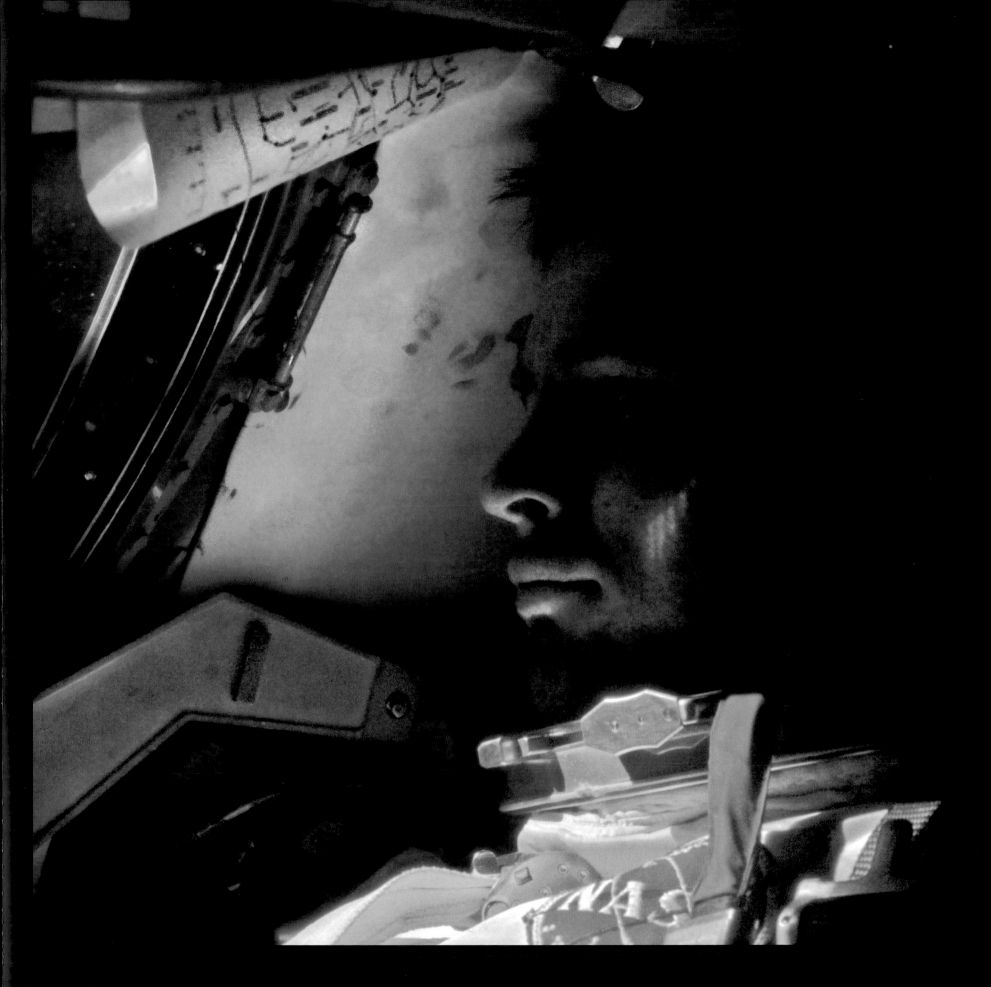

June 3–7, 1965 ZEISS IKON CONTAREX 35MM. LENS 50MM F/2 | BY JIM McDIVITT NASA ID: **GT4-37149-014 & 016**

Gemini IV. Ed White gazes out into the heavens from his Gemini capsule. A star map can be seen above his head. White said that coming in from the EVA was the saddest day of his life. He was killed alongside crewmates Grissom and Roger Chaffee in the Apollo 1 fire two years later. *(Panorama, EL: 5/5)*

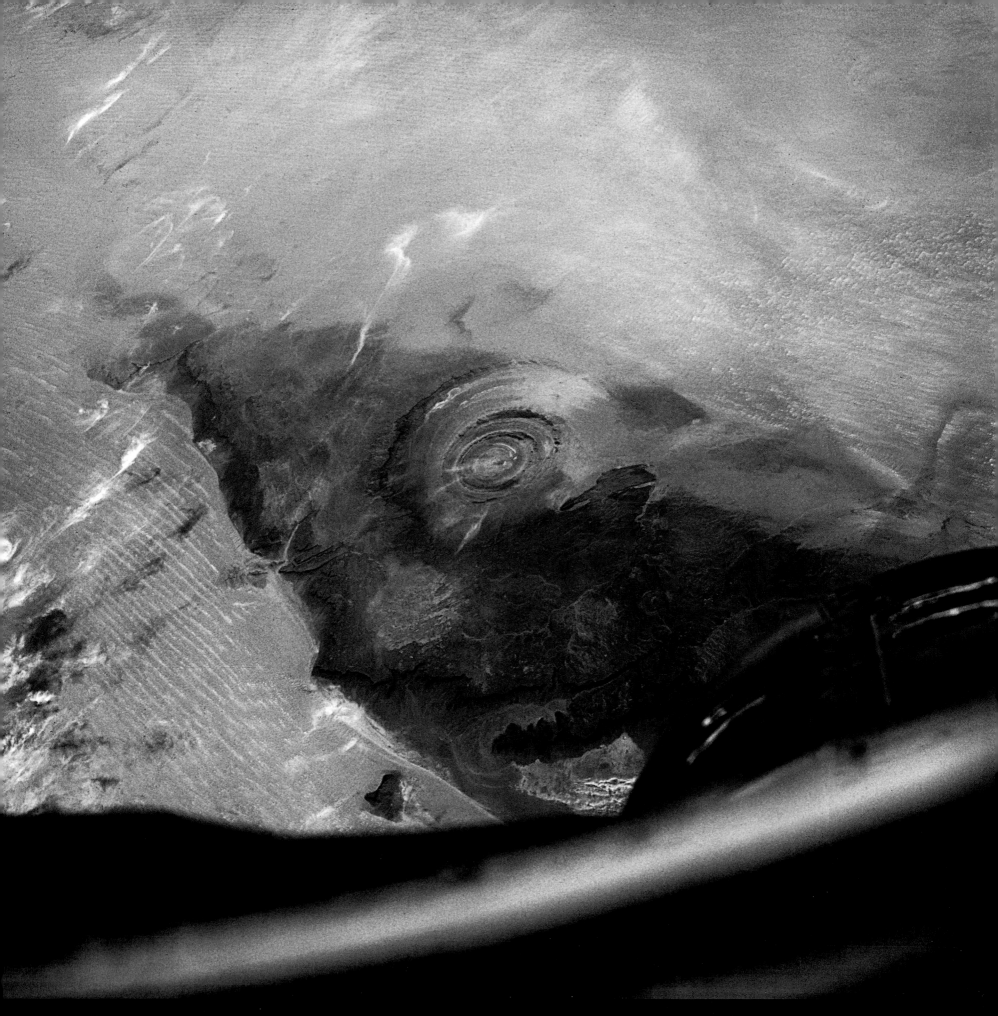

June 3–7, 1965 HASSELBLAD 70MM. LENS 80MM F/2.8 | BY JIM McDIVITT NASA ID: S65-3467C

Gemini IV. Mission Control: "Have you taken any pictures yet? . . . Has your weather been good around the orbit?" Due to the overwhelming timeframes associated with the race to the Moon, every spaceflight pushed the boundaries and was packed with mission objectives. The crew replied: "Frankly, we really had time to look out too much." When they did, they were created with views of Earth, such as here, the "Eye of Africa" – the Richat Structure, Mauritania. (Rotated. Fly 5/5)

August 21–29, 1965　　　　　　　HASSELBLAD 70MM. LENS 80MM F/2.8 | BY UNKNOWN　　　　　　　NASA ID: **S65-45721**

Gemini V. This was the first week-long stay in space, crewed by Mercury astronaut Gordon Cooper and Pete Conrad, who would later walk on the Moon as Commander of Apollo 12. The spectacular images from Gemini IV convinced NASA of the importance of space photography, especially from a public affairs perspective. The longer-duration missions also afforded more time to undertake photography of Earth, such as this image of the Kavir Salt Flats, Iran. *(EL: 5/5)*

December 4–18, 1965 HASSELBLAD 70MM. LENS 80MM F/2.8 | BY JIM LOVELL NASA ID: **S65-63873**

Gemini VII. Destination Moon. Rendezvous of two vehicles in space was an essential element of NASA's plans for the Apollo missions to the Moon. The crew of Frank Borman and Jim Lovell would perform the world's first rendezvous in space with Gemini VI-A, launched out of sequence 11 days later. Lovell and Borman would later join Bill Anders to crew humankind's first voyage beyond the confines of Earth, to the Moon on Apollo 8. Lovell would also command the ill-fated Apollo 13. *(Rotated, EL: 3/5)*

December 15–16, 1965

HASSELBLAD 70MM. LENS 80MM F/2.8 | BY UNKNOWN

NASA ID: **S65-63201**

Gemini VI-A. An ethereal view of the Gemini VII capsule, with Borman and Lovell on board, as it "hangs" in the blackness of space, backlit by the Sun. It was taken during stationkeeping after the world's first rendezvous in space was achieved. Gemini VI-A was crewed by Mercury astronaut Wally Schirra, who was instrumental in the selection of the Hasselblad cameras for use in space, and Tom Stafford. Schirra would later command the first Apollo mission (Apollo 7) and Stafford would fly to the Moon on Apollo 10. *(FL: 4/5)*

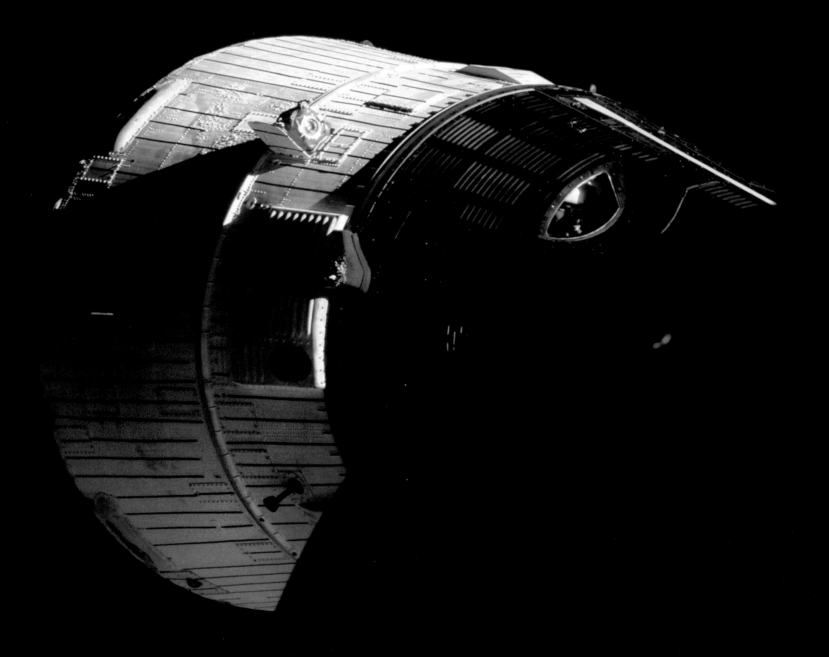

December 15–16, 1965 HASSELBLAD 70MM. LENS 80MM F/2.8 | PROBABLY BY WALLY SCHIRRA NASA ID: S65-63192

Gemini VI-A. At the closest point, Gemini VI-A and Gemini VII were just 12 inches apart, flying at over 17,000 mph high above the Pacific Ocean. Here, Lovell is clearly visible in the right-hand window as he photographs back at Gemini VI-A. Schirra joked about the beards developed by the Gemini VII crew during their two weeks in orbit, which he could observe through their windows. The two spacecraft continued to stationkeep for three orbits. *(Cropped, rotated, EL: 4/5)*

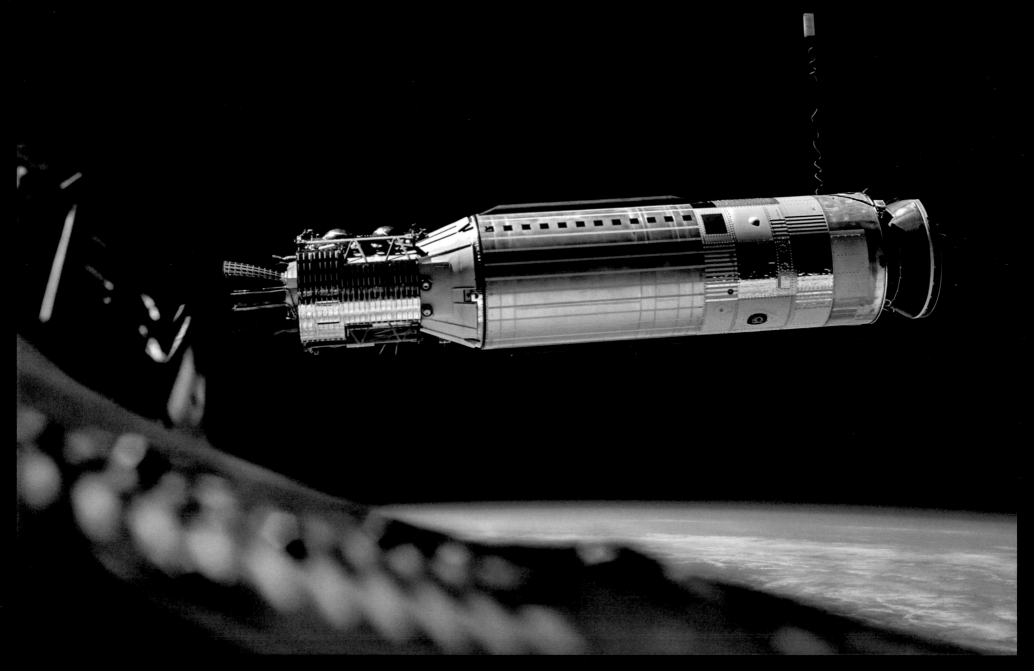

March 16–17, 1966

HASSELBLAD 70MM. LENS 80MM F/2.8 | BY DAVE SCOTT

NASA ID: S66-25782

Gemini VIII. The world's first hard docking in space was the next critical milestone toward lunar mission capability. The task fell to Neil Armstrong and Dave Scott. Shortly after the successful docking with the uncrewed Agena target vehicle, disaster struck when they started to tumble out of control. After separating from the Agena, Gemini VIII tumbled even faster, end over end at up to one revolution per second. Almost passing out, Armstrong's quick thinking and skill saved their lives, switching to re-entry thrusters to bring the spacecraft back under control. *(EL: 3/5)*

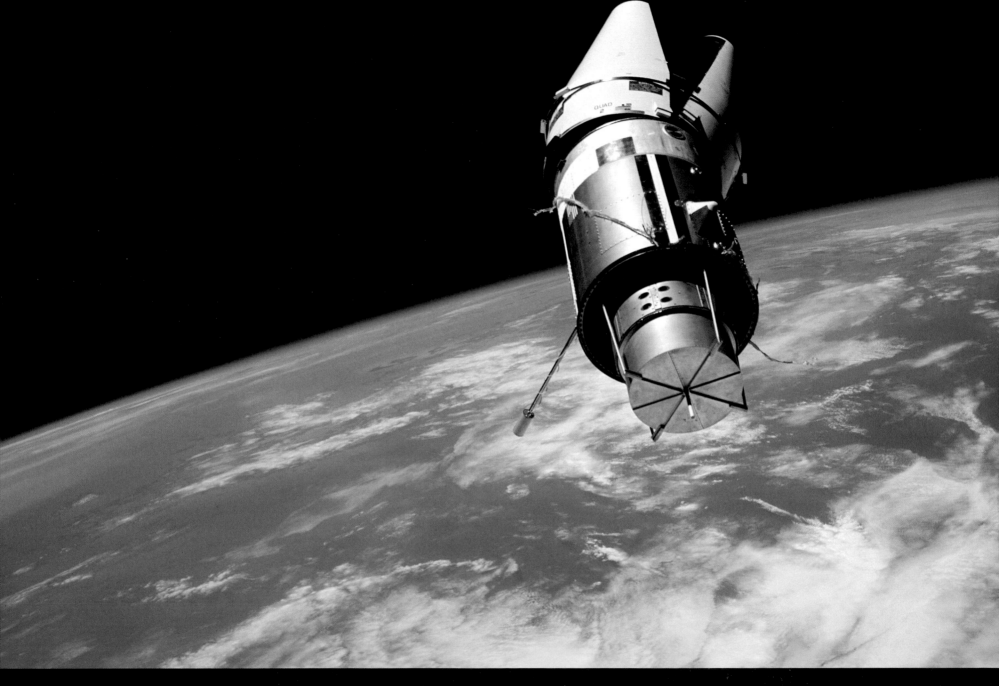

June 3–6, 1966　　　　　　　　HASSELBLAD 70MM. LENS 80MM F/2.8 | BY UNKNOWN　　　　　　　　NASA ID: S66-37970

Gemini IX-A. The tragic loss of Elliot See and Charles Bassett in their T-38 training jet, on the way to inspect their spacecraft, bumped back-up crew Tom Stafford and Gene Cernan up to prime crew. After their Agena target vehicle was destroyed following a launch failure, the back-up ATDA (Augmented Target Docking Adapter) vehicle's fairings failed to fully separate, making docking impossible. Stafford: "It looks like an angry alligator out here rotating around!" (EL: 275)

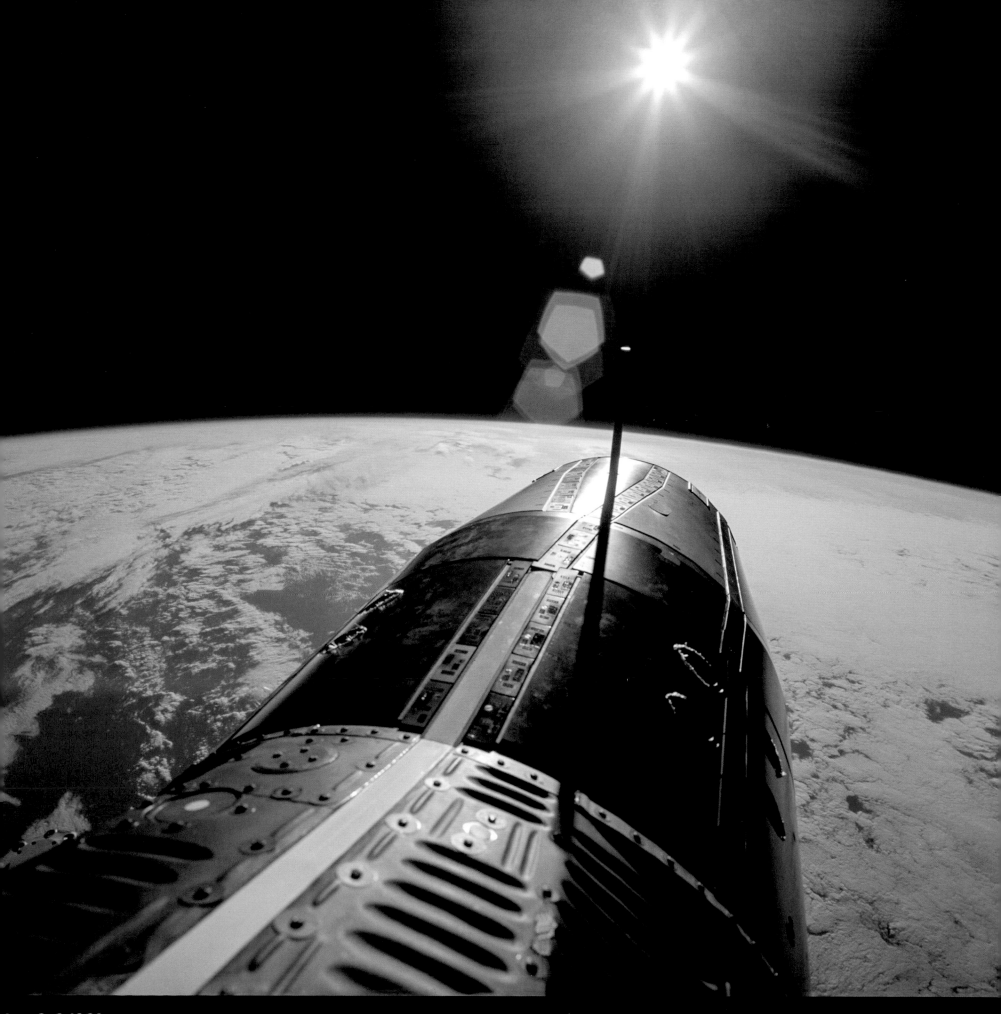

June 3–6, 1966　　　　HASSELBLAD SWC 70MM. LENS 38MM F/4.5 | BY GENE CERNAN　　　　NASA ID: S66-38032

Gemini IX-A. Taken by Cernan, standing in the hatch of the Gemini capsule over the Pacific Ocean at the start of a two-hour EVA. The Hasselblad Super Wide Camera (SWC) captures much of the capsule in terrific detail, set against the blue ocean-covered Earth. Note the apparently rudimentary construction of panels and fixings. (FL: 5/5)

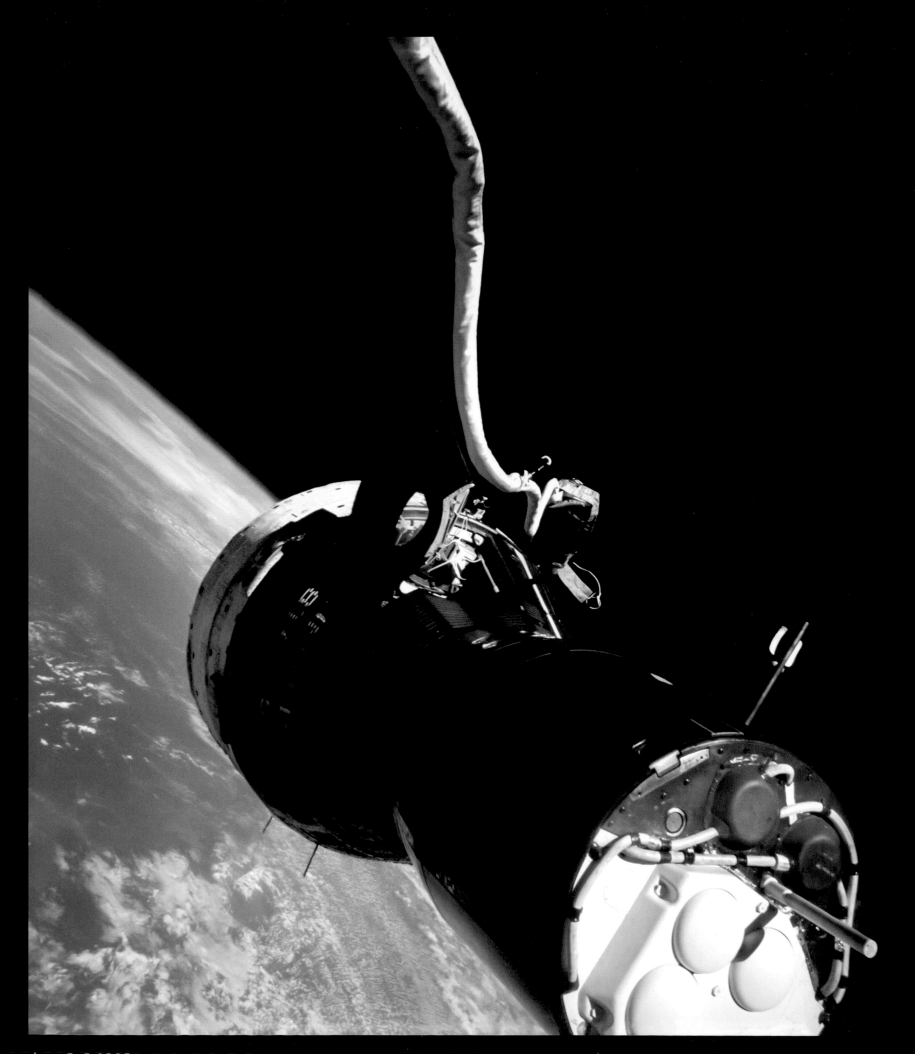

June 3–6, 1966 HASSELBLAD SWC 70MM. LENS 38MM F/4.5 | BY GENE CERNAN NASA ID: S66-38048

Gemini IX-A. Cernan's breathtaking view of his Gemini capsule, with Stafford on board, orbiting 148 miles above Earth at over 17,000mph, during his grueling EVA. Command Pilot Stafford would cut the spacewalk short as Cernan suffered severe exhaustion and overheating, describing his suit flexibility as akin to a rusty suit of armor. He also became effectively blind as his perspiration in an overworked air-cooled suit caused his helmet to completely fog over. The Apollo EVA suit would be more flexible and water-cooled. (EL: 5/5)

July 18–21, 1966 HASSELBLAD SWC 70MM. LENS 38MM F/4.5 | BY MICHAEL COLLINS NASA ID: S66-46249

Gemini X. The firing of the docked Agena, which threw the crew of John Young and Michael Collins forward into their restraining belts and to a new altitude record of 412 nautical miles. Young: "Fire and sparks started coming out of the back end of that rascal. The light was something fierce . . ." Collins (later CMP on Apollo 11) performed a spacewalk over to a second Agena; to date the only spacewalk not captured with photographs as he lost his Hasselblad SWC in the process. *(EL: 3/5)*

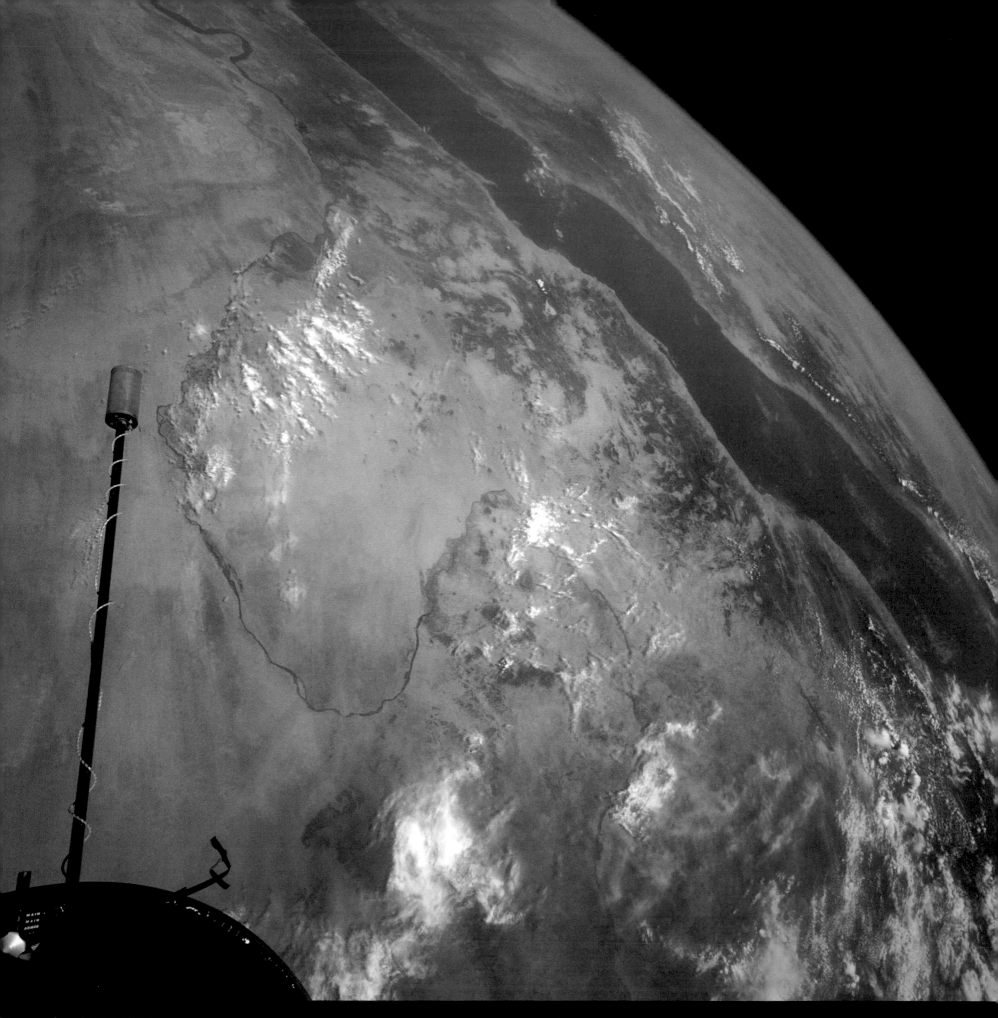

September 12–15, 1966 HASSELBLAD SWC 70MM. LENS 38MM F/4.5 │ BY RICHARD GORDON NASA ID: S66-54531

Gemini XI. "Whoop-de-do!" exclaimed Conrad; after a 26-second burn from the docked Agena, the crew of Pete Conrad and Richard Gordon were treated to this view, 310 miles above Earth That water really stands out and . . . the curvature of Earth." Taken over Sudan, looking east; Egypt is upper left, Ethiopia lower right, the Red Sea upper right and Saudi Arabia under the thin blue atmosphere beyond. The Nile can be seen from the Great Bend at Luxor, upper left, 800 miles to Khartoum, bottom center. (FL: 3/5)

September 12–15, 1966 HASSELBLAD SWC 70MM. LENS 38MM F/4.5 | BY RICHARD GORDON NASA ID: S66-54713

Gemini XI. The 26-second Agena burn continued to push the crew to a record 740 nautical miles above Earth. To the present day, no crew has been higher during an Earth orbit (the International Space Station operates at a third of this altitude). Only by escaping Earth's gravity completely, during the Apollo missions, would humans be farther from home. This atmospheric photograph was taken near apogee over the east coast of Australia as Gemini XI passed into the night side of Earth. Note Gordon's reflection with his Hasselblad SWC. (EL: 5/5)

September 12–15, 1966 HASSELBLAD SWC 70MM. LENS 38MM F/4.5 | BY PETE CONRAD NASA ID: S66-54653

Gemini XI. After another burn from the docked Agena, Gemini XI was brought back to a 160-mile orbit. Gordon would perform his second EVA of the mission. This shot shows him at the start of the EVA. The open hatch is behind his head as the bright white, unfiltered sunlight streams into the capsule. The ink-black void of space is upper right and the control panels above and left. Conrad and Gordon would later join Alan Bean to form the crew of Apollo 12. *(EL: 4/5)*

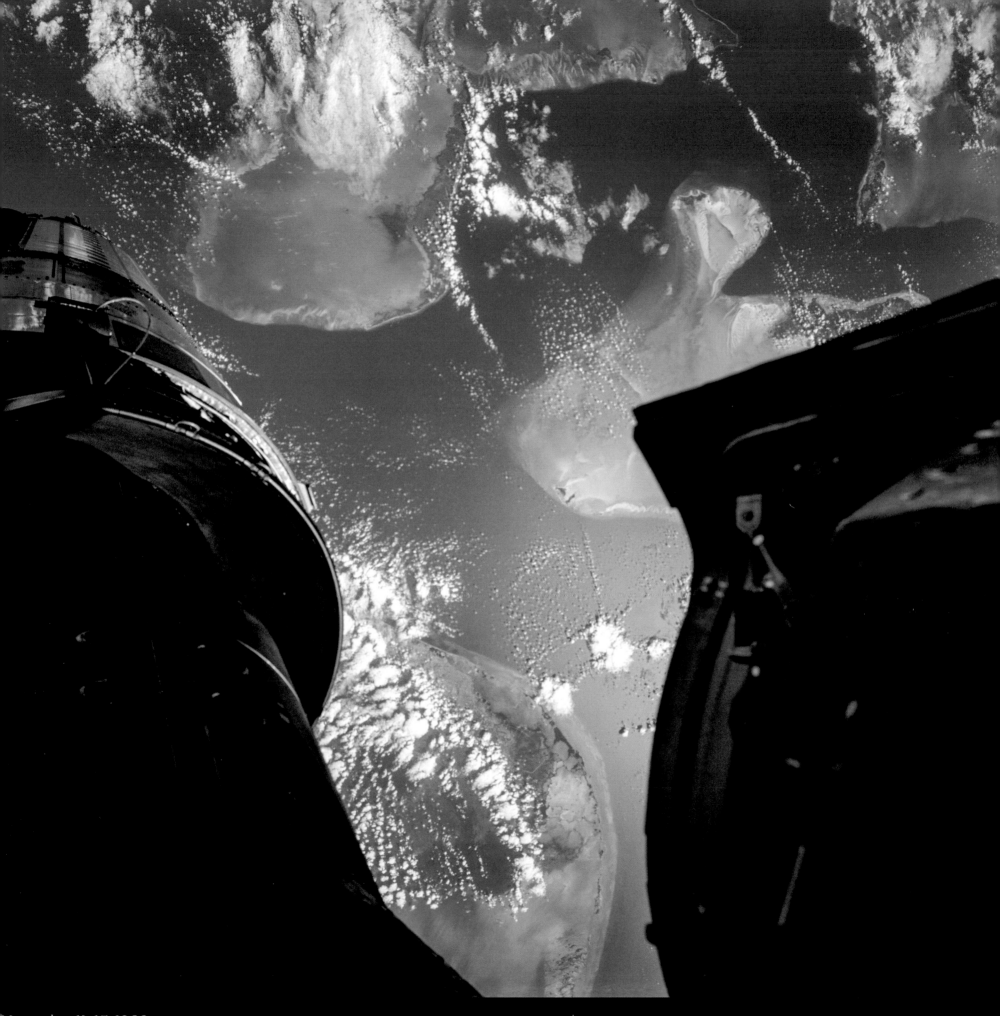

November 11–15, 1966

HASSELBLAD SWC 70MM. LENS 38MM F/4.5 | BY BUZZ ALDRIN

NASA ID: S66-62908

Gemini XII. The final mission of the Gemini program was crewed by Jim Lovell, making his second spaceflight, and Buzz Aldrin, making his first. A key objective was to demonstrate that EVA could be completed more effectively. As a scuba diver, Aldrin pioneered the use of underwater neutral buoyancy training. Restraints were also added to the outside of the capsule. Here, Aldrin opens, then stands in the hatch and appreciates the view of Miami, the Florida Keys and the Bahamas. (EL: 5/5)

November 11–15, 1966 HASSELBLAD SWC 70MM. LENS 38MM F/4.5 | BY BUZZ ALDRIN NASA ID: S66-63451

Gemini XII. This underexposed shot is enhanced to reveal Lovell, in sunglasses, gazing out at Earth through the capsule window. As Command Pilot, Lovell occupied the left-hand seat in the capsule. Aldrin, in the right seat, would undertake the three EVAs, totaling five and a half hours. On Apollo, it would be the Commander who was first out on the EVA, partly due to the Lunar Module (LM) hatch opening to the right, making Armstrong, and not Aldrin (to Armstrong's right), the first man on the Moon. *(EL: 5/5)*

November 11–15, 1966 HASSELBLAD SWC 70MM. LENS 38MM F/4.5 | BY JIM LOVELL NASA ID: **S66-62983**

Gemini XII. Another underexposed photograph in the dark capsule reveals Aldrin (in the right-hand seat) with a pipe in his mouth, resting. Aldrin rarely smoked a pipe but liked to chew on its tip. Floating nearby is his slide-rule. During rendezvous with the Agena, the radar failed to lock on. Applying his MIT doctoral research, Aldrin used a sextant, printed charts and the slide-rule to calculate and undertake a "manual" docking. *(EL: 5/5)*

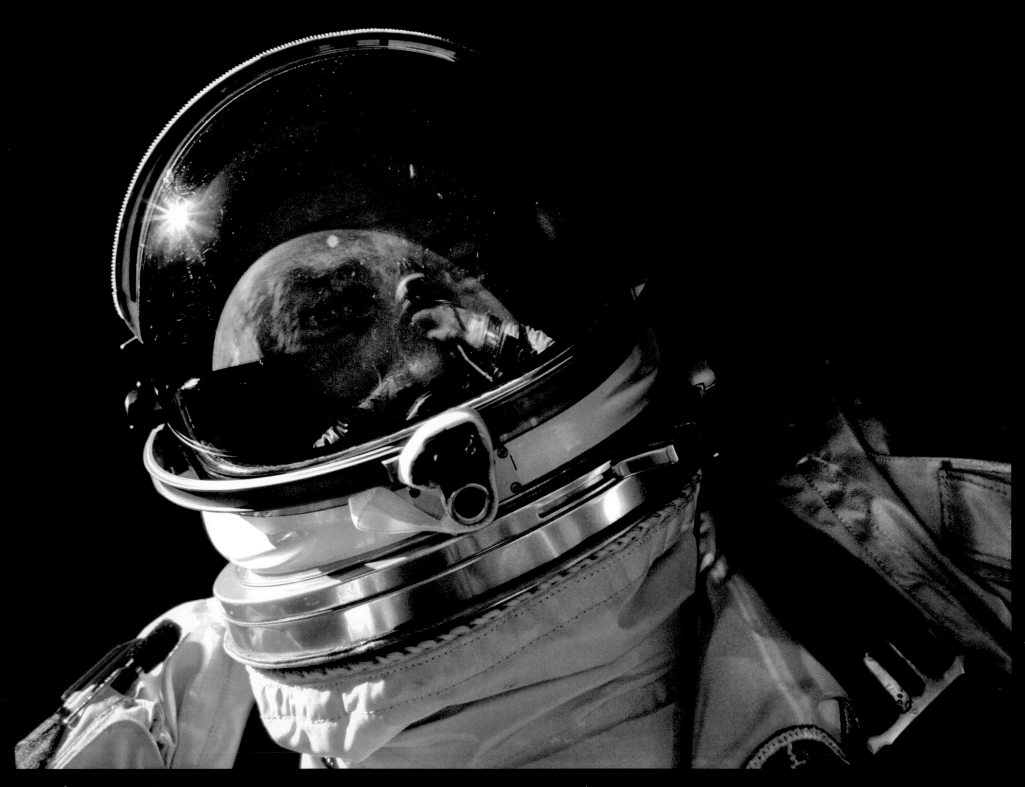

November 11–15, 1966 HASSELBLAD SWC 70MM. LENS 38MM F/4.5 | BY BUZZ ALDRIN NASA ID: **S66-62922**

Gemini XII. The first selfies in space. Aldrin supports his camera on the open hatch and takes a series of photographs of himself, utilizing the wide-angle lens of the Hasselblad SWC. The convex reflection in his visor shows a large portion of Earth below and the Sun above. His left hand is holding the camera on the hatch, and the nose of the Gemini capsule (docked to the Agena) can be seen beyond. *(EL: 5/5)*

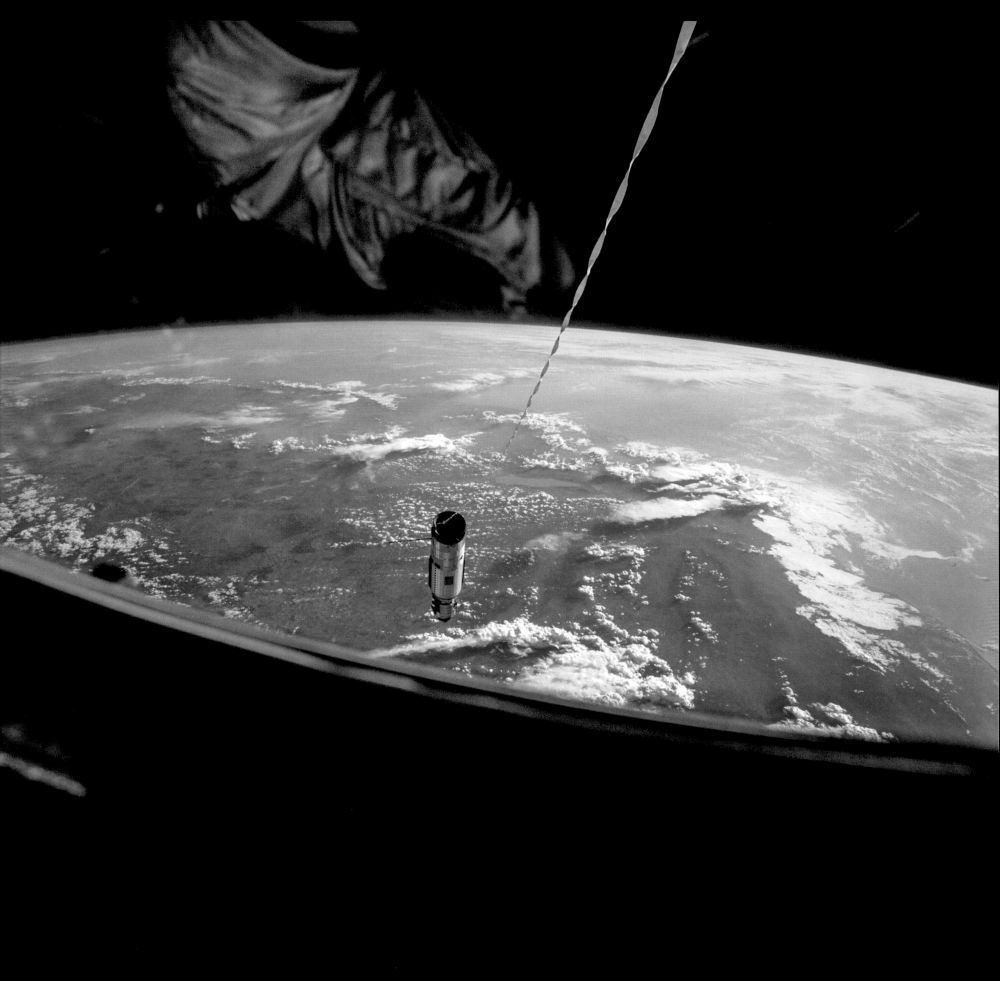

November 11–15, 1966 HASSELBLAD SWC 70MM. LENS 38MM F/4.5 | BY BUZZ ALDRIN NASA ID: S66-63523

Gemini XII. The final Gemini mission included a gravity-gradient experiment. With a 100-foot tether joining the Gemini capsule to the Agena, the crew fired their side thrusters to rotate the combined spacecraft. The centrifugal force created a small amount of artificial gravity. Here, the tethered Agena is seen through the window over Mexico. Completing a highly successful program, NASA's next crewed spaceflight, almost two years later, would be Apollo 7. *(Rotated, EL: 3/5)*

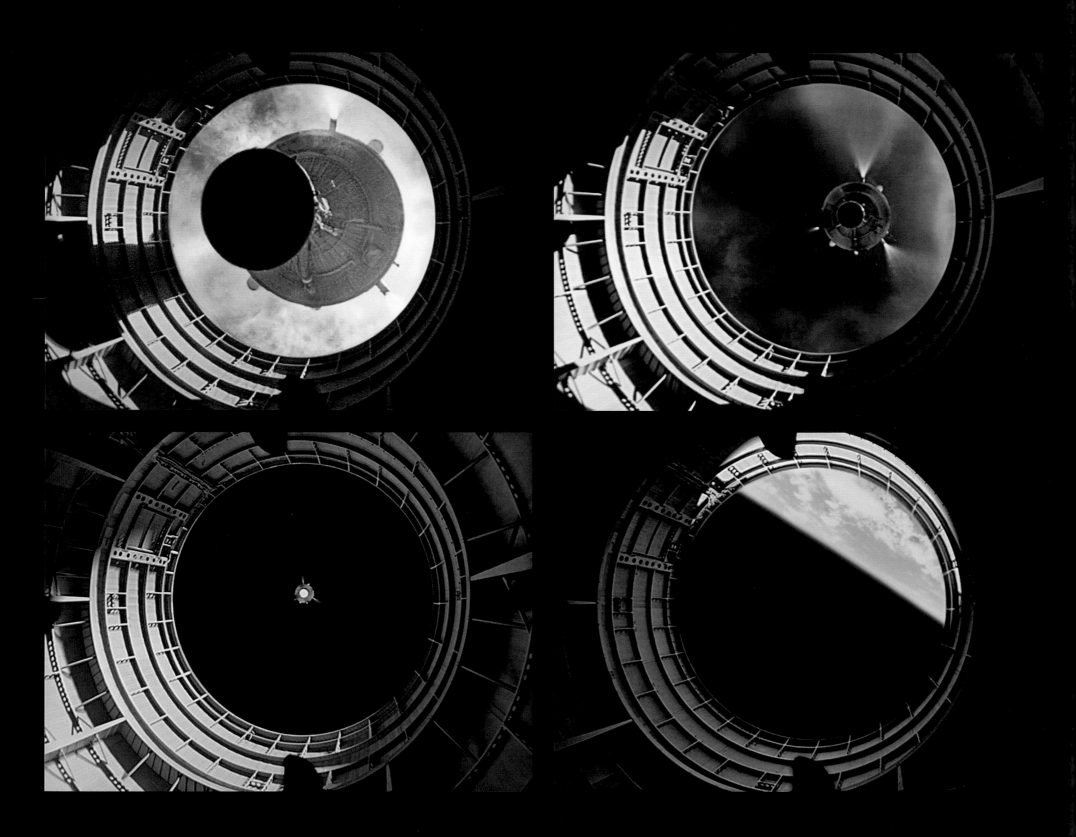

August 25, 1966　　　　　　　　　20–66 FRAMES OF 16MM FILM, STACKED AND PROCESSED　　　　　　　　　NASA ID: **N/A**

Apollo-Saturn 202. Before the end of project Gemini, several key uncrewed Apollo test missions were undertaken. AS-202 was the final test flight involving the Command and Service Module (CSM) atop a Saturn-IB rocket, before this particular combination would be flown with the first crew on Apollo 7. These images were captured from inside the S-IB as the S-IVB separated and then ignited. The S-IVB was the third stage of the Saturn V rocket that would be used to put the spacecraft on course for the Moon.

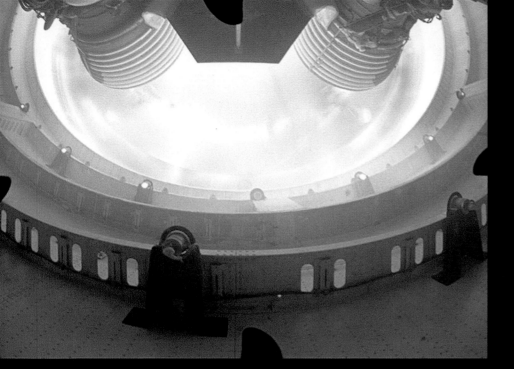

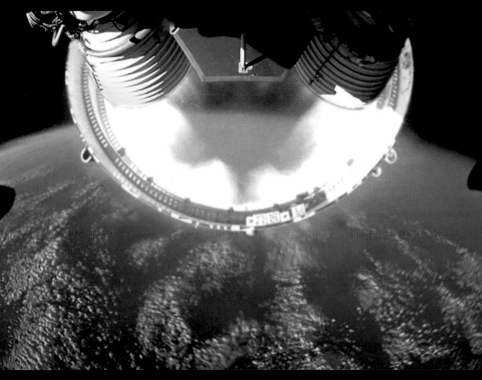

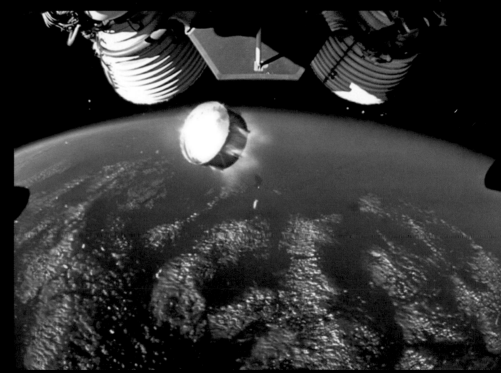

November 9, 1967 7–15 FRAMES OF 16MM FILM, STACKED AND PROCESSED NASA ID: N/A

Apollo 4. The first test flight of the huge Saturn V rocket that would propel the first humans to the Moon. It was the first time the S-IC first stage and S-II second stages flew and the first time the S-IVB third stage was restarted in flight. Captured 42 miles above the Atlantic from inside the S-II, these images show the first-stage S-IC appearing to fall back to Earth at stage separation. Thirty seconds later the fiery inter-stage ring tumbled away.

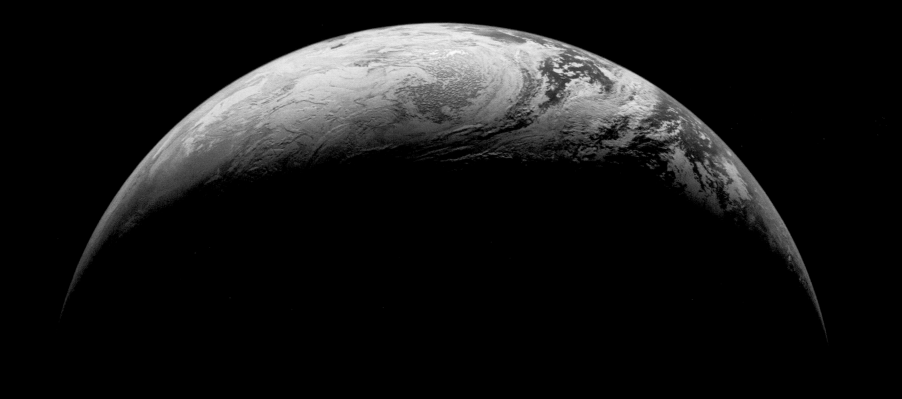

November 9, 1967 MAURER 220G 70MM. LENS 76MM F/2.8 │ BY AUTO TIME-LAPSE NASA ID: **AS04-01-0532**

Apollo 4. Captured high above Earth, this photograph was a first tantalizing indication of the spectacular images the Apollo program promised to deliver. After two further test flights (Apollo 5 and Apollo 6), it would be time for the first crewed mission of the Apollo program – Apollo 7. *(Rotated, cropped, EL: 3/5)*

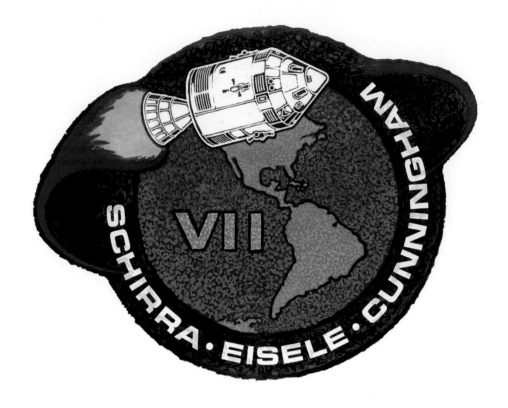

THE DETAILS

ROCKET Saturn-IB (AS-205)	**LAUNCH** 15:02 GMT, October 11, 1968, Launch Complex 34	**DURATION** 10 days, 20 hours, 9 minutes	**SPLASHDOWN** 11:11 GMT, October 22, 1968, Atlantic Ocean, Southeast of Bermuda
COMMAND AND SERVICE MODULE Unnamed (CSM-101)	**LANDING SITE** N/A	**SURFACE TIME** N/A	
LUNAR MODULE None	**DISTANCE** 4,546,918 miles	**EARTH ORBITS** 163	**RECOVERY SHIP** USS *Essex*

THE CREW

Walter "Wally" Schirra Jr.
COMMANDER (CDR)

One of the "Original 7" astronauts and largely credited for the introduction of Hasselblad cameras for space photography. Schirra was the only astronaut to fly Mercury, Gemini and Apollo missions. Apollo 7 would be his final mission.

Donn F. Eisele
COMMAND MODULE PILOT (CMP)

Born June 23, 1930. Named on the Apollo 1 crew, but a dislocated shoulder led to Roger Chaffee replacing him. Despite a back-up position on Apollo 10, Eisele retired from the Astronaut Office and never flew in space again.

R. Walter Cunningham
LUNAR MODULE PILOT (LMP)

Born March 16, 1932. An ex-fighter pilot with the Marine Corps and one of the third group of astronauts selected by NASA in 1963. This would be his only mission before taking a role heading up NASA's Skylab Branch of the Astronaut Office.

October 11–22, 1968

APOLLO 7

THE MISSION

Coming 20 months after the devastating Apollo 1 pad fire which cost the lives of Virgil I. "Gus" Grissom, Edward H. White II and Roger B. Chaffee, Apollo 7 was the first crewed flight of Project Apollo. Mission success was critical to demonstrate that NASA had recovered, and had learned from the crippling setback, and that the redesigned Command and Service Module (CSM) was not only safe, but could perform as expected on a long-duration space mission. Cunningham told me that despite the public's concerns after the Apollo 1 fire, they were trained, ready and keen to get on with pushing toward the ultimate goal. It was a mission packed with objectives and Cunningham stressed its relentlessness: "To this day, 52 years later, Apollo 7 is still the longest, most ambitious, most successful first test flight of any new mission."

Its primary objectives were to test the Service Module's engine – the Service Propulsion System (SPS) – which would be needed to place future flights into lunar orbit and fire the crew back to Earth, to test guidance and navigation systems including rendezvous, and to perform an accurate re-entry and splashdown.

The Saturn-IB rocket performed flawlessly on its first flight carrying a human crew and powered Apollo 7 on a tower of flames into the blue Florida sky. Ten minutes later, Apollo 7 reached its planned orbit, and within three hours Schirra separated the CSM from its spent booster.

The CSM fired its Reaction Control System (RCS) thrusters to perform a simulated Lunar Module extraction from the S-IVB. In the absence of an actual Lunar Module (LM), a small round target was installed in its place.

The CSM was then put into an orbit to separate itself from the S-IVB by a distance of 76 miles. The following day, for the first time, the SPS engine was fired to perform a simulated rendezvous. The crew was taken aback with the force of the engine. "Yabadabadoo!" exclaimed Schirra. Eisele remembered it as a real "boot in the ass." Schirra closed the gap to around 70 feet, having performed a similar rendezvous on Gemini VI-A (Image S65-63192) and maneuvered around the S-IVB allowing for a photo inspection. In all, the SPS fired eight times during the mission and worked flawlessly.

The crew noted that one of the adapter panels on the S-IVB did not fully open. On a mission to the Moon this would have made docking and extraction of the LM very difficult, possibly leading to an abort scenario. This reinforced NASA's decision to fully jettison the panels on all future missions.

Despite constellations of frozen urine (after venting into space) obscuring his view, Eisele was able to prove the CSM's sextant, in combination with the guidance computer, would be able to effectively navigate a crew to the Moon – even without Earth-based data transmissions.

The first-ever live TV broadcast from space was another success, although its timing caused friction with a crew who were feeling overworked, ill and no doubt mindful of the pressure for this mission to succeed. Tensions with the ground led to a "mini-mutiny." Schirra and his crew insisted, against Mission Control's approval, to undertake re-entry and splashdown without their helmets on, as they needed to clear their sinuses and were concerned the changes in pressure could burst their eardrums. This was unprecedented – in addition to protecting the crew's head and neck on splashdown, the helmets would also protect against emergencies such as sudden depressurization. Ultimately, Apollo 7 splashed down without incident. All future Apollo crews would re-enter without their helmets.

America's first three-man spaceflight was a highly successful mission, proving the key hardware, systems, procedures and livability of the CSM on a long-duration spaceflight. It paved the way for the brave decision to redefine the following mission, Apollo 8.

THE PHOTOGRAPHY

Utilizing the Hasselblad 500C, the key photographic task for the mission was to obtain high-quality weather and terrain images to help assess their usefulness and the relative effectiveness of color versus black and white film for such studies.

One recommendation after the mission was that sufficient attitude-control fuel must be allocated for photographic duties, as photographs of targets on Earth could only be taken when a window happened to be pointing down.

Three of the five windows fogged up due to off-gassing of sealant. Two of them also had soot deposits from the escape tower jettison and another two had condensation. Although this didn't severely restrict photography, the problems couldn't be fixed until the flight of Apollo 9.

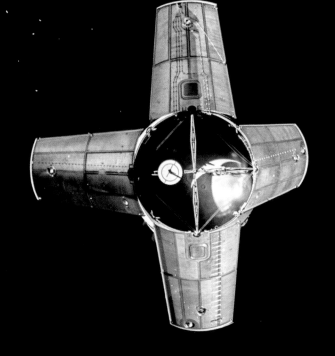

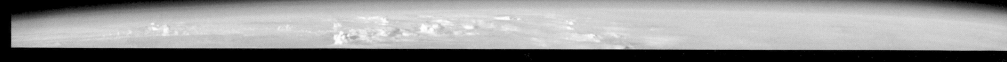

October 11, 1968 HASSELBLAD 70MM. LENS 80MM F/2.8 | PROBABLY BY DONN EISELE NASA ID: **AS07-03-1518**

The Saturn launch vehicle's S-IVB stage shortly after separation, with Earth's limb below. Schirra: "I can see little tiny particles out the right-hand window way down . . . Looks like pieces of chaff. I would assume that came from the separation of the S-IVB." Cunningham: "Mostly between 3 o'clock and 5 o'clock from my point of view here in the right seat and between 9 o'clock and 12 o'clock. The other two quadrants are relatively clean." *(Rotated, EL: 1/5)*

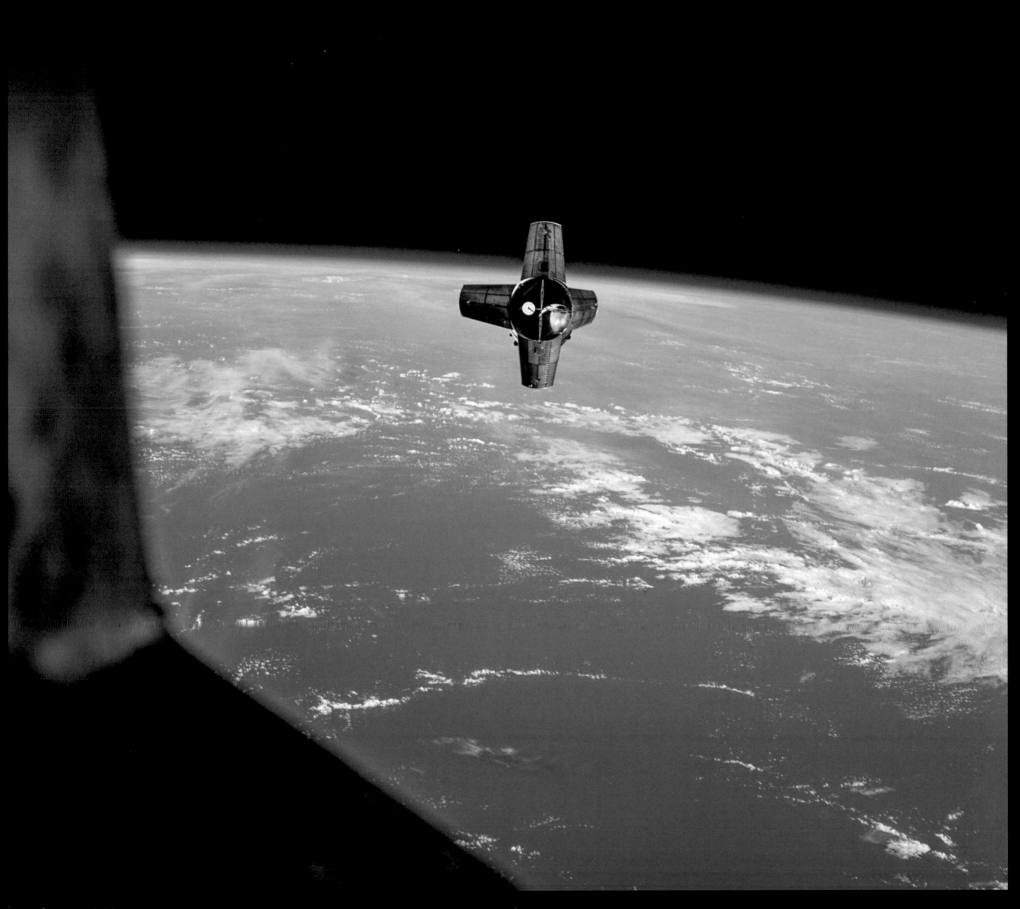

October 11, 1968　　　　　　　HASSELBLAD 70MM. LENS 80MM F/2.8 | PROBABLY BY WALTER CUNNINGHAM　　　　　　　NASA ID: **AS07-03-1521**

On future flights, the Lunar Module (LM) would be present on top of the S-IVB, but for Apollo 7's simulated docking, the circular target was used in its place. Schirra: "It's absolutely beautiful here . . . Except for that one panel, everything looks like it's just as you'd expect." One adapter panel failed to fully open, which would have made a real LM extraction difficult, leading to a possible abort scenario — substantiating the plan for all future missions to use a system to completely jettison the panels. *(EL: 2/5)*

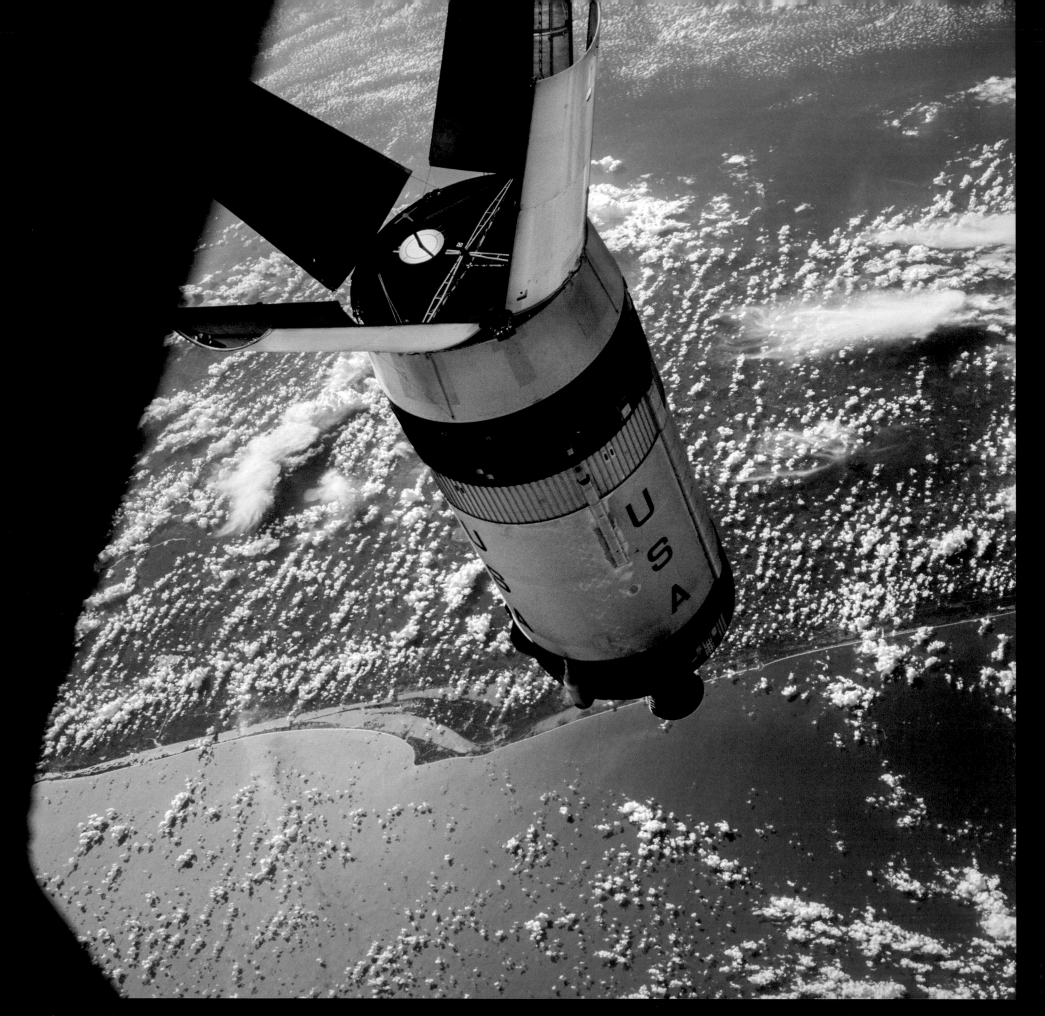

October 11, 1968 HASSELBLAD 70MM. LENS 80MM F/2.8 | BY WALTER CUNNINGHAM NASA ID: **AS07-03-1545**

A view of the expended S-IVB from approximately 100 feet, as the crew passes over their launch site at an altitude of 125 nautical miles. Cunningham: "We're looking right down at the Cape. We can get a picture of it in the background . . . We got some real great stuff here." Schirra: "Engine is set up facing down toward the Atlantic Ocean . . . We're pointing straight down." *(EL: 3/5)*

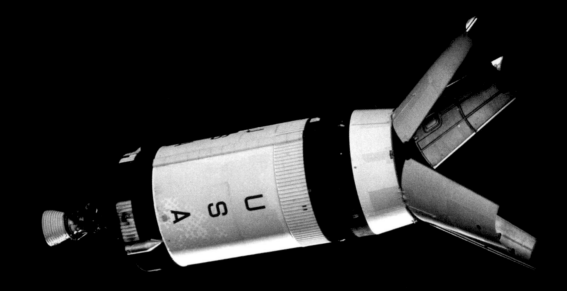

October 12, 1968 HASSELBLAD 70MM. LENS 80MM F/2.8 | BY UNKNOWN NASA ID: **AS07-04-1574**

After a separation of 76 miles, the SPS engine was fired for the first time in space, as Apollo 7 hunted down the S-IVB during a simulated rendezvous. Schirra was impressed with the SPS, "Like a bomb! Yabadabadoo! Great, man! That's like a ride and a half." The crew spotted the S-IVB. Cunningham: "I want to record on tape, it looks like all four SLA panels are equally deployed now." (Cropped, EL: 3/5)

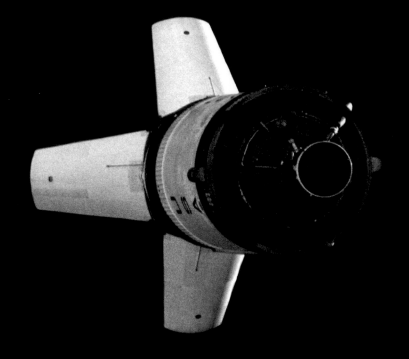

October 12, 1968

HASSELBLAD 70MM. LENS 80MM F/2.8 | BY UNKNOWN NASA ID: **AS07-04-1577**

The crew, in the Command Module, closed to within 70 feet. Eisele: "Hey. Break out the champagne. God damn it, we made it!" Schirra was concerned about closing further, telling Mission Control: "It's tumbling rather wildly, so we are starting to stay away from it." This super-crisp shot shows great detail, particularly around the engine. Eisele: "Isn't that pretty?" *(Cropped, rotated, EL: 4/5)*

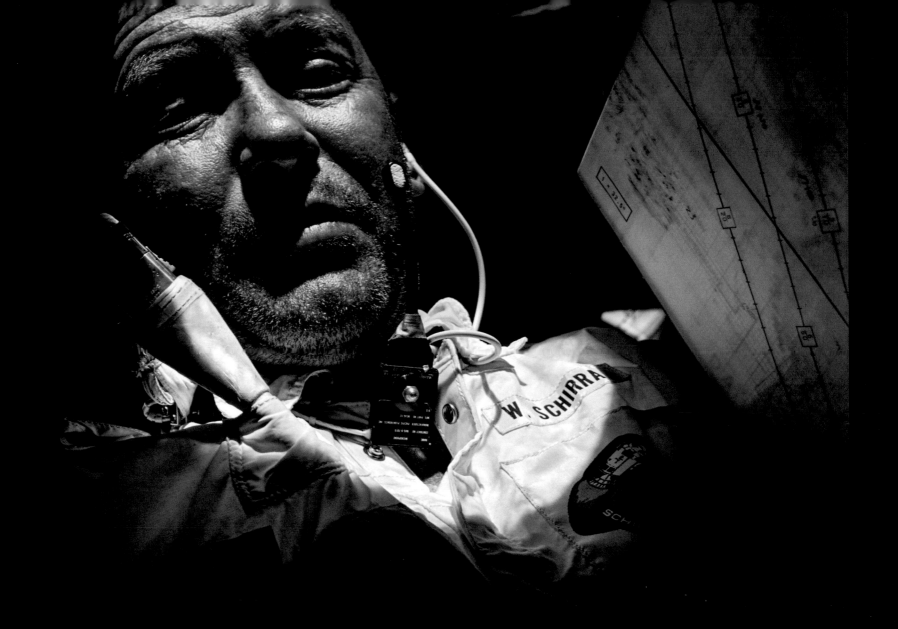

October 12, 1968 HASSELBLAD 70MM. LENS 80MM F/2.8 | BY WALTER CUNNINGHAM NASA ID: **AS07-04-1582**

Commander Schirra with a world map and translucent overlay of the spacecraft's orbital path and ground track. Schirra was already suffering from a severe head cold at this early stage in the mission. A head cold in space is particularly troublesome as the sinuses don't drain naturally due to the absence of gravity. (Cropped. FL: 3/5)

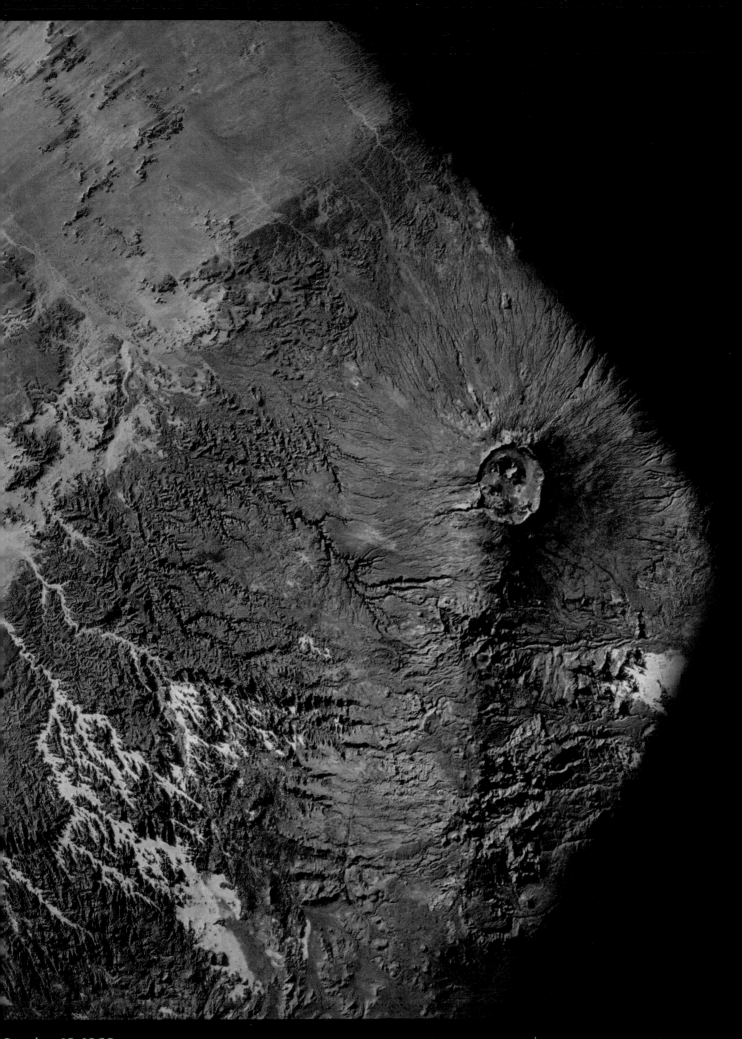

October 13, 1968

HASSELBLAD 70MM. LENS 80MM F/2.8 | BY WALTER CUNNINGHAM

NASA ID: AS07-05-1621

The crew spent almost 11 days in Earth orbit. Cunningham: "At 38 hours 48 minutes into the flight, we're taking color pictures over Africa. Magazine Q . . . These are up around frame 6. There's a beautiful shot of a crater." The "crater" was Emi Koussi volcano in Chad in the central Sahara, seen from an altitude of 133 miles. *(EL: 3/5)*

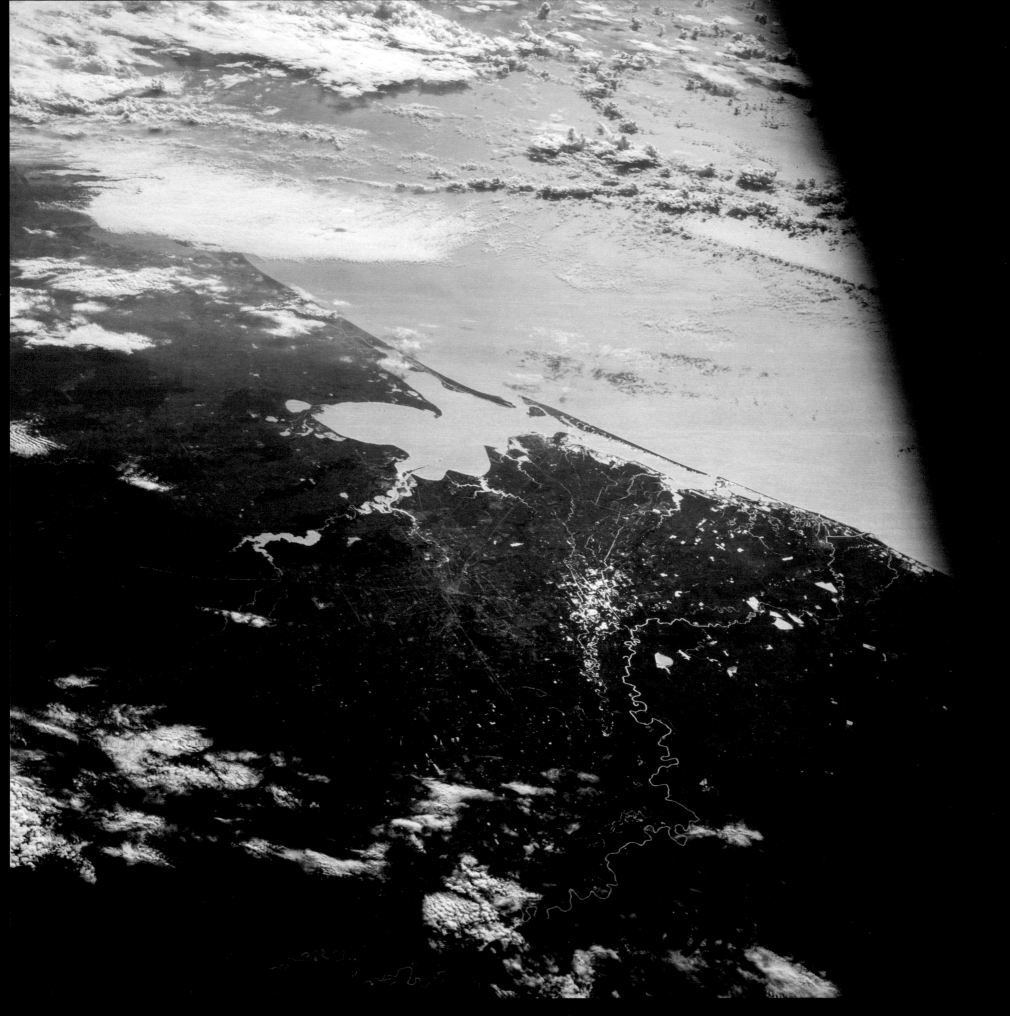

October 17, 1968　　　HASSELBLAD 70MM. LENS 80MM F/2.8 | BY DONN EISELE　　　NASA ID: **AS07-07-1872**

Eisele informs Mission Control: "Magazine S, pictures 127 to 130, were taken of Houston." Mission Control itself was captured in these photographs on the 91st orbit from 101 nautical miles altitude. The low morning light illuminated Houston and the Gulf Coast area, reflecting off canals and rice fields west of Alvin. Even highways and the Astrodome, home of the Houston Astros baseball team, were captured from orbit. (Cropped, rotated, EL: 3/5)

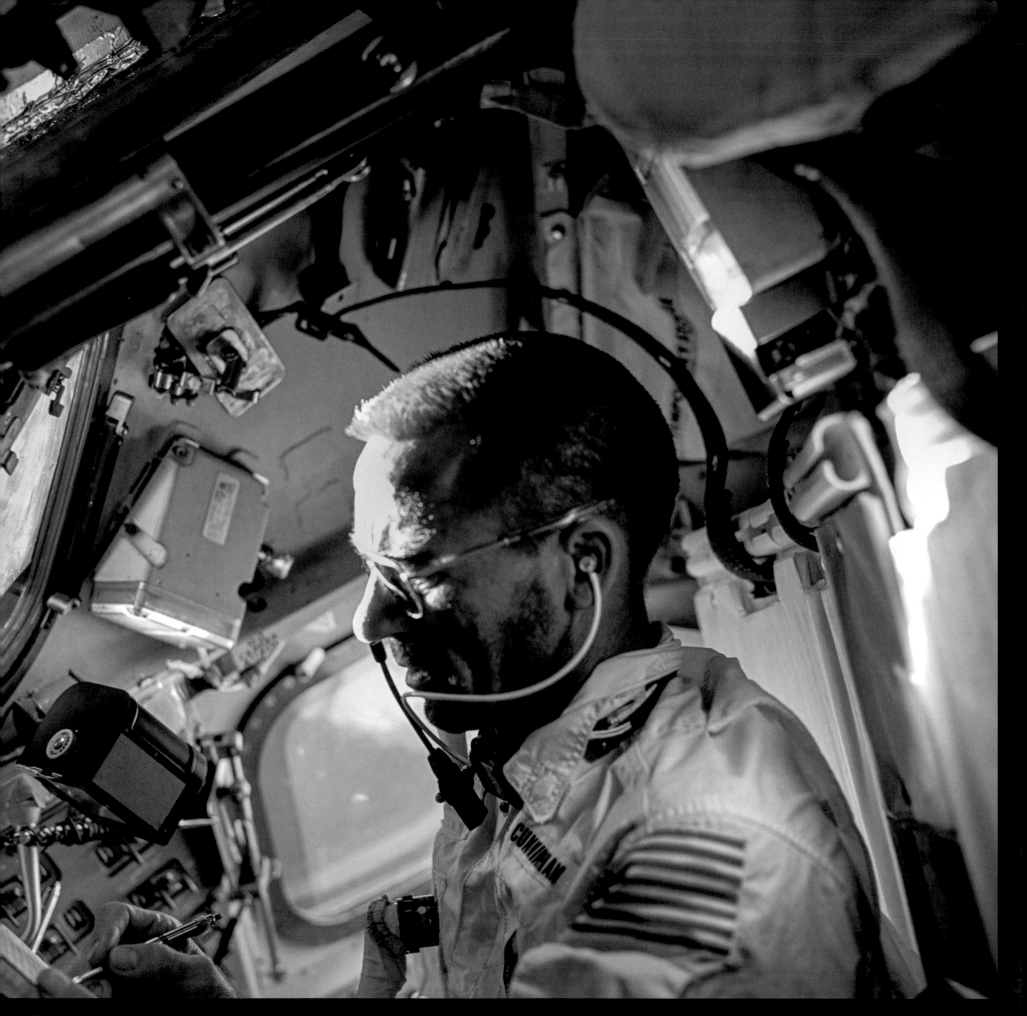

October 20, 1968 HASSELBLAD 70MM. LENS 80MM F/2.8 | PROBABLY BY DON EISELE NASA ID: AS07-04-1586

Lunar Module Pilot (LMP) Walter Cunningham makes notes with his space pen during the ninth day of the mission. A 70mm Hasselblad magazine is floating above his hand in the microgravity environment. Contrary to popular belief, Soviet cosmonauts also used space pens, in addition to pencils. (Cropped, rotated, EL: 2/5)

October 20, 1968 HASSELBLAD 70MM. LENS 80MM F/2.8 | PROBABLY BY DONN EISELE NASA ID: AS07-04-1588

Eisele: "Man, that Sun is brighter than hell!" Schirra: "Yes, that's why you need sunglasses." Walter Cunningham apparently naps as the Sun streams into the CM cabin; a significant challenge for on board photography. Sleeping was a problem for the crew, Donn Eisele would say later: "I'd get by on catnaps for two days and collapse every third 'night' for a solid six to eight hours." (Rotated, EL: 4/5)

October 20, 1968

HASSELBLAD 70MM. LENS 80MM F/2.8 | PROBABLY BY DONN EISELE

NASA ID: **AS07-04-1596**

Schirra's face illuminated, as he gazes out of the rendezvous window from his Commander's station on day nine. Note the plastic food packs taped to the headrest. Due to their head colds the crew insisted, against Mission Control's orders, on not wearing their helmets for re-entry and splashdown (a "Valsalva" device was added to later helmet designs). The packaging was an attempt to protect their head and neck. *(Rotated, EL: 4/5)*

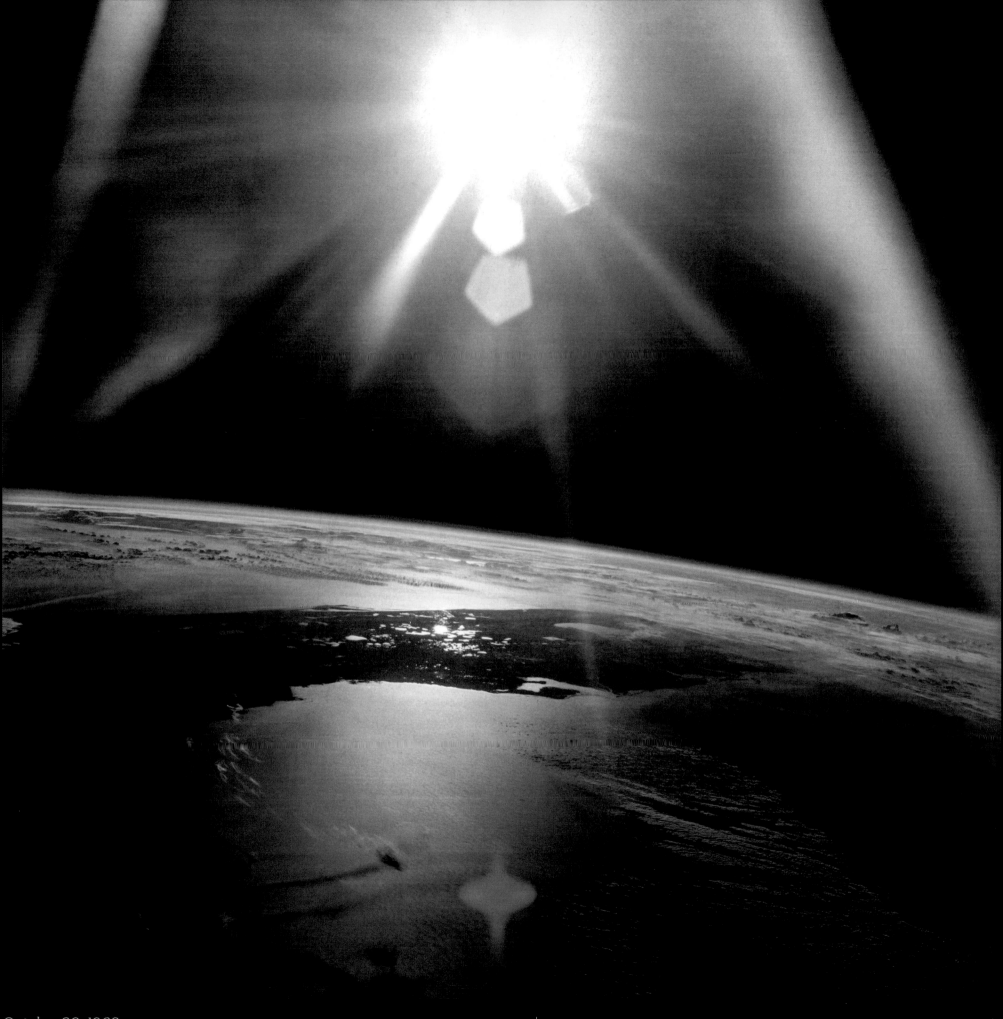

October 20, 1968 HASSELBLAD 70MM. LENS 80MM F/2.8 | BY WALTER CUNNINGHAM NASA ID: **AS07-08-1933**

Schirra: "That's one of the most spectacular sights I've seen, just now, all the way across the States. You can see the whole Florida peninsula lit up by the sunrays. It's morning, of course, all the way from the west coast, all the way across the Gulf Coast." A silhouette of almost the whole of Florida as viewed from 120 nautical miles on day nine of the 11-day mission. The morning Sun is reflecting off the Atlantic Ocean and Gulf of Mexico. *(EL: 4/5)*

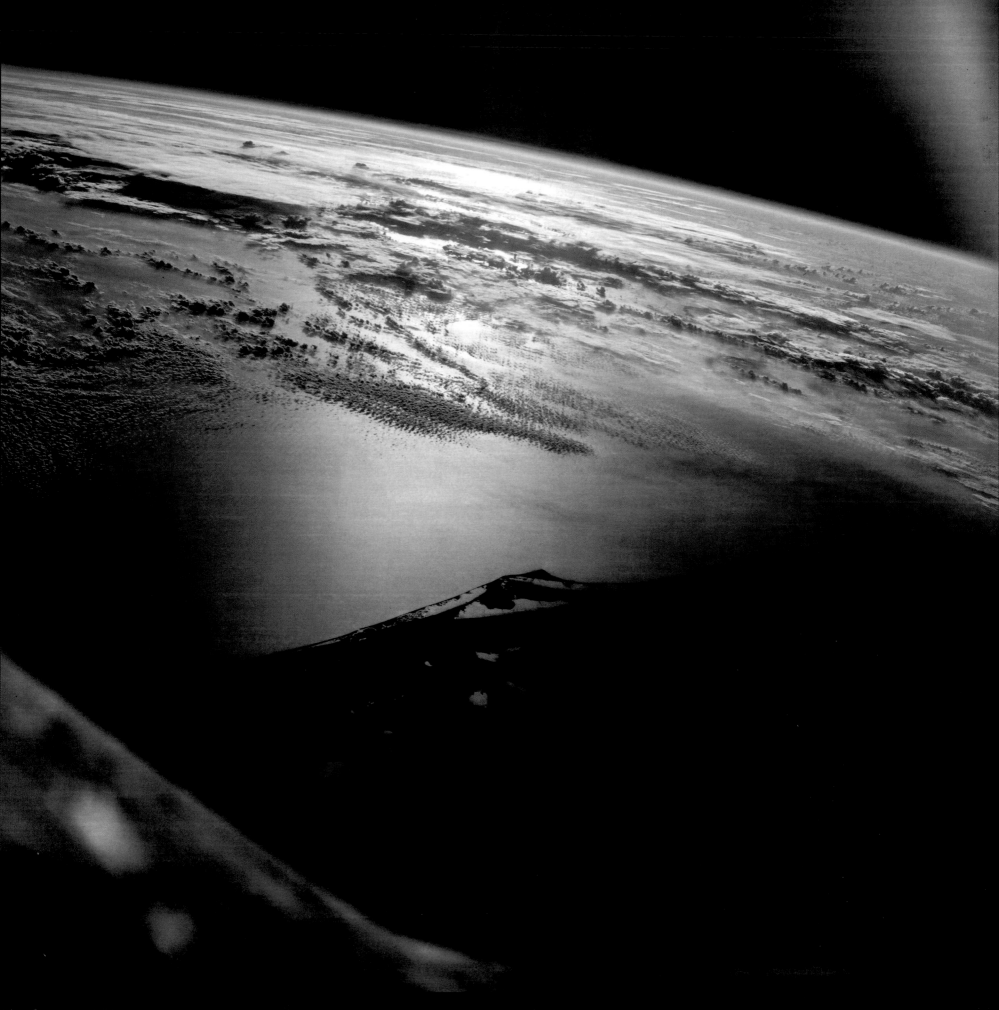

October 20, 1968 HASSELBLAD 70MM. LENS 80MM F/2.8 | BY WALTER CUNNINGHAM NASA ID: **AS07-08-1935**

Two frames after AS07-08-1933, Kennedy Space Center and the whole Cape are captured as a silhouette against the ocean and curvature of Earth. Cunningham to Mission Control: "There's a beautiful sight today. The Sun's lighting up the whole Gulf of Mexico. Hey, Jack, on magazine R, frames 58, 59, and 60 were taken looking toward Florida on this pass . . . The last one is looking down at the Cape. Got a lot of Sun coming in the lens. I hope we have some nice pictures of it." *(EL: 3/5)*

October 21, 1968　　　　　　3 AND 8 FRAMES OF 16MM FILM, STACKED AND PROCESSED　　　　　　NASA ID: **APOLLO 7 MAG 1069-C**

LEFT: Eisele: "We just took some movies of Walt getting in his suit." Cunningham dons his pressure suit as part of a suit-up exercise in the tight confines of the Command Module. RIGHT: A rare full-length shot of an astronaut in their AL-7 pressure suit inside the CM. This was the first use of the AL-7 suit in space. It would eventually be worn on the Moon during Apollo 11, but on Apollo 7 it was only used during launch and, partially (due to the sinus issue), for re-entry on this orbital mission. Eisele: "That was magazine C . . . The first few feet on it is part of a suiting exercise we took in the spacecraft a little earlier."

October 11–22, 1968 20 FRAMES OF 16MM FILM, STACKED AND PROCESSED NASA ID: **APOLLO 7 MAG 1075-I** & **1072-F**

LEFT: Donn Eisele organizes food pouches in the lower equipment bay of the Command Module. The viewpoint is through the folded center seat. The hatch leading to the tunnel that would access the LM on future flights can be seen above Eisele's head. RIGHT: Commander Wally Schirra, the only astronaut to fly on Mercury, Gemini and Apollo missions, pans the shot and captures himself in the lower equipment bay of the Command Module.

THE DETAILS

ROCKET Saturn V (AS-503)	LAUNCH 12:51 GMT, December 21, 1968, Pad 39A	DURATION 6 days, 3 hours, 42 seconds	SPLASHDOWN 15:52 GMT, December 27, 1968, Pacific Ocean
COMMAND AND SERVICE MODULE Unnamed (CSM-103)	LANDING SITE N/A	SURFACE TIME N/A	
LUNAR MODULE None	DISTANCE 579,607 miles	LUNAR ORBITS 10	RECOVERY SHIP USS *Yorktown*

THE CREW

Frank Borman
COMMANDER (CDR)

Born March 14, 1928. Borman was Command Pilot of Gemini VII, with Apollo 8 crewmate Jim Lovell. He was the only astronaut on the review board of the Apollo 1 fire. It has been claimed that Borman was offered the opportunity to command the first lunar landing mission and become the first man on the Moon but he turned it down. Apollo 8 would be Borman's final space mission.

James A. Lovell Jr.
COMMAND MODULE PILOT (CMP)

Born March 25, 1928. Lovell's first flight was as Pilot on Gemini VII, with Frank Borman as Command Pilot. He was then Command Pilot on Gemini XII, the final Gemini mission, with Buzz Aldrin. Lovell would go on to become Commander of Apollo 13 – one of only three men to have flown to the Moon twice.

William A. Anders
LUNAR MODULE PILOT (LMP)

Born October 17, 1933. Part of the third group of astronauts, Anders was back-up Pilot for Gemini XI and back-up CMP for Apollo 11. Despite being slated to be CMP on the Apollo 14 mission, he turned this down and resigned from NASA in 1969. Apollo 8 would be his only journey into space.

December 21–27, 1968

APOLLO 8

THE MISSION

Apollo 8 was originally planned to test the CSM and Lunar Module (LM) in Earth orbit only. Several factors convinced NASA to boldly change the mission to humankind's first trip around the Moon. There was concern that the Soviets were planning to beat the U.S. to this feat, and the LM (not required for an orbital mission) was facing delays. So, buoyed by the success of Apollo 7 and "convinced" by the fixes applied after severe problems during the Saturn V's previous launch (a violent "pogo effect" on the uncrewed Apollo 6 test flight caused parts of the adapter panels to buckle and fall away, and the engines to shut down early), the decision was made. Borman, Lovell and Anders would become the first humans to make the journey from the Earth to the Moon.

The sheer boldness of this mission cannot be overstated. NASA privately gave the crew a 50/50 chance of survival, with Anders later recalling his belief that his chances of making it home were more like 1 in 3. Borman's wife was convinced she was sending her husband on a no-return journey.

The huge Saturn V, standing 363 feet tall, roared from Pad 39A producing 7.5 million pounds of thrust, carrying its first human passengers. Despite some slight pogo effect and vibration, Borman described the ride as "very smooth," until Main Engine Cut Off (MECO). When the S-IC first stage completed its burn at an altitude of around 43 miles, traveling at over 6,000mph, the crew were thrown violently forward into their restraining belts before the S-II second stage ignited, pushing them back into their couches. The second stage took them to an altitude of 109 miles and 15,000mph, when the third-stage S-IVB kicked in, taking Apollo 8 into Earth orbit at a speed of over 17,000mph.

During the second orbit, two hours 50 minutes after launch, in Mission Control, Capsule Communicator (CAPCOM) Michael Collins gave the most understated, technical instruction for what was one of the defining moments in our history: "Apollo 8, you are Go for TLI [trans-lunar injection]." The S-IVB re-ignited and burned for five minutes to increase Apollo 8's speed to 24,226mph, enough to overcome Earth's gravity and send it on a trajectory toward the Moon.

The crew barely saw their destination during the three-day journey and upon arrival the Service Module's SPS engine, tested only once before in space, would need to work perfectly to slow the spacecraft and enter lunar orbit. The crew would be cut off from communications with Earth for the burn. "See you on the other side," Lovell said. The crew became the first humans to see the farside of the Moon. The crew read from Genesis during what was the largest TV audience in history, on Christmas Eve. Then after ten orbits, on Christmas Day, the SPS engine had to fire flawlessly again, or the crew would never make it home. Once again the burn happened on the farside during loss of signal. Upon acquisition of signal, Lovell communicated the news of a perfect burn to an apprehensive Mission Control: "Please be informed, there *is* a Santa Claus!"

Three days later the Command Module smashed into Earth's atmosphere at 24,000mph and its three parachutes facilitated a safe splashdown to complete the historic six-day mission.

The crew would later reflect on seeing the whole Earth from such great distance for the first time. Lovell remembered how he could cover it, its 5 billion inhabitants, and everything he'd ever known with the tip of his thumb: "A grand oasis in the big vastness of space." Borman recalled: "It was the most beautiful, heart-catching sight of my life . . . It was the only thing in space that had any color to it." Anders likened it to a single colorful Christmas tree ornament, hanging in a completely darkened room, and noted that, despite all the effort and focus on going to the Moon, "what we really discovered . . . was the Earth."

THE PHOTOGRAPHY

A principal objective of the mission was to return high-resolution photographs of proposed Apollo landing sites and locations of scientific interest. "Targets of opportunity" were identified and included in planning charts, along with exposure details, in order to assist the crew. It was the first use of the Hasselblad HEC camera. Two Hasselblads, each with a Planar 80mm f/2.8 lens plus a single Sonnar 250mm f/5.6 telephoto lens and seven magazines were carried on board, in addition to a 16mm DAC camera, various lenses and five magazines.

Almost all the photographic objectives were accomplished, despite being hampered by three of the five windows fogging up, as experienced on Apollo 7. The lunar surface was also photographed by a Hasselblad mounted in the Command Module's window and hooked up to a remote control device (intervalometer), which took photographs every 20 seconds. The purpose of these overlapping automatic sequences, or stereo-strip photography, was to determine the elevation as well as the geographical position of lunar features.

Most notably, the mission provided the world with the first-ever photographs taken by one of us of the whole Earth, not to mention one of the most famous, important and reproduced photographs of all time, "Earthrise." It was quite the conclusion to a tumultuous year of violence, political turmoil and social injustice in the U.S. One telegram that Frank Borman later recalled, from the thousands received, summarized it perfectly: "Thank you Apollo 8, you saved 1968."

December 21–27, 1968 80 FRAMES OF 16MM FILM, STACKED AND PROCESSED NASA ID: **APOLLO 8 MAG 1013-R**

Bill Anders films his pre-made cue cards to help document the mission ahead. Frank Borman can be seen in the left-hand Commander's seat. The two Hasselblad cameras carried on the mission, with 80mm lens and magazines attached, can be seen in their stowed position, upper left.

Shortly after trans-lunar injection (TLI), three hours after lift-off, the Apollo 8 CSM separated from the Saturn V third stage (S-IVB). Borman: "Man, where's the S-IVB? Anybody see it now?" Lovell: "Right in the middle of my window! There's not a panel around." Looking back at the top of the S-IVB, surrounded by debris from separation, is the LM test article which simulated the mass of the real thing. The huge 29-foot adapter panels have already been fully jettisoned. *(Rotated, EL: 3/5)*

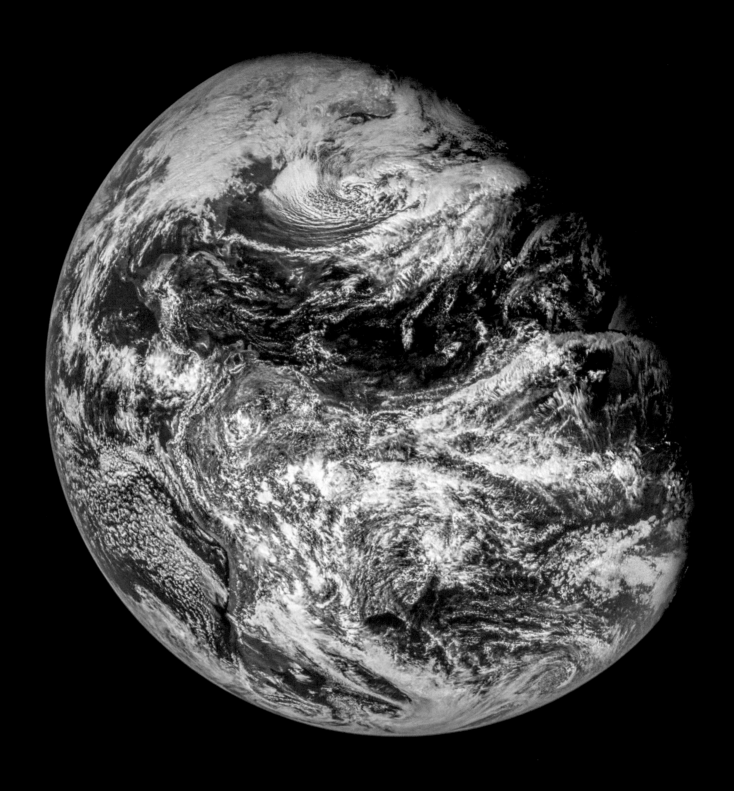

December 21, 1968 HASSELBLAD 70MM. LENS 80MM F/2.8 │ PROBABLY BY BILL ANDERS NASA ID: **AS08-16-2593**

The first-ever photograph of the whole Earth taken by one of us. Borman: "I can still see the Cape and isthmus of Central America." Captured from approximately 17,000 miles out, South America can be seen, with Central America to the north, leading up to Florida and the launch site. Anders: "I can see it out my side window, and it's a beautiful view with numerous cloud vortex." (Cropped, rotated, EL: 2/5)

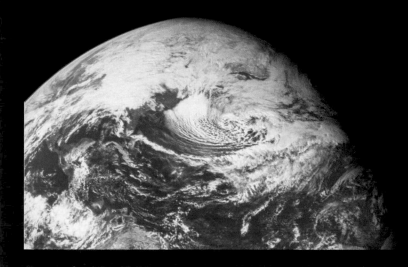

December 21, 1968 HASSELBLAD 70MM. LENS 80MM F/2.8 | BY FRANK BORMAN NASA ID: **AS08-16-2594**

Borman: "I have a beautiful view of the S-IVB and the Earth here in one. I'll try and get a picture for you." This extraordinary image, taken five hours into the flight during trans-lunar coast, shows the increasingly distant Earth and the now tiny S-IVB, at the upper edge of the frame, approximately 3,000 feet away. The S-IVB was put on a trajectory to fly past the Moon and enter a heliocentric orbit (around the Sun). *(Rotated, EL: 2/5)*

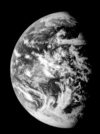

December 22, 1968 HASSELBLAD 70MM. LENS 80MM F/2.8 │ BY UNKNOWN NASA ID: **AS08-16-2600**

This photograph was taken looking back at Earth from a distance of approximately 100,000 miles. Antarctica and Australia can be identified in the south. Borman: "This is a mighty nice view we have down there today . . . There is quite a bit of cloud cover; but even through the hazy windows, it's mighty nice." It was at this point in the journey that the first live TV transmission was also made, in which Jim Lovell took the opportunity to wish his mother a Happy Birthday. *(Rotated, EL: 2/5)*

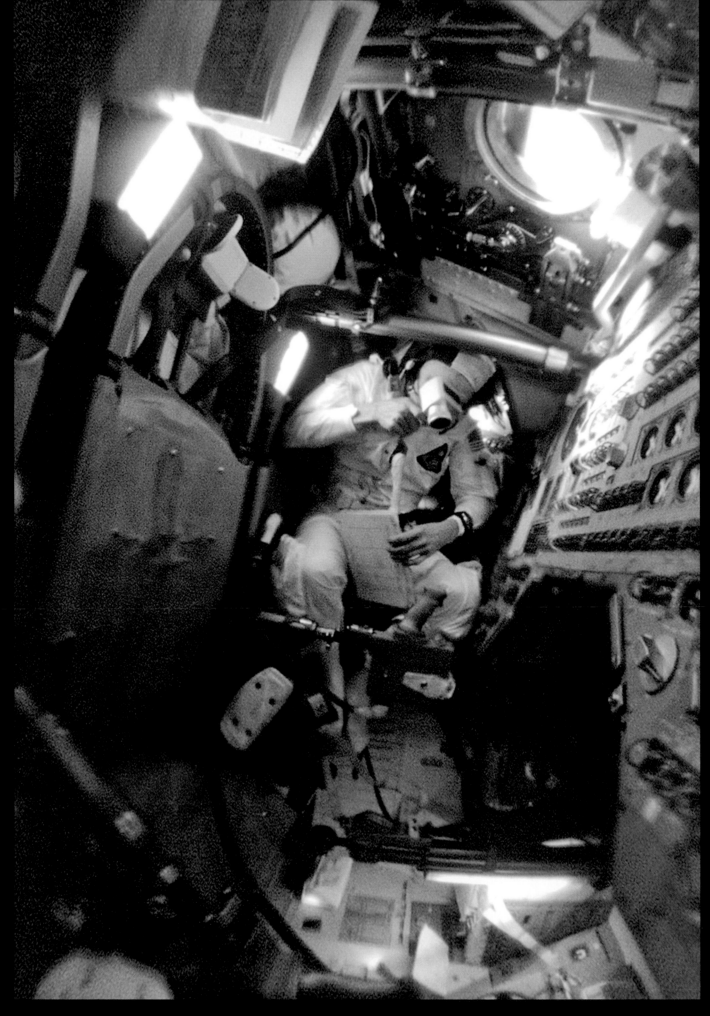

40 FRAMES OF 16MM FILM, STACKED AND PROCESSED

NASA ID: **APOLLO 8**

Frank Borman floats above his Commander's couch as he uses the Minolta Space Meter. The light meter was used to inform the camera settings required for correct exposure. T[...]
Module that felt cramped on Earth, particularly in full pressure suits, felt decidedly roomy when zero-G afforded every corner to be utilized.

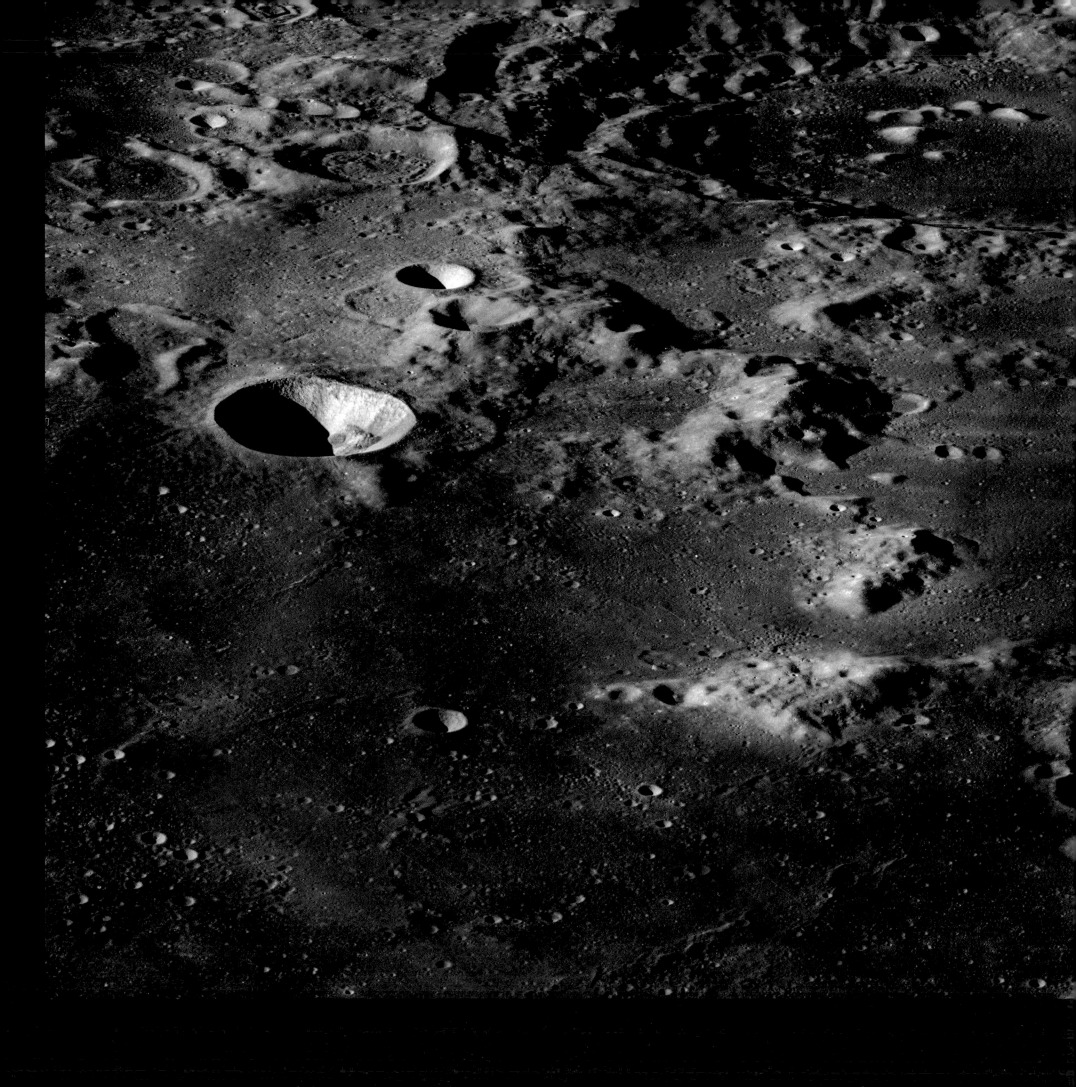

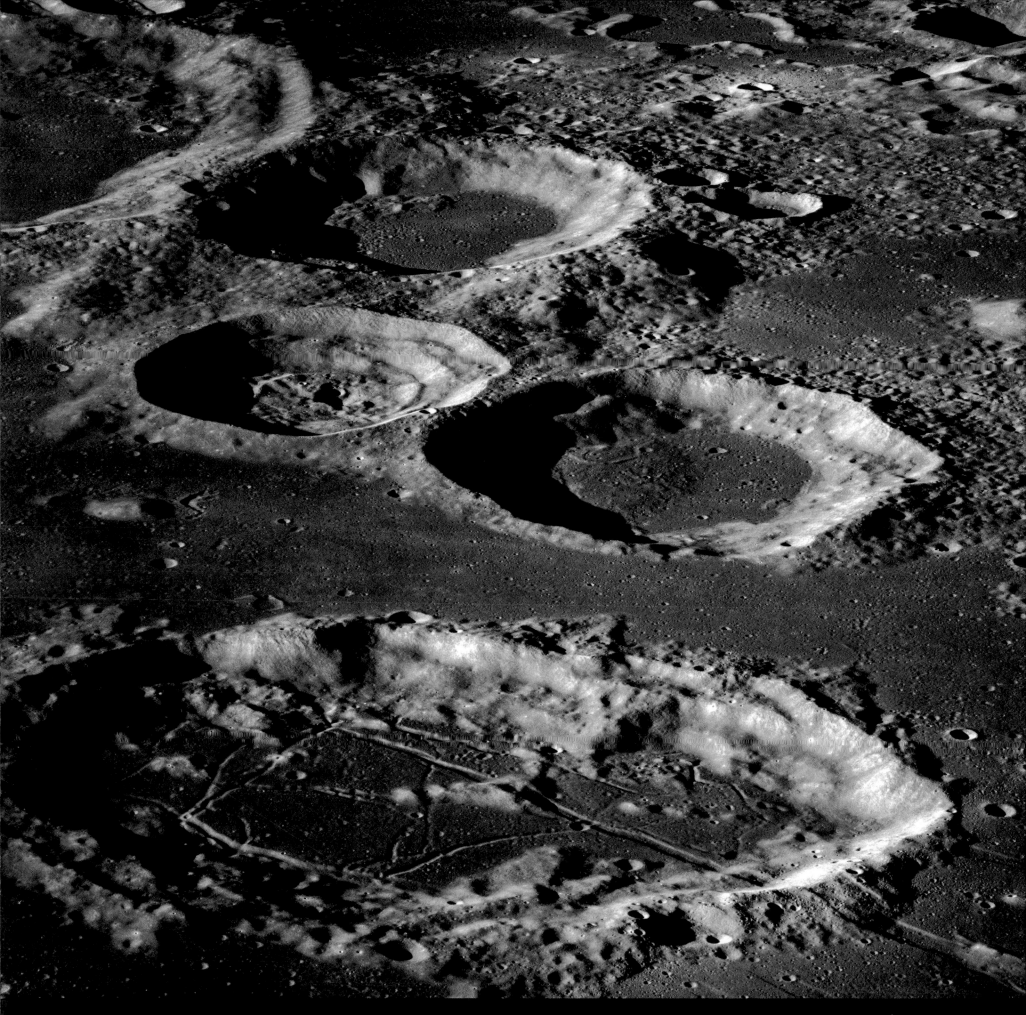

December 24, 1968 HASSELBLAD 70MM. LENS 250MM F/5.6. B&W │ BY AUTO SEQUENCE NASA ID: AS08-13-2221 TO 2225

Mission Control: "What does the ole Moon look like from 60 miles? Over." Lovell: "Okay, Houston. The Moon is essentially gray, no color; looks like plaster of Paris or sort of a grayish beach sand.
We can see quite a bit of detail. The Sea of Fertility doesn't stand out as well here as it does back on Earth." The view of the Sea of Fertility on the Moon's nearside. The crater in the foreground is
Goclenius, with a diameter of 40 miles. *(Panorama, EL: 3/5)*

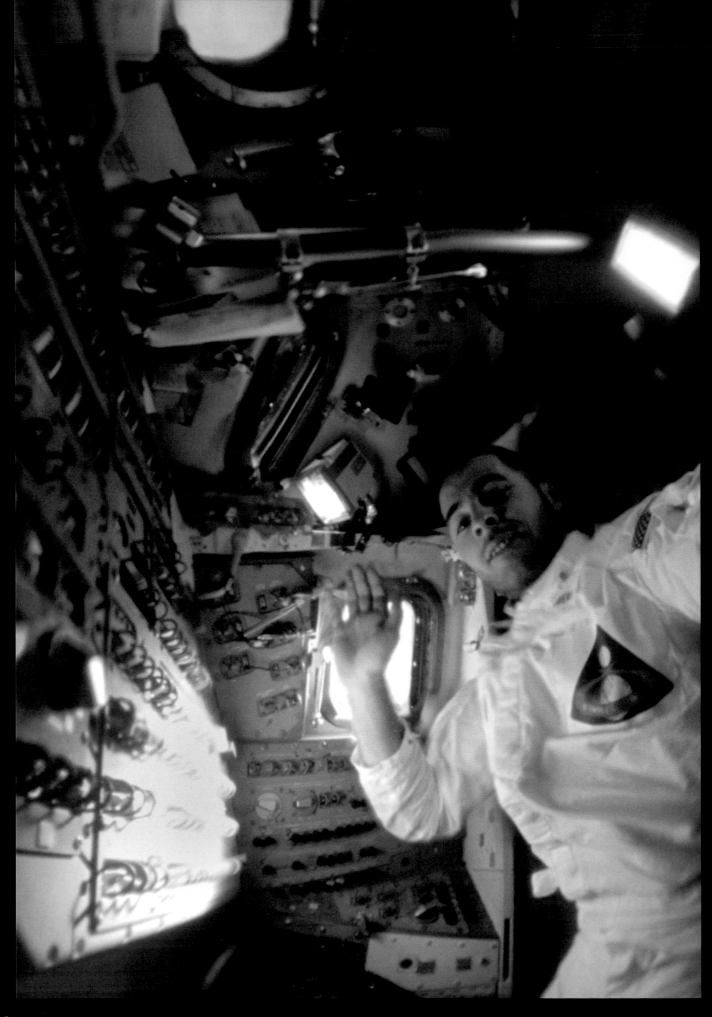

December 21–27, 1968 60 FRAMES OF 16MM FILM, STACKED AND PROCESSED NASA ID: **APOLLO 8 MAG 1013**

Bill Anders films himself with the 16mm DAC camera. Three of the five windows in the Command Module available for photography can be seen. The problem of fogged up windows experienced on Apollo 7 also blighted this mission and included the windows behind Anders' hand and the hatch window at the top.

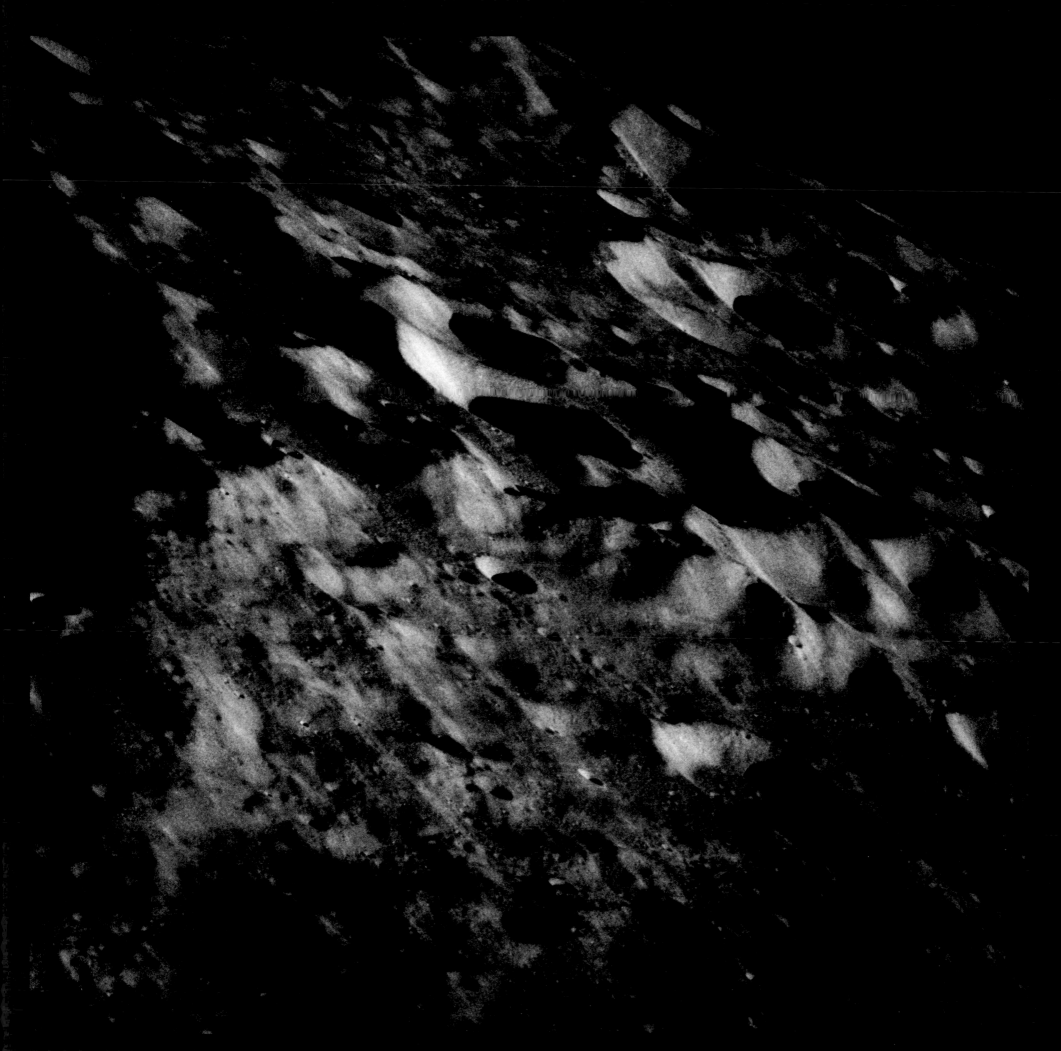

December 24, 1968

HASSELBLAD 70MM. LENS 250MM F/5.6. B&W | BY BILL ANDERS

NASA ID: **AS08-18-2834**

At the start of the second lunar orbit, this photograph was one of a series mistakenly taken with a 2000 ASA (fast, light-sensitive) rated film intended for astronomical photography and not the bright lunar surface. When Anders realized, he informed Mission Control. The images were treated with a special chemical process upon return and further digital enhancement here, has produced a grainy but striking image of the undulating, battered farside of the Moon. *(EL: 5/5)*

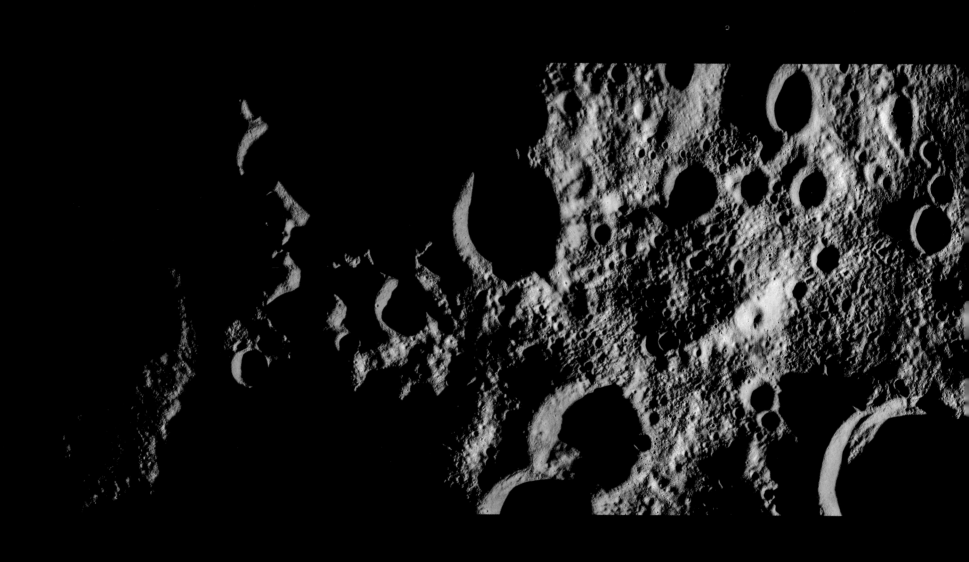

December 24, 1968 HASSELBLAD 70MM. LENS 80MM F/2.8. B&W | BY AUTO SEQUENCE NASA ID: **AS08-12-2044 TO 2053**

A series of images of the lunar farside, across the terminator, into the Moon's shadow into the sunlit region over the huge, 272-mile-wide Korolev crater basin, named after the Soviet rocket scientist. The keyhole-shaped craters, upper right, were pre-designated "Control Point 1." Jim Lovell would aim the optics at the control points so the computer could precisely take coordinates in order to produce the most accurate maps to that date of the farside of the Moon. South is up. *(Panorama, EL: 4/5)*

December 24–25, 1968 HASSELBLAD 70MM. LENS 250MM F/5.6. B&W | BY UNKNOWN NASA ID: **AS08-13-2319**

"Target of opportunity" no. 10 on the lunar farside – the mountains along the northern rim of the enormous South Pole–Aitken basin. One of the largest known impact craters in the solar system, and the largest, oldest and deepest on the Moon. The basin is 1,600 miles across, 5 miles deep and the mountains at the rim soar 5 miles into the lunar sky. *(EL: 5/5)*

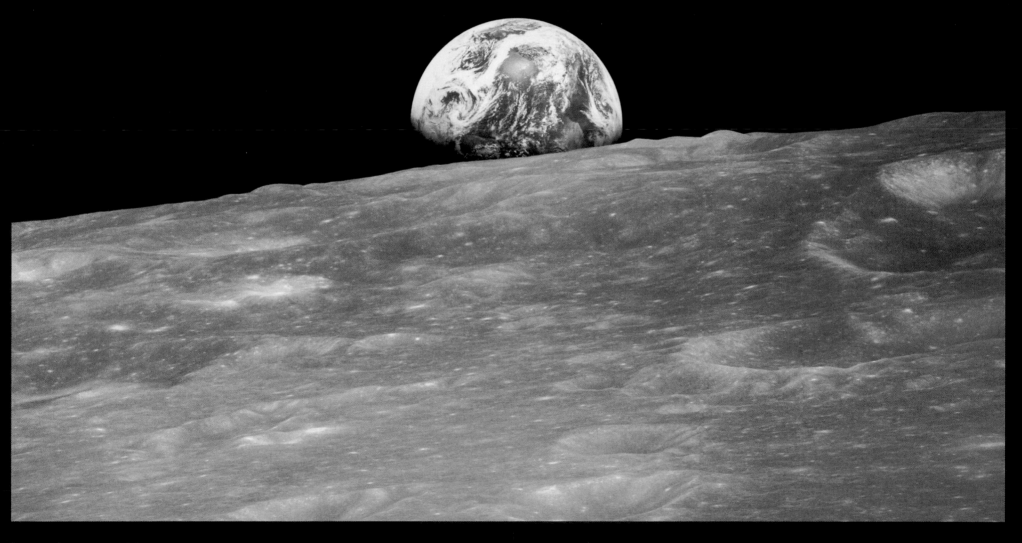

December 24, 1968 HASSELBLAD 70MM. LENS 250MM F/5.6. B&W | BY BILL ANDERS NASA ID: **AS08-13-2329**

Contrary to popular belief, this extraordinary photograph was the first-ever taken of Earth from the Moon by one of us. Anders: "Oh, my God! Look at that picture over there! Here's the Earth coming up. Wow, is that pretty!" Borman quipped that he couldn't take the photo as it wasn't scheduled. Anders was concerned he'd missed the opportunity for a color shot that would later become one of the most famous photographs of all time. *(Croppped, EL: 4/5)*

December 24, 1968

HASSELBLAD 70MM. LENS 250MM F/5.6 | BY BILL ANDERS

NASA ID: **AS08-14-2383**

"Earthrise" – arguably one of the most famous photographs ever taken. Anders: "Hand me that roll of color, quick!" – moments after the black and white shot (AS08-13-2329), Lovell found a color magazine for Anders and he got his shot, through the rendezvous window. Earthrise was not noticed on the first three orbits due to the orientation of the windows. Only a roll of the spacecraft, performed by Borman, brought it into view this time around; the photograph was a real crew effort. *(Rotated, EL: 3/5)*

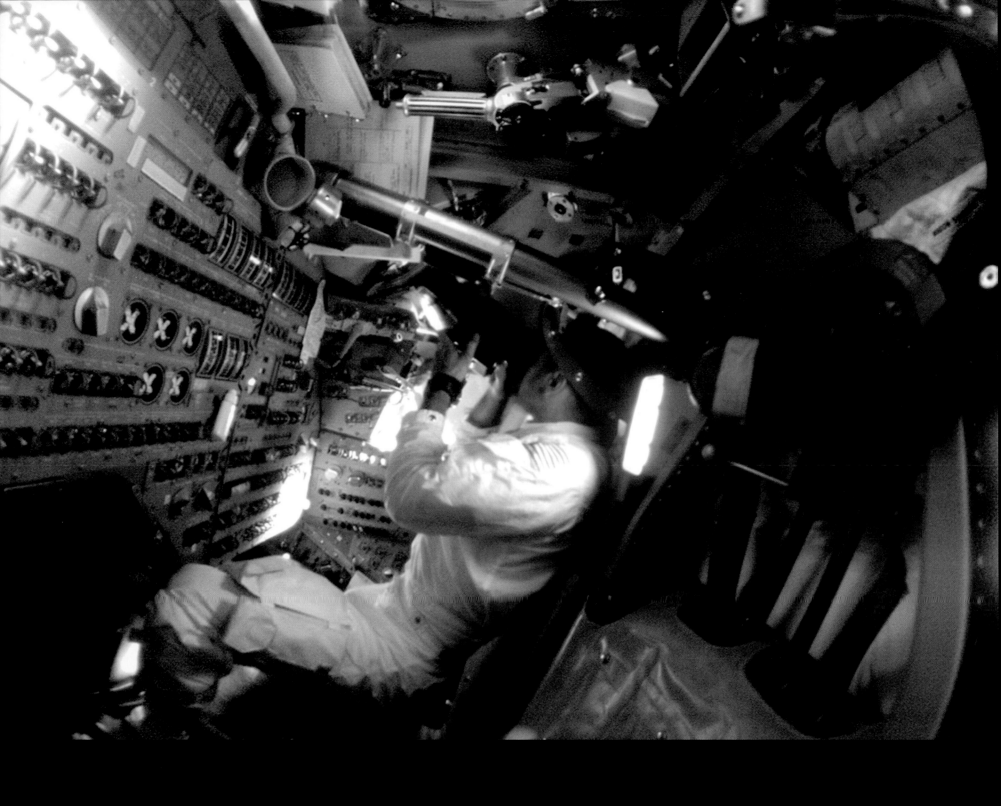

December 21–27, 1968 35 FRAMES OF 16MM FILM, STACKED AND PROCESSED NASA ID: **APOLLO 8 MAG 1013-K**

Bill Anders, in the Command Module, points the Hasselblad HEC, with its 250mm lens, through the rendezvous window. Anders pointed the same camera and lens through the same window to capture the famous "Earthrise" photograph (opposite).

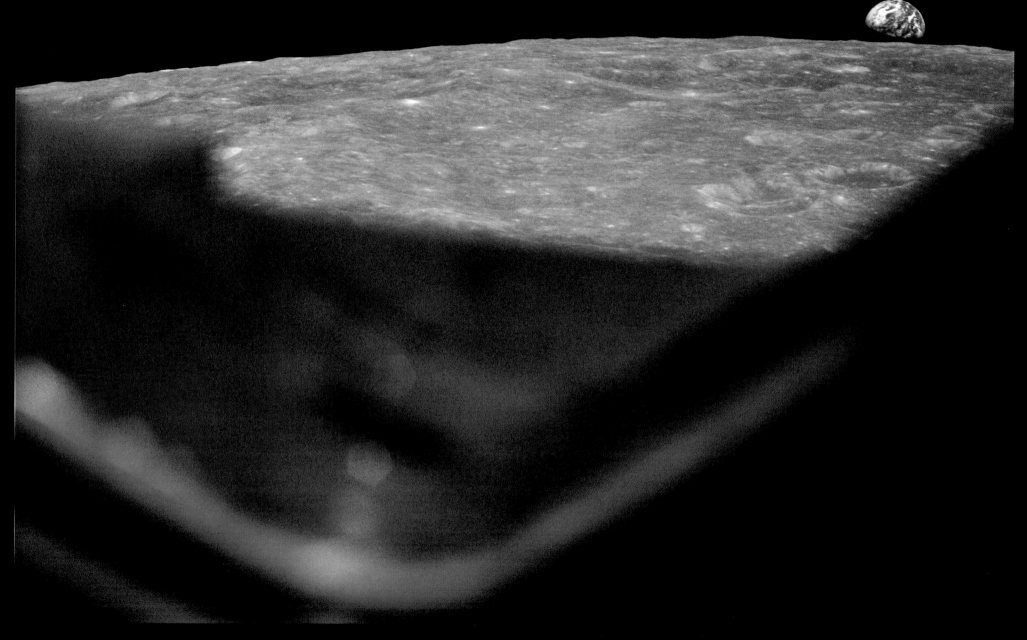

December 24, 1968 HASSELBLAD 70MM. LENS 80MM F/5.6 | BY UNKNOWN NASA ID: AS08-14-2393

Over the lunar farside, Lovell described sunrise: "I can see the Sun before it comes up . . . like zodiacal light . . . Oh boy! . . . It fans out all over the horizon . . . It's an even light." Forty minutes later, another Earthrise is viewed over Humboldt crater at the start of the sixth orbit. As communications with Earth were re-acquired, Anders described the farside: "The back-side looks like a sand pile my kids have been playing in for a long time. It's all beat up, no definition. Just a lot of bumps and holes." *(Rotated, EL: 3/5)*

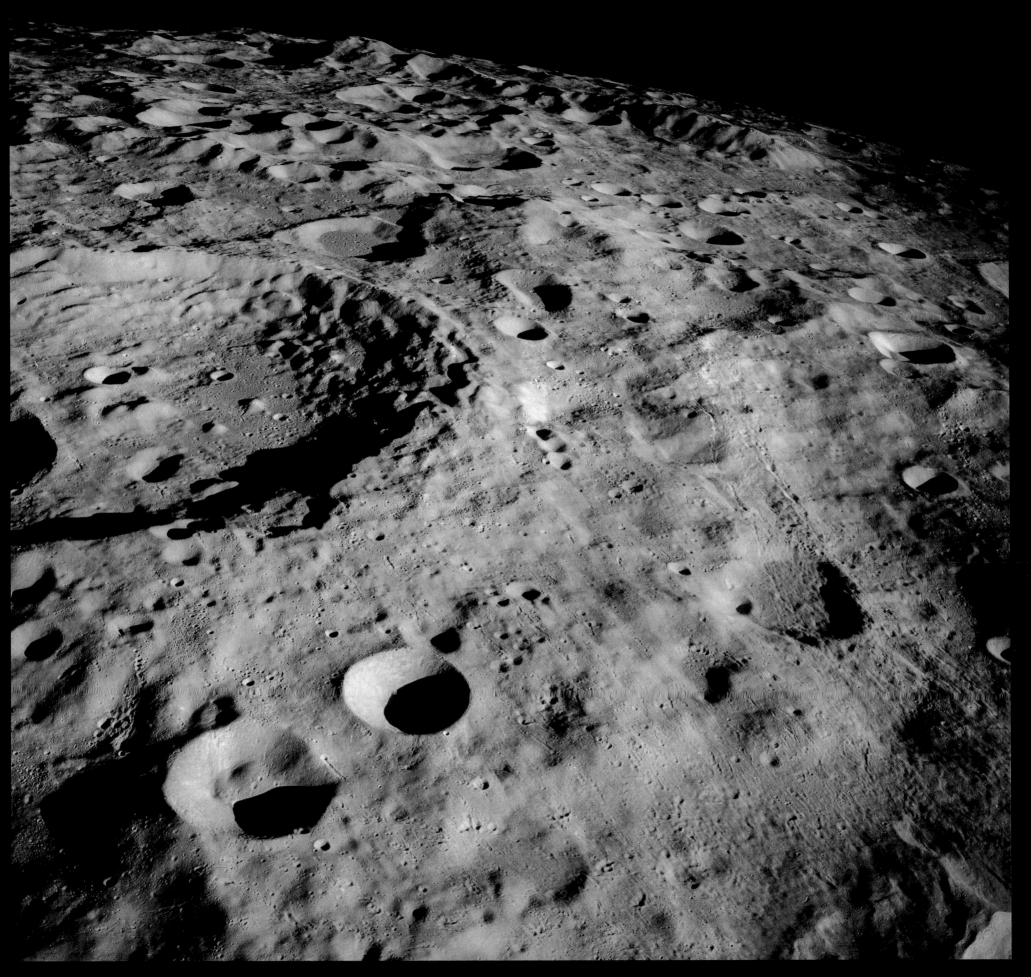

December 24–25, 1968 HASSELBLAD 70MM. LENS 250MM F/5.6. B&W | BY UNKNOWN NASA ID: AS08-13-2244

The farside of the Moon and its varied "beat up" landscape, scarred by billions of years of meteorite impacts. This was "target of opportunity" no. 12 – a fresh crater with trails of birds-foot secondary craters caused by ejecta. The defined small crater in the foreground is 9 miles across, and the large crater on the left is 70 miles in diameter. (Rotated. FL: 4/5)

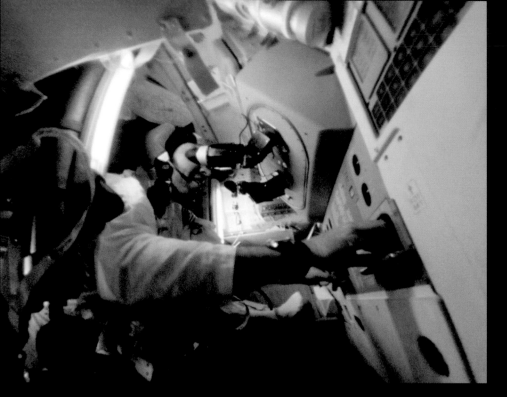

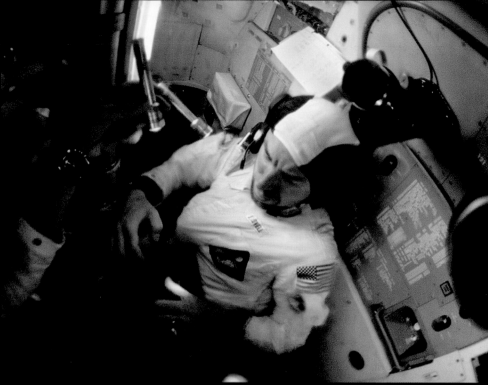

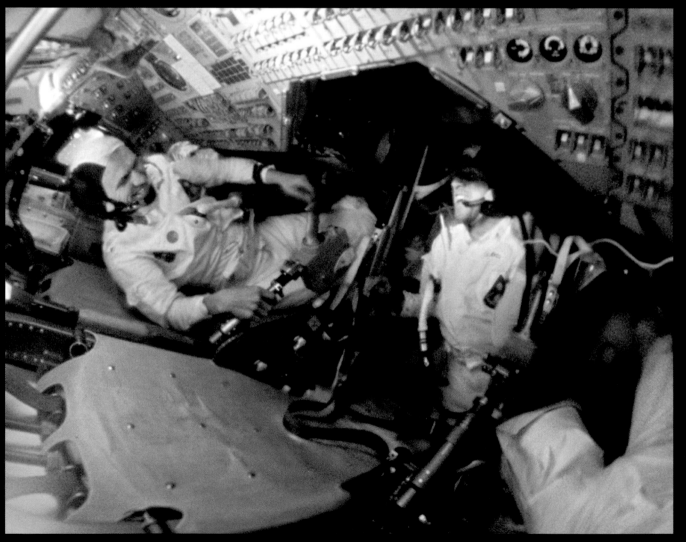

December 21–27, 1968　　　　　　10–25 FRAMES OF 16MM FILM, STACKED AND PROCESSED　　　　　　NASA ID: **APOLLO 8 MAG 1013-R**

TOP LEFT: Lovell: "Boy, you ought to see the lunar surface with this 28-power scope! This is utterly fantastic!" The sextant is a rudimentary device widely used by sailors in the 1700s for navigation using the stars. Lovell used the Command Module's sextant for navigation, but also to track control points and landmarks on the Moon. TOP RIGHT: Anders positions two flashlights in zero gravity to aid Lovell's preparation of a fresh square-shaped CO_2 filter. The filters remove harmful CO_2 build-up in the Command Module from the crew's breath. Famously, Lovell would experience issues with the square CSM filters in the Lunar Module on Apollo 13, which are . . . round. BOTTOM: "In the beginning God created the heavens and the Earth." Christmas at the Moon: Anders (leg bottom right) continues his "home movies," showing Lovell and Borman in high spirits. On Christmas Eve, all three crewmembers participated in a TV broadcast that had the largest TV audience in history. A shared reading from the book of Genesis was deemed most appropriate. "And from the crew of Apollo 8, we close with good night, good luck, a Merry Christmas – and God bless all of you, all of you on the good Earth."

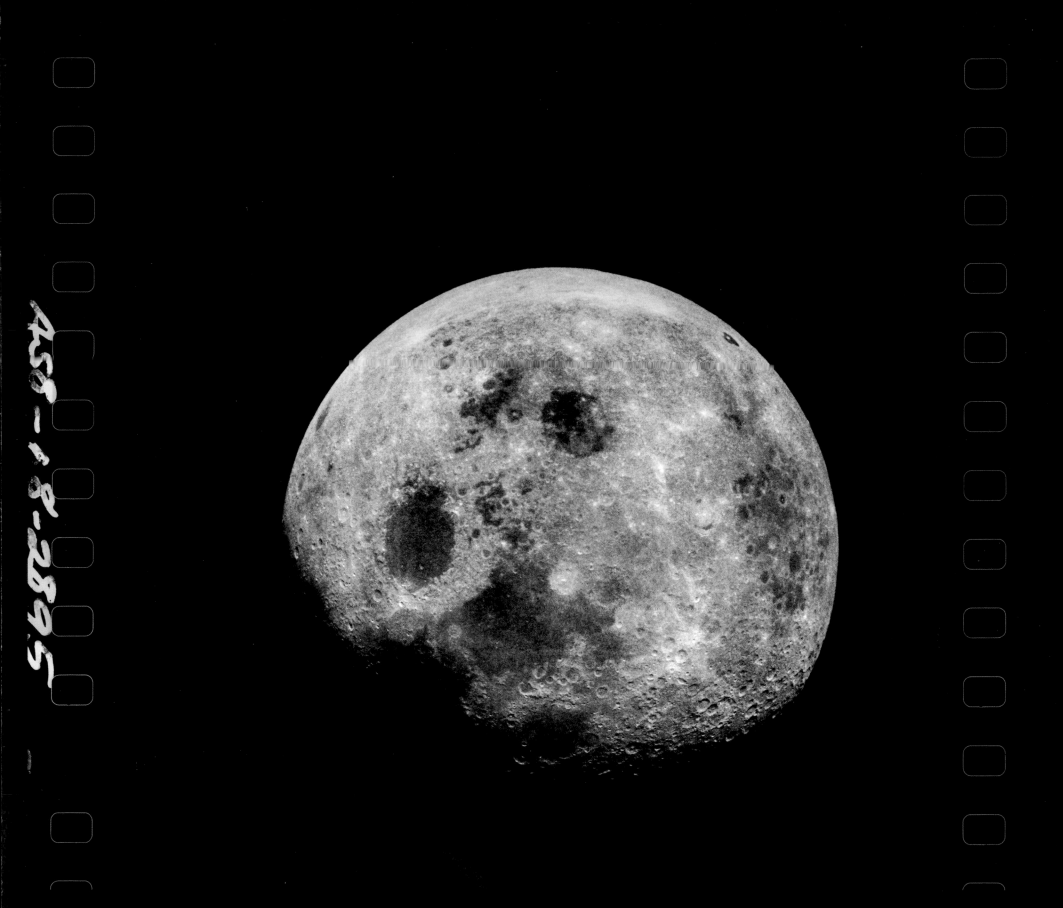

December 26, 1968 HASSELBLAD 70MM. LENS 80MM F/5.6. B&W | BY BILL ANDERS NASA ID: **AS08-18-2895**

On Christmas Day, the long SPS burn required to get the crew home occurred out of radio contact with Mission Control. After a nervous wait, Lovell's voice crackled over the airwaves: "Houston, Apollo 8, over . . . Please be informed, there *is* a Santa Claus!" Within an hour, he and Borman would try to sleep, as Anders continued to take photographs, including this one of the whole Moon through the CM window, approximately 7,000 miles out, on the journey home. *(EL: 4/5)*

THE DETAILS

ROCKET
Saturn V (AS-504)

COMMAND AND SERVICE MODULE
Gumdrop (CSM-104)

LUNAR MODULE
Spider (LM-3)

LAUNCH
16:00 GMT,
March 3, 1969, Pad 39A

LANDING SITE
N/A

DISTANCE
4,214,543 miles

DURATION
10 days, 1 hour, 54 seconds

SURFACE TIME
N/A

EARTH ORBITS
151

SPLASHDOWN
17:01 GMT,
March 13, 1969,
Atlantic Ocean

RECOVERY SHIP
USS *Guadalcanal*

THE CREW

James A. McDivitt
COMMANDER (CDR)

Born June 10, 1929. McDivitt was Command Pilot of Gemini IV, the US's first long-duration space mission during which crewmate Ed White performed the first U.S. spacewalk. After Apollo 9, McDivitt became Apollo Spacecraft Program Manager for Apollo 12 through to Apollo 16.

David R. Scott
COMMAND MODULE PILOT (CMP)

Born June 6, 1932. Scott was Pilot on Gemini VIII with Neil Armstrong as Command Pilot, and both were fortunate to survive after their spacecraft began to spin uncontrollably when attached to the Agena target vehicle. He later became Commander of Apollo 15, retiring from NASA in 1977.

Russell L. "Rusty" Schweickart
LUNAR MODULE PILOT (LMP)

Born October 25, 1935. Selected in the third group of astronauts in 1963, Schweickart was a former USAF fighter pilot. Apollo 9 would be his only spaceflight. He retired from NASA in 1977, having served as back-up Commander for the first Skylab mission in 1973.

March 3–13, 1969

APOLLO 9

THE MISSION

As with Apollo 7, the third crewed Apollo mission would be carried out entirely in Earth orbit, covering many of the engineering tests originally planned for the reprioritized Apollo 8 mission. The key objective was to test the full Apollo spacecraft, including the Lunar Module (LM) for the first time. The Portable Life Support System (PLSS) backpack would also be tested for the first time in space, as the mission would incorporate the last EVA before the PLSS would be needed by the first man to walk on the Moon.

The flight was described as "smooth" except for the jolt at separation as experienced on Apollo 8. An underperformance from the first two stages was made up by the third-stage S-IVB, and two hours 40 minutes later the CSM separated and turned around to find an actual LM, rather than a target as on Apollo 7, or Apollo 8's test article.

After a successful docking and extraction of the LM, when at a "safe" distance of around 1,000 feet, the crew observed the S-IVB as it was remotely re-ignited to further test the engine, sending it beyond the gravitational pull of Earth and into an orbit around the Sun. In effect this was a test trans-lunar injection burn.

Schweickart and McDivitt entered the LM, but the contortions involved in donning their pressure suits and moving through the tunnel from the CM made them feel ill – particularly Schweickart, who vomited more than once. Although they successfully tested the LM's communications and life support system, and fired its descent engine to propel the stack of both spacecraft (a back-up that would be needed for real on Apollo 13), McDivitt seemed a little unimpressed with the initial LM checkout. In discussions with Scott he complained, " There's a lot of little things that have to be fixed up . . . I bet you there's not 50 percent of the things over there that work."

The planned EVA could not go ahead with any risk of vomiting, as this could prove fatal in a spacesuit. Schweickart later recalled: "We thought seriously that we may have to cancel the mission . . . We were going to miss Kennedy's commitment to go to the Moon [by the end of the decade]." The EVA was delayed and, when the time came, McDivitt asked Schweickart if he felt well enough to go ahead. McDivitt told Mission Control that an attempt would be made.

The EVA was successful, and the only mishap was Scott's jammed 16mm magazine. This gave Schweickart a rare few minutes to simply observe and take in the situation. The contrast between the total silence and the incredible view led to a life-changing epiphany, as he contemplated: "Humanity has reached this point where we're moving out from the Earth . . . And how does that happen in history, and what does it mean?"

On day five, the LM separated from the CSM to undertake its first independent flight test. McDivitt fired its throttleable descent engine, which would be necessary to take astronauts down to the lunar surface on future missions. The LM would then rendezvous and dock again with the CSM, as if in lunar orbit, returning from the surface. This would be the world's first docking of two crewed vehicles in space (with an internal transfer of the crew). The LM's controls were designed for a line-of-sight out the forward windows, but looking up required McDivitt to make a 90-degree translation of the controls. Schweickart told me: "For a pilot, it's difficult to explain the ridiculous process of a LM active docking . . . Poor Jim was left trying to make this transformation in his head. That is a very, *very* difficult flying task." LM *Spider* would later be jettisoned and its ascent engine (which would be used to ascend from the lunar surface) remotely fired.

The remaining five days continued at a comparatively leisurely pace, focused on the CSM and navigation, and included photography experiments and Earth observation.

THE PHOTOGRAPHY

On such a complex mission, testing many events and procedures for the first time, much of the photography was focused on recording them for evaluation back on Earth, in preparation for the next step in the program. Schweickart pointed out to me that: "The reason that Dave had the DAC taking these pictures was to prove I wasn't flopping all around and risking poking a hole in the suit or anything."

Perhaps due to the skill of the astronaut-photographers, the use of the Hasselblad SWC, and the quality of reflected light from Earth, Apollo 9 brought back some of the finest images of the whole program.

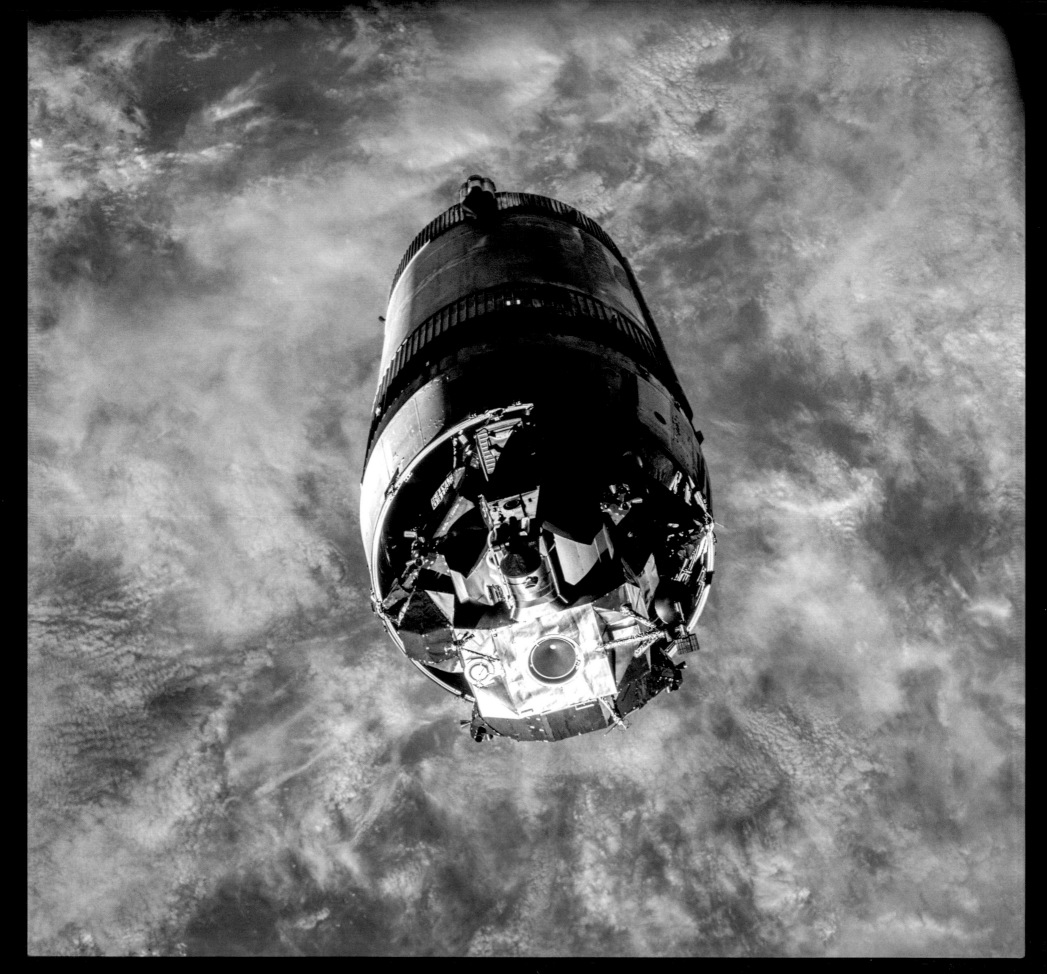

March 3, 1969

HASSELBLAD 70MM. LENS 80MM F/2.8 | BY RUSTY SCHWEICKART

NASA ID: **AS09-19-2921**

Almost three hours into the flight, the CSM separated from the S-IVB third stage and Scott began Apollo's first docking and extraction of a Lunar Module. On future missions this would occur after TLI on the way to the Moon. This image shows just how tightly packed the LM is in the base of the Spacecraft Lunar Module Adapter (SLA), on top of the S-IVB stage. The adapter panels have already been jettisoned. *(EL: 4/5)*

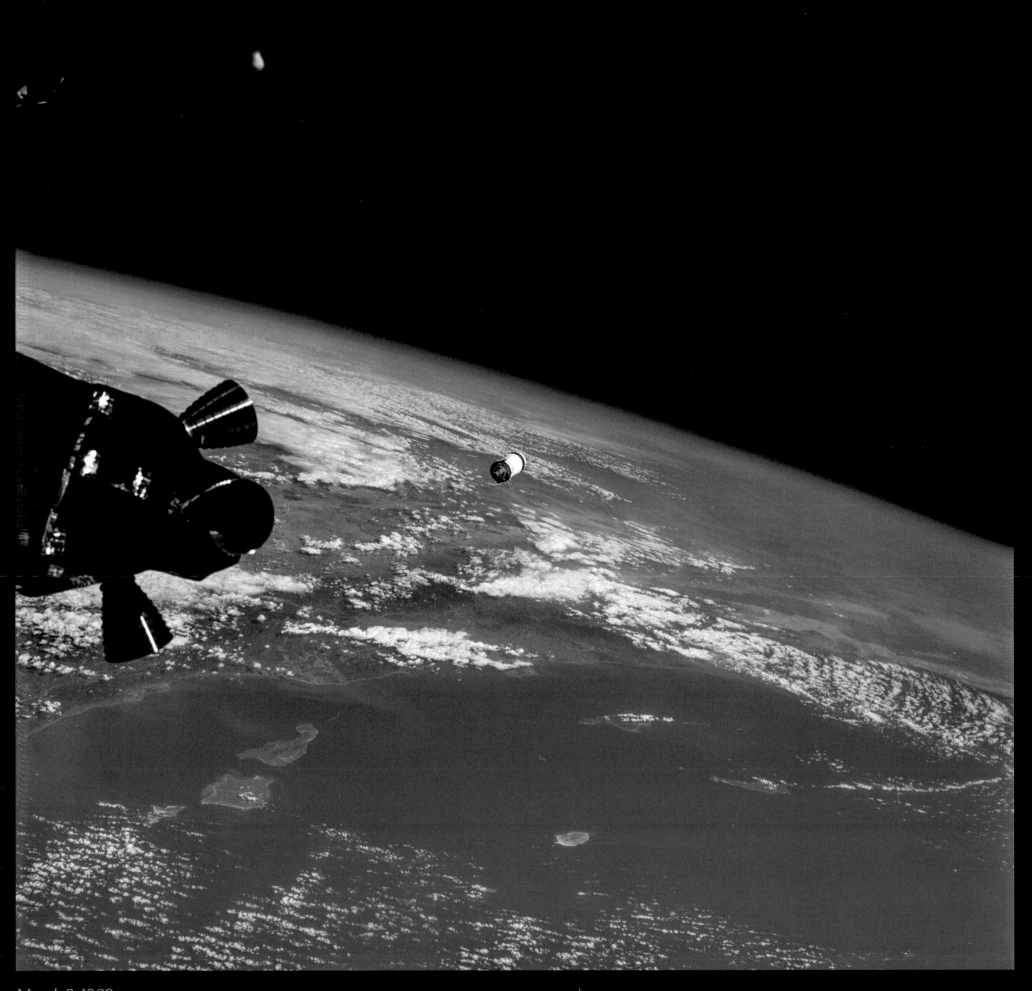

March 3, 1969

HASSELBLAD 70MM. LENS 80MM F/2.8 | BY UNKNOWN NASA ID: **AS09-19-2949**

The S-IVB over California as seen from the Command Module. The reaction control system (RCS) thrusters of the LM, now attached, can be seen at the left. The view is looking southeast from Santa Barbara down to San Diego. The whole Apollo spacecraft stack maintained a range of 1,000 feet in order to observe an imminent re-ignition of the S-IVB. *(Rotated, EL: 2/5)*

March 3, 1969

HASSELBLAD 70MM. LENS 80MM F/2.8 | BY UNKNOWN

NASA ID: AS09-19-2953

McDivitt: "Houston, we're going to be just about down his tailpipe. It looks like about 1,000 feet or so." From this vantage point the crew observed and photographed the re-ignition of the S-IVB. This was a further test of its engine — a simulated TLI in effect — which increased its speed to escape velocity and disappeared "like a bright star" into an orbit around the Sun. On all future missions the CSM/LM (pre-extraction) and crew would still be attached to the top of the S-IVB. (Cropped. EL: 3/5)

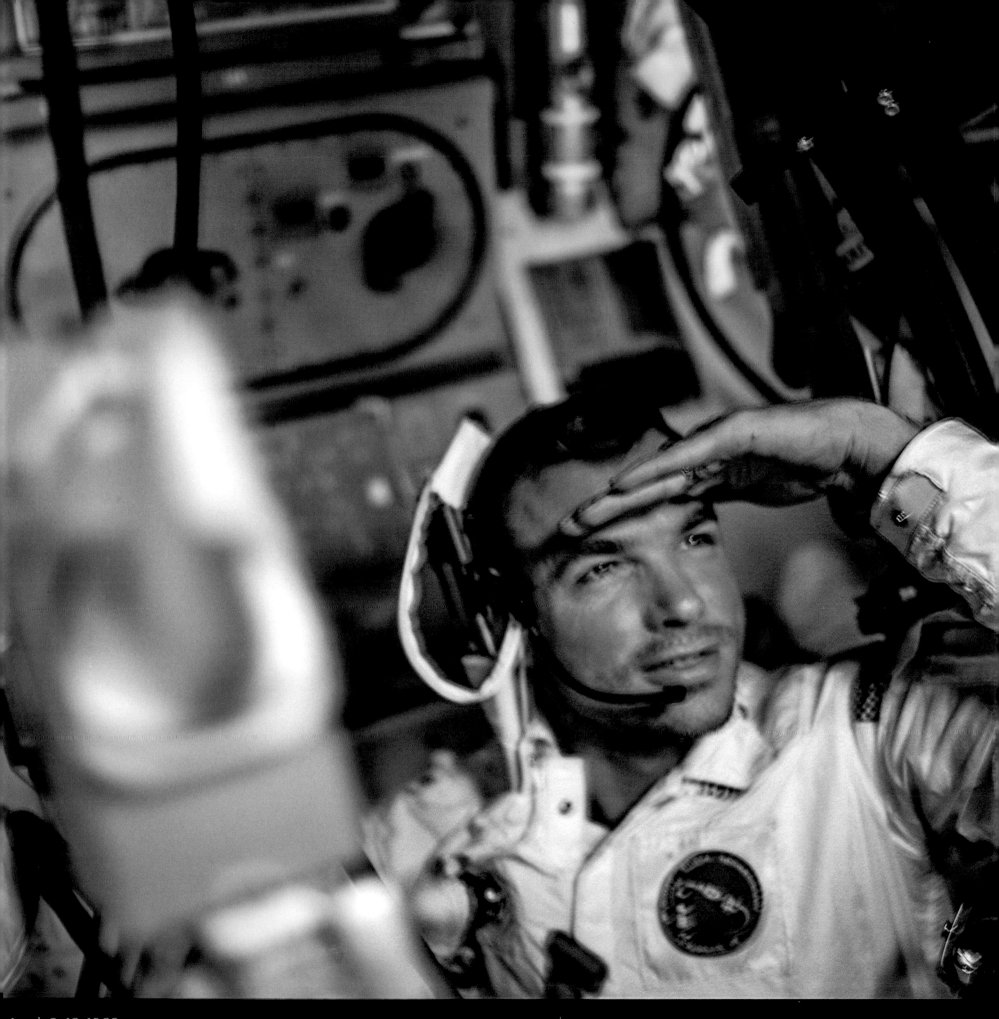

HASSELBLAD 70MM. LENS 80MM F/2.8 | BY JIM McDIVITT

MP Scott in the Command Module. On day three of the mission, LMP Schweickart and CDR McDivitt donned their pressure suits (the movement caused them to feel queasy) and climbed through the tunnel into a Lunar Module for the first time during Project Apollo. They would prepare it for flight, test systems, comms and its throttleable descent engine. At this time Schweickart's queasiness turned into a serious bout of (the then relatively unknown) "space adaption sickness," which threatened the whole mission. (FL: 2/5)

March 6, 1969 HASSELBLAD SWC 70MM. LENS 38MM F/4.5 | BY JIM McDIVITT NASA ID: **AS09-20-3054**

The start of a shortened EVA due to Schweickart's sickness – Scott, connected to the Command Module's life support system via an umbilical, pokes his head out of the hatch, as Schweickart, feeling much better, egresses from the LM hatch. Photographed through the LM rendezvous window; the 16mm DAC camera can be seen mounted to the hatch to Scott's left (see Apollo 9 Mag SN-1060, opposite page). *(EL: 4/5)*

March 6, 1969 290 FRAMES OF 16MM FILM, STACKED AND PROCESSED NASA ID: **APOLLO 9 MAG SN-1060**

Schweickart: "Boy, oh boy; what a view!" Scott (foreground, right): "Why don't you say hello to the camera or something?" Schweickart: "Hello there, camera. Boy, is this great!" The view from Scott's 16mm DAC camera with Schweickart on the LM porch, Earth reflected in both men's visors. Having been bashed around, the camera would eventually fail to start after changing the magazine, giving Schweickart four minutes to simply admire the view and contemplate his place in the universe.

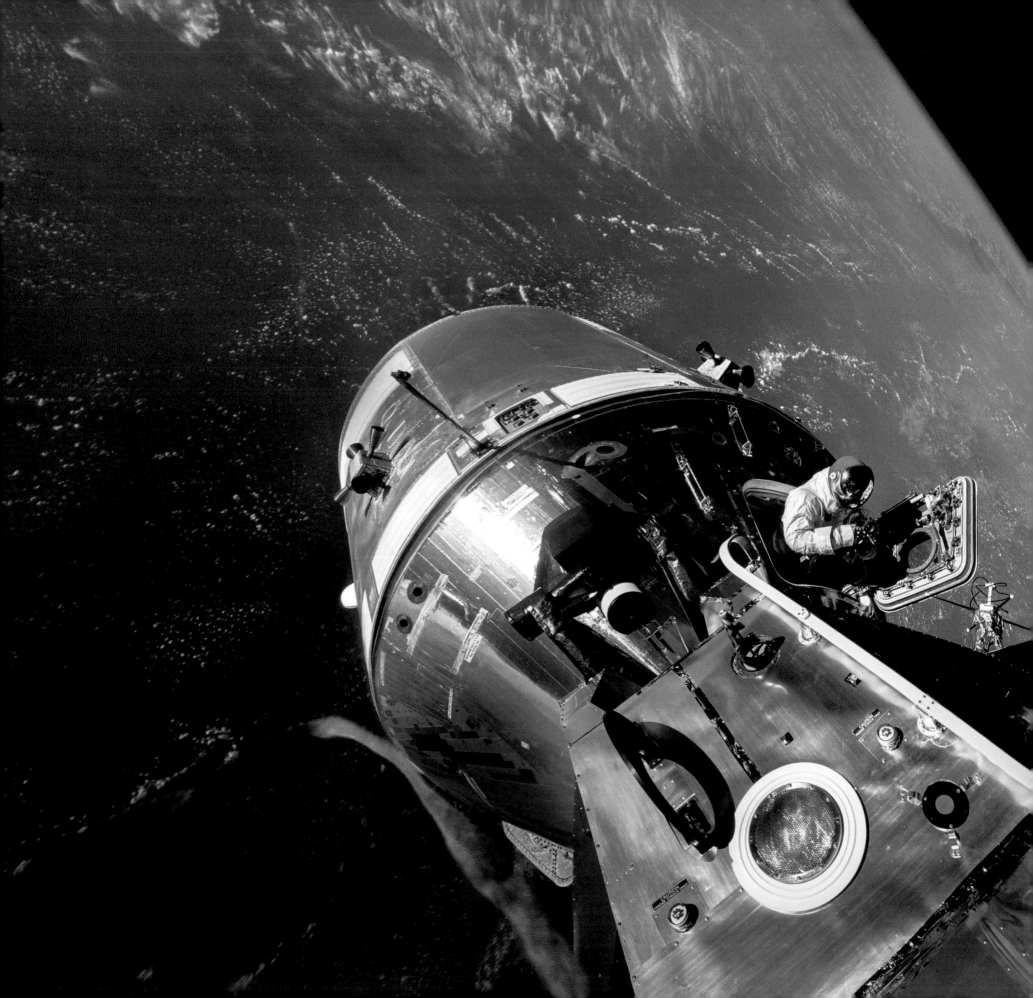

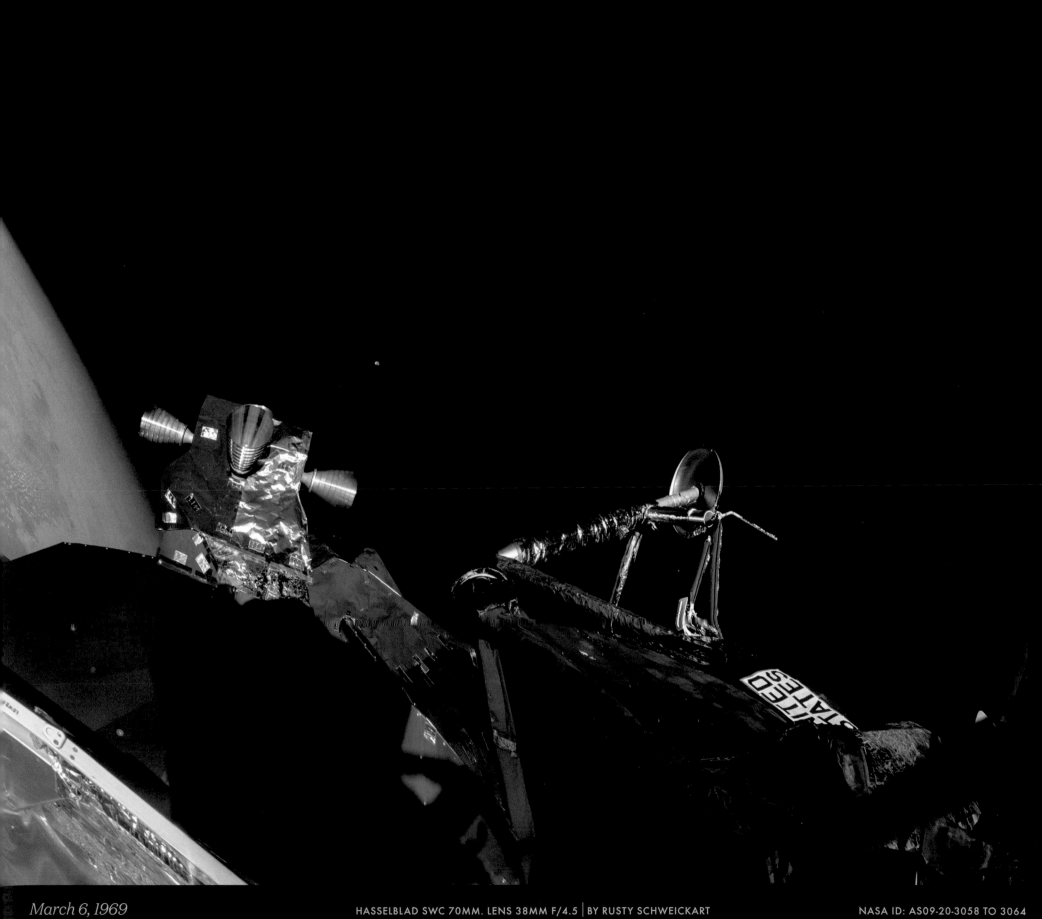

March 6, 1969 HASSELBLAD SWC 70MM. LENS 38MM F/4.5 | BY RUSTY SCHWEICKART NASA ID: AS09-20-3058 TO 3064

At this early stage of Apollo, the Moon still seemed so far away – seen here above the LM's quad thrusters. Schweickart had this rare vantage point; able to view the whole Apollo LM and CSM stack. Scott is in the Command Module hatch, also taking a picture, with his Hasselblad 500C (note, front-mounted shutter release and manual film advance winder): "We're all taking pictures of everybody taking pictures!" *(Panorama, EL: 4/5)*

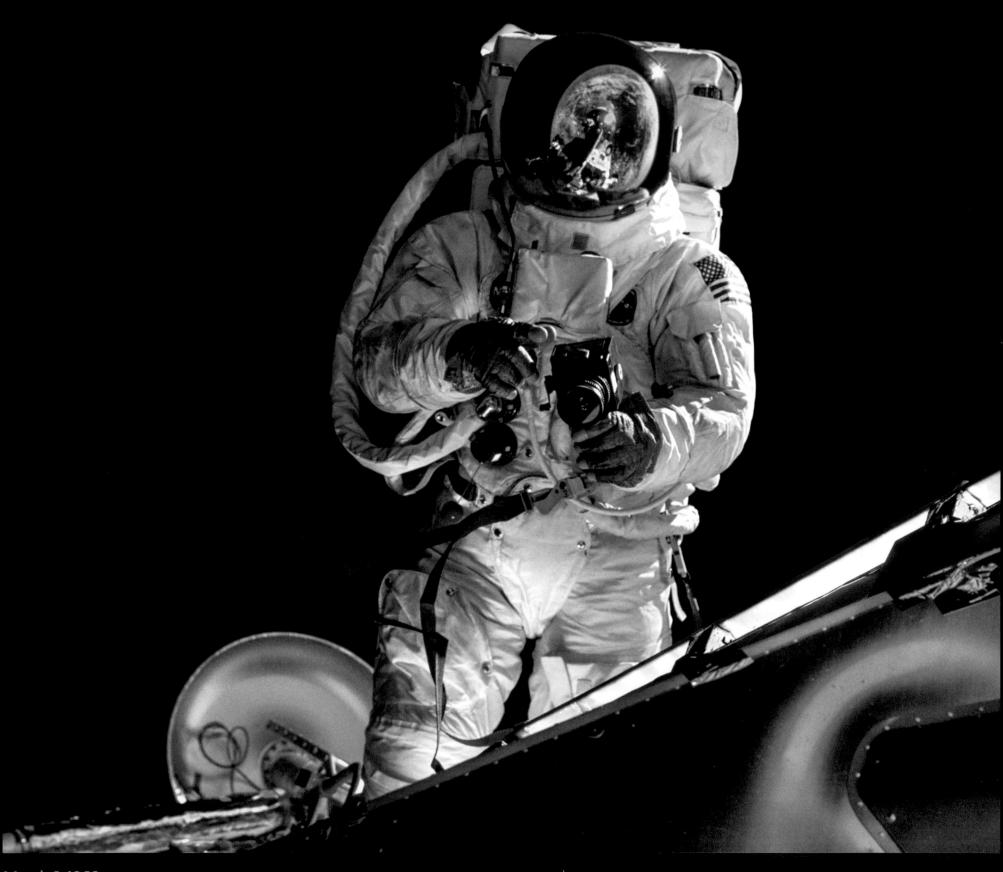

March 6, 1969

HASSELBLAD 70MM. LENS 80MM F/2.8 | BY DAVE SCOTT

NASA ID: **AS09-19-2982**

McDivitt: "Oh, I've got to have that camera and get you! . . . In your visor, our spacecraft *Gumdrop* completely all the way down to the bottom of the service module and the whole Earth behind you!" Scott: "Oh, hey! I got one of those too now that you mention it. Just don't move, Russell." Scott's view back at Schweickart using his Hasselblad SWC (note, top-mounted shutter release and manual film advance winder) and the LM, CSM, Scott and the whole Earth reflected in his visor. *(Cropped, rotated, EL: 4/5)*

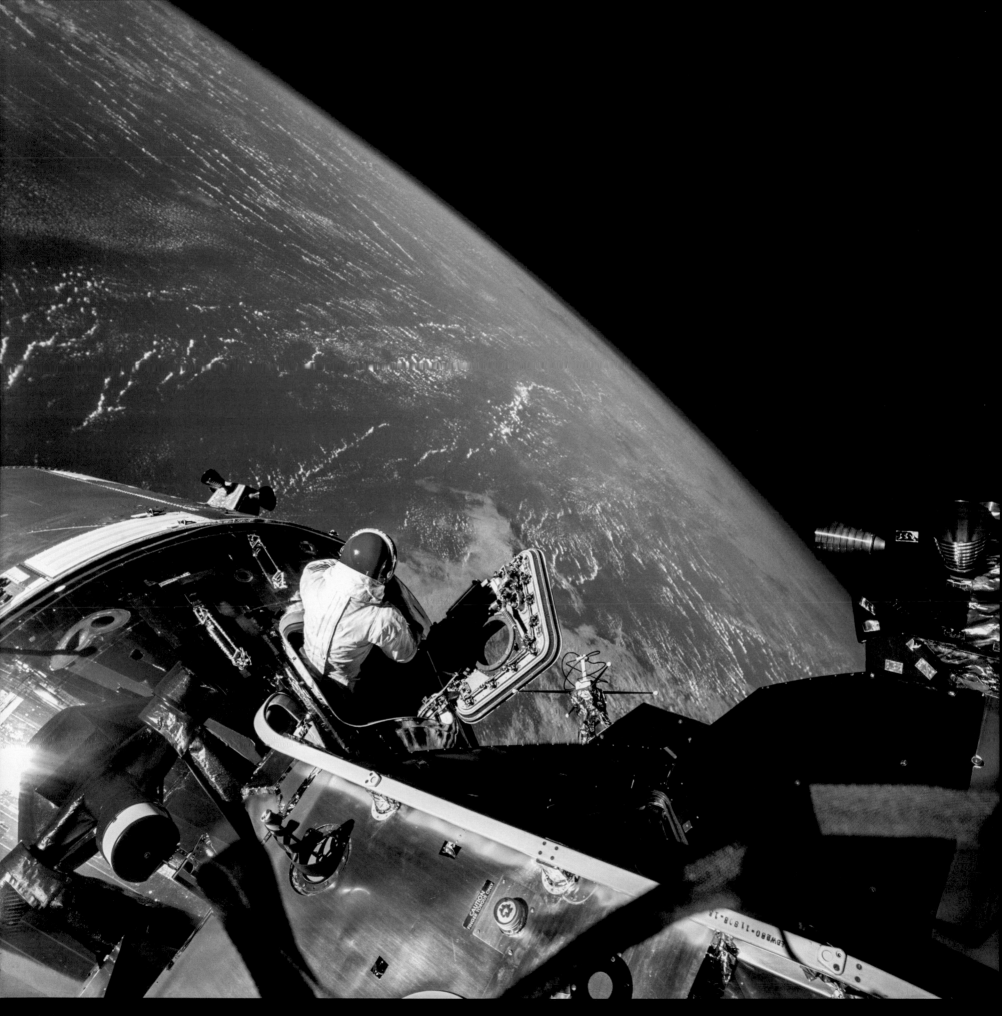

March 6, 1969 HASSELBLAD SWC 70MM. LENS 38MM F/4.5 | BY RUSTY SCHWEICKART NASA ID: **AS09-20-3065**

Dave Scott takes a moment while collecting a thermal sample to take in this astonishing view of Earth as it curves away into the distance. The red EVVA helmet differed from the later, more familiar white LEVA lunar helmet. Due to Schweickart's sickness, the delayed EVA was shortened from two hours to just 40 minutes, but largely achieved its key objectives, including testing the PLSS, returning thermal samples, and traversing the LM using the handrails. *(EL: 4/5)*

CAUTION
FINGER TORQUE ONLY

TO DUMP

March 6, 1969 HASSELBLAD SWC 70MM. LENS 38MM F/4.5 | BY RUSTY SCHWEICKART NASA ID: **AS09-20-3067**

McDivitt can be seen in the Lunar Module window, smiling for the camera and observing proceedings, probably filming Schweickart with the 16mm DAC. This super-sharp image arguably shows the finest detail of the exterior of a Lunar Module in flight. *(EL: 3/5)*

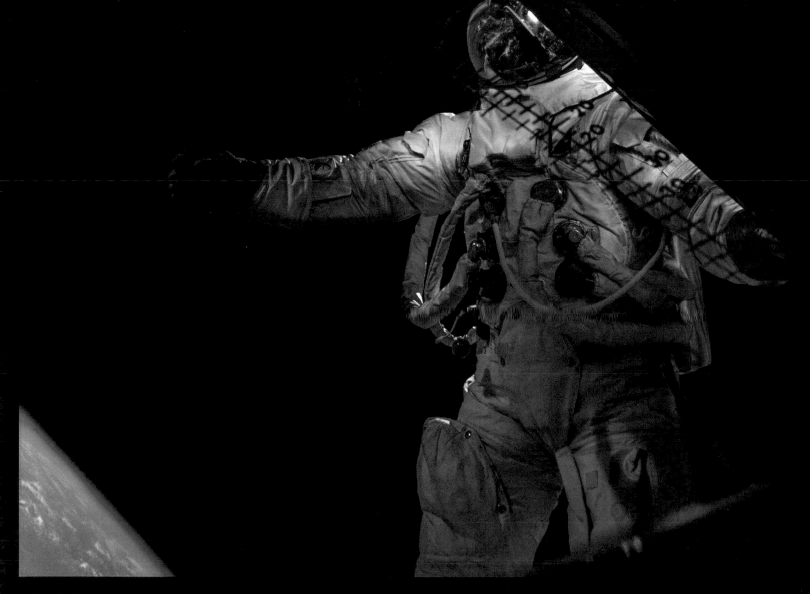

March 6, 1969 HASSELBLAD SWC 70MM. LENS 38MM F/4.5 | BY JIM McDIVITT NASA ID: **AS09-20-3094**

Scott was struggling to replace the magazine on the DAC. McDivitt: "Well, you've got four minutes . . . then we are going to have to come back in, with or without the movies." Schweickart had a few precious moments – he released his right hand from the handrail and turned his body to face Earth. During his "epiphany," his body floated within his suit and there was an incomprehensible depth of silence, in huge contrast to the unobstructed, spectacular view. *(EL: 4/5)*

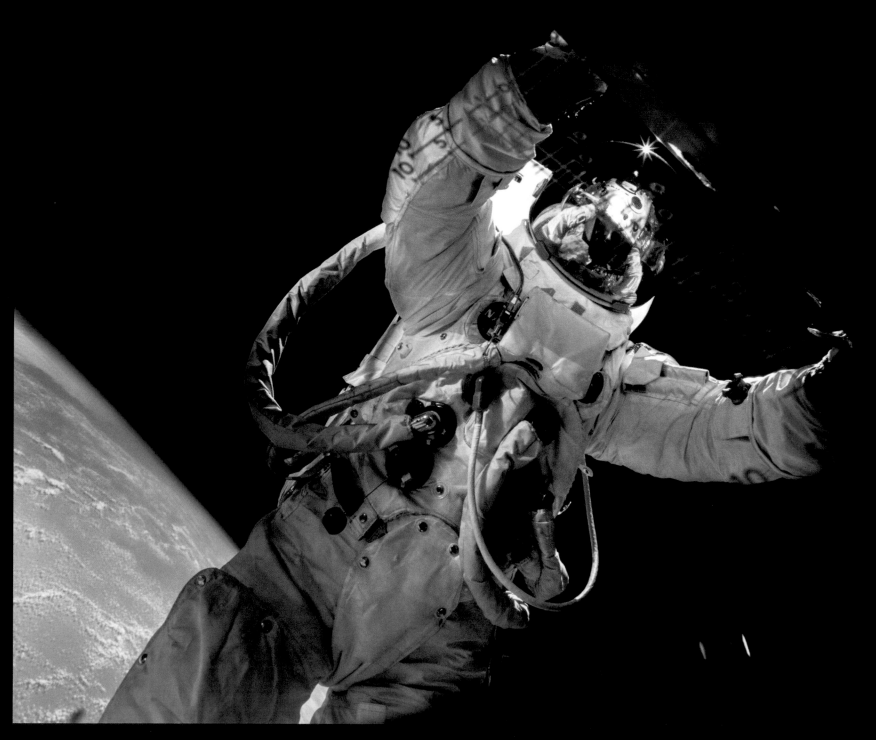

March 6, 1969

HASSELBLAD SWC 70MM. LENS 38MM F/4.5 | BY JIM McDIVITT

NASA ID: AS09-20-3097

McDivitt: "Come around the window here, can you?" Schweickart: "I'm in the shade, though . . . Now you got to get a good picture." A pin-sharp image of this historic EVA. The markings etched on the inner and outer pane of the LM window are the Landing Point Designator (LPD). On lunar landings the pilot will line up these marks and be able to read off the degrees from the LM computer to view the expected landing spot. *(EL: 4/5)*

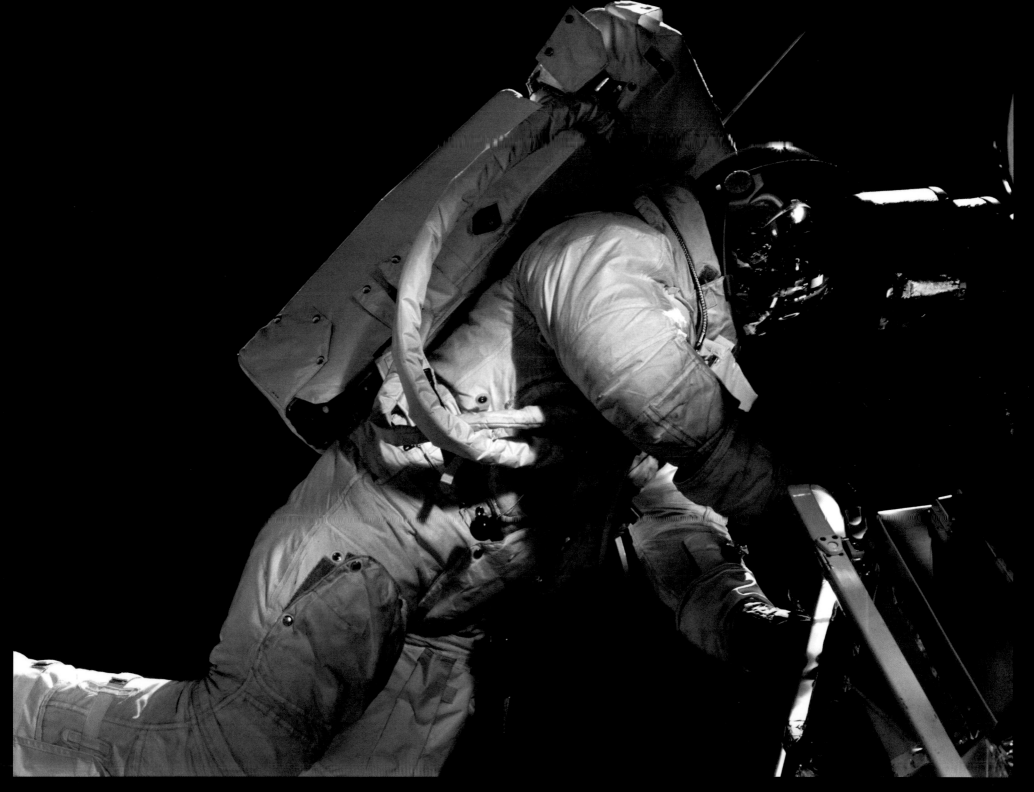

March 6, 1969

HASSELBLAD 70MM. LENS 80MM F/2.8 | BY DAVE SCOTT

NASA ID: AS09-19-2999

Beautifully lit by the pale blue reflected light from Earth, connected to the spacecraft with only a nylon rope, Schweickart makes his move around the LM utilizing the handholds. His PLSS (Portable Life Support System) is clearly shown on its first use in space. The next time a PLSS would be worn on an EVA would be by Neil Armstrong on the Moon. *(Rotated, EL: 3/5)*

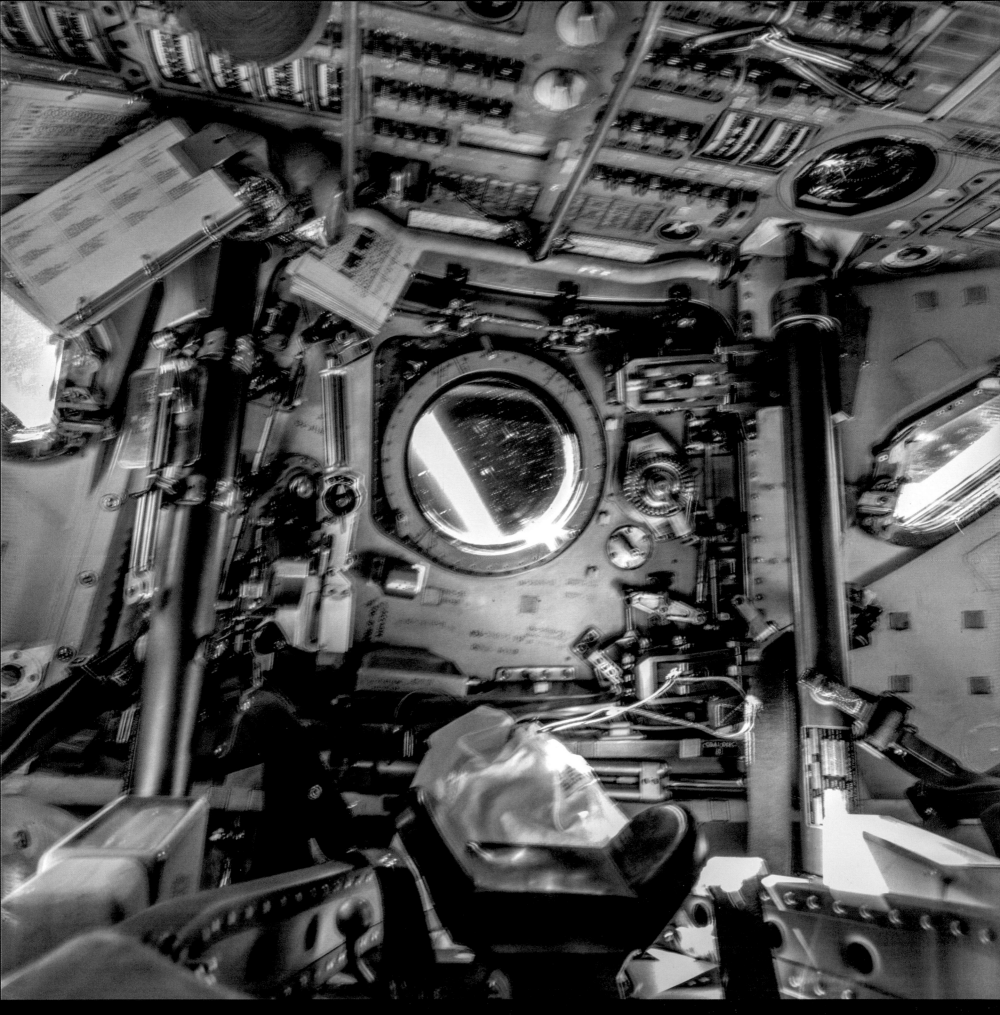

March 6–13, 1969 HASSELBLAD SWC 70MM. LENS 38MM F/4.5 | BY UNKNOWN NASA ID: AS09-20-3104

After ingress from the EVA, the hatch in which Scott stood was closed and the cabin repressurized. A blurred but well-exposed shot showing the interior of Command Module *Gumdrop,* looking up from the center couch with Earth's limb visible through the hatch's porthole window. *(EL: 2/5)*

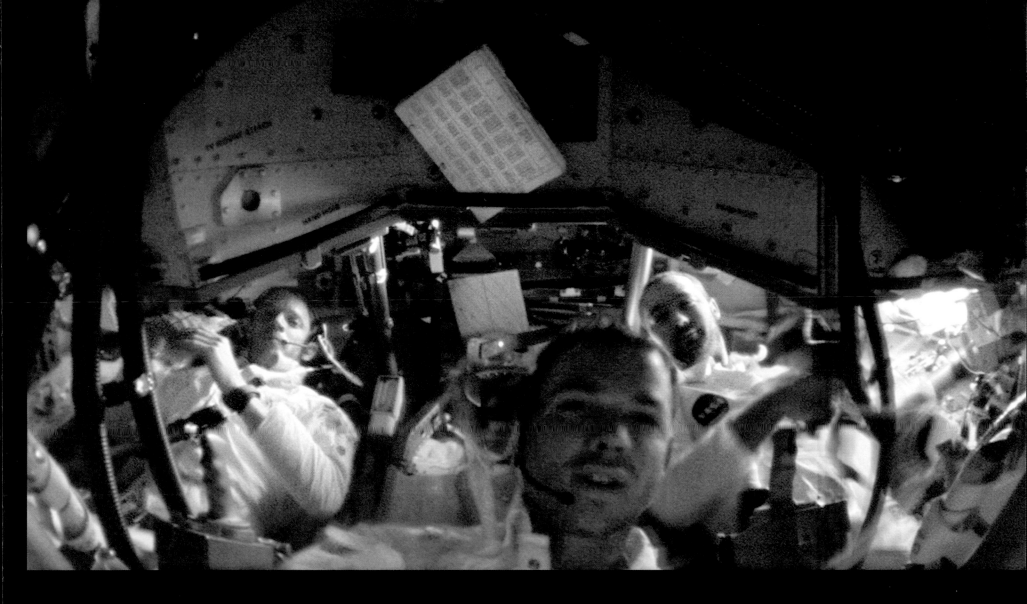

March 6–13, 1969 30 FRAMES OF 16MM FILM, STACKED AND PROCESSED NASA ID: **APOLLO 9 MAG SN-1071**

An extremely rare portrait of a full Apollo crew during a mission. Scott holds the DAC to capture the crew of Apollo 9 in their Command Module *Gumdrop* (left to right: Rusty Schweickart, Dave Scott, Jim McDivitt).

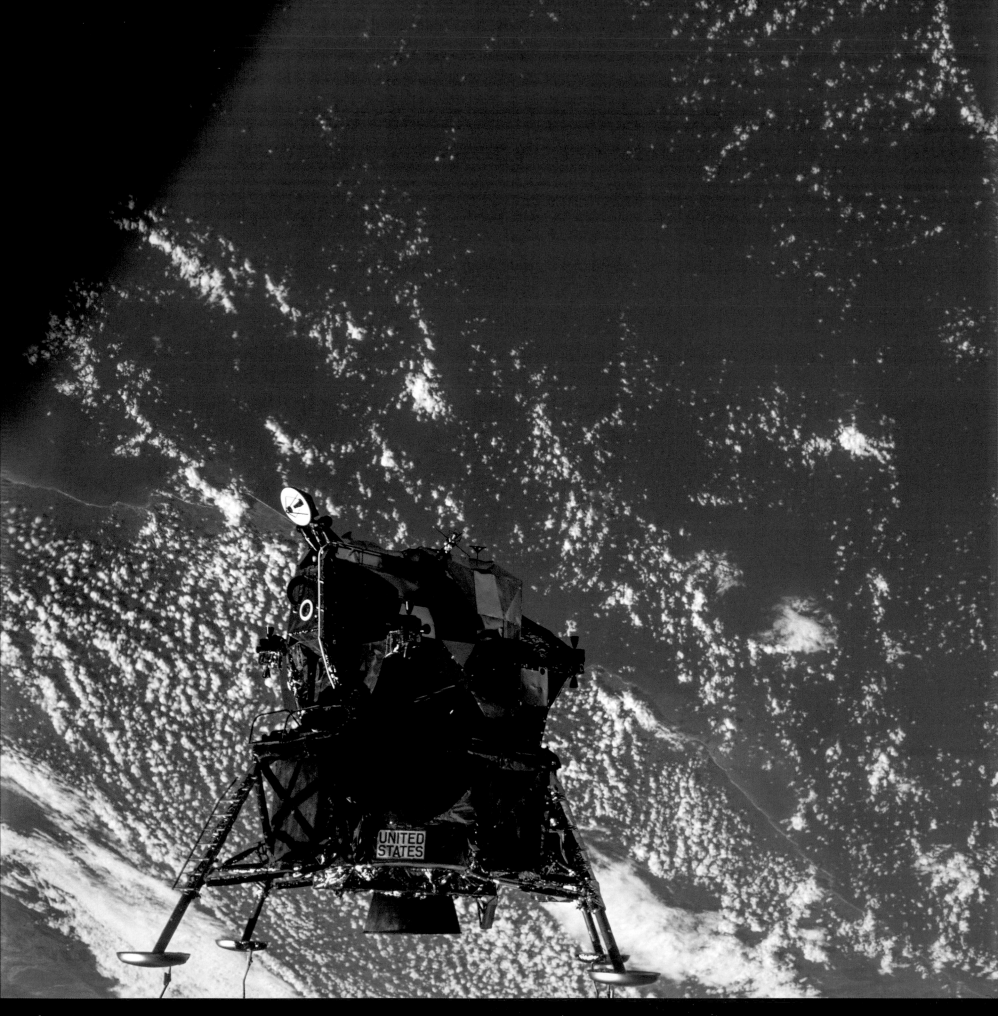

March 7, 1969　　　　　　　　HASSELBLAD 70MM. LENS 80MM F/2.8 | BY DAVE SCOTT　　　　　　　　NASA ID: AS09-21-3206

A key event of the whole mission was separation and rendezvous of the LM and the CSM. LM *Spider* is flying independently for the first time as seen from the CSM after undocking – McDivitt can just be seen in his left-hand window. As the LM was designed only for lunar landing, this was the first time humans had flown a spacecraft incapable of getting them home. This would put significant pressure on the success of Apollo's upcoming first docking in space. *(Cropped, EL: 4/5)*

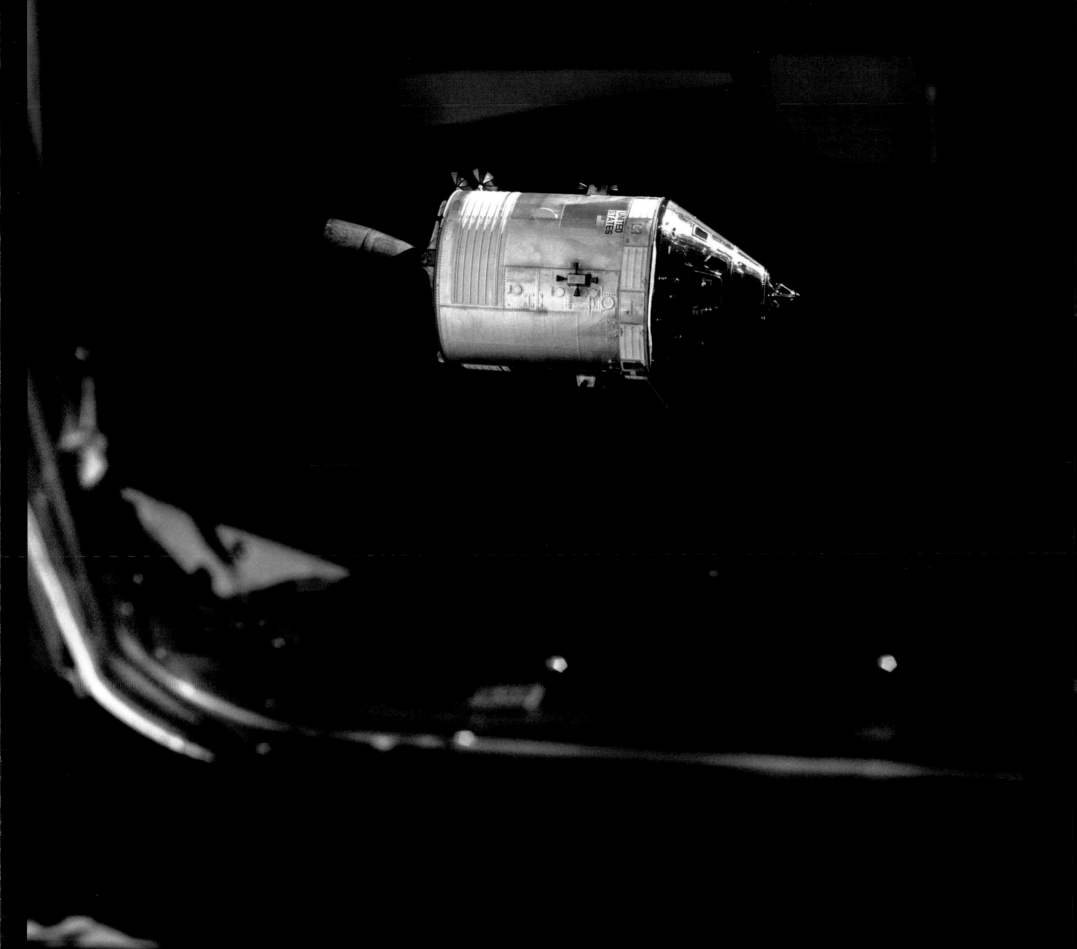

March 7, 1969

HASSELBLAD 70MM. LENS 80MM F/2.8 | BY JIM McDIVITT

NASA ID: **AS09-24-3641**

Looking back from the window of the LM – a perfect portrait of CSM *Gumdrop*. The docking probe can be seen (far right) and the Command Module hatch. At the rear, we see the texture of the engine nozzle along with two of the four high-gain antenna dishes and individual rivets and fixings across the paneling. *(Rotated, EL: 5/5)*

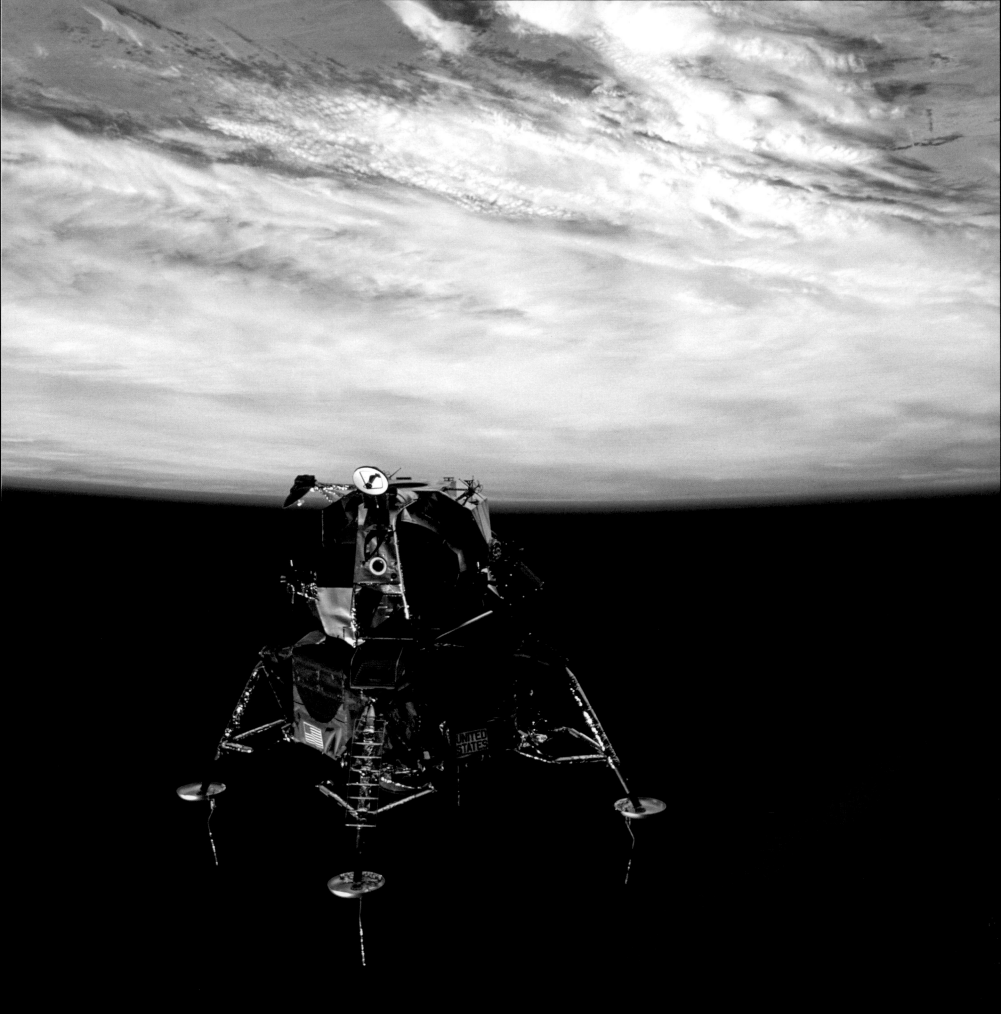

March 7, 1969 HASSELBLAD 70MM. LENS 80MM F/2.8 | BY DAVE SCOTT NASA ID: AS09-21-3212

Lunar Module *Spider* in orbit over the desert landmasses of our planet. On the porch (at the top of the ladder) we can make out the "golden slippers" which were footholds used by Schweickart during his EVA. McDivitt tested the LM's descent engine at various throttle settings. *(EL: 3/5)*

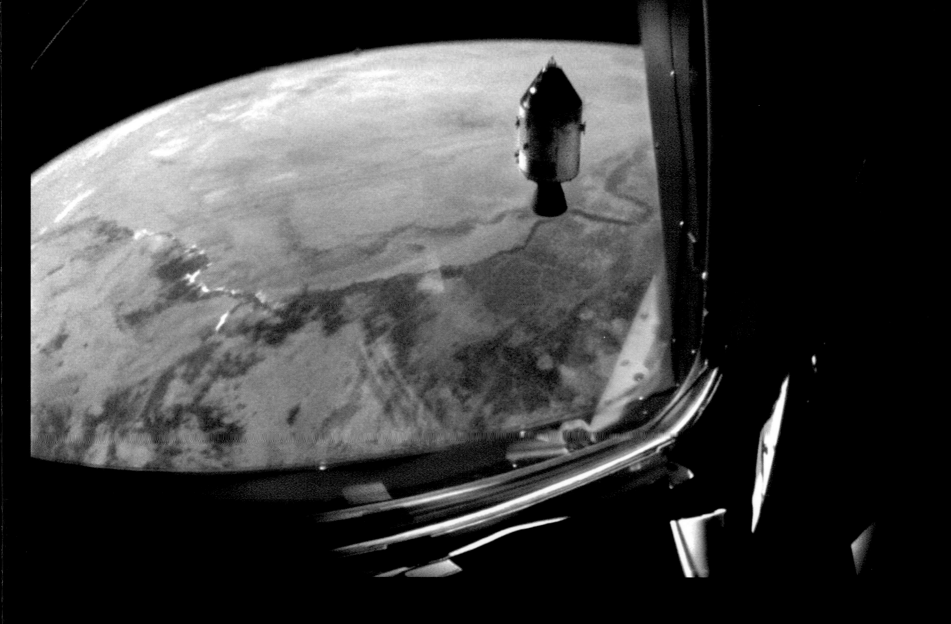

March 7, 1969 80 FRAMES OF 16MM FILM, STACKED AND PROCESSED NASA ID: **APOLLO 9 MAG SN-1066**

CSM *Gumdrop*, with Scott on board, orbits above the deserts of Earth as viewed through McDivitt's left-hand Lunar Module window. Schweickart, as Lunar Module Pilot, occupied the right-hand LM station.

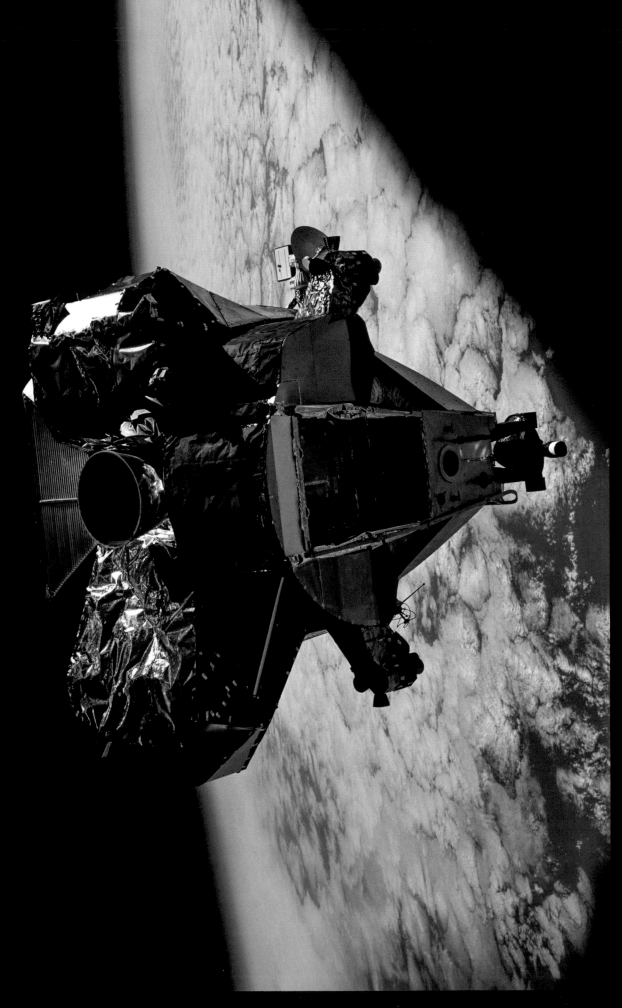

March 7, 1969

HASSELBLAD 70MM. LENS 80MM F/2.8 | BY DAVE SCOTT

NASA ID: AS09-21-3236

The descent engine burns took the LM 111 miles away from the CSM. The descent stage was then jettisoned (on lunar landing missions it would remain on the surface) and the ascent stage engine tested, to return and rendezvous with the CSM. McDivitt then maneuvered the LM to allow Scott to inspect for damage, prior to the first docking attempt. *(EL: 4/5)*

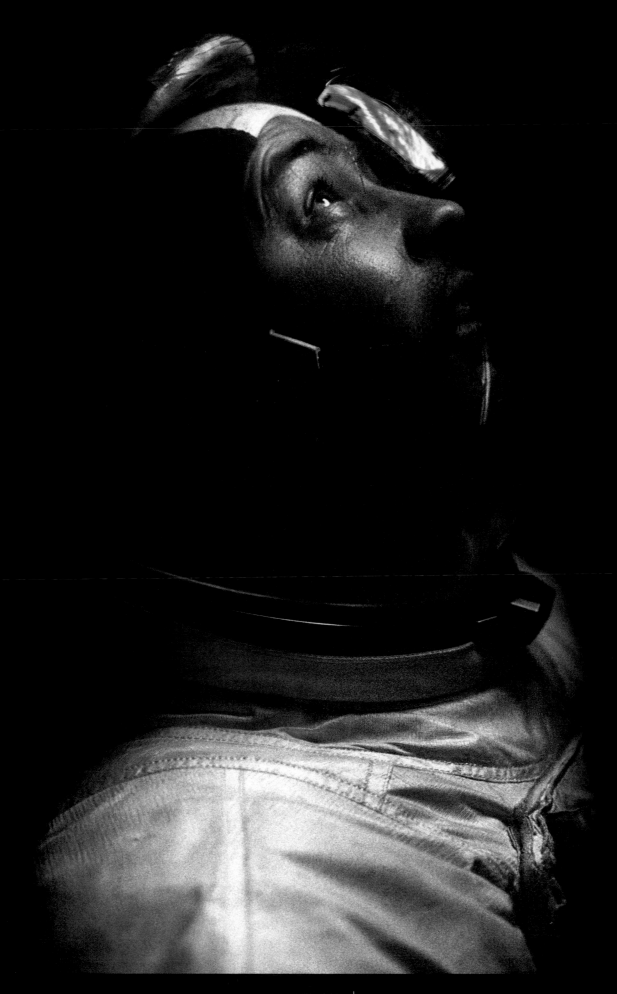

March 7, 1969 HASSELBLAD 70MM. LENS 80MM F/2.8 | BY RUSTY SCHWEICKART NASA ID: **AS09-24-3665**

A studio-like portrait recovered from underexposed film reveals McDivitt undertaking the world's first docking of two crewed spacecraft (with internal transfer). As McDivitt looked up, he had to translate the LM's controls by 90 degrees in his head – Schweickart told me this was "most impossible task." The reflection of the docking window, Earth and COAS (guidance) sight can be seen in his "bubble" helmet. This is the only photograph of an Apollo astronaut in their full suit and "bubble" helmet during flight. *(Cropped, EL: 5/5)*

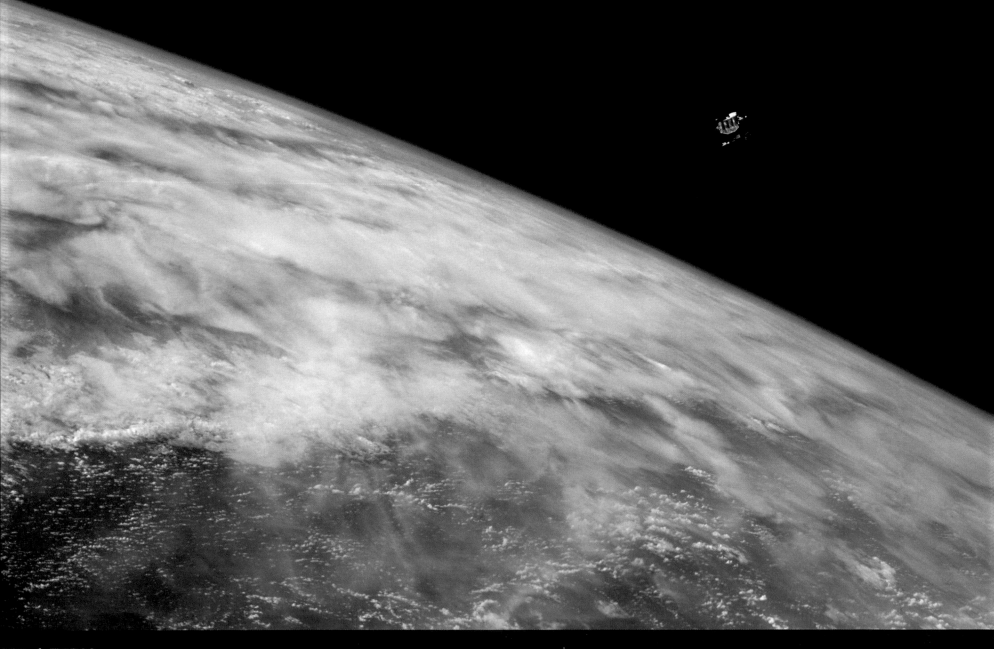

March 7, 1969

HASSELBLAD 70MM. LENS 80MM F/2.8 | BY UNKNOWN

NASA ID: AS09-21-3254

After LM *Spider* was jettisoned, its ascent stage engine was re-ignited remotely by Mission Control to further test the engine and simulate an ascent from the lunar surface. *Spider* would eventually
burn up in Earth's atmosphere in 1981. *(Rotated, EL: 3/5)*

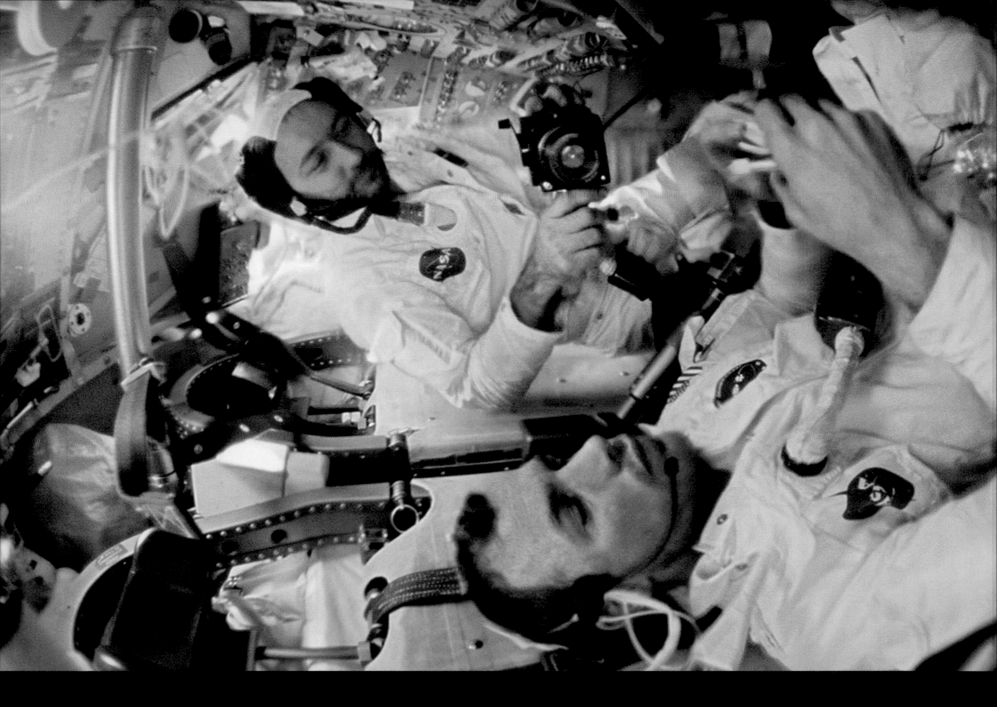

March 3–13, 1969 30 FRAMES OF 16MM FILM, STACKED AND PROCESSED NASA ID: **APOLLO 9 MAG SN-1071**

Commander McDivitt, with his Hasselblad 500C (note, front-mounted shutter release and manual film advance winder) with 80mm lens attached. The 500C was adapted to incorporate a handle for ease of use during Scott's EVA. Scott is unwrapping a snack during a more relaxed moment on board the Command Module.

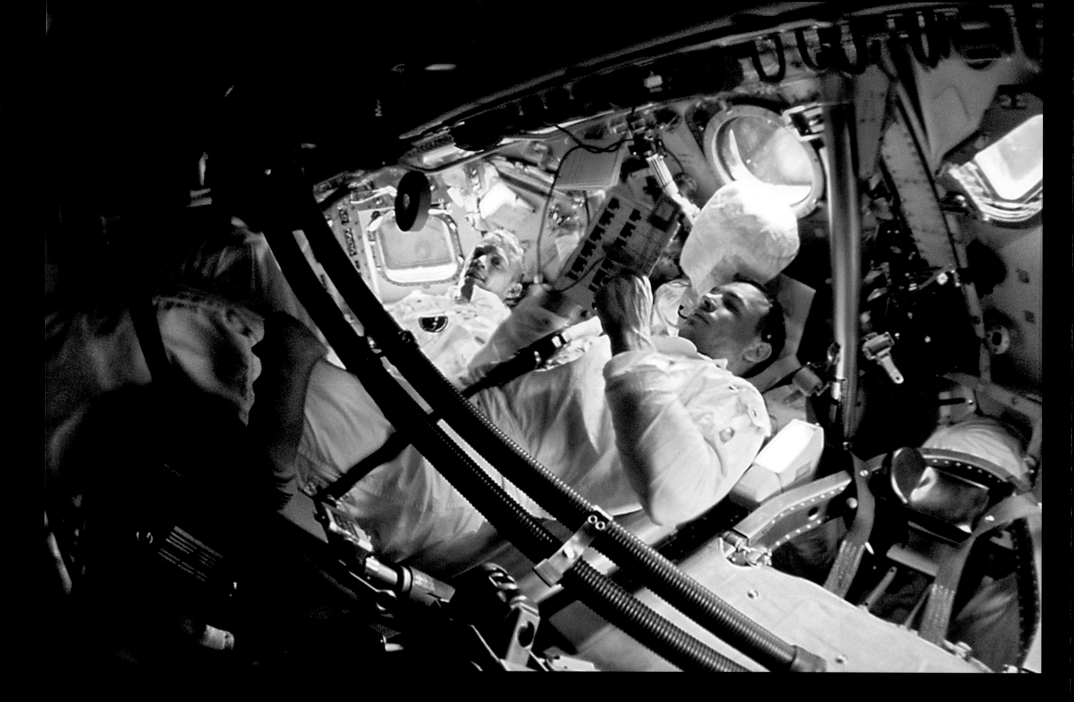

March 3–13, 1969 130 FRAMES OF 16MM FILM, STACKED AND PROCESSED NASA ID: **APOLLO 9 MAG SN-1073**

Schweickart (left) and Scott in their respective seats in the Command Module. Scott makes notes as a roll of tape floats by. A 16mm DAC film magazine can be seen stowed upper left, as can four of the Command Module's five windows.

March 3–13, 1969

HASSELBLAD 70MM. LENS 80MM F/2.8 | BY UNKNOWN

The crew captured this image showing the dry river channel and tributaries of Wadi Hadramawt, which eventually join the Gulf of Aden, Yemen. Many hard restrictions affected the photography of Earth's surface – including the specific ground track, brief daylight hours per orbit, cloud cover, and the orientation of the windows at any given moment. After recommendations from Apollo 7, additional fuel was budgeted to orient the spacecraft for photography. *(EL: 4/5)*

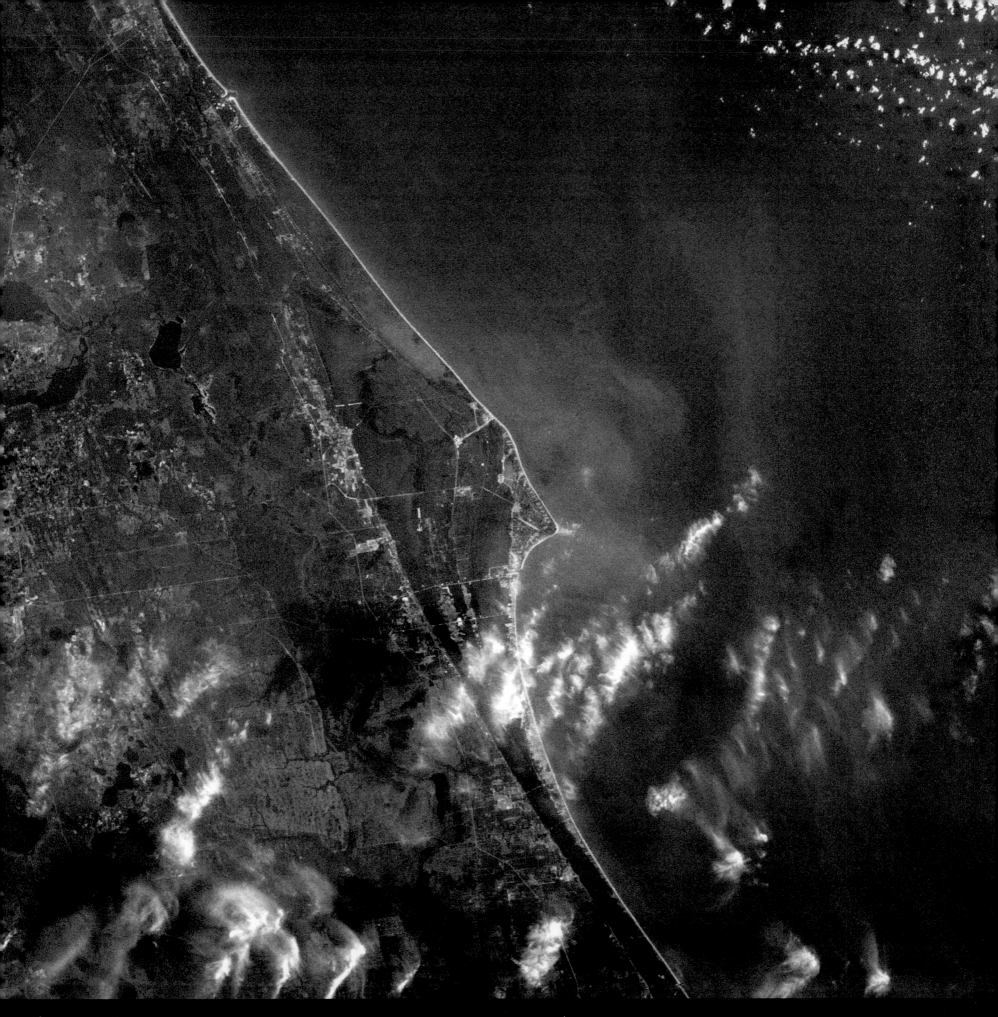

March 3–13, 1969

HASSELBLAD 70MM. LENS 80MM F/2.8 | BY UNKNOWN NASA ID: AS09-23-3545

One of the finest views of the Cape and launch complex taken from orbit during Projects Mercury, Gemini or Apollo. Pad 39A, from where Apollo 9 launched, can be seen along with the Vehicle Assembly Building (VAB). Such was the pace of the Apollo program, that the Saturn V for Apollo 10 was being rolled out from the VAB to the Pad around this time. (FL: 3/5)

March 11, 1969 HASSELBLAD 70MM. LENS 80MM F/2.8 | PROBABLY BY RUSTY SCHWEICKART NASA ID: **AS09-23-3552**

Later in the mission, with many key tasks complete, the crew, in particular Schweickart, had the opportunity to better observe and capture the sights from the Command Module window. A near cloudless day in Florida allowed for this view of almost the whole peninsula, looking south from Live Oak and Jacksonville down past the Cape to Miami and Key West. *(Rotated, FL: 3/5)*

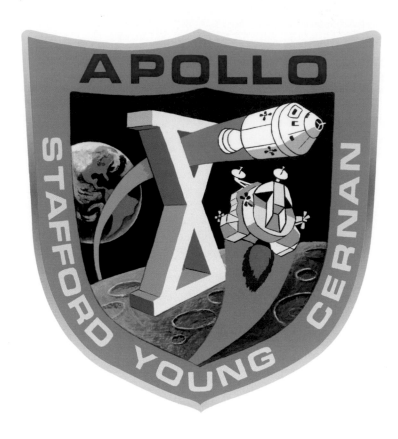

THE DETAILS

ROCKET	LAUNCH	DURATION	SPLASHDOWN
Saturn V (AS-505)	16:49 GMT,	8 days, 3 minutes, 23 seconds	16:52 GMT,
	18th May, 1969, Pad 39B		26th May, 1969,
COMMAND AND SERVICE MODULE		SURFACE TIME	Pacific Ocean
Charlie Brown (CSM-106)	LANDING SITE	N/A	
	N/A		RECOVERY SHIP
LUNAR MODULE		LUNAR ORBITS	USS *Princeton*
Snoopy (LM-4)	DISTANCE	31	
	829,438 miles		

THE CREW

Thomas P. Stafford
COMMANDER (CDR)

Born September 17, 1930. Stafford's first spaceflight was on Gemini VI-A, which was the first U.S. rendezvous mission, and he was later Command Pilot on Gemini IX-A along with Apollo 10 crewmate Cernan. He would later command the Apollo-Soyuz Test Project in 1975.

John W. Young
COMMAND MODULE PILOT (CMP)

Born September 24, 1930. Often described as the astronaut's astronaut, Young was Pilot of Gemini's first crewed mission, Gemini III, and Command Pilot of Gemini X with Michael Collins. Young would go on to walk on the Moon, as Commander of Apollo 16 and command the first Space Shuttle mission in 1981.

Eugene A. Cernan
LUNAR MODULE PILOT (LMP)

Born March 14, 1934. Cernan's first flight was on Gemini IX-A, with Stafford as Commander, where he performed the world's third spacewalk. Cernan would later command Apollo 17, and to this day is the last human to have walked on the Moon.

May 18–26, 1969

APOLLO 10

THE MISSION

Such was the pace of flight testing leading up to the first lunar landing that Apollo 10 was rolled out to Pad 39B while Apollo 9 was still in orbit overhead. It was, in effect, a full dress rehearsal for Apollo 11, minus the landing. The complete, crewed Apollo spacecraft and all systems would be tested in orbit around the Moon, with the Lunar Module descending to within 7.8 miles of the surface. The LM's programmed trajectories (especially in the presence of the Moon's irregular mass concentrations) and radar functionality would need to be fully tested, and the proposed landing site photographed before a landing could be attempted.

Following a successful launch, requiring only minor midcourse corrections, the spacecraft approached the Moon on May 21. Given that Apollo's lunar missions had to intersect the Moon's path around Earth at the precise moment of arrival, and that the approach was mostly on the shadow side of the Moon, the crews saw little of it until they actually arrived. Cernan: "It just went pitch dark outside ... That's really something, after having the Sun out of one window all the time. We are in *total* darkness." At this point an unimaginable number of stars could be seen in every direction, with the exception of one large black void – the Moon. The astronauts could feel its presence. And once they emerged from the shadows, Cernan: "God dang. We're right on top of it. I can see it! God, that Moon is beautiful ... incredible!" Stafford confirmed: "We're about 60 miles, I guess."

After 12 orbits, LM descent engine burns (simulating a landing mission) took Stafford and Cernan down over the proposed Apollo 11 landing site in the Sea of Tranquility. Stafford remarked: "It looks like we're getting so close, all you have to do is put your tail hook down and we're there." Cernan said it was "almost like you could reach out and touch Moltke [crater]." In reality, the LM's fuel/weight ratio wasn't sufficient to land and return to lunar orbit safely.

A serious problem occurred during descent-stage jettison, when the LM started to oscillate, and suddenly spin and flip over uncontrollably, triggering a gimbal lock warning (gimbal lock would spell disaster as they would have no reference for their location or how to return to the CSM). "Son of a bitch!" Cernan yelled. "We're in trouble," Stafford concurred. Stafford quickly took over manual control and brought the LM back to its correct attitude. Crew error had led to the Abort Guidance System switch being in the wrong position.

Having achieved the first-ever rendezvous and docking in lunar orbit, Apollo 10 spent the remainder of the time on landmark tracking and photography. After the SPS engine burn put them on a course for Earth, the Moon grew progressively smaller in the windows. At around 2,000 miles out, unlike on approach days earlier, the crew were treated to a spectacular view. Cernan marveled: "It just about fills up, roundwise, right smack in the hatch window. Boy, and is this a *full* Moon!" Stafford enthused: "The view is actually just incredible ... Just looking at it ... It's a good thing we came in backwards at night-time where we couldn't see it because if we came in from this angle you'd really have to shut your eyes." The next time a crew would get this close to the Moon, they would take one final, giant leap.

THE PHOTOGRAPHY

The mission encompassed the first-ever live color TV broadcast from space. A key objective was to undertake landmark tracking and photography along the flight path to the Sea of Tranquility, and to observe the proposed landing site for Apollo 11. Photography from the LM during their low pass across the lunar surface was not originally considered a priority until Stafford persuaded NASA management to allow them to carry the cameras.

Although some low-altitude shots were taken on the approach, the Hasselblad malfunctioned (due to recurrent magazine jams) just before the landing site. Cernan was displeased: "Son of a bitch! That's inexcusable. Get out here a million miles from nowhere, and the God-dang film packs won't work." He was limited to visual observations: "We're going just right over the landing site right this moment, and it's ... a lot of rounded-off craters, a few fresh ones, but basically, it looks pretty smooth, like a gummy grayish sand."

Capturing an incredible Earthrise was particularly rewarding for Stafford and Cernan, having missed out on the opportunity from the LM due to the magazine malfunctions. Stafford: "Hey, look at – look at the Earth ... Isn't that beautiful?" Young: "Oh, God ... That's just fantastic ... Oh, that is unbelievable ... Look at that!"

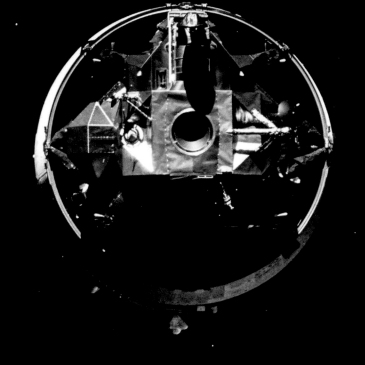

May 18, 1969 HASSELBLAD 70MM. LENS 80MM F/2.8 | BY UNKNOWN NASA ID: AS10-34-5011

Three hours into the flight, and 25 minutes after TLI, CSM *Charlie Brown* separates and turns around to dock with, then extract, the LM, *Snoopy*. Stafford: "Okay. I got the S-IVB." Cernan: "And there goes another [SLA] panel!" *Snoopy* can be seen in this photograph inside the Spacecraft Lunar Module Adapter (SLA) atop the Saturn V's third stage, S-IVB, surrounded by debris from separation and adapter panel jettison. *(Rotated, EL: 3/5)*

May 19–21, 1969 HASSELBLAD 70MM. LENS 80MM F/2.8 | BY UNKNOWN NASA ID: AS10-34-5066

A close-up of LM *Snoopy* taken from the CM during trans-lunar coast, approximately halfway to the Moon. Textural detail of the aluminum panels and mechanical fixings used can be seen in this shot, along with the rendezvous window and markings. *(EL: 3/5)*

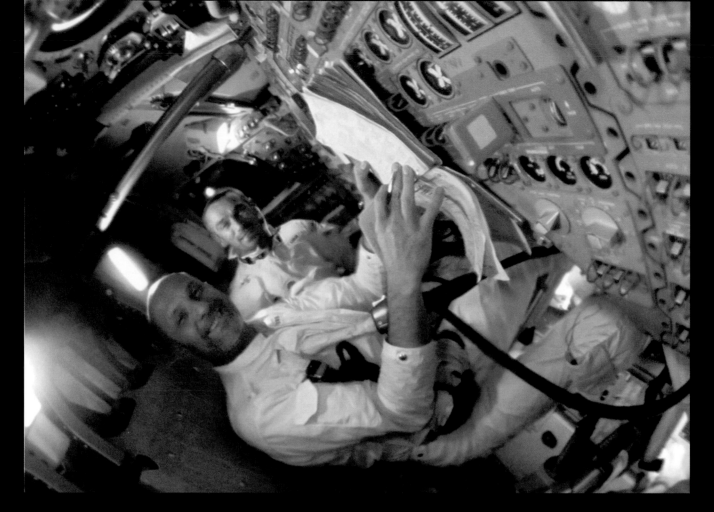

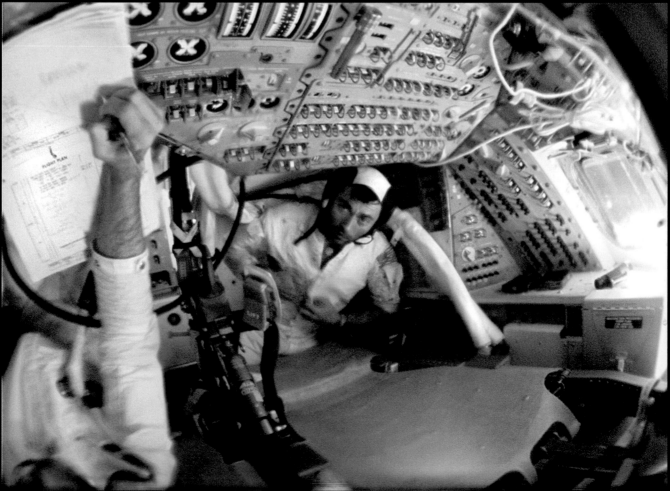

May 18–26, 1969 9 AND 8 FRAMES OF 16MM FILM, STACKED AND PROCESSED NASA ID: **APOLLO 10 MAG SN-1103-AA**

TOP: A smiling Commander Stafford (foreground), and Lunar Module Pilot Cernan in the Command Module *Charlie Brown*. The round hatch window (top) would later provide a perfect frame for the Moon. BOTTOM: Stafford makes notes on the flight plan with his space pen as Command Module Pilot Young buttons up his coverall jacket. The Apollo coveralls had reinforced holes for medical connectors to pass and a slippery Teflon coating, which helped the astronauts dress with ease in a weightless environment.

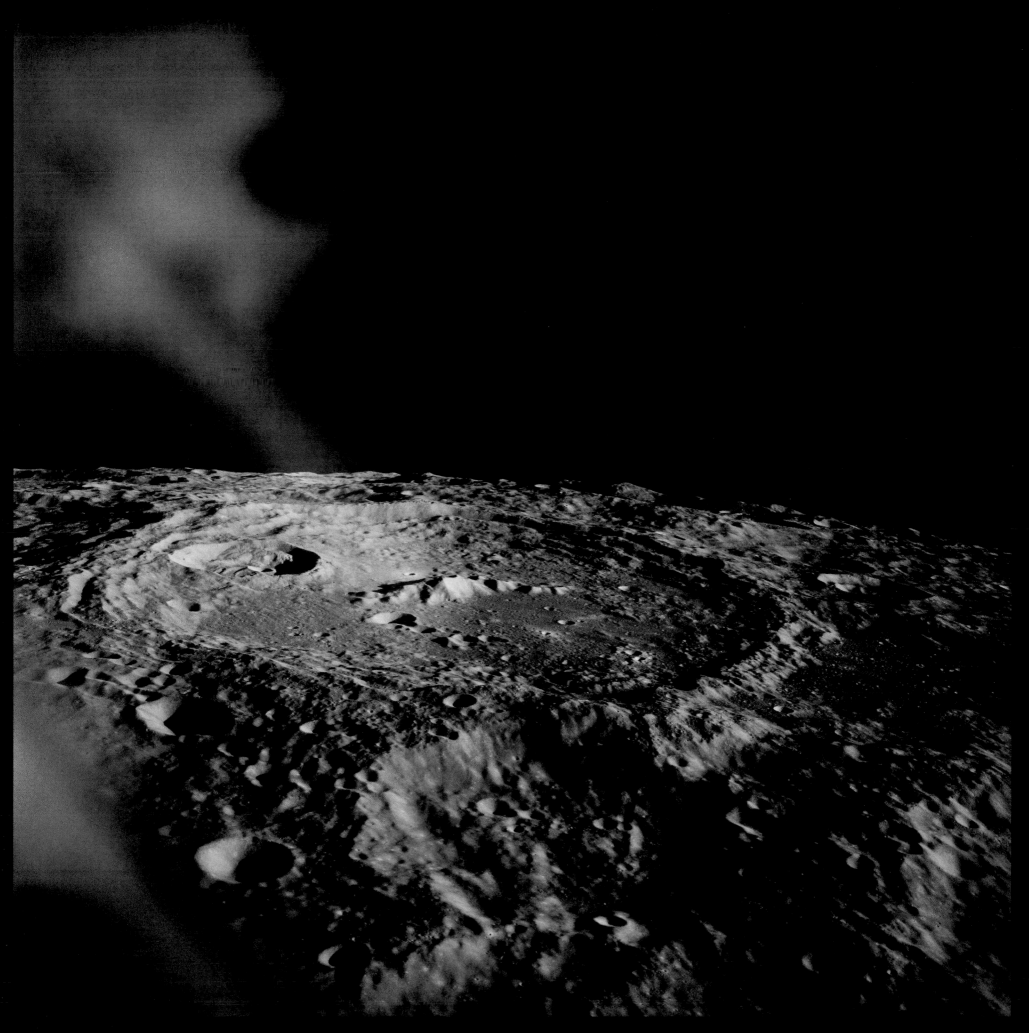

May 21–26, 1969

HASSELBLAD 70MM. LENS 80MM F/2.8. B&W | BY UNKNOWN

NASA ID: **AS10-32-4790**

Apollo 10's arrival at the Moon was confirmed with a completed lunar orbit insertion burn at 20:50GMT on May 21. Cernan: "God, that Moon is beautiful; we're right on top of it . . . There's the lunar horizon . . . I guess we has [sic] arrived!" Young: "I'll tell you something . . . By God, they are craters Get some pictures, you guys." Keeler crater (100 miles wide) can be seen here on the farside of the Moon. *(Rotated, EL: 4/5)*

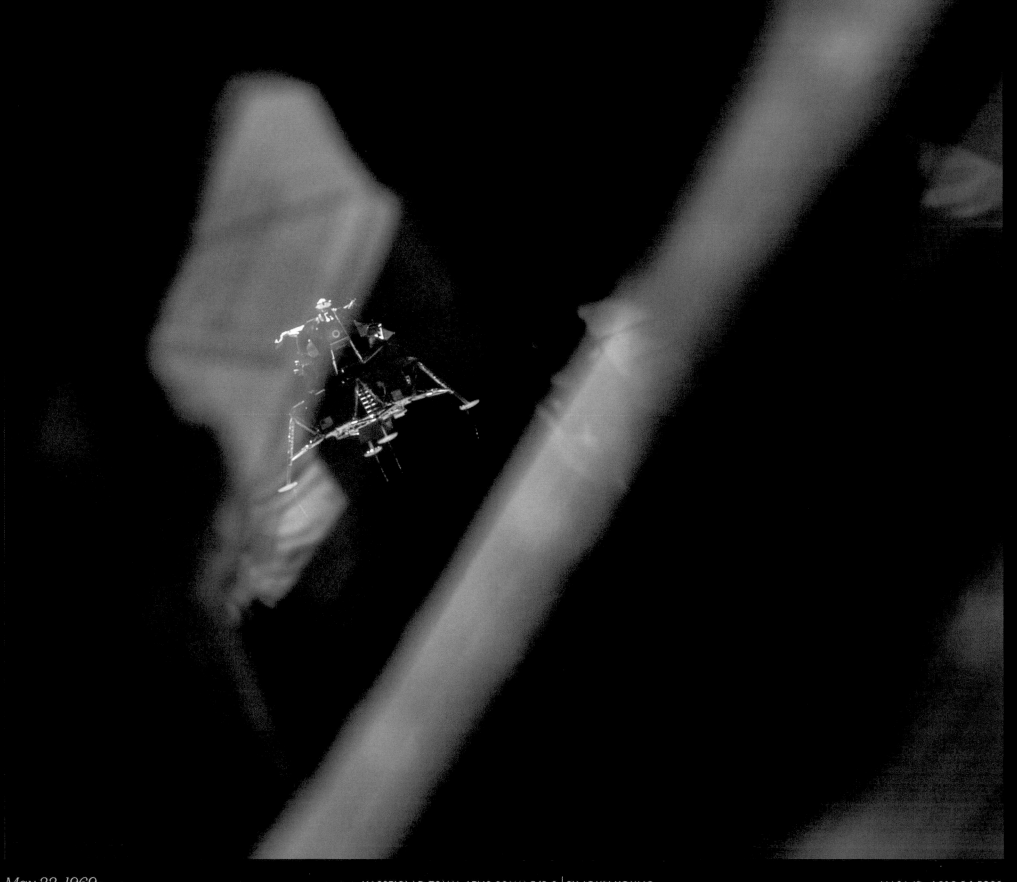

May 22, 1969 HASSELBLAD 70MM. LENS 80MM F/2.8 | BY JOHN YOUNG NASA ID: AS10-34-5083

When *Snoopy* undocked and separated from the CSM, Young confirmed: "Your gear is all down and locked, bab___ the thin rods hanging from each foot are the contact probes which will confirm when touchdown occurs on landing missions. The pro___ the foot of the ladder was later removed at Arms___ s request, for fear it may bend upward, creating a dangerous obstacle. Stafford: "I'm trying to match you, John. Should I be upside down to you, babe? . . . Man, that fuel is going down like mud, too." (EL: 5/5)

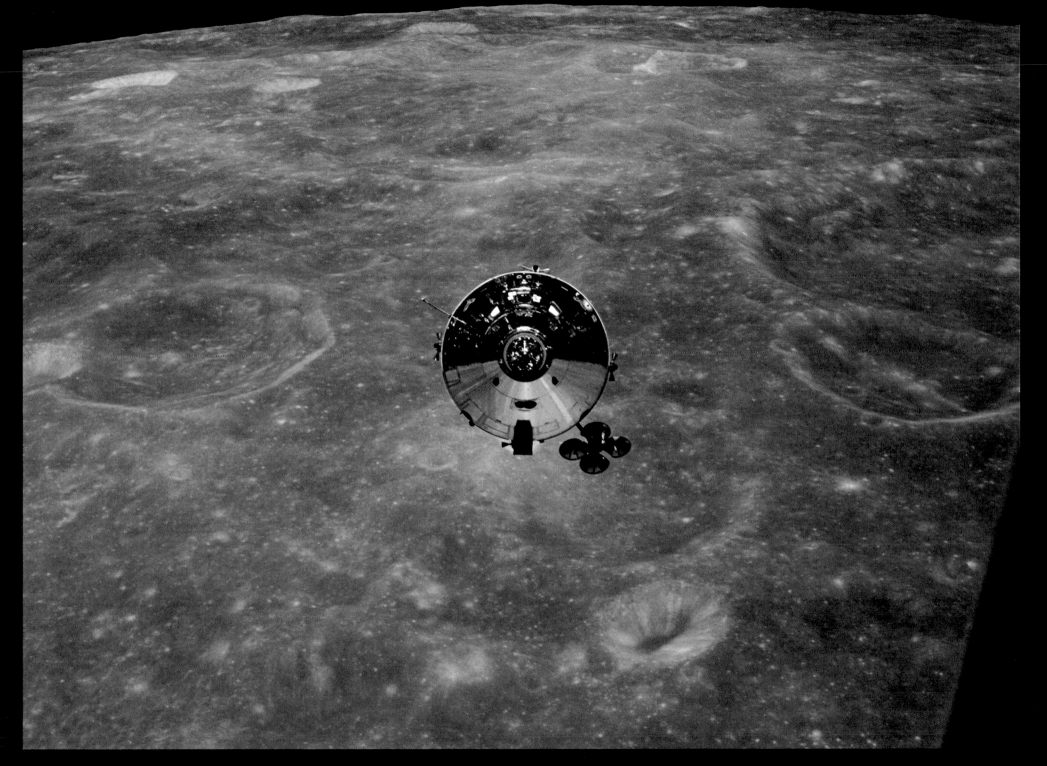

May 22, 1969 HASSELBLAD 70MM. LENS 250MM F/5.6 │ PROBABLY BY TOM STAFFORD NASA ID: **AS10-27-3873**

Cernan: "Get the Hasselblad, Tom, I'll catch him when we come around . . . I'll tell you, John, these pictures of you against that Moon ought to be fantastic!" A view of *Charlie Brown*, as seen from the LM during stationkeeping after undocking. Saenger P crater is on the left of the image and Saha W to the right. Cernan: "John, you're the first vehicle photographed by another around the Moon. How does that grab you?" *(EL: 3/5)*

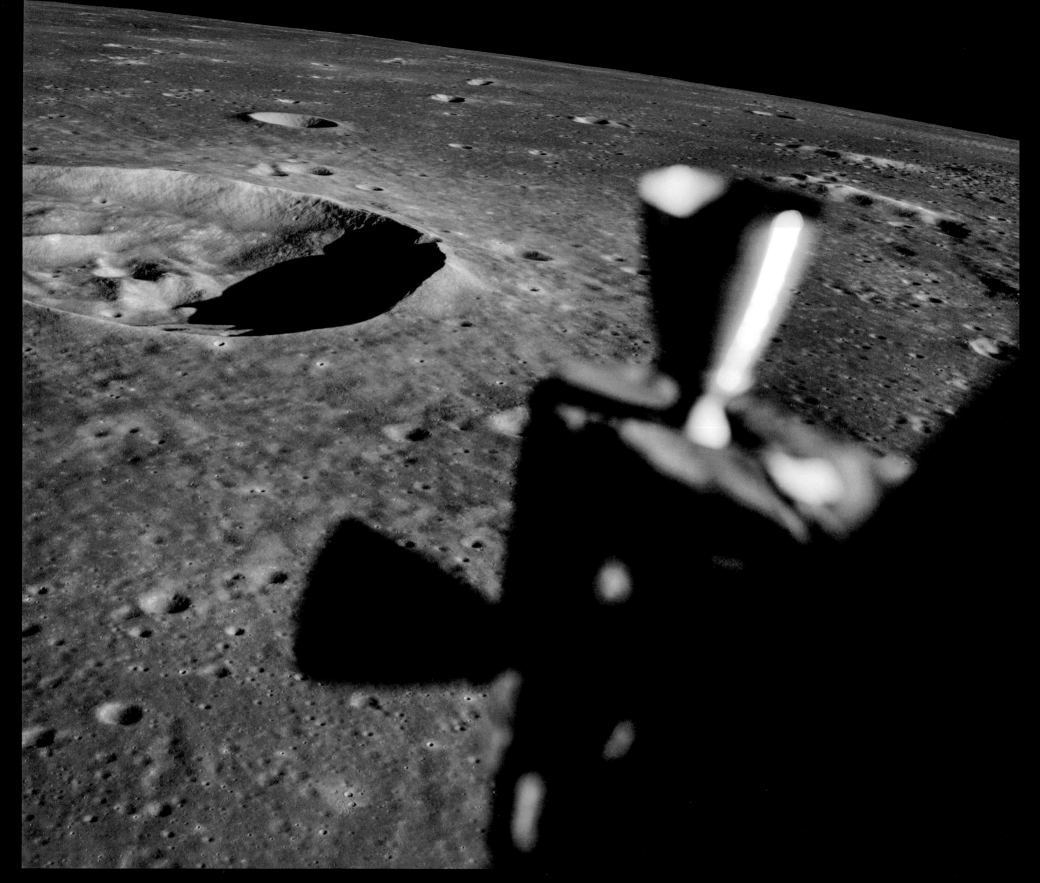

May 22, 1969 HASSELBLAD 70MM. LENS 80MM F/2.8. B&W │ BY GENE CERNAN NASA ID: **AS10-29-4296**

Stafford: "Whoa, we're dropping down, Gene-o!" Cernan: "You bet your life we're dropping down!" After a 27-second burn of the descent stage engine, simulating the Apollo 11 landing, *Snoopy* achieved its closest approach of 7.8 miles above the surface. Maskelyne crater, leading to the Sea of Tranquility in the distance, is photographed from the right-hand window of the LM. *(EL: 4/5)*

May 22, 1969

45 FRAMES OF 16MM FILM, STACKED AND PROCESSED

NASA ID: **APOLLO 10 MAG SN-1109-L**

After the near-disaster (see chapter Preface) at descent stage jettison, Cernan was looking forward to rendezvous: "One more big burn, and then it's like Gemini." Stafford: "Like the good old days, Gene-o." After the burn, they took off their helmets and captured a short sequence with the 16mm DAC; Cernan: "[Let's] take some inside while the Sun's on us." Stafford, in his pressure suit, is reflected in the left-hand Commander's window as he peers out.

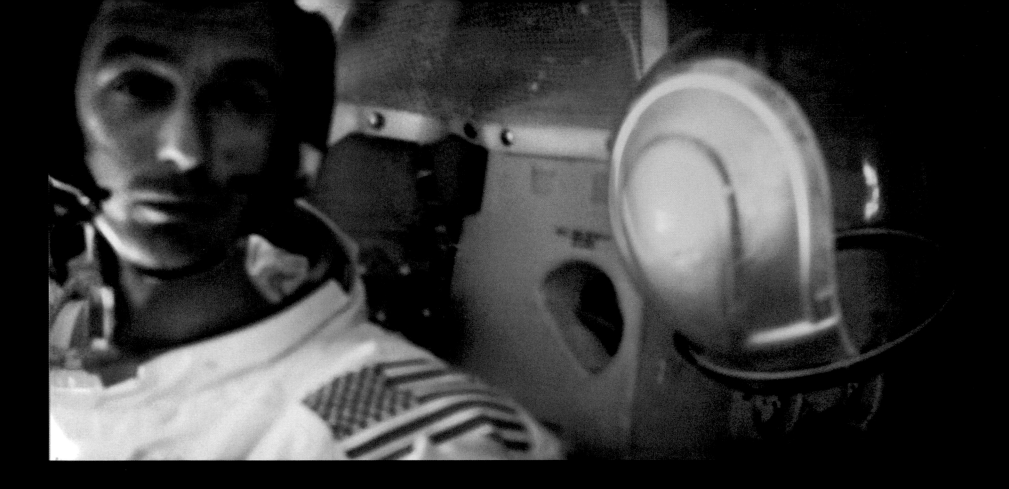

May 22, 1969 32 FRAMES OF 16MM FILM, STACKED AND PROCESSED NASA ID: **APOLLO 10 MAG SN-1109-L**

Cernan to camera: "Hello there, from the men in the Moon!" Helmets and gloves were worn for key stages of LM flight. After removing them, Cernan looks on as his "bubble" helmet floats next to him during the LM's first-ever flight in its intended design environment. Without the helmet, the noises within the LM were more evident. Stafford: "John, you ought to hear these thrusters firing in here. It's really like a big garbage can getting banged around."

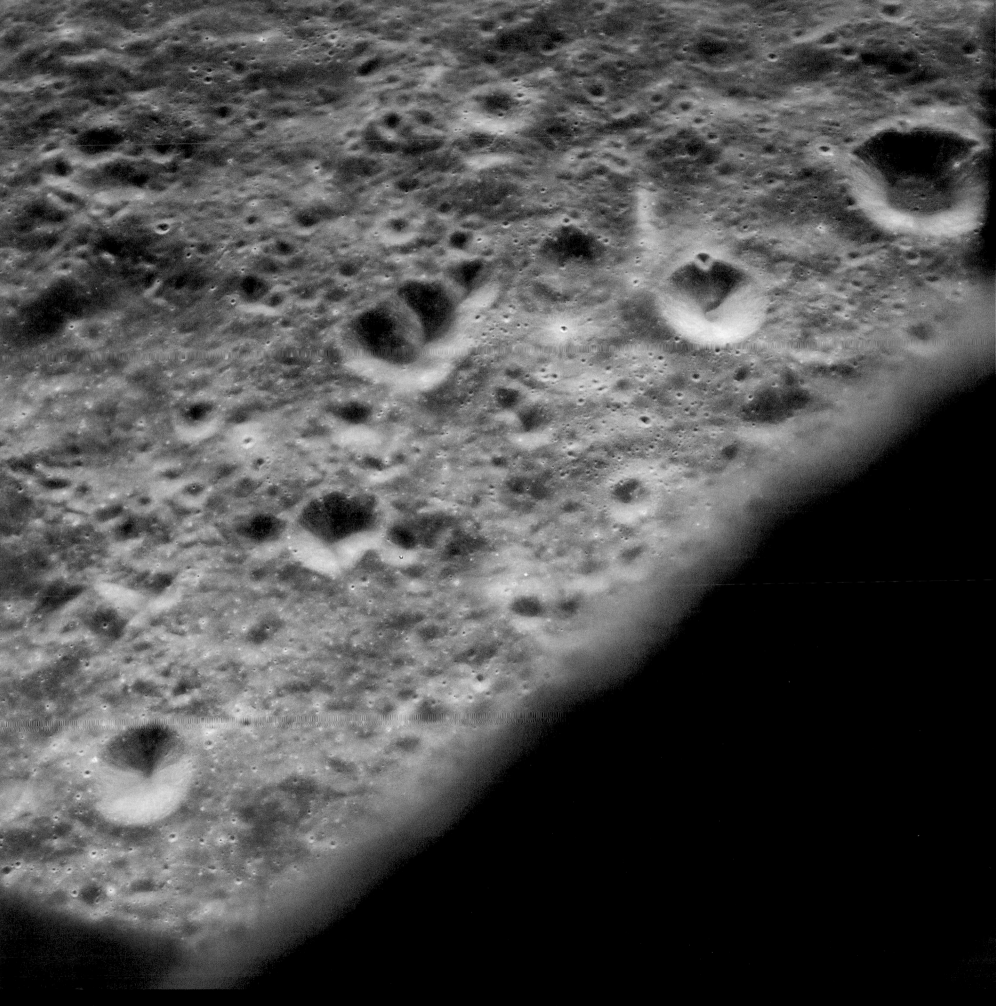

May 22–23, 1969 HASSELBLAD 70MM. LENS 80MM F/2.8 | BY JOHN YOUNG NASA ID: **AS10-34-5101**

The LM ascent engine burned for 15 seconds to bring it closer to the CSM's orbit. Stafford spotted their target's flashing light from 42 miles away. In the other direction, incredibly (after a further burn), *Snoopy* can be seen from the CSM window in this photograph as a tiny dot over the sunlit half of a crater, lower left of center. *(Rotated, EL: 3/5)*

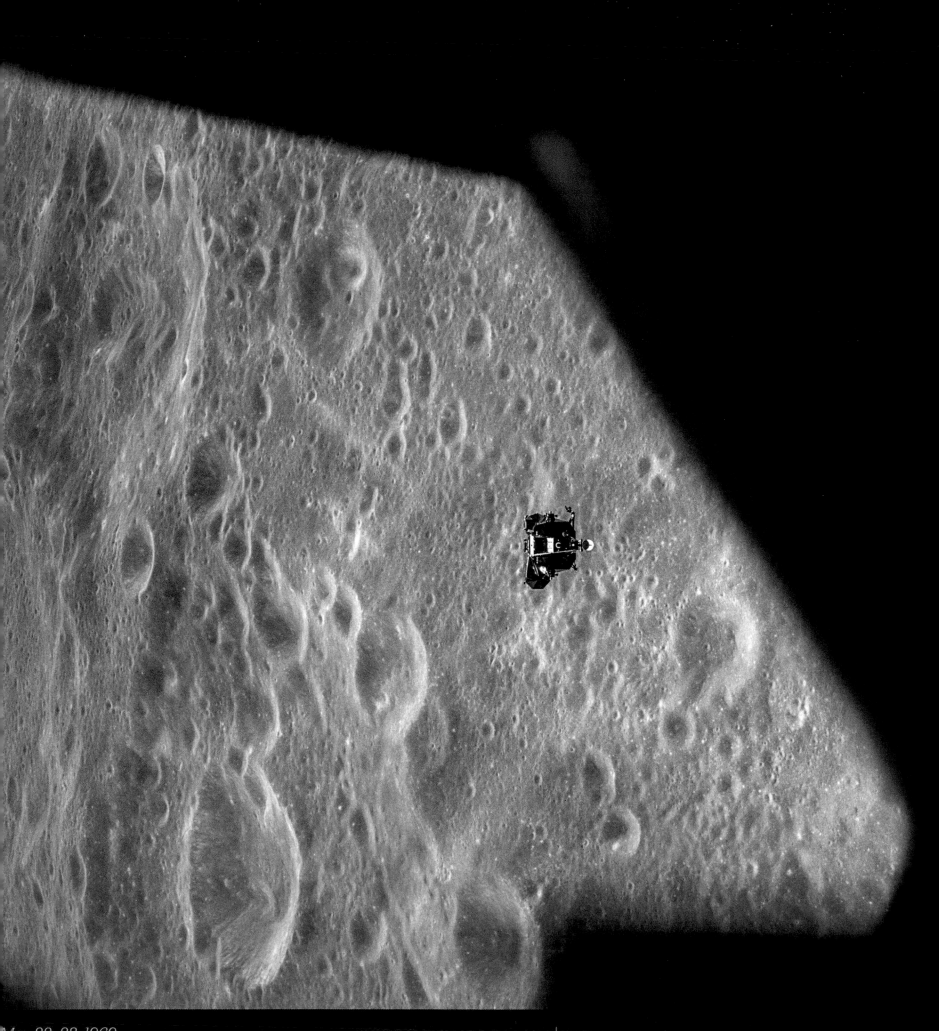

May 22–23, 1969

HASSELBLAD 70MM. LENS 80MM F/2.8 | BY JOHN YOUNG

NASA ID: AS10-34-5108

Stafford: "Houston, this is *Snoopy*. You can't believe how noisy those thrusters are . . . It sounds like being inside a big rain tub with about 2-inch hail beating all over you . . . We have solid lock, and first update appears real good." This image shows the LM, with Stafford and Cernan on board, closing its approach with the CSM. Rendezvous and docking would be completed 57.4 miles above the lunar surface after eight hours of LM flight. *(Rotated, EL: 3/5)*

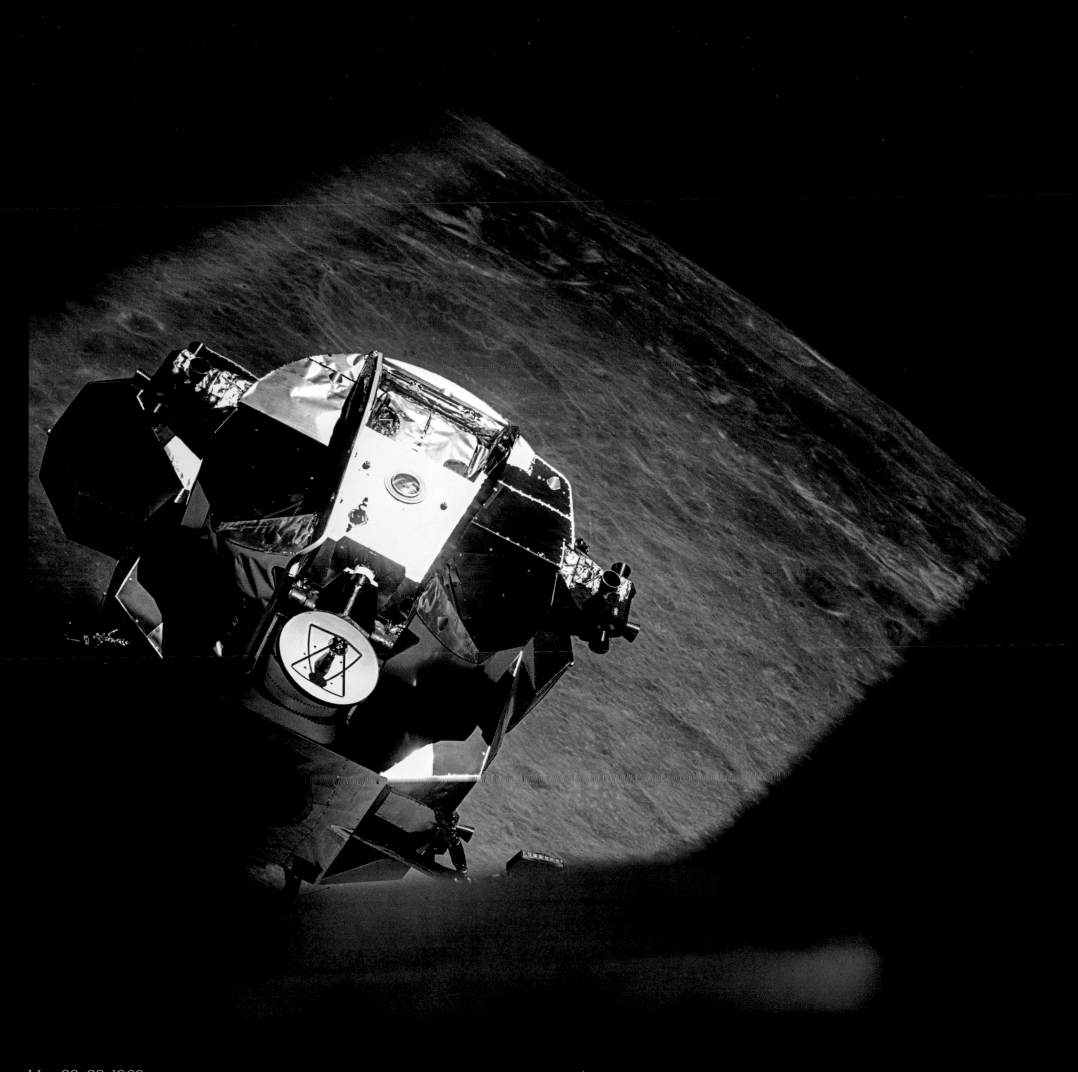

May 22–23, 1969 HASSELBLAD 70MM. LENS 80MM F/2.8 | BY JOHN YOUNG NASA ID: **AS10-34-5117**

Stafford pitches *Snoopy* over to orient it for the final docking maneuver, undertaken by Young in the CSM – the first-ever docking of two crewed spacecraft in lunar orbit. *Snoopy* is the only LM that wasn't purposely destroyed after jettison; instead a remote 249-second burn put it into an orbit around the Sun. *(EL: 4/5)*

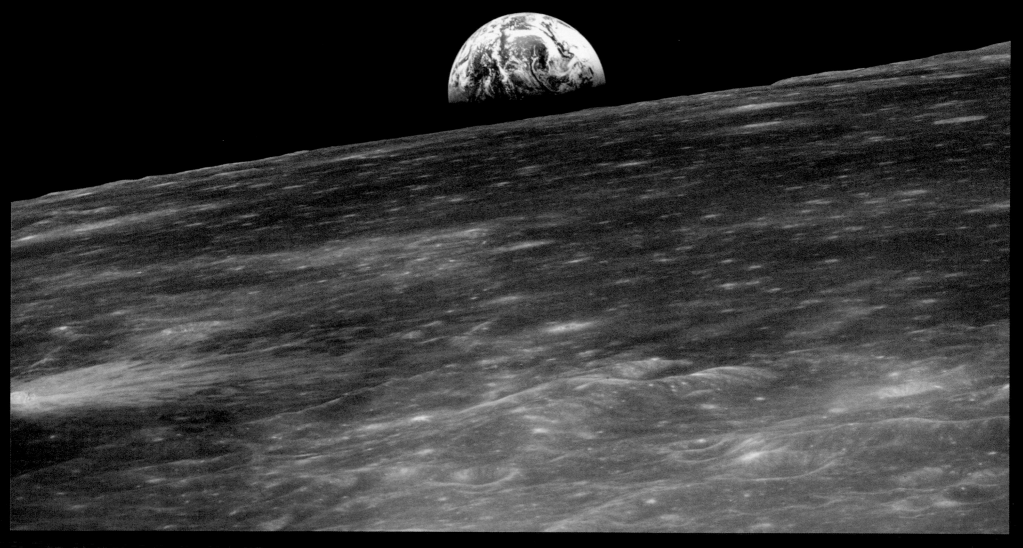

May 23–24, 1969 HASSELBLAD 70MM. LENS 250MM F/5.6 | BY GENE CERNAN NASA ID: **AS10-27-3889**

The crew, now together on board the CSM, continued in lunar orbit and witnessed this perfect Earthrise over Mare Smythii on the eastern edge of the Moon's nearside. Having missed out on capturing Earthrise due to their jammed camera, Cernan and Stafford were fully prepared and shot with two cameras simultaneously. Stafford: "It's got to be f/11 at 1/250th on both of them, right? OK babe, get the [dark] slide out and we'll be all set. We'll make these go boom, boom, boom!" *(Rotated, EL: 3/5)*

May 23–24, 1969 HASSELBLAD 70MM. LENS 250MM F/5.6. B&W │ BY UNKNOWN NASA ID: **AS10-31-4603**

As the dress rehearsal for the first landing, one of Apollo 10's key objectives included photographing landmarks on approach to the planned Apollo 11 landing site. This photograph covers approximately 50 miles of the Sea of Tranquility from bottom to top. Apollo 11 would eventually touch down upper left of the center, and the three prominent craters along the right side would later be named Armstrong, Collins and Aldrin. *(EL: 2/5)*

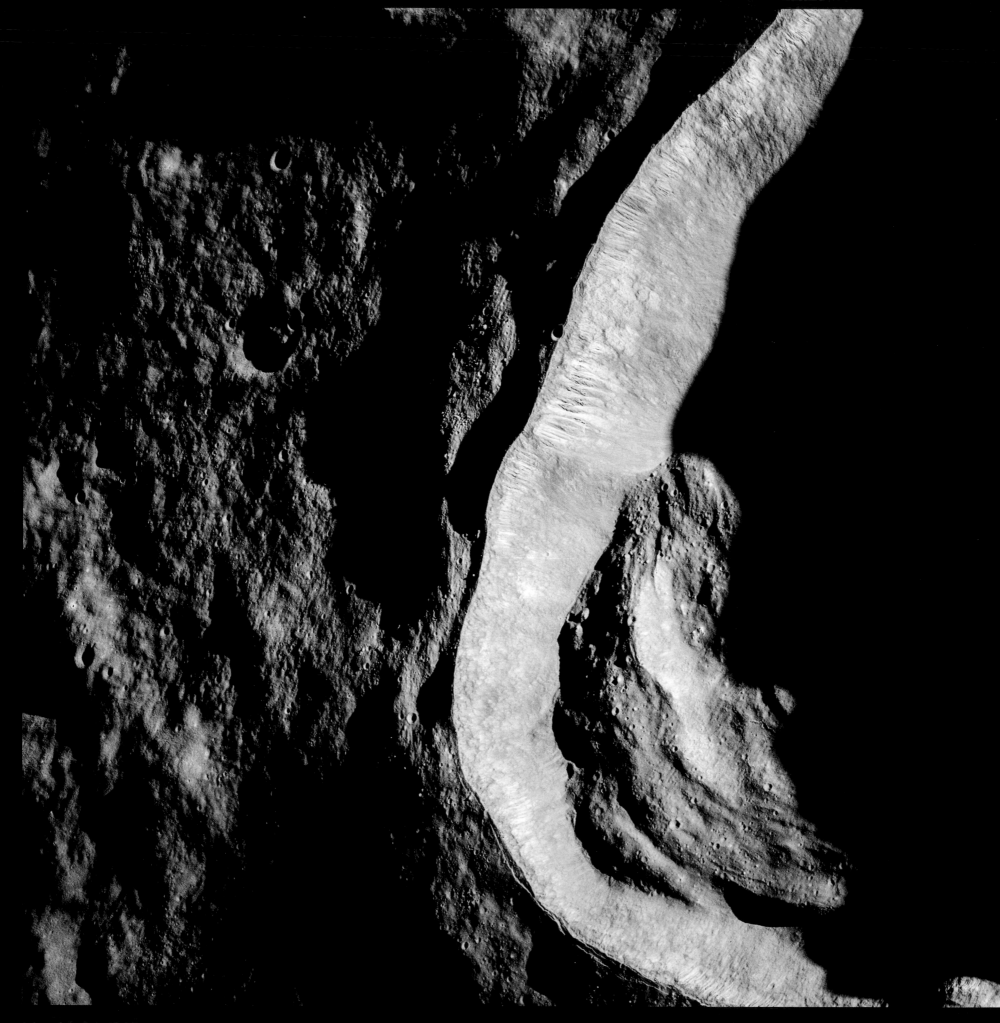

May 23–24, 1969

HASSELBLAD 70MM. LENS 250MM F/5.6 | BY UNKNOWN

NASA ID: **AS10-34-5165**

A close-up telephoto view of the western rim of Godin crater, which lies east of Sinus Medii on the Earth-facing side of the Moon. Godin is 2 miles deep and the photograph covers approximately 21 miles top to bottom. Cernan: "The walls are very light, whitish-gray and the bottom is a dirty, dirty, tan. And it's got a central peak that – it's got very big boulders in the bottom." *(EL: 4/5)*

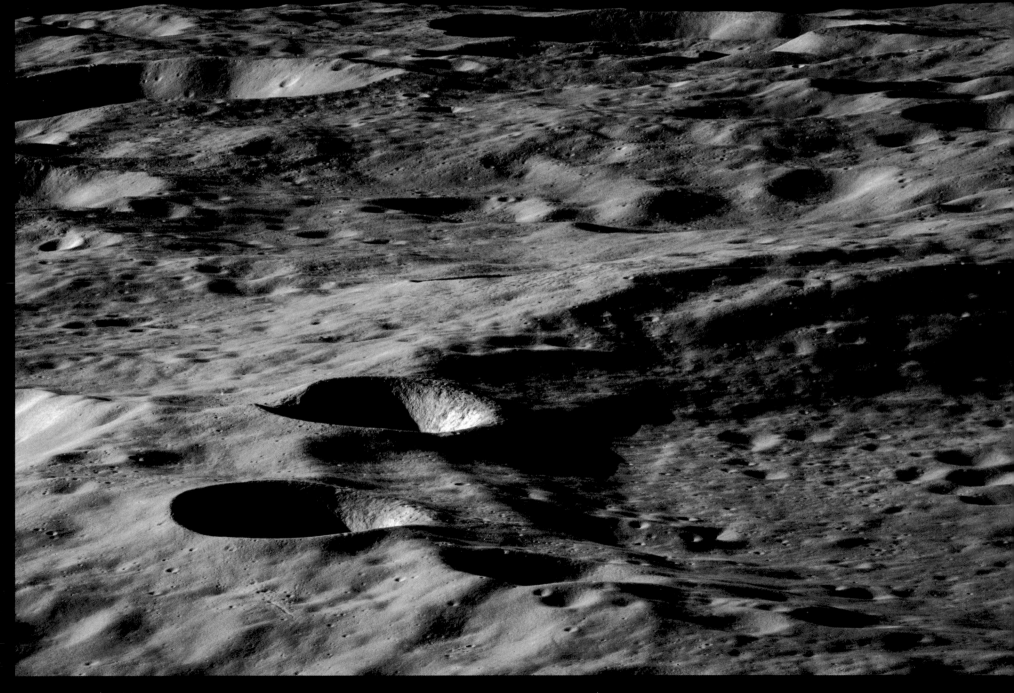

May 23–24, 1969

HASSELBLAD 70MM. LENS 250MM F/5.6. B&W | BY UNKNOWN

NASA ID: AS10-31-4658

During the remaining orbits, the crew continued with landmark tracking and photography, impressed by the lunar landscape, Young: "Oh, yes, the best view I've ever seen! . . . That crater right there, isn't that beautiful? . . . That part of the country out there looks pretty rugged." Stafford: "Look at those funny humpbacks that they were talking about the other day." A stunning oblique taken of Papaleksi crater on the lunar farside. *(Rotated, EL: 4/5)*

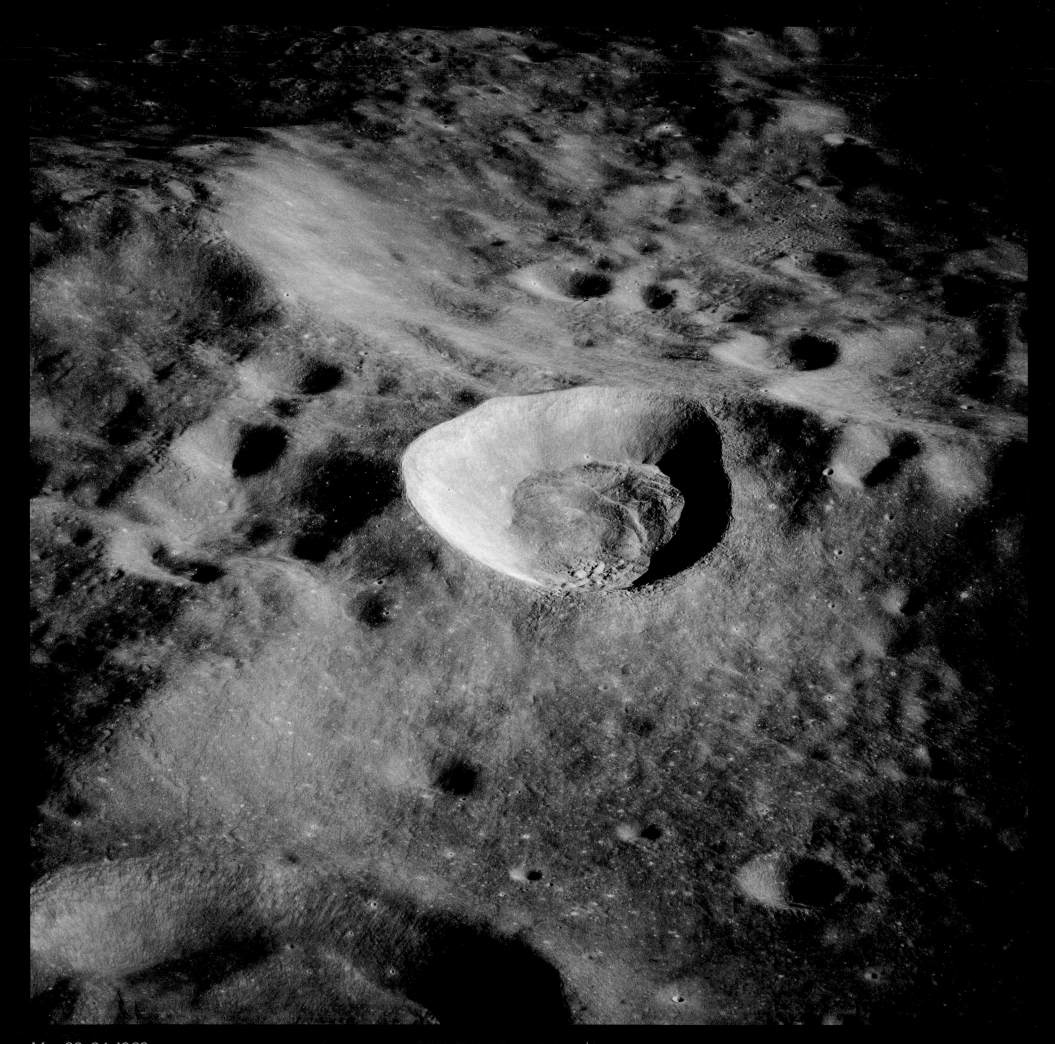

May 23–24, 1969 HASSELBLAD 70MM. LENS 80MM F/2.8 | BY JOHN YOUNG NASA ID: **AS10-34-5172**

With targets of opportunity and landmarks coming thick and fast, the crew work together to spot and photograph them. Stafford: "You know, it's kind of fun just to sit around and do this after rendezvous . . . Hey, here's a good example of what fills up craters . . . You know, from here you can see boulders in that one." Oblique photograph of Ventris M, an 11-mile-wide impact crater on the lunar farside. *(Rotated, EL: 3/5)*

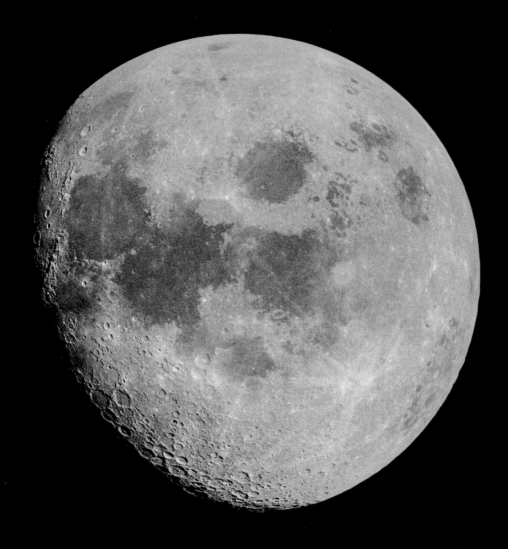

May 24, 1969

HASSELBLAD 70MM. LENS 80MM F/2.8 | BY UNKNOWN NASA ID: **AS10-35-5251**

The SPS engine fired to put Apollo 10 on a course for home. The Moon, unlike on approach, was illuminated by the Sun. At approximately 2,000 miles out it filled the round hatch window and the crew were utterly mesmerized. Stafford: "And the whole view now is getting so fantastic!" Cernan: "It's still incredible. It almost doesn't look real. This Moon is set against a blackest black . . . you can ever imagine." *(EL: 5/5)*

THE DETAILS

ROCKET Saturn V (AS-506)	LAUNCH 13:32 GMT, July 16, 1969, Pad 39A	DURATION 8 days, 3 hours, 18 minutes, 35 seconds	SPLASHDOWN 16:51 GMT, July 24, 1969, Pacific Ocean
COMMAND AND SERVICE MODULE *Columbia* (CSM-106)	LANDING SITE Sea of Tranquility	SURFACE TIME 21 hours, 36 minutes	RECOVERY SHIP USS *Hornet*
LUNAR MODULE *Eagle* (LM-5)	DISTANCE 953,054 miles	LUNAR ORBITS 30	

THE CREW

Neil A. Armstrong
COMMANDER (CDR)

Born August 5, 1930. An ex-naval aviator and test pilot, Armstrong's first spaceflight came as Command Pilot of Gemini 8 with Dave Scott. Their spacecraft began to spin uncontrollably when attached to the Agena target vehicle, but the crew escaped with their lives thanks to Armstrong's quick thinking and skill. After Apollo 11, Armstrong never flew in space again, retiring from NASA in 1971.

Michael Collins
COMMAND MODULE PILOT (CMP)

Born October 31, 1930. Part of the third astronaut intake in 1963, Collins was Pilot of Gemini X, performing two EVAs. Collins would have flown Apollo 8 but for a disc herniation, requiring surgery and was replaced by Jim Lovell. Apollo 11 would be his last spaceflight. He would later become the founding Director of the Smithsonian's Air and Space Museum.

Edwin E. "Buzz" Aldrin
LUNAR MODULE PILOT (LMP)

Born January 20, 1930. An ex-fighter pilot, flying 66 combat missions, Aldrin was selected by NASA in 1963. During his first spaceflight, Gemini XII, Aldrin spent five hours on EVAs. Nicknamed "Dr. Rendezvous," he used a handheld sextant and slide-rule to navigate when the Gemini radar malfunctioned. Apollo 11 would be his last spaceflight, but he continued to actively advocate space exploration.

July 16–24, 1969

APOLLO 11

THE MISSION

After the countless test flights and crewed Mercury, Gemini and Apollo flights, Kennedy's 1961 commitment to "achieving the goal, before this decade is out, of landing a man on the Moon and returning him safely to the Earth" had yet to be accomplished. The Apollo 10 "dress rehearsal" had ventured to within several miles of the lunar surface and Apollo 11's main objective was to take that one final, giant leap.

An estimated one million people lined the beaches and freeways of the Florida Space Coast to witness the launch of this historic mission. The huge Saturn V roared from Pad 39A into the blue Florida sky on a tower of flame, carrying the crew and the hopes of the whole world with it. Armstrong himself only gave the mission a 50/50 chance of success. The first two stages put Apollo 11 into a low-Earth orbit in less than 12 minutes. Two hours 32 minutes later, the third-stage S-IVB fired to put Apollo 11 on its path to the Moon.

Three days after launch, while on the lunar farside and out of contact with Earth, the 358-second SPS engine burn slowed the spacecraft sufficiently to enter lunar orbit. As with previous missions, the crew were struck by what they saw. Armstrong: "What a spectacular view!" Collins was equally impressed: "God, look at that Moon!", while Aldrin calmly observed: "Boy, that sure is eerie looking..."

On the 13th orbit, LM *Eagle* undocked from CSM *Columbia* and began its descent to the lunar surface. Armstrong noticed landmark checkpoints were coming up three seconds early and as such they would land 3 miles "long." A "1202" and "1201" program alarm, signifying a computer overload, would follow. As the LM pitched over, Armstrong got his first view of the landing site via the Landing Point Designator (LPD) in his window, and they were heading for a boulder field. He took over manual control and steered *Eagle* over the boulder-strewn area and adjacent large crater. With only 17 seconds of fuel remaining, the contact probes under *Eagle*'s landing gear brushed the surface and a blue light illuminated on the LM's control panel; Aldrin verified: "Contact light!" and Armstrong confirmed humankind's arrival on another world: "Houston, Tranquility Base here, the *Eagle* has landed."

Forfeiting a rest period, four hours later Armstrong emerged from the hatch and activated the LM's TV camera located in the Modular Equipment Stowage Assembly (MESA). The world watched as he placed his left foot onto the surface, and uttered his immortal words: "That's one small step for [a] man, one giant leap for mankind." Aldrin joined him, some 20 minutes later. Together they planted the American flag, set up scientific experiments, took photographs and collected rock samples. After the 2-hour-31-minute EVA, they returned to *Eagle*, and attempted to sleep. The ascent engine fired to return *Eagle* to lunar orbit after their 21-hour-36 minute stay on the Moon.

During this time, Collins had made 14 orbits of the Moon alone, but contrary to popular belief didn't feel like the "loneliest person in the Universe" during his time on the lunar farside. Three days after the CSM's trans-Earth injection burn, *Columbia* smashed into the atmosphere at 24,678mph, generating 5,000 degree Fahrenheit temperatures as it slowed enough to allow deployment of three red-and-white striped parachutes. A safe splashdown in the Pacific Ocean marked the end of the mission, the completion of Kennedy's goal and arguably humankind's greatest ever achievement.

THE PHOTOGRAPHY

The key photographic objectives were to document the historic event, photograph the lunar terrain and areas of scientific interest, record the condition of the LM hardware and undertake close-up photography to assess lunar soil mechanics.

All these objectives were achieved, but it would be a handful of incredible photographs, not necessarily acclaimed for their engineering or scientific merit, that would capture the world's attention and become the most reproduced and important photographs ever taken.

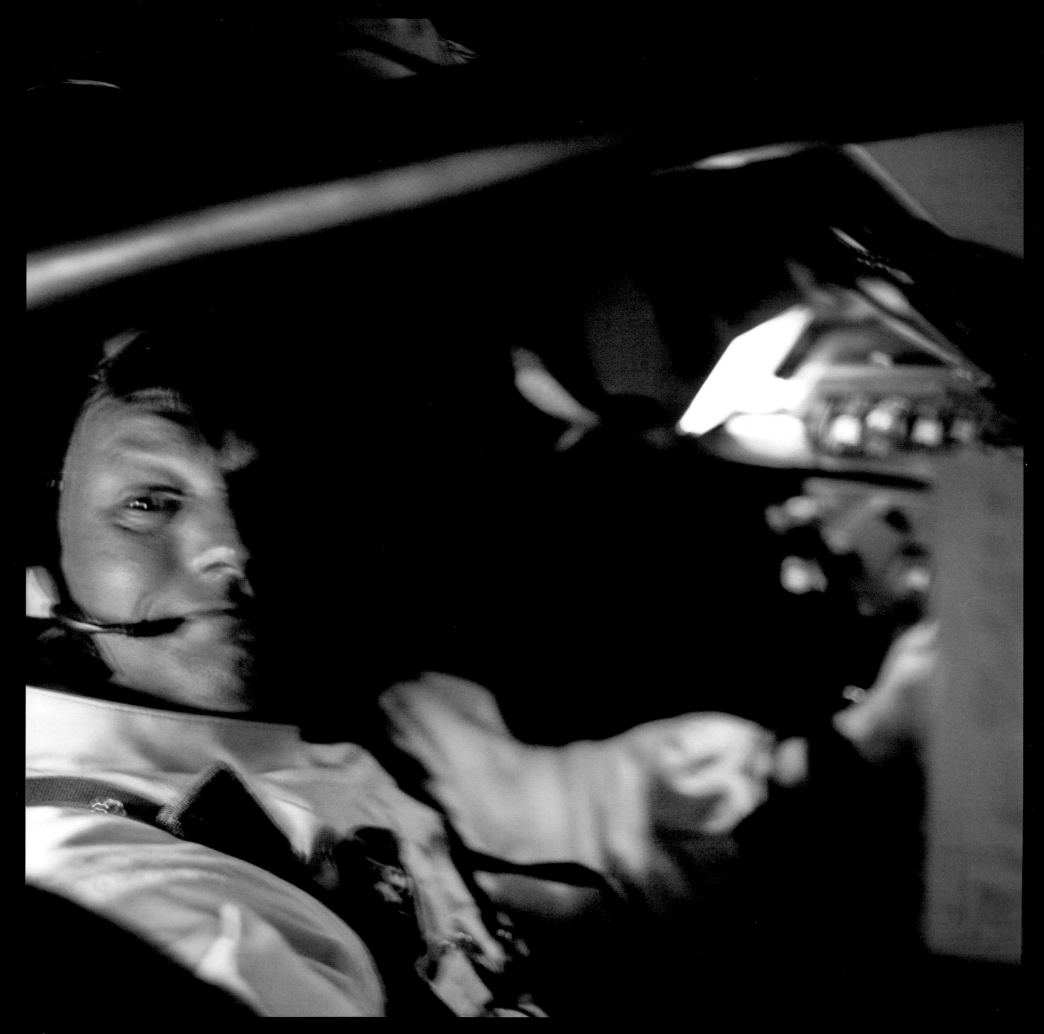

July 16, 1969

HASSELBLAD 70MM. LENS 80MM F/2.8 | BY BUZZ ALDRIN

NASA ID: **AS11-36-5291**

The first photograph of the Apollo 11 mission, taken shortly after the Saturn V put them into Earth orbit. Aldrin: "Let's get into the Hasselblad . . . Get the right settings on it." He then turns to his left to take this photograph of Commander Neil Armstrong, still in his loosened restraining belts from launch. The astronauts removed their pressure "bubble" helmets and gloves once in orbit. *(EL: 4/5)*

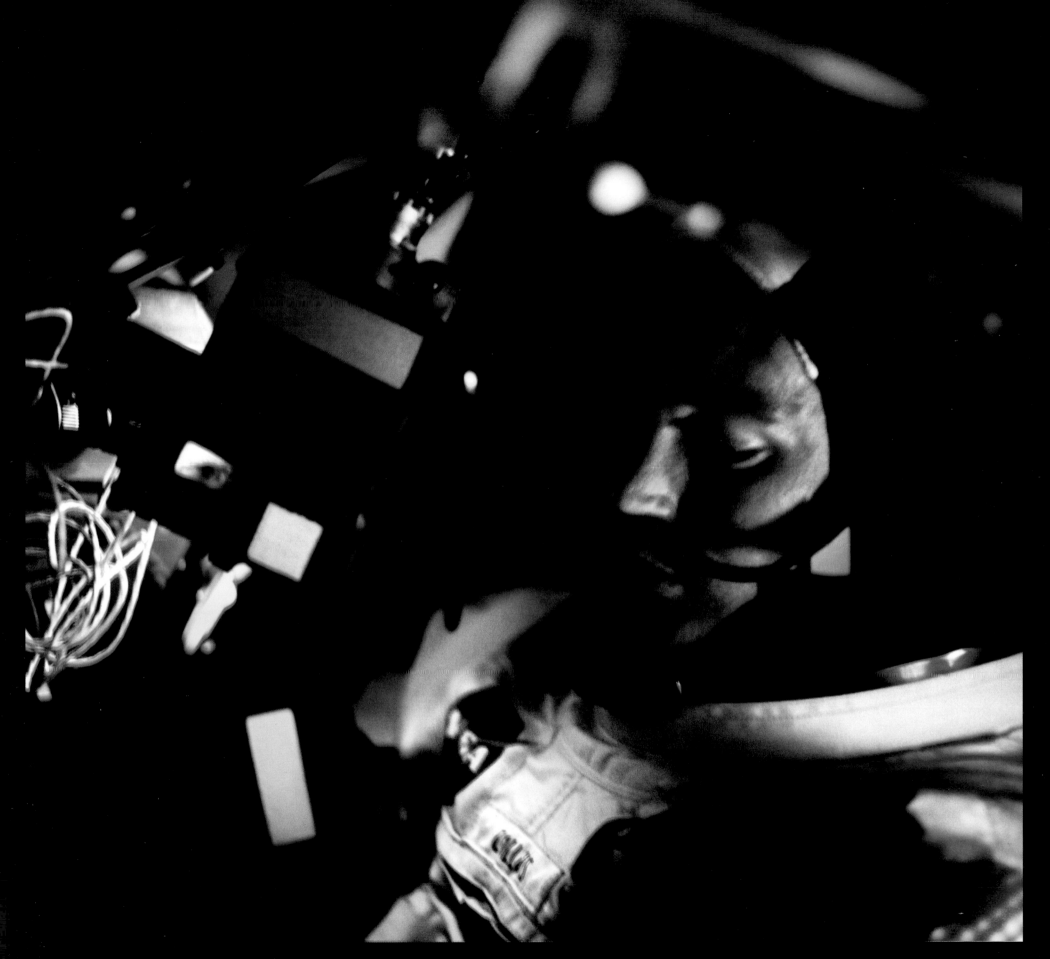

July 16, 1969 HASSELBLAD 70MM. LENS 80MM F/2.8 | BY BUZZ ALDRIN NASA ID: **AS11-36-5292**

Aldrin turns to his right to take this, the only photograph of Michael Collins during the entire mission. The seat positions for all Apollo launches were Commander on the left, CMP in the middle and LMP on the right. Apollo 11 was the exception to the rule with Aldrin in the center couch. The 16mm DAC camera can be seen, at the top. *(EL: 5/5)*

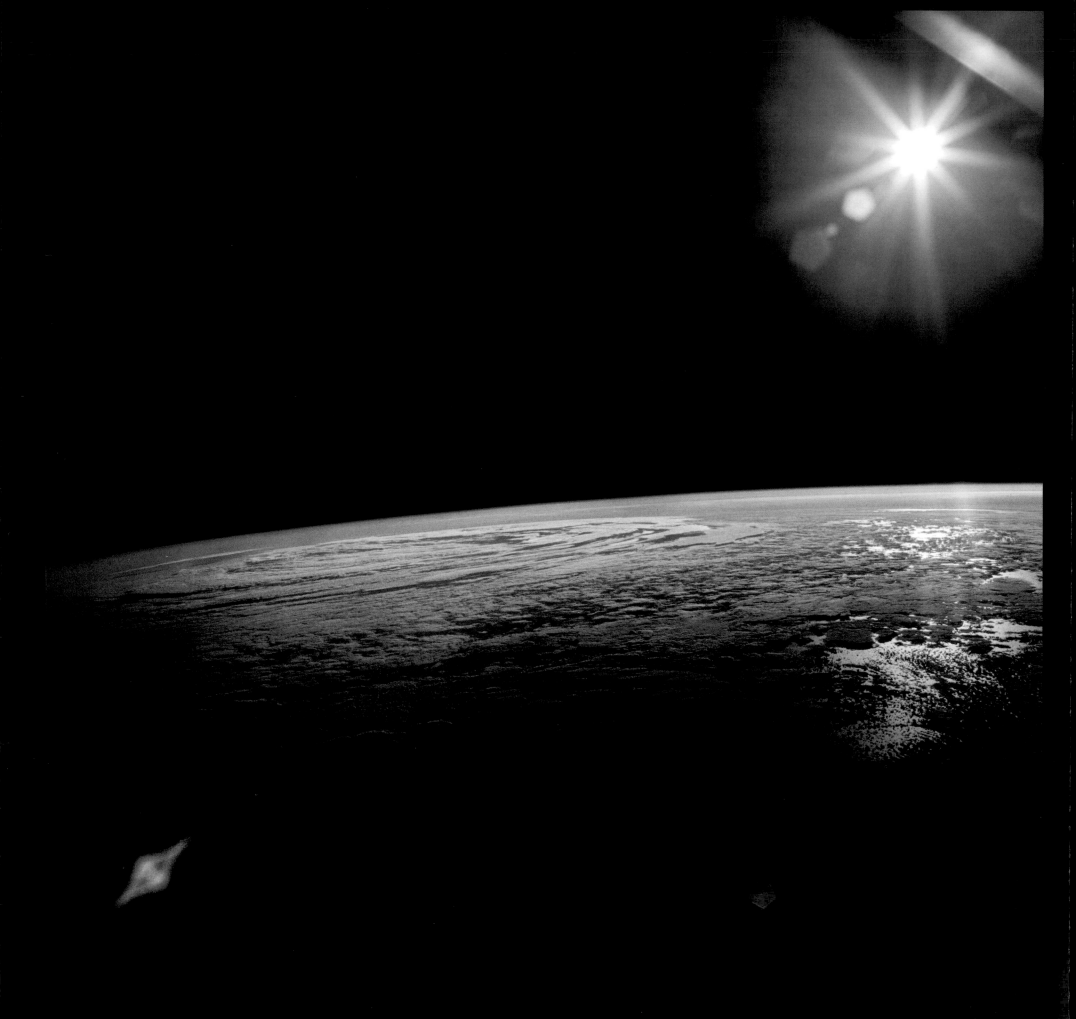

July 16, 1969

70MM HASSELBLAD. LENS 80MM F/2.8 | BY MICHAEL COLLINS

NASA ID: **AS11-36-5293**

Collins: "Jesus Christ, look at that horizon!" Armstrong: "Isn't that something?" Collins: "God damn, that's pretty! This is unreal." Armstrong: "Get a picture of that." Collins: "I've lost a Hasselblad . . . Has anybody seen a Hasselblad floating by? It couldn't have gone very far . . . I seem to be prone to that." (referring to his lost camera overboard on Gemini X). Collins finds it floating in the aft bulkhead and takes this shot of Earth shortly after sunrise. *(Rotated, EL: 3/5)*

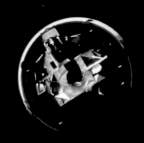
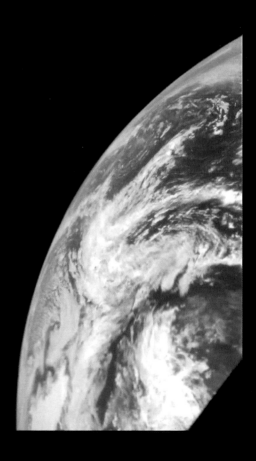

July 16, 1969 120 FRAMES OF 16MM FILM, STACKED, PROCESSED AND STITCHED NASA ID: **APOLLO 11 MAG 1116-A**

Collins: "Beautiful. I hope you got some pictures, Buzz?" Aldrin: "I got the 16-millimeter going . . . Sixteen frames at f/8." Two hours 50 minutes after launch, the trans-lunar injection (TLI) burn from the S-IVB (Saturn V's third stage) occurred to put Apollo 11 on course for the Moon. Thirty minutes later, Aldrin pans the camera from Earth to the S-IVB, and *Eagle,* approximately 100ft away, surrounded by debris caused by separation with the CSM.

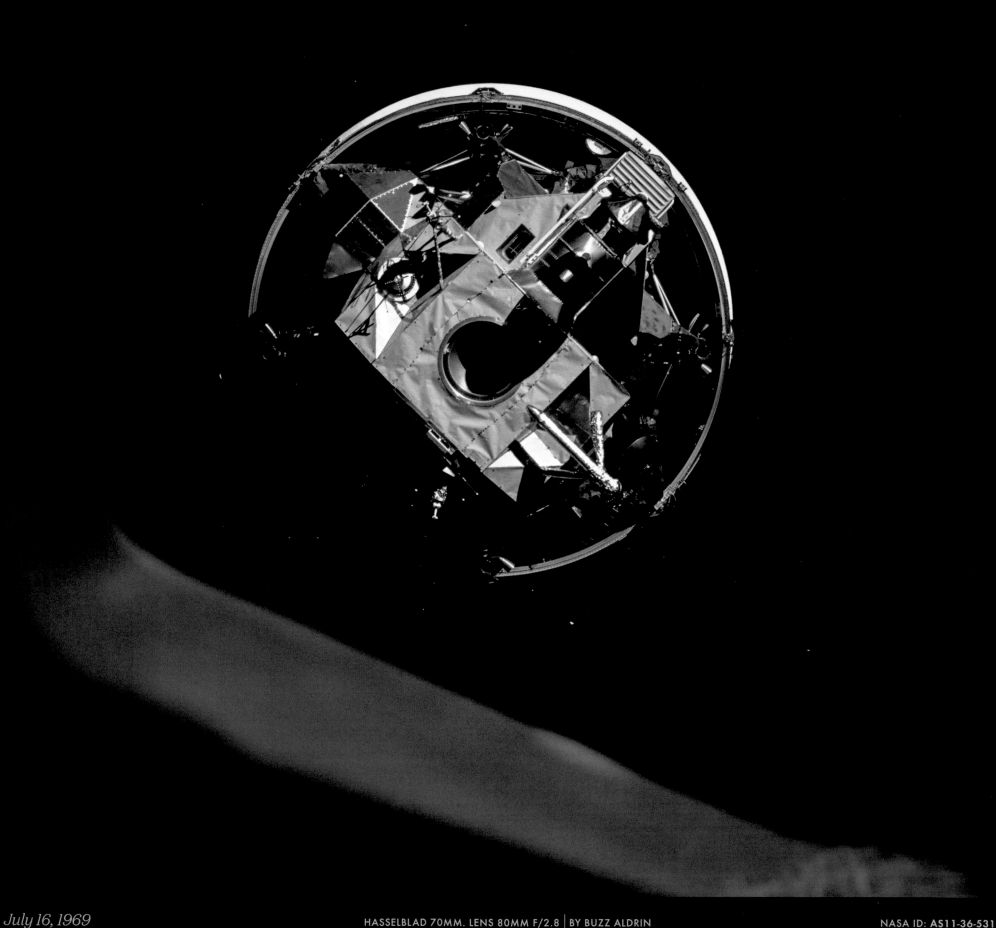

July 16, 1969

HASSELBLAD 70MM. LENS 80MM F/2.8 | BY BUZZ ALDRIN

NASA ID: **AS11-36-5313**

As Collins undertakes transposition and docking maneuvers, closing in on LM *Eagle*, this photograph was taken through the Command Module's window. Collins: "Hey, we're closing in a leisurely fashion . . . Stand by, we're getting pretty close." Despite his calm words, Collins was tense. The top of *Eagle* can be seen in the Spacecraft Lunar Module Adapter (SLA) on top of the S-IVB. The CM's probe had to be inserted into the LM's black, circular drogue. *(EL: 4/5)*

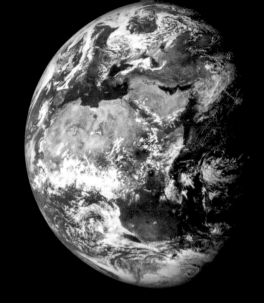

July 17, 1969

HASSELBLAD 70MM. LENS 250MM F/5.6 | BY UNKNOWN

NASA ID: AS11-36-5355

Armstrong would later describe feeling motionless, with Earth slowly sinking away into the inky blackness. Captured on day two of the mission with a telephoto lens, Earth is approximately 100,000 miles away in this photograph. The whole of Africa is visible and up to Italy, Spain and the UK can be seen in the upper left. Along with "Earthrise" (AS08-14-2383) and the "Blue Marble" (AS17-148-22727) this is one of the most widely reproduced photographs of Earth from Apollo. *(EL: 2/5)*

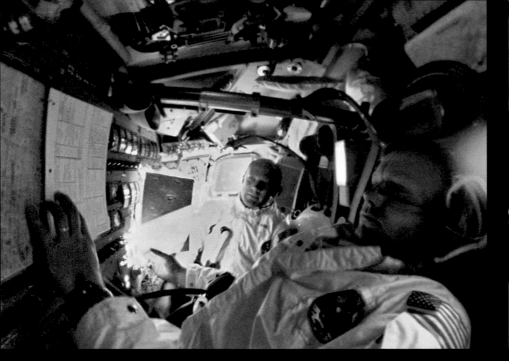
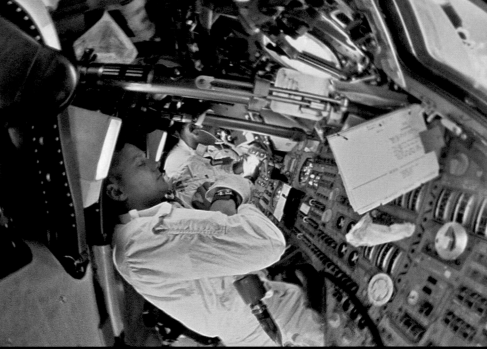
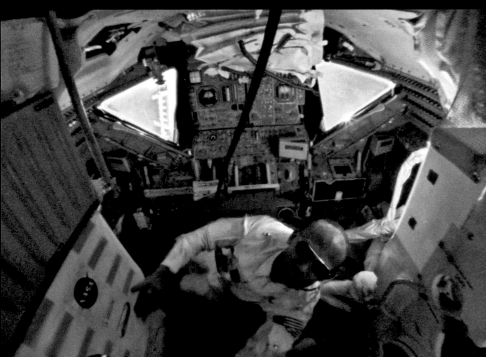
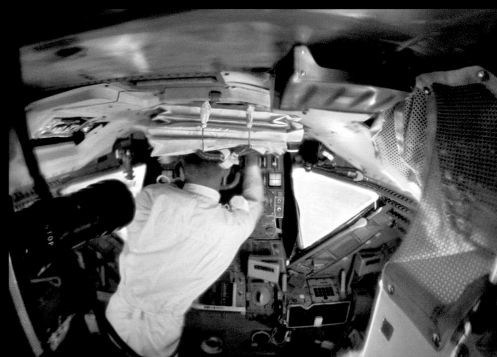

July 17–18, 1969 5–75 FRAMES OF 16MM FILM, STACKED AND PROCESSED NASA ID: **APOLLO 11 MAG 1118-B**

TOP LEFT: Armstrong (foreground) and Aldrin in the Command Module, cross-referencing ▇▇ps of the lunar surface during trans-lunar coast. TOP RIGHT: Armstrong (foreground) and Collins taking a catnap during the three-day journey. Although rest periods were scheduled, sleep was often of low quality. BOTTOM LEFT: Aldrin in LM *Eagle* during initial checkout. His right hand is on Armstrong's PLSS backpack, which Armstrong would wear on the lunar surface. During descent and ascent from the surface Aldrin will occupy the right side of the cabin. BOTTOM RIGHT: Aldrin looks through the Alignment Optical Telescope (AOT) during initial checkout. Armstrong would hook a strap to this to provide support for his legs in an attempt to sleep on the lunar surface. The live TV camera lens can be seen, left.

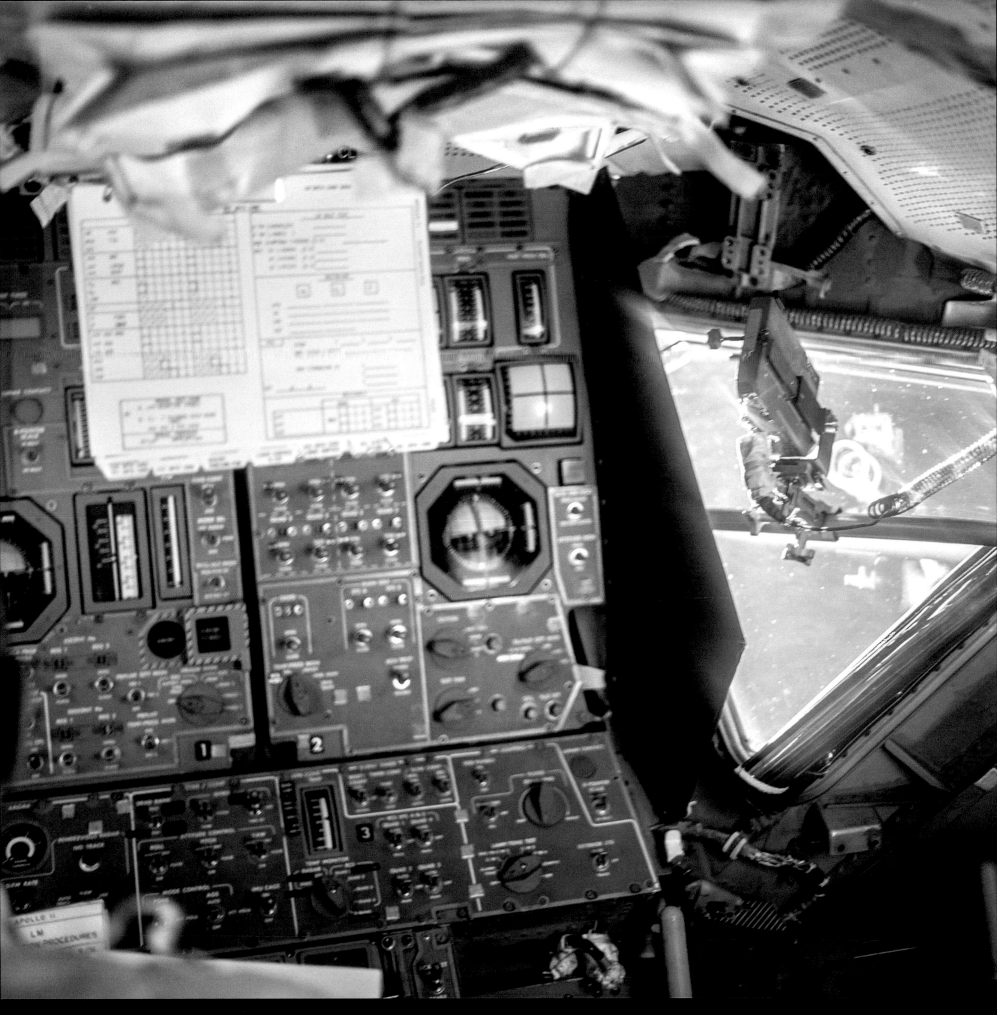

July 18, 1969 HASSELBLAD 70MM. LENS 80MM F/2.8 | BY NEIL ARMSTRONG NASA ID: AS11-36-5389

Armstrong and Aldrin are in *Eagle* for the initial checkout. Here's a detailed view of the instrument panels that helped guide them to the lunar surface. The two blue "Contact light" indicators that would confirm "the *Eagle* has landed" are in the upper-left and lower-right corners of the control panel. The 16mm camera that recorded the first steps is mounted in the right window, as Aldrin checks out the LM Malfunction Procedures handbook. *(Rotated, EL: 3/5)*

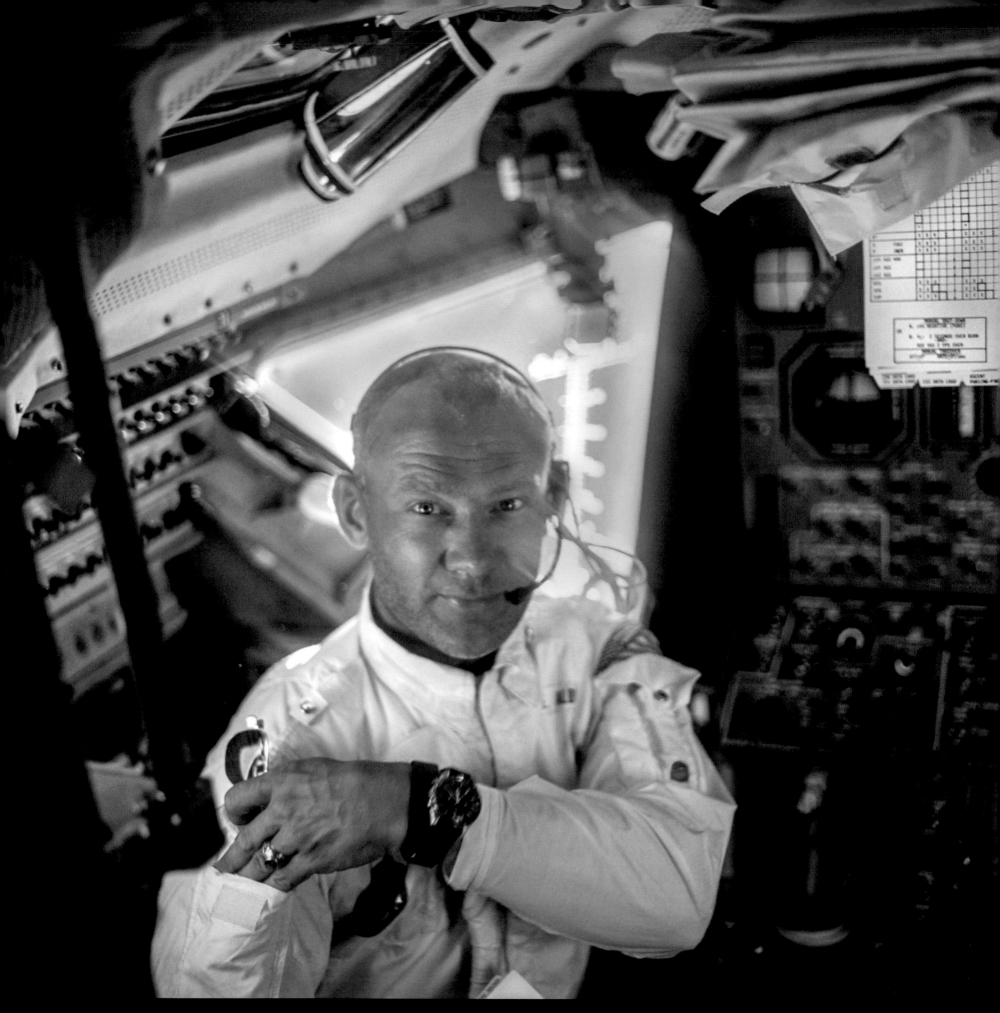

July 18, 1969 HASSELBLAD 70MM. LENS 80MM F/2.8 | BY NEIL ARMSTRONG NASA ID: AS11-36-5390

Armstrong: "The lighting in the LM is very nice now, just like completely daylit." A classic shot of Aldrin as he returns his sunglasses to his pocket. Aldrin to Mission Control: "Charlie [Duke], is
here any concern about the duration that we ought to have the window shades open? We don't have any circulation in here, and it might get a little on the warm side." As Commander

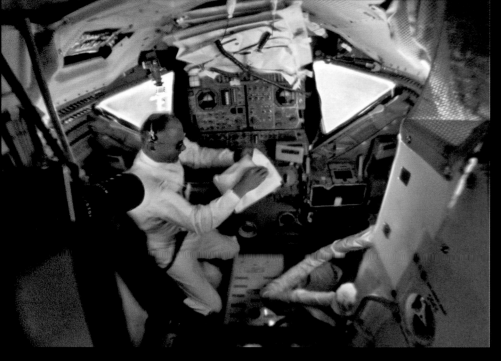

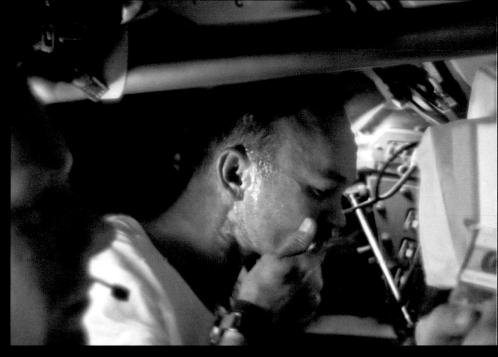

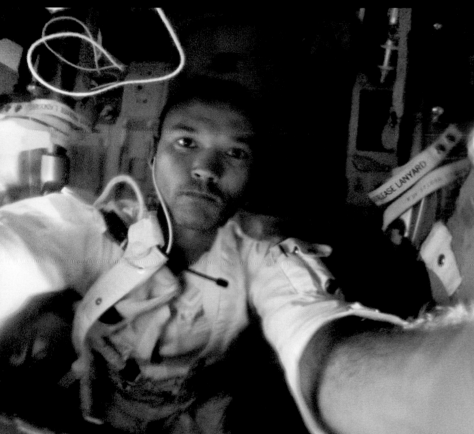

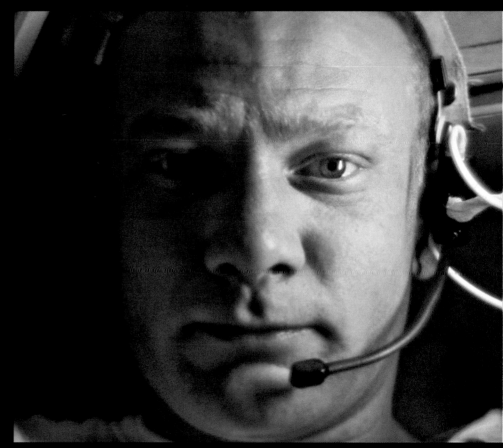

July 18–24, 1969 14–25 FRAMES OF 16MM FILM, STACKED AND PROCESSED NASA ID: **APOLLO 11 MAG 1118-B**

TOP LEFT: A wide-angle view of the cabin of LM *Eagle*. Aldrin's PLSS backpack is under his knee, the EVA helmets are either side of it and the hatch that would lead out to the lunar surface behind.
TOP RIGHT: Life on board the Command Module *Columbia* on a journey to the Moon. Collins is shaving as Armstrong considers the music selection on a cassette tape. BOTTOM LEFT: Collins captures himself on the 16mm DAC camera from the Command Module's center-seat position; the lower equipment bay is behind him. BOTTOM RIGHT: Aldrin captures himself on the 16mm DAC camera; taken in the lower equipment bay. One of the Command Module's two guidance computer interface "DSKY" panels can be seen to his right.

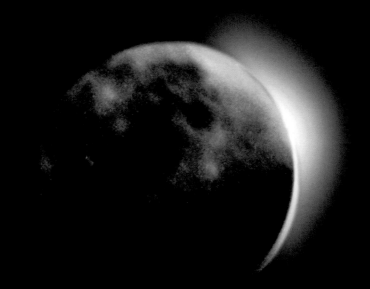

July 19, 1969

HASSELBLAD 70MM. LENS 80MM F/2.8. B&W | BY UNKNOWN NASA ID: AS11-42-6179

Approximately 12,000 miles from the Moon, Apollo 11 flew into its shadow, revealing a sky full of stars. Aldrin: "It's quite an eerie sight. There's a very marked three-dimensional aspect of having the Sun's corona coming from behind the Moon." Reflected blue light from Earth (Earthshine) illuminated the Moon's surface just enough for the crew to recognize surface features, now revealed in this enhanced image. Armstrong would later conclude: "It was the most beautiful sight I'd ever seen." *(Cropped, EL: 5/5)*

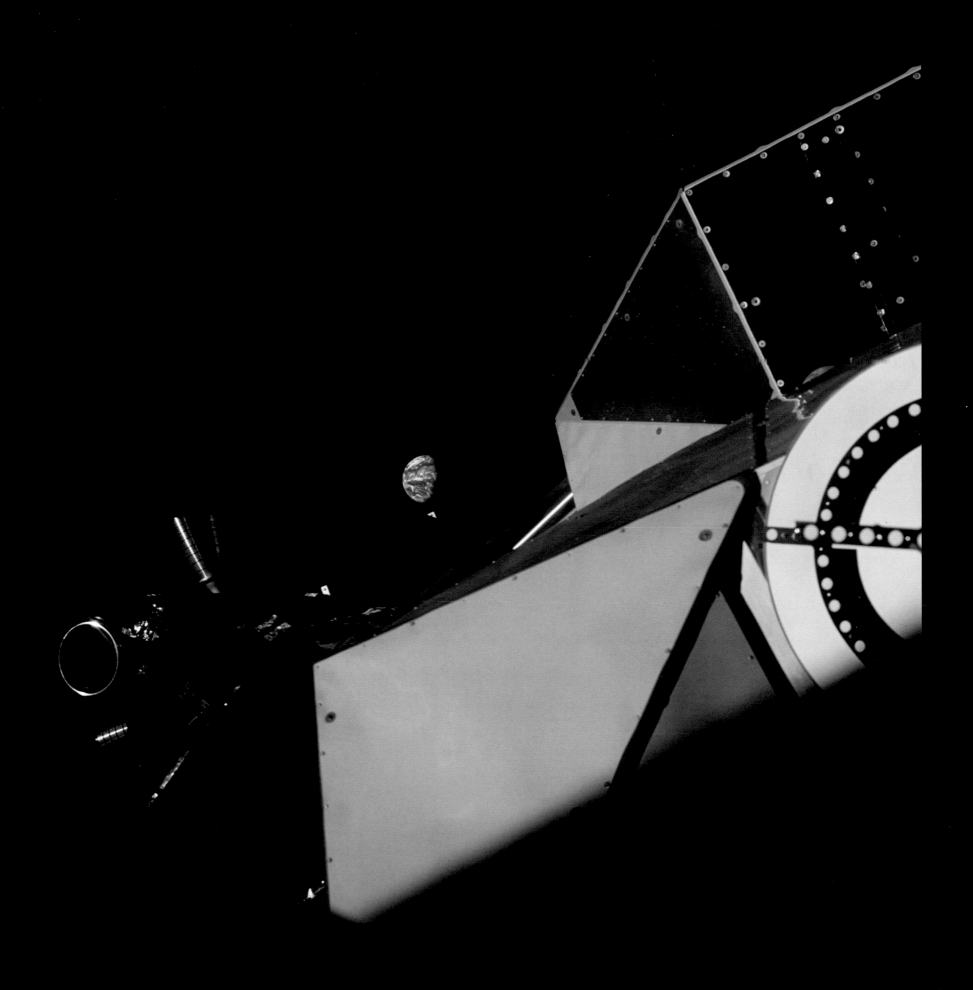

July 19, 1969 HASSELBLAD 70MM. LENS 80MM F/2.8 | BY UNKNOWN NASA ID: **AS11-36-5404**

Looking back at Earth as Apollo 11 approaches the Moon. Taken from CSM *Columbia* looking past the top of the docked *Eagle*. The circular disc to the right is the LM's docking target. Armstrong was also impressed with the opposing view: "The view of the Moon that we've been having recently is really spectacular . . . We can see the entire circumference, even though part of it is in complete shadow and part of it is in Earthshine. It's a view worth the price of the trip." *(EL: 2/5)*

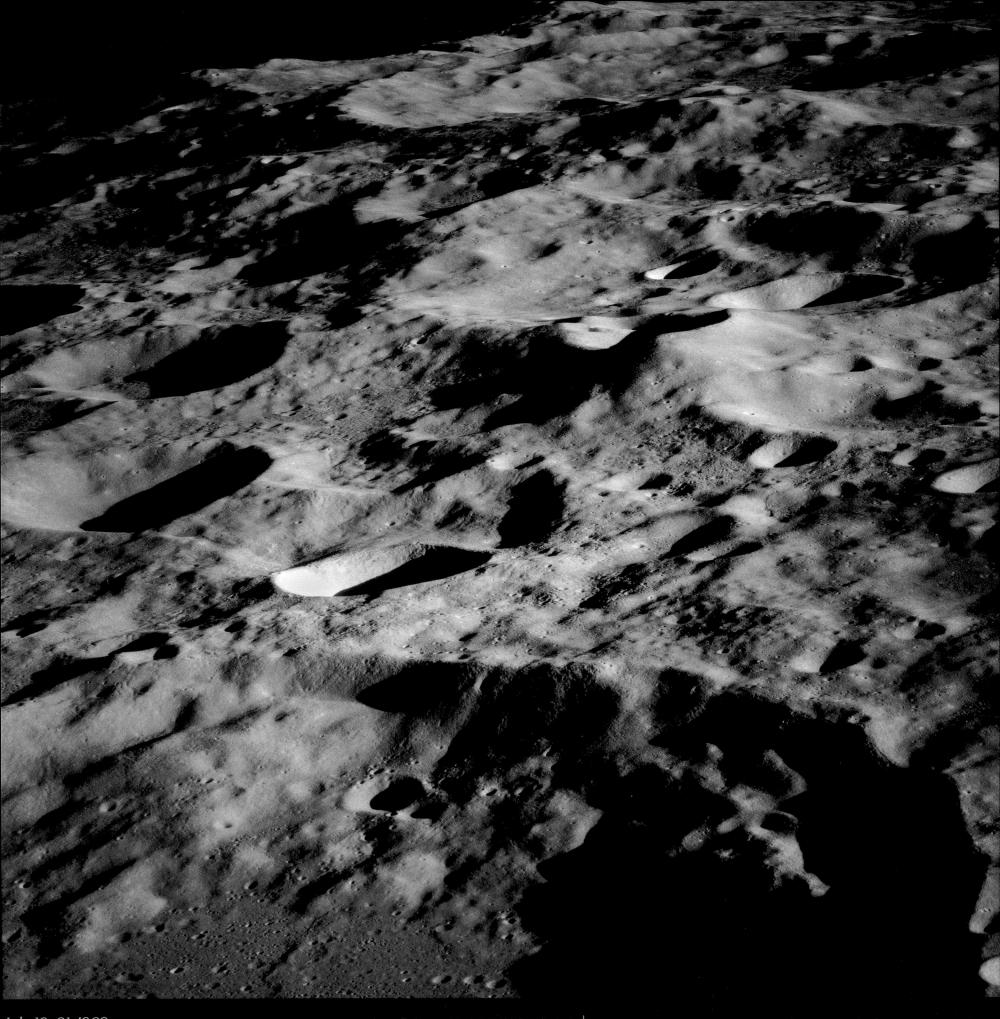

HASSELBLAD 70MM. LENS 250MM F/5.6. B&W │ BY UNKNOWN

NASA ID: AS11-38-5560

Traveling at 5,200mph, 75 hours after leaving Earth, Apollo 11's SPS engine fired for 358 seconds to slow the spacecraft and enter an orbit around the Moon. Armstrong: "That was a beautiful burn." Collins: "Yes, the Moon is there, boy – in all its splendor." Aldrin: "Man, look at it!" This photograph (probably taken later) shows an area close to Daedalus crater, halfway round the farside of the Moon. *(Rotated, EL: 4/5)*

July 19–21, 1969 54 FRAMES OF 16MM FILM, STACKED AND PROCESSED NASA ID: **APOLLO 11 MAG 1124-F**

Collins: "God, look at that Moon!" Armstrong: "What a spectacular view!" During the first orbit the crew were torn between observing, photographing and filming the farside of the Moon; preparing for acquisition of signal; and anticipating an impending Earthrise. Collins: "At these low Sun angles, there's no trace of brown; it's now returned to a very gray appearance." The crew were unanimous that at high Sun angles the Moon was a brown/tan color.

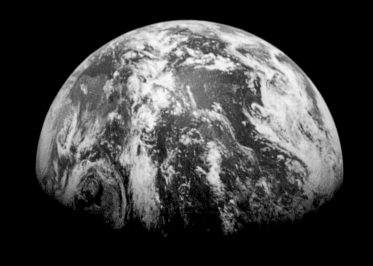
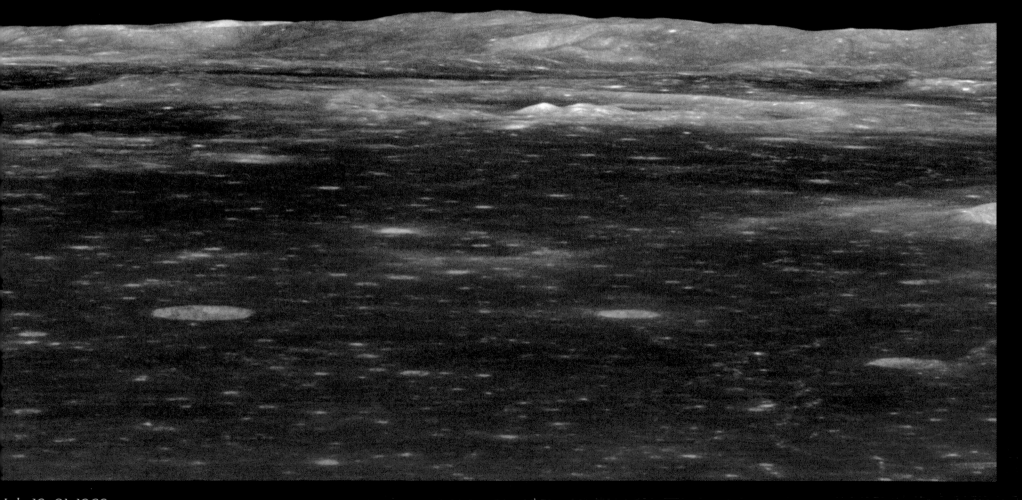

July 19–21, 1969 HASSELBLAD 70MM. LENS 250MM F/5.6 | PROBABLY BY BUZZ ALDRIN NASA ID: **AS11-44-6551**

Aldrin: "There it is; it's coming up!" At the moment Apollo 11 re-acquired signal with Earth, after emerging from the lunar farside, they witnessed their first Earthrise. Despite some issues with frosted windows, this Earthrise image was captured a little later at the start of their sixth revolution. *(Cropped, rotated, EL: 3/5)*

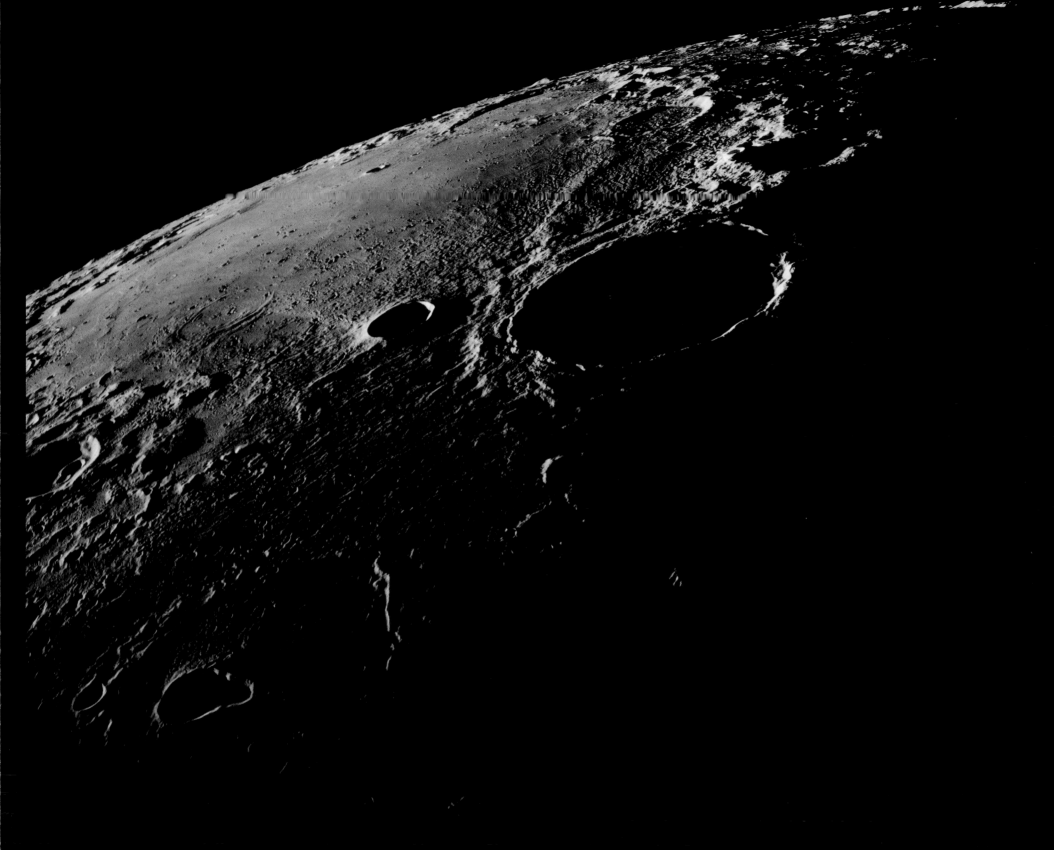

July 19–21, 1969 HASSELBLAD 70MM. LENS 80MM F/2.8. B&W │ BY UNKNOWN NASA ID: **AS11-42-6241**

Apollo 11 completed 12 orbits before Armstrong and Aldrin would descend to the surface. In the meantime they had further opportunities to observe and photograph the Moon. Collins: "Well, there's no doubt that this is a little smaller than the Earth . . . Look at that curvature." Theophilus crater is on the nearside of the Moon and is 62 miles in diameter. *(Rotated, EL: 4/5)*

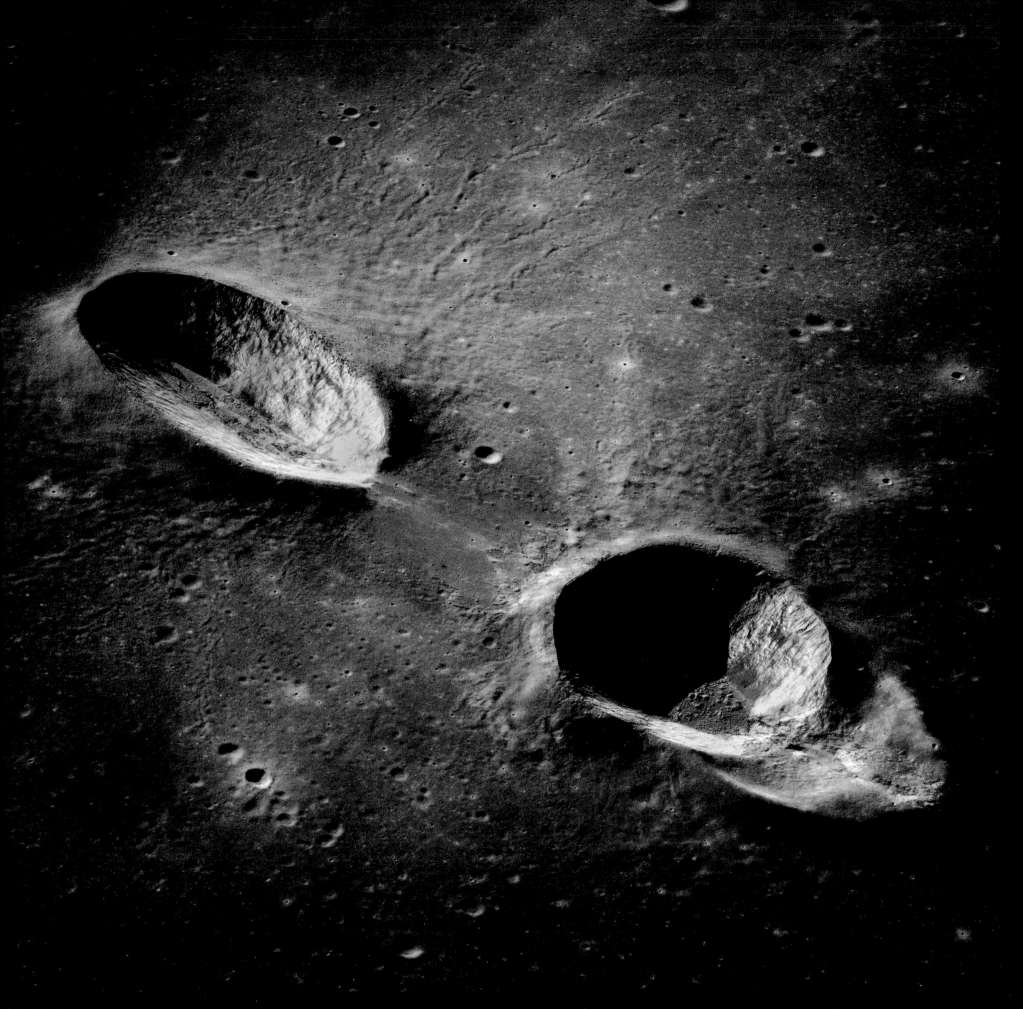

July 19–21, 1969

HASSELBLAD 70MM. LENS 250MM F/5.6. B&W | BY UNKNOWN NASA ID: AS11-42-6304

Armstrong: "We're going over the Messier series of craters right at the time, looking vertically down on them, and Messier A, we can see good-sized blocks in the bottom of the crater." Messier A is on the right and is 7 miles in diameter. The Messier series was a useful reference point leading to Mount Marilyn (informally named after Jim Lovell's wife) – a checkpoint reference for the start of powered descent to the surface. *(EL: 5/5)*

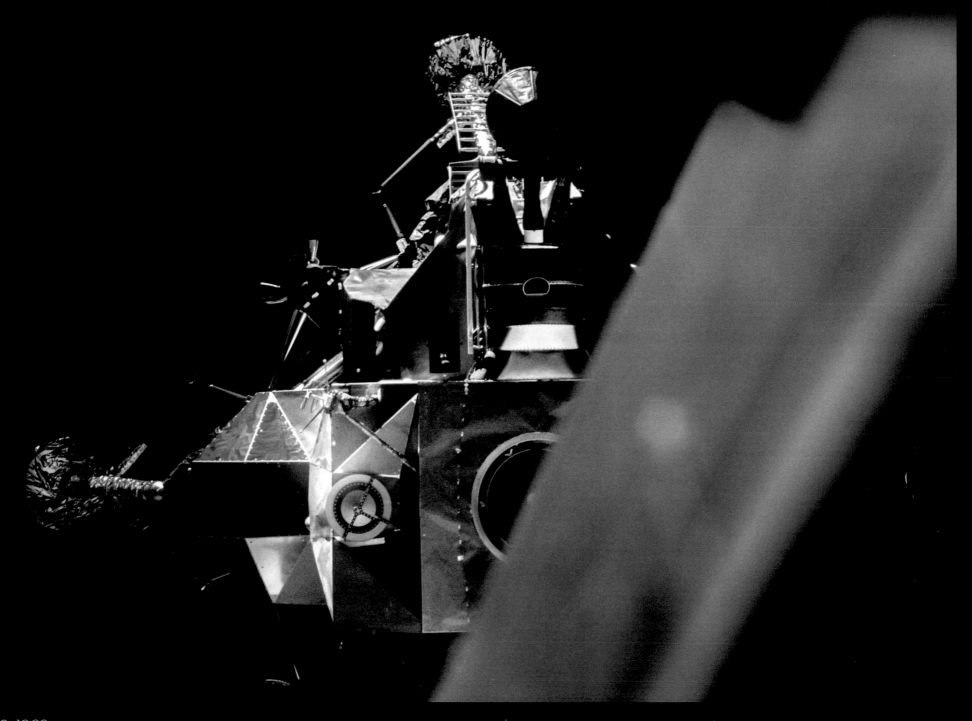

July 20, 1969 HASSELBLAD 70MM. LENS 80MM F/2.8 | BY MICHAEL COLLINS NASA ID: **AS11-44-6568**

Aldrin: "Neil, we got two magazines . . . I'm going to put the "R" in the reserve camera . . . and the "S" in the surface camera." Armstrong: "Good idea." Magazine "S" would be the only one exposed during the EVA and would record the most important moments in our history. Cameras stowed, 100 hours into the mission, *Eagle* takes flight as it undocks from *Columbia*. Armstrong's "bubble" helmet can be seen through the docking window as he pilots the LM. *(EL: 4/5)*

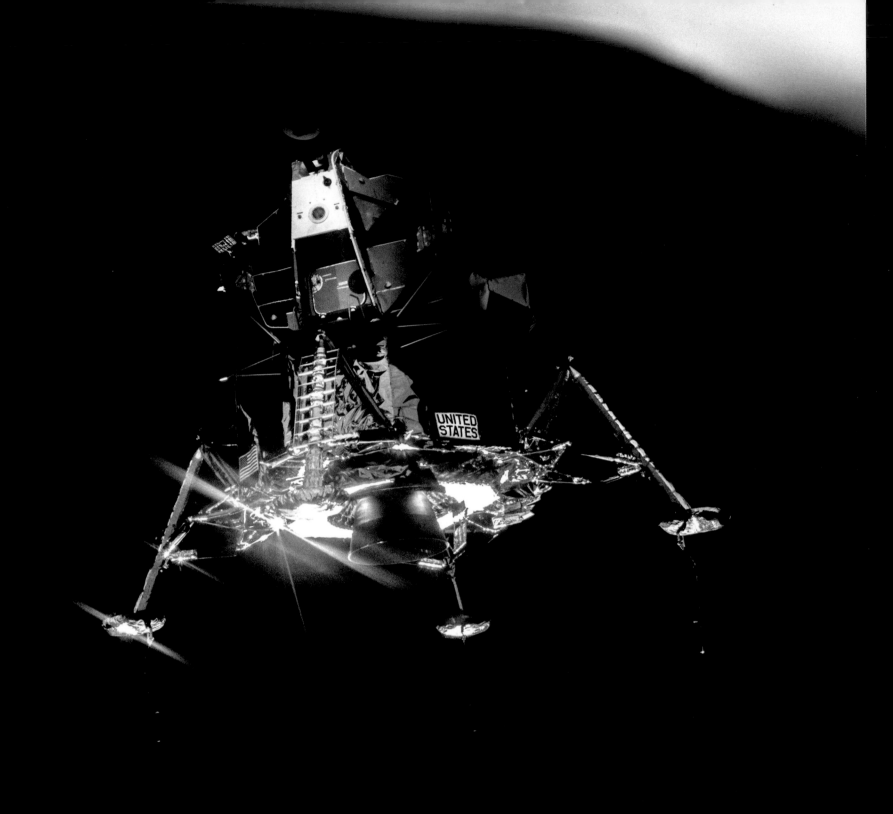

July 20, 1969

HASSELBLAD 70MM. LENS 80MM F/2.8 | BY MICHAEL COLLINS

NASA ID: **AS11-44-6576**

Collins: "Okay, there you go. Beautiful!" Duke (CAPCOM): "How does it look, Neil?" Armstrong: "The *Eagle* has wings!" Armstrong takes control to enable a visual inspection of the LM, prior to the Descent Orbit Insertion (DOI) burn. Note the absence of a contact probe hanging from the foot of the ladder leg – removed due to Armstrong's concern that it may bend upward, presenting a hazard upon descending the ladder. Armstrong may be just visible, at the helm in the LM's left triangular window. *(Cropped, rotated, EL: 5/5)*

July 20, 1969 5 FRAMES OF 16MM FILM, STACKED, PROCESSED AND STITCHED NASA ID: **APOLLO 11 MAG 1127-G**

As Aldrin was preparing the 16mm "movie" camera to record the historic flight, he inadvertently captured Armstrong in a few fleeting frames. In his "bubble" helmet, he appears to be looking down to the left, perhaps at the CSM through the triangular window. Images of any Apollo astronaut flying the LM are extremely rare, making this tantalizing glimpse of Commander Neil Armstrong, in full pressure suit, at the helm as he prepares to pilot *Eagle* to humankind's first landing on another world, all the more special.

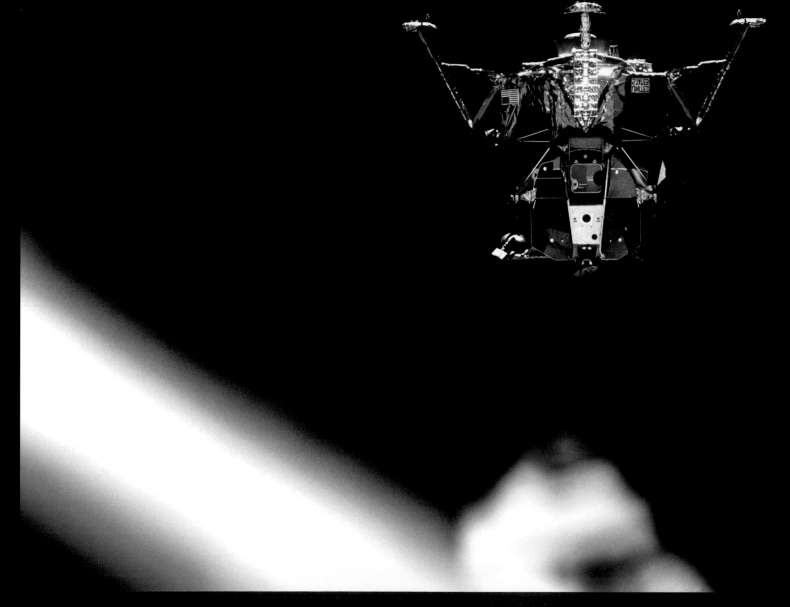

July 20, 1969 HASSELBLAD 70MM. LENS 80MM F/2.8 | BY MICHAEL COLLINS NASA ID: AS11-44-6598

Collins: "I think you've got a fine-looking flying machine there, *Eagle*, despite the fact you're upside down." In space, who's to say who is upside down, or what the right way up is? This prompted Armstrong's instant riposte: "*Somebody's* upside down." A picture-perfect portrait of *Eagle*. Armstrong may be just visible in the LM's left-hand window. *(Rotated, EL: 3/5)*

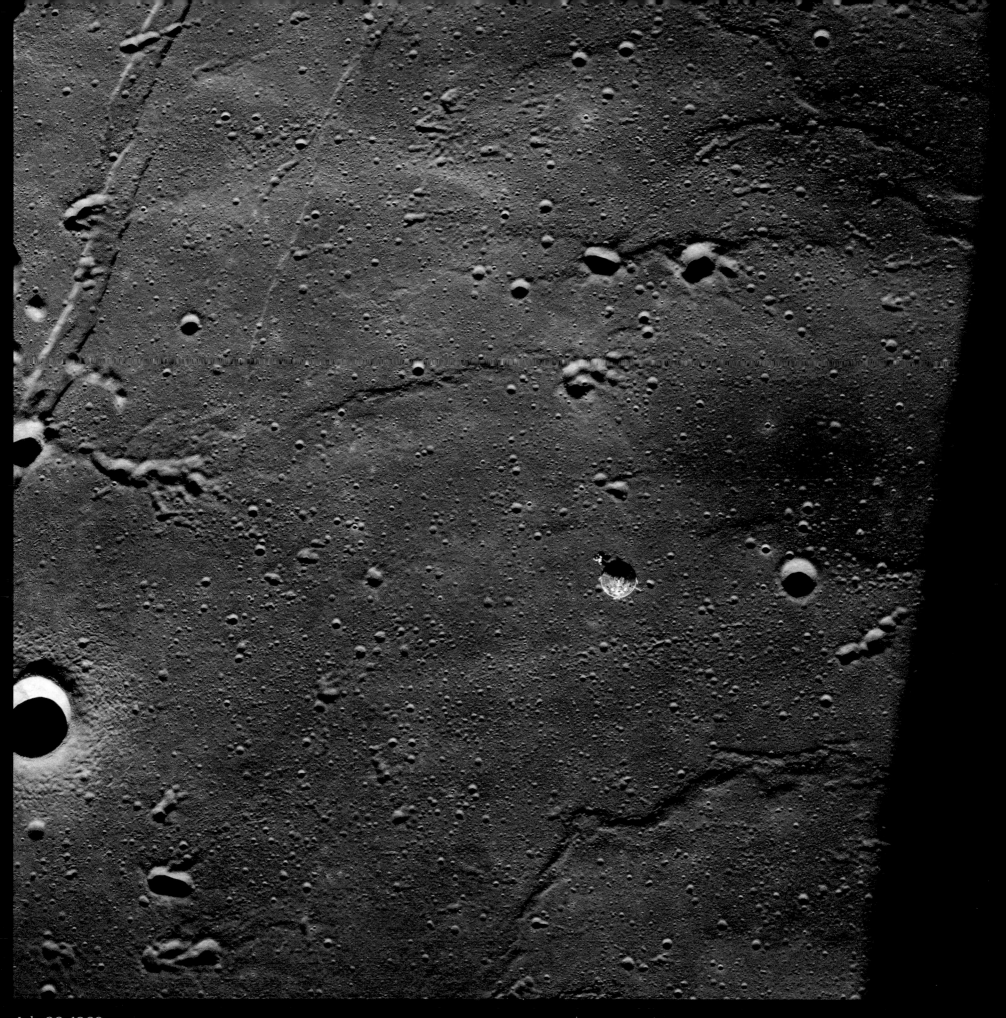

July 20, 1969

HASSELBLAD 70MM. LENS 80MM F/2.8 | BY UNKNOWN

NASA ID: **AS11-37-5447**

Armstrong: "You're going right down U.S.1, Mike." On the final pass before descent, CSM *Columbia*, with Collins on board, passed almost directly over the landing site. The DOI burn then occurred over the lunar farside to put *Eagle* into a 60 by 9 mile orbit. At the orbit lowpoint, CAPCOM Duke conf█████: "You're Go for PDI [Powered Descent Initiation]." After landmark tracking confirmation, Armstrong's simple understated confirmation: "Ignition," signaled the start of 13 of the most important and tense minutes in the history of flight. *(FL. 2/5)*

July 20, 1969

30 FRAMES OF 16MM FILM, STACKED AND PROCESSED

NASA ID: APOLLO 11 MAG 1080-I

Aldrin: "Picking up some dust . . . Contact light!" Despite initial landmark tracking indicating they were 3 seconds (and miles) "long," and after a tense descent including computer overload alarms and a boulder field in the LPD (requiring Armstrong to take over manual control), *Eagle* touched down at 20:17GMT, on July 20, 1969 with only 17 seconds of fuel remaining. Armstrong confirmed: "Houston, Tranquility Base here, the *Eagle* has landed."

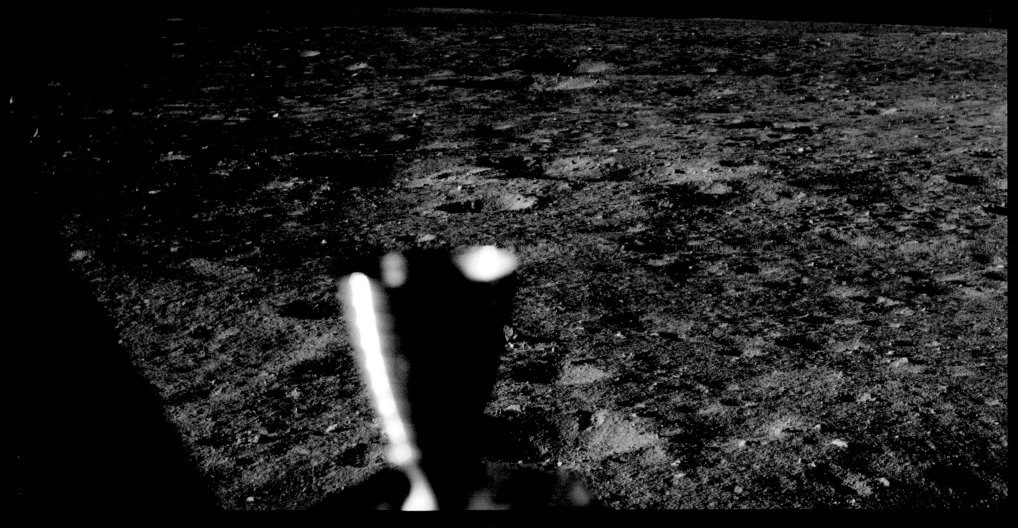

July 20, 1969 HASSELBLAD 70MM. LENS 80MM F/2.8 │ BY NEIL ARMSTRONG NASA ID: **AS11-37-5449**

CAPCOM Duke: "We copy you down *Eagle* . . . You got a bunch of guys about to turn blue. We're breathing again. Thanks a lot." After a very busy hour since the landing, undergoing "stay or no stay" checks, the crew surveyed, and took the first-ever photographs from the surface of the Moon. This is likely the very first – Armstrong's view out of his window into the silent vacuum and a desolate Tranquility Base. Aldrin: "It looks like a collection of just . . . about every variety of rock you could find." *(EL: 3/5)*

July 20, 1969 MULTIPLE FRAMES OF 16MM FILM, STACKED AND PROCESSED NASA ID: **APOLLO 11 MAG 1081-J**

Forfeiting a planned rest period, two hours of EVA preparation commenced. After donning their suits and depressurizing the cabin, the hatch was opened and the remaining pressure and moist cabin air rushed out into the vacuum. Armstrong: "Okay. Houston, I'm on the porch." CAPCOM McCandless: "1/60th second for shadow photography on the sequence camera." Aldrin adjusts the 16mm camera in his window. At 22:56 EDT on July 20th, 1969 (02:56 GMT 21st), Armstrong sets foot upon the Moon. TOP LEFT: Armstrong descends the ladder. TOP RIGHT: A first glance down at the lunar surface. CENTER LEFT: "OK I'm going to step off the LM now . . ." CENTER RIGHT: "That's one small step for (a) man . . ." BOTTOM LEFT: ". . . one giant leap for mankind." BOTTOM RIGHT: Armstrong fully steps off the footpad, his face is just visible."

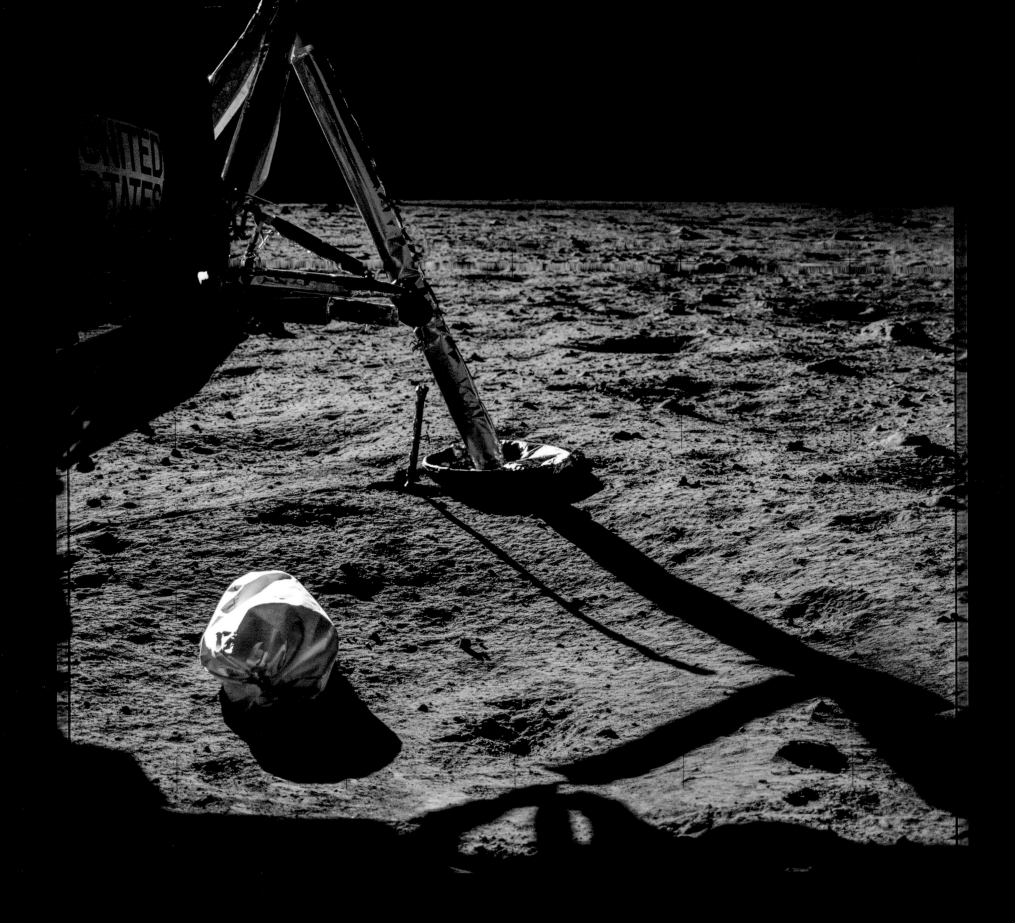

July 20, 1969 HASSELBLAD 70MM. LENS 60MM F/5.6 | BY NEIL ARMSTRONG NASA ID: AS11-40-5850

Armstrong: "Okay, Buzz, we ready to bring down the camera?" Contrary to the flight plan, Armstrong decides to bring the camera down on the "clothesline" Lunar Equipment Conveyor (LEC) and take some initial photographs rather than collect a contingency sample first. Armstrong: "I'll step out and take some of my first pictures here." This is the first photograph (showing landing gear and waste jettison bag) taken by a human standing on another celestial body. *(EL: 3/5)*

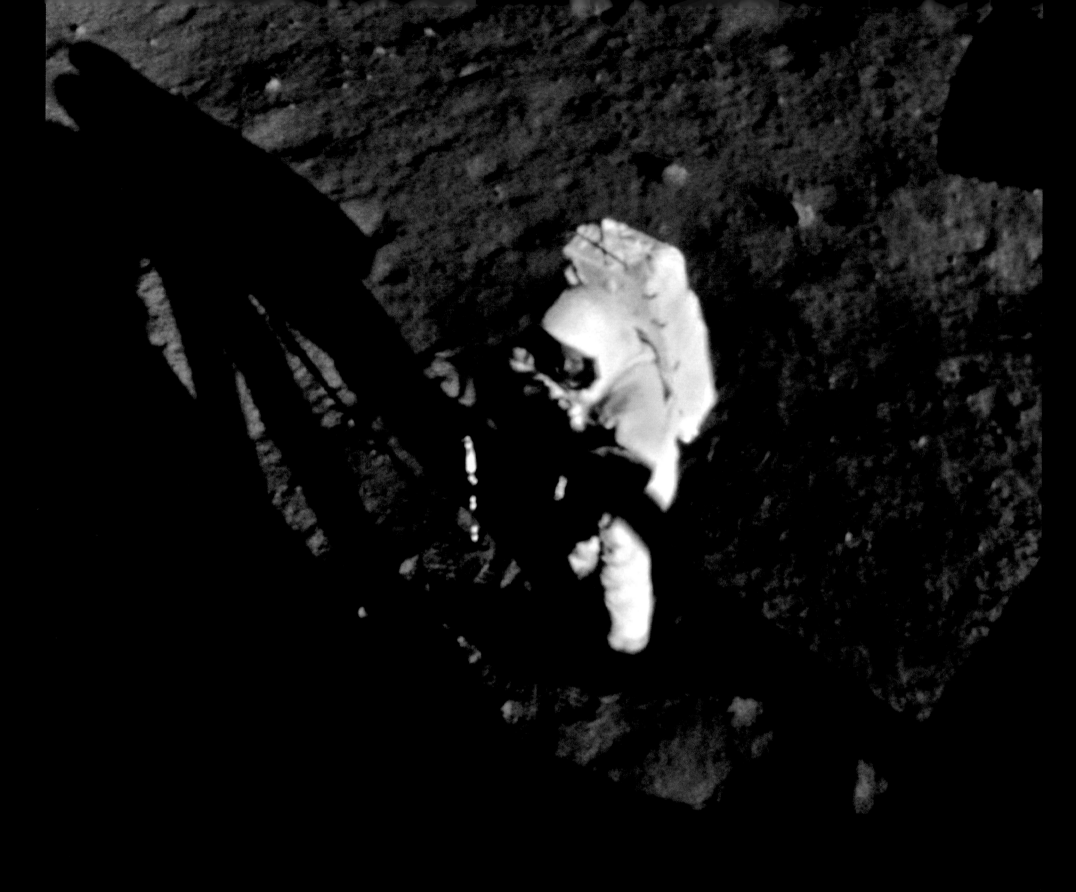

July 20, 1969

6 FRAMES OF 16MM FILM, STACKED AND PROCESSED

NASA ID: **APOLLO 11 MAG 1082-K**

Armstrong progressed with collecting the contingency soil sample in case an emergency required an early abort. He's preparing it in order to fit it into his thigh pocket. Regarded as the clearest image of Armstrong on the Moon, this shows for the first time, fine details and the recognizable features of the first man on the Moon.

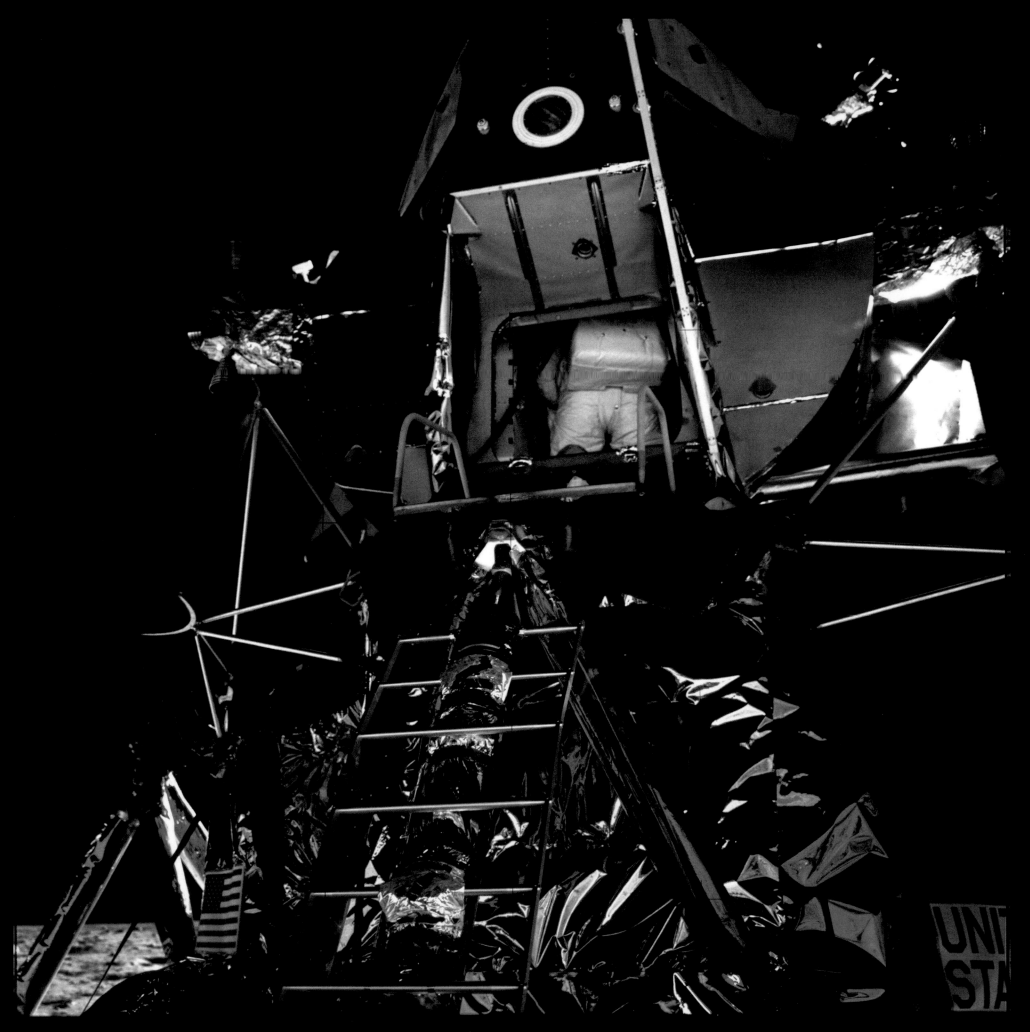

July 20, 1969 HASSELBLAD 70MM. LENS 60MM F/5.6 | BY NEIL ARMSTRONG NASA ID: **AS11-40-5862**

Aldrin: "Okay. Are you ready for me to come out?" Armstrong: "Okay. You saw what difficulties I was having. I'll try to watch your PLSS from underneath here." Sixteen minutes after Armstrong, Aldrin began his egress from *Eagle*. Aldrin: "All right; the back-up camera's positioned." The back-up Hasselblad was positioned just inside the hatch in case they needed to go back for it. However, this was a HEC, not designed for use in the extreme thermal environment; thankfully it was never needed. *(EL: 4/5)*

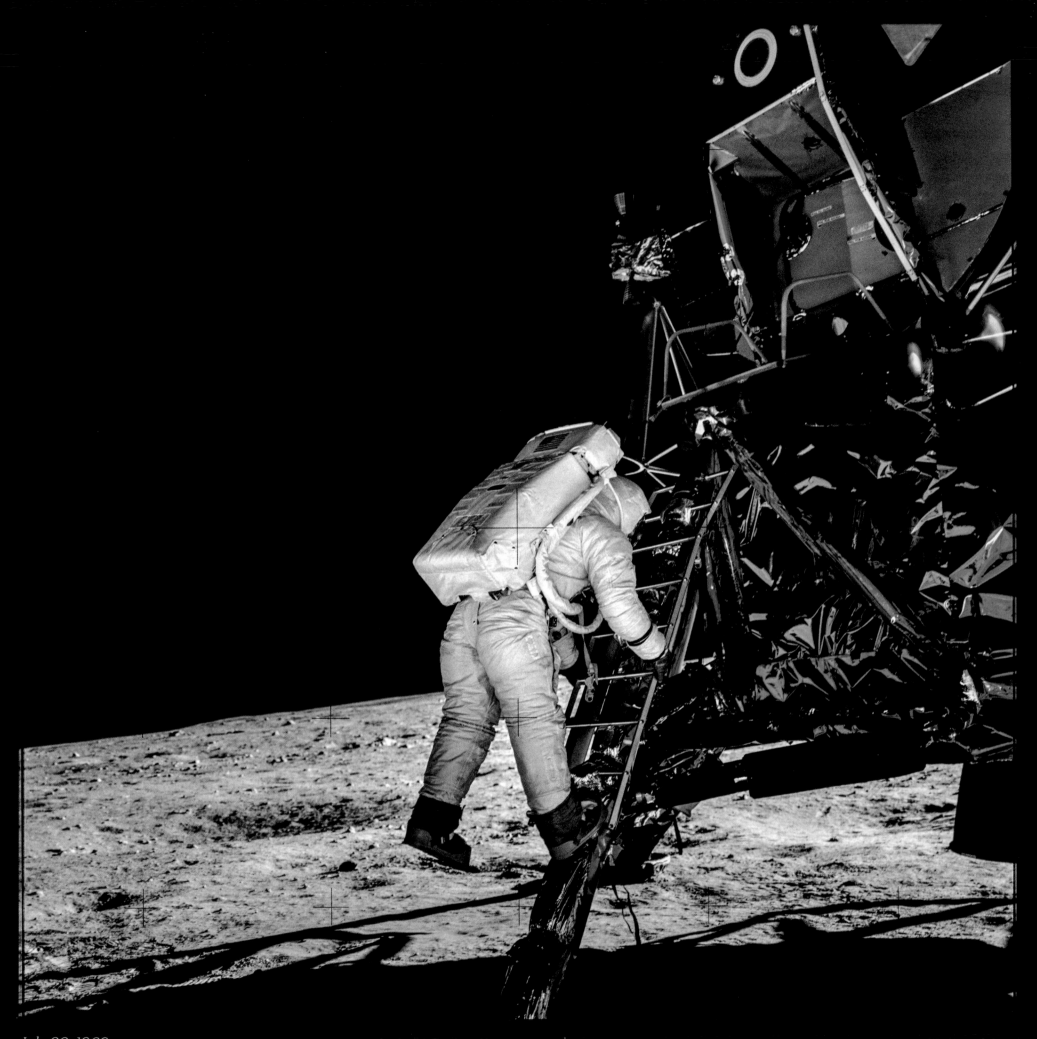

July 20, 1969 HASSELBLAD 70MM. LENS 60MM F/5.6 | BY NEIL ARMSTRONG NASA ID: **AS11-40-5868**

Aldrin: "Okay. Now I want to back up and partially close the hatch. Making sure not to lock it on my way out!" Armstrong continues to guide Aldrin as he descends the ladder to become the second human to set foot on the Moon. Aldrin: "I'm going to leave that one foot up there and both hands down to about the fourth rung up" (pictured). The last step off the ladder is a long one. Aldrin commented on the view: "Magnificent desolation . . ." *(EL: 3/5)*

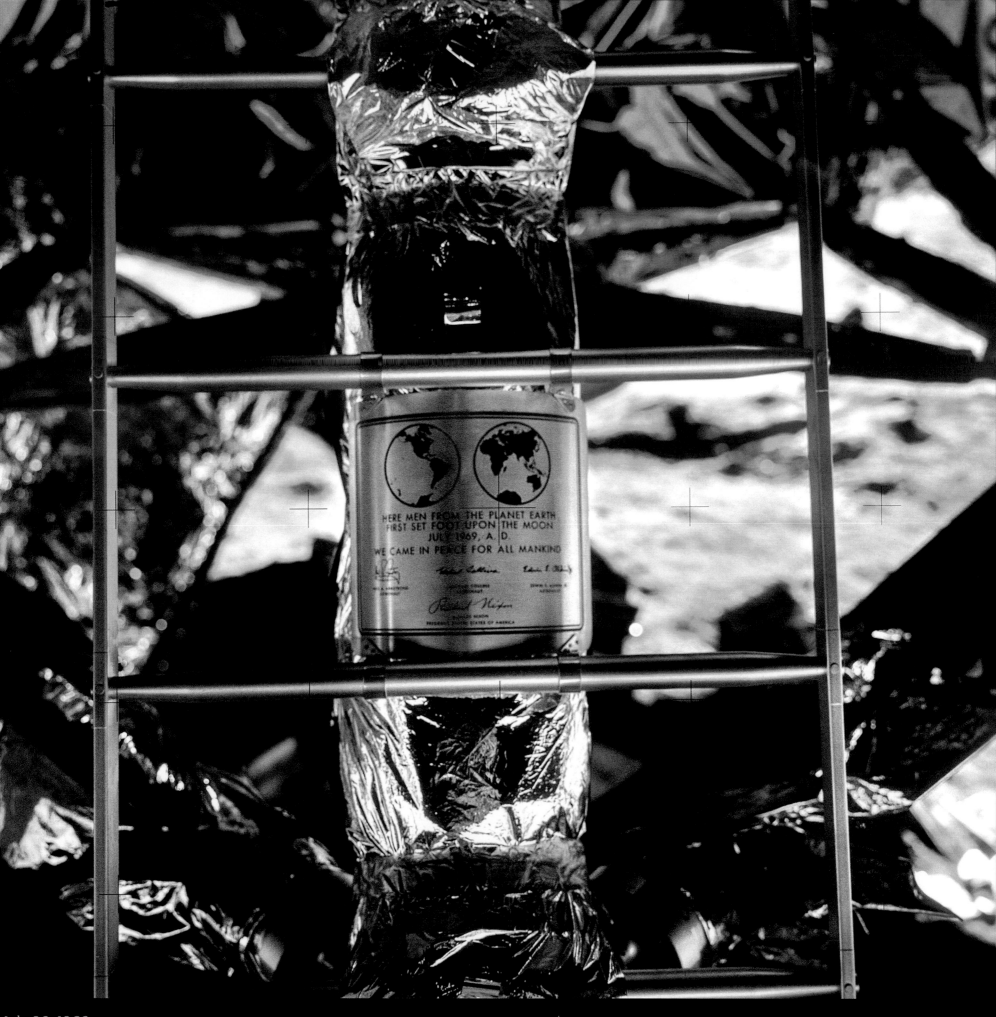

July 20, 1969 HASSELBLAD 70MM. LENS 60MM F/5.6 | BY BUZZ ALDRIN NASA ID: AS11-40-5899

Once Armstrong had changed the lens on the live TV camera he proceeded to unveil the plaque on the LM's front landing gear. With Aldrin by his side he then read out the plaque to the watching TV audience: "Here men from the planet Earth first set foot upon the Moon, July 1969, A.D. We came in peace for all mankind." This photograph of the plaque was taken a little later in the EVA. *(EL: 5/5)*

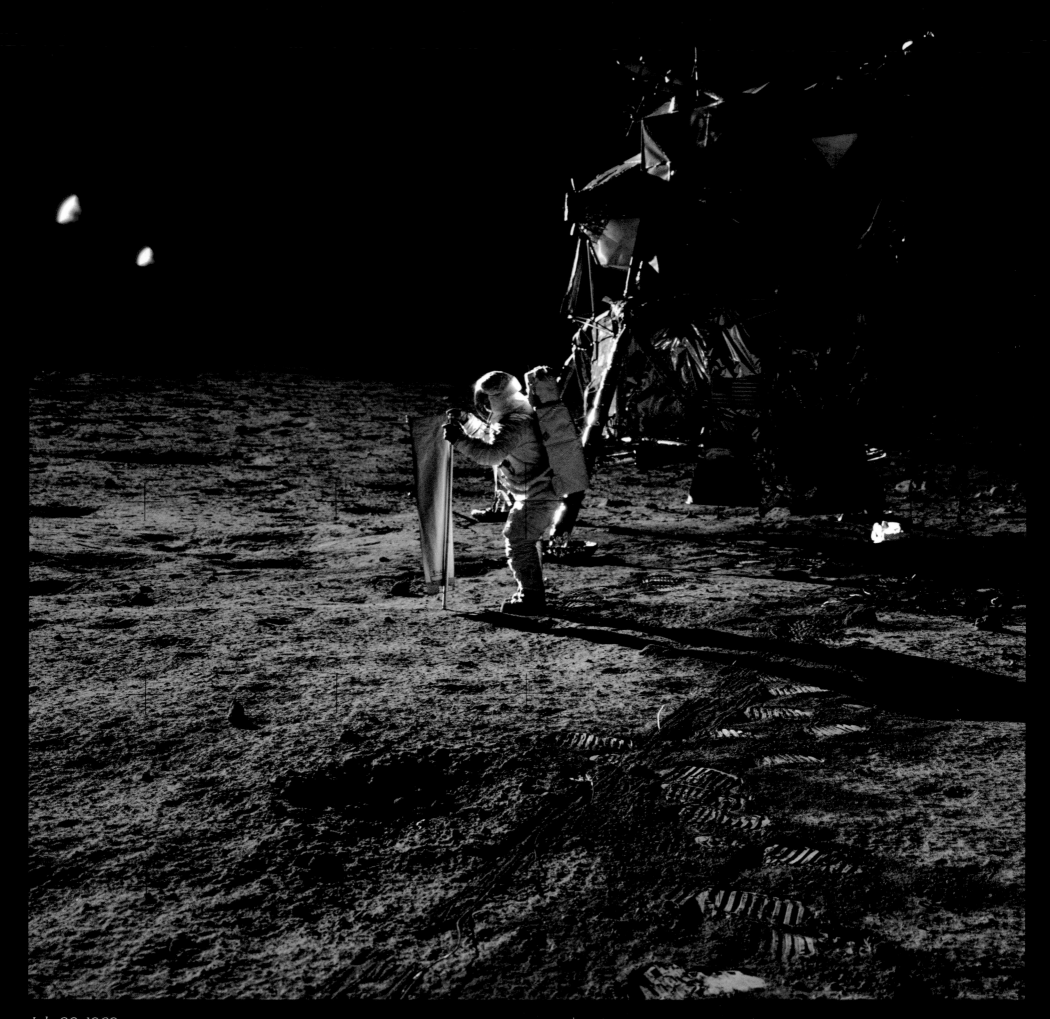

July 20, 1969

HASSELBLAD 70MM. LENS 60MM F/5.6 | BY NEIL ARMSTRONG

NASA ID: **AS11-40-5872**

Forty-five minutes after the start of the EVA, Aldrin sets up the solar wind experiment. Here, he's pointing the correct side at the Sun to collect ions from the solar wind. At the end of the mission it will be wrapped up and brought back for analysis. Note something unusual in the small crater in the foreground. Armstrong: "Something interesting in the bottom of this little crater here . . . It may be . . ." Armstrong didn't complete his sentence. *(EL: 3/5)*

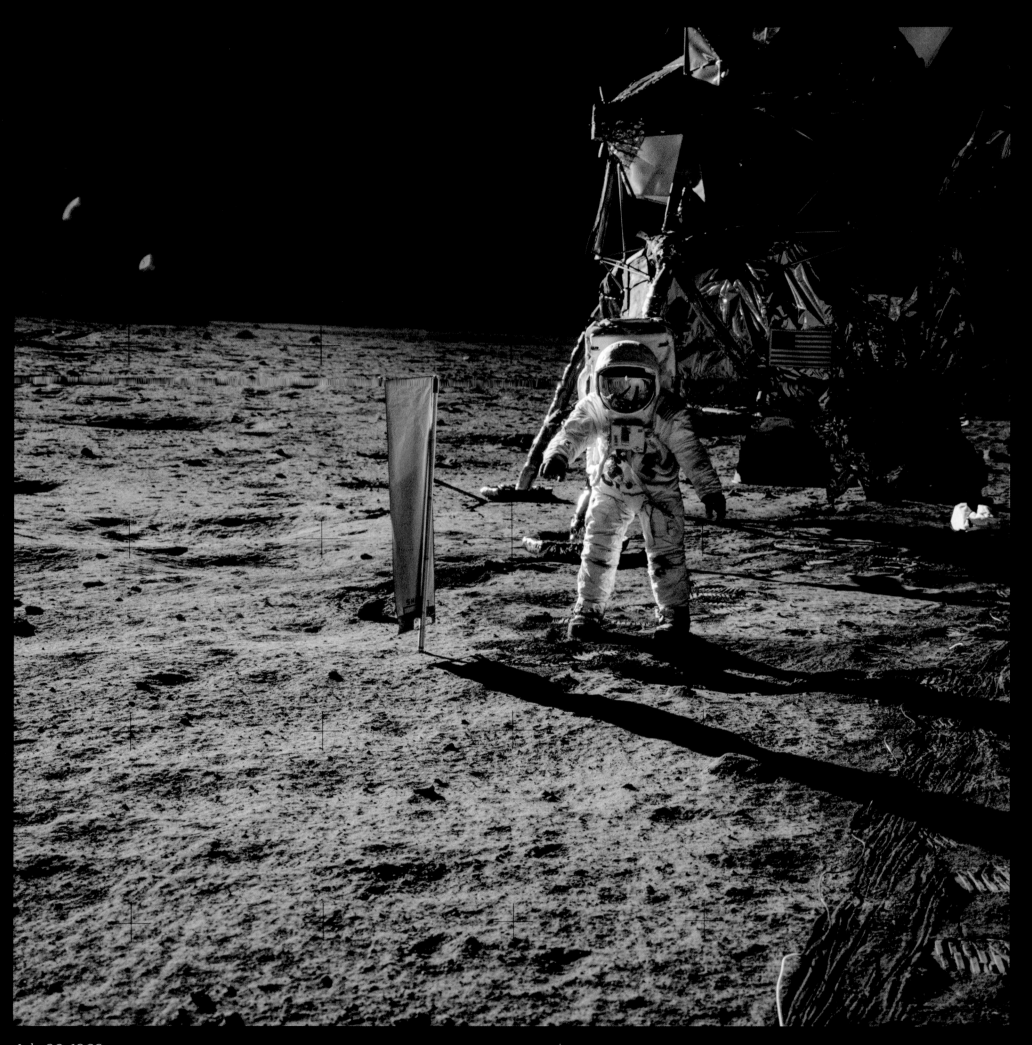

July 20, 1969 HASSELBLAD 70MM. LENS 60MM F/5.6 │ BY NEIL ARMSTRONG NASA ID: **AS11-40-5873**

Aldrin has set up the solar wind experiment: "Incidentally, you can use the shadow that the staff makes to assist you getting it perpendicular [to the Sun]." The lines in the lunar soil were caused by the TV cable as Armstrong dragged it out from its location in the MESA. When in the MESA, this camera beamed down to Earth the live fuzzy images of Armstrong's first steps. The MESA can be seen hanging down from the bottom of the LM, right of the U.S. flag. *(EL: 4/5)*

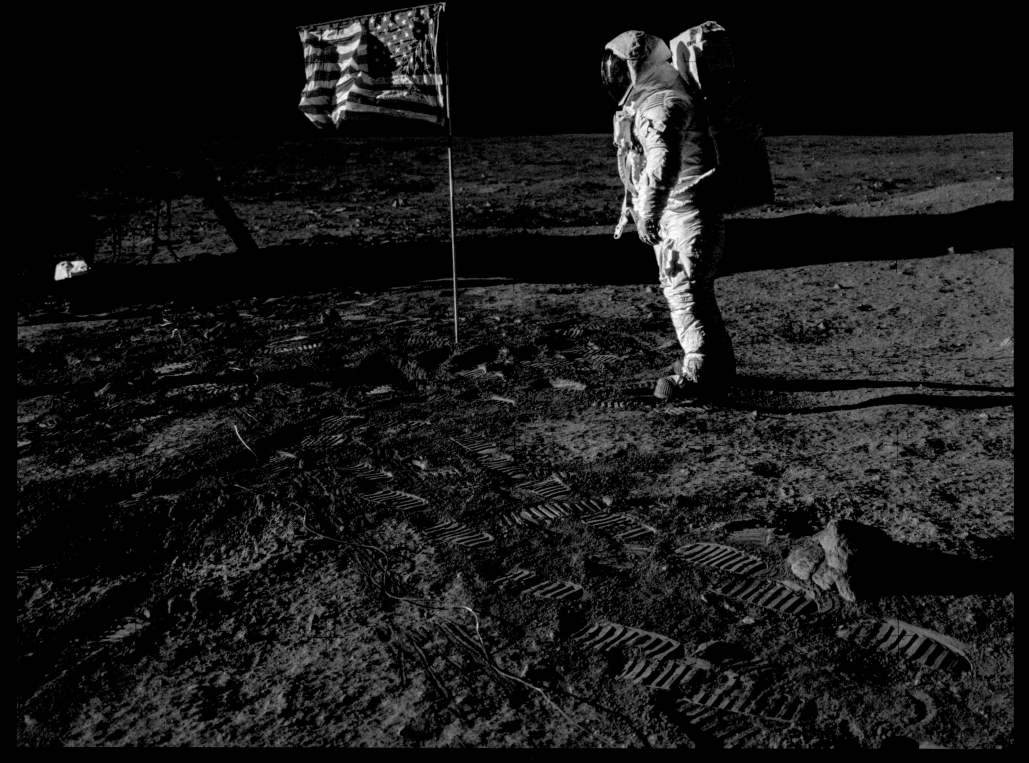

July 20, 1969 HASSELBLAD 70MM. LENS 60MM F/5.6 | BY NEIL ARMSTRONG NASA ID: **AS11-40-5875**

After a struggle to get the flag into the hard lunar regolith, Armstrong took this iconic photograph. Immediately after capturing Aldrin's salute, Aldrin turned to Armstrong, as if to check that it had been taken. A little light penetrates Aldrin's gold visor and his face is barely visible. Now enhanced, Aldrin is more clearly visible, revealing a hint of a smile through his visor. *(EL: 4/5)*

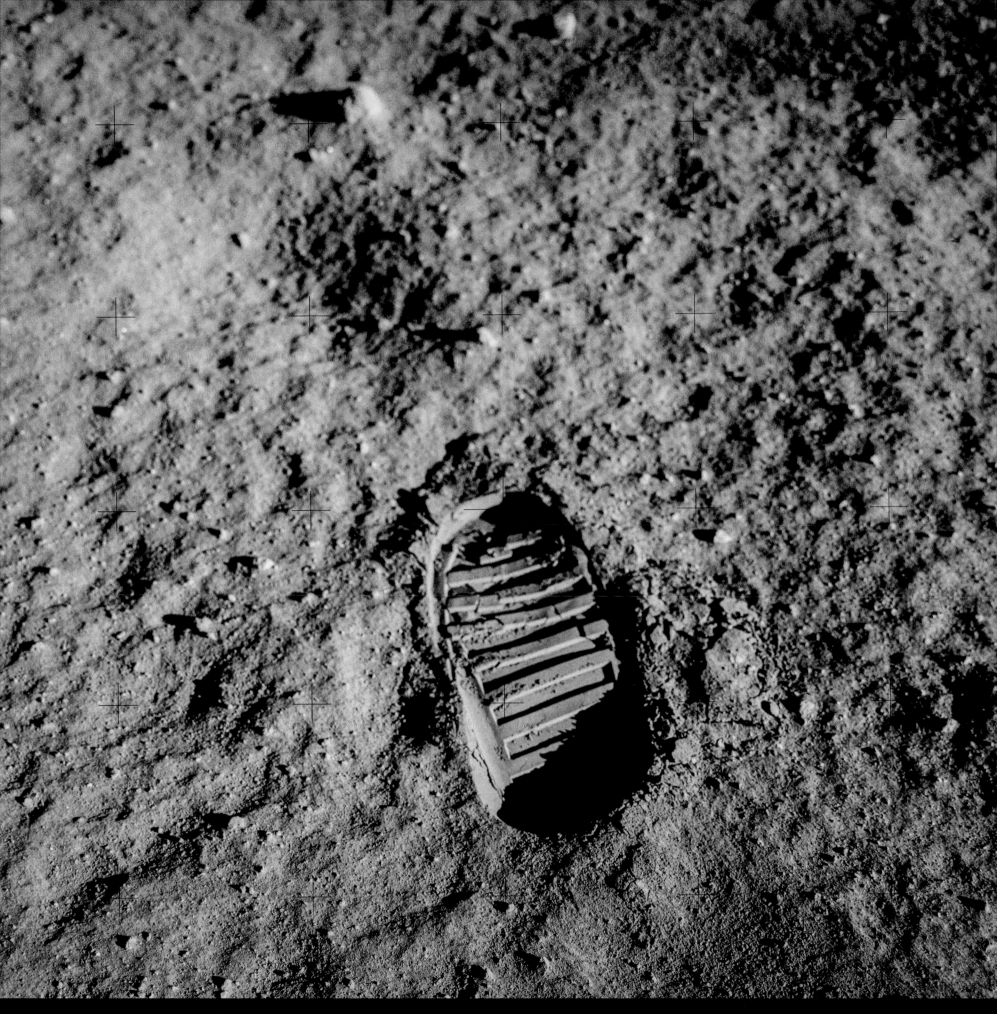

July 20, 1969 HASSELBLAD 70MM. LENS 60MM F/5.6 | BY BUZZ ALDRIN NASA ID: **AS11-40-5877**

Aldrin picks up the Hasselblad that Armstrong left on the MESA to undertake the "Pene-Photo Footprint" task on his cuff checklist (to assess lunar soil mechanics). The boots, measuring 13 inches x 6 inches, with a silicone sole are worn over the pressure suit. Often mistaken as Armstrong's first step, this iconic, poignant image of Buzz Aldrin's bootprint has come to represent the epitome of human exploration and our first steps on another world. *(EL: 2/5)*

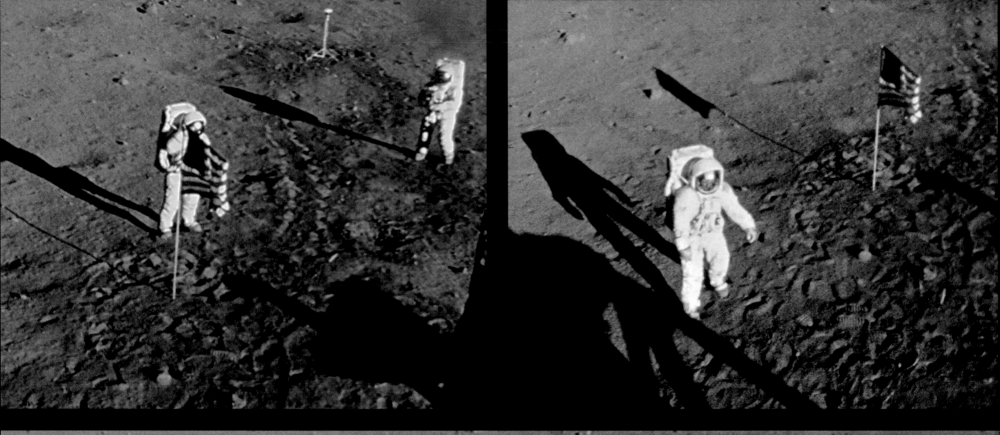

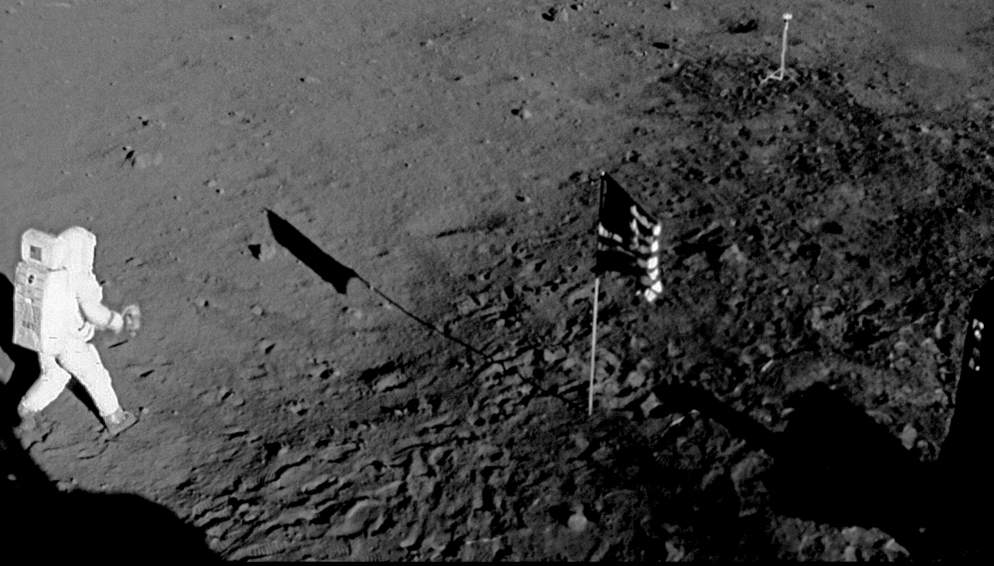

July 20, 1969 1–14 FRAMES OF 16MM FILM, STACKED AND PROCESSED NASA ID: **APOLLO 11 MAG 1082-K**

TOP LEFT: The precise moment Armstrong captures one of the most iconic photographs from Apollo – Aldrin saluting the American flag. Armstrong had difficulty pushing the flag more than 6 to 8 inches into the surface. It was eventually blown over during lift-off from the Moon. TOP RIGHT: A recognizable Buzz Aldrin, with his gold visor up as he undertakes mobility tests to better understand maneuverability in 1/6th gravity. BOTTOM: Aldrin takes another famous image of his boot and bootprint (see next page).

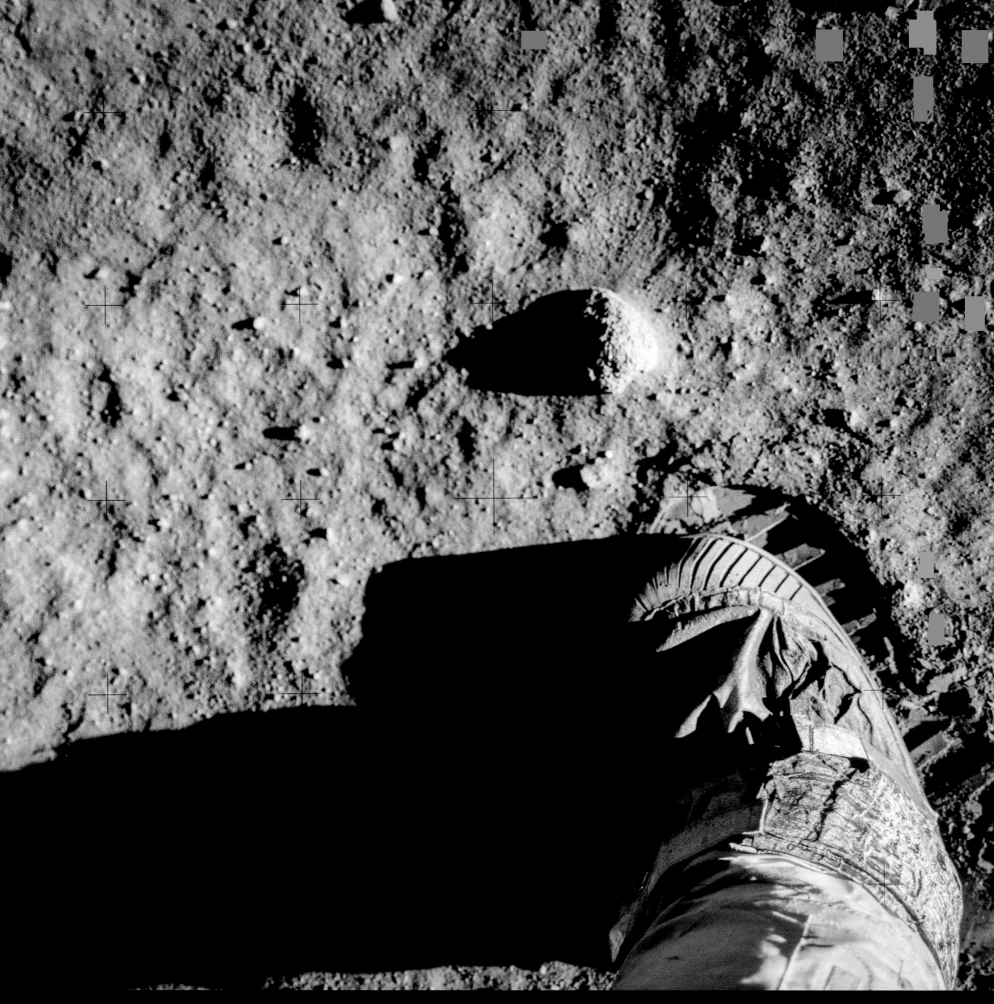

July 20, 1969 HASSELBLAD 70MM. LENS 60MM F/5.6 | BY BUZZ ALDRIN NASA ID: **AS11-40-5880**

Another famous bootprint photograph as part of the soil mechanics experiment a███ ███ws Aldrin's right foot. A separate analysis of the 16mm film (see previous page) confirms that in making this second print, Aldrin's heel disturbs the toe section of the previous, pristine bootprint (AS11-40-5877). However, both remain large█, ███isturbed for the rest of the mission and as such, due to a lack of atmospheric erosion (and only very slow micrometeorite erosion), they will remain for millions of years. *(EL: 2/5)*

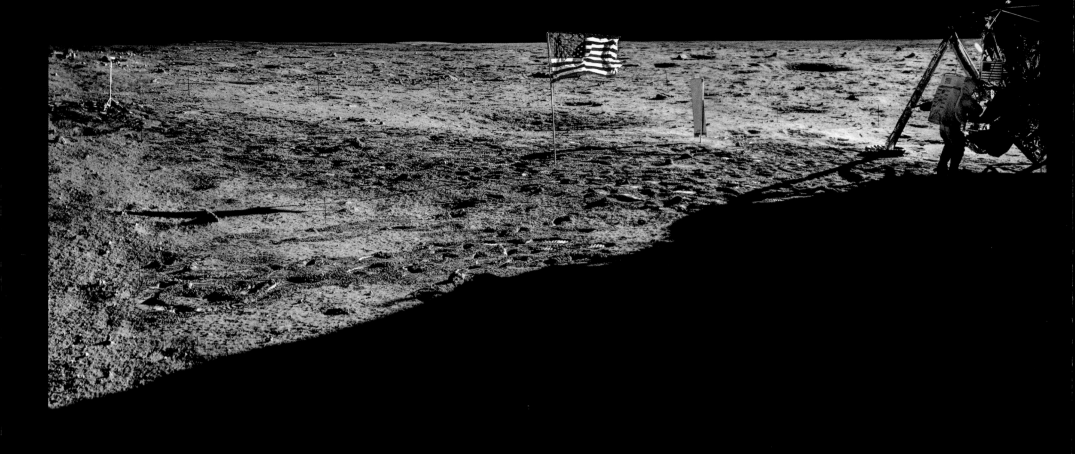

July 20, 1969 HASSELBLAD 70MM. LENS 60MM F/5.6 | BY BUZZ ALDRIN NASA ID: **AS11-40-5884 TO 5886**

Aldrin: "[The] panorama I'll be taking is about 30 to 40 feet out." Still with the camera, Aldrin took this planned panorama approximately 40 feet from the LM. It captures the back of Armstrong at the MESA. Until 1987, NASA did not believe there were any still photographs of the first man on the Moon, despite Armstrong himself suspecting that this single image did include him. The red lettering of Armstrong's PLSS name tag (Aldrin's is in black) can be seen in the full versions of this enhanced image. *(Panorama, EL: 4/5)*

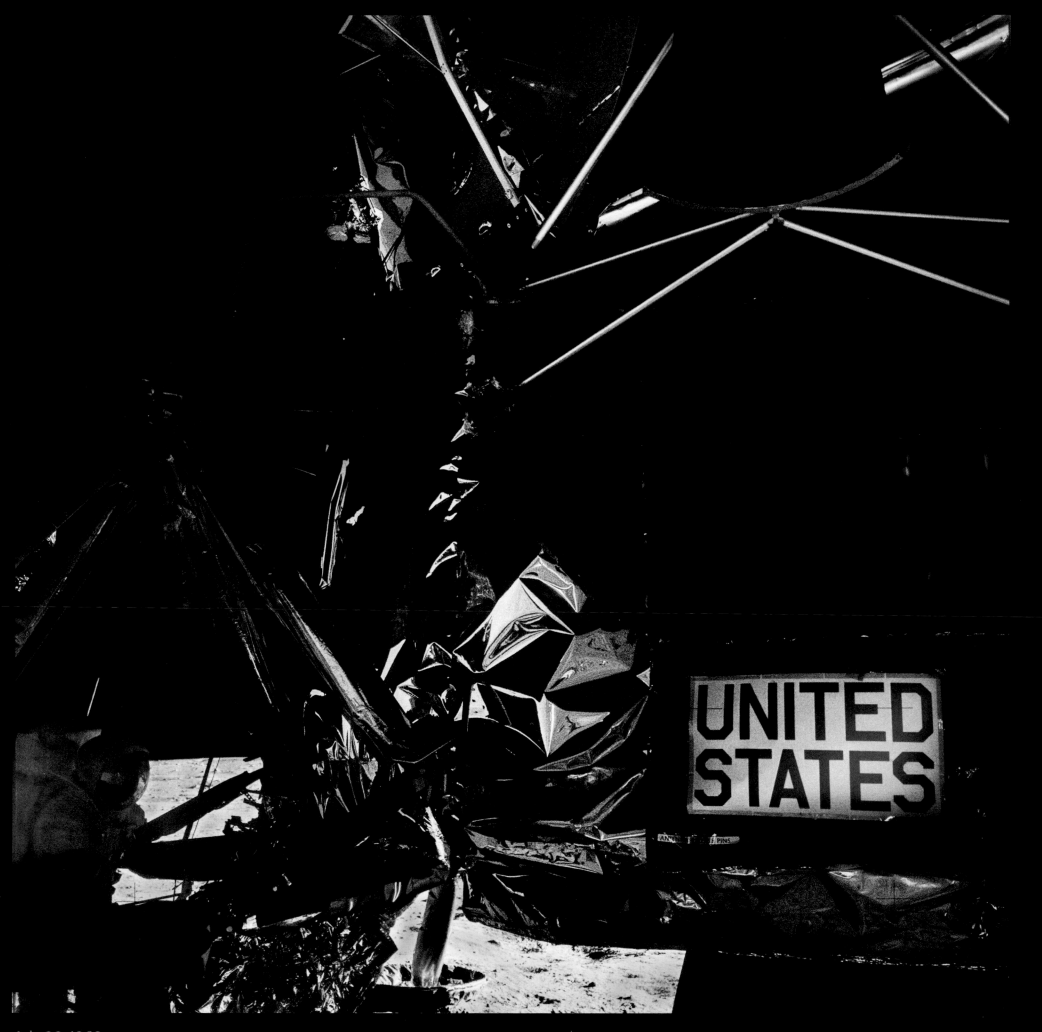

July 20, 1969

HASSELBLAD 70MM. LENS 60MM F/5.6 | BY BUZZ ALDRIN

NASA ID: **AS11-40-5894**

"Out of the shadows of *Eagle.*" A challenge from science journalist Paolo Attivissimo in 2019 led me to work on recovering this hugely underexposed image. It now clearly reveals Armstrong at the MESA, in the shadow of the LM. The ladder, porch and hatch of *Eagle* can also be seen. This shot is the only frontal still photograph of Neil Armstrong on the Moon. (5/5)

UNITED STATES

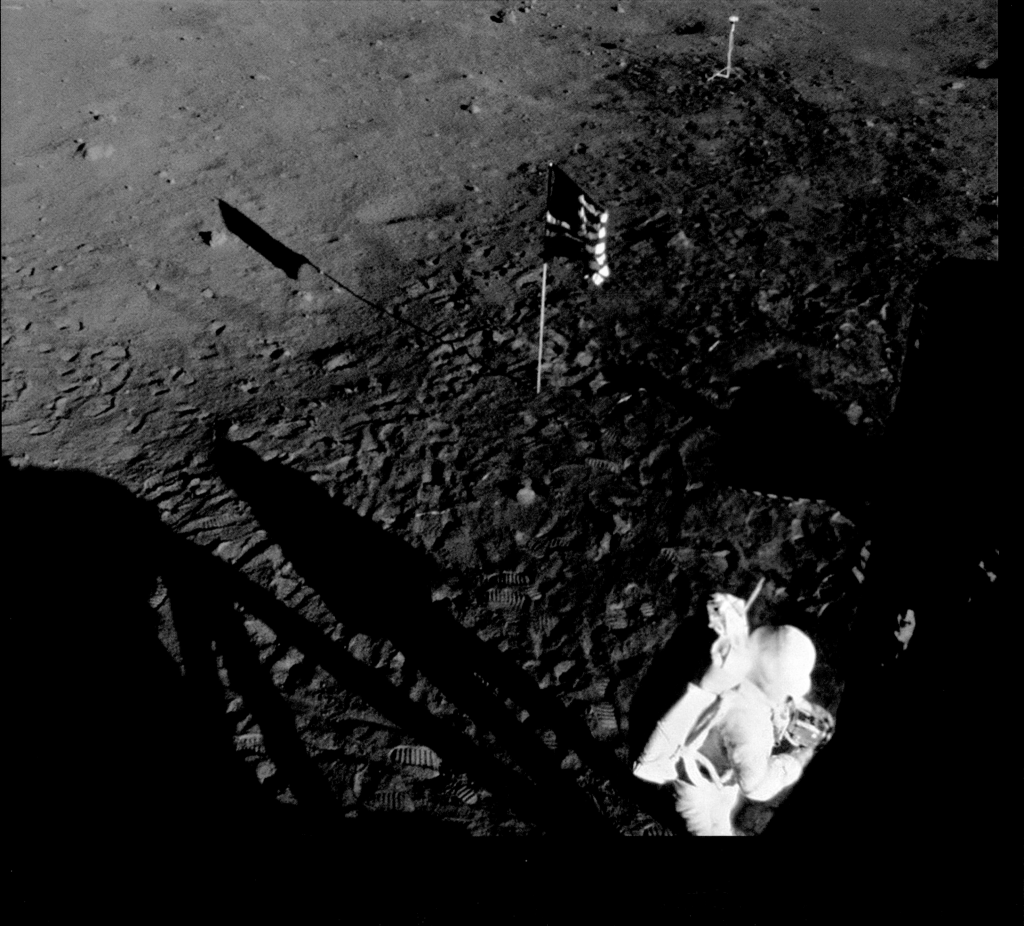

14 FRAMES OF 16MM FILM, STACKED AND PROCESSED

NASA ID: **APOLLO 11 MAG 1082-K**

The precise moment Neil Armstrong takes Buzz Aldrin's portrait in what would become the most reproduced image from Apollo 11, and one of the most famous photographs ever taken, "A Man on the Moon" (see opposite).

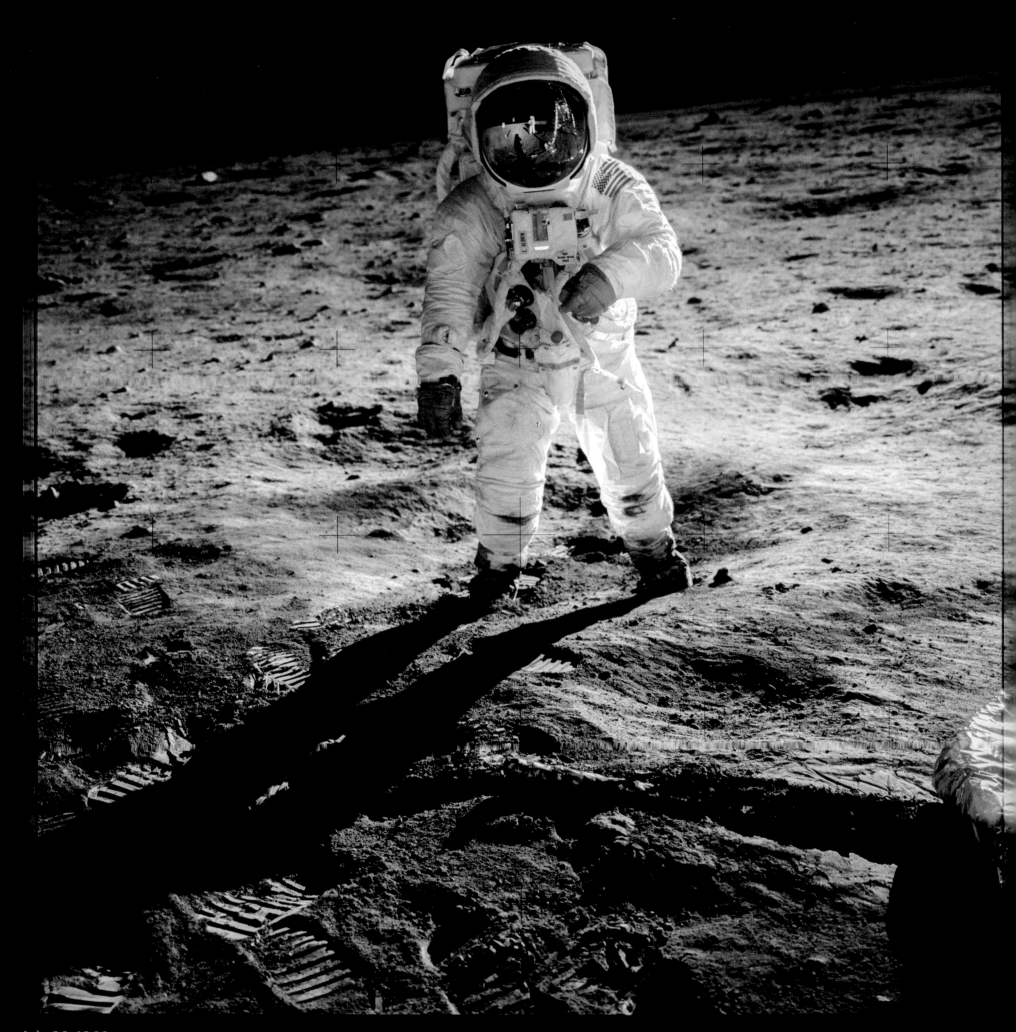

July 20, 1969

HASSELBLAD 70MM. LENS 60MM F/5.6 | BY NEIL ARMSTRONG

NASA ID: AS11-40-5903

"A Man on the Moon." The most reproduced Apollo 11 image and one of the most famous photographs ever taken. Most reproductions of this image have the color pulled out, due to the misconception that the Moon must be perfectly gray and the spacesuit white. In fact, Aldrin is predominantly illuminated by reflected light – much of it from the gold-colored Kapton on the LM Armstrong can also be seen reflected in Aldrin's visor, and the dot in the sky above Armstrong is, almost certainly, Earth. Perfection. *(EL: 3/5)*

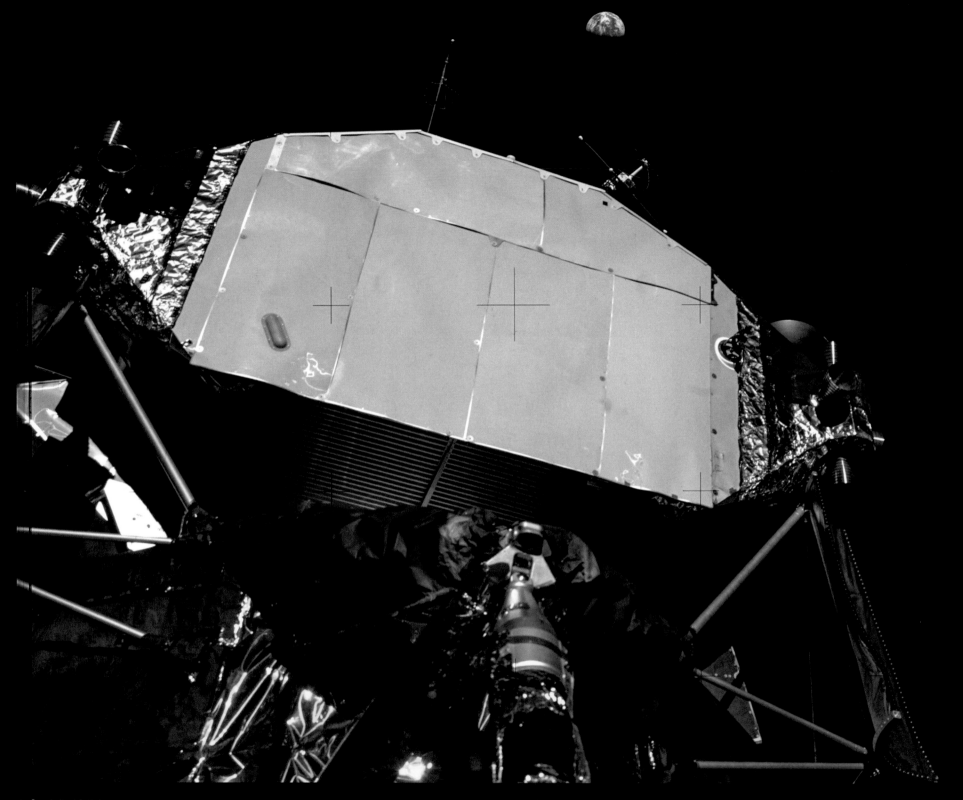

July 20, 1969

HASSELBLAD 70MM. LENS 60MM F/5.6 | PROBABLY BY BUZZ ALDRIN

NASA ID: AS11-40-5924

Earth as seen from the surface of the Moon. Note that the S-Band antenna dish (above the RCS thrusters, right) is pointing home as it transmits the first live TV pictures to ground tracking stations. Australia, the location of the Honeysuckle Creek and Parkes receiving stations, is the illuminated landmass upper left. The steerable antenna could also be used to communicate with the Command Module. *(EL: 2/5)*

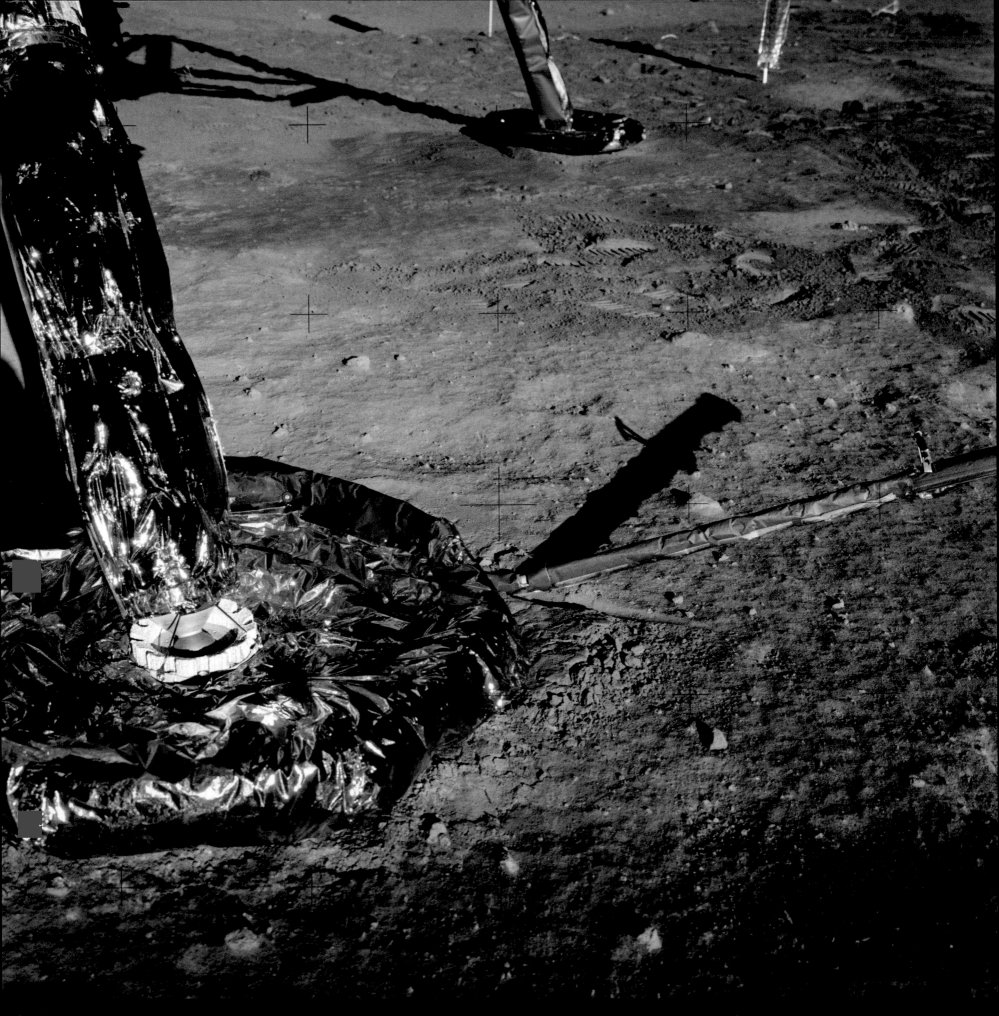

July 20, 1969　　　　HASSELBLAD 70MM. LENS 60MM F/5.6 | BY BUZZ ALDRIN　　　　NASA ID: AS11-40-5925

The crew noted that the footpads only sank two or three inches into the lunar surface upon landing. The minus-Z (east) footpad, with bent contact probe, is photographed with the north footpad in the background. The south footpad's contact probe had bent into a near upright angle (see AS11-40-5850), vindicating Armstrong's request to remove the probe on the ladder leg. Note the different material facing the engine nozzle to protect against heating. Aldrin: "And, Neil, if you'll take the camera . . ." *(EL: 3/5)*

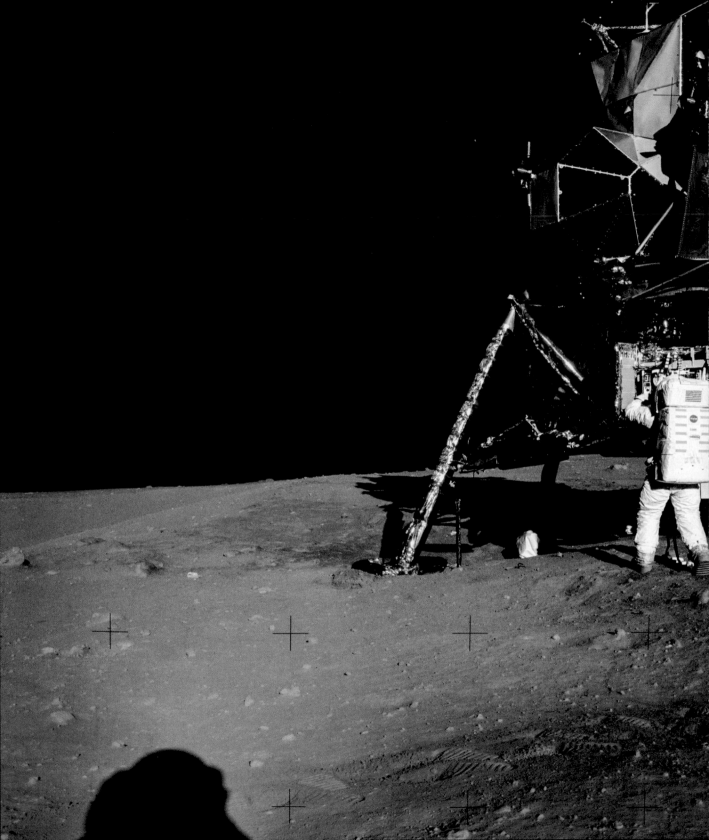

July 20, 1969

HASSELBLAD 70MM. LENS 60MM F/5.6 | BY NEIL ARMSTRONG

NASA ID: **AS11-40-5927 TO 5729**

Aldrin: "All right. The doors are open, and it looks like they are going to stay up without any problem." Aldrin unloads the EASEP (Early Apollo Scientific Experiments Package) from the side of the LM. The tape seen hanging down is used, via a pulley, to open the access d▮▮▮ Armstrong: "And the panorama is complete. I'm at a▮▮▮ ▮he LM 7:30 position at about 60 feet." *(Panorama, 3/5)*

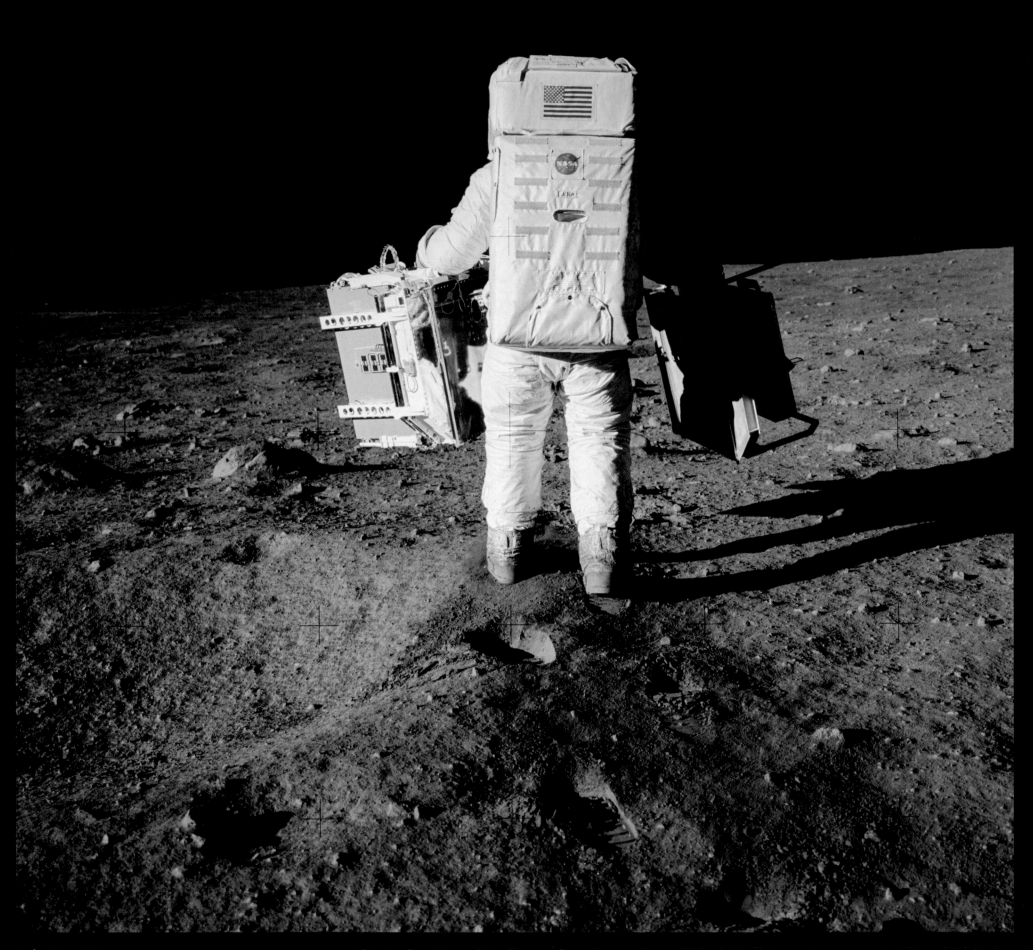

July 20, 1969 HASSELBLAD 70MM. LENS 60MM F/5.6 | BY NEIL ARMSTRONG NASA ID: **AS11-40-5942**

Aldrin: "Watch it. The edge of that crater is really soft." Armstrong: "The top of that next little ridge there. Wouldn't that be a pretty good place?" Aldrin carries the EASEP, looking for a level area south of the LM to set it down. In his left hand is a seismometer and in his right, a laser ranging retroreflector to measure the precise distance from Earth to the Moon. *(EL: 2/5)*

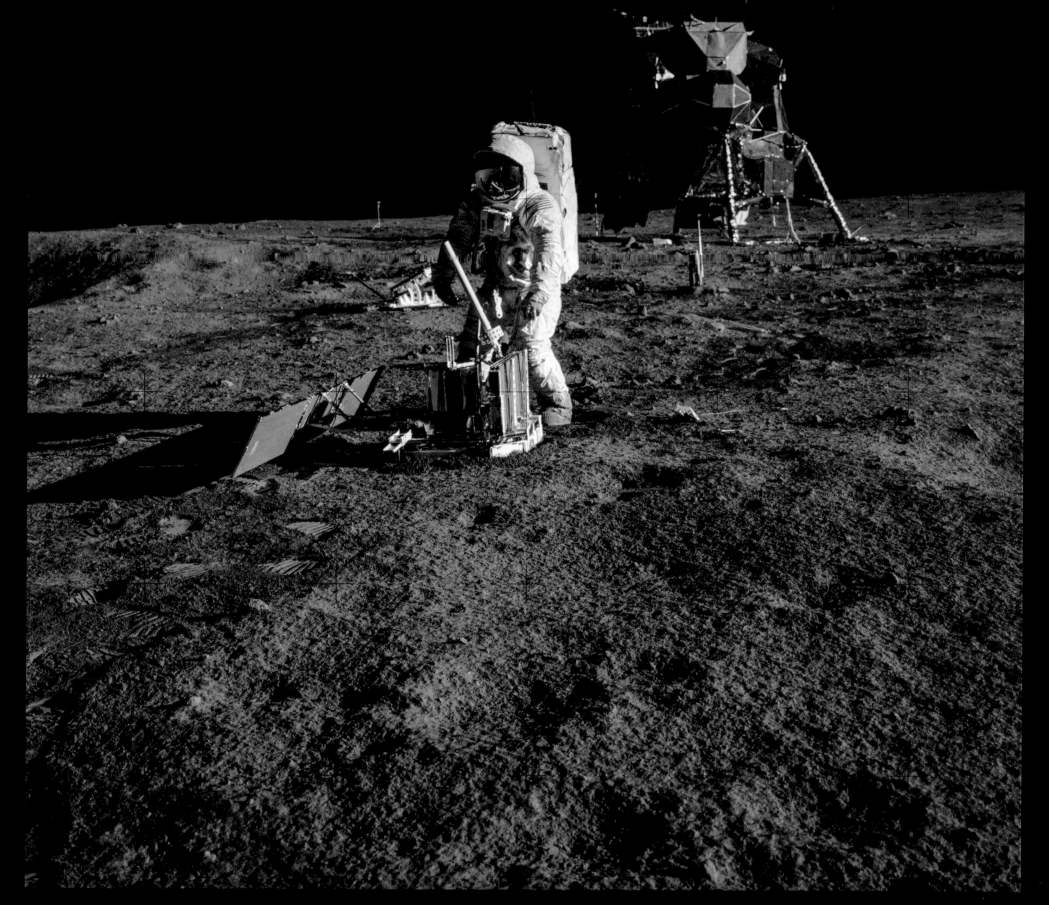

July 20, 1969 HASSELBLAD 70MM. LENS 60MM F/5.6 | BY NEIL ARMSTRONG NASA ID: **AS11-40-5947**

Aldrin sets up the seismometer; one of its solar arrays is already deployed. Behind his right hand is the laser retroreflector and beyond that, on the horizon, is the TV camera. Between Aldrin and the LM, standing upright, is the "Gold" camera. Considered a late, unwelcome intruder by the crew, the "Gold" camera was used to take close-up stereoscopic photographs of the lunar surface. *(EL: 4/5)*

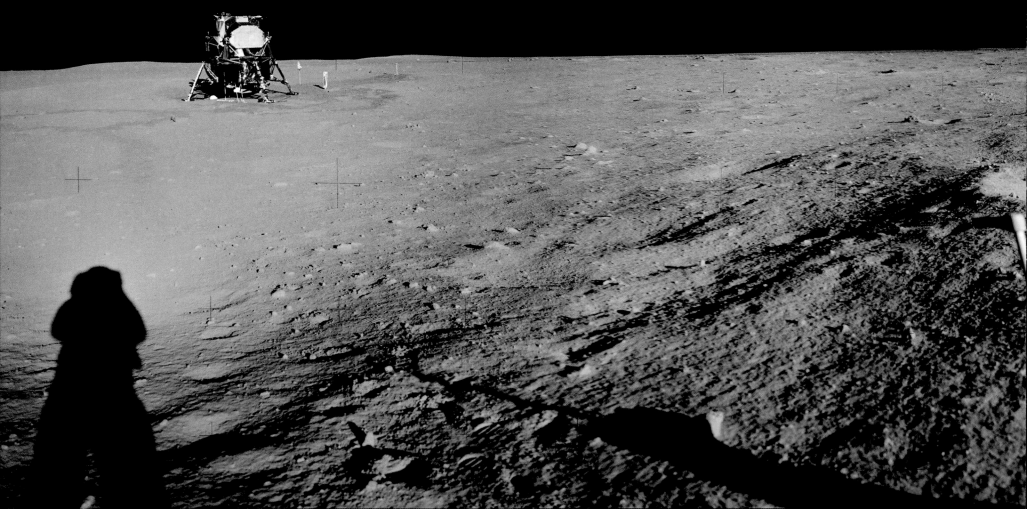

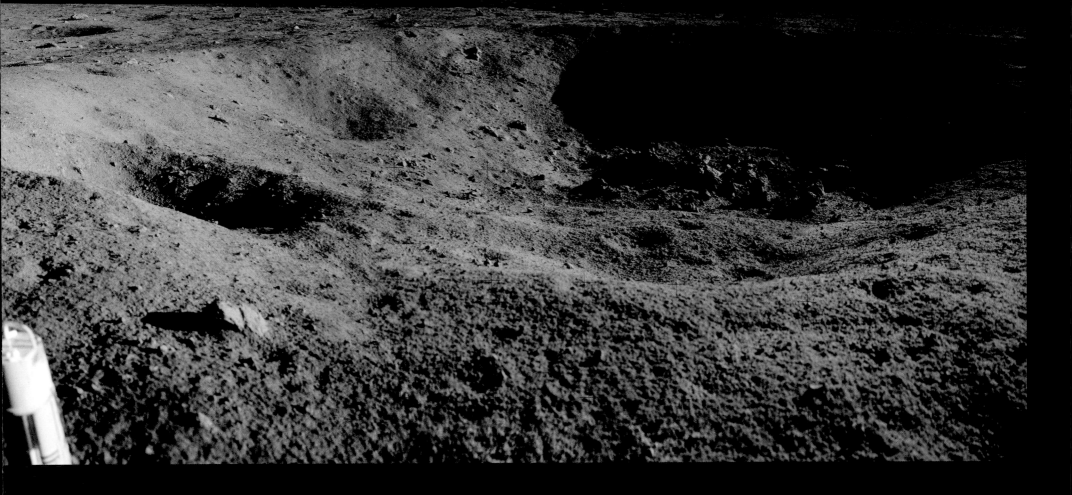

July 20, 1969 HASSELBLAD 70MM. LENS 60MM F/5.6 | BY NEIL ARMSTRONG NASA ID: **AS11-40-5955 TO 5961**

With Aldrin back at the MESA and only 10 minutes remaining before preparations for ending the EVA, Armstrong made an unplanned diversion to Little West crater. He "ran" the 200 feet (the furthest either crewmember ventured from the LM) and captured this panoramic sequence. It has been claimed he later referred to this as "Muffie's crater," after Karen, the daughter he tragically lost at two years of age. *(Panorama, EL: 4/5)*

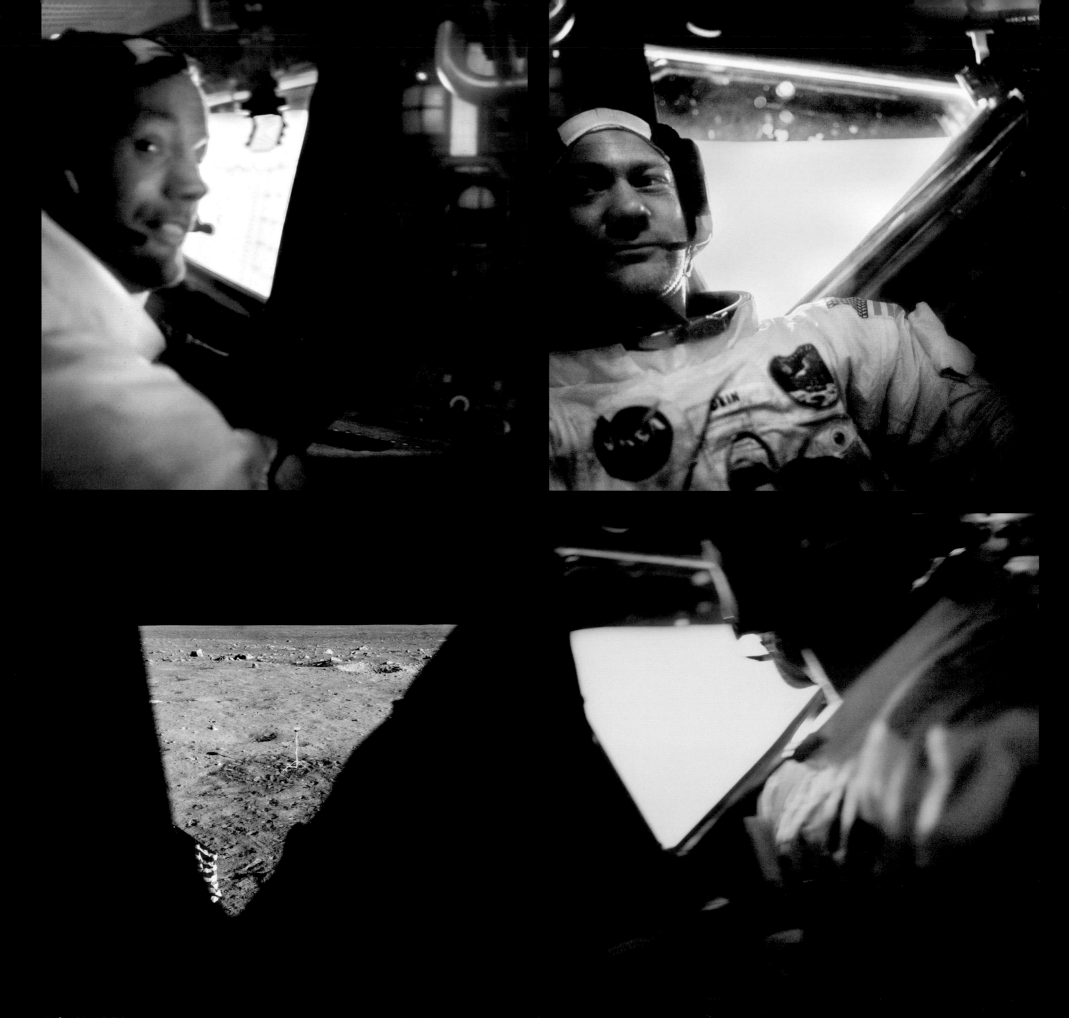

July 21, 1969　　　　　HASSELBLAD 70MM. LENS 80MM F/5.6 │ BY NEIL ARMSTRONG AND BUZZ ALDRIN　　　　　NASA ID: **AS11-37-5529, 5534, 5520, 5532**

Aldrin: "Okay, the hatch is closed and latched, and verified secured." The historic EVA, lasting 2 hours 31 minutes, was completed at 05:11GMT on 21st July. After cabin re-pressurization, the crew ate, and used up the remaining film in the cameras. Aldrin: "We've probably got another half an hour's worth of picture taking." Of the 147 photographs taken during this time in the LM, only seven were of each other. *(EL: 5/5)*

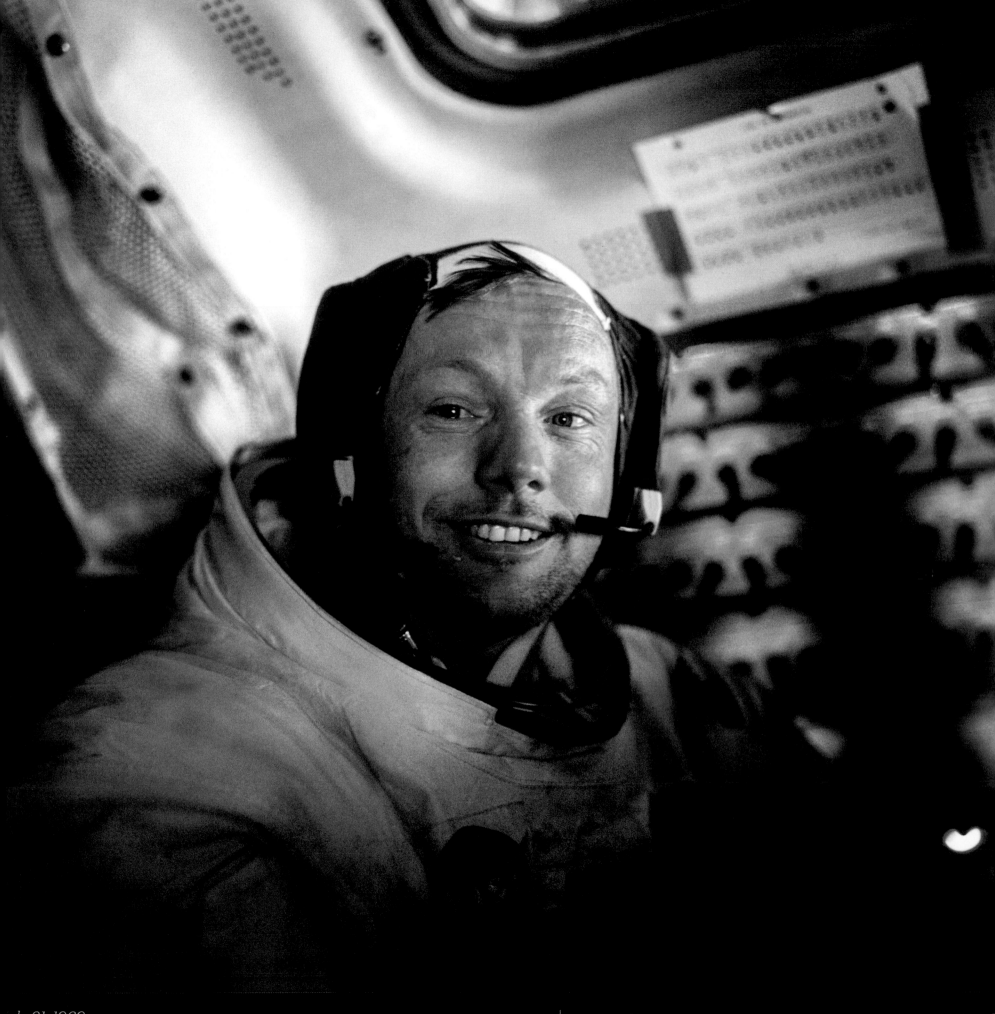

July 21, 1969 HASSELBLAD 70MM. LENS 80MM F/2.8 | BY BUZZ ALDRIN NASA ID: AS11-37-5528

One of the finest portraits of the Apollo program. Buzz Aldrin captures a tired but elated Neil Armstrong, after returning to the relative safety of the Lunar Module *Eagle* from their historic moonwalk. Dry air, pressure changes, Moon-dust irritation and sheer exhaustion are thought to have contributed to Armstrong's red, teary eyes. (FL: 4/5)

he crew depressurized the cabin once more and jettisoned unneeded hardware to save weight and space. The vibrations were picked up by the seismometer and relayed to Earth. Armstrong

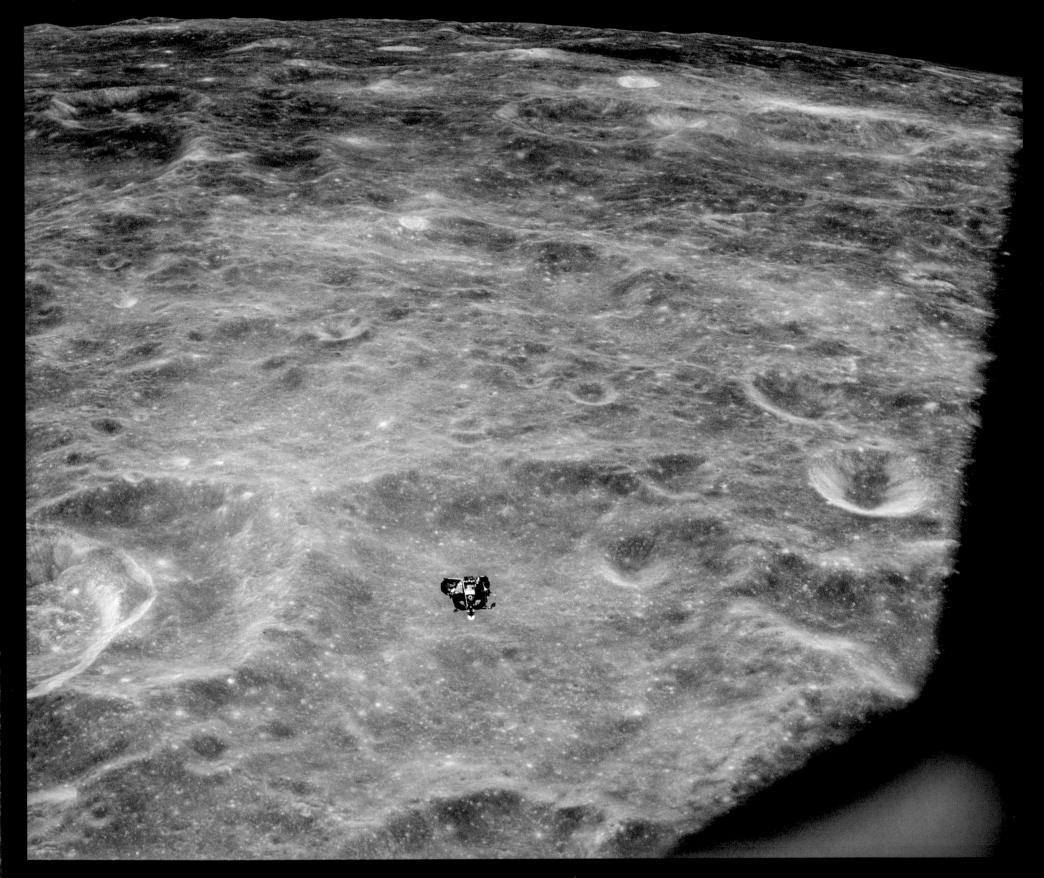

July 21, 1969

HASSELBLAD 70MM. LENS 80MM F/2.8 | BY MICHAEL COLLINS

NASA ID: AS11-44-6621

Aldrin: "It's been a long day, see you again tomorrow." The crew had been awake for 21 hours, but got little sleep during their seven-hour rest period in the LM. Aldrin slept on the floor, Armstrong on the ascent engine cover with a waist tether he'd hooked up to suspend his legs, both still in their suits and helmets. After fixing a broken Engine Arm switch, *Eagle* lifted off from Tranquility Base to rendezvous with Collins in the orbiting CSM. *(EL: 2/5)*

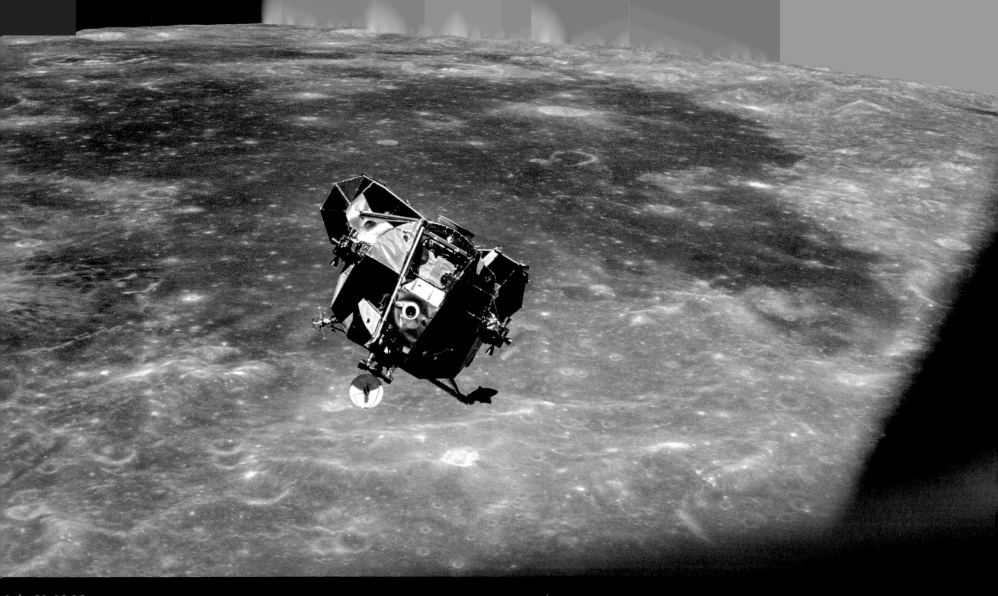

July 21, 1969

HASSELBLAD 70MM. LENS 80MM. F/2.8 | BY MICHAEL COLLINS

NASA ID: AS11-44-6642

Having listened in to events on the lunar surface, Collins patiently piloted *Columbia* for 14 ▮▮▮ orbits ▮▮ ot the Earth coming up . . . It's fantastic!" Collins scrambled for his camera and too his picture – a picture that tel▮ ▮ housand ▮▮ rs. He is the only person alive, or has ever ▮▮▮▮ who is ▮▮ within the frame of this photograph. *(Rotated. FL: 3/5)*

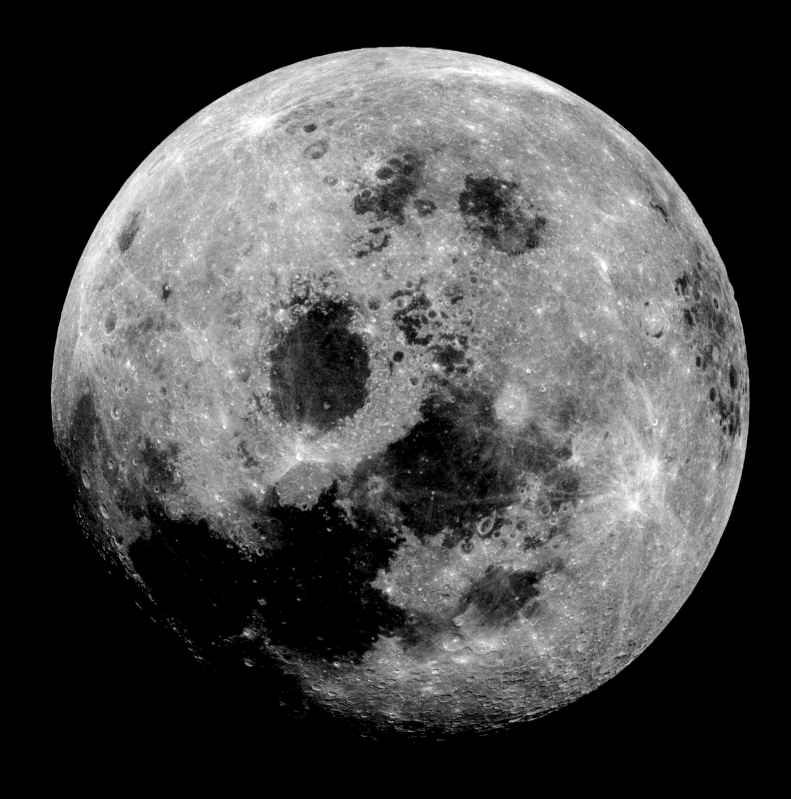

July 21, 1969

HASSELBLAD 70MM. LENS 80MM F/2.8 | BY UNKNOWN

NASA ID: **AS11-44-6667**

Houston read up the numbers required for the essential TEI burn. Collins read them back diligently to ensure no mistakes. He would later confirm (to CAPCOM Duke): "Hey, Charlie boy, looking good here. That was a beautiful burn. They don't come any finer!" CSM *Columbia's* SPS engine burned for two and a half minutes on the farside of the Moon to put Apollo 11 on a course for home. The crew were treated to this view of a near-full Moon, receding in the windows as Earth, their home, grew larger. *(Cropped, EL: 3/5)*

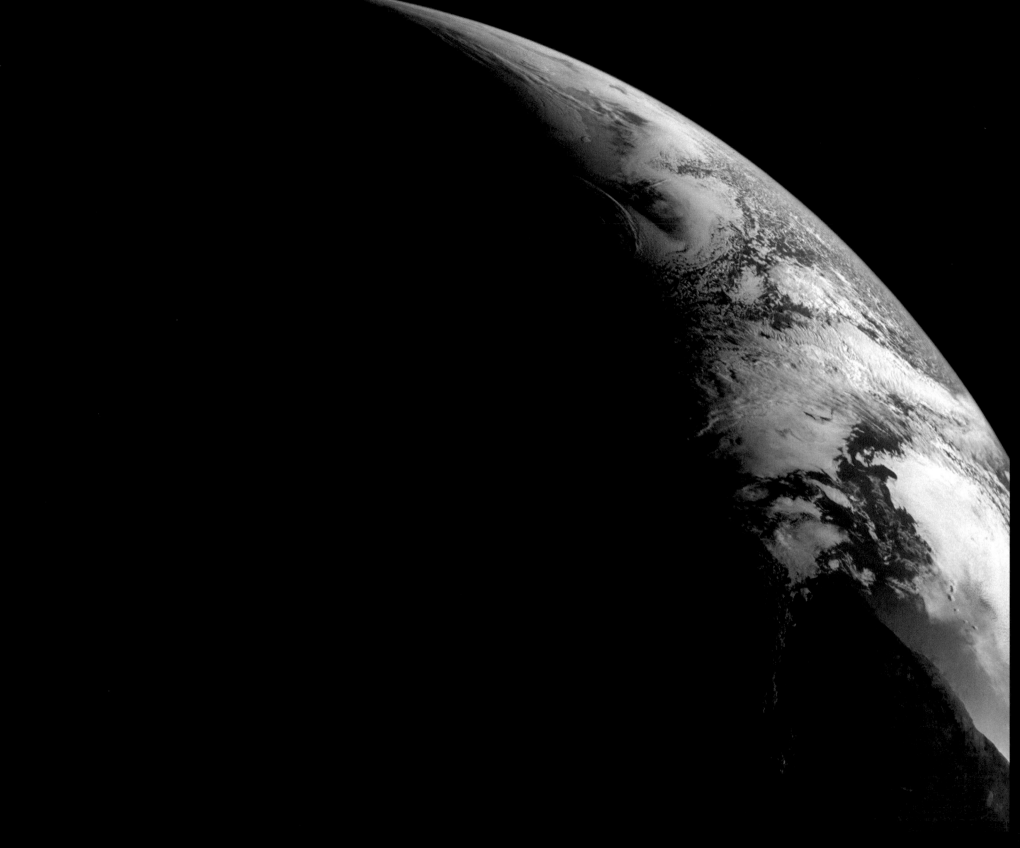

July 24th, 1969 HASSELBLAD 70MM. LENS 80MM F/2.8 | BY MICHAEL COLLINS NASA ID: AS11-44-6693

Collins: "The Earth is really getting bigger up here . . ." The crew made final preparations for re-entry as the welcome sight of home grew large in the windows. Aldrin: "We've just been taking a couple of last-minute pictures." Armstrong's last transmission was simply; "See you later," then *Columbia* smashed into the atmosphere at 24,678mph in a fireball, with temperatures reaching 5,000 degrees Fahrenheit. A safe splashdown marked the completion of Kennedy's goal, and the pinnacle of human achievement. *(Cropped, EL: 3/5)*

THE DETAILS

ROCKET	LAUNCH	DURATION	SPLASHDOWN
Saturn V (AS-507)	16:22 GMT, November 14, 1969, Pad 39A	10 days, 4 hours, 36 minutes, 25 seconds	20:58 GMT, November 24, 1969, Pacific Ocean
COMMAND AND SERVICE MODULE *Yankee Clipper* (CSM-108)	LANDING SITE Ocean of Storms	SURFACE TIME 31 hours, 31 minutes	RECOVERY SHIP USS *Hornet*
LUNAR MODULE *Intrepid* (LM-6)	DISTANCE 952,354 miles	LUNAR ORBITS 45	

THE CREW

Charles "Pete' Conrad Jr.
COMMANDER (CDR)

Born June 2, 1930. An Ivy League graduate, fighter pilot and test pilot, Conrad's first spaceflight was on Gemini V, which broke the world record for duration. He was then Command Pilot on Gemini XI (also with crewmate Gordon), setting the Earth orbit altitude record, which stands to this day. After becoming the world's third Moonwalker he went on to Command Skylab 2, retiring in 1973.

Richard F. Gordon Jr.
COMMAND MODULE PILOT (CMP)

Born October 5, 1929. Naval officer and test pilot Gordon joined NASA in October 1963 as part of the third intake of astronauts. His first spaceflight was also with Conrad, on the record-breaking Gemini XI mission. As back-up on Apollo 15, crew rotation would have made him Commander of Apollo 18, but the mission was canceled due to budget cuts.

Alan L. Bean
LUNAR MODULE PILOT (LMP)

Born March 15, 1932. Bean joined NASA as part of the third intake of astronauts, along with crewmate Gordon. Apollo 12 would be Bean's first spaceflight. The fourth man on the Moon would later serve as Commander on Skylab 3. Upon leaving NASA in 1981, Bean would focus on painting many of the scenes he'd witnessed first-hand on his missions.

November 14–24, 1969

APOLLO 12

THE MISSION

Only four months after the first manned lunar landing, Apollo 12 was ready at the Cape. Following Apollo 11's issues in over-shooting the landing site, a key objective was to demonstrate the techniques for a precision landing at a site some 950 miles west of Tranquility Base. The crew would also deploy the first full Apollo Lunar Surface Experiments Package (ALSEP), develop the capability for extended work in the lunar environment, and photograph candidate exploration sites. The pinpoint landing would be demonstrated by visiting Surveyor 3, a robotic spacecraft which had landed on the slope of a crater in April, 1967. The crew planned to return parts of the spacecraft for analysis.

Despite a cold front bringing rain and stratocumulus clouds over the launch area, Apollo 12 lifted off from Pad 39A on schedule. After only 36 seconds, however, Gordon exclaimed: "What the hell was that!?" Conrad: "Where are we going? . . . I don't know what happened here; we had everything in the world drop out!" The Saturn V had been struck by lightning, twice, knocking out the CSM's three fuel cells, triggering countless warning lights and the master alarm. Mission Control could only receive garbled telemetry and then the CSM's guidance system completely lost its position in "space." Under immense pressure, Mission Control's technical suggestion, "Try SCE to AUX," was welcomed by Conrad with, "What the hell is that!?" Bean found the switch and restored the platform and telemetry.

The hope was that the landing would be less eventful. On approach to the landing site, there was exuberance from the crew as they were "right down the middle of the road." Despite kicked-up dust obscuring the view of the surface and horizon, all of Conrad's hours in the simulator paid off as he used his 8-ball (attitude indicator) to land safely, just 600 feet from Surveyor.

The world would not have the opportunity to watch events on the surface unfold as the TV camera was permanently damaged when Bean inadvertently pointed it at the Sun during set-up. A largely successful deployment of the first ALSEP was completed during the first EVA, which was 60 percent longer than Armstrong and Aldrin's.

After eating, recharging backpacks and a five-hour rest period, Conrad and Bean started their second EVA. They would make their way into the adjacent crater for a close inspection of Surveyor. The spacecraft had turned from white to a tan color during its two and a half years in the lunar environment. It was later determined from samples returned that this was caused by being "sandblasted" with lunar dust, kicked up from the engines as it landed, and accentuated by a further fine layer of Moon dust swept up as LM *Intrepid*'s descent engine lowered the human visitors to the surface.

After a successful splashdown, Apollo 12 had developed the techniques for extended, multiple EVAs and for pinpoint landings, paving the way for future Apollo missions to more ambitious, scientifically valuable locations.

THE PHOTOGRAPHY

After NASA's public affairs considerations led to the selection of color film for the first lunar landing, Apollo 12 would introduce black and white film into the mix for surface use. This was deemed by a more engineering-minded audience to have its advantages over color.

The loss of the TV camera early in the first EVA unfortunately set the tone for many photographic difficulties and missed opportunities. Conrad had sneaked an auto-timer he'd bought in a local camera store into his flight suit pocket at launch. The plan was to secretly take a portrait of Bean and himself, together with Surveyor, but the timer was lost among the rock samples in the HTC (Hand Tool Carrier) bag at the crucial moment.

Both Hasselblad trigger/handle assemblies came loose, leading to misfires on Conrad's and rendering Bean's inoperable. The ensuing confusion in switching magazines ultimately led to a color magazine, complete with exposed photographs, being left on the Moon. A magazine containing shots taken with the 500mm camera fell apart during use on the return journey and, to add "injury to insult," Bean was briefly knocked unconscious by a falling 16mm camera at splashdown.

Perhaps it was the close friendship of the crew that led to significantly more posed shots than on other missions, and one of the finest portraits from the program. The crew were treated to an extraordinary event closer to home during the return journey, when they witnessed a solar eclipse. A solar eclipse from space is special enough, but it was Earth, rather than the Moon that eclipsed the Sun. They berated their lack of a color magazine for the Hasselblad, but a stacked, processed image produced from the color 16mm film is presented at the end of this chapter.

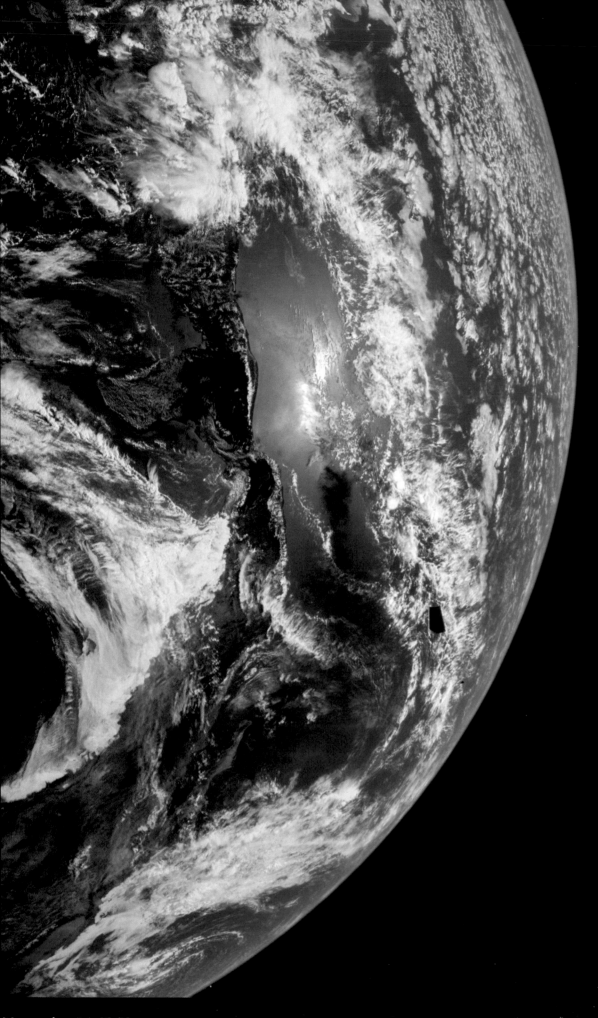

November 14, 1969 HASSELBLAD 70MM. LENS 80MM F/2.8 | BY UNKNOWN NASA ID: **AS12-50-7326**

After the lightning strike at launch, TLI thankfully went perfectly. At 3,800 miles altitude, the CSM separated from the S-IVB and the SLA panels jettisoned; one is seen here against Earth. Bean: "There's a lot of stuff floating up out of the S-IVB . . . Ice or white paint chips . . . Look at the Earth; isn't that sharp!?" Gordon: "We can see the whole United States, Houston." Conrad: "I got an awful pretty-looking *Intrepid* sitting out the window here, gang. We'll go get her." *(EL: 1/5)*

November 16, 1969 HASSELBLAD 70MM. LENS 80MM F/2.8 | BY UNKNOWN NASA ID: **AS12-50-7369**

Ice formed on the windows early in the flight and, even after evaporation/sublimation, would affect visibility and photography. Conrad: "We have a fine deposit of water droplets; whatever was in the water has adhered to the window and that's all in streaks . . . Some of this may have come when the tower was jettisoned; we're not sure . . . [We'll] try and photograph this as best we can for you to see." Each crewmember had a personalized baseball cap – see upper left. *(EL: 4/5)*

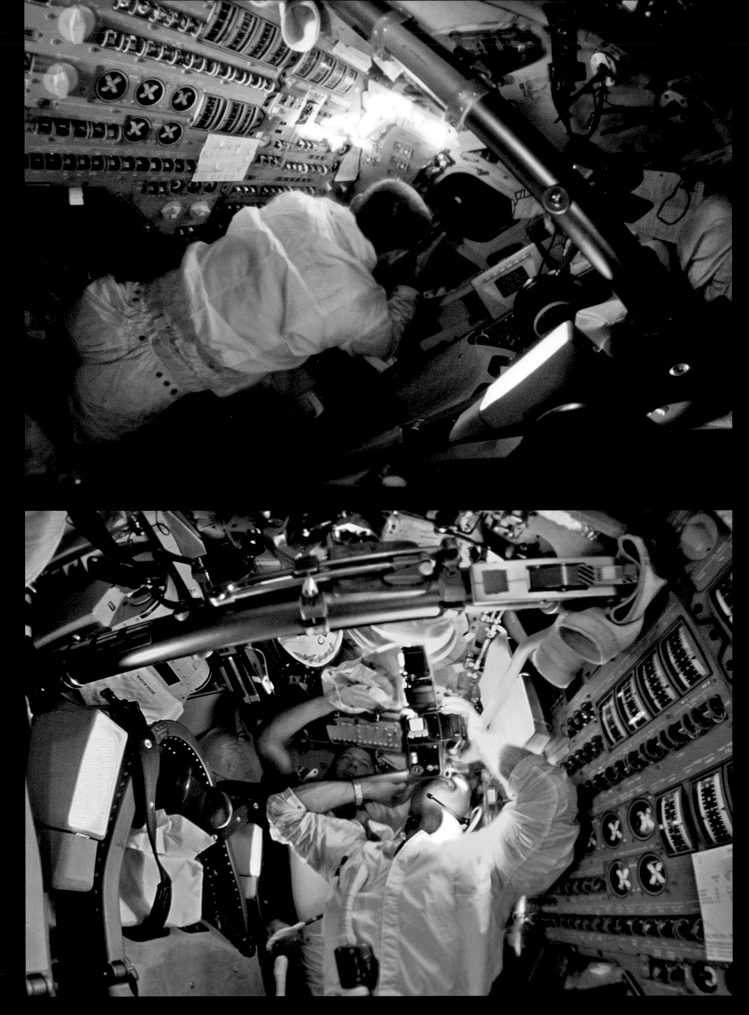

November 14–24, 1969 35 AND 140 FRAMES OF 16MM FILM, STACKED AND PROCESSED NASA ID: **APOLLO 12 MAG 1111-H**

TOP: Bean uses the Hasselblad HEC camera out of the Command Module window, exemplifying the difficulty of maintaining a steady posture to shoot in zero gravity. BOTTOM: Conrad uses his baseball cap to shield the super-bright sunlight streaming through the hatch window as Gordon uses the HEC with 250mm lens attached.

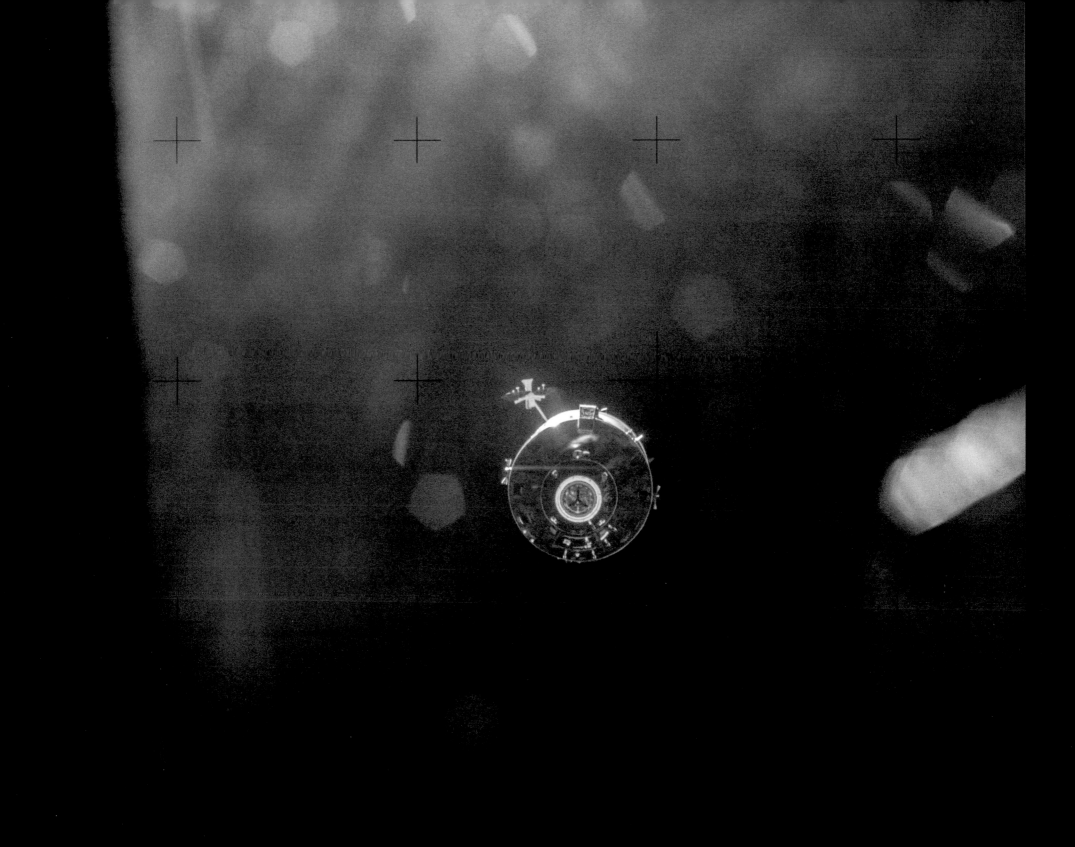

November 19, 1969 HASSELBLAD 70MM. LENS 80MM F/2.8 | BY UNKNOWN NASA ID: AS12-47-6877

When Apollo 12 entered lunar orbit, there was a familiar reaction; Conrad: "Son of a gun . . . That's a God-forsaken place; but it's beautiful, isn't it? . . . I guess, like everybody else that just arrived, all three of us are plastered to the windows looking." This photograph was taken after LM undocking. Later in the mission Bean would observe: "Look at the umbilical cover — do you

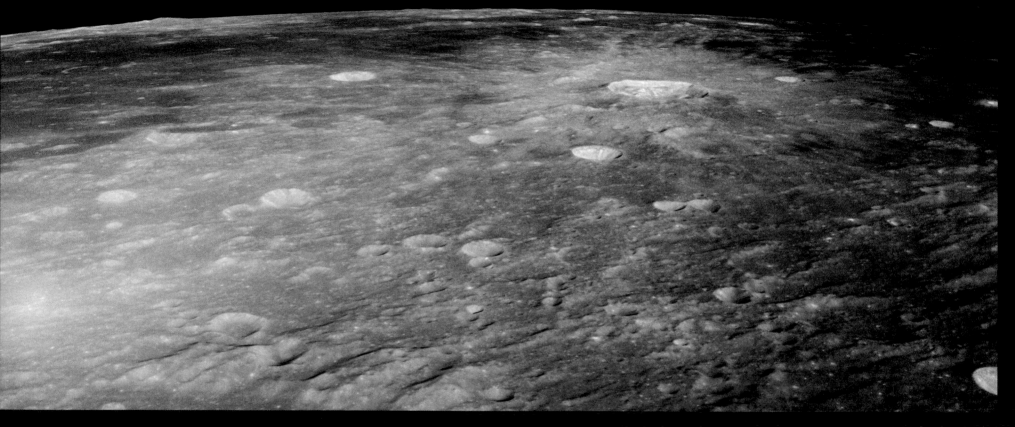

November 19, 1969 HASSELBLAD 70MM. LENS 80MM F/2.8 | BY RICHARD GORDON NASA ID: AS12-51-7508

LM *Intrepid* above the Moon in preparation for powered descent. Conrad: "Boy, this thing sure flies nice . . . I sure hope you have us lined up right, Houston, because there sure is some big mountains [laughing] right in front of us." At 6,000 feet, Conrad caught a glimpse of their target, Snowman: "There it is! Son of a gun! Right down the middle of the road!" Despite significant dust obscuring the view, Conrad used his 8-ball to guide *Intrepid* to a safe landing. Gordon: "Congratulations from *Yankee Clipper* . . . Have a ball!" *(Cropped, rotated, EL: 3/5)*

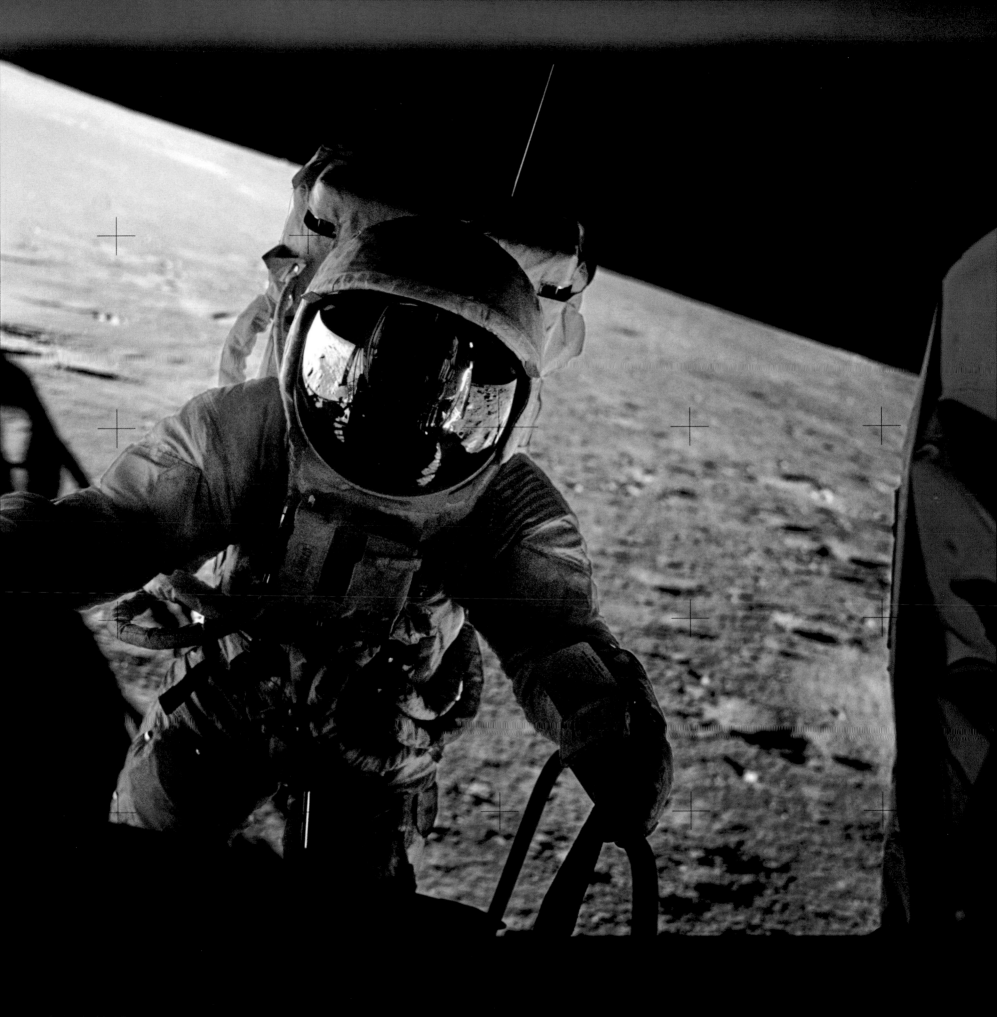

November 19, 1969 **EVA-1** HASSELBLAD 70MM. LENS 60MM F/5.6 | BY ALAN BEAN NASA ID: **AS12-46-6715**

Conrad descends the ladder, about to become the third human to walk on the Moon. Bean: "Okay; wait. Let me get the old camera on you, babe." The Lunar Module hatch is visible in Conrad's visor reflection – Bean is seen bending over to take the photograph from around knee height. Conrad was instrumental in ensuring the Lunar Module design accommodated a square-shaped hatch rather than the original, circular one, to aid egress. *(Rotated, EL: 5/5)*

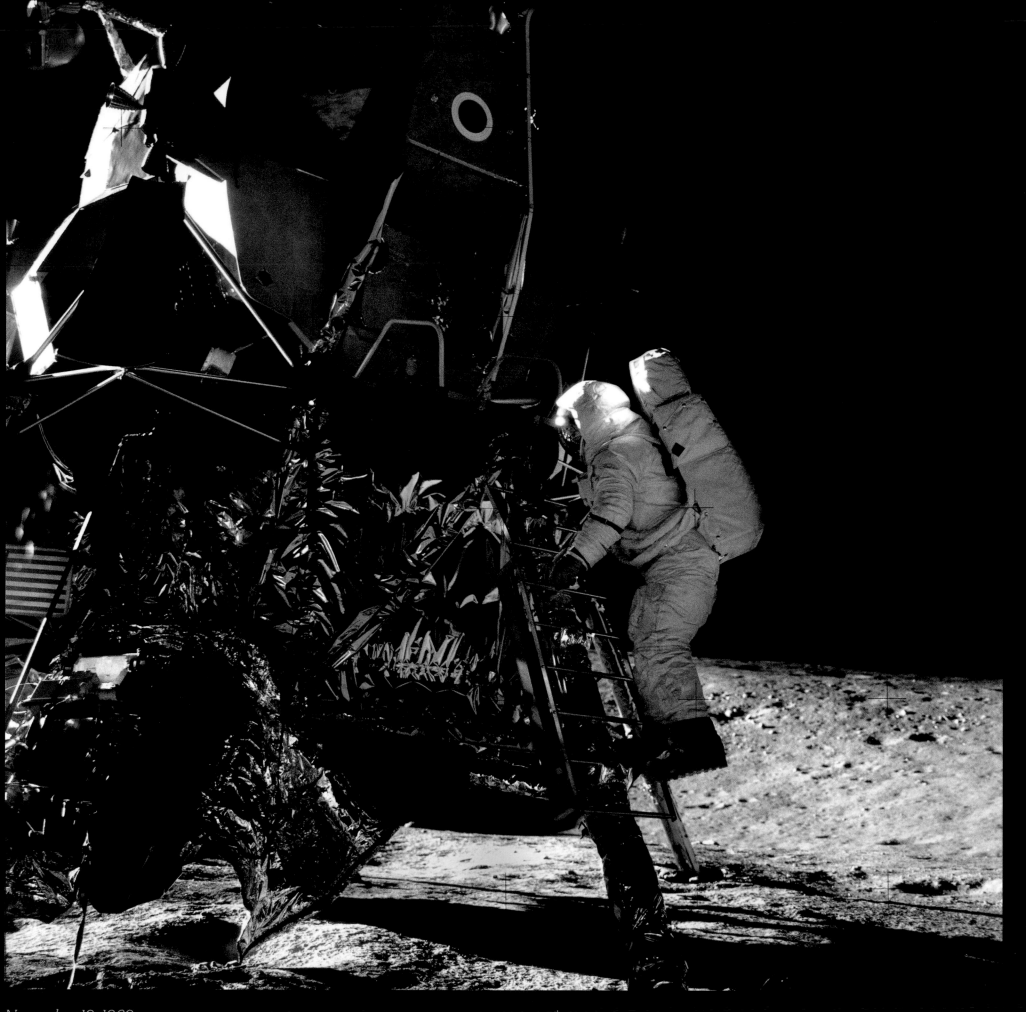

November 19, 1969 EVA-1 HASSELBLAD 70MM. LENS 60MM F/5.6 | BY PETE CONRAD NASA ID: AS12-46-6728

Almost immediately, Conrad spotted something: "Boy, you'll never believe it. Guess what I see sitting on the side of the crater! . . . The old Surveyor! Yes, sir, does that look neat . . . How about that!?" Bean descended the ladder 40 minutes later: "Be out in a minute." Conrad: "All right. Let me know so I can photograph you." The live TV camera can be clearly seen in the MESA, lower left. (EL: 4/5)

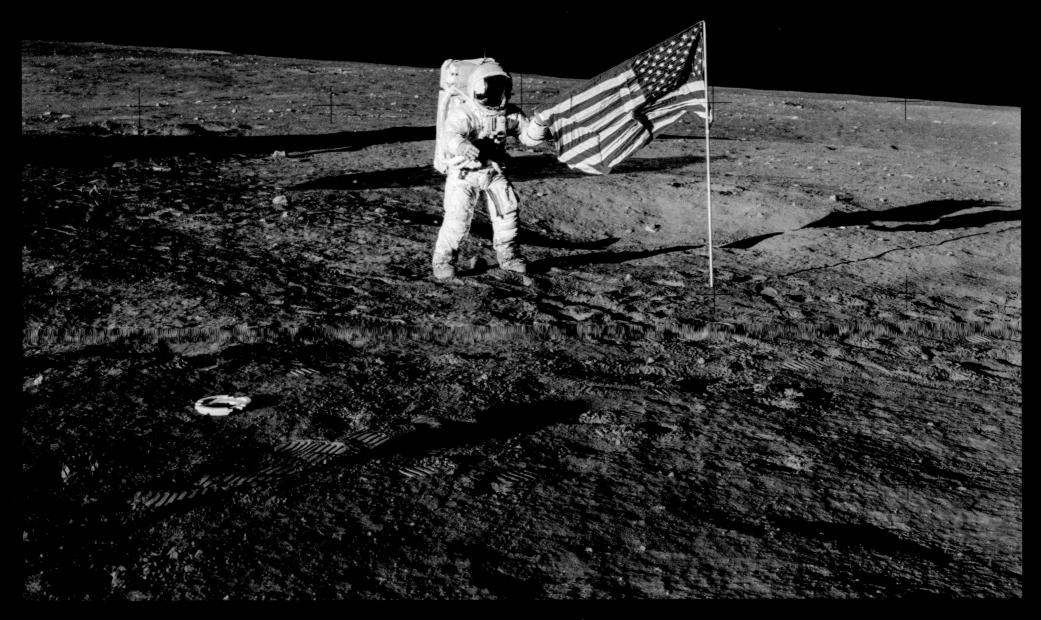

November 19, 1969 EVA-1 HASSELBLAD 70MM. LENS 60MM F/5.6 | BY ALAN BEAN NASA ID: AS12-47-6897

After the problems planting the flag on Apollo 11, Bean used a hammer to pound it a foot into the ground. Conrad: "Can we have a quickie [photo] here?" Conrad can be seen holding the flag up, as the pin to hold it horizontally had broken. In desperation, Bean would also try to fix the TV camera by hitting it with his hammer (he had inadvertently pointed the TV camera at the Sun during set-up, permanently damaging it). *(EL: 2/5)*

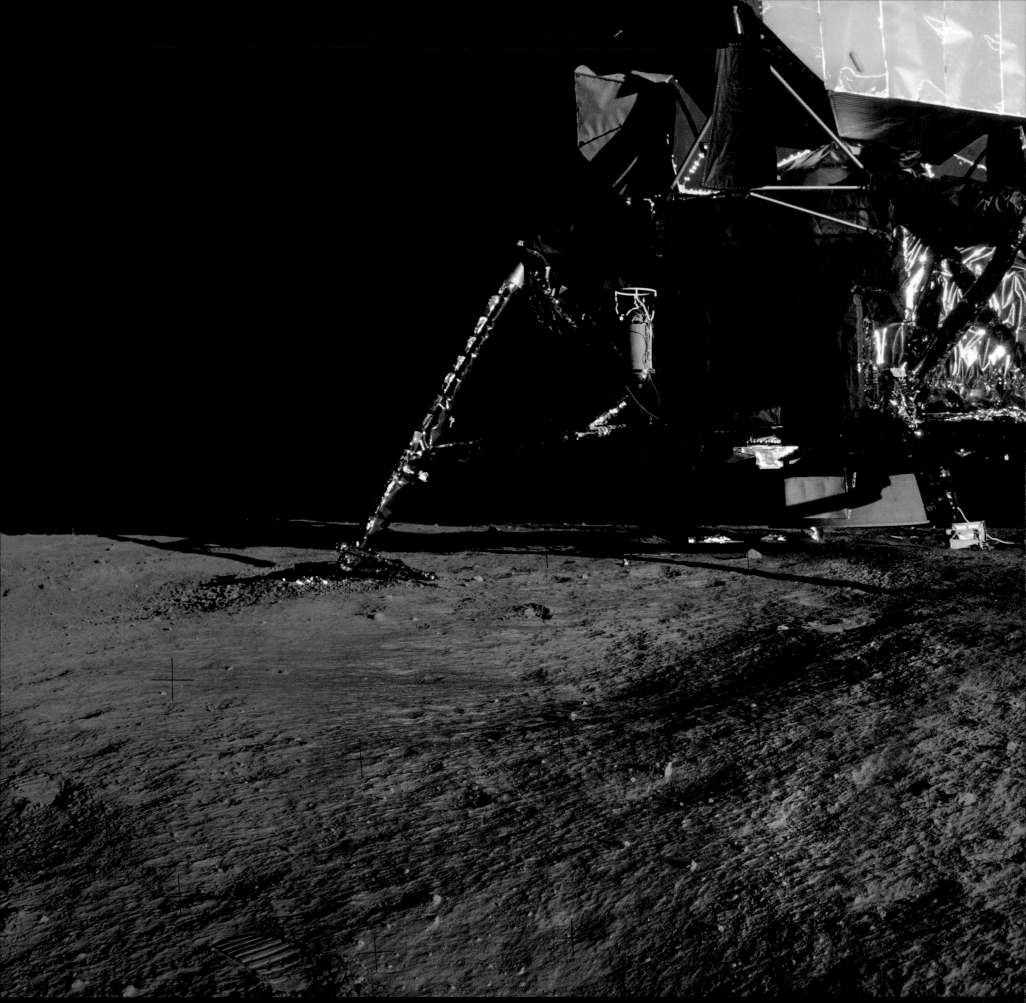

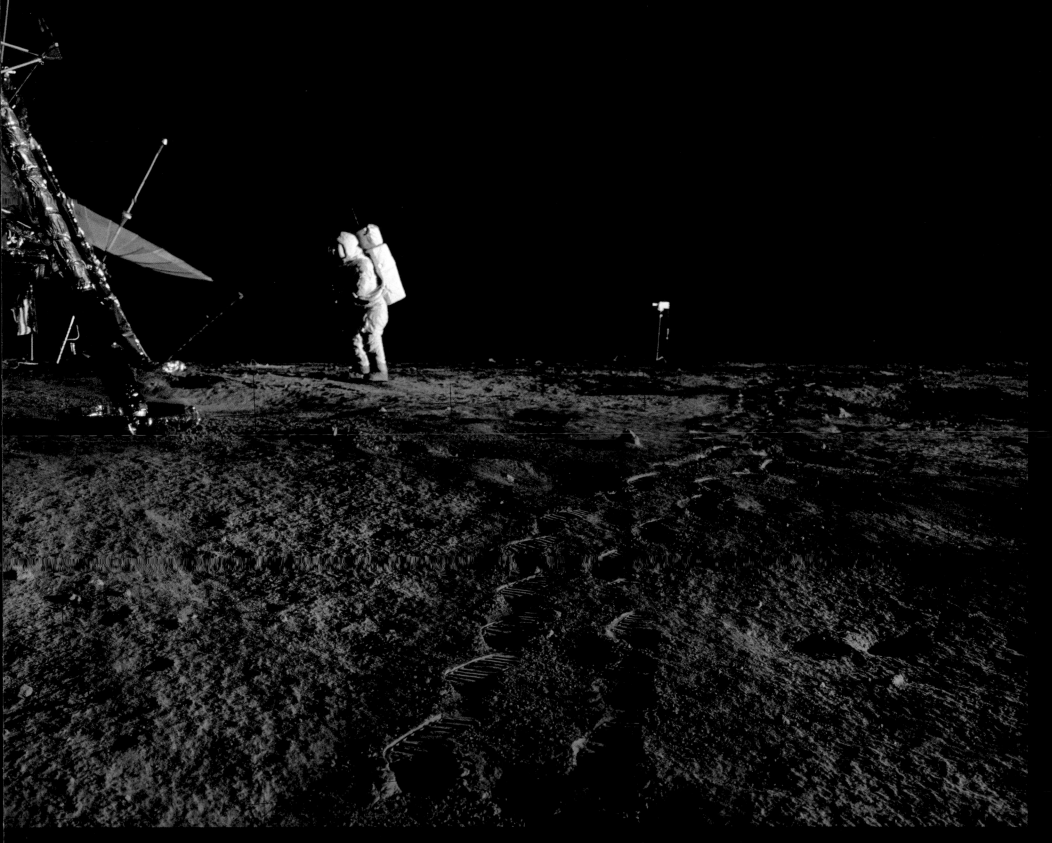

November 19, 1969 EVA-1　　　HASSELBLAD 70MM. LENS 60MM F/5.6 | BY PETE CONRAD　　　NASA ID: AS12-46-6777 TO 6780

Conrad: "I'm going to head down into the crater a little bit for this set of pans." Almost losing his footing, Conrad took this panorama from a low elevation. Bean can be seen photographing the landing gear while reporting to Mission Control: "These pads went in a little bit further than did Neil's [Armstrong's] . . . and it sort of looked like we were moving slightly forward." The now defunct TV camera can be seen far right. (Panorama, EL: 3/5)

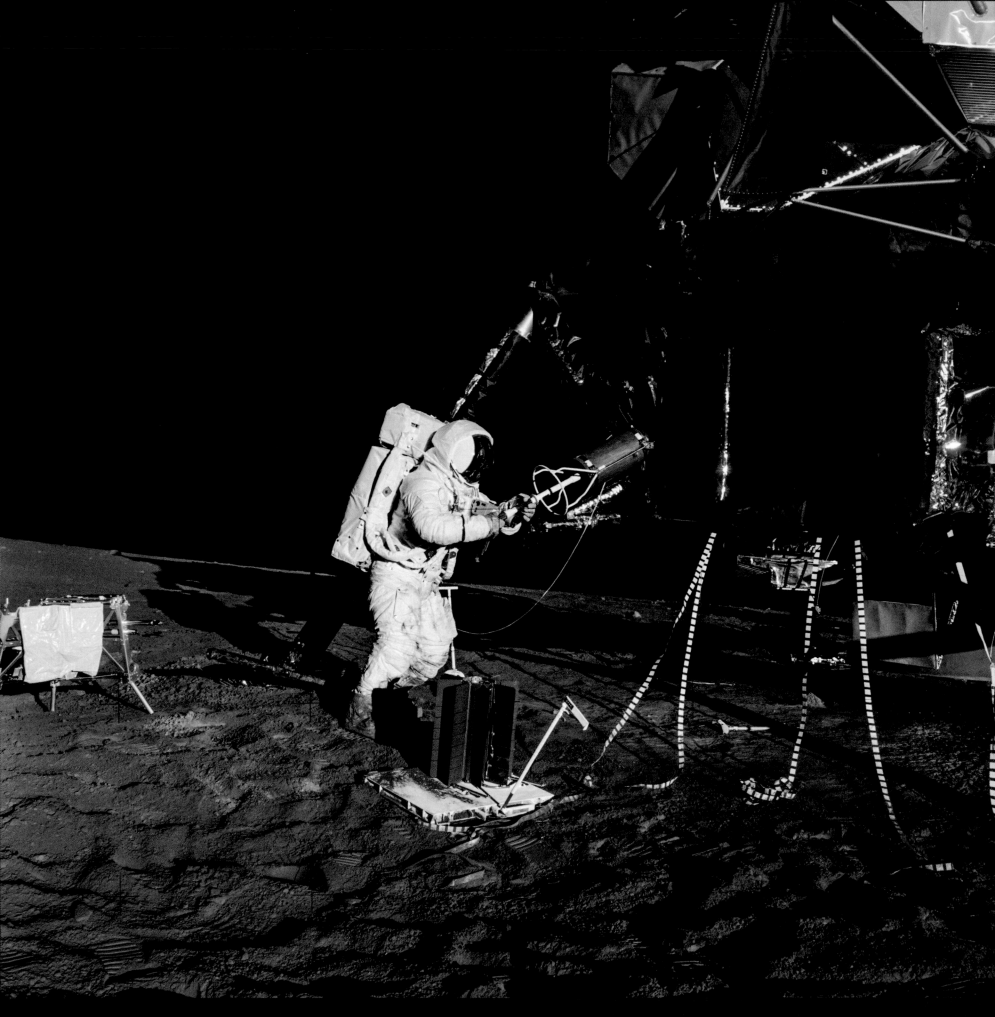

November 19, 1969 EVA-1　　　　　　　　HASSELBLAD 70MM. LENS 60MM F/5.6 │ BY PETE CONRAD　　　　　　　　NASA ID: AS12-46-6790

Bean: "The LM exterior looks beautiful the whole way around." The ALSEP was removed from the side of *Intrepid*. Bean is using an extraction tool to remove the plutonium fuel element for the Radioisotope Thermoelectric Generator (RTG) from its cask, which will power the ALSEP experiments. On the ground, the fins that act as radiators to cool the RTG can be seen. The shield close to the engine bell (right) is thermal protection for the landing radar. *(EL: 2/5)*

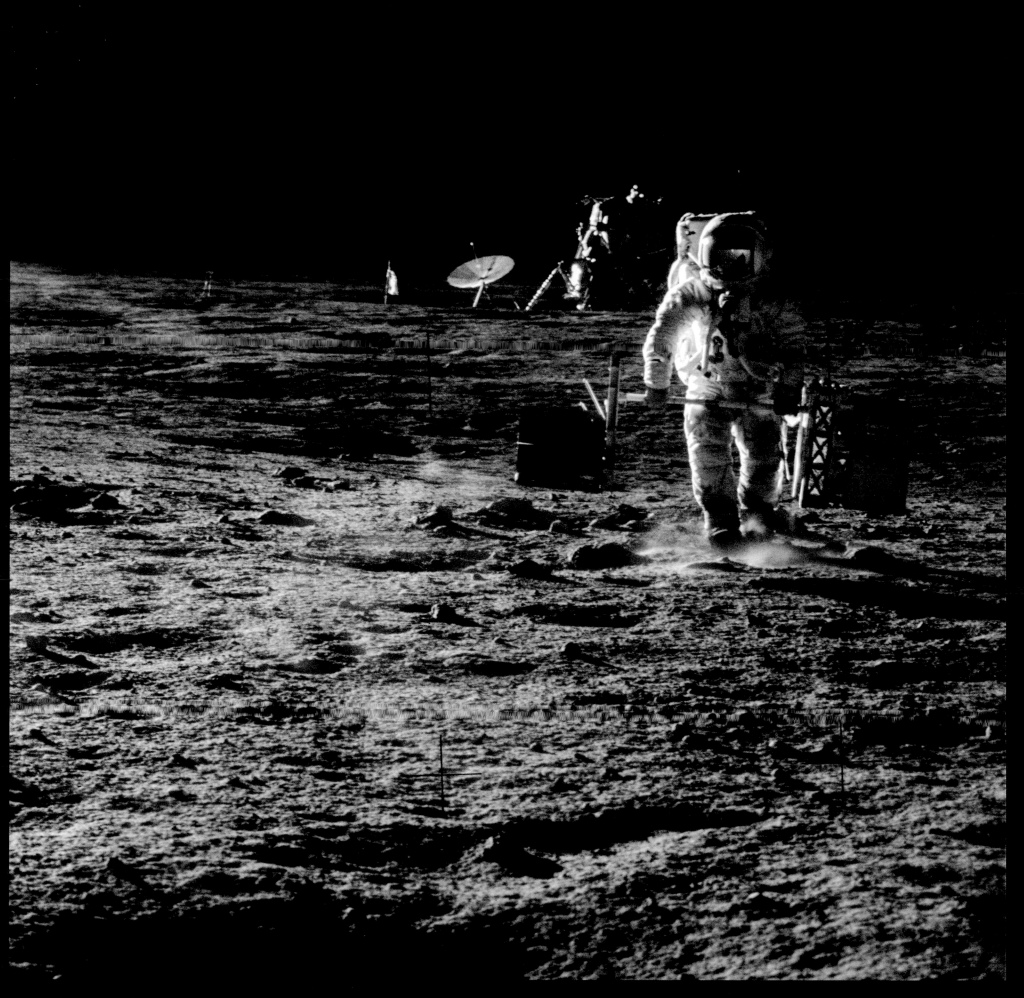

November 19, 1969 **EVA-1** HASSELBLAD 70MM. LENS 60MM F/5.6 | BY PETE CONRAD NASA ID: **AS12-46-6806**

Almost halfway into the first EVA, Bean is kicking up some dust as he carries the ALSEP from *Intrepid* to its deployment site. Weighing in at 280lbs on Earth, the Moon's 1/6th gravity made carrying it possible. Conrad: "Hey Al, here's a neat spot to put it out up here." Bean: "Okay. It's a good long ways away too; it must be at least, what, 500 feet from the LM?" (Cropped. FL: 5/5)

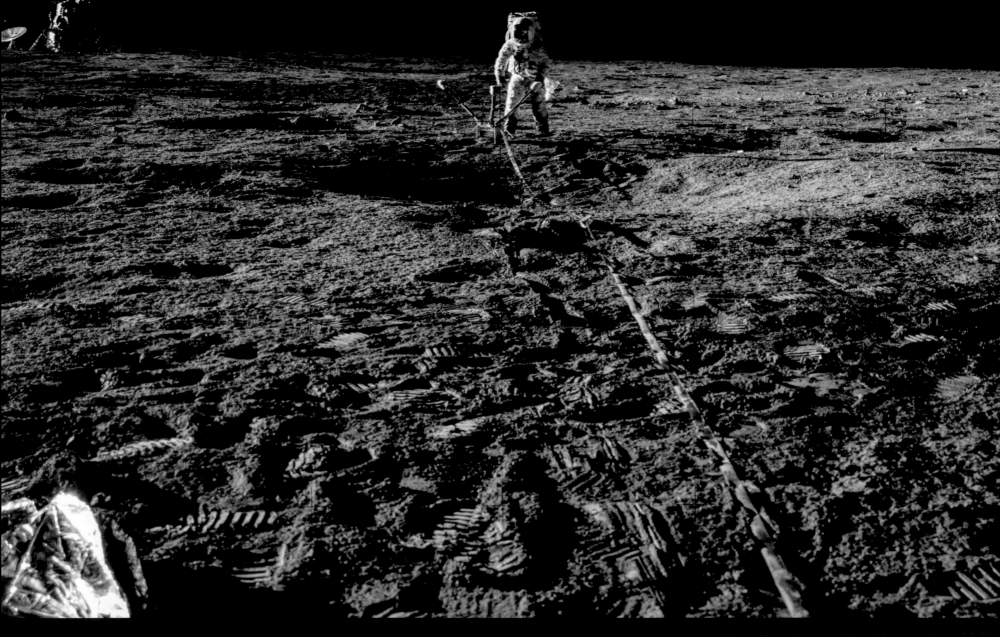

November 19, 1969 EVA-1 HASSELBLAD 70MM. LENS 60MM F/5.6 | BY PETE CONRAD NASA ID: AS12-46-6813

Conrad: "Where'd you go, Al?" Bean: "I'm right over here, babe." Conrad turns: "Oh, you're miles away!" Bean is standing by the deployed magnetometer, which is positioned 50 feet from the Central Station. Apollo 12 was the first to use the ALSEP, which consisted of the Central Station, powered by the RTG and various configurations of connected experiments positioned around it. The Lunar Module and S-band antenna can be seen in the distance. *(EL: 4/5)*

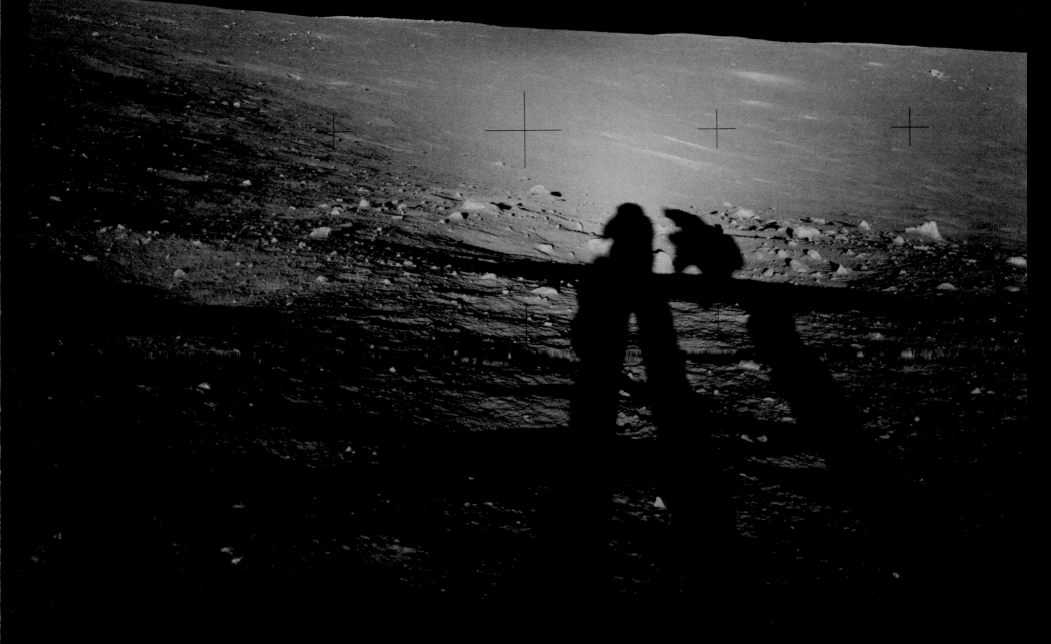

November 19, 1969 EVA-1 HASSELBLAD 70MM. LENS 60MM F/5.6 │ BY PETE CONRAD NASA ID: AS12-46-6842

Conrad: "Get right to the edge of this crater and photograph it." Bean: "Hey, there's bedrock down here . . . Why don't you go ahead and pan . . ." Conrad: "Yeah, let me get to 74 [feet focus] . . . F/8, right?" This is as close as we get to a photograph of Conrad (left) and Bean (right) together. They had hatched a secret plan to take a portrait at Surveyor, utilizing an auto-timer that Conrad had bought and sneaked on board, but they misplaced it at the crucial moment. *(EL: 2/5)*

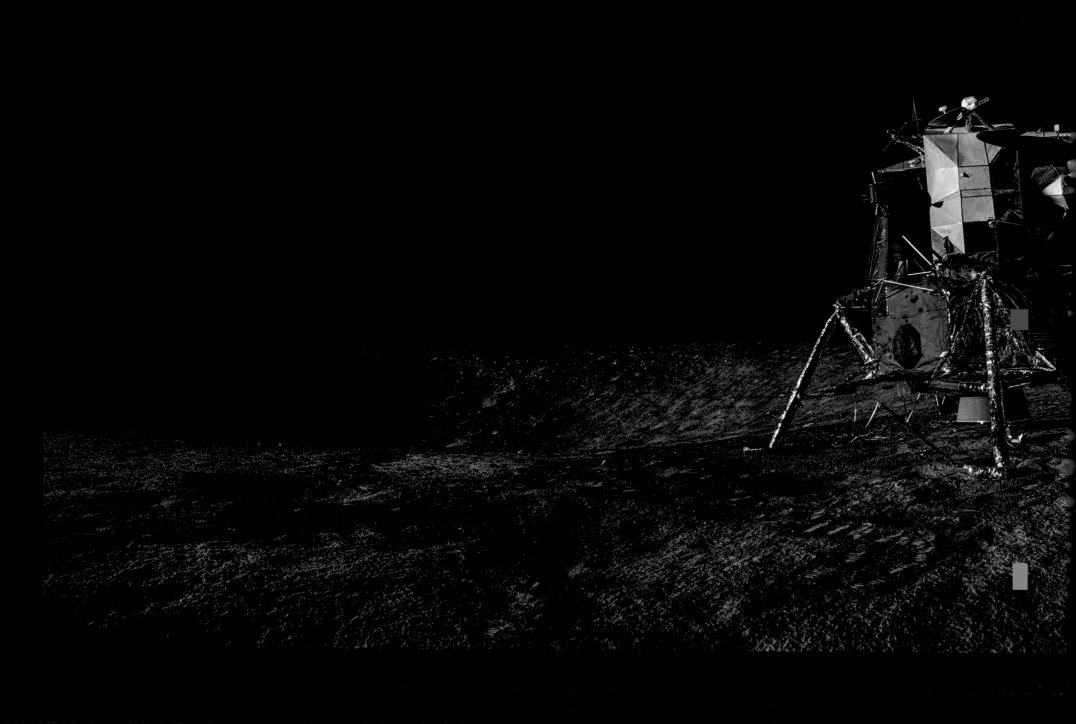

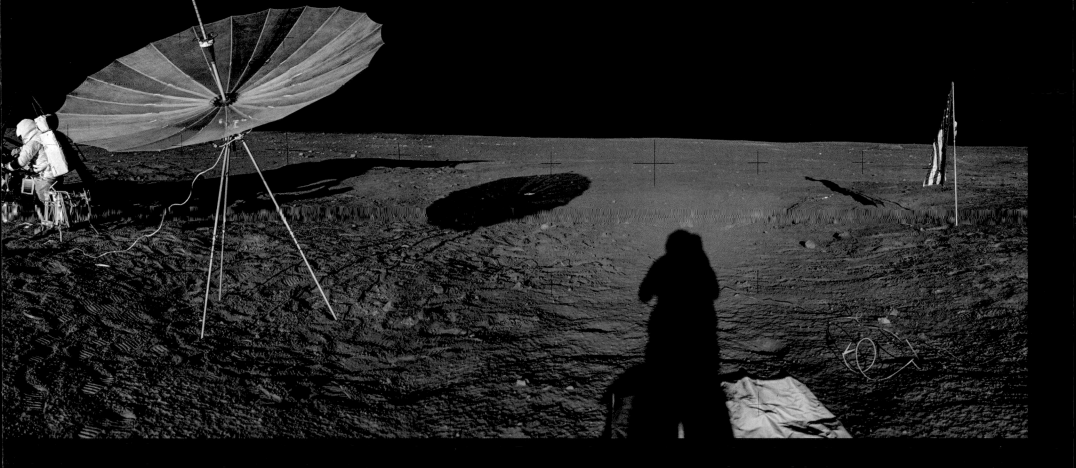

November 19, 1969 EVA-1 HASSELBLAD 70MM. LENS 60MM F/5.6 | BY ALAN BEAN NASA ID: AS12-47-6984 TO 6992

This panorama illustrates the landing site and the vicinity of the LM to Surveyor crater. Surveyor itself can just be seen far left in the deep shadows of the crater. Even later, on EVA-2, the shadows would regress to reveal the spacecraft that landed two and a half years earlier. Conrad is at the MESA storing tools and collected rocks, the S-band antenna is in the foreground and the drooping flag is seen far right. *(Panorama, EL: 4/5)*

November 19, 1969 **EVA-1** HASSELBLAD 70MM. LENS 60MM F/5.6 │ BY ALAN BEAN NASA ID: **AS12-47-701**

Bean: "Okay. Want me to help clos█ █at box?" At the end of the first EVA, Conrad and Bean struggled to seal a stuffed metal "rock box" (or Apollo Lunar Sample Return Container) full of thei█ collected samples. Conrad: "And t█████s a rock box that's full of rocks . . . Okay. Close the door [lid]." Bean then accidentally triggered this exposure as he removed his Hasselblad from hi█

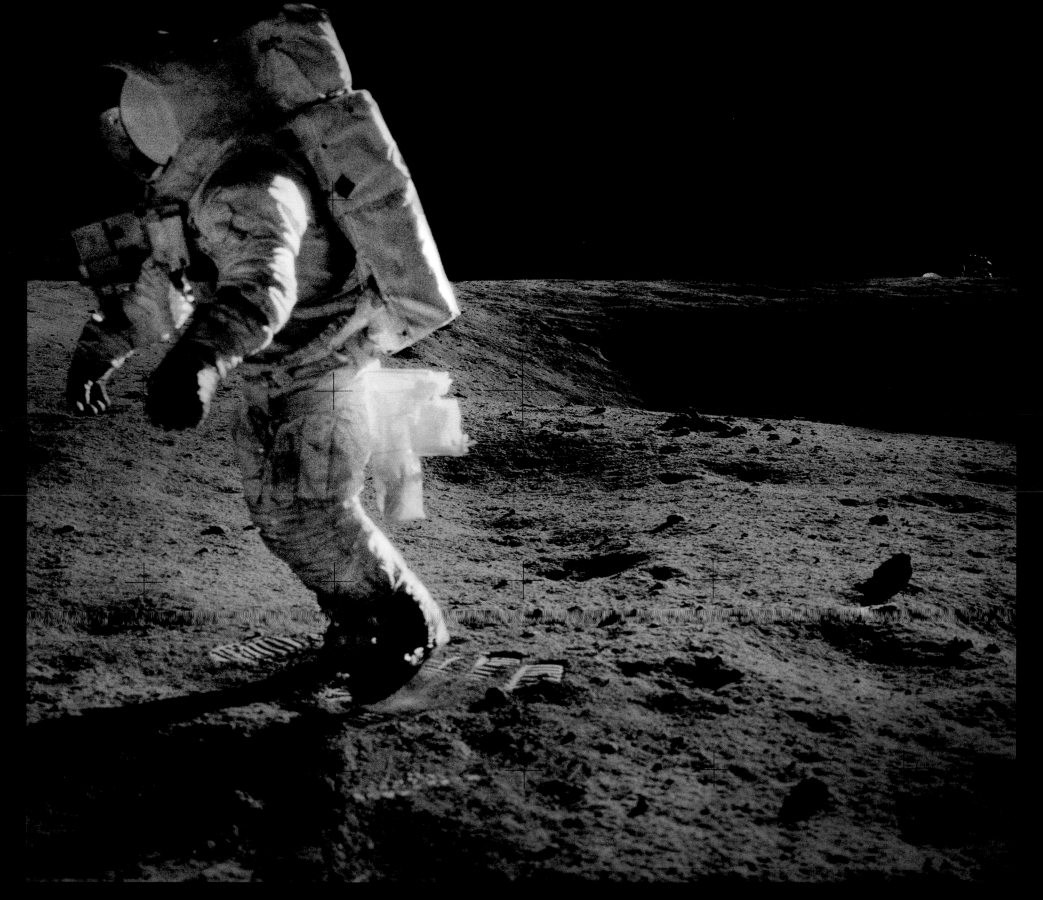

November 20, 1969 EVA-2 HASSELBLAD 70MM. LENS 60MM F/5.6. B&W | BY PETE CONRAD NASA ID: **AS12-49-7213**

Conrad: "Look at these craters, Al! . . . It's really a sh████ Houston; we could work out here for eight or ███ hours. The work is no strain at all." The pair continually dropped hints to Mission Control in the hope their EVAs would be extended. █████ "These rocks obviously came out of the crater██ We probably ought to grab a big one of them . . . There's an interesting [one] . . . Let's get it." Bean skips out of frame from Head crater. The LM is peeking up over the horizon, 650 feet away. *(EL: 4/5)*

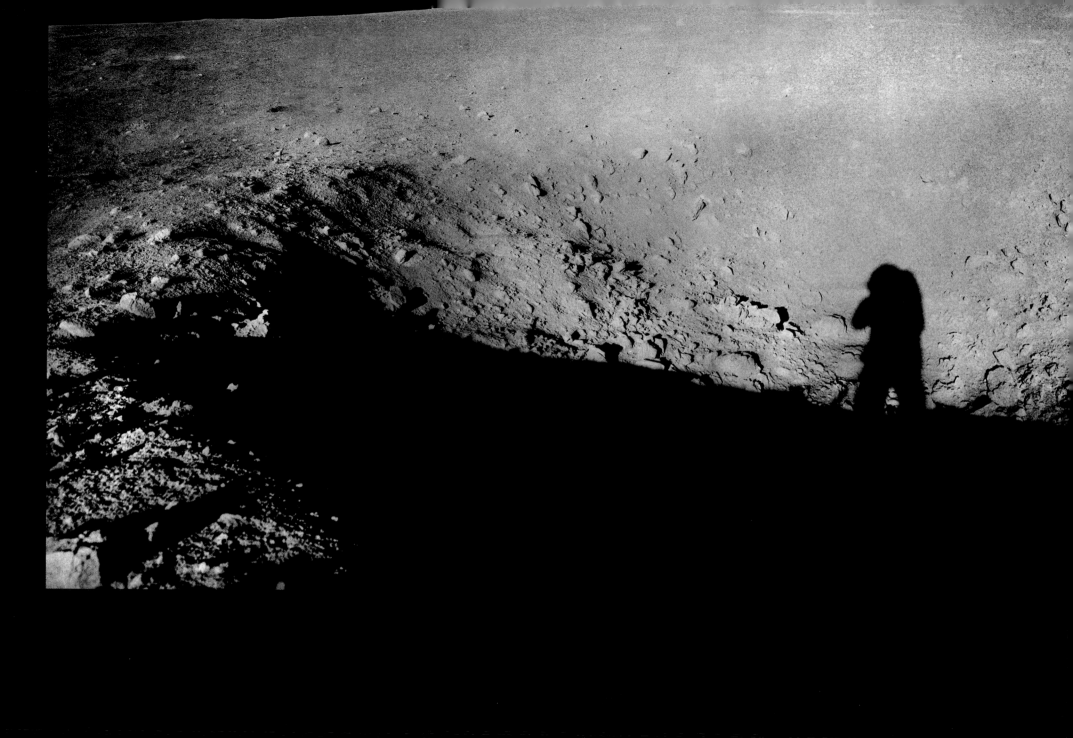

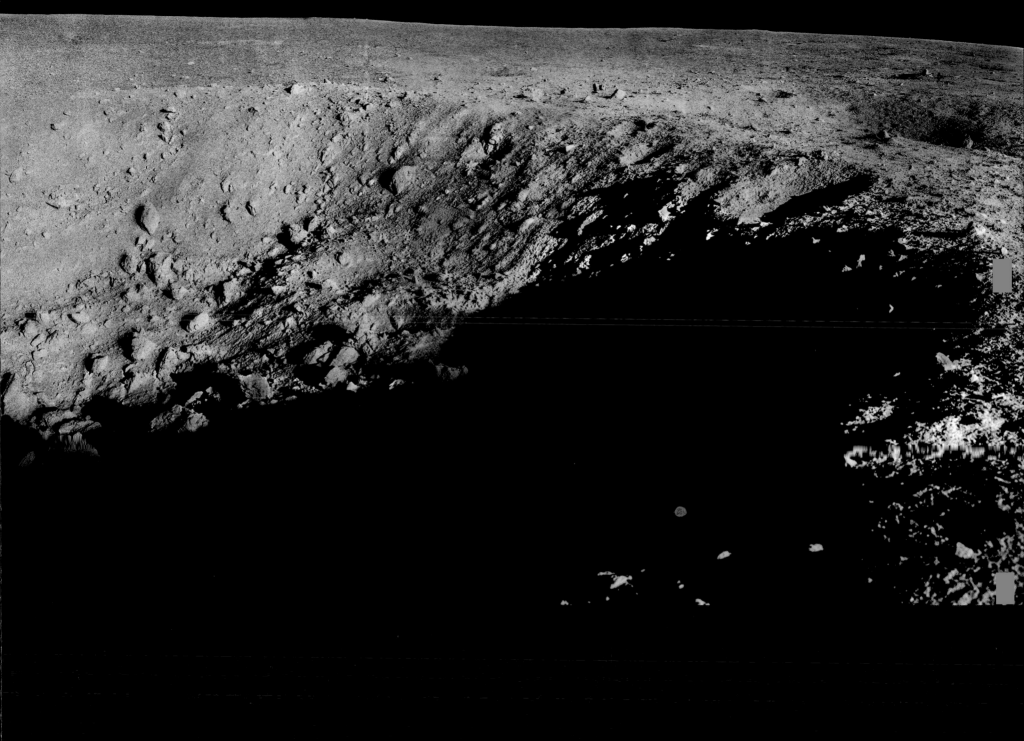

November 20, 1969 EVA-2 HASSELBLAD 70MM. LENS 60MM F/5.6. B&W │ BY PETE CONRAD NASA ID: AS12-49-7270 TO 7275

Conrad: "Sharp crater, where are you? . . . No. I can't find it . . . Man, does that LM look small back there!" The crew eventually found the 40-foot-diameter fresh impact crater. Bean: "It's got a nice raised rim on it." Conrad: "Holy Christmas! Look at the bottom of that . . . Looks like it's got blast effects radial all around. This has got to be fairly fresh to the . . . Hey, look at that, Al. Isn't that neat? Wait till I get some pictures of that!" (Panorama, fiducial mark removal, EL: 5/5)

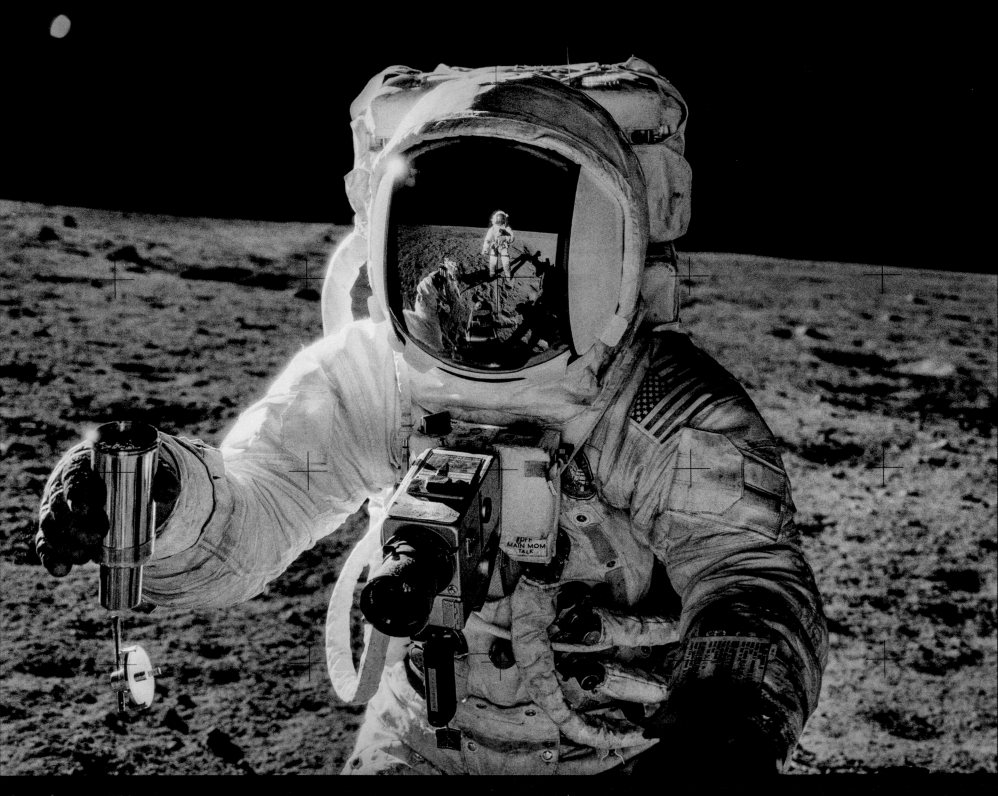

November 20, 1969 **EVA-2** HASSELBLAD 70MM. LENS 60MM F/5.6. B&W | BY PETE CONRAD NASA ID: **AS12-49-7278**

One of the finest, sharpest portraits of any Apollo astronaut on the Moon. Still at Sharp crater; Conrad, referring to the vacuum-sealed Lunar Environmental Sample Container that Bean is holding: "Now what do we want to do? Fill that with dirt and rocks?" After giggling like schoolboys trying to fill the container, Conrad, seen reflected in Bean's visor, takes this stunning photograph. Conrad is also reflected in the Carl Zeiss lens. *(EL: 3/5)*

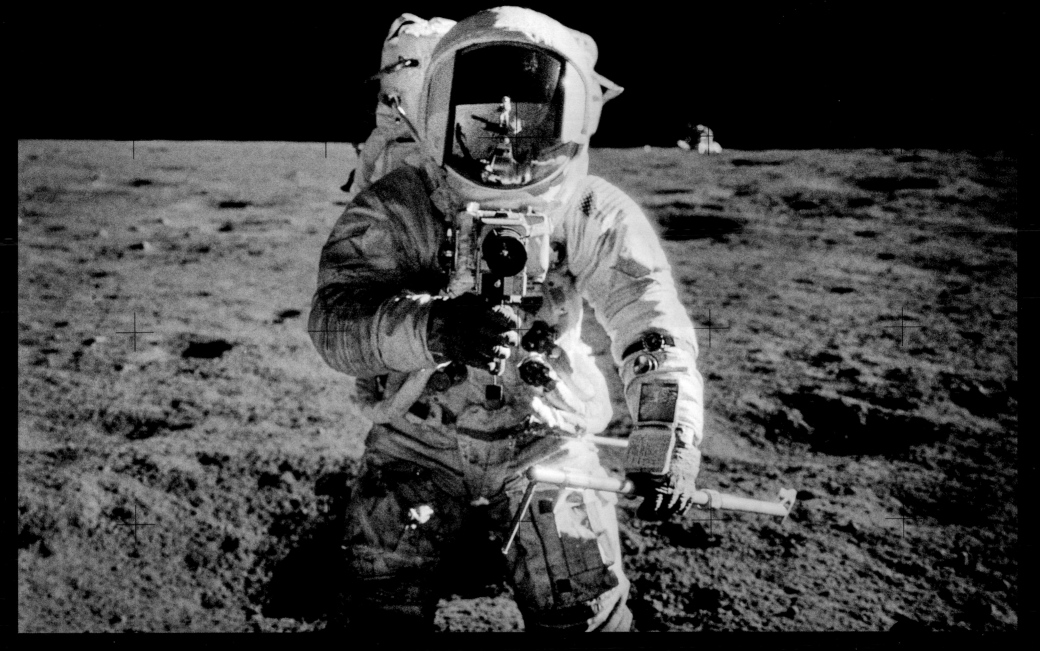

November 20, 1969 EVA-2 HASSELBLAD 70MM. LENS 60MM F/5.6. B&W | BY ALAN BEAN NASA ID: AS12-48-7071

Conrad: "Let's see, we're cross-Sun, right? Look over here at me and smile." Bean: "Okay. I'll get you; you're right there by a crater." Conrad and Bean took portraits of each other at the same moment. Bean can be seen in Conrad's visor reflection, whose cuff checklist is open at a page showing a *Playboy* Playmate, only discovered during the EVA – a joke played on them by back-up crewmember Dave Scott. Conrad was keen to achieve a great composition: "Where's the LM?" Bean: "Right in the background." *(EL: 3/5)*

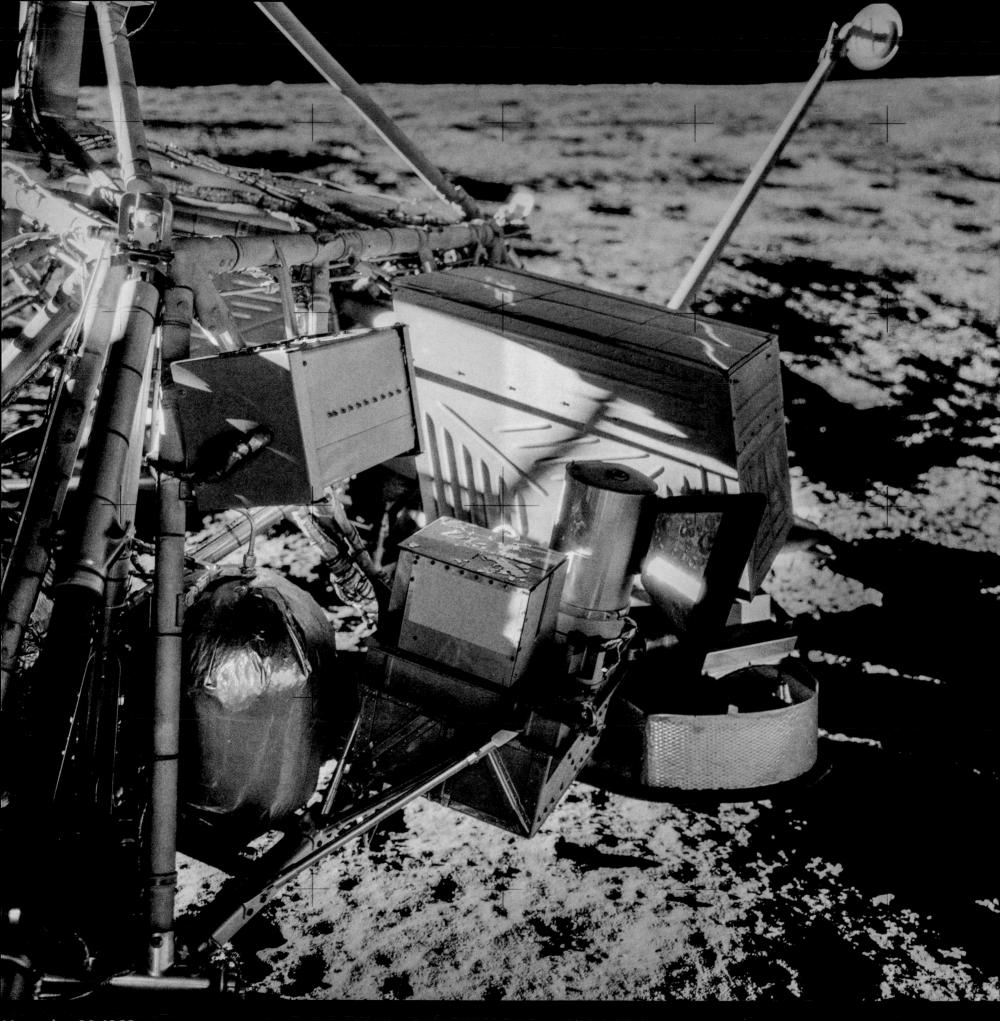

November 20, 1969 EVA-2 HASSELBLAD 70MM. LENS 60MM F/5.6. B&W | BY ALAN BEAN NASA ID: AS12-48-7125

With the shadows having regressed since the landing, the crew headed into Surveyor crater. Bean: "Boy, that's going to make some beautiful pictures on the way that's weathered since . . ." The Surveyor 3 spacecraft had turned from white to a tan color during its two and a half years on the lunar surface. It later transpired this was due, in part, to a fine covering of lunar dust blown onto it from the LM during descent. *(EL: 3/5)*

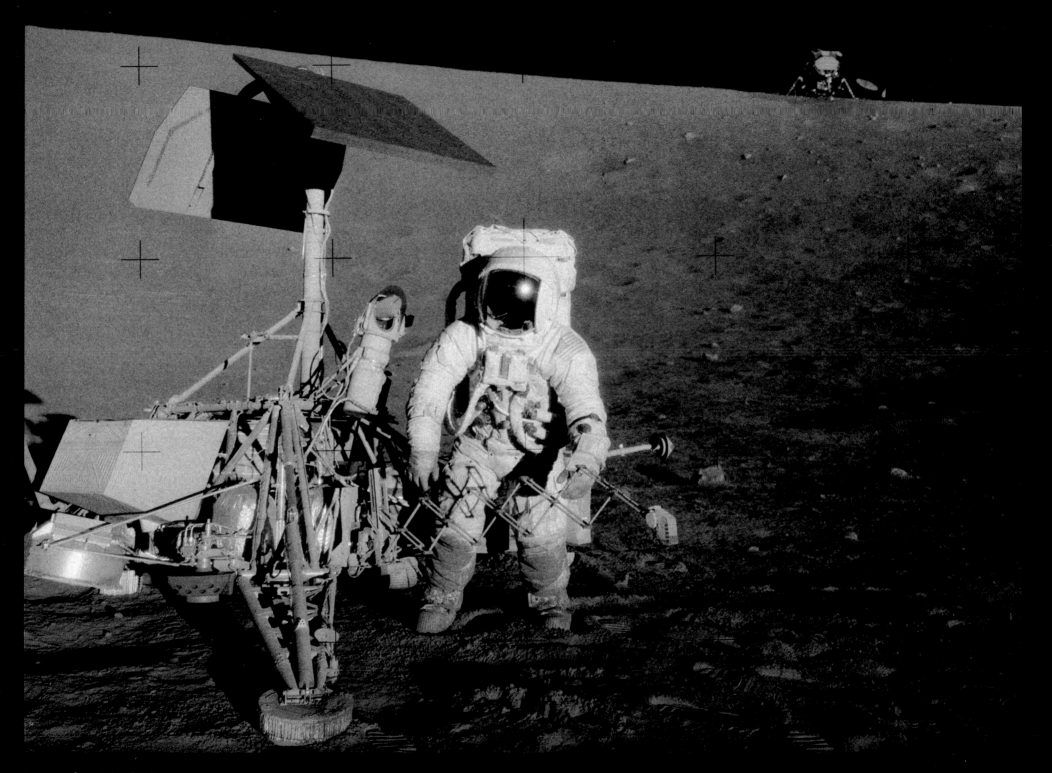

November 20, 1969 **EVA-2** HASSELBLAD 70MM. LENS 60MM F/5.6. B&W │ BY PETE CONRAD NASA ID: AS12-48-7136

Bean: "You don't get a chance like this every day. Shoot up the extras; we've got lots of film". Conrad: "Why don't you get yourself in the photo, too? . . . [Give me] a big smile!" Bean and Conrad took "tourist" photographs of each other with Surveyor using the only remaining fully functioning camera. *Intrepid,* up on the edge of Surveyor crater (approximately 600 feet away), gives perspective, highlighting the accuracy of the landing. *(EL: 3/5)*

November 20, 1969 EVA-2 KODAK 35MM. LENS 46MM F/17 | CLOSE-UP BY ALAN BEAN NASA ID: AS12-57-8448

The anatomy of a lunar bootprint. At the end of the EVA, Bean used the close-up "Gold" camera: "I'm taking a picture of Pete's footprint in the soil. You can take a look at the interaction of that." It shows a detailed view of a 72mm x 83mm section of the lunar regolith and how it forms the bootprint. Bootprints are formed more distinctly than on Earth, due to the low gravity and being made up of electrostatically charged, irregular, sharp-edged grains (due to a lack of erosion). *(EL: 4/5)*

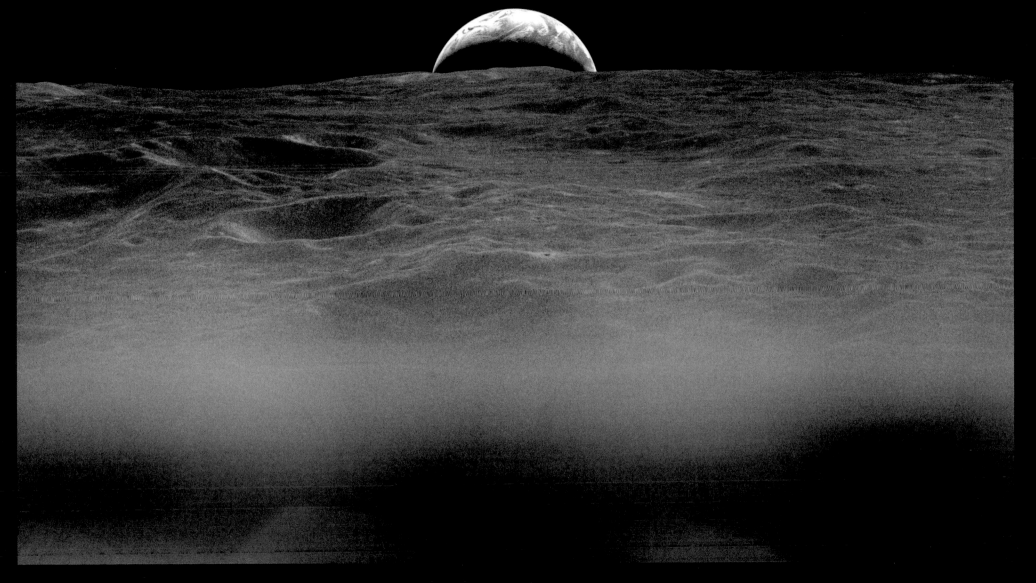

November 19–21, 1969

HASSELBLAD 70MM. LENS 80MM F/2.8 | PROBABLY BY RICHARD GORDON NASA ID: AS12-51-7525

Gordon had spent the previous 31 hours alone, orbiting in *Yankee Clipper*. As well as spotting his crewmates' ▮▮▮ Module and the Surveyor 3 spacecraft on the surface t▮▮▮▮ the onboard sextant, he was also treated to the wonders of Earthrise. This photograph was taken later in the mission through one of the Command Module's windows as Earth emerged above the horizon, west of Pasteur crater on the lunar farside. *(Rotated, EL: 3/5)*

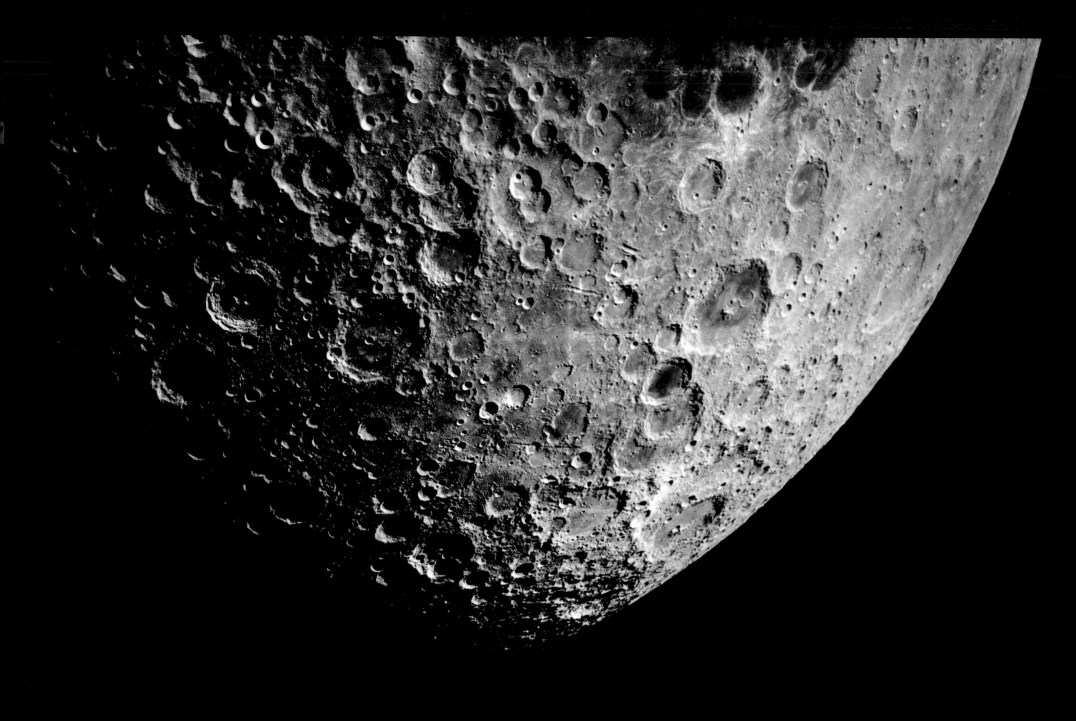

November 21, 1969

HASSELBLAD 70MM. LENS 250MM F/5.6. B&W | BY UNKNOWN NASA ID: **AS12-55-8206**

Gordon: "Houston, 12. The star check's okay." Apollo 12 prepared for trans-Earth injection while on the lunar farside. Conrad: "See you on the other side." The SPS engine burn put the crew on course for Earth as the Moon grew smaller. Bean: "It's really getting small in a hurry. It's just sort of unreal to look outside. It's almost like a photograph moving away from you. It doesn't seem possible it can be a whole sphere that you were orbiting a couple of hours ago." *(Rotated, EL: 3/5)*

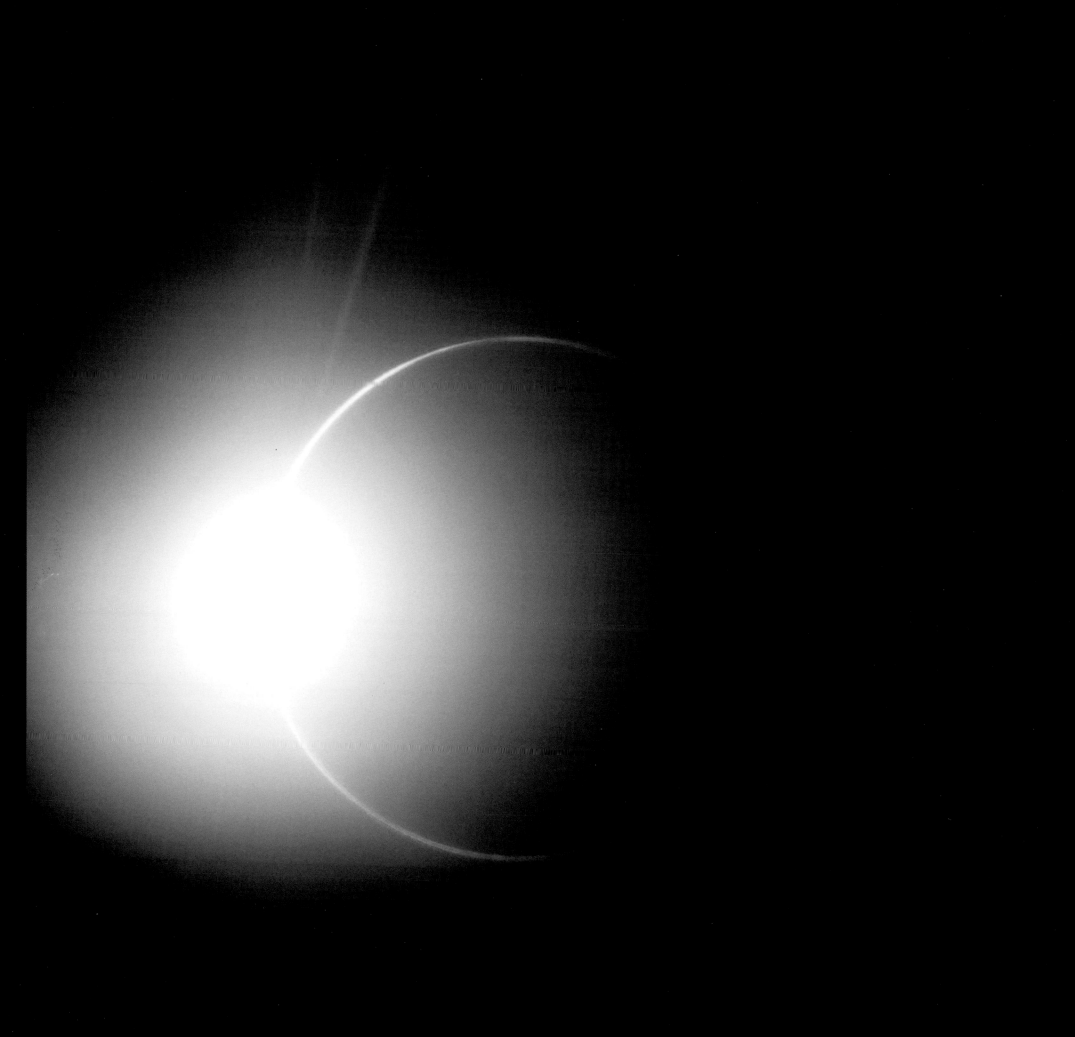

November 24, 1969 15 FRAMES OF 16MM FILM, STACKED AND PROCESSED NASA ID: **APOLLO 12 MAG 1133-F**

Thirty thousand miles from home, the crew witnessed an incredible event as Earth eclipsed the Sun. Gordon: "The atmosphere of the Earth is completely illuminated all the way around." Bean: "Even though the Sun is still on what looks like the western limb . . . the Earth now looks . . . 15 times the diameter of the Sun." Conrad: "[The atmosphere] has blues and pinks in it, but instead of being banded, it's augmented, which is very peculiar." Bean: "This has got to be the most spectacular sight of the whole flight!"

THE DETAILS

ROCKET	LAUNCH	DURATION	SPLASHDOWN
Saturn V (AS-508)	19:13 GMT, April 11, 1970, Pad 39A	5 days, 22 hours, 54 minutes, 41 seconds	18:07 GMT, 17 April, 1970, Pacific Ocean

COMMAND AND SERVICE MODULE
Odyssey (CSM-109)

LANDING SITE
NA (Fra Mauro landing aborted)

SURFACE TIME
N/A (landing aborted)

RECOVERY SHIP
USS *Iwo Jima*

LUNAR MODULE
Aquarius (LM-7)

DISTANCE
622,268 miles

LUNAR ORBITS
N/A (free return trajectory)

THE CREW

James A. Lovell Jr.
COMMANDER (CDR)

Born March 25, 1928. Lovell's first spaceflight was on NASA's first rendezvous mission, Gemini VII; he was then Command Pilot of the final mission of that program on Gemini XII, with Buzz Aldrin. Lovell was one of the first three humans to leave the confines of Earth and journey to the Moon, on Apollo 8. Apollo 13 would be his final space mission.

John L. "Jack" Swigert Jr.
COMMAND MODULE PILOT (CMP)

Born August 30, 1931. Former fighter pilot and test pilot, Apollo 13 would be his first spaceflight. Swigert was originally the back-up to Ken Mattingly, but moved to the prime crew just 72 hours before launch when it was discovered Mattingly had been exposed to the measles (which he ultimately never contracted). Apollo 13 would be his only spaceflight.

Fred W. Haise Jr.
LUNAR MODULE PILOT (LMP)

Born November 14, 1933. A former fighter pilot in the U.S. Marine Corps and USAF test pilot, Apollo 13 was his first spaceflight. Haise would likely have commanded Apollo 19, but the mission was canceled due to budget cuts. Although he went on to perform Space Shuttle approach and landing tests, Apollo 13 would be his only spaceflight.

April 11–17, 1970

APOLLO 13

THE MISSION

After the incredible achievement of the first landing on Apollo 11, then the loss of live TV pictures for Apollo 12, the public's interest in Apollo had begun to wane. Missions to the Moon were starting to be seen as routine. Apollo 13 would change all of that, when the world united to witness NASA's finest hour, as the dramatic rescue mission unfolded into one of the greatest stories of triumph over adversity ever told.

Unlike on Apollo 12, the first few minutes of launch were relatively uneventful, until one of the five second-stage engines shut down two minutes early. The remaining engines and the S-IVB third stage had to burn longer to make up the difference. TLI and transposition/docking went smoothly, as did the first two days of the mission, with Mission Control joking that they were bored to tears. Then, almost 56 hours after launch, the now famous words crackled over the airwaves from 178,000 miles out in space: "Houston, we've had a problem."

A year earlier, a cryogenic oxygen tank was dropped, from only two inches, during preparations for Apollo 10. The tank was replaced and the damaged tank checked over, and passed fit to be installed on Apollo 13. When liquid oxygen wouldn't expel after a demonstration test weeks before launch, the decision was made to use the tank's electrical heater to boil it off. Unbeknown to anyone, underrated components were damaged from the 65 volts applied.

When the routine request to stir the oxygen tanks during the mission came from Mission Control, Oxygen Tank 2 exploded. With fuel cells knocked out and Oxygen Tank 1 also leaking, *Odyssey* was dying. Lovell struggled for the next hour to maintain attitude control and the decision was made to abandon the Command Module and use the Lunar Module as a lifeboat.

The crew would have to learn to fly the stack of two spacecraft in a manner for which they were not designed – utilizing the descent engine of the LM to push them onto a free-return trajectory around the Moon. A further, longer burn from the descent engine would speed up their return by 10 hours. The burns would only be successful if the navigational data, translated by hand from the CM platform before it was shut down, to the LM platform were correct. Verifying the alignment with the stars was impossible due to the amount of debris surrounding the spacecraft and so the crew had to use the Sun.

Since the LM was only designed for two people for 45 hours, the spacecraft was going to run out of power, water and breathable air. All non-essential systems would be shut down to conserve power, and water was severely rationed, leading to a cold, sick, exhausted crew. There was real concern that exhaustion and the environment would affect their decision making and focus throughout the complex, mission-critical procedures that lay ahead.

The three crewmembers in the confined LM would be poisoned by their own breath had a hack not been devised by Mission Control to allow the CM's square CO_2 scrubbers to fit the LM's round "hole."

With the guidance computer powered down, the final major hurdle before re-entry was to perform a perfect manual midcourse correction to hit the atmosphere at an exact angle. The crew would eyeball Earth through the window to maintain the correct attitude through the 14-second burn that was hand-timed on a wristwatch.

At re-entry, there was still concern that the heat shield may have been damaged, or if enough electrical power was remaining for the critical final steps of the mission. After a nerve-wracking communications blackout, lasting 1 minute 27 seconds longer than expected, Apollo 13 splashed down safely in the Pacific.

THE PHOTOGRAPHY

Few images were captured in the hours after the explosion. Many *were* taken, however, by first-time Moon voyagers Haise and Swigert when the spacecraft swung behind the Moon during its closest approach. During the return, photographic tasks were reprioritized to capture the damage caused by the explosion in order to help determine what caused the catastrophic failure. Haise told me that is was he and Swigert who took these photographs, through two windows, in both color and black and white.

The crew also had the presence of mind to record life on board their "lifeboat," *Aquarius*, with the 16mm DAC camera. The stacked, reprocessed images from this film reveal the camaraderie between the crew who appear to be in surprisingly good spirits, given the grave nature of their predicament.

April 11, 1970

HASSELBLAD 70MM. LENS 80MM F/2.8 | BY UNKNOWN

NASA ID: **AS13-60-8584**

Lovell: "Houston, what's the story on engine five?" One of the Saturn V's second-stage J2 engines shut down early, but a longer burn of the remaining engines and S-IVB put Apollo 13 into orbit. *Aquarius'* RCS thrusters (left) and the spent S-IVB can be seen in this photograph after LM extraction. Lovell: "Okay. I can see the S-IVB now out the hatch window . . . I can see the gold shroud around the IU [instrument unit], and it looks that it's all intact." *(Cropped, EL: 3/5)*

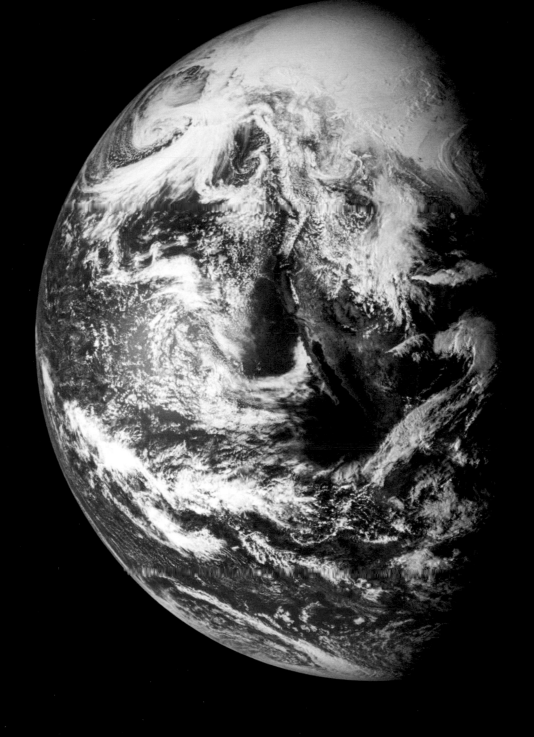

April 11, 1970 HASSELBLAD 70MM. LENS 80MM F/2.8 │ PROBABLY BY JIM LOVELL NASA ID: **AS13-60-8588**

Haise: "The windows came through in real good shape." Lovell: "We're going to take some Earth weather photography." Baja California is prominent in this photograph taken seven hours into the flight, approximately 30,000 miles from Earth. The Earth was much smaller 49 hours later, when, 178,000 miles from home, Mission Control routinely requested: "We'd like you to stir up your cryo tanks." Two minutes 37 seconds later, Lovell's famous words crackled across the airwaves: "Houston, we've had a problem." *(EL: 2/5)*

April 14, 1970 HASSELBLAD 70MM. LENS 60MM F/5.6 │ BY JIM LOVELL NASA ID: **AS13-62-8885**

The electrical short that caused the overheating and explosion of the cryogenic oxygen tank significantly altered the mission objectives; the Moon landing was lost, and the crew may not make it home alive. With the CSM dying, the crew moved into *Aquarius*. A midcourse correction burn of the LM descent engine was required to put Apollo 13 on a free-return trajectory around the Moon. Lovell: "Could you give us a little bit more time? . . . We want to do it right." *(Cropped, EL: 5/5)*

April 15, 1970

HASSELBLAD 70MM. LENS 80MM F/2.8 | BY UNKNOWN

NASA ID: **AS13-60-8606**

Lovell: "We are in the shadow of the Moon now. The Sun is just about set as far as I can see and the stars are all coming out." After a successful midcourse correction burn, Apollo 13 passed behind the Moon. As they came out of the shadow, the crew would get a tantalizing glimpse of this alien world from 139 miles above the surface. Lovell is the only person to visit the Moon twice and not walk on its surface. *(Cropped, EL: 4/5)*

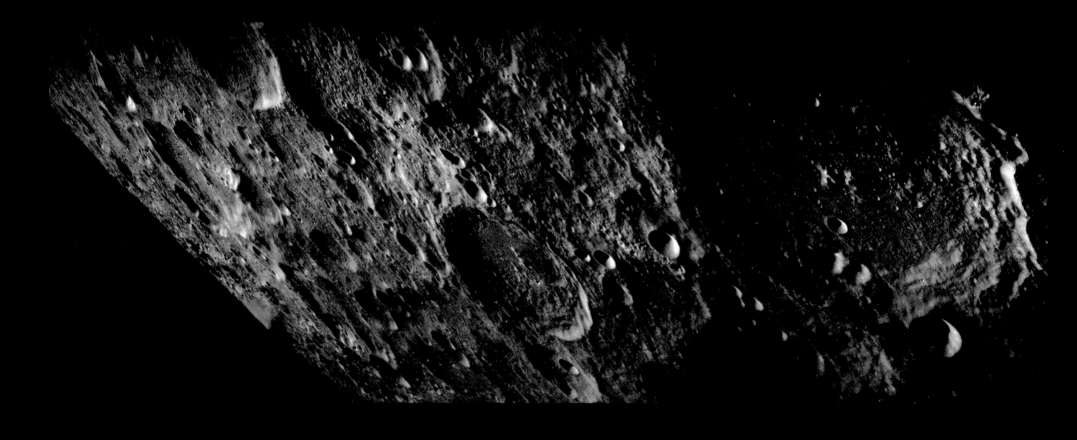

April 15, 1970

HASSELBLAD 70MM. LENS 80MM F/2.8 | BY UNKNOWN

NASA ID: AS13-60-8607 TO 8611

Chaplygin crater is in the foreground in this assembled panorama of the lunar farside. First-time Moon voyagers Haise and Swigert were glued to the windows photographing the surface when Lovell looked at them incredulously: "Okay, look . . . Let's get the cameras squared away; let's get all set to burn. We got one chance now." He reminded them that if the next maneuver wasn't performed correctly, they'd never get their pictures developed. *(Panorama, EL: 5/5)*

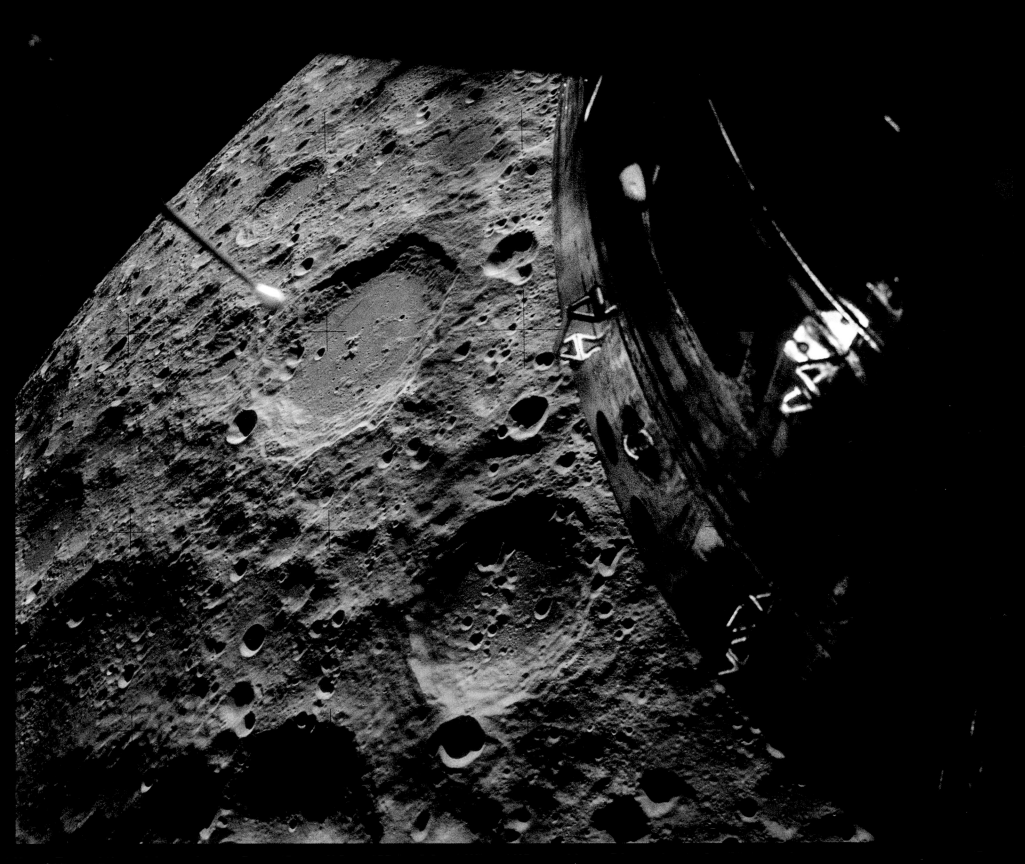

April 15, 1970　　　　　HASSELBLAD 70MM. LENS 60MM F/5.6 | BY UNKNOWN　　　　　NASA ID: **AS13-62-8909**

The crippled Command Module, *Odyssey*, on the farside of the Moon, as photographed through the docking window of the attached LM *Aquarius*. The prominent impact crater Chaplygin (top) is 76 miles in diameter. The free-return trajectory put the Apollo 13 crew further away from Earth than any humans before or since. *(EL: 3/5)*

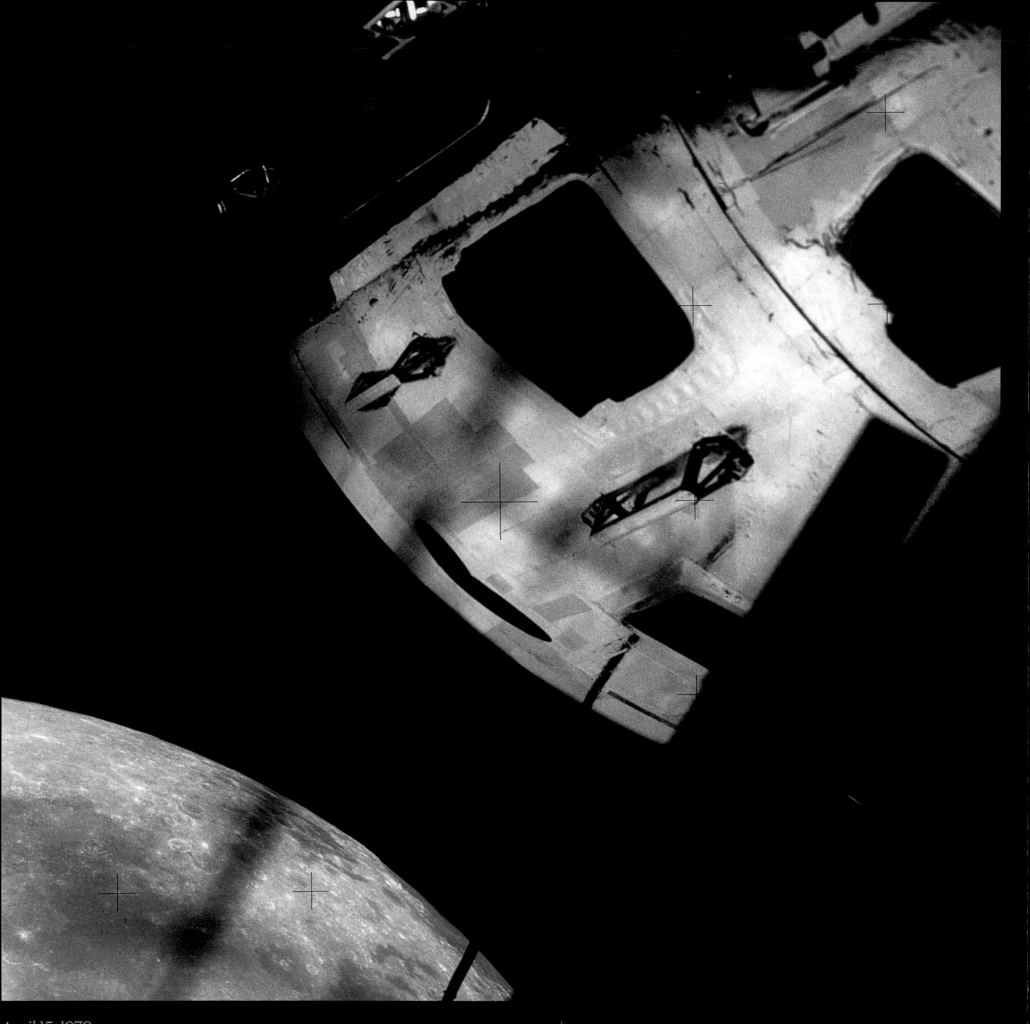

April 15, 1970

HASSELBLAD 70MM. LENS 60MM F/5.6 | BY UNKNOWN

NASA ID: **AS13-61-8739**

Lovell: "Stand by for AOS . . . All right, we're going up on Mare Smythii now . . . Oh, yes, yes, we're no longer 139 miles; we're leaving!" Haise: "Yes, look at that curvature." Mare Smythii, seen here is on the easternmost edge of the lunar nearside. With electrical power and water running short, the imminent 4-minute-24-second burn from the LM's descent engine would shorten their return by 10 hours. Mission Control: "Jim, you are Go for the burn. Go for the burn." *(EL: 4/5)*

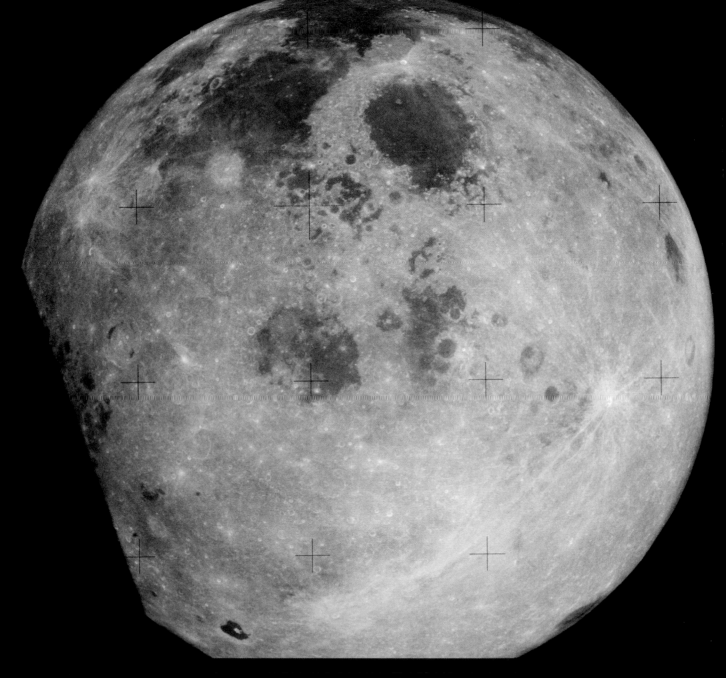

April 15, 1970

HASSELBLAD 70MM. LENS 60MM F/5.6 | BY UNKNOWN

NASA ID: AS13-61-8762

Haise: "There she goes, gang. The Moon." For the critical burn to be successful, the accuracy of the LM's alignment platform, which had been manually transferred from the dying CSM, had to be checked with the stars, but debris from the explosion made this impossible. One very bright star, the Sun, was used instead, and the burn, undertaken 5,500 miles from the Moon, was near perfect. Lovell: "Shutdown [of the engine] . . . and now we want to power down as soon as possible." *(EL: 2/5)*

April 15–16, 1970 HASSELBLAD 70MM. LENS 60MM F/5.6 | BY UNKNOWN NASA ID: AS13-62-8929

Lovell: "We just don't want to go to sleep here and forget about the rise in CO_2." As *Aquarius* was designed for only two crewmembers for 45 hours on the Moon, the three crewmembers would be poisoned by their own breath and needed to use the CO_2 filters from *Odyssey*. However, the CM's filters were square, and the LM's were round. Mission Control famously designed a workaround from the limited parts the crew had access to. *(EL: 2/5)*

April 15–16, 1970 HASSELBLAD 70MM. LENS 60MM F/5.6 | BY UNKNOWN NASA ID: **AS13-62-8932**

After the critical burn, all non-critical LM systems were powered down in an effort to save every last milliamp. This recovered image shows the darkened *Aquarius'* control panel. Also visible are sticky handwritten notes applied by Lovell and Haise, as reminders of how to control the spacecraft, in a very different manner than how they had trained. In the center is the blue "Contact light," which would confirm a lunar landing; this light would never illuminate. *(EL: 5/5)*

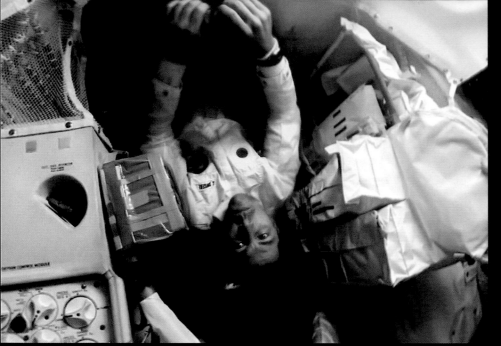

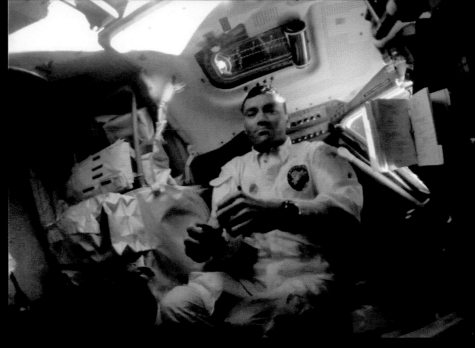

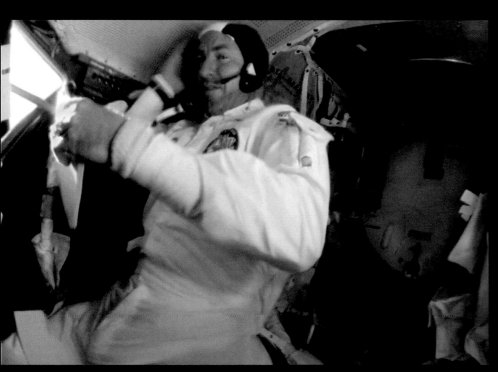

April 15–16, 1970 6–27 FRAMES OF 16MM FILM, STACKED AND PROCESSED NASA ID: **APOLLO 13 MAG 1142 & 1193**

Life on board Apollo 13. TOP LEFT: Swigert floats through the tunnel from the Command Module into the LM. The improvised, "mailbox" filter can be seen in-situ on the left. TOP RIGHT: Haise floats in *Aquarius*; the docking window is above his head and the tunnel to his right. BOTTOM LEFT: Lovell adjusts his communications headset; the "mailbox" scrubber and hatch/tunnel are behind him. BOTTOM RIGHT: Haise gazes out into space, the LM's *Guidance and Navigation Dictionary* to his right.

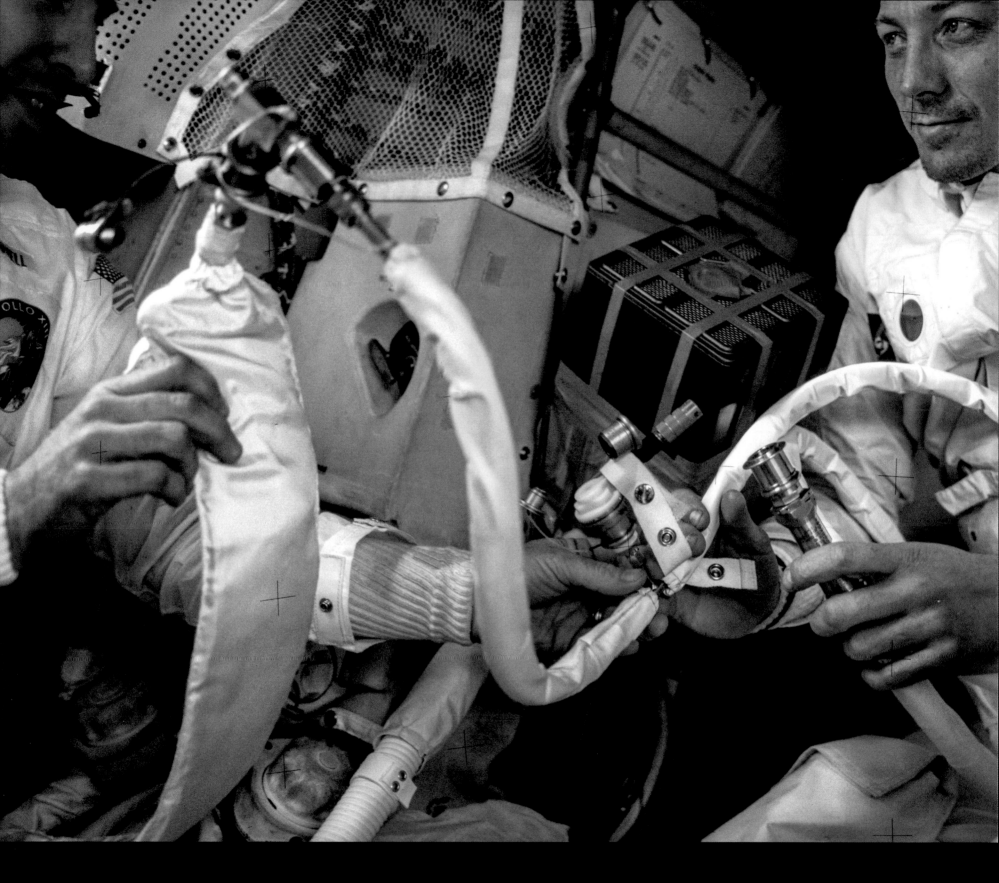

April 15–16, 1970 HASSELBLAD 70MM. LENS 60MM F/5.6 | BY FRED HAISE NASA ID: AS13-62-9003 TO 9004

This stitched panorama shows Lovell (left) and Swigert, working together on their water supply hoses close to the improvised CO_2 scrubber. The CO_2 hack included the use of plastic garment bags, socks, duct tape and a page torn from the flight plan (perhaps the one near Swigert's shoulder). Water, required for equipment cooling as well as drinking, was severely rationed, leading to acute dehydration. This contributed to Haise becoming ill, contracting a urinary tract infection. *(Panorama, EL: 3/5)*

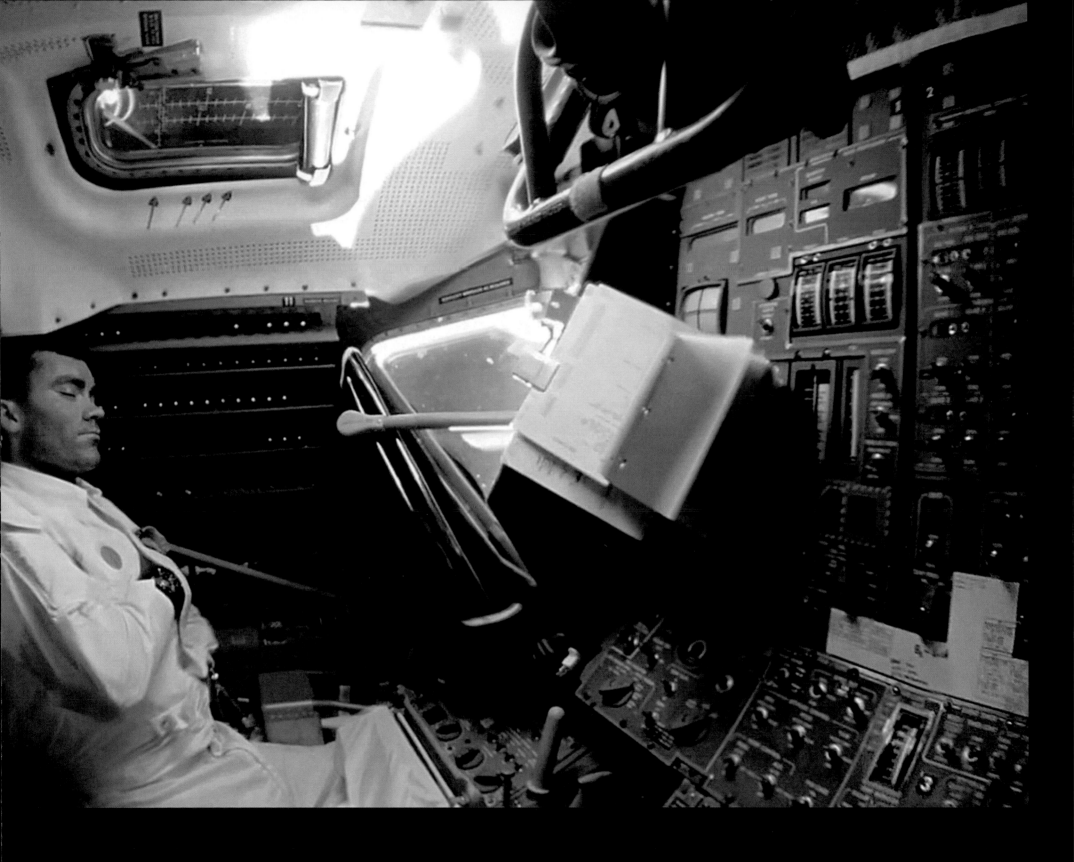

April 15–16, 1970 21 FRAMES OF 16MM FILM, STACKED, PROCESSED AND STITCHED NASA ID: **APOLLO 13 MAG 1142**

Lovell: "You know, we've gone a hell of a long time without any sleep." Commander Lovell (hand, left) keeps watch over his ship and crew as they try to rest in the cold, dark LM. Haise has his arm tucked away while Swigert is curled up on the ascent engine cover in the storage area; the tunnel to the CM is above him.

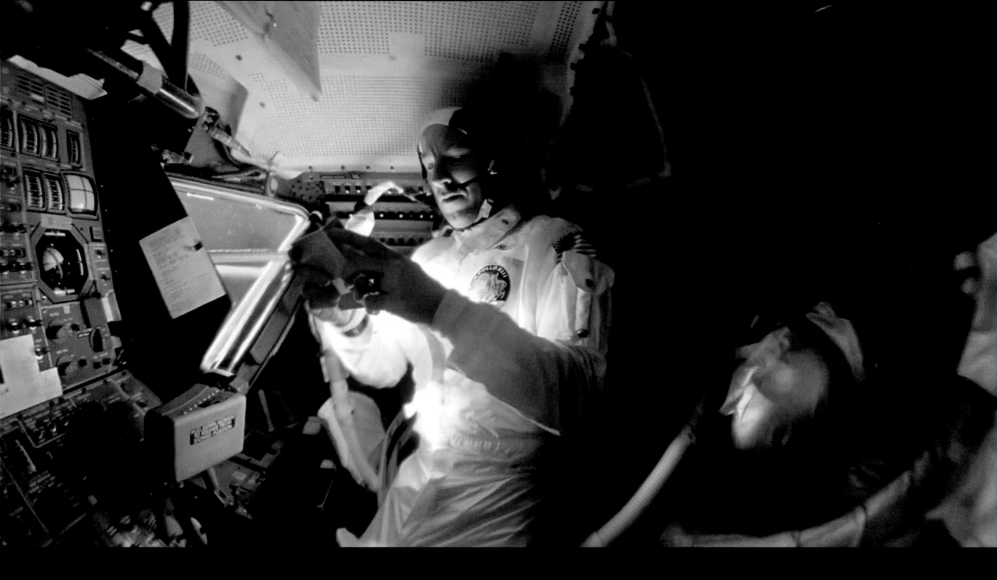

April 15–16, 1970 21 FRAMES OF 16MM FILM, STACKED, PROCESSED AND STITCHED NASA ID: **APOLLO 13 MAG 1142**

Lovell selects some music on the portable tape player – the playlist included "The Age Of Aquarius" and "2001: A Space Odyssey." Swigert is curled up asleep on the ascent engine cover near the tunnel; this was the warmest area of the freezing spacecraft.

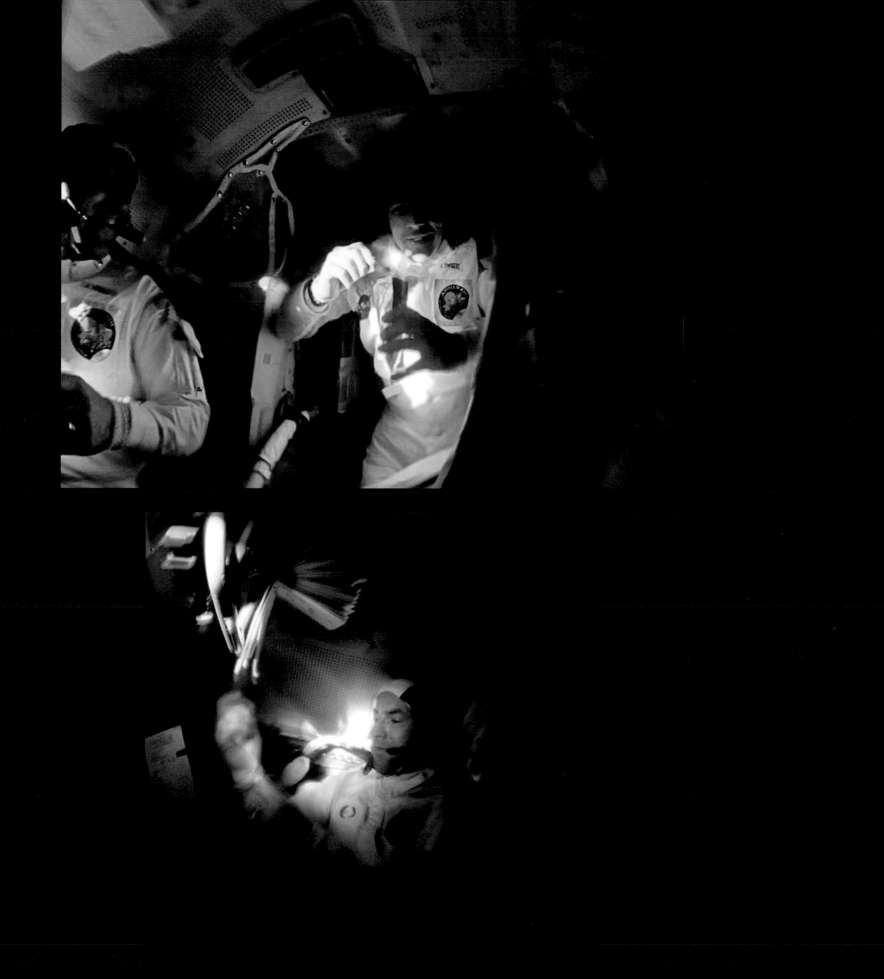

April 15–16, 1970　　　　6 AND 75 FRAMES OF 16MM FILM, STACKED AND PROCESSED　　　　NASA ID: **APOLLO 13 MAG 1208 & 1193**

TOP: The crew in apparently high spirits as they take on some food. Only cold water was now available for the freeze-dried food; Lovell lost 14lbs during the mission. BOTTOM: Lovell adjusts his Speedmaster wristwatch – a critical, manual midcourse correction burn was soon required that would need to be hand-timed.

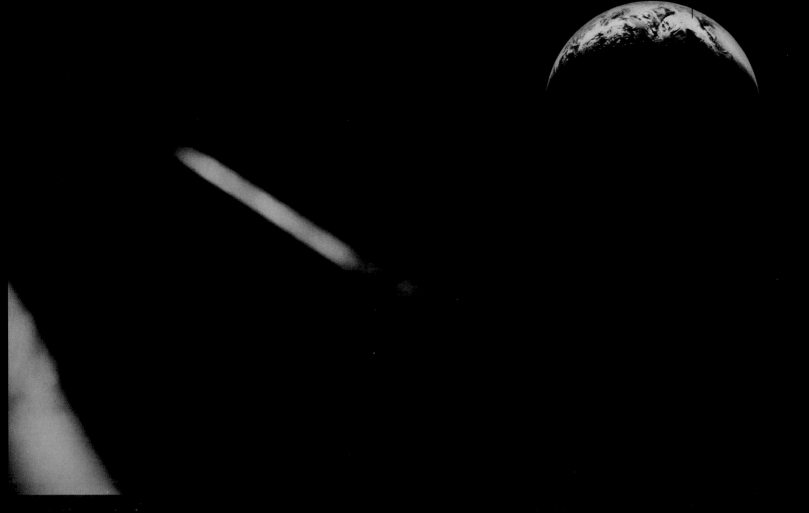

April 15–16, 1970

HASSELBLAD 70MM. LENS 60MM F/5.6. B&W | BY UNKNOWN

NASA ID: AS13-59-8495

To save electrical power, the LM's guidance computer had been powered down. A manual midcourse correction burn would need to be perfect or the crew would later burn up in the atmosphere or skip right off it and never return. Earth's terminator (the shadow line between "day" and "night") would be "eyeballed" and kept in the COAS cross-hairs in the window to maintain the correct attitude. Lovell controlled pitch and roll, Haise controlled yaw, and Swigert timed the 14-second burn on his wristwatch. Mission Control: "Looks good. Nice work." Haise: "Let's hope it was . . ." (EL: 4/5)

April 15–16, 1970 HASSELBLAD 70MM. LENS 60MM F/5.6 | BY FRED HAISE NASA ID: **AS13-62-8988 & 8990**

Swigert to Mission Control: "I'll tell you, Deke, it's cold up in there [in *Odyssey*]. I don't know whether we'll be able to sleep up there tonight; it must be about 35 or 40 degrees [Fahrenheit] (2–4 degrees Centigrade)." Mission Control: "Have you guys put on any extra clothes?" Lovell: "Well, the lunar boots and two pair of underwear . . ." Lovell can be seen here in his unused lunar boots, trying to keep warm as he takes a nap in *Aquarius*. *(Panorama, EL: 5/5)*

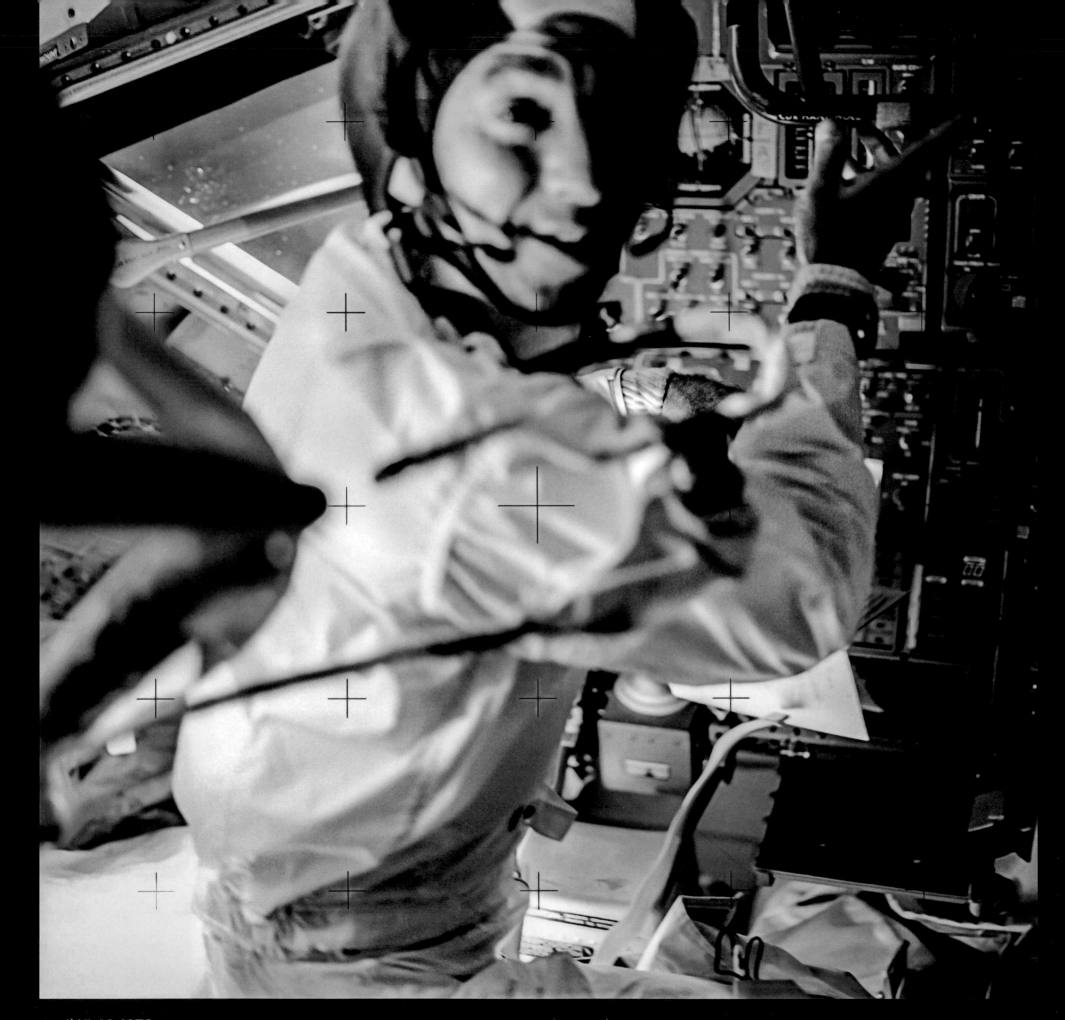

April 15–16, 1970 HASSELBLAD 70MM. LENS 60MM F/5.6. B&W │ BY JACK SWIGERT NASA ID: **AS13-59-8484**

Lovell to Mission Control: "Soon as we get rid of the Service Module, Joe, I think I'll be able to maneuver a lot better." Since the explosion, the crew has had to learn to fly the stack of two spacecraft, using the LM's descent engine; an engine only designed to lower the LM to the lunar surface. As Earth grew larger in the windows, Lovell prepared to jettison the Service Module. It would give the crew their first view of the damage caused by the explosion 82 hours earlier. *(EL: 4/5)*

April 17, 1970

HASSELBLAD 70MM. LENS 250MM F/5.6 | BY UNKNOWN

NASA ID: AS13-58-8464

Lovell: "Okay, I've got her, Houston . . . And there's one whole side of that spacecraft missing! . . . Right by the high-gain antenna, the whole panel is blown out, almost from the base to the engine." The crew relayed their observations to Mission Control and photographed the crippled Service Module from *Aquarius*, at a range of around 880 feet. Haise: "Yes, it looks like it got to the SPS bell, too, Houston . . . unless that's just a dark brown streak. It's really a mess." (Cropped. Fl: 5/5)

April 17, 1970 HASSELBLAD 70MM AND 16MM DAC FILM, STACKED AND PROCESSED NASA IDS: **AS13-59-8500, APOLLO 13 MAG 1038, AS13-58-8464**

Some of the most detailed images of the damaged Service Module to date. Bay 4 is clearly seen with its cover blown off by the blast from cryogenic Oxygen Tank 2. Two of the three fuel cells (top); parts of the hydrogen tank, cables, hoses, shelves and blown-out Mylar/Kapton are visible and the large stain/damage to the engine nozzle is evident. *(Cropped, rotated, EL: 5/5)*

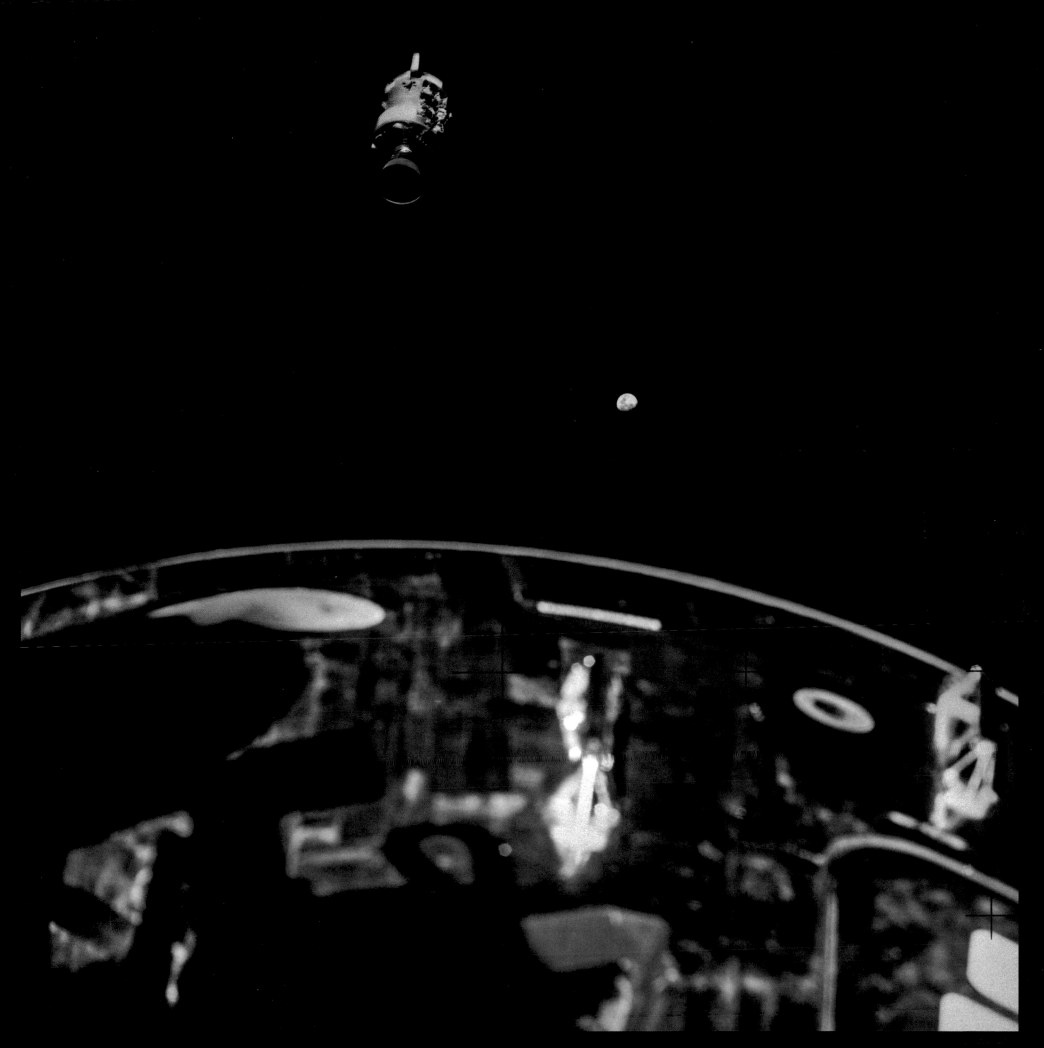

April 17, 1970

HASSELBLAD 70MM. LENS 60MM F/5.6. B&W | BY UNKNOWN NASA ID: AS13-59-8500

Lovell and Haise were in the LM and Swigert was alone in the CM to activate the Service Module separation, but had placed tape over the LM separation switch in case he raised that one by accident. Mission Control: "We'd like you to get some pictures, but . . . don't make unnecessary maneuvers." Lovell: "She's drifting right down in front of our windows now, Houston." At a distance of 35,000 miles from Earth, the damaged, separated Service Module, Command Module Odyssey and the lost Moon in one photograph. (Rotated. FL: 5/5)

April 15–17, 1970 HASSELBLAD 70MM. LENS 60MM F/5.6 | BY UNKNOWN NASA ID: **AS13-62-903**

Odyssey, pictured through the LM's docking window, had been powered down since the explosion. A trickle charge from the LM would boost the little battery power remaining, which was vital for re-entry systems, including operation of the parachutes. A detailed, lengthy power-up procedure to limit consumption and awaken Odyssey from its deep sleep, was designed and read up to Swigert. Opportunity for errors, owing to the crew's condition and lack of sleep was becoming a major concern. *(EL: 3/5)*

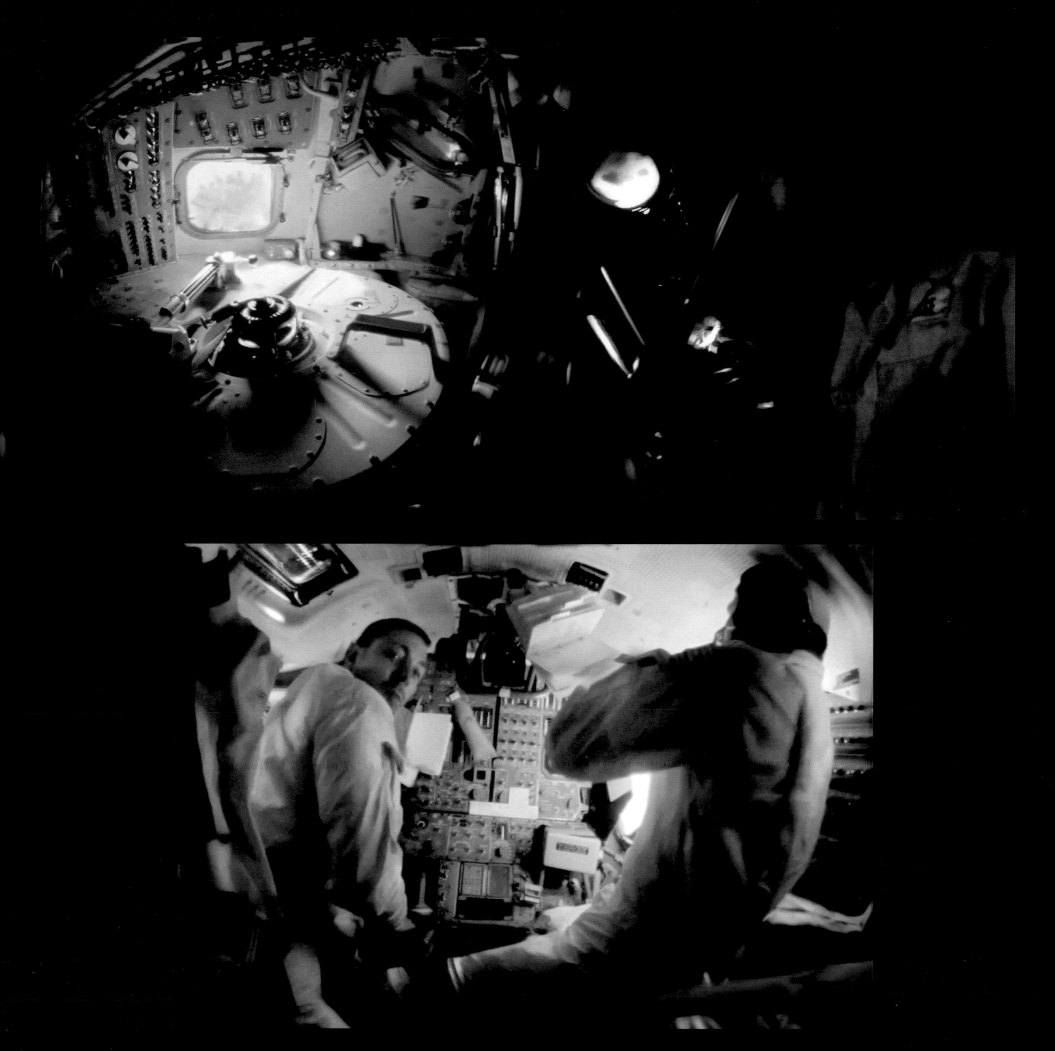

April 15–17, 1970 40 AND 8 FRAMES OF 16MM FILM, STACKED, PROCESSED AND STITCHED NASA ID: **APOLLO 13 MAG 1193**

TOP: Haise checks out the dark, powered-down *Odyssey*. The hatch is strapped down and the windows had frosted over in the near-freezing, damp environment. The panels and switches were soaking wet. Haise wiped them down with a towel before Swigert went through the power-up procedure. Breakers were only reinserted six at a time to allow the crew time to smell burning insulation and deal with any short circuits if they occurred. Improvements as a result of the Apollo 1 fire contributed significantly to *Odyssey*'s hardiness. BOTTOM: Haise returns through the tunnel to *Aquarius*.

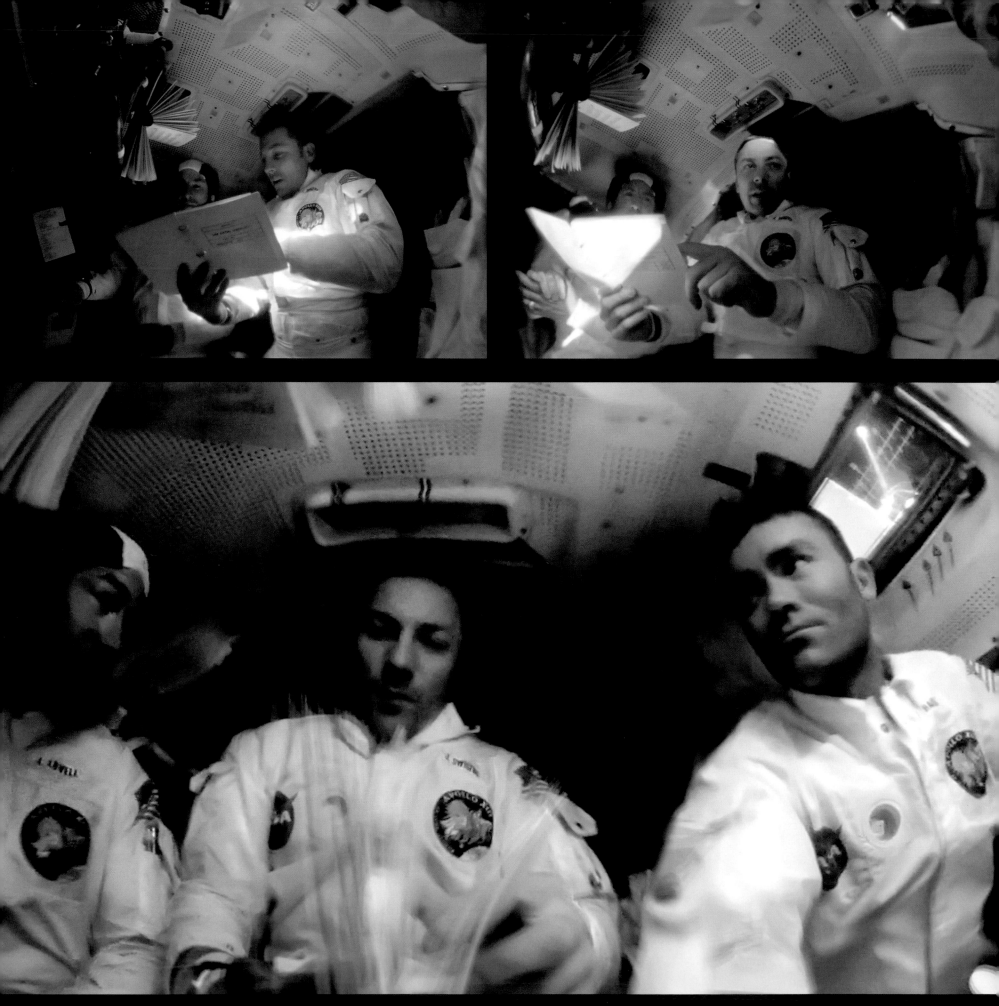

April 15–17, 1970 12–35 FRAMES OF 16MM FILM, STACKED AND PROCESSED NASA ID: **APOLLO 13 MAG 1193**

The crew of Apollo 13, (left to right) Lovell, Swigert and Haise, together as they prepare for re-entry into Earth's atmosphere. The document "Apollo 13 CSM Entry Checklist" contained the procedures they would need to follow. At this late stage in the mission, it was still unclear whether the heat shield would protect them or if the parachutes would function with the little power remaining. Commander Lovell was the last to leave the LM: "Okay, Houston; Aquarius. I am at the LM Sep attitude and I'm planning on bailing out."

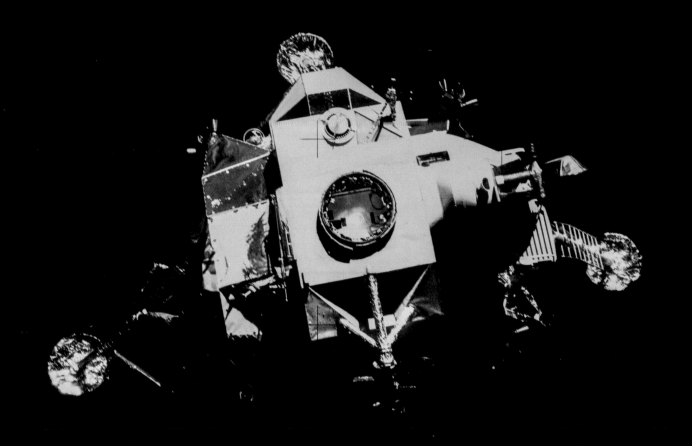

April 17, 1970 HASSELBLAD 70MM. LENS 60MM F/5.6. B&W | BY UNKNOWN NASA ID: **AS13-59-8567**

An hour before re-entry, having moved into *Odyssey*, the crew jettisoned the LM that had kept them alive and got them home. Mission Control: "Farewell *Aquarius* and we thank you." Swigert: "She sure was a good ship." With doubts remaining about the integrity of the heat shield and countless other variables, Apollo 13 plunged into the atmosphere. After a nerve-wracking communications blackout lasting one minute 27 seconds longer than expected, Apollo 13 splashed down safely in the Pacific Ocean. *(Cropped, EL: 4/5)*

THE DETAILS

ROCKET
Saturn V (AS-509)

COMMAND AND SERVICE MODULE
Kitty Hawk (CSM-110)

LUNAR MODULE
Antares (LM-8)

LAUNCH
21:03 GMT,
January 31, 1971, Pad 39A

LANDING SITE
Fra Mauro Highlands

DISTANCE
1,150,321 miles

DURATION
9 days, 1 minute, 58 seconds

SURFACE TIME
33 hours, 31 minutes

LUNAR ORBITS
34

SPLASHDOWN
21:05 GMT,
February 9, 1971,
Pacific Ocean

RECOVERY SHIP
USS *New Orleans*

THE CREW

Alan B. Shepard Jr.
COMMANDER (CDR)

Born November 18, 1923. Shepard was one of NASA's "Original 7" Mercury astronauts and in May 1961 became the first American in space. He would have been Command Pilot on the first Gemini mission, but was grounded due to an inner ear problem. A surgical correction in 1969 restored his flight status. At age 47, Apollo 14 would be his last spaceflight and he retired in 1974.

Stuart A. Roosa
COMMAND MODULE PILOT (CMP)

Born August 16, 1933. A former USAF pilot and test pilot, Roosa joined NASA in 1966 as part of their fifth intake of astronauts. He was CAPCOM and one of the first on the scene of the Apollo 1 fire. Apollo 14 was his first spaceflight and, despite being assigned as back-up CMP on Apollo 16 and Apollo 17, he never flew again in space and retired in 1976.

Edgar D. Mitchell
LUNAR MODULE PILOT (LMP)

Born September 17, 1930. A former U.S. Navy officer and test pilot, Mitchell joined NASA as part of their fifth intake of astronauts, along with Roosa, in 1966. He was back-up LMP on Apollo 10 and Apollo 16 but this would be his only spaceflight, and he would become the sixth man to walk on the Moon. He retired from the Navy and NASA in 1972.

January 31–February 9, 1971

APOLLO 14

THE MISSION

Originally scheduled for 1970, Apollo 14 was delayed, pending the investigation into the Apollo 13 explosion and recommended modifications to the CSM. Come launch day, tighter restrictions for acceptable launch conditions as a result of the Apollo 12 lightning strikes led to a delay of 40 minutes.

The "rookie crew" (with only a few minutes of experience in space between them: Shepard's suborbital Mercury flight, almost ten years earlier) encountered no further issues until after TLI. It took six attempts over a period of two hours to dock with the LM, ending Roosa's hopes of setting a record for the least fuel consumed during the maneuver. The crew brought the incommodious probe assembly into the CM for a close inspection, but could find no obvious defect. A failure to dock later in the mission when Shepard and Mitchell returned from the lunar surface could have led to an unthinkable, gut-wrenching scenario.

During LM checkout it was found that the computer was receiving an erroneous message to abort. A rather rudimentary investigative approach to assessing the problem, which involved Mitchell tapping the console near the switch to potentially shake something loose, worked only temporarily. The computer was programmed to ignore the abort command, to allow for a safe descent.

At 30,000 feet, the radar failed to lock onto the lunar surface. If it failed to lock on by 10,000 feet, flight rules would dictate an aborted landing. Recycling the breakers brought it back on-line and *Antares* touched down at Fra Mauro, just 87 feet from its target location.

EVA-1 included the successful deployment of the ALSEP. The crew then returned to *Antares*, but due to landing on an 8-degree angle there was little sleep during the scheduled rest period. They both had the feeling they were tipping over during the night and it was Mitchell's job to roll back the blinds and take a peek outside to ensure they were not.

EVA-2 involved a hike to the rim of Cone crater, 0.7 miles away. The steep, soft, boulder-strewn surface was tough going and the time-line dictated they had to give up on the search. It was later shown they had got to within a tantalizing 100 feet of the rim, but didn't recognize it, missing out on a doubtlessly incredible view and stunning photographs.

Despite all the great science and the near mission-ending problems, which, after Apollo 13, would have surely ended the whole program, Apollo 14 is perhaps best remembered for the final moments on the surface, when Shepard pulled out a 6-iron and two golf balls. Playing one-handed in a bulky spacesuit, from a terrible lie, in a giant sand trap (bunker) wasn't conducive to a great strike. The first attempt got "more dirt than ball." The second, Shepard famously declared, went "miles and miles and miles" in the low-gravity, airless environment. In research for this book, however, I found the elusive second ball and, by studying the 16mm film of the ascent, and Lunar Reconnaissance Orbiter imagery from 2009, calculated the distance at 40 yards. Less impressive, but an incredible effort in the circumstances and a public relations triumph. Shepard will forever be remembered as the first person to play sport on another world.

Apollo 14 recorded the longest time on the surface to that date, and traversed the greatest distance. That would soon change with the upcoming "J-missions" and the introduction of the lunar rover.

THE PHOTOGRAPHY

Due to the Apollo 13 accident, Apollo 14 was effectively the first mission to utilize the red "Commander Stripes" to identify one astronaut from the other in photographs. It was also the first time a Hasselblad camera made it back to Earth from the lunar surface, after Shepard encountered similar problems as the Apollo 12 crew with the handle. Also, as on Apollo 12, a mix-up led to a magazine being left on the lunar surface – this time a 16mm DAC magazine, still attached to the camera.

Photography of potential J-mission landing sites was completed from orbit. Meanwhile, on the surface, Shepard aimed his camera skyward to capture a crescent Earth above the LM, inadvertently also capturing Venus – two celestial bodies in one shot, photographed from another. Moments later he would play the two most famous, out-of-this-world golf shots in history.

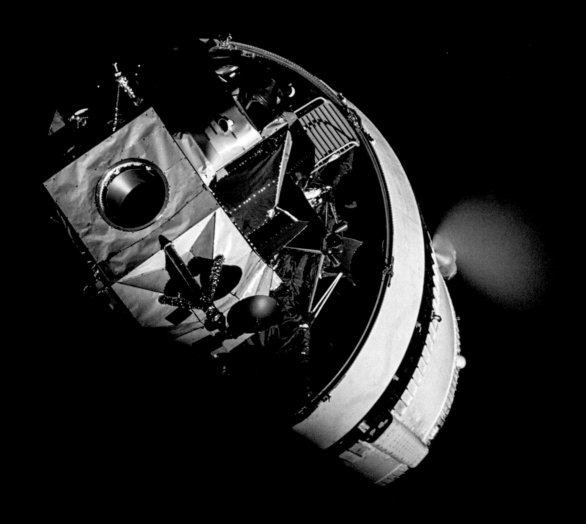

February 1, 1971 HASSELBLAD 70MM. LENS 80MM F/2.8 | BY UNKNOWN NASA ID: **AS14-72-9919**

Mission Control: "That vent is due in 30 seconds . . ." When the Sun heats up the liquid hydrogen in the S-IVB, it must be vented to avoid a dangerous pressure build-up. Roosa: "Man, that's beautiful!" The vent was required during a protracted docking sequence lasting two hours, as the CSM repeatedly failed to latch onto the LM. Roosa: "And here we come in again . . . 1, 2, 3, 4 – son of a bitch – nothing!" Finally, on the sixth attempt, the crew were relieved to hear the unmistakable sound of the latches engaging. *(Cropped, EL: 2/5)*

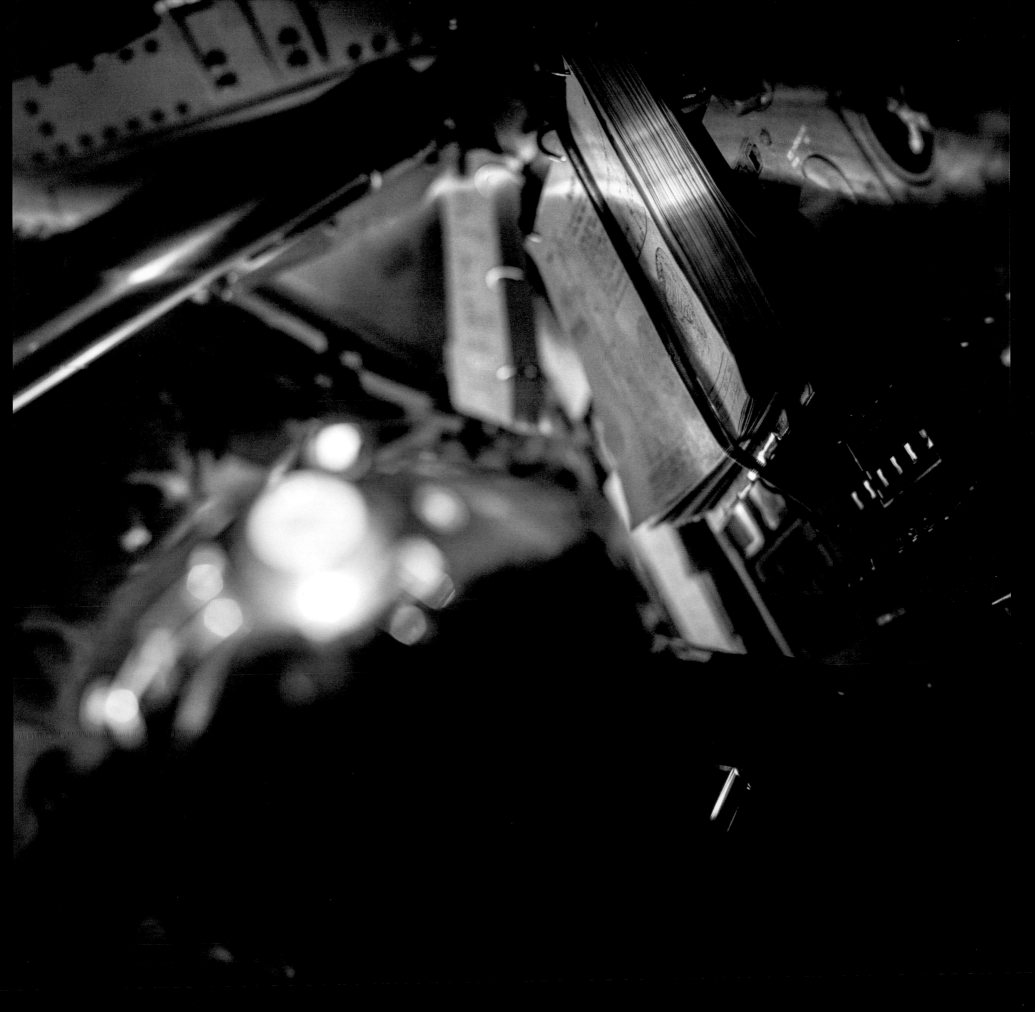

February 1, 1971 HASSELBLAD 70MM. LENS 80MM F/2.8 | BY UNKNOWN NASA ID: **AS14-76-10331**

At the end of day one, the crew brought the docking probe assembly inside the CM for close inspection. Roosa: "I can't see anything wrong with the probe anywhere." This recovered image shows the probe in the foreground, mission documents strapped to the CM's control panel and Roosa beyond. It is the only recognizable still photograph of any crewmember during the whole mission. *(EL: 5/5)*

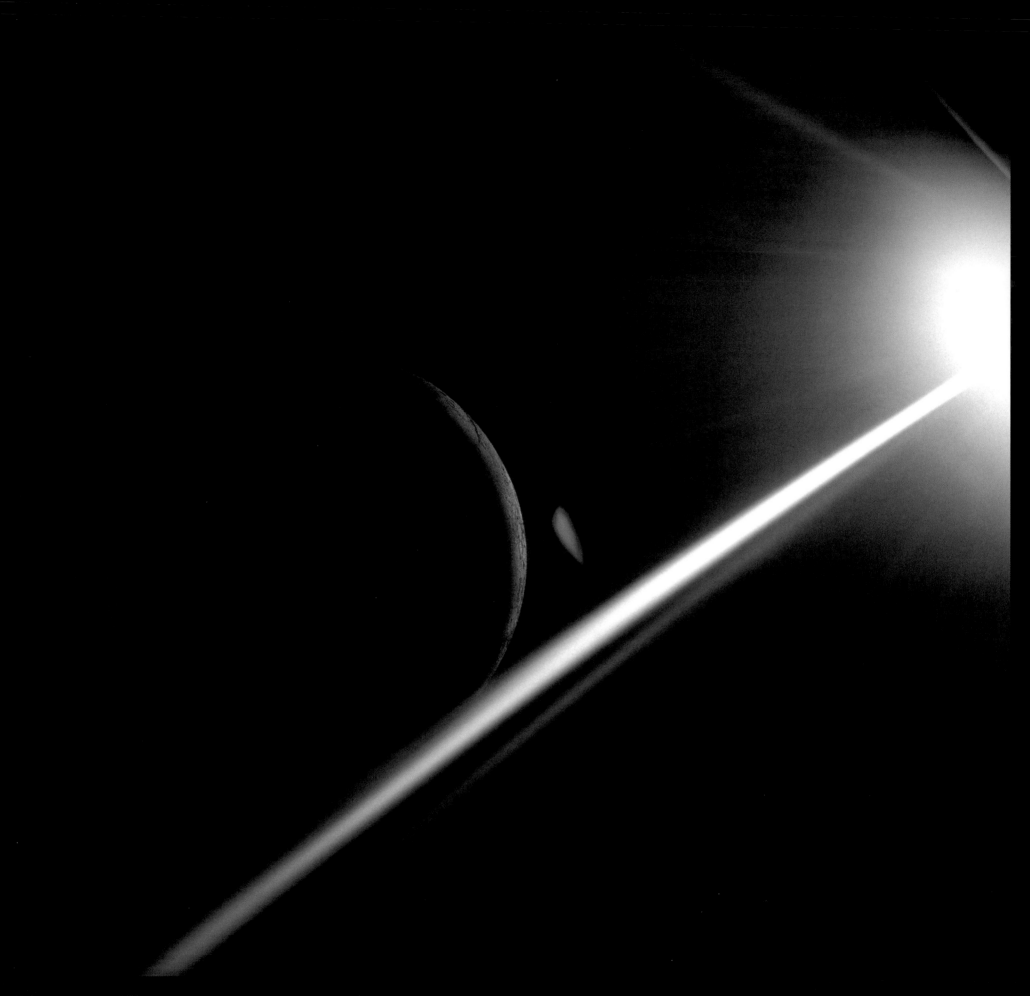

February 1–2, 1971 HASSELBLAD 70MM. LENS 500MM F/8 | PROBABLY BY STUART ROOSA NASA ID: **AS14-72-9938**

The Sun illuminates the Moon in this image taken during trans-lunar coast. Mitchell: "Houston, 14. We have the Moon out the hatch window right now. It's really starting to look very interesting from this point of view . . . As it swings past the window, it's very low; and I — we only have just a few minutes on each window. But it's a most inviting and magnificent view." *(Rotated, EL: 4/5)*

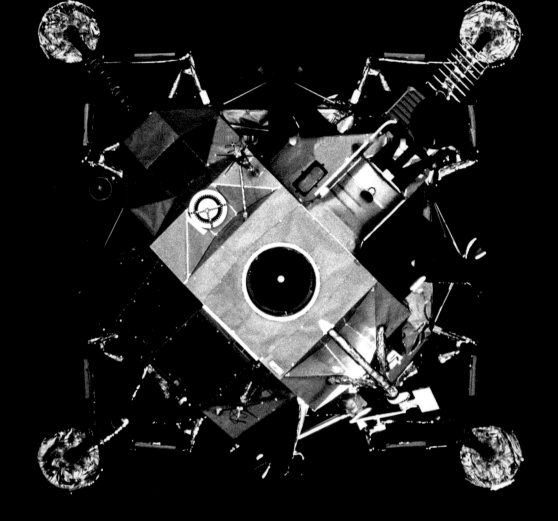

February 5, 1971 HASSELBLAD 70MM. LENS 80MM F/2.8 | BY STUART ROOSA NASA ID: AS14-74-10206

The previously troublesome docking mechanism functioned perfectly as LM *Antares* separated from *Kitty Hawk*. On board the LM, however, the computer was erroneously recognizing an abort request. It would spell disaster if this were to happen during descent to the surface. Haise (Mission Control): "Could you tap on the panel around the Abort push button and see if we can shake something loose?" This appeared to work, but only temporarily. The computer had to be re-programmed to ignore any abort request. *(Cropped, EL: 3/5)*

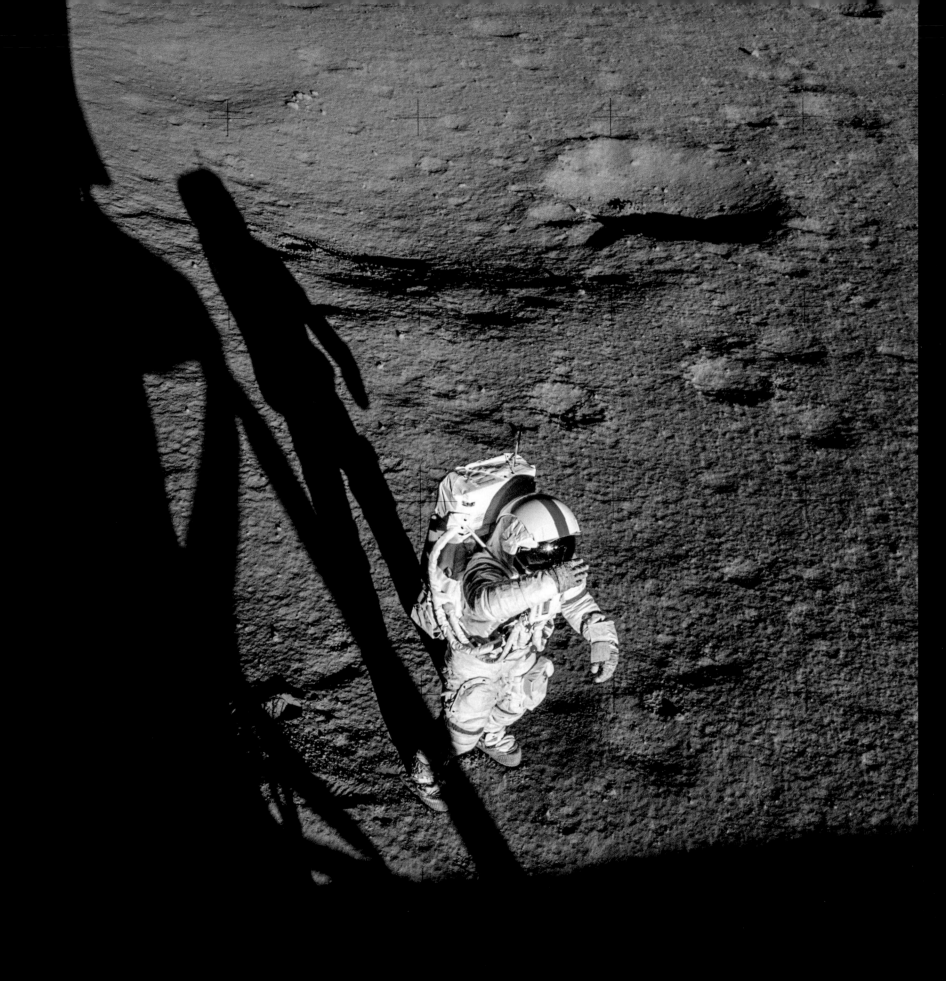

February 5, 1971 **EVA-1** HASSELBLAD 70MM. LENS 60MM F/5.6 | BY EDGAR MITCHELL NASA ID: **AS14-66-9230**

For the landing, Shepard took over manual control and touched down just 87 feet from the target landing site. Five hours later, Shepard, who had become the first American in space ten years earlier, set foot upon the Moon: "It's been a long way, but we're here!" Shielding his eyes from the Sun: "Take a look at Cone crater . . . which is right where it should be, and is a very impressive sight. You can see the boulders near the rim." Note Shepard's red "Commander Stripes." *(EL: 3/5)*

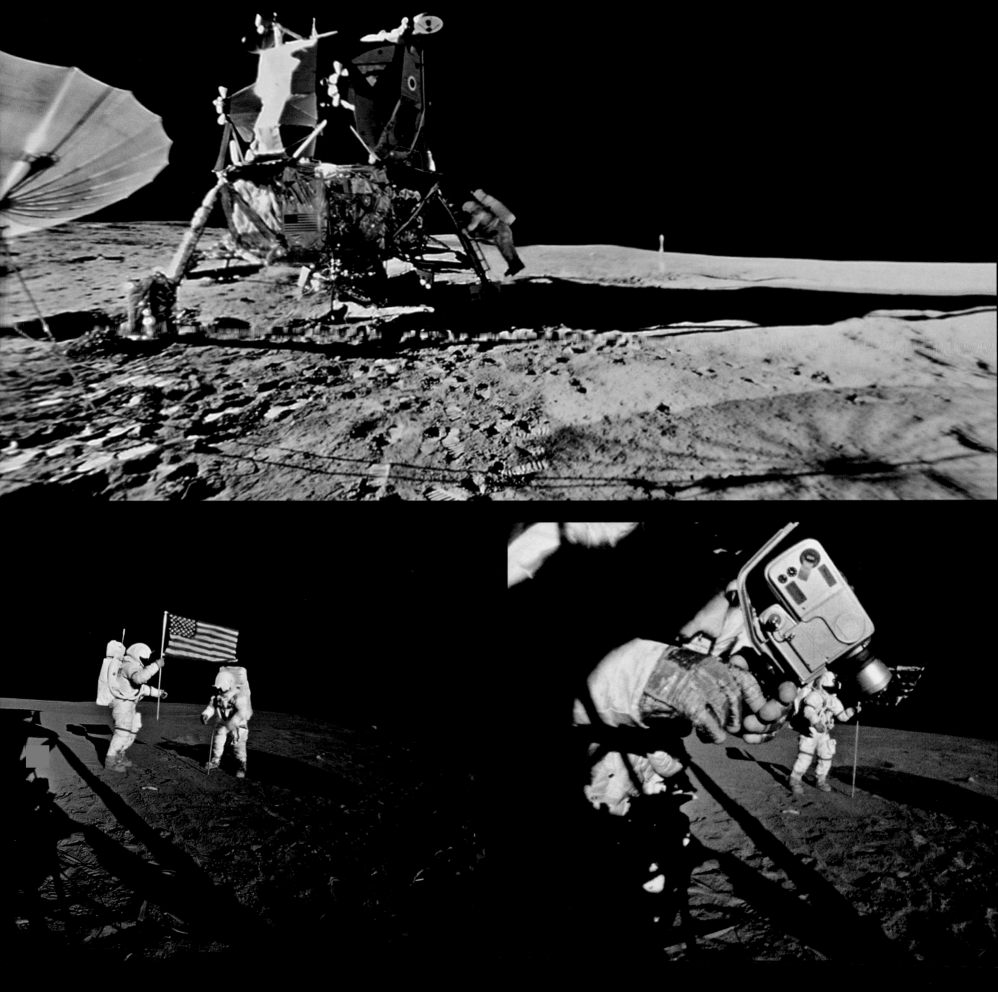

TOP: Unlike on previous missions, the LMP egressed almost immediately after the Commander. Here, Mitchell is descending the ladder for the second time, having re-entered the LM to switch to the ▮▮▮band antenna (foreground). BOTTOM LEFT: Mitchell: "OK, get my [16 mm] camera going here." Shepard holds the flag as Mitchell hammers the pole into the lunar regolith. BOTTOM RIGHT: A close-up of the Hasselblad HDC camera. Shepard is with the erected flag beyond.

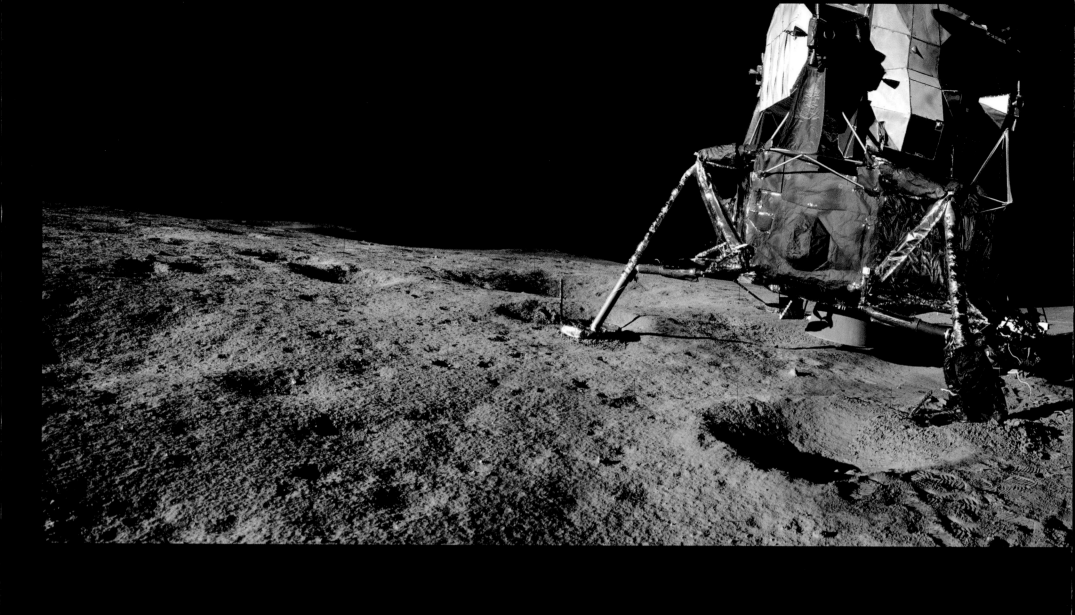

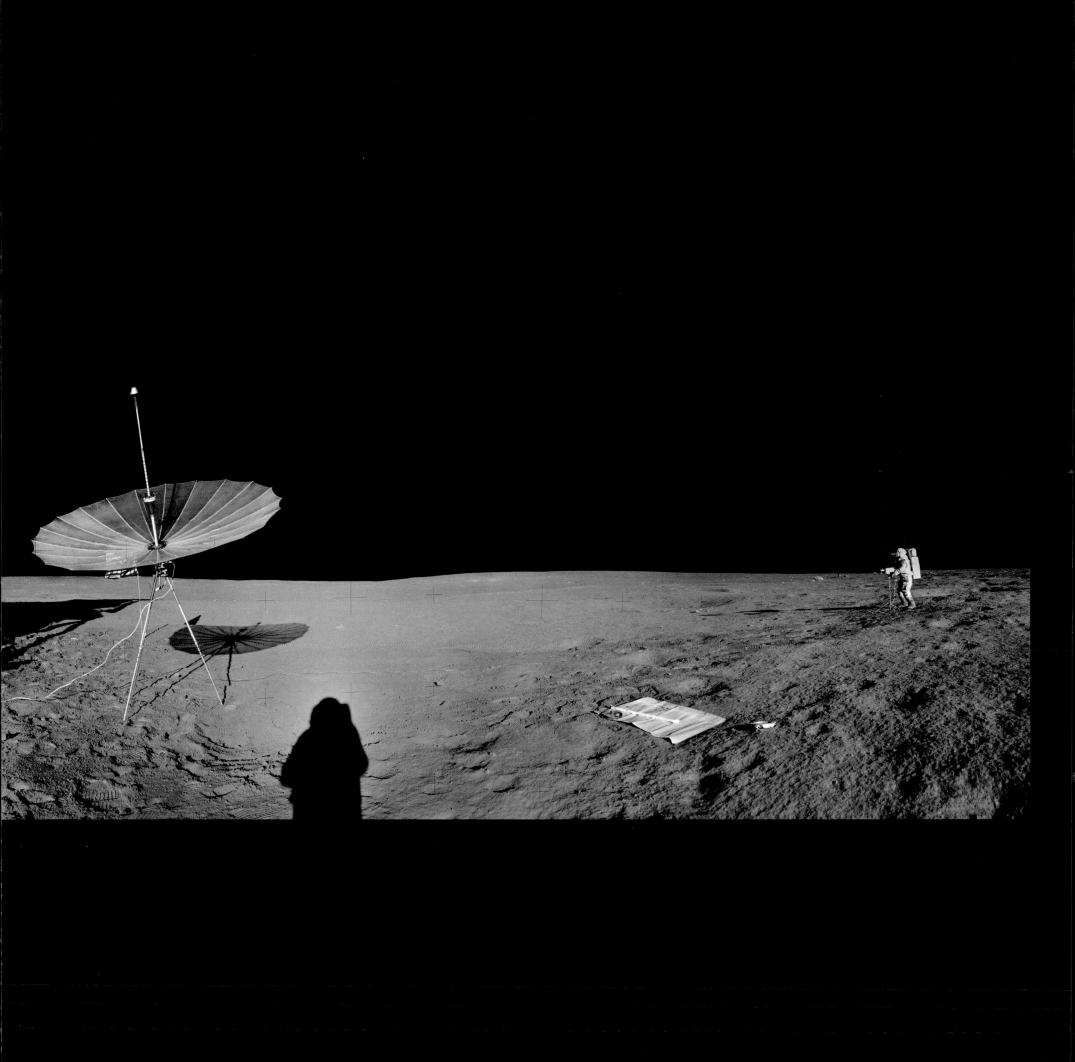

February 5, 1971 **EVA-1** HASSELBLAD 70MM. LENS 60MM F/5.6 | BY ALAN SHEPARD NASA ID: **AS14-66-9236 TO 9257**

Shepard: "Well, I can see the reason we have a tilt is because we landed on a slope." As Shepard takes panoramas of the LM and landing site, Mitchell (right) is at the TV camera, panning in sections, to show Mission Control their environment and any features of specific interest: "Okay. How's your picture now? . . . Can you see the horizon? . . . The far horizon, Bruce, is a ridge that seems to run around this bowl that we're sitting in." *(Panorama, EL: 3/5)*

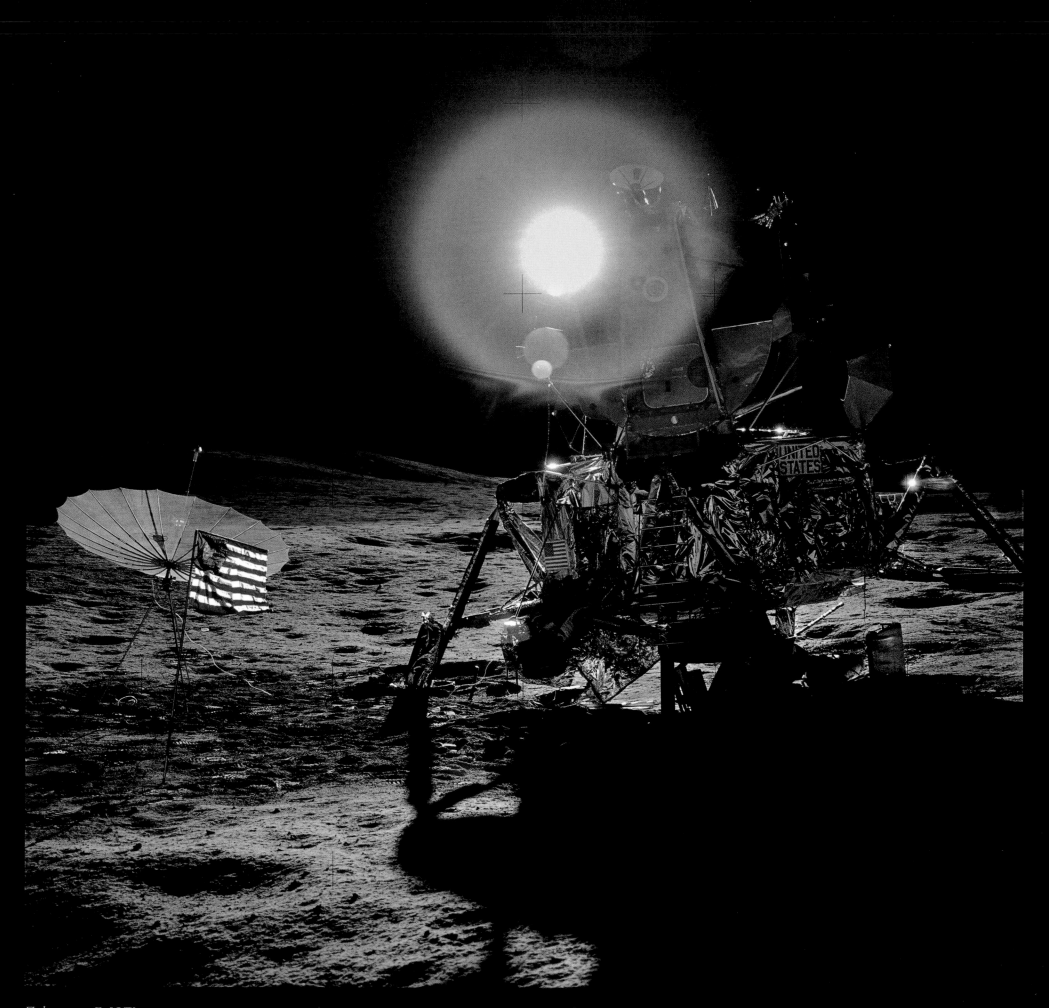

February 5, 1971 EVA-1 HASSELBLAD 70MM. LENS 60MM F/5.6 | BY ALAN SHEPARD NASA ID: AS14-66-9305

The low Sun casts long shadows at Fra Mauro. The lunar landings were planned such that the landing sites would be close to the terminator (shadow line) at the time of landing for this purpose. The rim of Cone crater is 0.7 miles in the distance. In the foreground, *Antares* is pitched over at an 8-degree angle, which contributed to a sleepless night for the crew. The limit, to enable a safe ascent from the surface, was 12 degrees. *(EL: 4/5)*

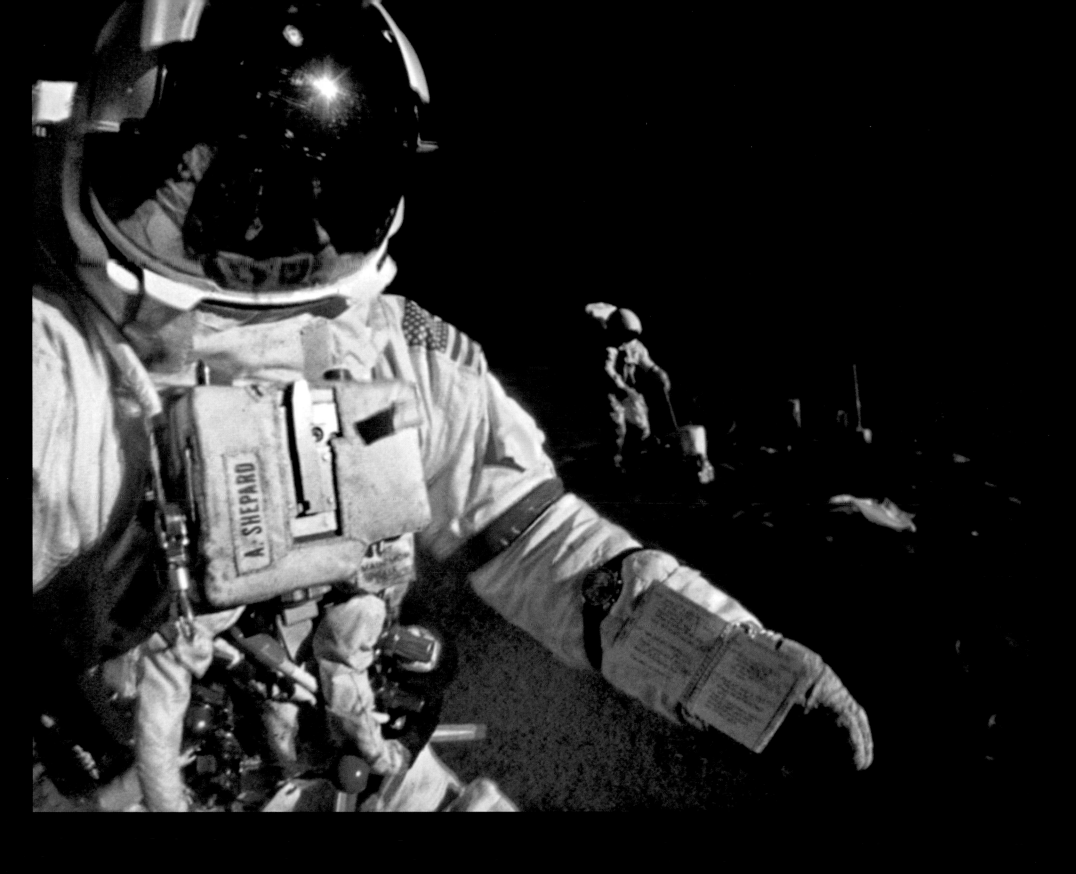

February 5, 1971 **EVA-1** 3 FRAMES OF 16MM FILM, STACKED AND PROCESSED NASA ID: **APOLLO 14 MAG 1180**

Shepard: "Houston, we will start the 16-millimeter going here . . . Magazine Echo-Echo will be going on. Okay; f/8, six frames per second, 250th." Shepard set the 16mm DAC camera up to record the ALSEP deployment and was inadvertently captured in the first few frames as he did so. Mitchell is in the background, continuing to set up the experiments package.

February 5, 1971 EVA-1 HASSELBLAD 70MM. LENS 60MM F/5.6 | BY ALAN SHEPARD NASA ID: AS14-67-936?

The Passive Seismic Experiment (PSE) was used to measure seismic events caused by moonquakes and meteor impacts. However, as with other Apollo seismic experiments, the Saturn V's, S-IVB boosters and LM ascent stages were also deliberately crashed into the Moon after use to calibrate the system. The seismic experiments continued to send useful data back to Earth until 1977.

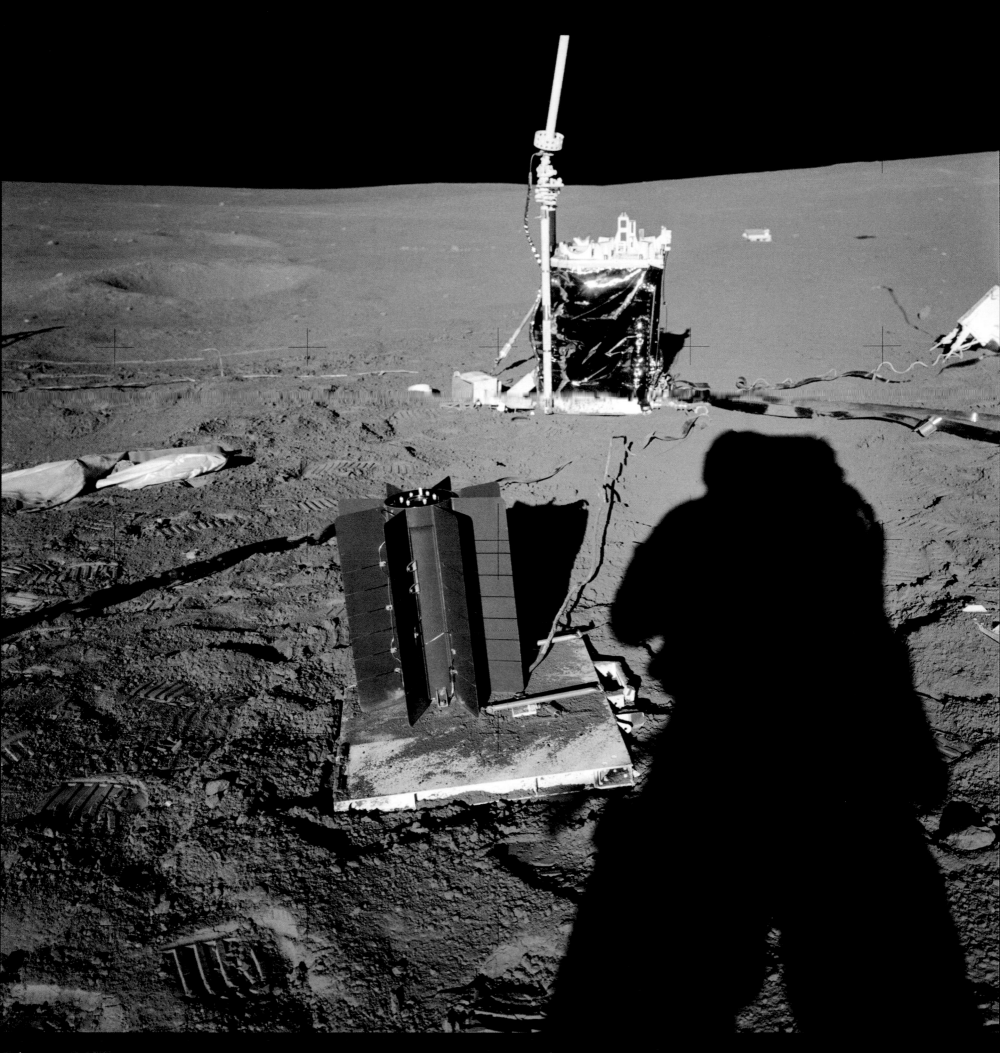

February 5, 1971 **EVA-1** HASSELBLAD 70MM. LENS 60MM F/5.6 | BY ALAN SHEPARD NASA ID: **AS14-67-9366**

The ALSEP was deployed approximately 600 feet from the LM. In the foreground is the RTG plutonium fuel element, which provided power for the experiments. The gold, Kapton-covered unit is the Central Station, to which each experiment was connected and which could communicate with Earth. In the distance is the laser reflector, used to accurately measure the distance from Earth, and far right is a mortar pack – part of the Active Seismic Experiment (ASE); it contains rocket-launched grenades. *(EL: 2/5)*

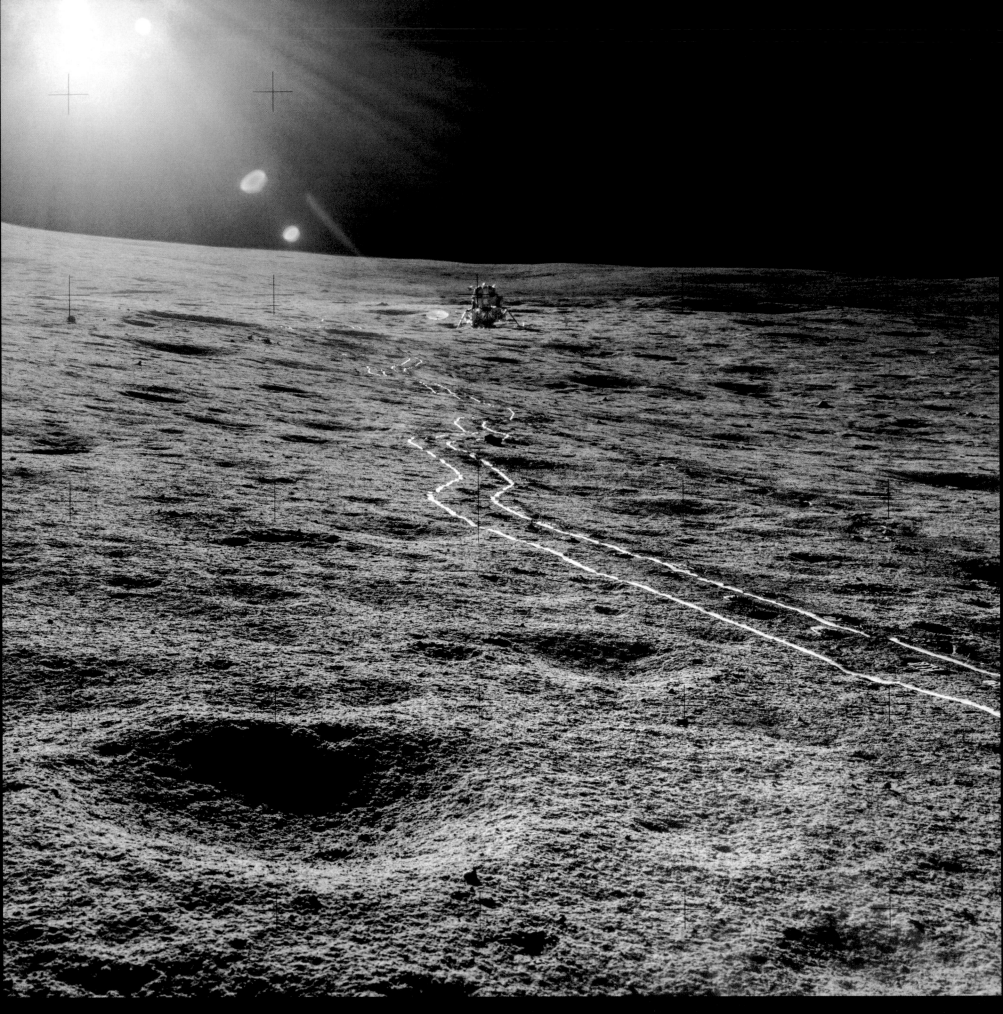

February 5, 1971 EVA-1 HASSELBLAD 70MM. LENS 60MM F/5.6 | BY ALAN SHEPARD NASA ID: AS14-67-9367

A look back at the crew's temporary home on the Moon from the ALSEP site, some 600 feet away. Mitchell: "We can see the MET tracks clear back to the LM. They're about three-quarters of an inch deep." The MET (Modular Equipment Transporter) was a two-wheeled hand-pulled vehicle used exclusively on Apollo 14. Its nitrogen-filled tires were designed by Goodyear. It carried equipment, tools and cameras, and could be used as a portable workbench. *(EL: 5/5)*

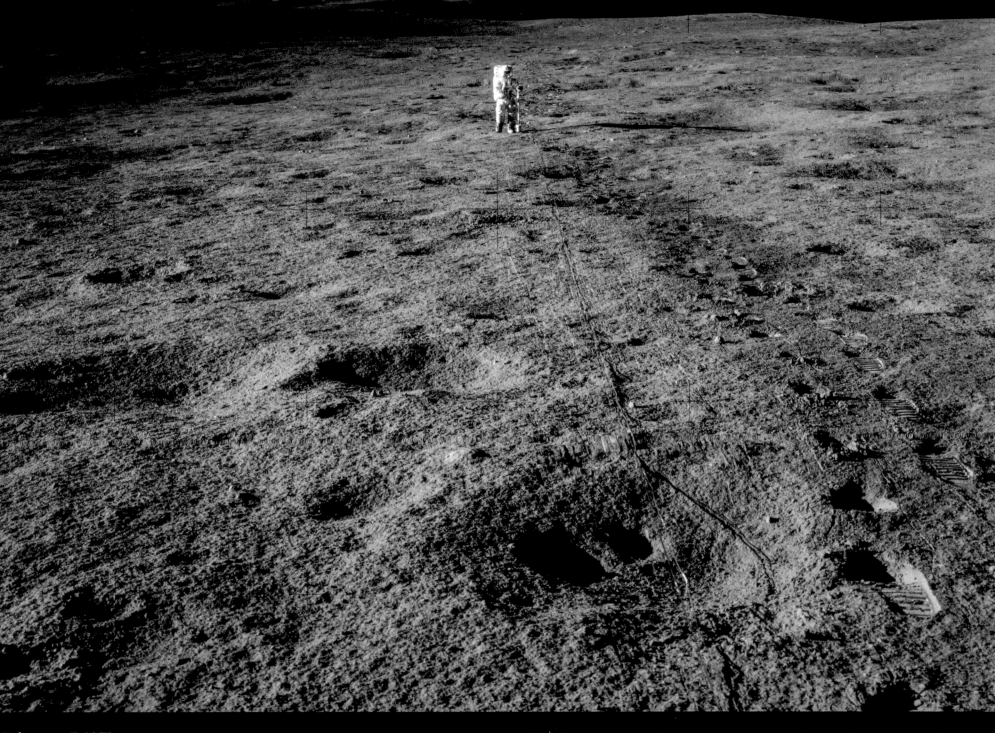

February 5, 1971 EVA-1 HASSELBLAD 70MM. LENS 60MM F/5.6 │ BY ALAN SHEPARD NASA ID: **AS14-67-9374**

Mitchell: "I'm going to have to go almost due south with the thumper . . . Al, you do take a picture down along this line, do you not?" The "thumper experiment," part of the ASE, involved detonating a series of small explosive charges to create miniature moonquakes, the measurement of which (via the 300-foot-long orange cables) could help determine the make-up of the local lunar substructure. *(EL: 3/5)*

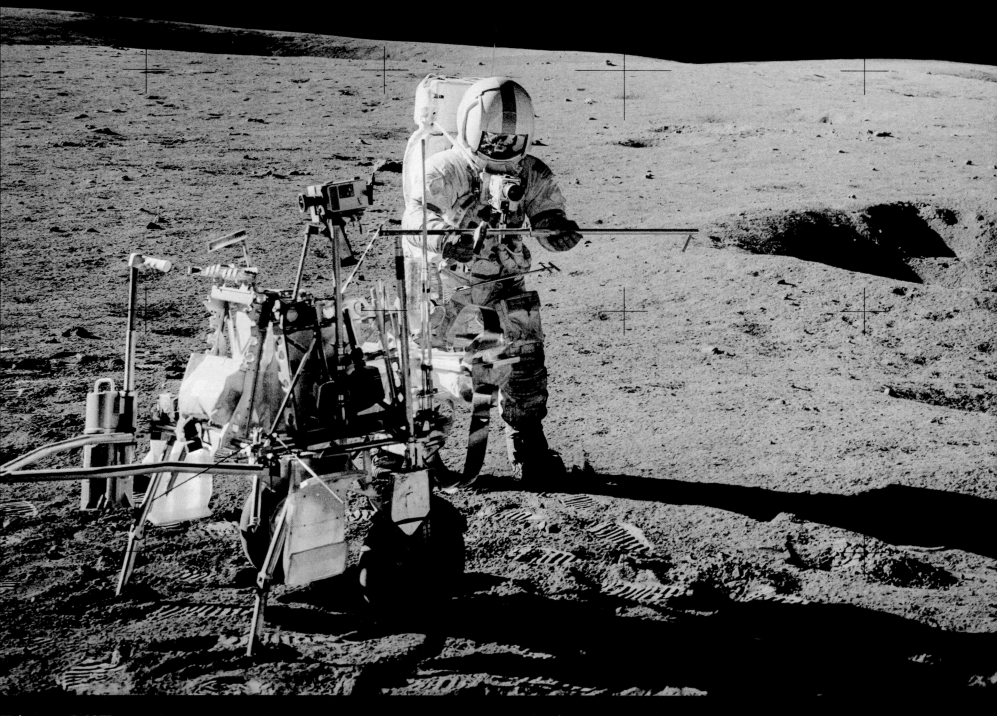

February 6, 1971 EVA-2 HASSELBLAD 70MM LENS 60MM F/5.6. B&W | BY EDGAR MITCHELL NASA ID: AS14-68-9405

Almost 13 hours after completing EVA-1, including a seven-hour rest period invo‌ little sleep, Shepard and Mitchell commenced their second EVA. The target was to hike up to the rim of Cone crater, pulling the MET, with various sampling stops along the way. Shep‌ at the MET preparing a double core sample tube which will collect a 16-inch-deep profile of the luna regolith. The 16mm DAC camera is mounted at the top of the MET and the close-up, "Gold" camera is far left. *(Cropped, EL: 3/5)*

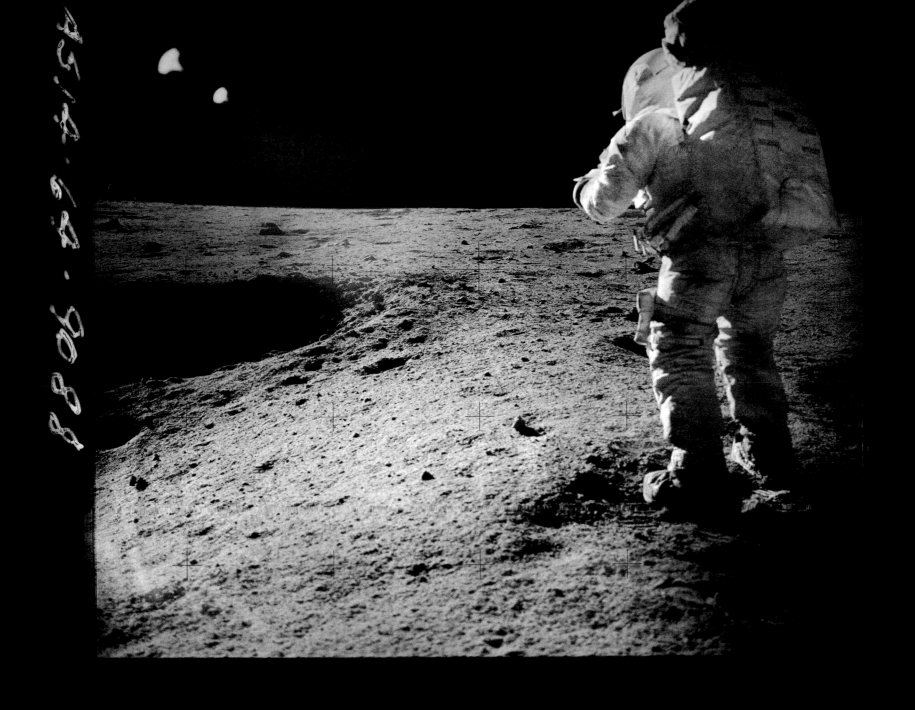

February 6, 1971 **EVA-2** HASSELBLAD 70MM. LENS 60MM F/5.6. B&W | BY ALAN SHEPARD NASA ID: **AS14-64-9088**

Approximately halfway to Cone crater, still pulling the MET, Shepard and Mitchell take a break from their hike. Mitchell: "Why don't we pull up beside this big crater . . . take a break, get the map, and see if we can find out exactly where we are." The crew only had 30 minutes to cover the second half of the hike, which also involved a 200-foot climb to the rim. *(EL: 5/5)*

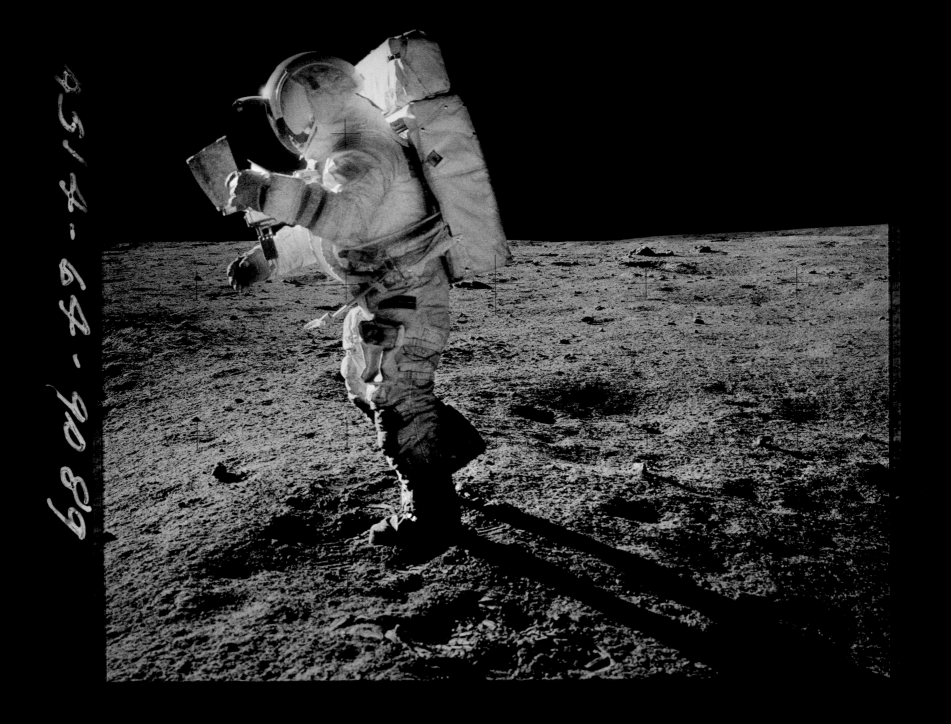

AS14-64-9089

February 6, 1971 EVA-2 HASSELBLAD 70MM. LENS 60MM F/5.6. B&W | BY ALAN SHEPARD NASA ID: AS14-64-9089

Mitchell: "I can't really spot this crater [on the map], but I think I know where we are . . . close to where you said." In fact, they were not as far along as suspected, but continued up the 10 percent incline on the soft, boulder-strewn surface. She█████ picked up the back of the MET to carry it – "Left, right, left, right" – but his 140bpm heart rate necessitated further breaks. Houston eventually called █ ████, to the crew's disappointment. █ ███ later shown they had got to within just 100 ████ of the rim. *(EL: 4/5)*

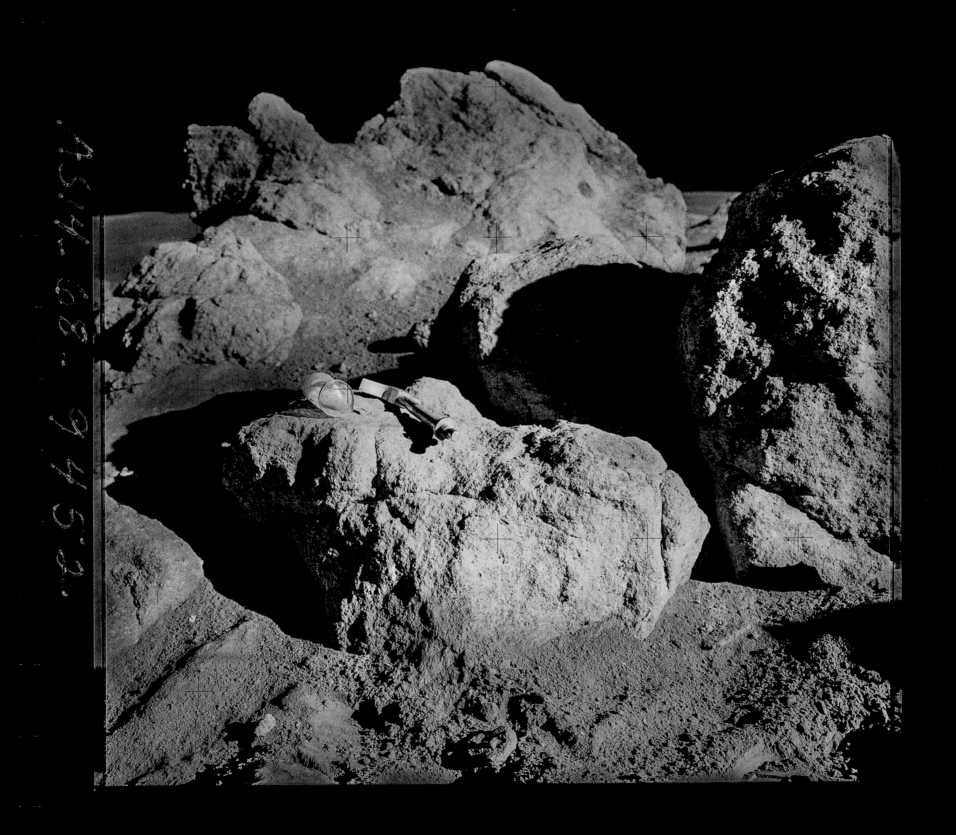

February 6, 1971 EVA-2 HASSELBLAD 70MM. LENS 60MM F/5.6. B&W | BY EDGAR MITCHELL NASA ID: **AS14-68-9452**

At the closest approach to the rim of Cone crater lay Saddle Rock. Mitchell: "They're really brown boulders on the outside, and the inner face that's broken is white." Mitchell would use the hammer to chip off a sample and place it in the adjacent "Dixie-Cup." It was discovered in 2019 that possibly the oldest Earth rock ever found, was found on the Moon during this mission. In total, 94.4lbs

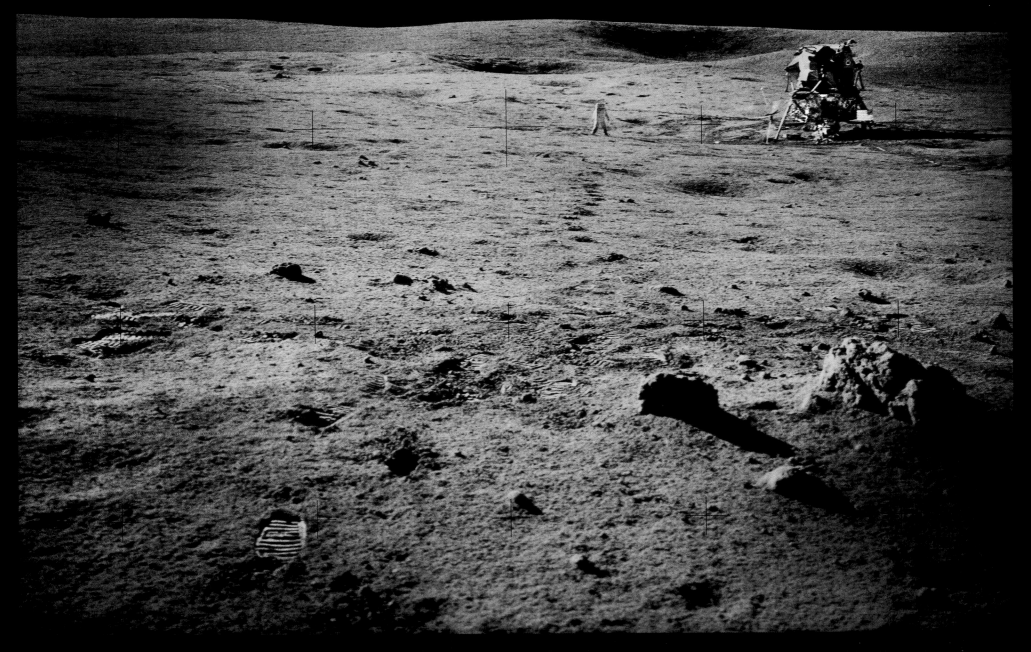

February 6, 1971 EVA-2 HASSELBLAD 70MM. LENS 60MM F/5.6. B&W │ BY EDGAR MITCHELL NASA ID: **AS14-68-9486**

Mission Control: "Okay, Al. You can proceed back to the vicinity of the LM and . . . shoot a few close-up pictures." Shepard is adjusting the TV camera, left of the LM, as Mitchell takes this photograph from Turtle Rock (Station H), some 300 feet away. "Old Nameless" crater is in the background and the MET tracks from their earlier assault on Cone crater can just be seen leading off to the upper left. *(EL: 5/5)*

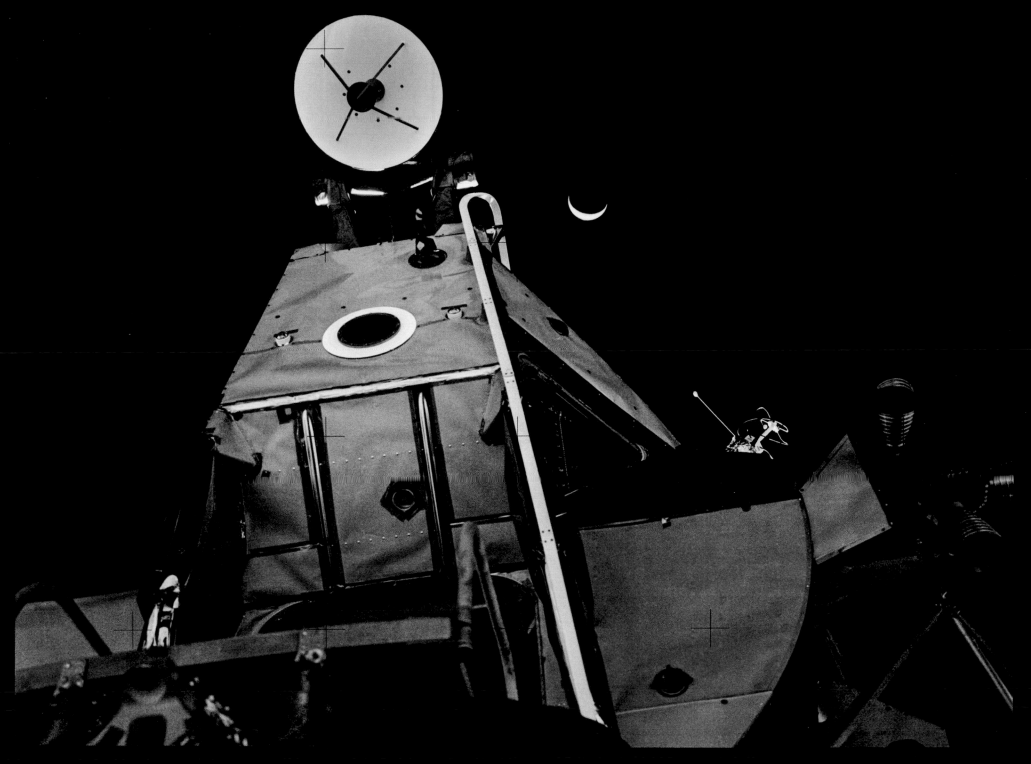

February 6, 1971 **EVA-2** HASSELBLAD 70MM. LENS 60MM F/5.6. B&W | BY ALAN SHEPARD NASA ID: **AS14-64-9190**

Earth and Venus (close to the antenna) photographed from the Moon. Now back at the LM, Shepard to CAPCOM Haise: "What setting would you like on that solar wind shot, Freddo?" As he waits for the reply, Shepard grips the base of the ladder and leans right back to capture this shot. Software to predict planetary alignment on this date, from this location, confirms that the tiny dot, seen in several frames, is indeed Venus. *(EL: 3/5)*

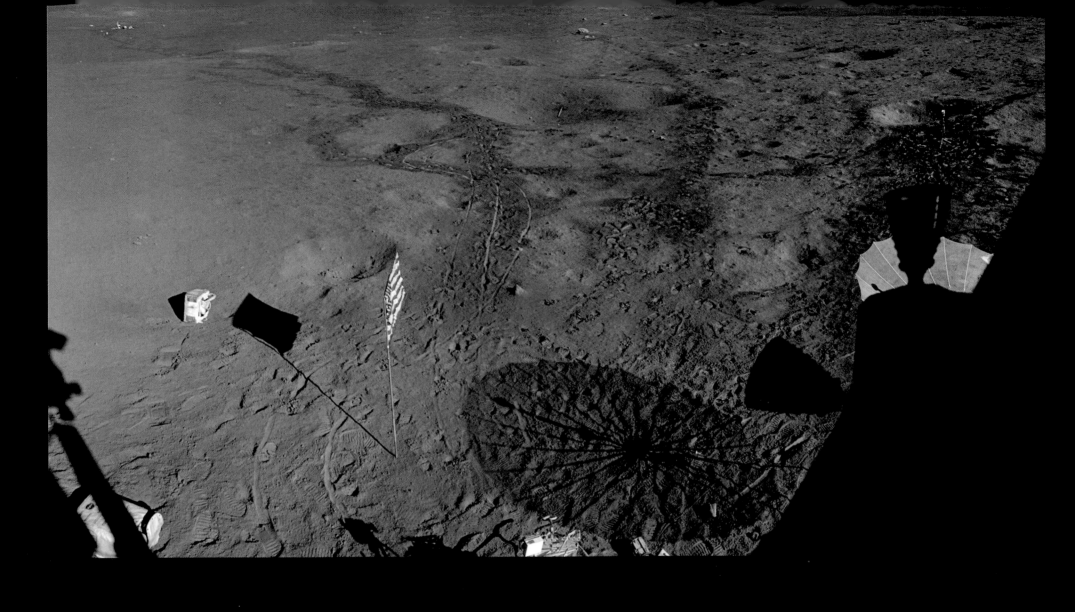

February 6, 1971

HASSELBLAD 70MM. LENS 60MM F/5.6 | BY EDGAR MITCHELL

NASA ID: **AS14-66-9336 TO 9343**

Back in the LM, the crew photographed the landing site just before leaving the Moon. This stitched panorama shows the scene as it would be found to this day. Mitchell's discarded PLSS is lower left. Shepard hurled his own significantly further. The ALSEP is upper left, Turtle Rock upper center and the TV camera far right. Both golf balls are also visible (in the crater, above center, and upper left on the "lunar fairway"). *(Panorama, fiducial mark removal, EL: 4/5)*

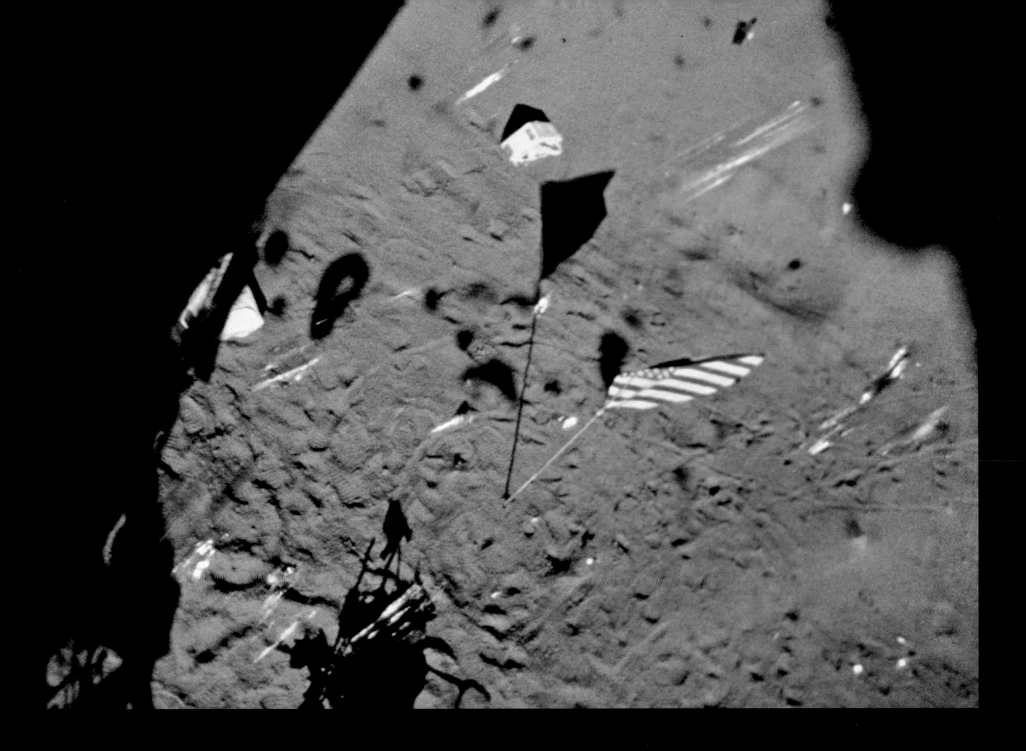

February 6, 1971 SINGLE PROCESSED 16MM FILM FRAME NASA ID: **APOLLO 14 MAG 1178**

Mitchell set the 16mm DAC camera running to record the launch. Shepard: "Okay, the abort stage is set. Ascent engine is armed. 5, 4, 3, 2, 1, 0 . . .we have ignition!" Mitchell: "What a lift-off!" Debris and pieces of torn-off gold and silver Kapton insulation are ripped from the LM as the ascent stage blasts away from the descent stage. The flag remained standing.

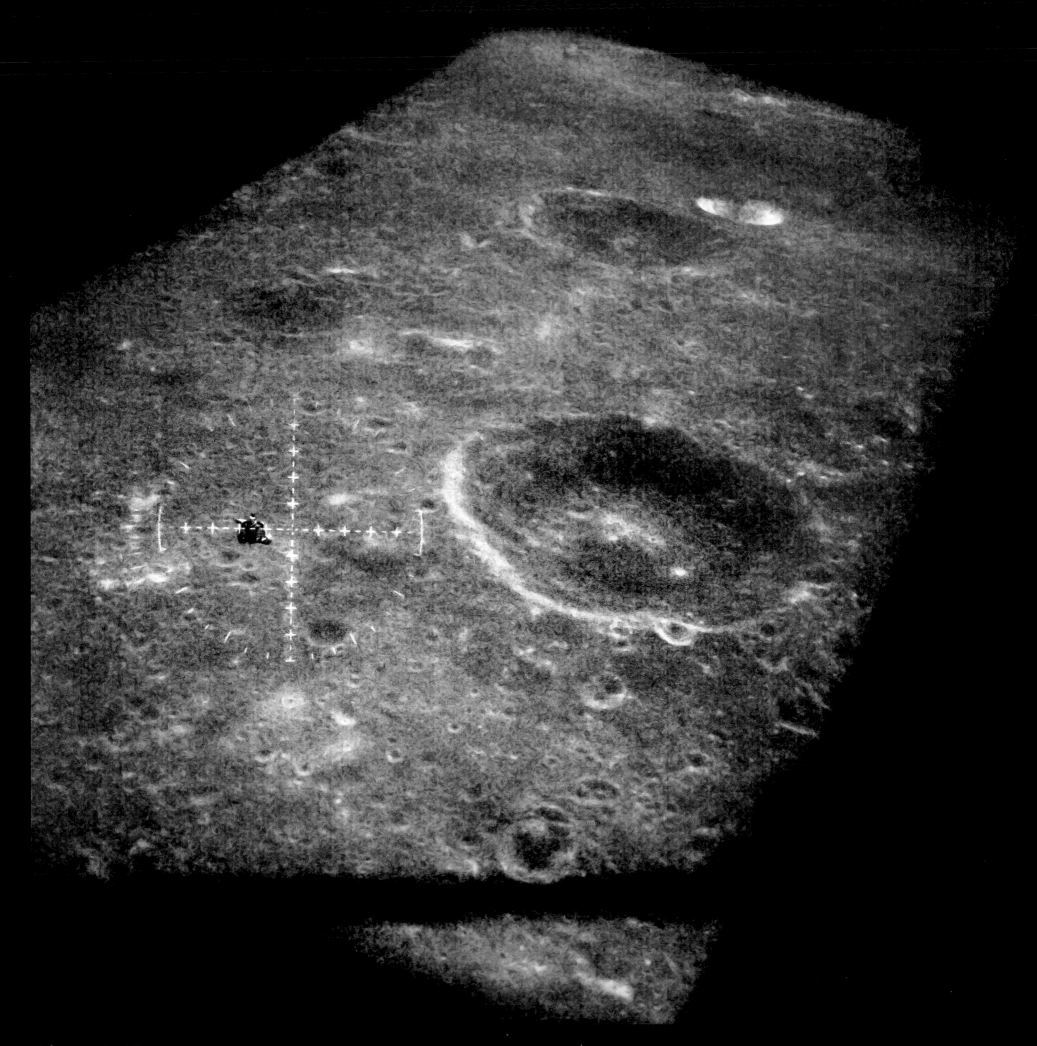

February 6, 1971　　HASSELBLAD 70MM. LENS 80MM F/2.8 | BY STUART ROOSA　　NASA ID: **AS14-74-10211**

After two days orbiting alone in the CSM, Roosa spotted *Antares* ascending from the lunar surface: "The line-of-sight through the COAS looks real good . . . I'll just have a few pictures of you here." The Crewman Optical Alignment Sight (COAS) produces a fixed line-of-sight reference image, providing range and closing rate cues during navigation, rendezvous and docking. Shepard: "Oh boy, I tell you it's sure nice when things go right." *(Rotated, EL: 5/5)*

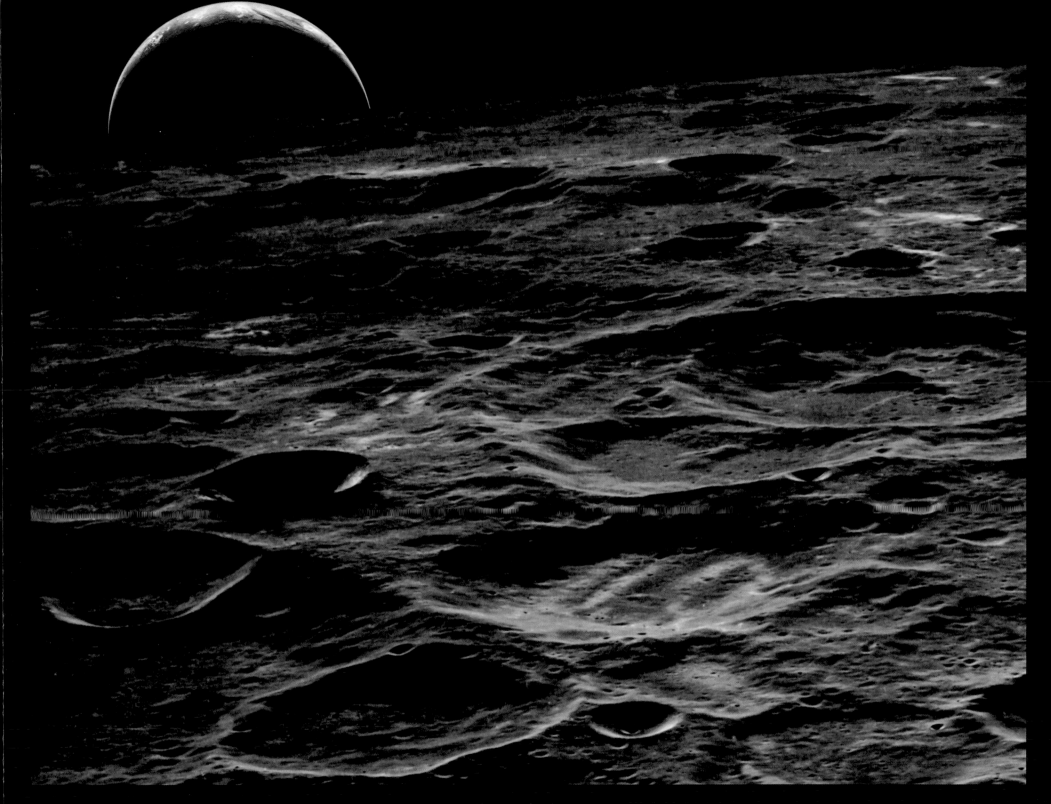

February 7, 1971

HASSELBLAD 70MM. LENS 80MM F/2.8. B&W | BY UNKNOWN

NASA ID: **AS14-71-9845**

There was some trepidation during rendezvous, given the docking problems earlier in the mission. Roosa: "Okay, we capture! . . . And we got a hard dock!" Mission Control: "There's a big sigh of relief being breathed around here." After the successful docking, this incredible photograph of a perfect crescent Earth rising above the rugged lunar farside was captured from *Kitty Hawk*. (Cropped, rotated, EL: 5/5)

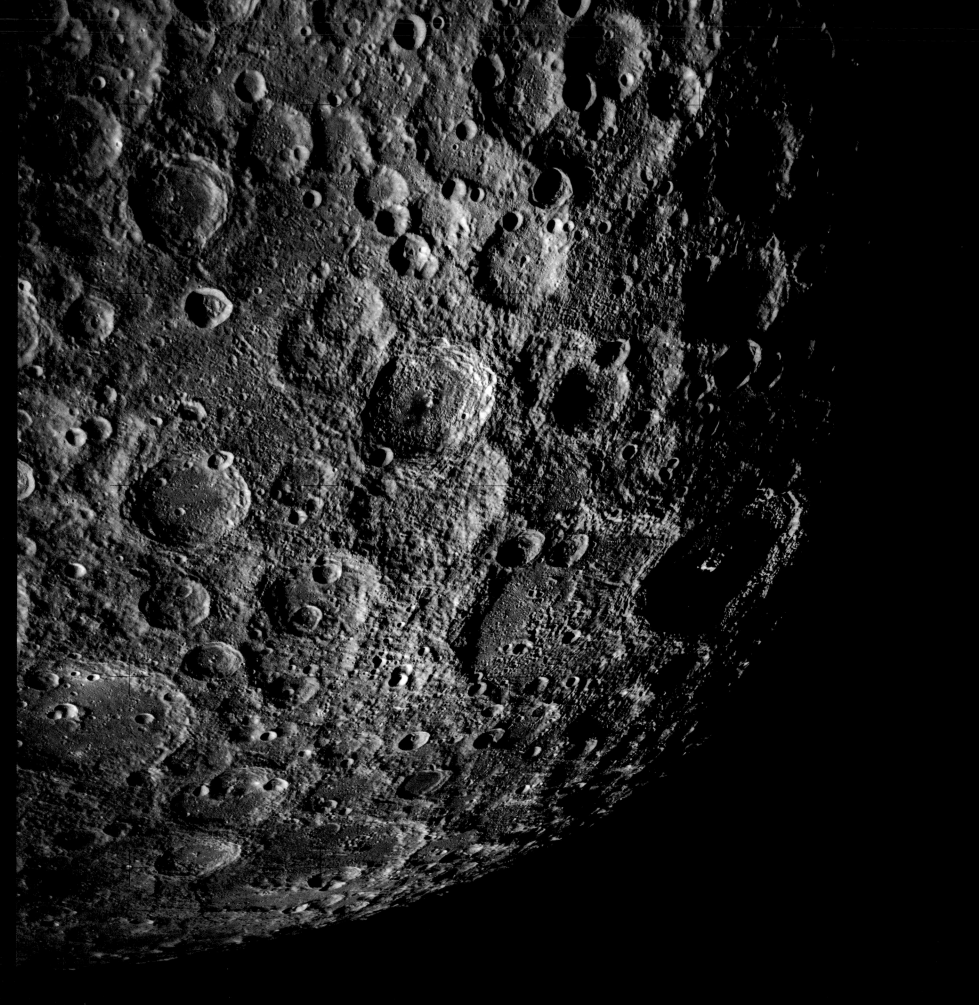

February 7, 1971

HASSELBLAD 70MM. LENS 60MM F/5.6. BY: UNKNOWN

NASA ID: AS_____10301

On acquisition of signal after the trans-Earth injection burn, Shepard reported: "Houston . . . We had _____ burn _____ We're on the way home . . . We're ma_____ ike tour_____ th the cameras right now . . . Just getting ready to go to sleep here, as soon as we finish these hand-held pictures." They captured this photograph of the lunar farside, including craters Belyak, Langemak and Danjon. *(EL: 4/5)*

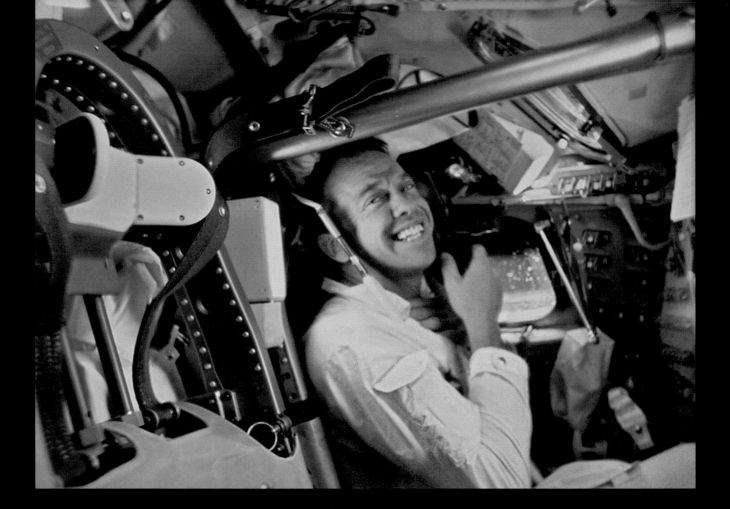

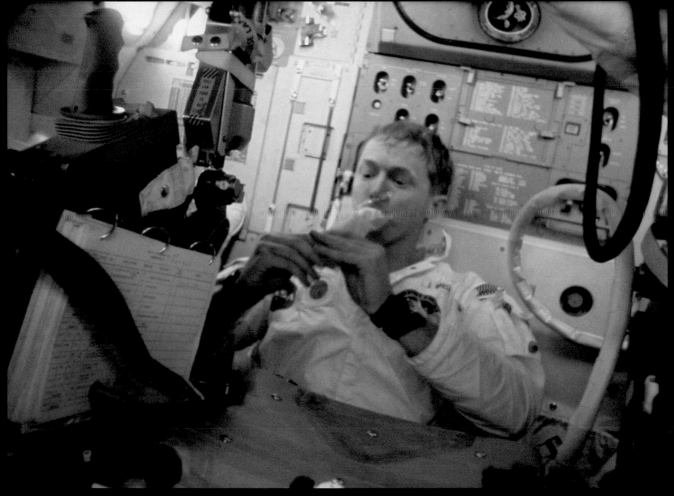

Life on board *Kitty Hawk* during the long journey home. TOP: Commander Shepard is shaving using a mechanical, wind-up shaver, before the crew settle down for a schedul

BOTTOM: Command Module Pilot Roosa is in the lower equipment bay drinking orange juice from a drinks pouch. The pouches required water to be injected and mixed with the

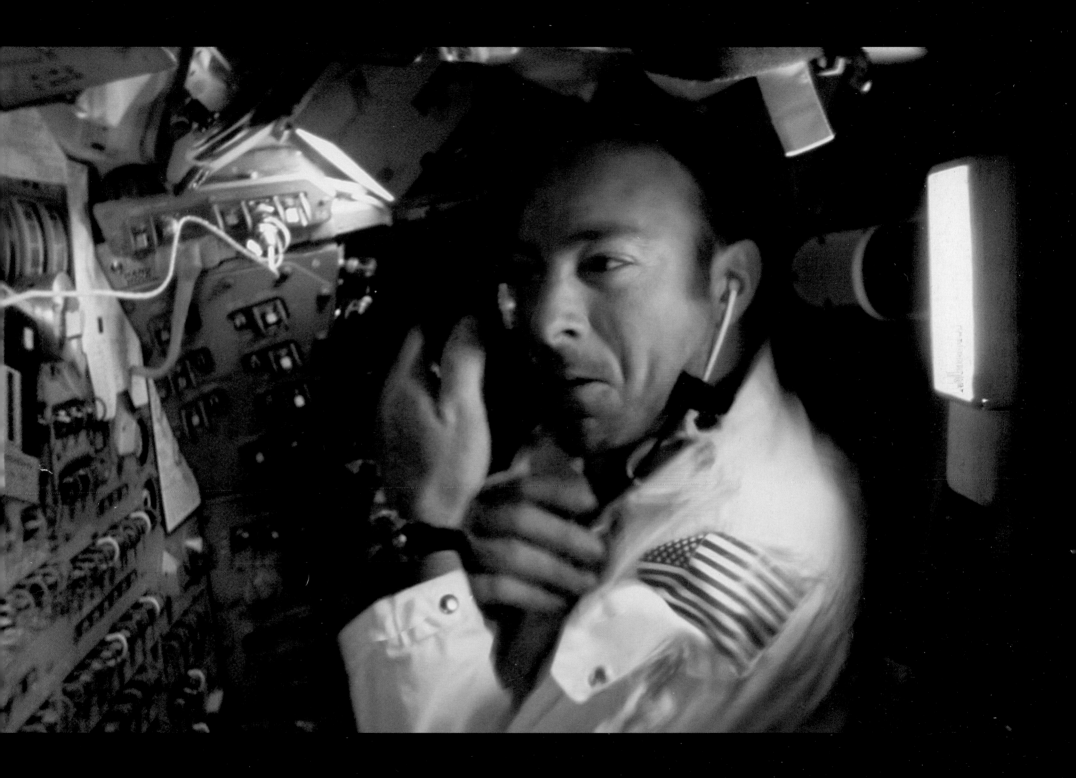

February 8, 1971 52 FRAMES OF 16MM FILM, STACKED, PROCESSED AND STITCHED NASA ID: **APOLLO 14 MAG 1202**

The Command Module's mission timer (top left), started at launch, shows an elapsed time of 190 hours, 33 minutes, 35 seconds – halfway between the Earth and the Moon. Lunar Module Pilot Mitchell is actually pretending to shave – he started growing a beard when he stepped onto the Moon, which he then sported for two years.

THE DETAILS

ROCKET
Saturn V (AS-510)

COMMAND AND SERVICE MODULE
Endeavor (CM-112)

LUNAR MODULE
Falcon (LM-10)

LAUNCH
13:34 GMT,
July 26, 1971, Pad 39A

LANDING SITE
Hadley Appenines

DISTANCE
1,274,137 miles

DURATION
12 days, 17 hours, 12 minutes

SURFACE TIME
66 hours, 55 minutes

LUNAR ORBITS
74

SPLASHDOWN
20:46 GMT,
August 7, 1971,
Pacific Ocean

RECOVERY SHIP
USS *Okinawa*

THE CREW

David R. Scott
COMMANDER (CDR)

Born June 6, 1932. Part of the third intake of astronauts in 1963, Scott's first spaceflight was on Gemini VIII with Command Pilot Neil Armstrong. The crew were fortunate to escape with their lives when their spacecraft began to spin uncontrollably when docked with the Agena target vehicle. After serving as director of NASA's Dryden Flight Research Center, Scott retired in 1977.

Alfred M. Worden
COMMAND MODULE PILOT (CMP)

Born February 7, 1932. Worden, like Scott, was a West Point graduate, but joined NASA later, in 1966. He served as back-up CMP on Apollo 12, but this would be his first and only spaceflight. He would perform the world's first deep-space EVA during the return journey from the Moon, to retrieve the Panoramic and Mapping camera film.

James B. Irwin
LUNAR MODULE PILOT (LMP)

Born March 17, 1930. Irwin was a former USAF pilot and test pilot. He joined NASA in 1966, as part of its fifth intake of astronauts, alongside crewmate Worden. He was back-up LMP on Apollo 12, but this would be his only spaceflight, and he became the eighth man to walk on the Moon. He retired from NASA in 1972.

July 30–August 7, 1971

APOLLO 15

THE MISSION

The landing site selected for the first "J-mission" was the spectacular Hadley-Apennine region; a horseshoe-shaped range of mountains reaching 14,000 feet into the sky, around a valley dominated by a mile-wide rille that meanders through it.

The "J-missions," considered true scientific missions, involved an adapted LM to carry a heavier payload and afford a longer, three-day stay on the lunar surface. The payload included the Lunar Roving Vehicle (LRV), or "Moon buggy," which allowed the crew to cover much greater distances. Adapted spacesuits and PLSS backpacks also afforded greater flexibility and extended EVAs up to 7.5 hours – essential for the thorough geological exploration of this hugely varied site.

The launch and TLI were uneventful and a short circuit in the SPS engine firing switch was successfully cleared with revised procedures for entering lunar orbit. A further SPS engine burn put the spacecraft into its elliptical descent orbit, with its lowest point over the landing site. The crew then bedded down for the night, awakening to find they were flying just 7.6 miles above the mountainous region – lower than expected due to the Moon's, not yet fully understood, mass and gravitational variations (mascons). The first-ever lunar subsatellite would be released from the CSM later in the mission to help better understand these mascons.

The LM's descent to the surface was the steepest and most spectacular to date. Having trained for years with only a forward view in the simulator, the crew were awestruck when pitch-over occurred at 7,000 feet. Irwin looked sideways out of Scott's left-hand window to discover the 13,000-foot Mount Hadley Delta was towering above them. *Falcon* landed hard, straddling a crater at an 11-degree angle, but came to rest safely on the "Hadley plain." A "Stand-up EVA" (simply observing and photographing from the overhead docking hatch) was followed by three surface EVAs, totaling over 18 hours and utilizing the LRV to cover 17.5 miles of the lunar landscape.

The crew were the first to be extensively trained as geologists, which paid off with the discovery and collection of the "Genesis Rock" – a piece of the Moon's primordial crust over 4 billion years old. This one rock helped revolutionize ideas about lunar formation and provided new insights into the age of the solar system.

Shortly after leaving the Moon, 171,000 nautical miles from Earth, Al Worden performed the world's first deep-space EVA. He used the handholds on the outside of the CSM to go and retrieve the Panoramic and Metric camera cassettes from the SIM bay – the first mission equipped with this Scientific Instrument Module.

Despite one parachute malfunctioning, the other two main parachutes brought Apollo 15 to a safe splashdown on Earth, 330 miles north of Hawaii.

THE PHOTOGRAPHY

For the first time, a ground-controlled TV camera was used. Installed on the rover, it allowed real-time selection of sampling locations by scientists based at Mission Control. The crew and geologists also fought hard to have a 500mm telephoto lens included on the manifest. Ultimately, abort propellant, equal to the mass of the heavy lens, was sacrificed to allow its inclusion. This decision was justified with images of great scientific interest, such as those of lineations in the distant Mount Hadley, and dramatic photographs, such as Scott's favorite of the mission, which shows *Falcon*, their temporary home on the Moon, on the "Hadley plain," 3 miles from their elevated position during EVA-2.

Extraordinarily detailed images of large areas of the lunar surface were captured from orbit with the introduction of the Metric Mapping and Panoramic cameras. As the crew were out on EVA-2, *Endeavor* passed directly overhead, capturing a stunning image of the whole region. In the full-resolution version of this photograph, incredibly, the LM and its shadow are also captured.

In photographing the solar corona for the first time with very fast film, the stars of constellation Leo were captured from lunar orbit. So too were two of the more renowned images from Apollo: Irwin as he salutes the flag with the LRV, *Falcon* and Mount Hadley Delta as the dramatic backdrop; and a perfect crescent Earth above the lunar farside.

The most notable attribute of the Apollo 15 photography, however, is undoubtedly the pure majesty and grandeur of this incredible, photogenic region of Earth's closest neighbor.

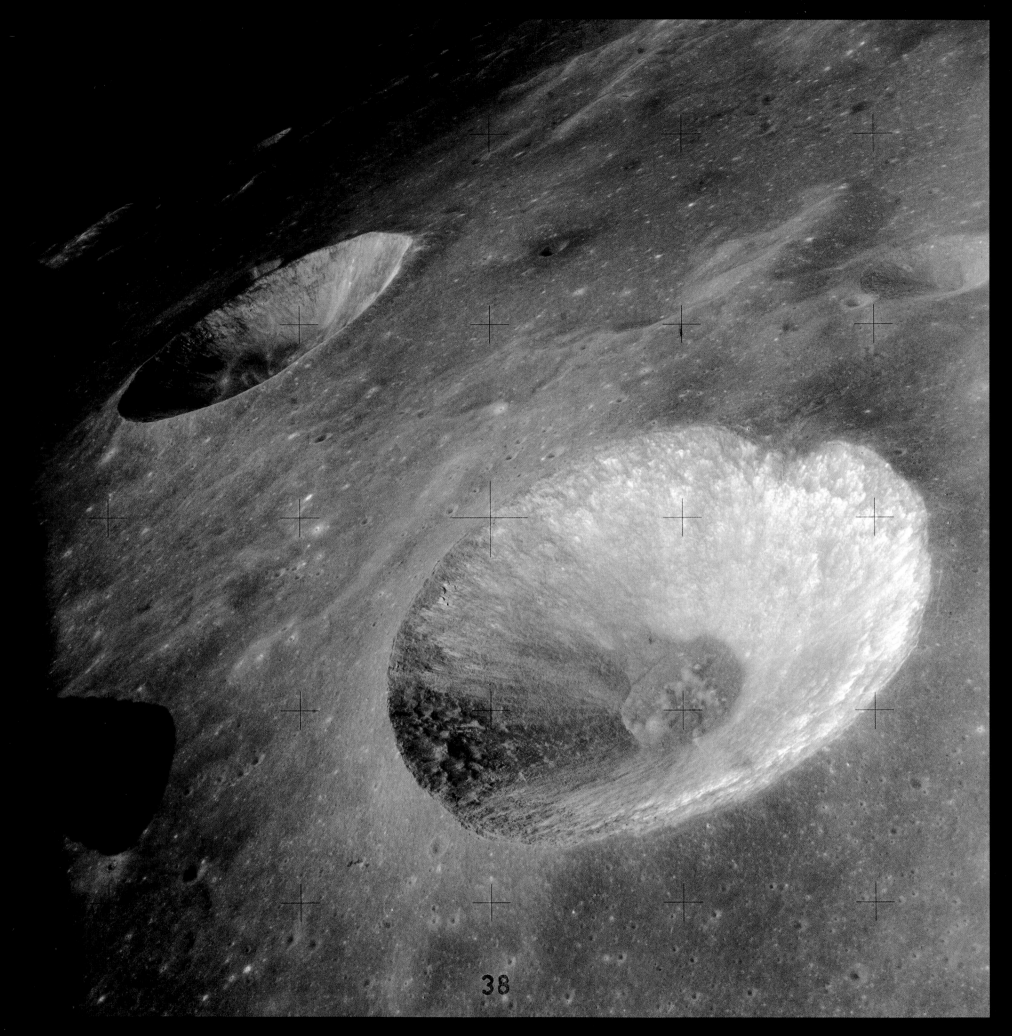

38

July 30, 1971 HASSELBLAD 70MM. LENS 60MM F/5.6 | BY DAVE SCOTT NASA ID: **AS15-87-11703**

After arriving at the Moon, and their descent orbit insertion burn, the crew bedded down for the night. They awoke to find their spacecraft was coasting just 7.6 miles above the Apennine Mountains at the lowest point in its orbit; 12 percent lower than expected, due to the Moon's mascons (concentrations of gravity). After LM separation, Scott and Irwin would make two orbits before PDI (Powered Descent Initiation), taking this photograph of craters Macrobius B and Macrobius A from the LM. *(EL: 3/5)*

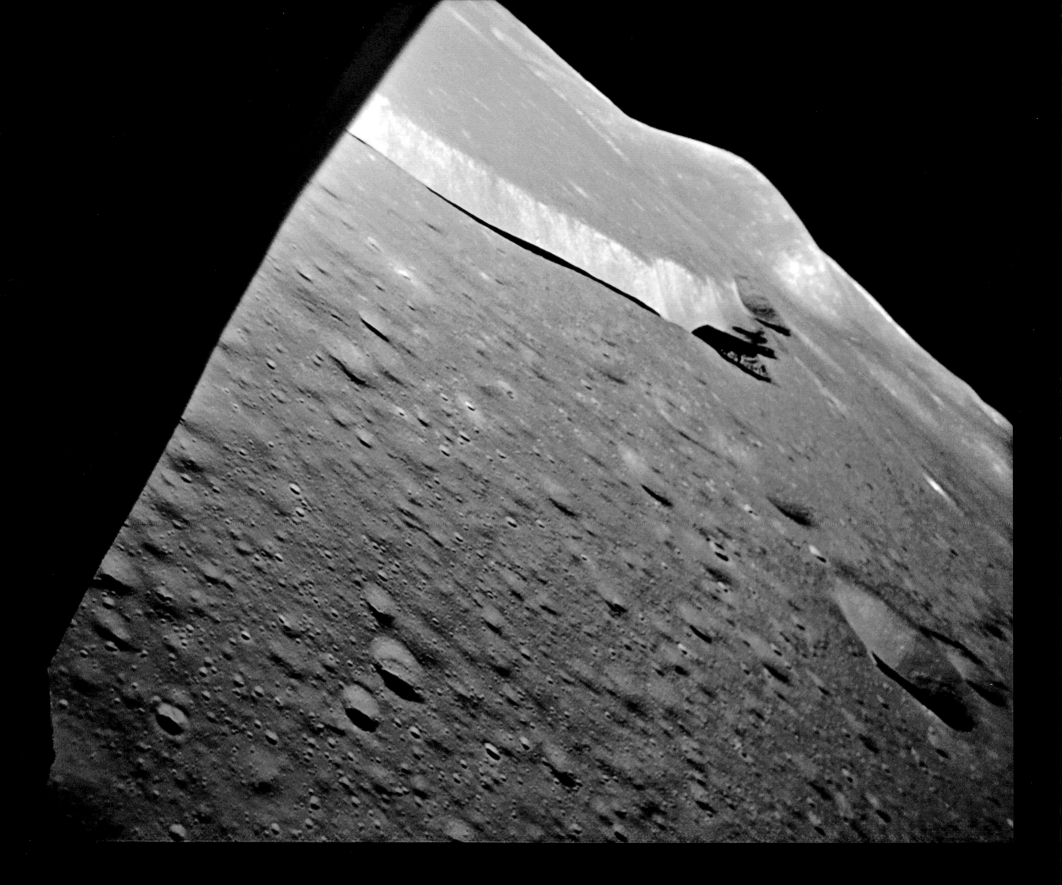

July 30, 1971 48 FRAMES OF 16MM FILM, STACKED AND PROCESSED NASA ID: **APOLLO 15 MAG 1257-F**

The LM fired its descent engine to begin the steepest approach to a landing yet. Having only seen a forward-facing view in the simulator, when *Falcon* pitched over at 7,000 feet the crew were startled at the sight of the 13,000-foot Mount Hadley Delta towering above them out of Scott's left-hand window. Hadley Rille then came reassuringly into view, seen here through Irwin's right-hand window at 3,000 feet.

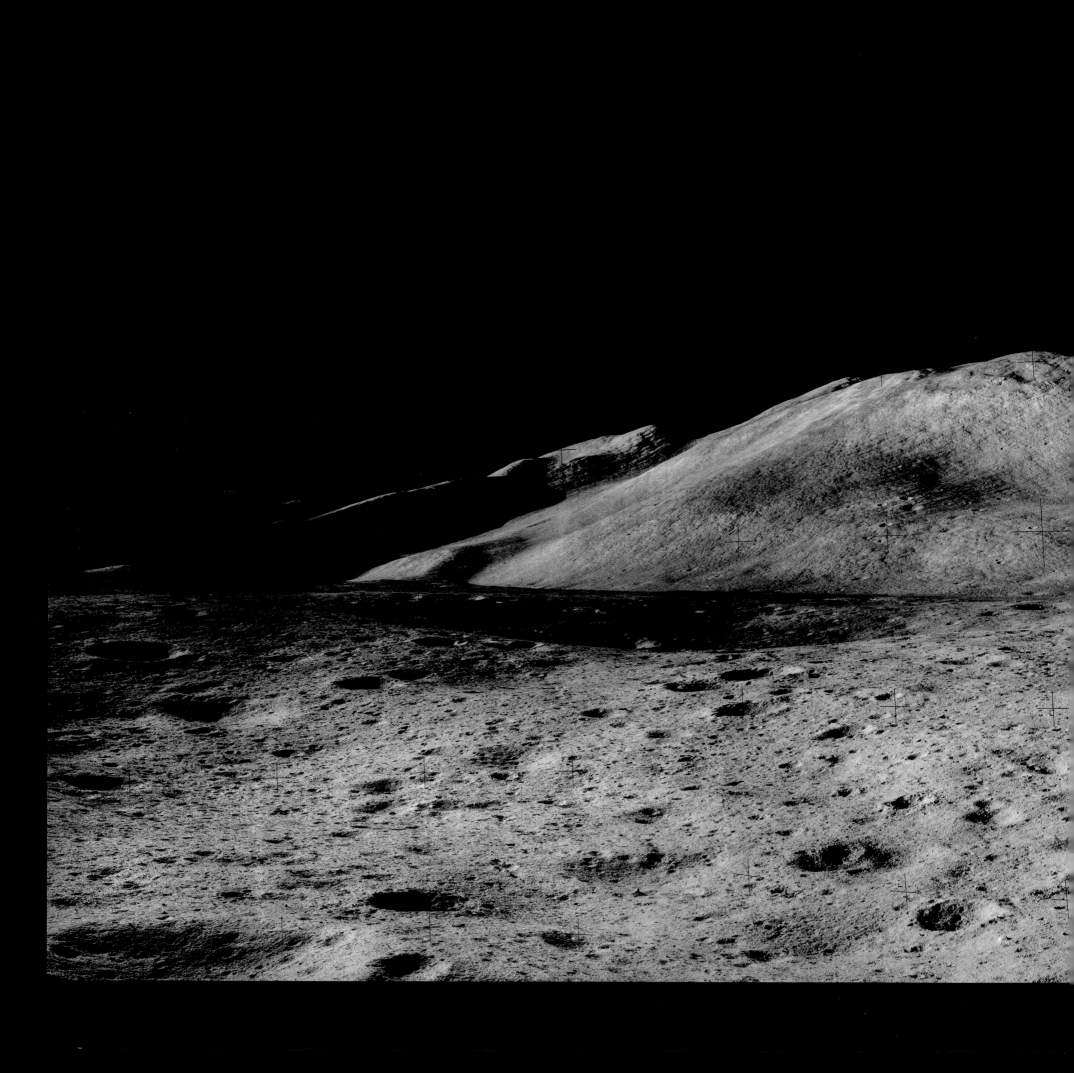

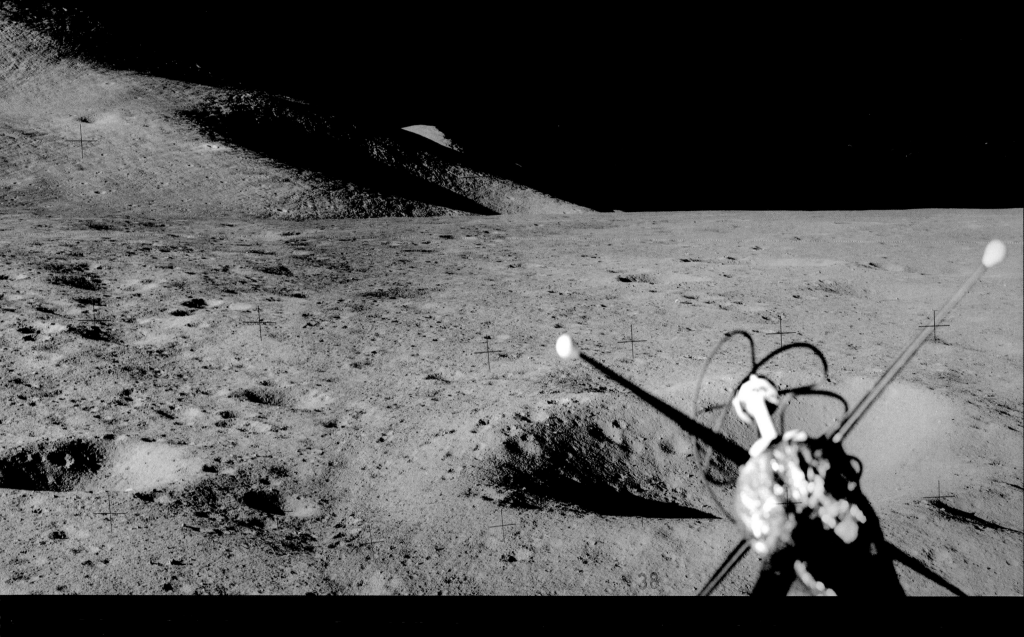

Irwin: "Contact. Bam!" Due to an immediate engine cut-off, the LM landed hard, shaking all the equipment on board. Scott: "Okay, Houston. The *Falcon* is on the plain at Hadley." Due to mission planning considerations, the first EVA would simply involve Scott standing up through the docking hatch, observing and photographing. Scott: "We're sure in a fine place here." Irwin: "Okay, you want 22 frames in the stereo pan, Dave." Mount Hadley Delta is center, and St. George crater, right. *(Panorama, EL: 4/5)*

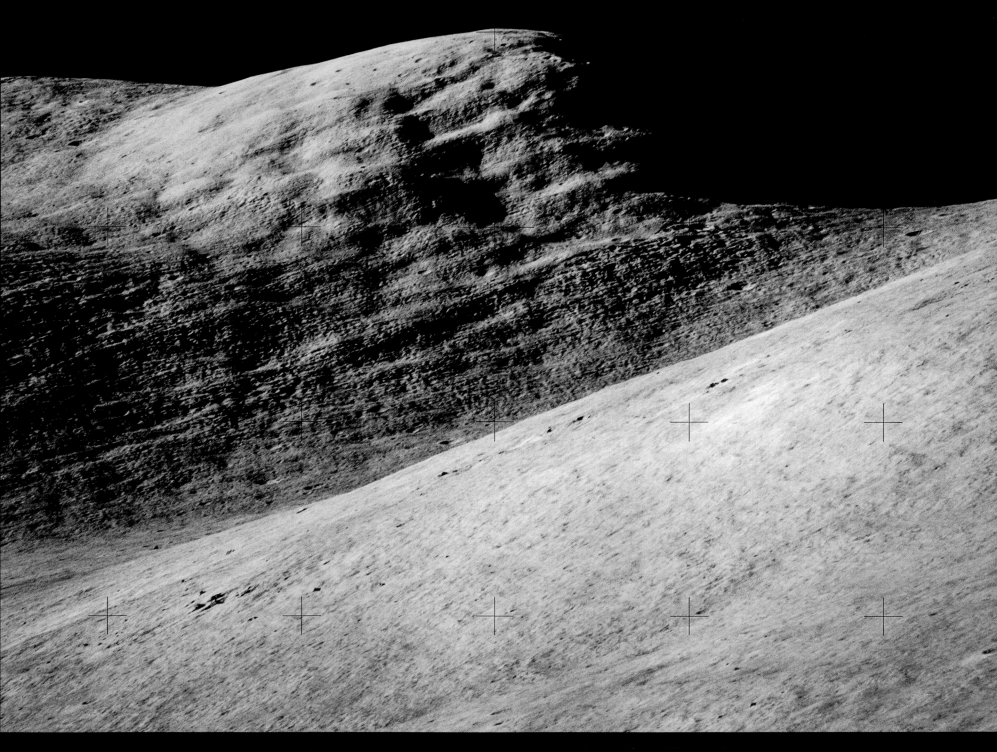

July 31, 1971 STAND-UP EVA HASSELBLAD 70MM. LENS 500MM F/8. B&W | BY DAVE SCOTT NASA ID: **AS15-84-11250**

Standing in the hatch was ideal to enable Scott to capture this fantastic, rock-steady photograph with the 500mm telephoto lens. The geologists and crew had fought hard to get the huge lens included on the flight; abort propellant was ultimately sacrificed, equal to the mass of the lens. Scott described the striking lineations seen in Silver Spur, named after geologist Lee Silver: "There are definite linear features there, dipping to the northeast, at about, I'd say, 30 degrees." *(Rotated, EL: 3/5)*

August 1, 1971 METRIC MAPPING CAMERA 115MM. LENS 76MM F/4.5. B&W NASA ID: **AS15-M-1011**

Worden, remaining in lunar orbit, would be responsible for activating the cameras in the SIM bay. Here, during the 27th orbit, he activated the Metric Mapping camera to capture features as it crossed the terminator. The low Sun angles close to the terminator help show details in the topography, such as the ghost crater, Lambert R, in the Mare Imbrium basin (bottom), which is almost completely covered by the mare. Crater Lambert (top) is 18.6 miles across. *(EL: 3/5)*

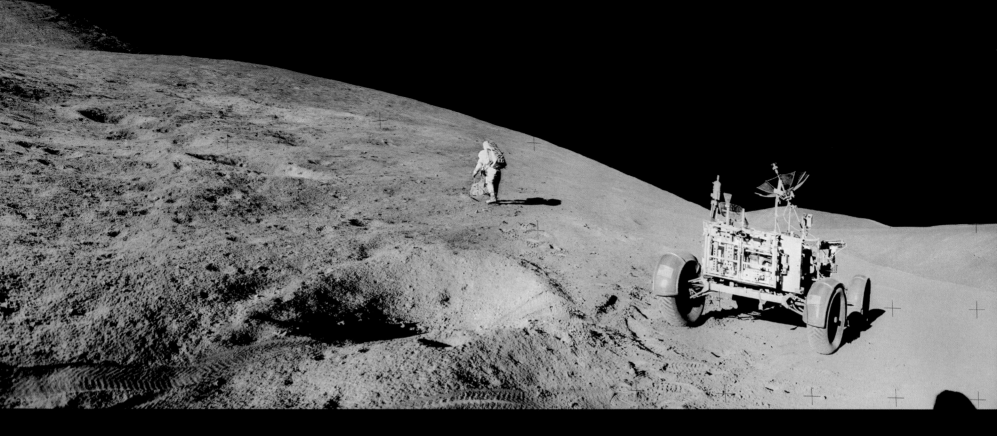

July 31, 1971 EVA-1 HASSELBLAD 70MM. LENS 60MM F/5.6. B&W | BY JIM IRWIN NASA ID: **AS15-85-11433 TO 11438**

On the surface, one of the first tasks was to unload and deploy the LRV – the first wheels on the Moon. Scott: "Whew! Hang on! . . . Get a feel for this thing." Irwin: "You really sit high . . . It's almost like standing up." Two hours later it had been driven 2.5 miles up to the foot of Mount Hadley Delta. Scott heads up the slopes: "Man, we're walking uphill, too! Is that ever uphill! There is one boulder . . . Very angular, very rough surface texture." *(Panorama, EL: 4/5)*

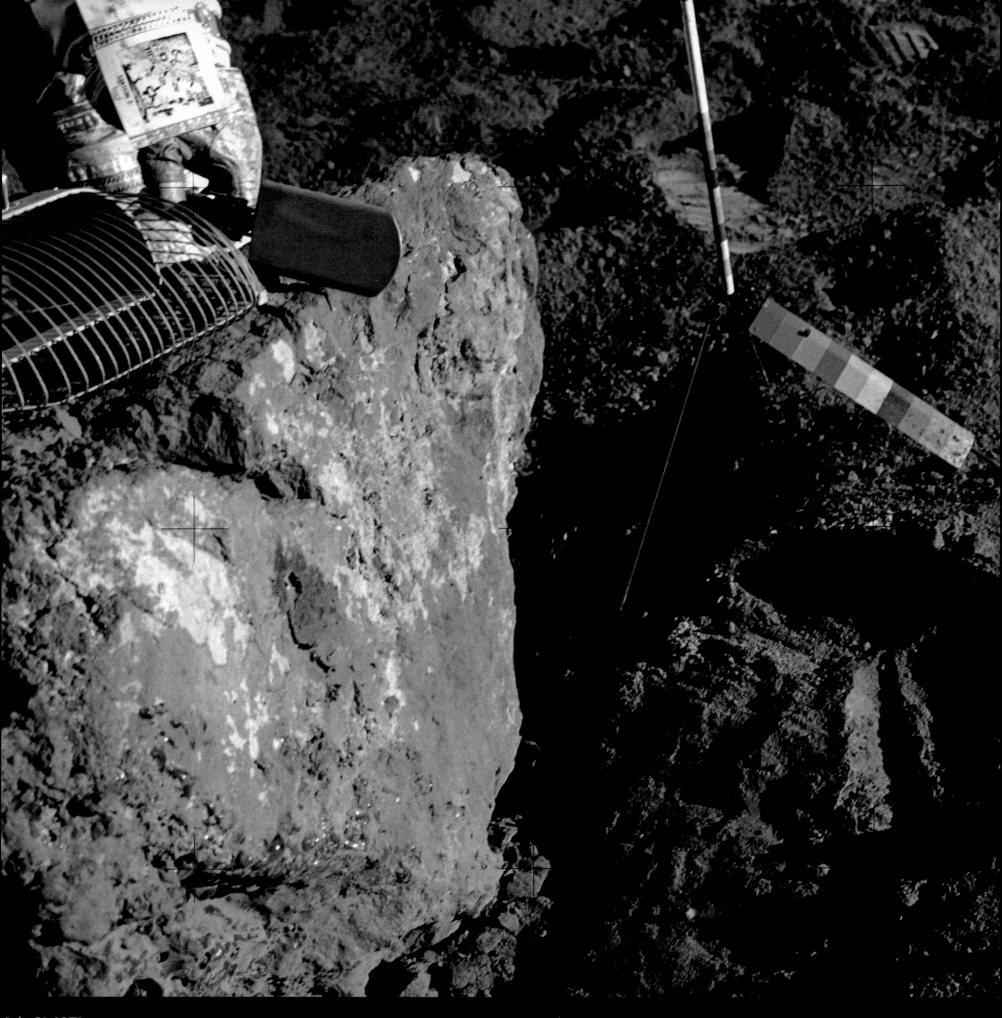

July 31, 1971 **EVA-1** HASSELBLAD 70MM. LENS 60MM F/5.6 | BY DAVE SCOTT NASA ID: **AS15-86-11566**

Scott: "Well, it's got glass on one side of it with lots of bubbles, and they're about a centimeter across." Breccia rocks are those formed from being repeatedly fused together then re-broken. This breccia with a partial glass coating is almost certainly ejecta material. Scott rolled it over: "Can you imagine that? Here sits this rock, and it's been here since before creatures roamed the sea in our little Earth." *(Cropped, EL: 2/5)*

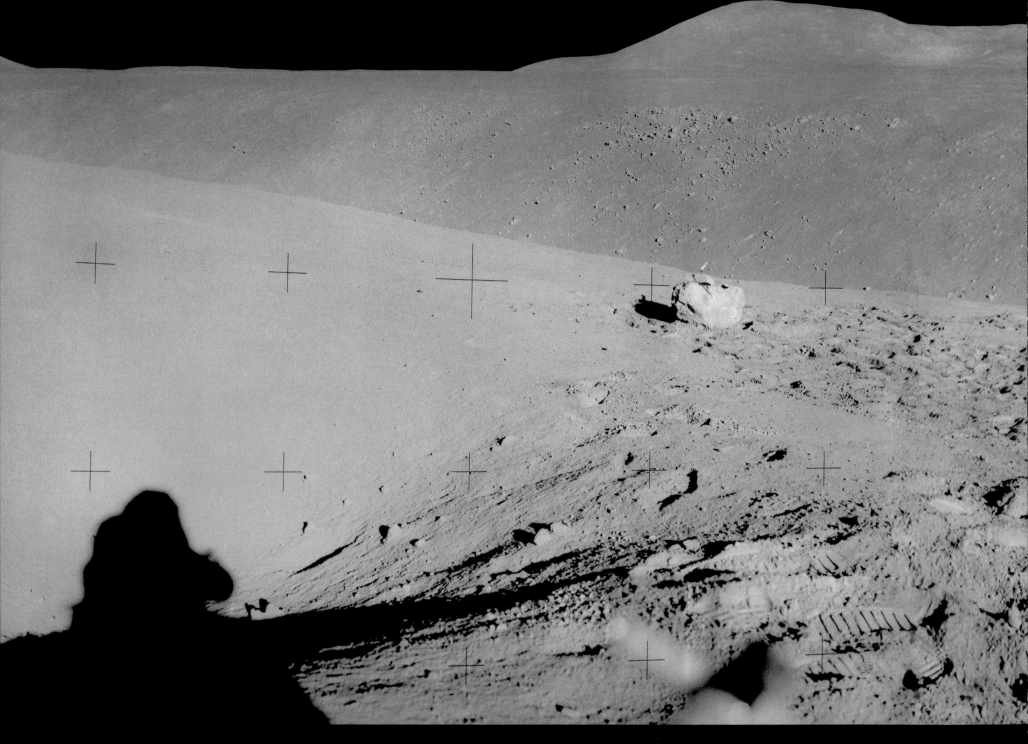

July 31, 1971 EVA-1　　　　　　　HASSELBLAD 70MM. LENS 60MM F/5.6. B&W | BY JIM IRWIN　　　　　　NASA ID: **AS15-85-11447 TO 11455**

Scott: "Oh, look back there, Jim! . . . We're up on a slope, Joe [CAPCOM], and we're looking back down into the valley and . . ." Irwin: "That's beautiful." Scott: "The most beautiful thing I've ever seen." As Scott went to the rover to collect the 500mm Hasselblad, Irwin took this series. The sampled boulder is to the left, Hadley Rille meanders through the valley, the 14,000-foot Mount Hadley is dominant on the horizon and the Swann Range is off to the right. *(Panorama, EL: 4/5)*

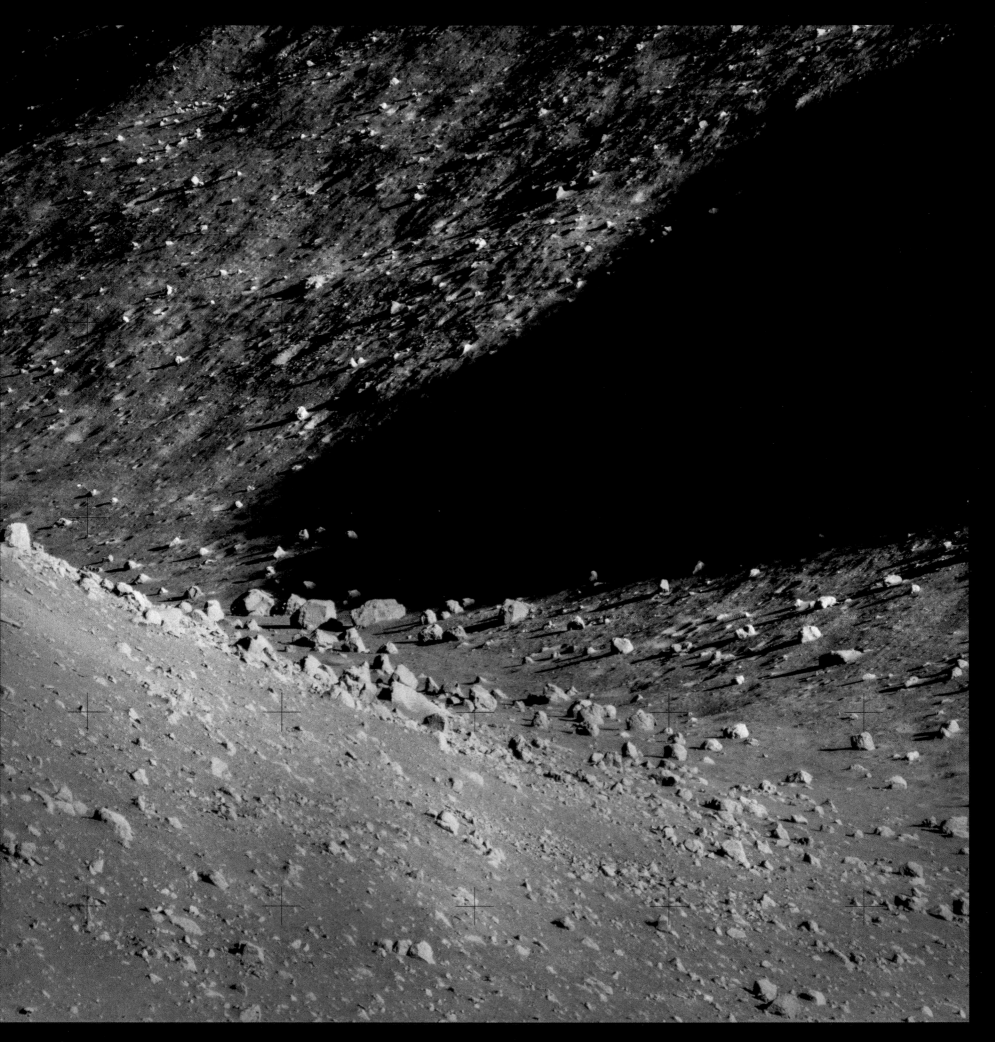

July 31, 1971 EVA-1 HASSELBLAD 70MM. LENS 500MM F/8. B&W │ BY DAVE SCOTT NASA ID: AS15-84-11287

One of Scott's 500mm shots down the rille, believed to have been formed by volcanic processes early in the Moon's history. Scott: "On the nearside of the rille . . . there seems to be quite a bit of debris; whereas in our present position near St. George [crater], there's very little . . . I can see several very large boulders [house-sized]. Very angular . . . They're sort of unique in the bottom of the rille – in that particular area. The other ones look like they're a half the size." *(Rotated, EL: 3/5)*

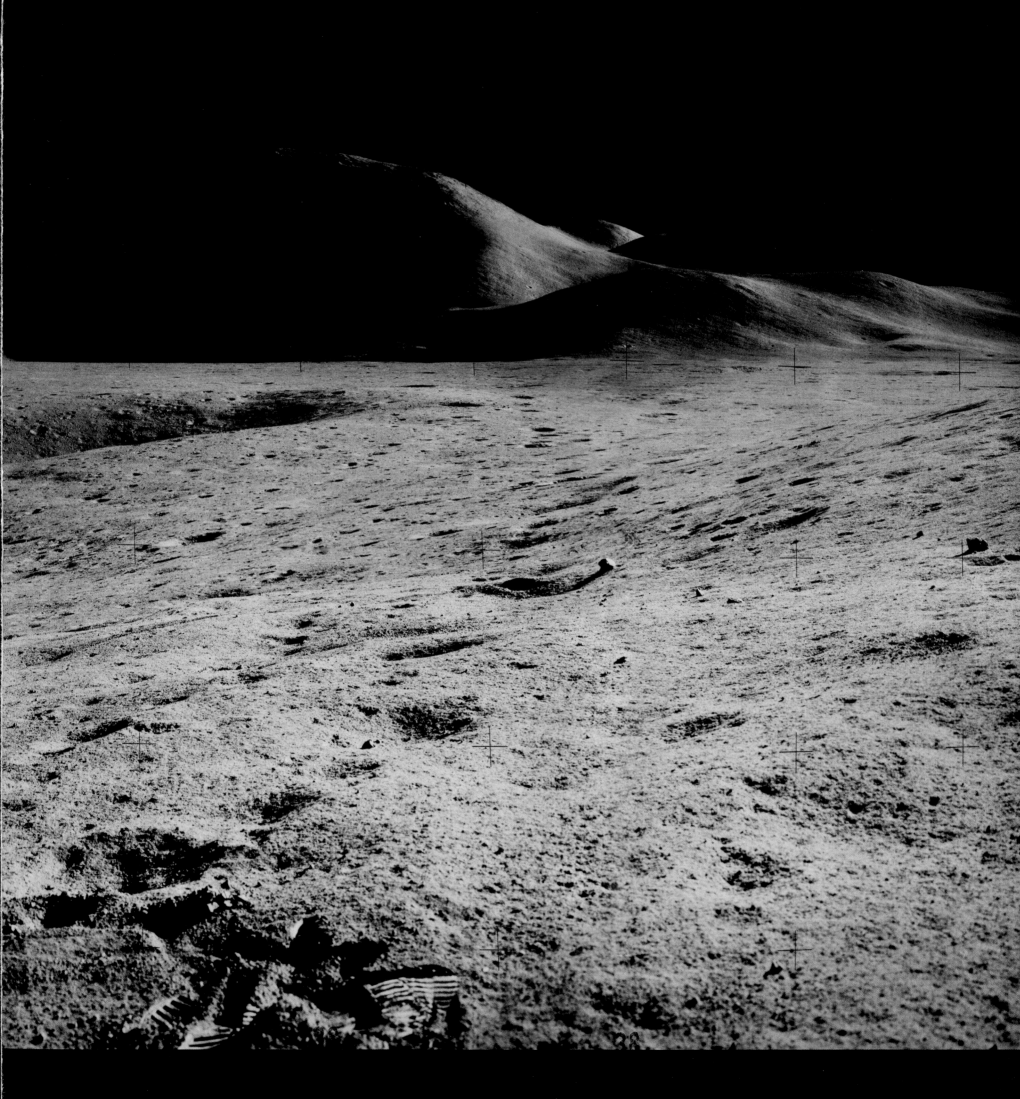

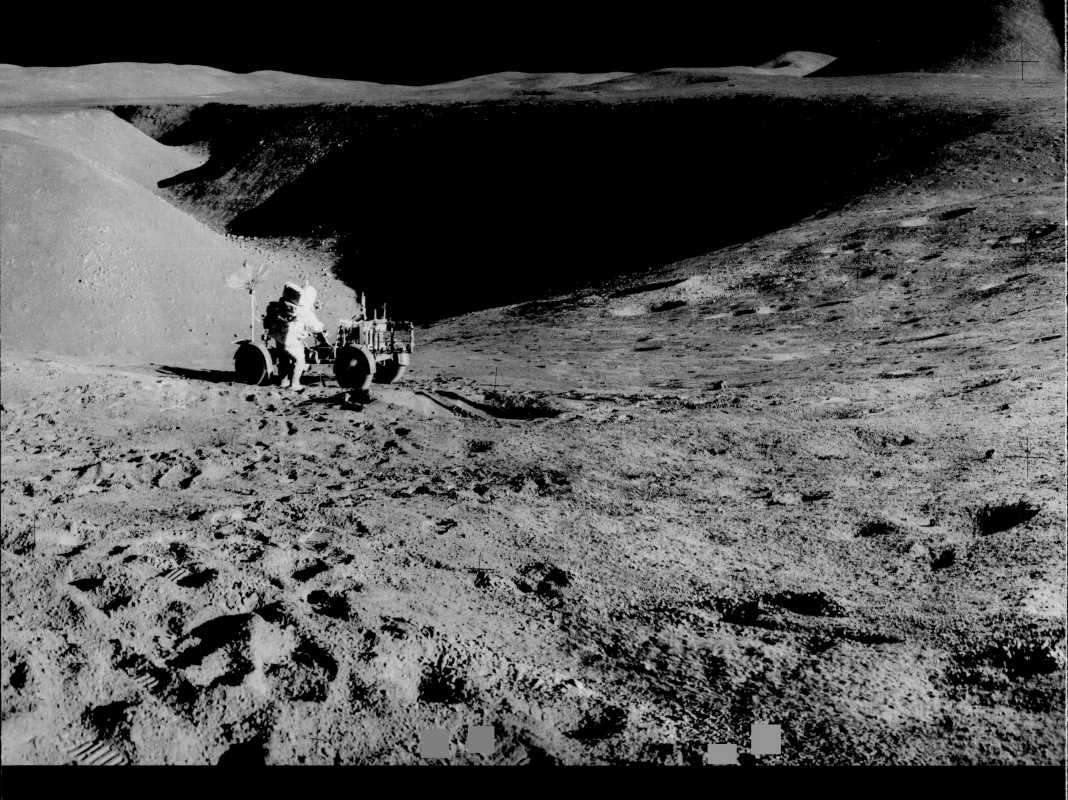

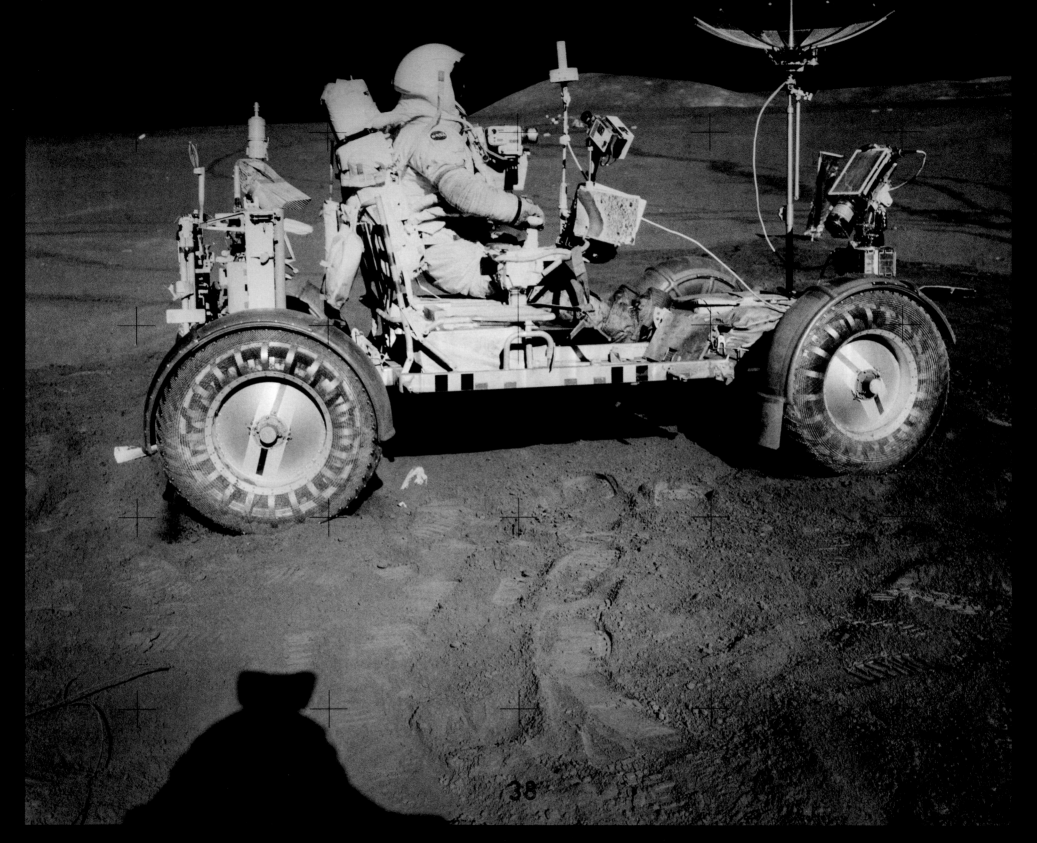

August 1, 1971 **EVA-2** HASSELBLAD 70MM. LENS 60MM F/5.6. B&W | BY JIM IRWIN NASA ID: **AS15-85-11471**

The crew were the first to take off their suits in the LM, and enjoyed a great sleep in their hammocks. Scott is preparing the LRV for its traverse at the start of the second EVA, with his Hasselblad mounted on his chest. The TV camera is at the front of the rover and the mounted 16mm DAC, which suffered many magazine jams, is above the traverse map. The ALSEP, deployed at the end of EVA-1, is just visible in the distance. *(EL: 3/5)*

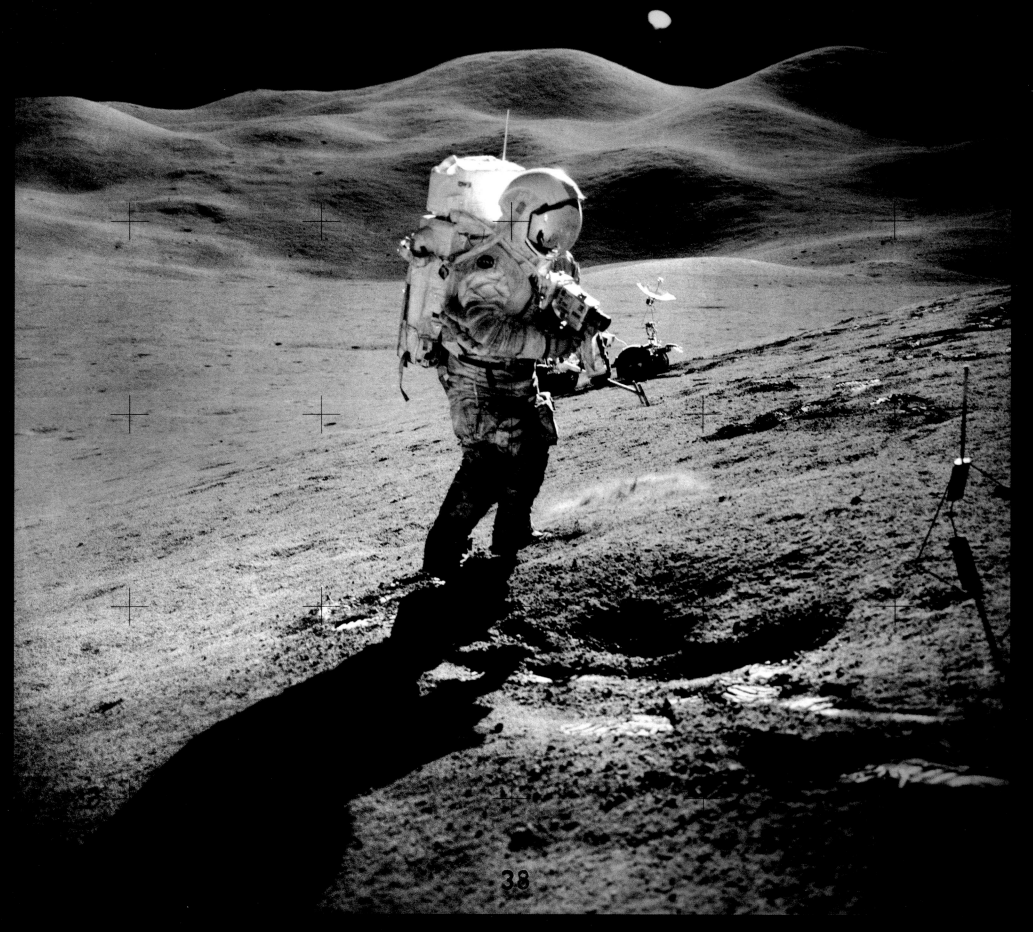

38

August 1, 1971 EVA-2　　　　　HASSELBLAD 70MM. LENS 60MM F/5.6. B&W │ BY JIM IRWIN　　　　　NASA ID: **AS15-85-11514**

Scott: "My oh my! That's as big a mountain as I ever looked up!" The first stop of the seven-hour EVA was Station 6, 3 miles along the base of the Apennine Mountains and 300 feet above the mare surface. Scott: "This rover is remarkable . . . climbed a steep hill and we didn't even really realize it!" Note the 10 percent slope the LRV is parked on as Scott kicks up dust photographing the sample site. The Swann Range is 10 miles in the distance. *(EL: 4/5)*

August 1, 1971 **EVA-2** HASSELBLAD 70MM. LENS 60MM F/5.6 | BY DAVE SCOTT NASA ID: **AS15-86-11649**

Boots on the Moon. The crew moved to an adjacent 30-foot crater on the side of the slope: Mission Control: "Do you suppose you could drive a single core down where it's white?" Scott: "Boy, the soil is more granular here, too. Quite a difference from one side of the rim to the other . . . Okay; I got the picture. 07's the [core tube] number." Fine Moon dust clings to surfaces like Irwin's boots and suit, due to its irregular sharp edges and electrostatic charge. *(Cropped, EL: 2/5)*

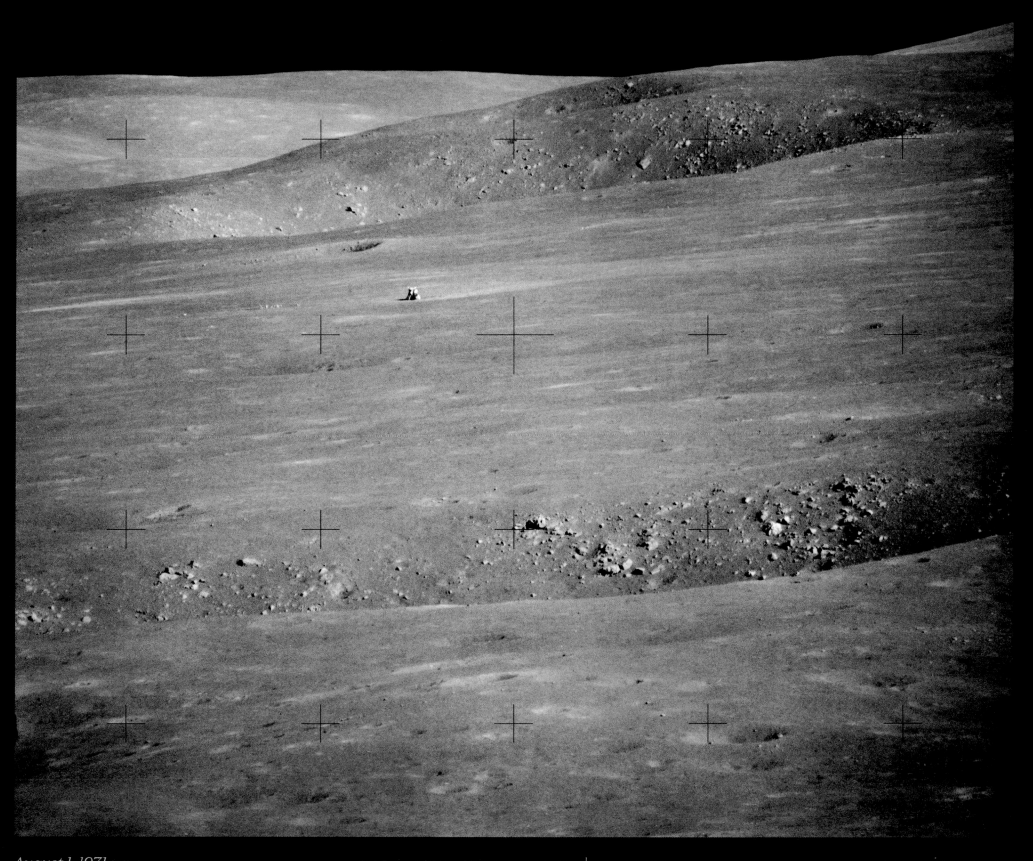

August 1, 1971 EVA-2 HASSELBLAD 70MM. LENS 500MM F/8. B&W | BY DAVE SCOTT NASA ID: **AS15-84-11324**

Before leaving Station 6, the 500mm lens was used to capture the vista. Scott: "And we can look back and see the . . . we can see the LM! Just as loud and clear as can be!" This is Scott's favorite photograph from the mission. Dune crater, in the foreground, is 1.25 miles away, the LM is 3 miles and Pluton crater is 5 miles in the distance. Scott: "Oh, what a beautiful sight. You know, we're a long way from the LM!" Irwin: "At least we can see it!" *(Rotated, EL: 3/5)*

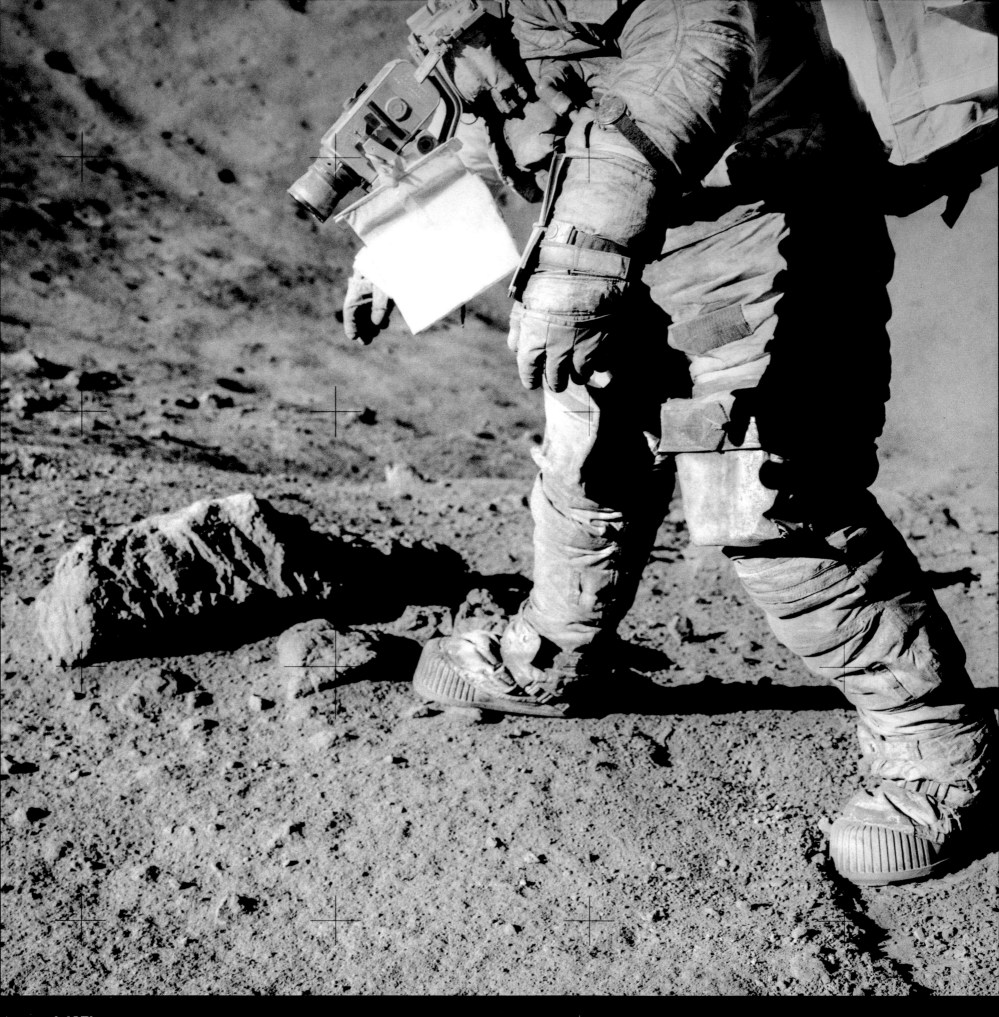

August 1, 1971 **EVA-2** HASSELBLAD 70MM. LENS 60MM F/5.6. B&W | BY JIM IRWIN NASA ID: **AS15-90-12235**

At Spur crater, the crew collected the 4-billion-year-old "Genesis Rock." Further samples were gathered from the crater's rim. Scott: "Why don't you come over here and get your scoop and scoop me up one big rock . . . this one . . . I've got my foot right there." His Speedmaster watch reads 10:40 and 17 seconds. At this precise moment, Worden passes overhead in *Endeavor*, its Mapping camera capturing the image of the landing site on the following page. *(Cropped, EL: 3/5)*

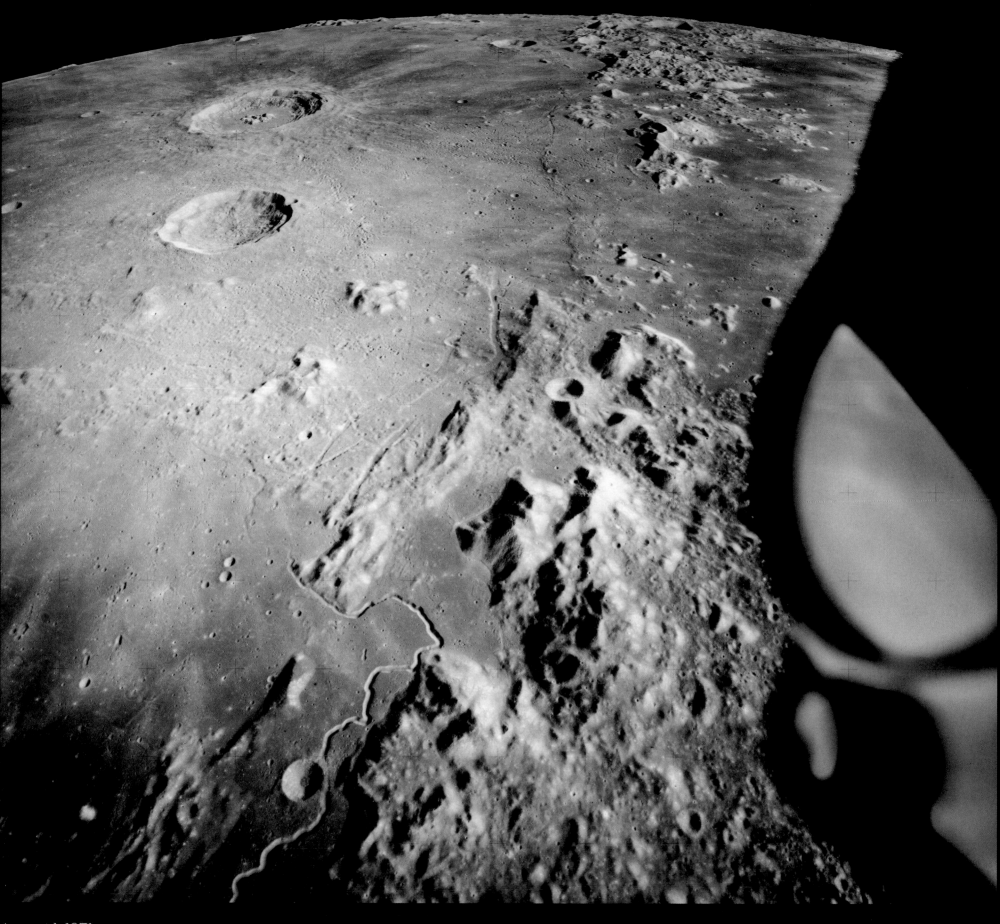

August 1, 1971

METRIC MAPPING CAMERA 115MM. LENS 76MM F/4.5. B&W

NASA ID: **AS15-M-1537**

As Scott and Irwin were collecting samples at Spur crater (previous image), Worden passed overhead in *Endeavor*. He had triggered the Mapping camera to commence a long sequence of images and captured this wonderful photograph of the landing site (bottom, center) and whole region. Such is the resolution of the camera, Scott and Irwin's temporary home on the Moon, the LM and its shadow are also captured in the full resolution digital scan of this frame. *(Rotated, EL: 4/5)*

July 31, 1971 HASSELBLAD 70MM. LENS 80MM F/2.8. B&W │ BY AL WORDEN NASA ID: **AS15-98-13311**

On the previous day, Worden also photographed the solar corona from orbit, just before the Sun "rose" from behind the Moon. The stars, including Regulus and the "head" of the constellation Leo are also visible, due to the use of very fast film. Worden to Hadley Base: ". . . I'm living the life of Riley up here now!" *(Rotated, EL: 4/5)*

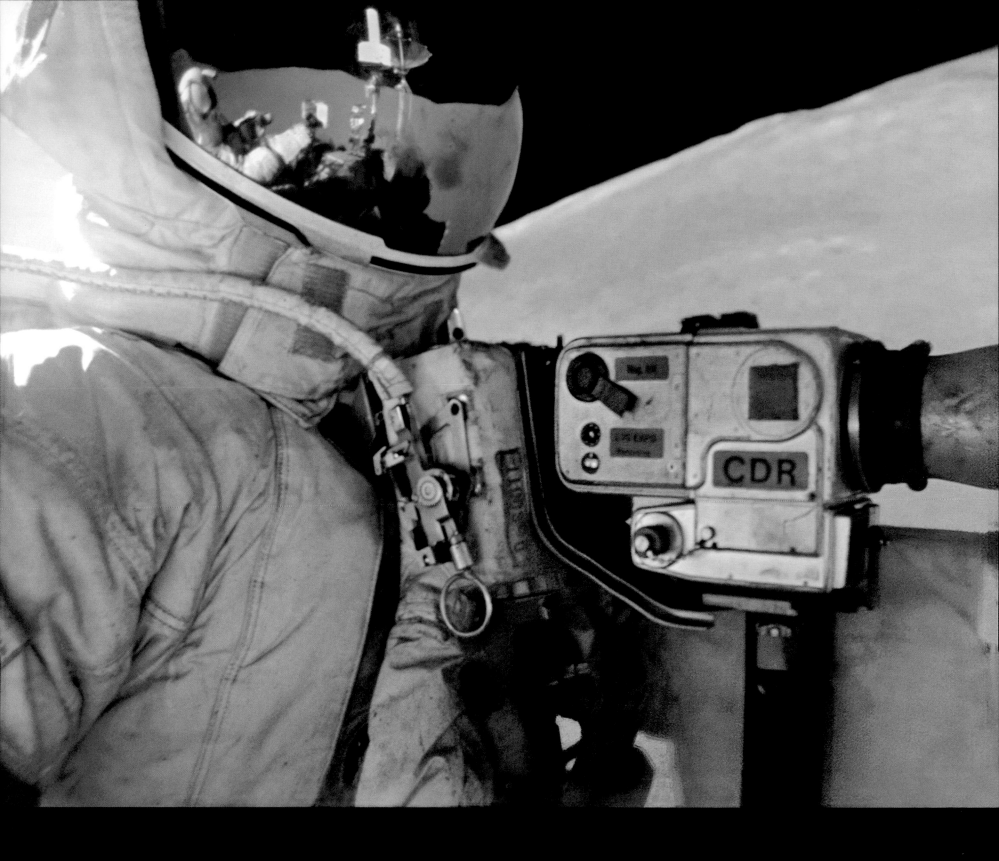

The crew head back on the LRV toward *Falcon*, with a scheduled stop at Dune crater. Scott: "Okay; give me a heading." Irwin: "I can see it over there, Dave . . . And the camera's running . . . We've got about half a mag on it." A great portrait of Commander Scott on the rover with Irwin reflected in his visor, adjusting the 16mm DAC to point at the designated driver. Scott's Hasselblad is looking well used; lunar sample bags hang off its far side.

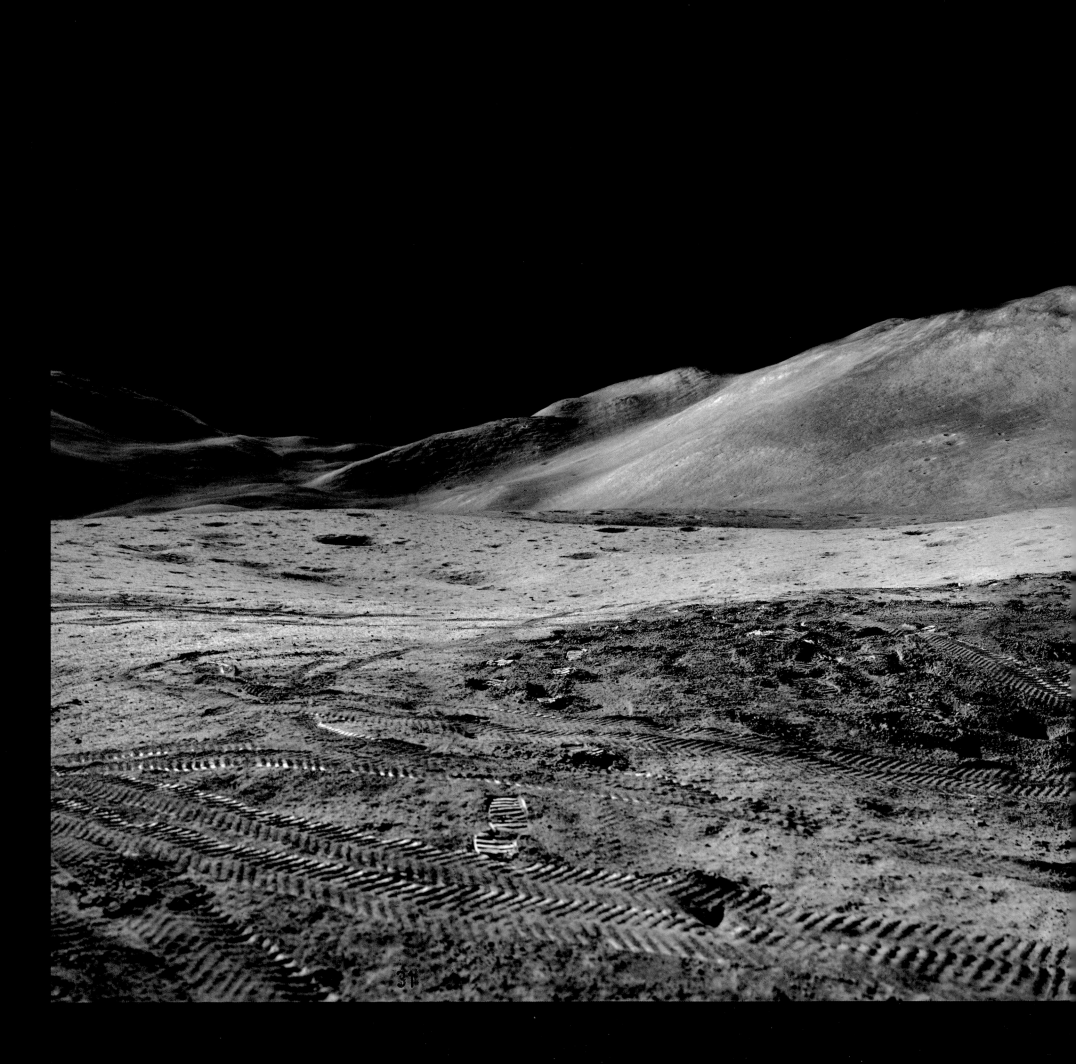

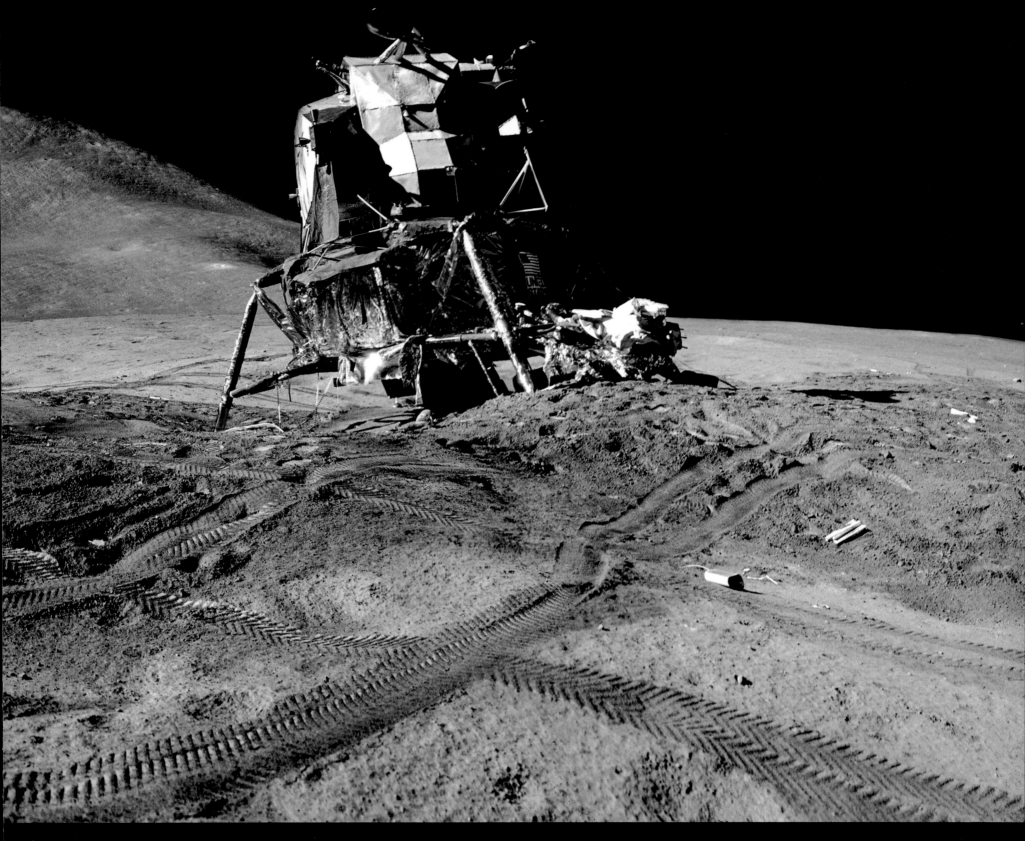

August 1, 1971 EVA-2　　　　　HASSELBLAD 70MM. LENS 60MM F/5.6. | BY JIM IRWIN　　　　　NASA ID: **AS15-87-11815 TO 11819**

This panorama highlights the undulating terrain that contributed to *Falcon's* hard landing as it came to rest on the rim of a 20-foot crater. The considerable 6.8 feet/second landing velocity was compounded as the near leg hit first, shunting the spacecraft to an 11-degree tilt, with one footpad completely off the surface and buckling the (extended) engine bell. The changing shadows can be compared to the "Stand-up EVA" panorama earlier in the mission (see **AS15-85-11370** to **11380**). *(Panorama, fiducial mark removal, EL: 3/5)*

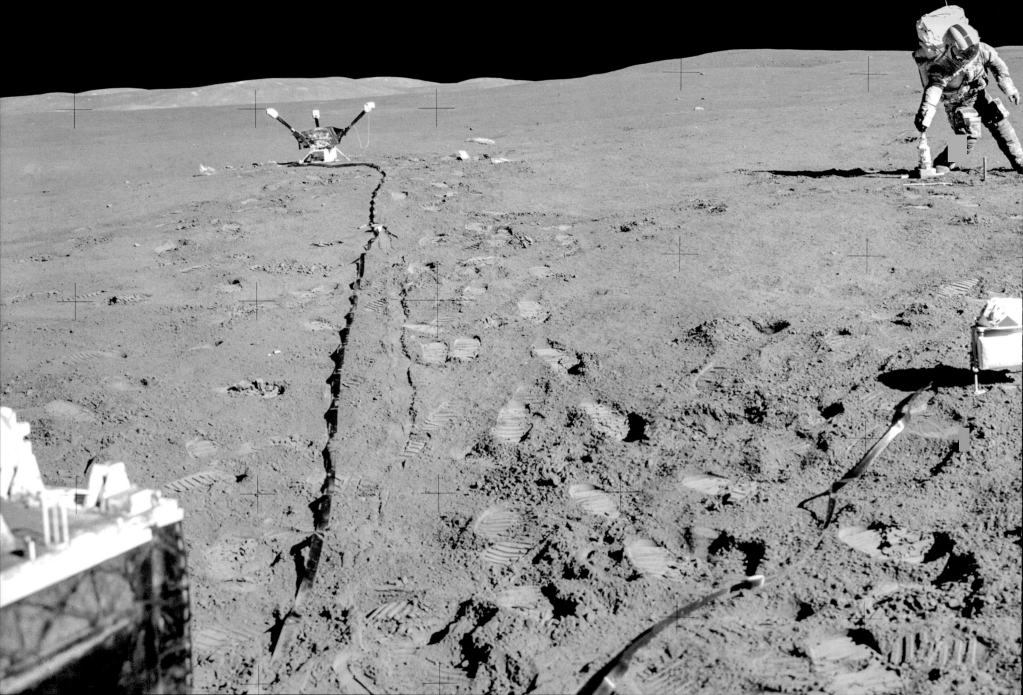

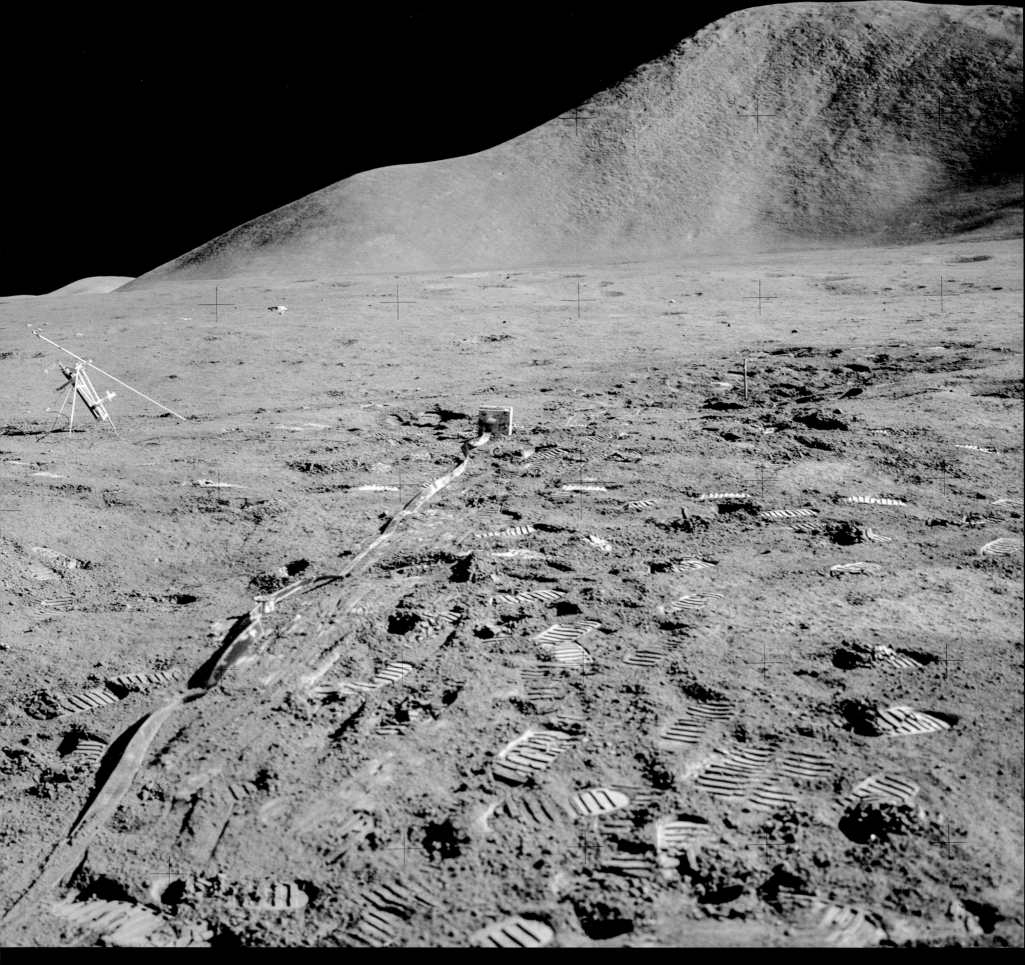

August 1, 1971 EVA-2 HASSELBLAD 70MM. LENS 60MM F/5.6 | BY JIM IRWIN NASA ID: AS15-87-11846 TO 11848

Scott picks up the drill he's been struggling with to bore 6.5 feet down into the lunar regolith for the heat-flow experiment. The ALSEP Central Station is lower left, with cables running to (left to right) the magnetometer, solar wind spectrometer and the heat-flow electronics box. Mount Hadley is 10 miles in the distance. Distances are difficult to judge on the Moon due to the absence of a hazy atmosphere and lack of objects of known size for perspective. *(Panorama, EL: 3/5)*

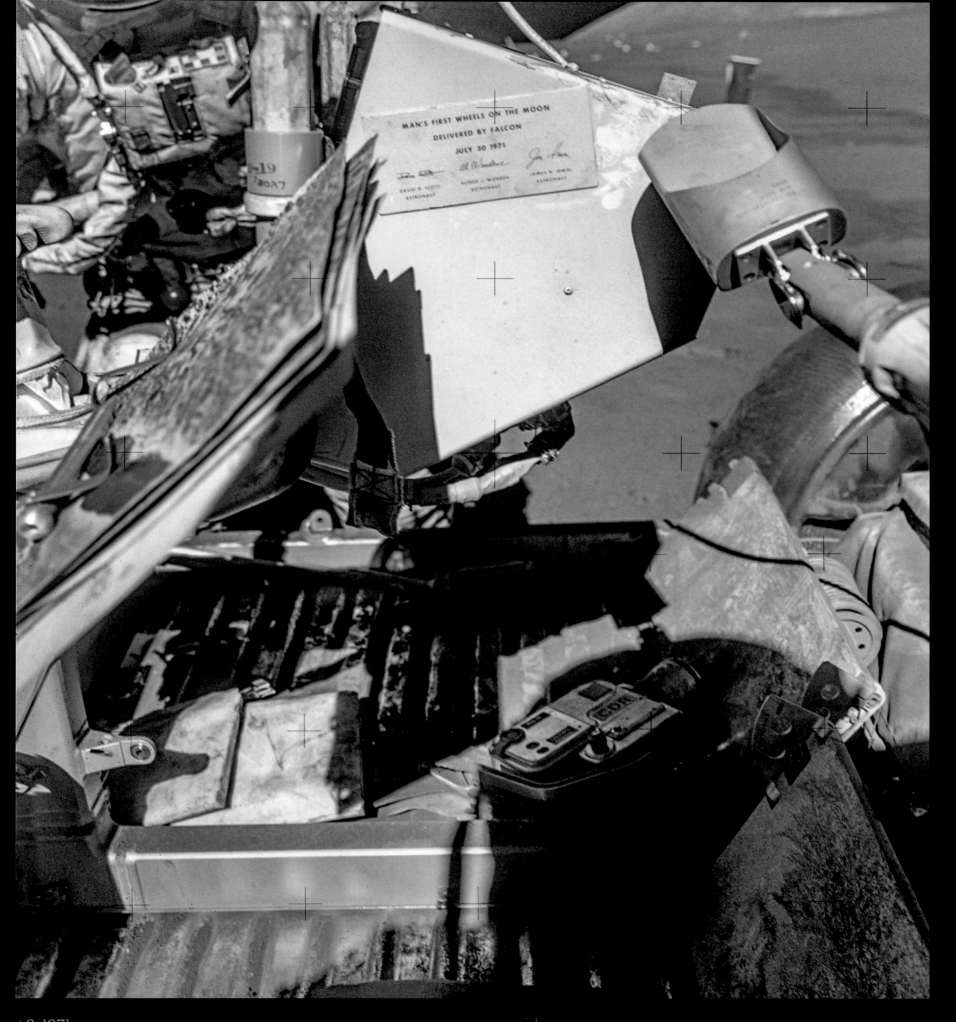

MAN'S FIRST WHEELS ON THE MOON
DELIVERED BY FALCON
JULY 30 1971

DAVID R. SCOTT
ASTRONAUT

ALFRED J. WORDEN
ASTRONAUT

JAMES B. IRWIN
ASTRONAUT

August 2, 1971 **EVA-3** HASSELBLAD 70MM. LENS 60MM F/5.6 | BY JIM IRWIN NASA ID: **AS15-88-11861 TO 118**

At the start of the final EVA, Irwin takes two photographs of the side of the LRV. Using his scoop (upper right) to get a precise distance for the focus setting, he captures a temporary sign affixed the console that commemorates "Man's first wheels on the Moon" and is signed by all three crewmembers. CDR Scott's Hasselblad is in the footwell. The traverse map is on the left and Scott standing in the background. *(Panorama, EL: 4/5)*

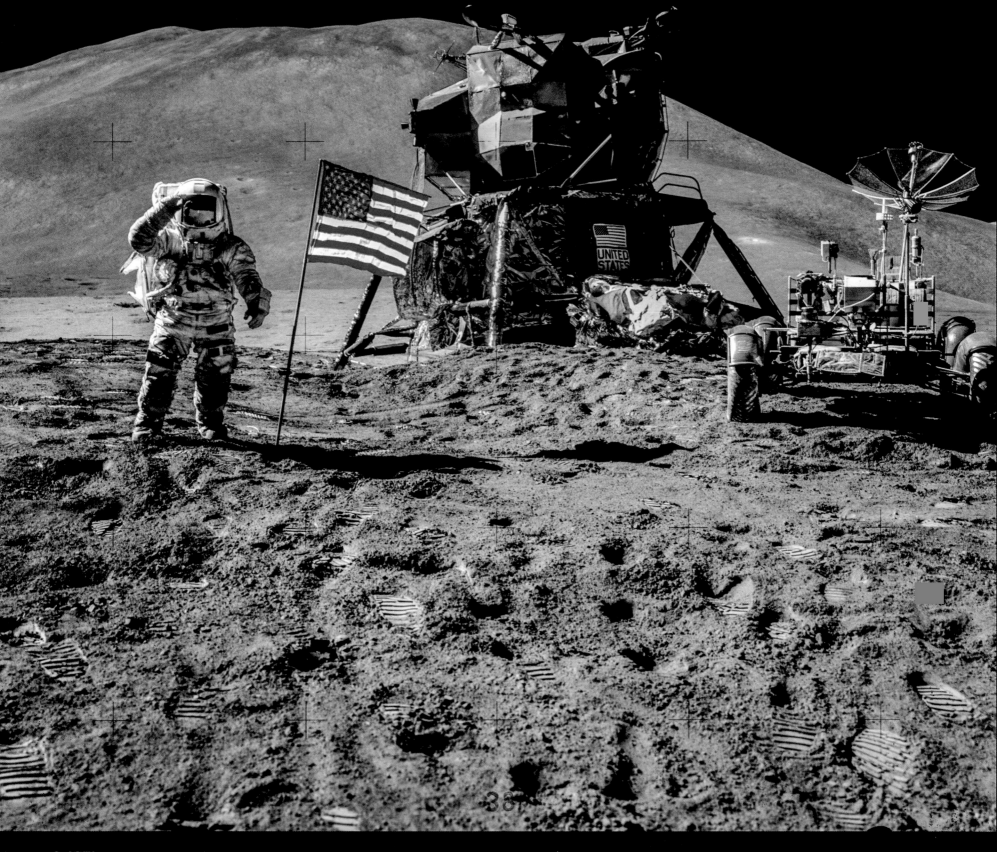

August 2, 1971 **EVA-3** HASSELBLAD 70MM. LENS 60MM F/5.6 │ BY DAVE SCOTT NASA ID: **AS15-88-11866**

Irwin realizes he has color film and that they haven't yet taken color portraits of each other: "One thing, Dave, before you leave." Scott: "Yeah, get my camera." The pick of the series is this one of Irwin – one of the most reproduced images from Apollo. He is saluting next to the flag, with the LRV and LM *Falcon* behind and the 13,000-foot Mount Hadley Delta beyond. *(EL: 2/5)*

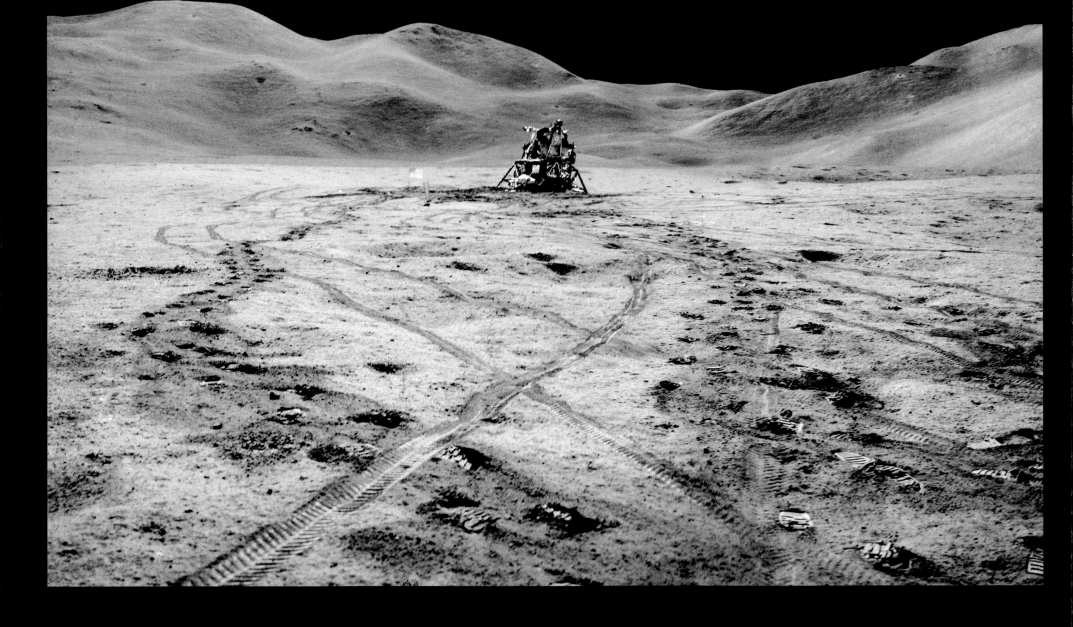

August 2, 1971 EVA-3 HASSELBLAD 70MM. LENS 60MM F/5.6. B&W | BY JIM IRWIN NASA ID: AS15-82-11056 TO 11057

Part of a panoramic sequence from the ALSEP station. Two of the up-Sun images, recovered and stitched, show the sheer majesty of the Apollo 15 landing site. The rover tracks lead to *Falcon*, which sits confidently on the Hadley plain. The Swann Range is a deceptive 10 miles in the distance and forms the horseshoe shape around the landing site, joining the prominent peaks of Mount Hadley and Mount Hadley Delta at either end. *(Panorama, fiducial mark removal, EL: 4/5)*

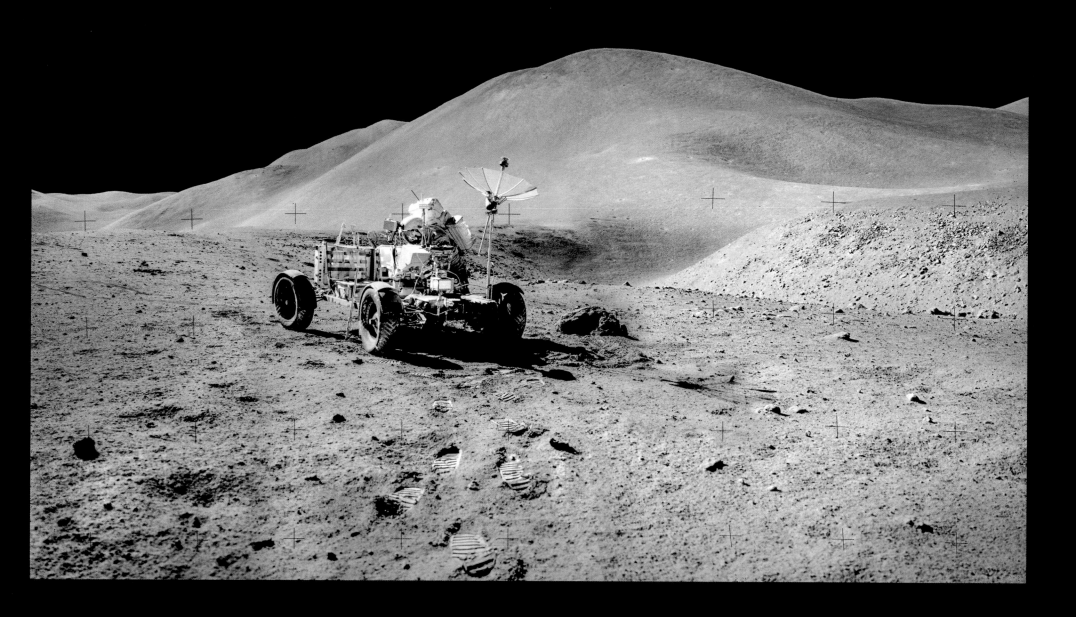

August 2, 1971 EVA-3 HASSELBLAD 70MM. LENS 60MM F/5.6. B&W | BY JIM IRWIN NASA ID: AS15-82-11120 TO 11122

The remainder of the final EVA included a traverse along the edge of Hadley Rille. Here, a mile west of the LM, Scott is lifting his seat on the rover to retrieve the 500mm Hasselblad. The one-mile-wide, 1,300-foot-deep rille sweeps away and around to the right, beneath St. George crater. Notice the different lighting conditions on Silver Spur/Swann Range (upper left) compared to the "Stand-up EVA" two days earlier (see AS15-85-11370 to 11380). *(Panorama, EL: 4/5)*

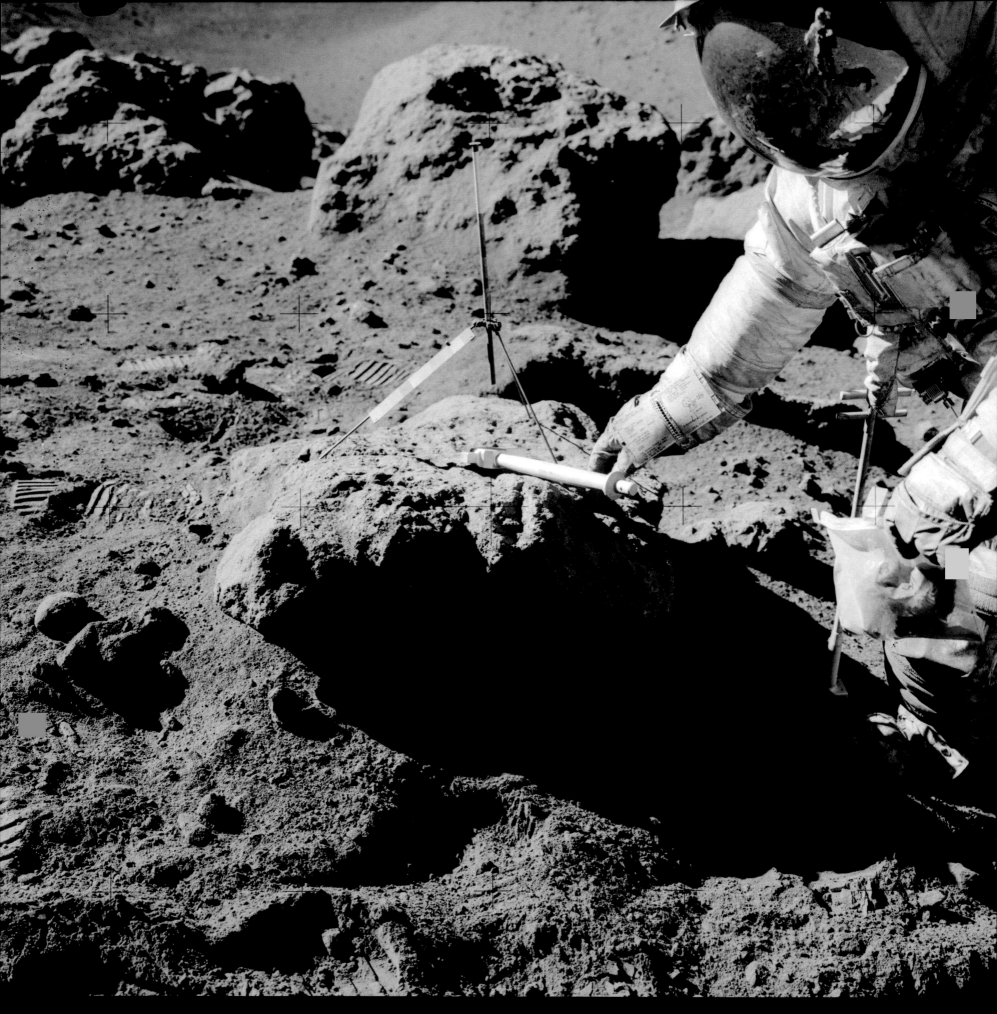

August 2, 1971 EVA-3 HASSELBLAD 70MM. LENS 60MM F/5.6. B&W | BY JIM IRWIN NASA ID: AS15-82-11146

Scott █████████ ning for his hammer, "Come on down here and let's get a frag off of one of these boulders and then we'll head on back to the rover." He has already placed some chipped-off rock into the sample bag in his left hand. With one camera inoperable, Scott doesn't have his camera mounted to his chest as Irwin is using it, as seen in the reflection. The rille is just visible in the background. *(EL: 2/5)*

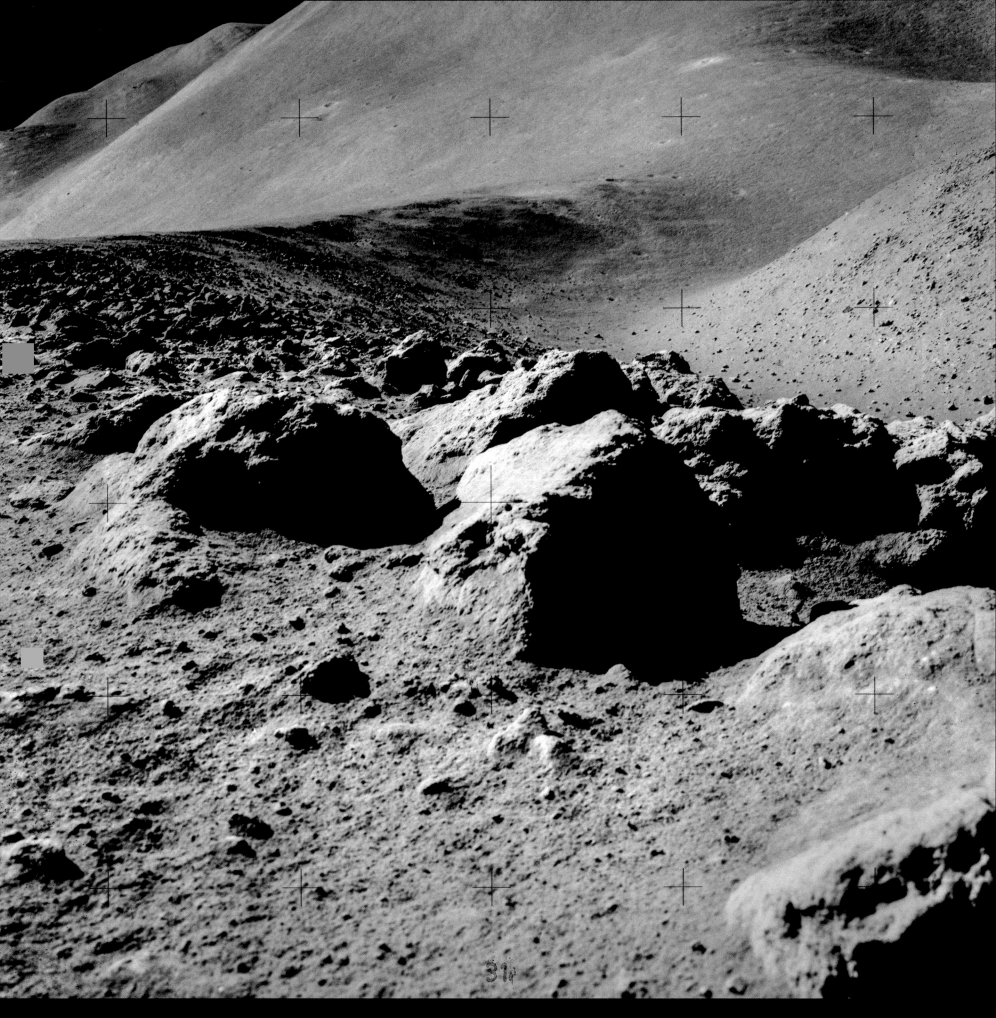

31

August 2, 1971 **EVA-3** HASSELBLAD 70MM. LENS 60MM F/5.6. B&W │ BY JIM IRWIN NASA ID: **AS15-82-11147**

Scott: "And I can look down to the south, and it's just a whole mass of great big boulders along the terrace here . . . Boy, it hurts not to have two cameras." Although Scott fixed Irwin's jamming Hasselblad overnight in the LM, it has stopped working again. Irwin: "Those blocks seem to be slightly different." Scott: "A little darker." Silver Spur is upper left and St. George crater, upper right. (*EL: 3/5*)

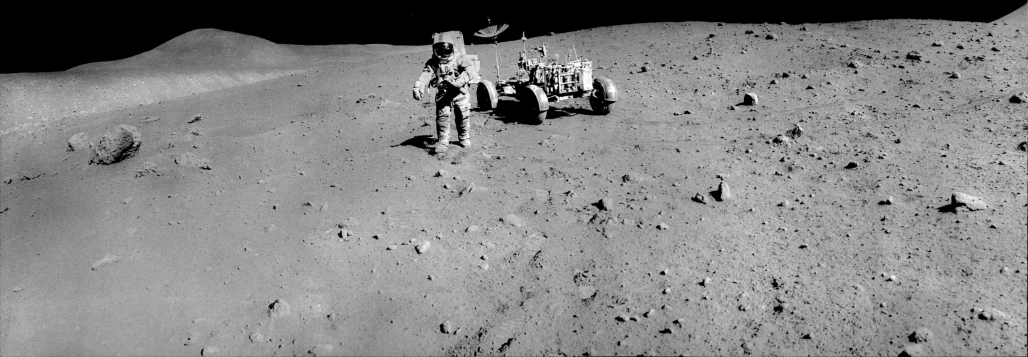

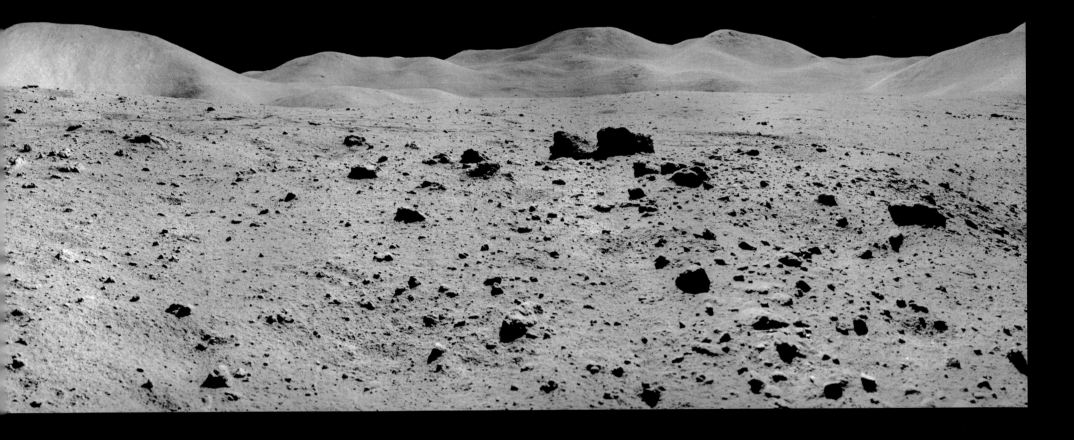

August 2, 1971 EVA-3 HASSELBLAD 70MM. LENS 60MM F/5.6. B&W | BY JIM IRWIN NASA ID: **AS15-82-11166 TO 11176**

Scott kicks up some dust as he strides from the rover with the Hasselblad and the huge 500mm lens attached. The rille is far left and the rover tracks can be followed off to the far right. The Swann Range comes in from the right, leading to Mount Hadley in the center. Scott used the 500mm to photograph Mount Hadley under different lighting conditions on the previous day (see following page). *(Panorama, fiducial mark removal, EL: 5/5)*

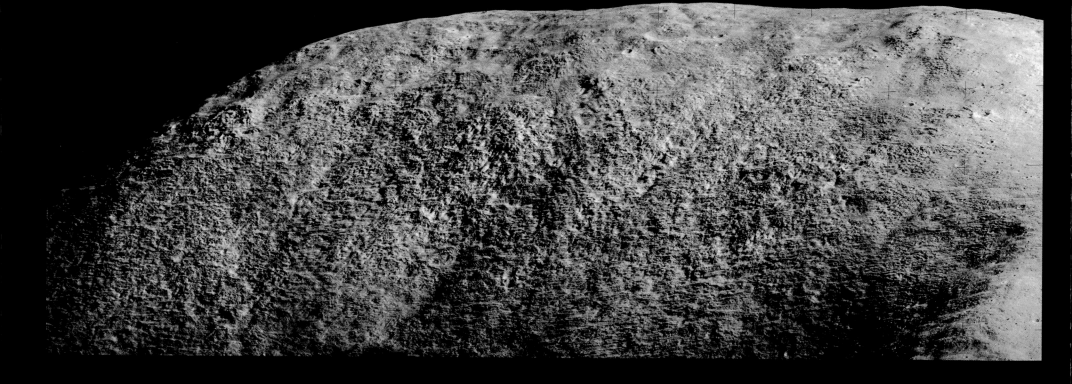

August 1, 1971 EVA-2 HASSELBLAD 70MM. LENS 60MM F/8. B&W | BY DAVE SCOTT NASA ID: **AS15-84-11302 TO 11308**

Scott took this panoramic sequence of Mount Hadley with the 500mm lens on EVA-2. Irwin: "Boy, I can't get over those lineations – that layering at Mount Hadley." Scott: "Boy, I can't either. That's really spectacular." Irwin: "That's really beautiful. Talk about organization . . . That's the most organized mountain I've ever seen!" The linear features dipping down to the left are thought to be benches resulting from slumping of the mountain face, accentuated by the specific lighting conditions. *(Panorama, EL: 2/5)*

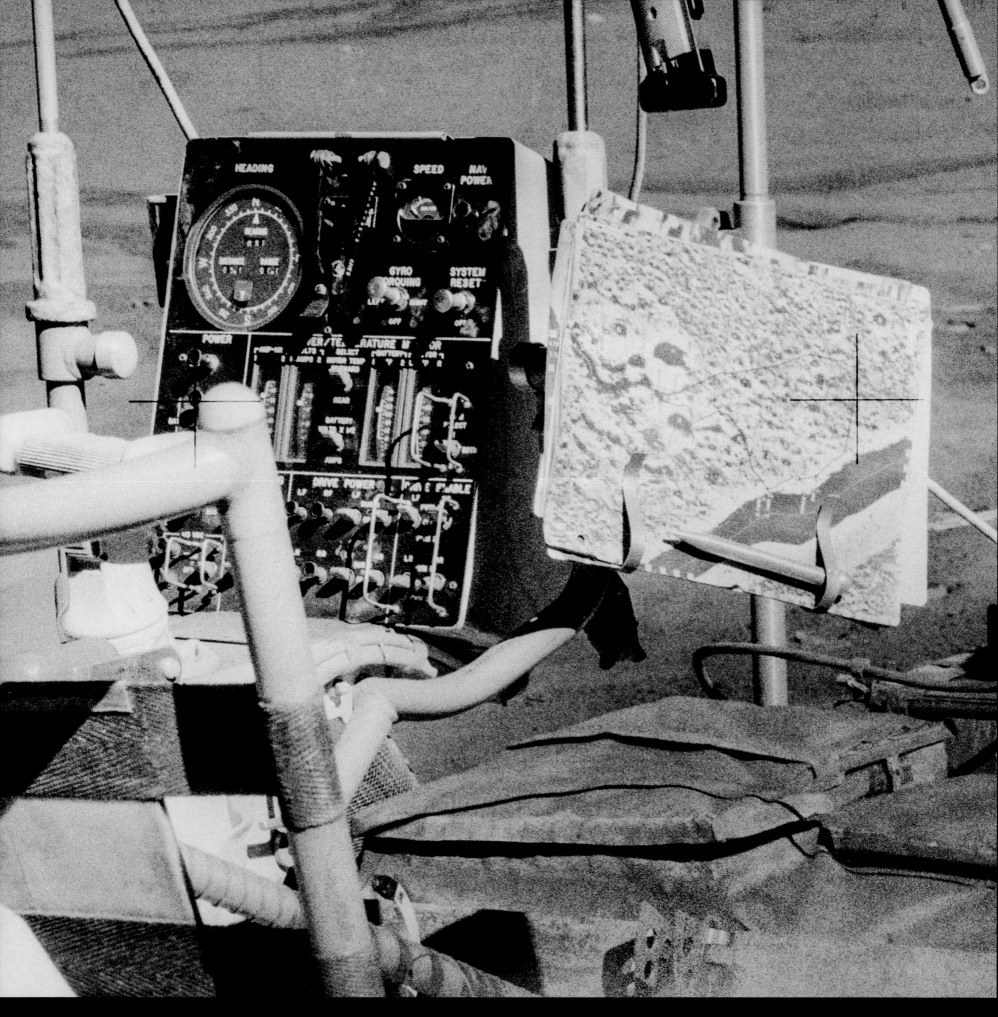

Back at the LM, closing out their final EVA, Scott: "Okay, I got a pan of the rover." Part of the panoramic sequence captured the clearest mission photograph of the gloriously analog LRV "dashboard." Heavily cropped here, many of the dials and switches can be read. "Distance" is showing 5.1 km (3.2 mi), which correlates with the total EVA-3 traverse. "Range" (to the LM) is 0.0 km and the rover is pointing north. The EVA-3 route is also visible, drawn out on the traverse map. (Cropped, EL: 4/5)

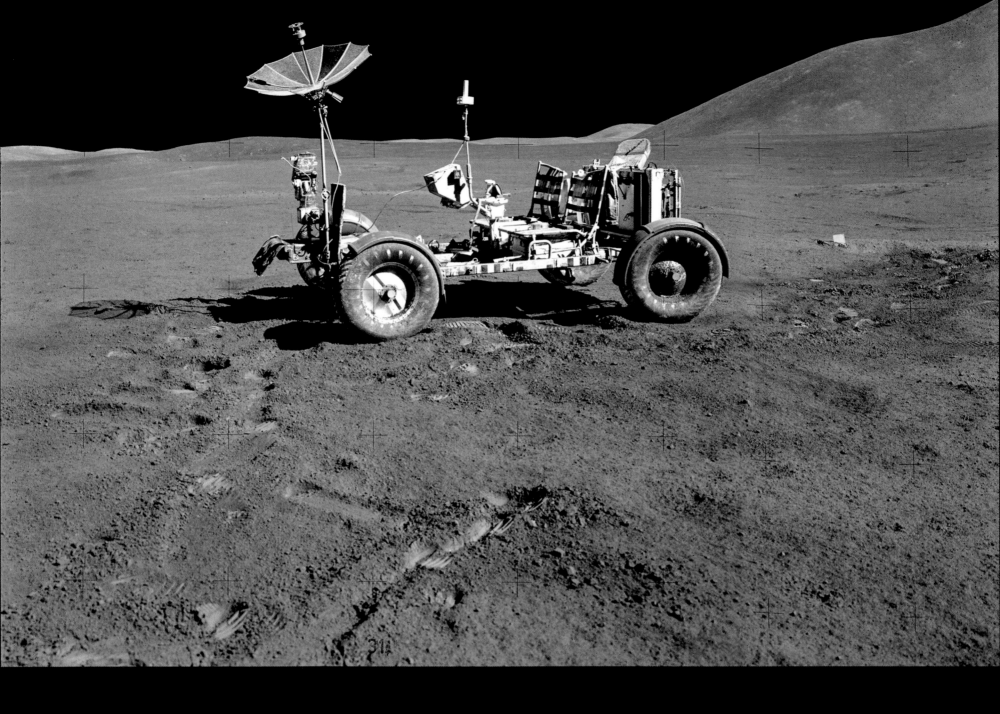

August 2, 1971 **EVA-3** HASSELBLAD 70MM. LENS 60MM F/5.6 | BY DAVE SCOTT NASA ID: **AS15-88-11901 TO 11902**

Scott: "Okay, I think I've got a good place for you. Right up on a rise. We're about 300 feet away . . . Switches are off. Brake's on." At the end of the final EVA, Scott parked the rover such that the TV camera could capture the ascent from the Moon for the first time. Seen on the control panel is a small red bible left by Scott, and the footsteps off to the right lead to a small monument to fallen astronauts. *(Panorama, EL: 2/5)*

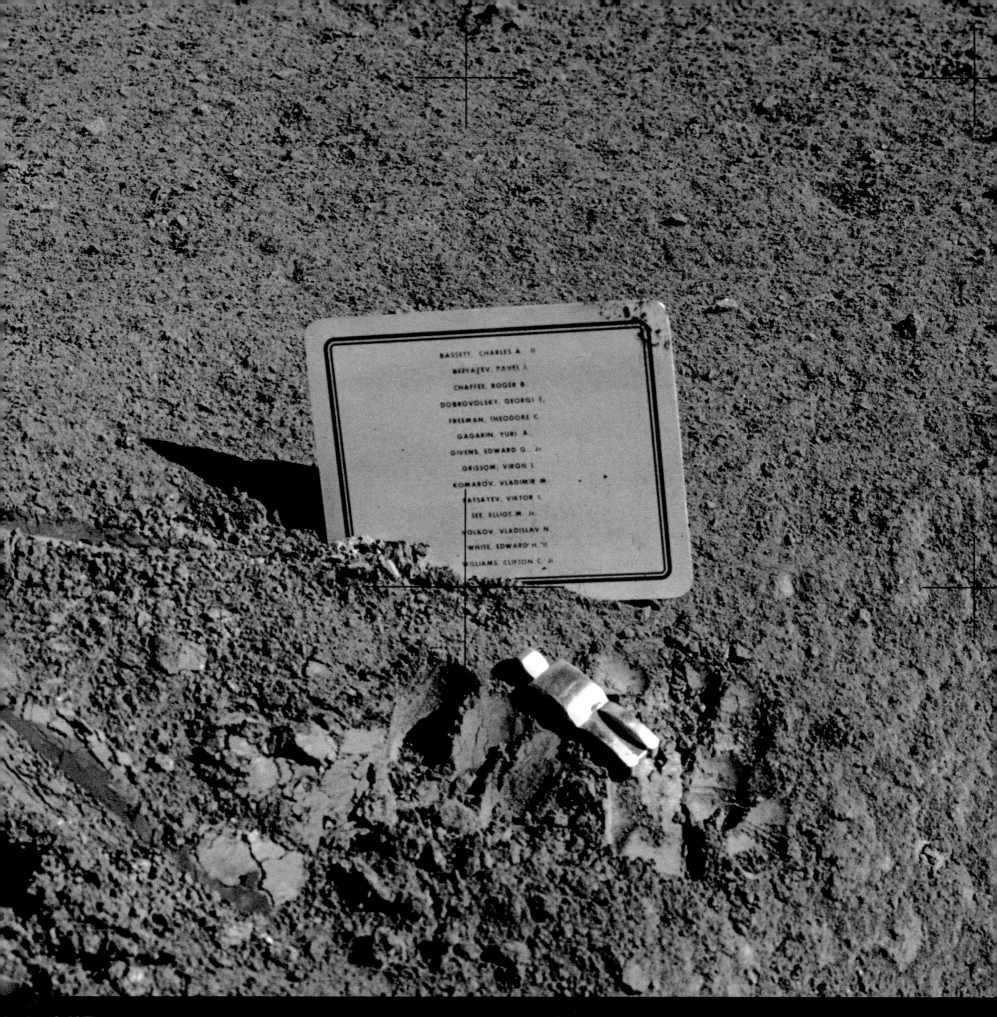

The plaque reads:

BASSETT, CHARLES A. II
BELYAYEV, PAVEL I.
CHAFFEE, ROGER B.
DOBROVOLSKY, GEORGI T.
FREEMAN, THEODORE C.
GAGARIN, YURI A.
GIVENS, EDWARD G. Jr.
GRISSOM, VIRGIL I.
KOMAROV, VLADIMIR M.
PATSAYEV, VIKTOR I.
SEE, ELLIOT M. Jr.
VOLKOV, VLADISLAV N.
WHITE, EDWARD H. II
WILLIAMS, CLIFTON C. Jr.

August 2, 1971 EVA-3 HASSELBLAD 70MM. LENS 60MM F/5.6 | BY DAVE SCOTT NASA ID: AS15-88-1189

The Fallen Astronaut. Mission Control: "Dave, give me a call on your present activity." Scott: "Oh, just cleaning up the back of the rover, here, a little." In fact, unbeknownst to Houston, Scott was placing this memorial, a small figurine, The Fallen Astronaut and a plaque with the names of the astronauts and cosmonauts who had lost their lives prior to Apollo 15. (Cropped. FL: 4/5)

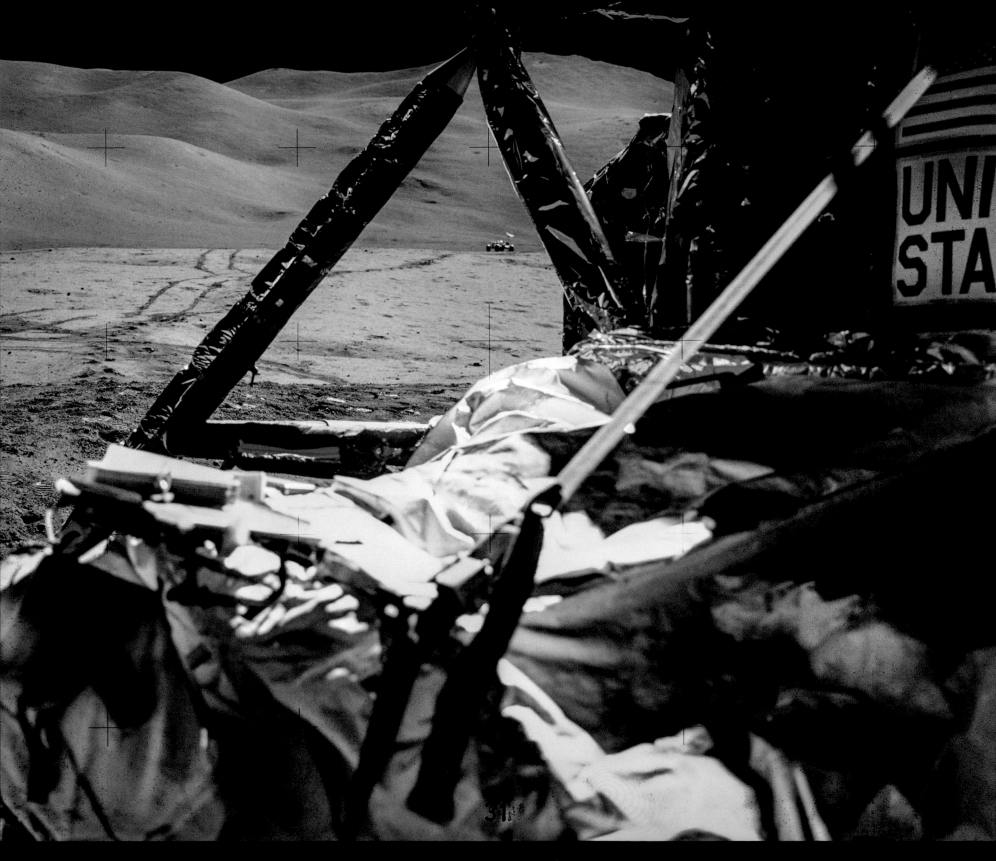

August 2, 1971 EVA-3 HASSELBLAD 70MM. LENS 60MM F/5.6 | BY DAVE SCOTT NASA ID: AS15-88-11930

The last EVA photograph of the mission. The rover is pictured from the MESA through *Falcon's* landing gear, in its final resting spot, dwarfed by the Apennine Mountains 10 miles in the distance. Three hours later, *Falcon's* ascent engine would ignite as it lifted off from this spectacular lunar landscape – captured by the rover's TV camera. *(EL: 4/5)*

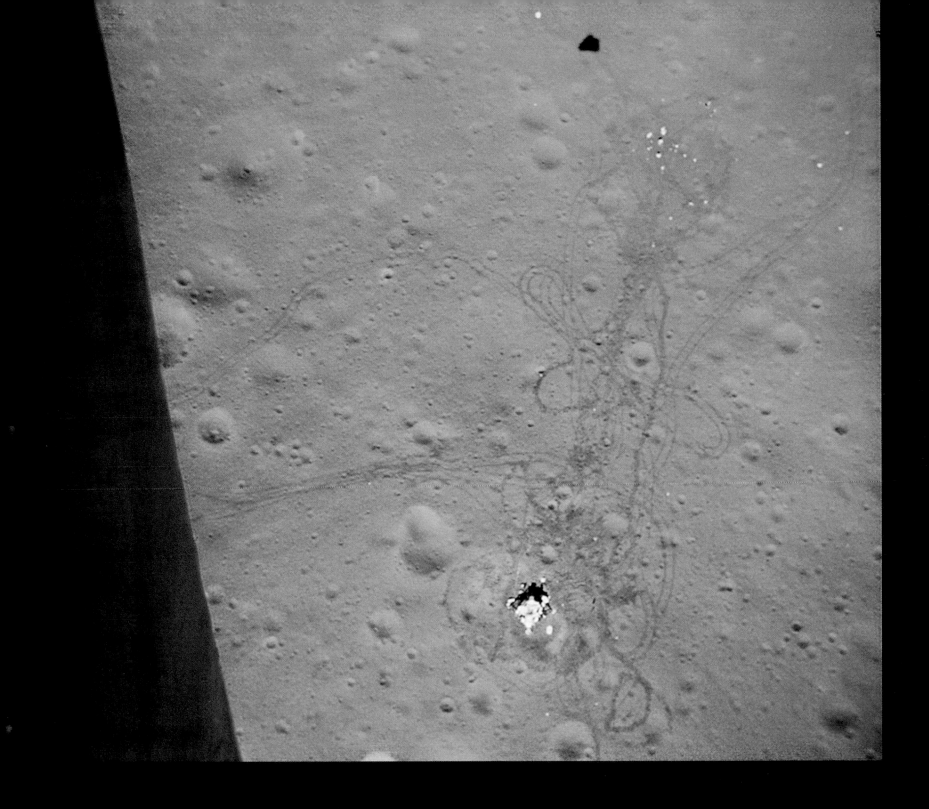

August 2, 1971

24 FRAMES OF 16MM FILM, STACKED AND PROCESSED

NASA ID: **APOLLO 15 MAG 1241-BB**

Music was heard in Mission Control coming from *Falcon* at lift-off – the "Air Force Song" was transmitted down from *Endeavor*. Scott: "Good lift-off . . . Good smooth ride . . . It almost sounds like the wind whistling." Standing in the LM, lift-off from the Moon was likened to an elevator. The LM descent stage and the first vehicle tracks on the Moon can be clearly seen. The ALSEP is upper right and the shadow of *Falcon* is heading out of shot.

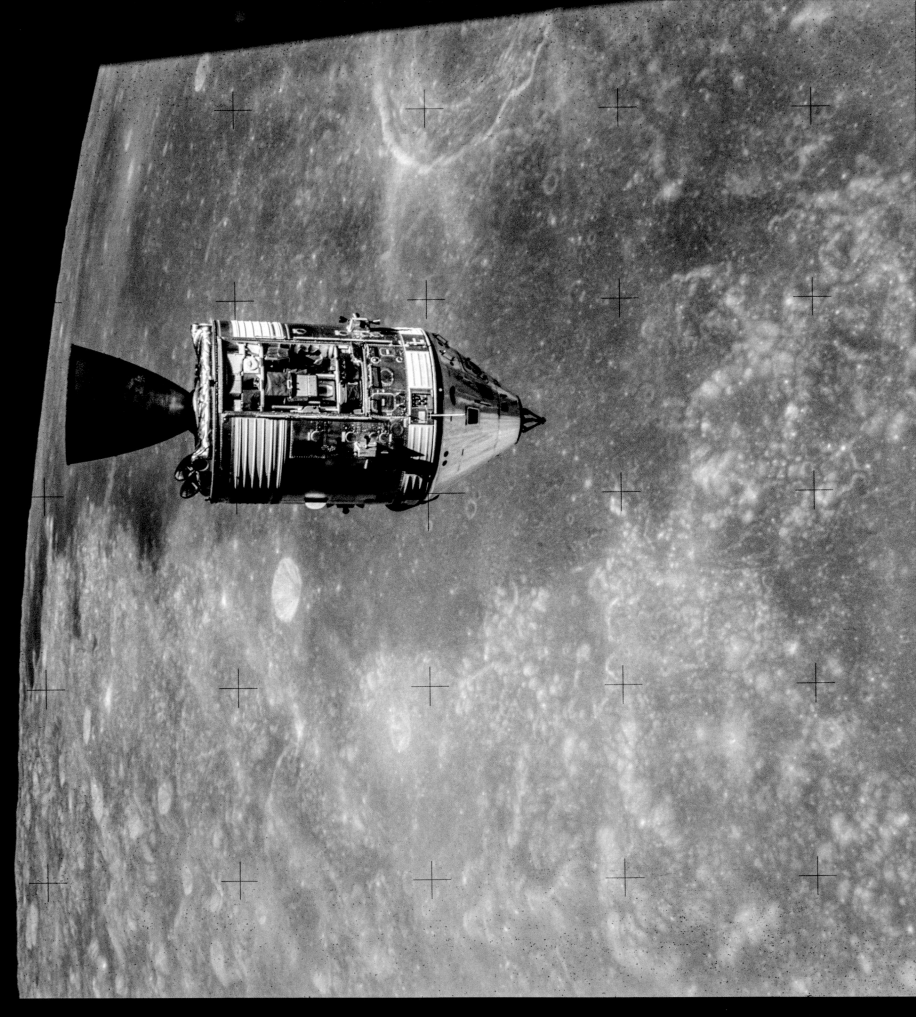

August 2, 1971

HASSELBLAD 70MM. LENS 60MM F/5.6 │ BY JIM IRWIN

NASA ID: **AS15-88-11972**

On board *Endeavor*, Worden spots the approaching LM: "Oh, you're shining in the sunlight now! Boy, is that pretty!" CSM *Endeavor* is seen here over the Sea of Fertility; Scott: "Okay, Houston. We're stationkeeping at about 120 feet . . ." Mission Control requested that *Endeavor* perform a maneuver in order for the open SIM bay, containing the Panoramic and Mapping cameras, to be photographed from the LM. *(Rotated, EL: 2/5)*

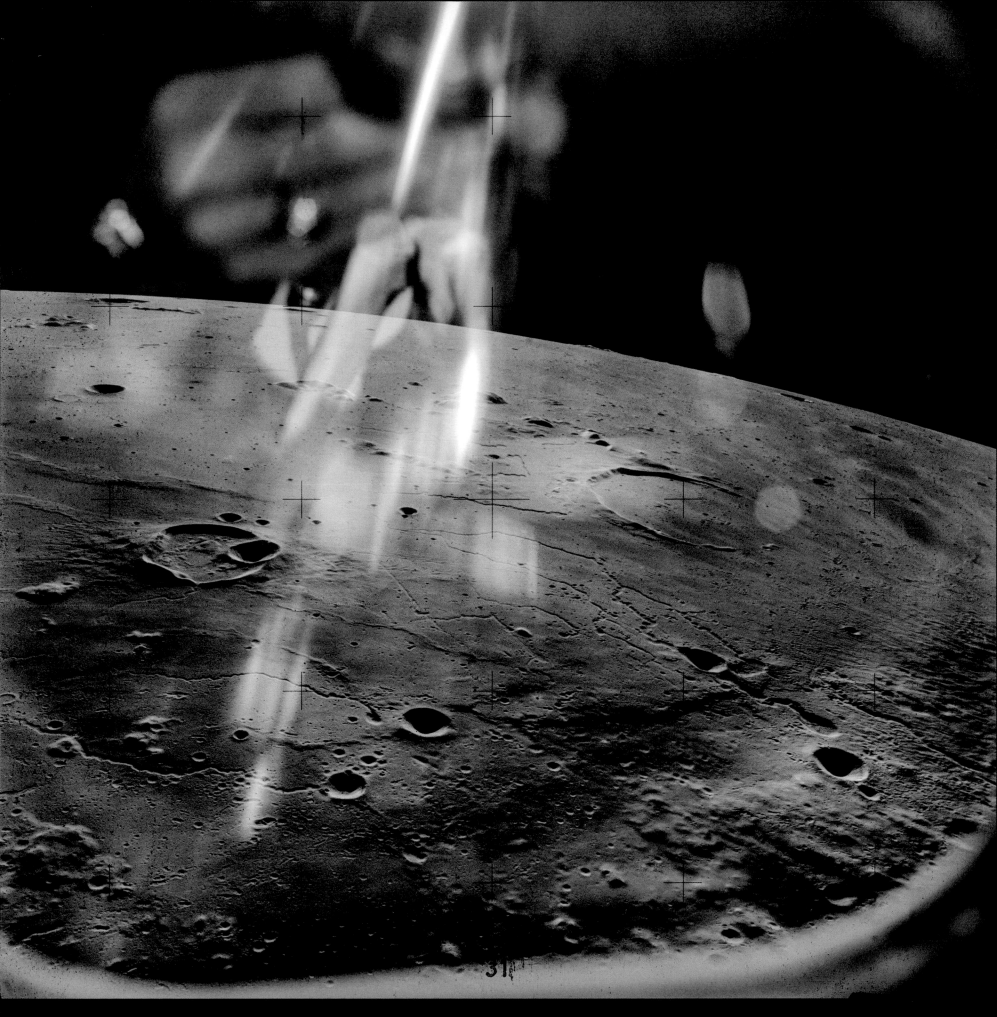

August 4, 1971 HASSELBLAD 70MM. LENS 60MM F/5.6 | BY DAVE SCOTT NASA ID: **AS15-88-12004**

Day ten of the mission and Oceanus Procellarum, on the western edge of the nearside of the Moon, is photographed from the Command Module window. Note the Réseau cross-marks – unusually, the lunar surface camera and 60mm lens is used (and returned to Earth), capturing a unique perspective including the window itself. Crater Krieger is to the left and the 28-mile-wide lava-flooded Prinz crater is to the right. *(EL: 3/5)*

August 4, 1971

HASSELBLAD 70MM. LENS 250MM F/5.6 | BY AL WORDEN

NASA ID: AS15-97-13267

Earth rises above the farside of the Moon. Al Worden captured the shot during the 70th revolution of the Moon from the Command Module window. The enormous 3.2-mile-deep wall of Humboldt crater is on the horizon. (Cropped, rotated, EL: 5/5)

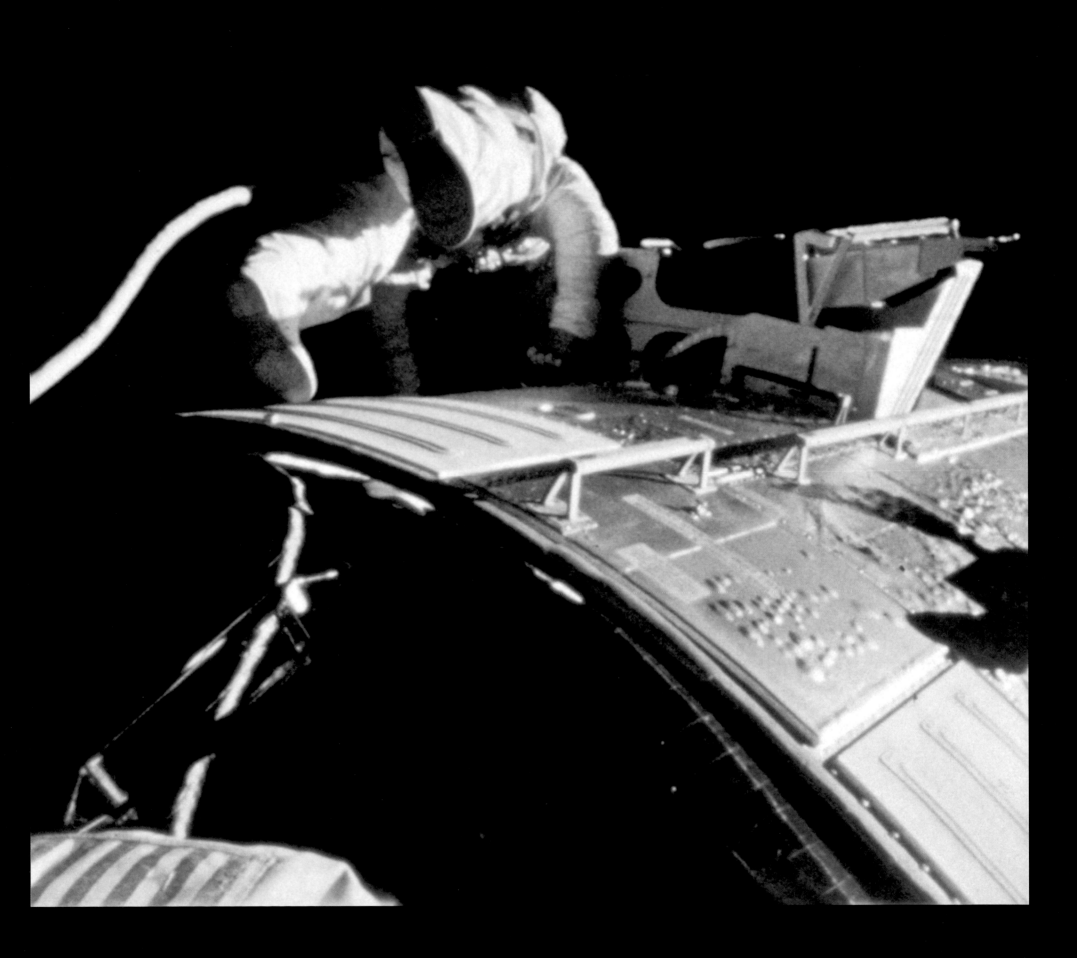

August 5, 1971

SINGLE PROCESSED 16MM FILM FRAME

NASA ID: **APOLLO 15 MAG 1257-F**

The world's first-ever deep-space EVA – 171,000 nautical miles from Earth: Worden heads out to retrieve the Mapping and Panoramic film cassettes, as Irwin assists from the hatch; "Jim, you look absolutely fantastic against that Moon back there. That is really a most unbelievable, remarkable thing." This single (accidentally turned off) 16mm film frame is the only well-exposed image of Worden captured on flight film during the whole mission.

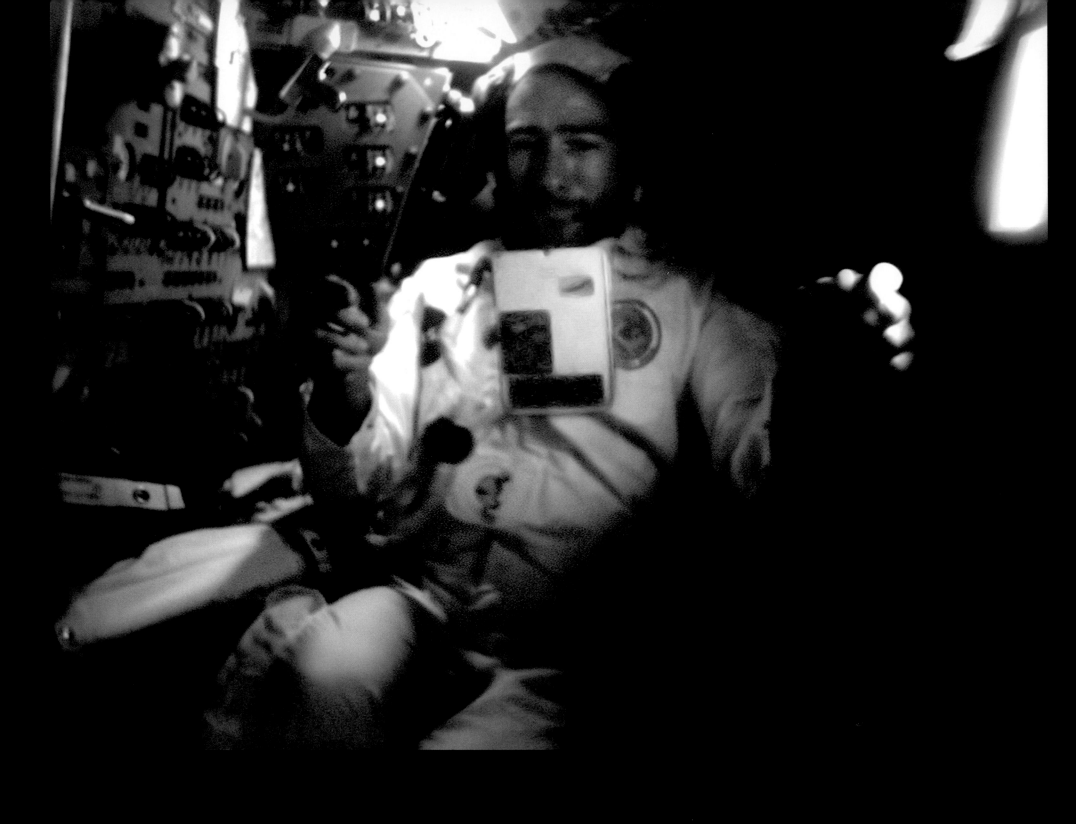

August 4–7, 1971 37 FRAMES OF 16MM FILM, STACKED AND PROCESSED NASA ID: **APOLLO 15 MAG 1257-F**

Jim Irwin relaxes and plays around with a 16mm DAC magazine in zero gravity during the long journey home. He was unaware at this stage that Mission Control had observed serious irregularities in his heartbeat. They chose not to inform the crew – he was being monitored, and zero gravity with a 100% oxygen environment was a good place for him to be. Irwin died in 1991 of a heart attack, aged 61.

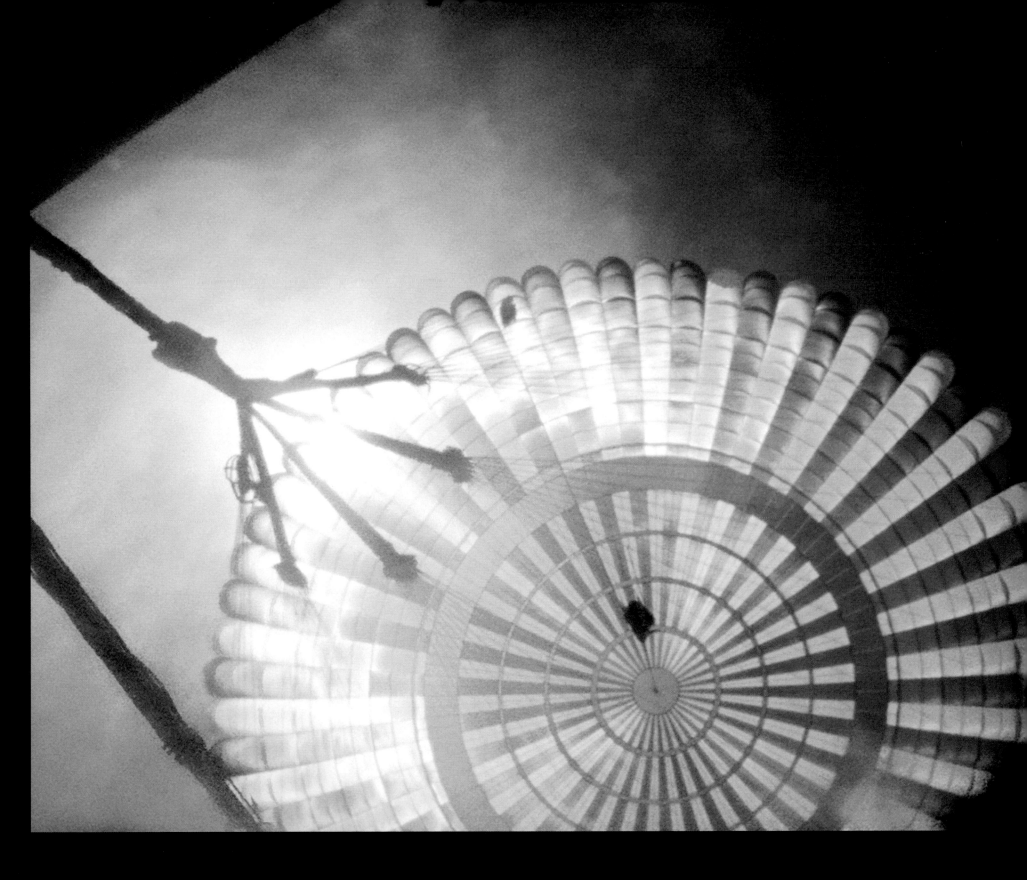

August 7, 1971 12 FRAMES OF 16MM FILM, STACKED AND PROCESSED NASA ID: **APOLLO 15 MAG 1253-**

Despite the loss of one of the three main parachutes, Apollo 15 splashed down safely in the Pacific, 330 miles north of Hawaii. The Apollo Command Module capsules were designed to safely land on two parachutes; the third was redundancy against one malfunctioning. The highly successful first "J-mission" paved the way for Apollo 16 the following year.

THE DETAILS

ROCKET Saturn V (SA-511)	LAUNCH 17:54 GMT, April 16, 1972, Pad 39A	DURATION 11 days, 1 hour, 51 minutes	SPLASHDOWN 19:45 GMT, April 27, 1972, Pacific Ocean
COMMAND AND SERVICE MODULE *Casper* (CM-113)	LANDING SITE Descartes Highlands	SURFACE TIME 71 hours, 02 minutes	RECOVERY SHIP
LUNAR MODULE *Orion* (LM-11)	DISTANCE 1,391,550 miles	LUNAR ORBITS 64	USS *Ticonderoga*

THE CREW

John W. Young
COMMANDER (CDR)

Born September 24, 1930. Often described as the astronaut's astronaut, Young was Pilot of Gemini's first crewed mission, Gemini III, and Command Pilot of Gemini X with Michael Collins. One of only three men to fly to the Moon twice, he orbited the Moon as CMP on Apollo 10 and went on to command the first Space Shuttle mission in 1981.

Thomas K. "Ken" Mattingly II
COMMAND MODULE PILOT (CMP)

Born March 17, 1936. Mattingly was famously scheduled to be CMP of Apollo 13, but exposure to measles (which he ultimately never contracted) via Charlie Duke led to his replacement by Jack Swigert, three days before launch. He would later go on to command two Space Shuttle missions in 1982 and 1985.

Charles M. Duke Jr.
LUNAR MODULE PILOT (LMP)

Born October 3, 1935. A former USAF fighter pilot and test pilot, Duke was part of NASA's fifth intake of astronauts, in April, 1966. He was back-up LMP for Apollo 13 and Apollo 17. Duke became the tenth and youngest person to walk on the Moon and retired from NASA in 1976.

April 16–25, 1972

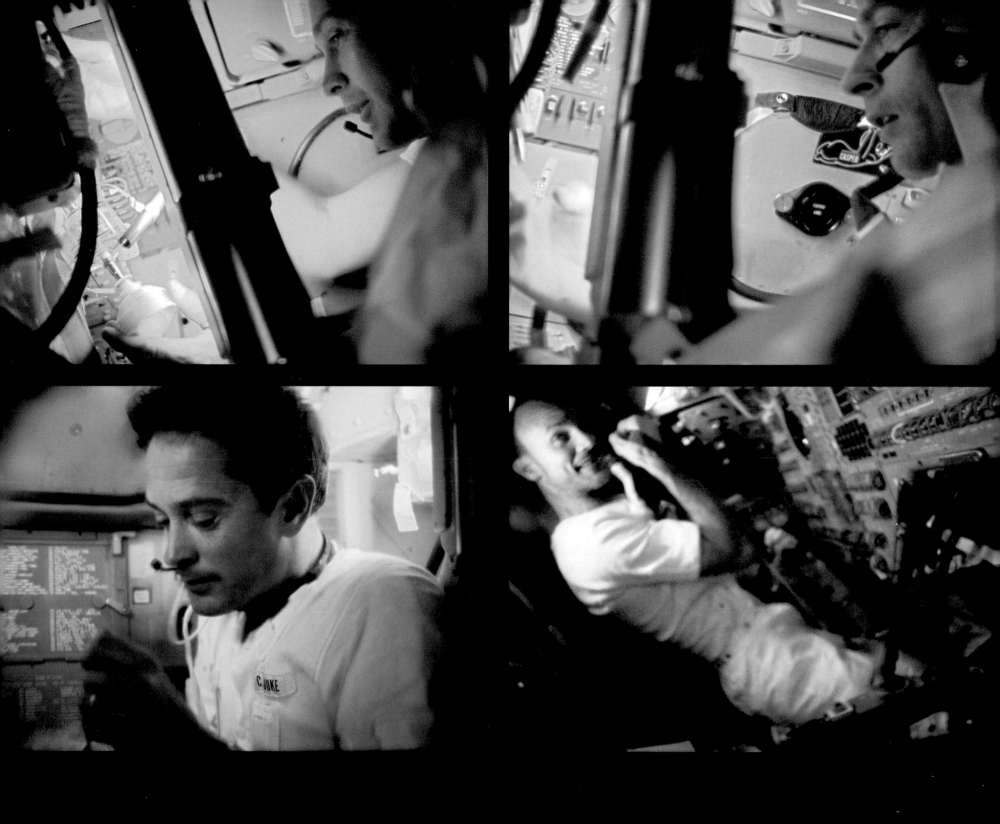

April 16–18, 1972 5–33 FRAMES 16MM FILM, STACKED AND PROCESSED NASA ID: APOLLO 16 MAG 1319-J

Life on board the Command Module Casper during trans-lunar coast. Duke (upper left) and Young (upper right) prepare lunch at the water dispenser in the lower equipment bay. The three meals per day, providing 2,800 calories, were mostly freeze-dried. Duke (lower left) is taking on some tinned food. Mattingly (lower right) is burning off some calories during an exercise

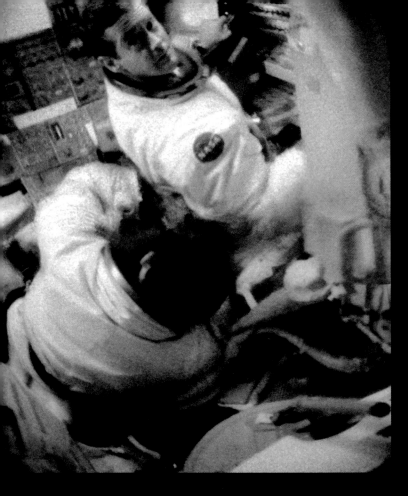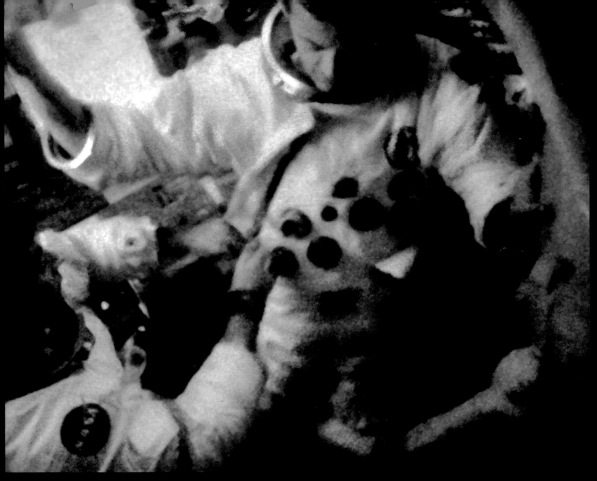

April 18, 1972 65 AND 15 FRAMES OF 16MM FILM, STACKED, PROCESSED AND STITCHED NASA ID: **APOLLO 16 MAG 1309-H**

On day three, Young and Duke entered the LM for initial checkout and donned their pressure suits. Duke: "John had an extremely difficult time getting the restraint zipper closed across the small of my back." It was considered too risky to carry out Young's suggestion of using his pliers, but ultimately the suits were slowly but successfully donned when the time came for undocking and powered descent to the lunar surface. These are the only images from Apollo showing this process during a mission.

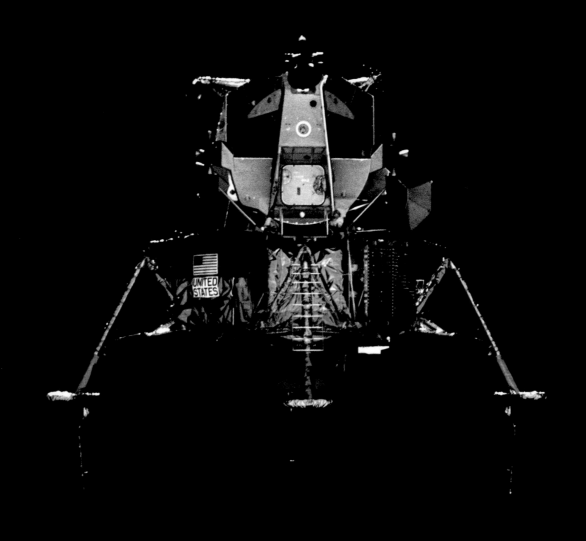

April 20, 1972 HASSELBLAD 70MM. LENS 80MM F/2.8 | BY KEN MATTINGLY NASA ID: **AS16-118-18894**

After 12 orbits of the Moon, *Orion* separated from *Casper* in preparation for powered descent to the surface. Mattingly, in the CSM, undertook a visual inspection of the LM: "You sure look good!"
An essential check was that all landing gear was properly deployed. Here, the U.S. flags on the LRV's fenders can be seen to the right of the ladder, through the gap in what appears to be a door,
but is actually the chassis of the folded LRV. *(Cropped, rotated, EL: 3/5)*

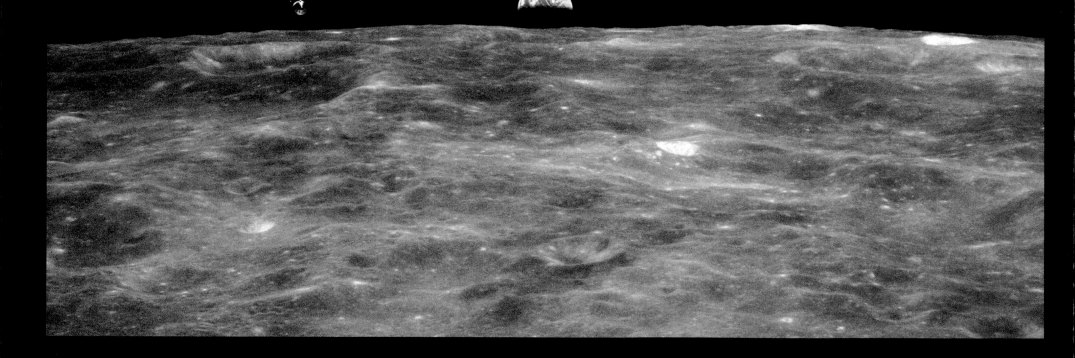

April 20, 1972

HASSELBLAD 70MM. LENS 60MM F/5.6 | BY CHARLIE DUKE

NASA ID: AS16-113-18288

Duke: "Here comes Earthrise. See it? . . . That's spectacular!" A problem with *Casper's* SPS engine gimbal, and *Orion's* steerable antenna (losing auto-updates from Mission Control) transpired during loss of signal on the lunar farside. The predicament led to this photograph – the CSM, with Mattingly on board, above the lunar surface as Earth rises above the horizon. Duke told me: "Mission Control had just informed us to rendezvous, so John was busy with that. It was such a unique opportunity I could not pass up." *(Cropped, rotated, fiducial mark removal, EL: 3/5)*

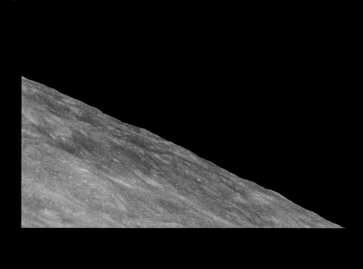

April 20, 1972　　　　HASSELBLAD 70MM. LENS 80MM F/2.8 | BY KEN MATTINGLY　　　　NASA ID: AS16-118-18895

Mattingly: "I got an unusually bright star. I bet that's you . . . [No,] must be a planet." Maintaining a maximum one-mile separation was not easy. Young: "Okay. Well, we ▓▓▓ in front of you and we're . . . upside down, and the Sun is over our shoulder, and we're looking back at you." Mattingly: "I don't see ▓▓▓ hat can be . . . Okay, what I'm trying to do is to keep from hitting you. I'd like to get a visual on you." *(Cropped, rotated, EL: 3/5)*

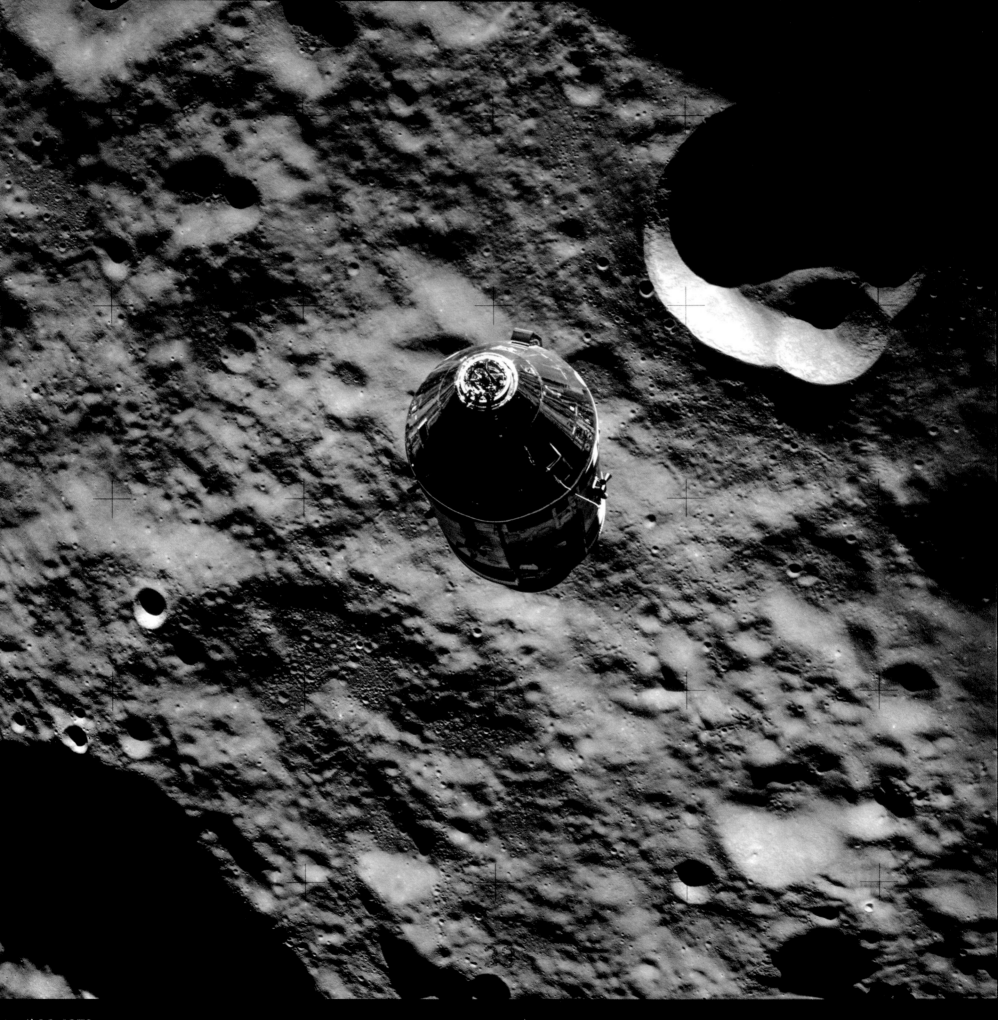

April 20, 1972 HASSELBLAD 70MM. LENS 60MM F/5.6 │ PROBABLY BY CHARLIE DUKE NASA ID: AS16-113-18294

Mattingly: "'Thrust down' means toward the M▮▮▮▮▮ down as you see it?" Duke: "Toward the Moon." Mattingly: "Okay . . . I'll tell you which way the needle moves." Young: "That's the wrong way, Ken . . . Okay, thrust away from the Moon▮▮▮▮ After a tense, complex "brute force" rendezvous, t▮▮ photograph was taken a▮▮▮▮ the farside of the Moon. With the SPS engine problem assessed, Mission Control finally, boldly, gave ▮▮ go-ahead for descent to the Descartes Highlands. *(EL: 3/5)*

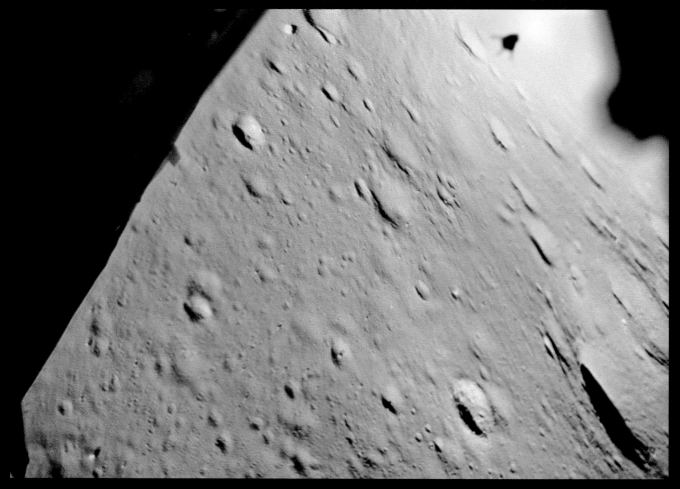

April 21, 1972 9 AND 23 FRAMES OF 16MM FILM, STACKED AND PROCESSED NASA ID: **APOLLO 16 MAG 1284-N**

TOP: Duke: "Looks like we're going to be able to make it, John. There's not too many blocks up there. Okay, 4,000 feet . . ." Identifying a flat, safe landing area, free of large boulders, LM *Orion* descends to the surface, its shadow signifying the arrival of the Moon's visitors from Earth. At around 450 feet, Duke: "Okay, fuel is good; 10 percent. There comes the [LM] shadow." The Contact light illuminated one minute later. "Contact. Stop. Boom. Pro. Engine arm. Wow! . . . Look at that!" BOTTOM (EVA-1): Young: "Well, we don't have to walk far to pick up rocks, Houston." After their first meal on the Moon, Young and Duke set up the cabin for sleep as the delays in orbit altered the time-line for their stay on the surface. The image shows Young's first steps on the Moon, 14 hours after touchdown. Young: "There you are, mysterious and [currently] unknown Descartes."

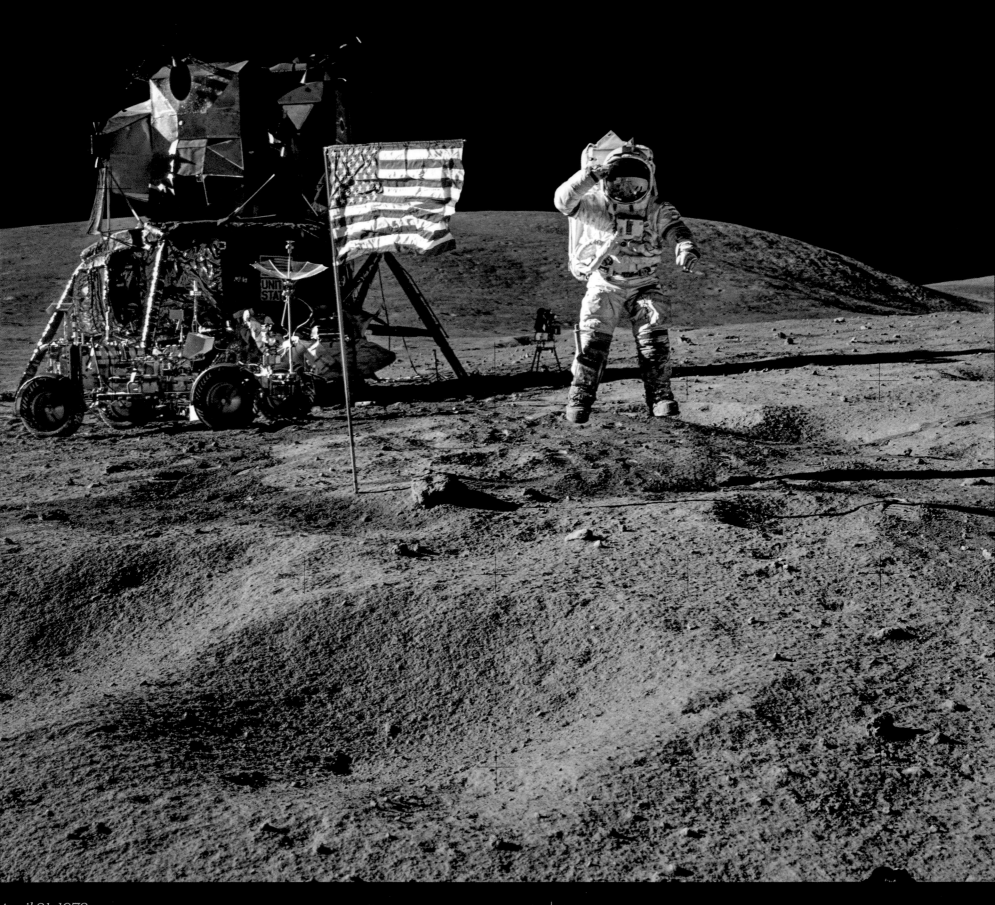

April 21, 1972 **EVA-1** HASSELBLAD 70MM. LENS 60MM F/5.6 | BY CHARLIE DUKE NASA ID: **AS16-113-18339**

Duke immediately followed Young: "Oh, that first foot on the lunar surface is super!" The first job was to unload equipment from the MESA, deploy the rover, and plant the flag. Duke: "Hey, John, this is perfect, with the LM and the rover and you and Stone Mountain. And the old flag. Come on out here and give me a salute. Big Navy salute." This is Young's own giant leap in 1/6th gravity. *(EL: 3/5)*

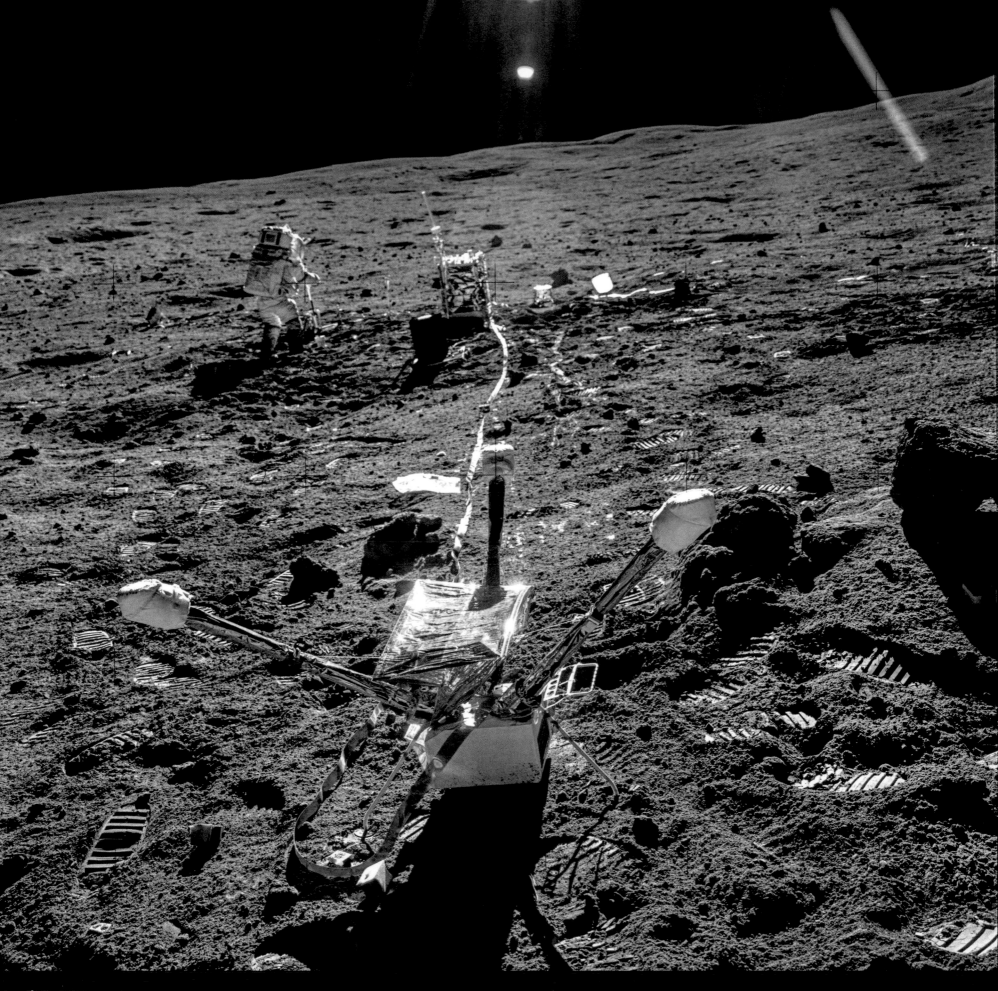

April 21, 1972 EVA-1 HASSELBLAD 70MM. LENS 60MM F/5.6 | BY CHARLIE DUKE NASA ID: AS16-113-18373

The ALSEP was set up approximately 300 feet southwest of the LM. In the foreground is the magnetometer and Young is seen continuing set-up, among the orange "spaghetti" ribbon cable.
Young would trip on the cable for the heat-flow experiment, rendering it inoperable: "God almighty! . . . I'm sorry, Charlie. God damn . . . I don't even know it." *(EL: 4/5)*

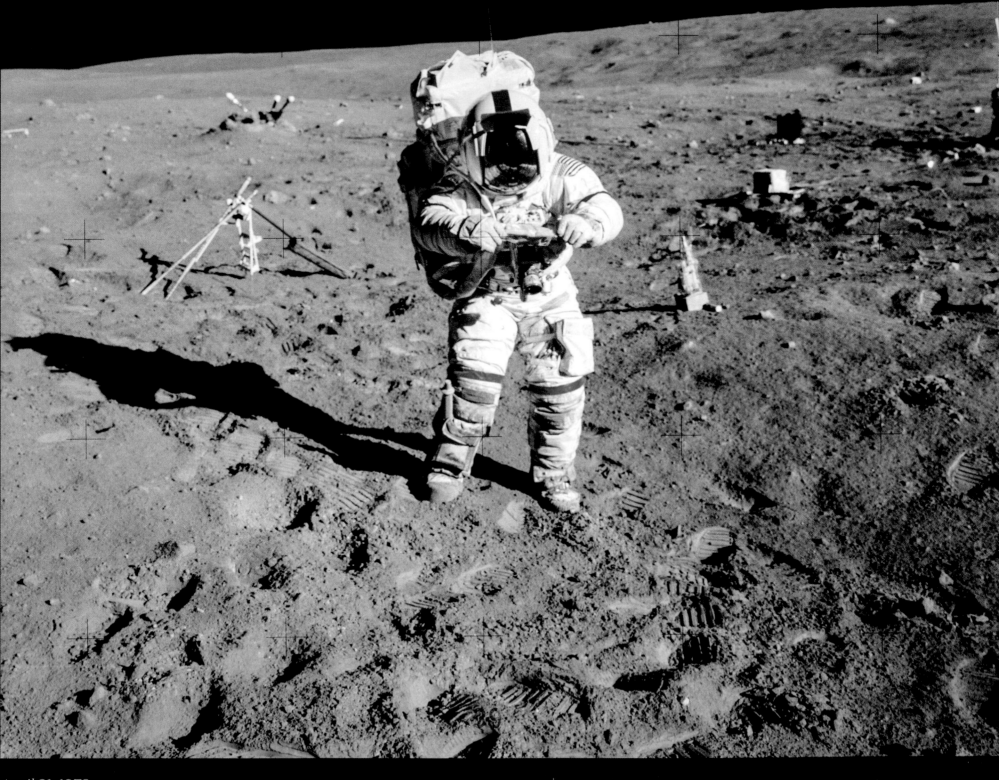

April 21, 1972 EVA-1 HASSELBLAD 70MM. LENS 60MM F/5.6 │ BY CHARLIE DUKE NASA ID: AS16-114-18387

Duke: "Come and look at it, John! It might be just a total white rock." Young: "Okay. Charlie, you got my camera?" Duke: "Yeah, and it's filthy." Young bags a sample in this pin-sharp photograph close to the ALSEP site using Duke's Hasselblad as a support. Young: "You got to clean off your lens – *my* lens." *(EL: 3/5)*

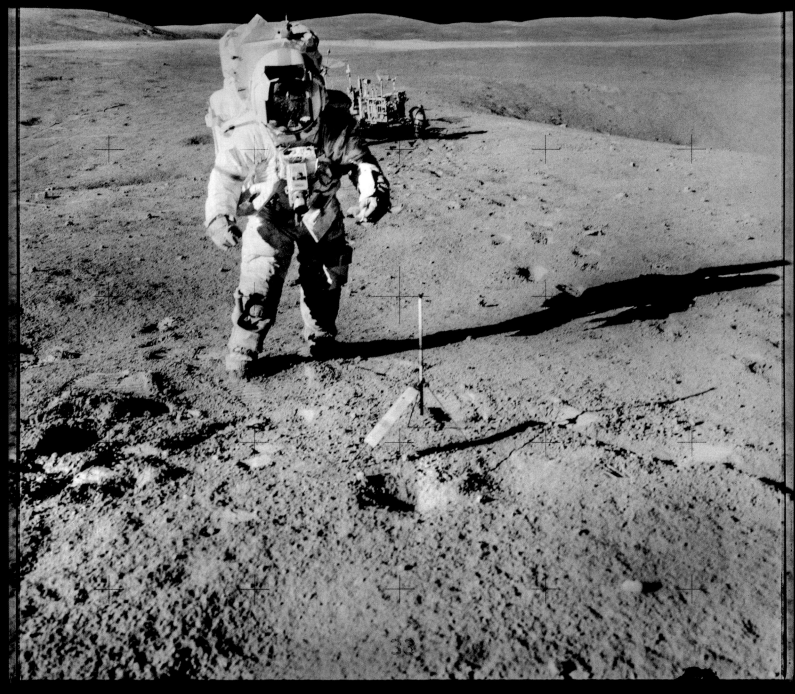

April 21, 1972 EVA-1　　　　　HASSELBLAD 70MM. LENS 60MM F/5.6. B&W | BY CHARLIE DUKE　　　　　NASA ID: AS16-109-17797

Duke joins Young on the rover for his first ride as they head off to Station 1. Young found it difficult to see craters as he drove and kept speeds to 3 or 4 mph. Duke, to CAPCOM England: "Okay Tony, we're parking right on the rim of Plumb. Dismounting." England: "Charlie, don't fall in that thing." This photograph was taken to record the sampling site and shows Young, with the rover parked on the edge of Plumb crater. (EL: 4/5)

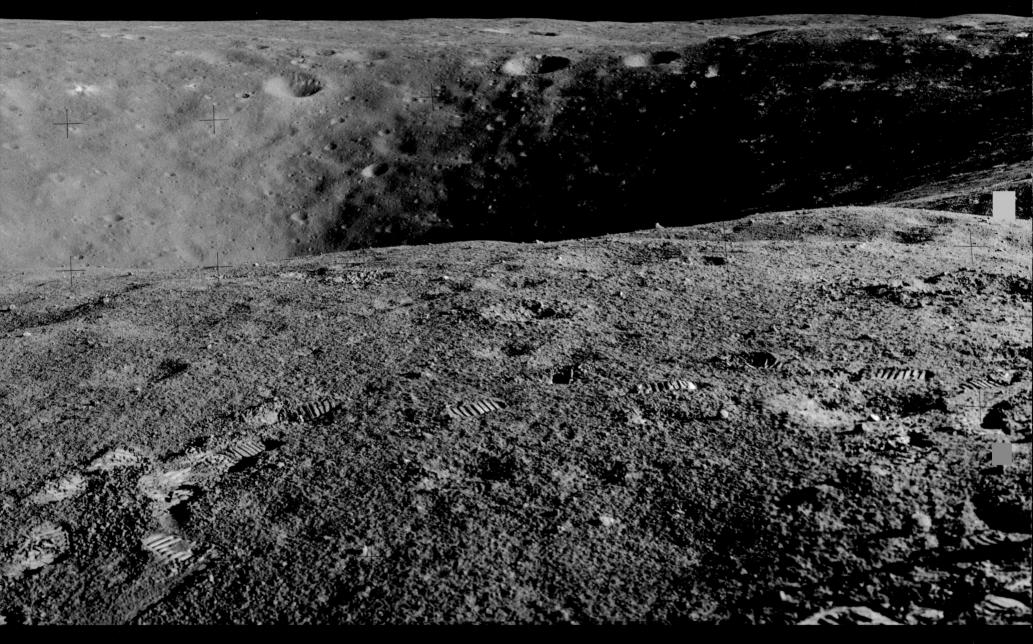

April 21, 1972 EVA-1 HASSELBLAD 70MM. LENS 60MM F/5.6 | BY JOHN YOUNG NASA ID: AS16-114-18418 TO 18425

Duke: "Man, that crater . . . That is really something . . . *Is it dark in those shadows!*" Mission Control requests a panorama from this spot; Young: "Yeah, I'm supposed to do that, ain't I?" Duke's footprints can be followed right around the edge of Plumb crater and back to the lunar rover's parking spot. Flag crater is far left. Duke then takes a few steps to his left as Young continues the panorama (see following page). *(Panorama, EL: 5/5)*

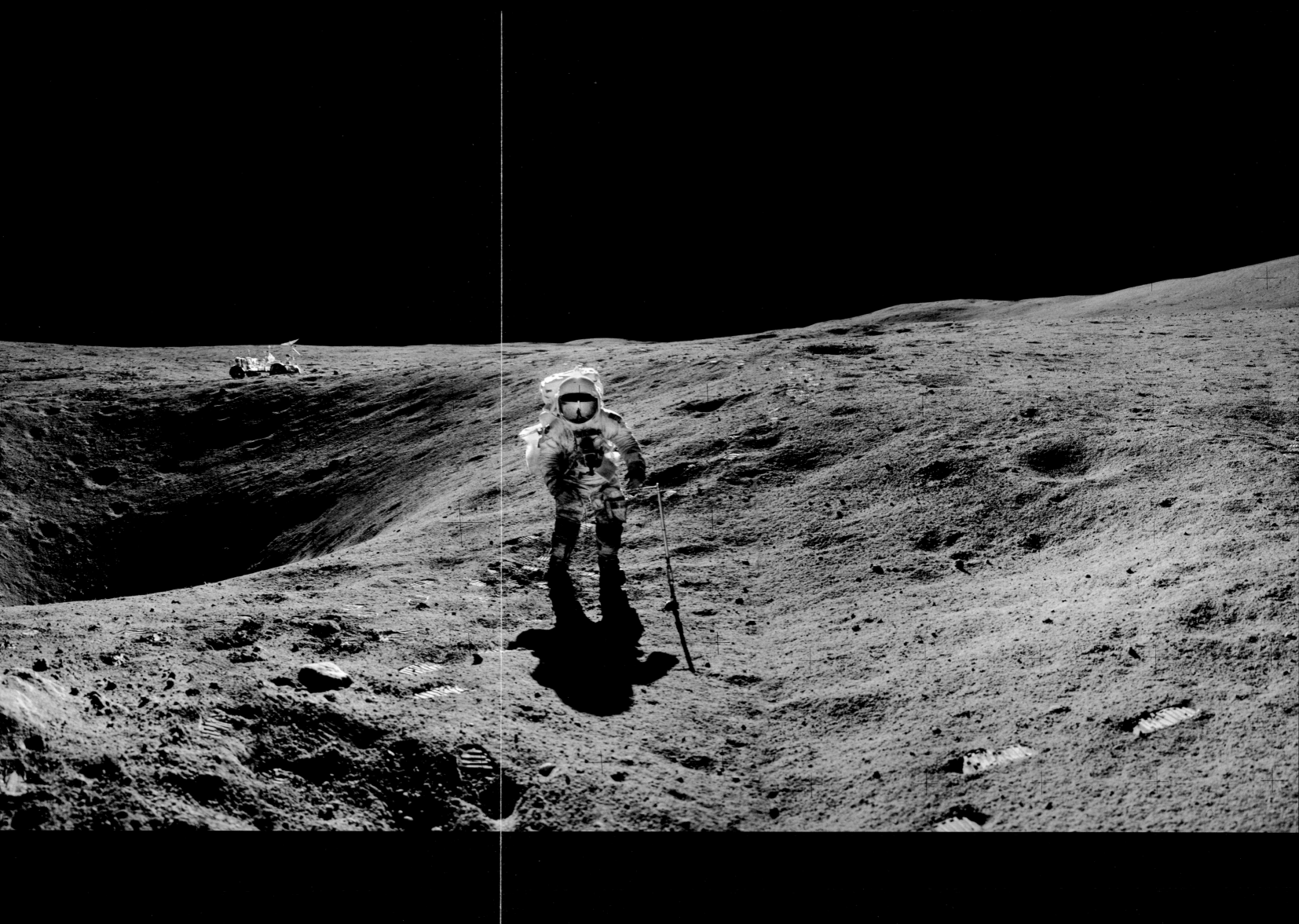

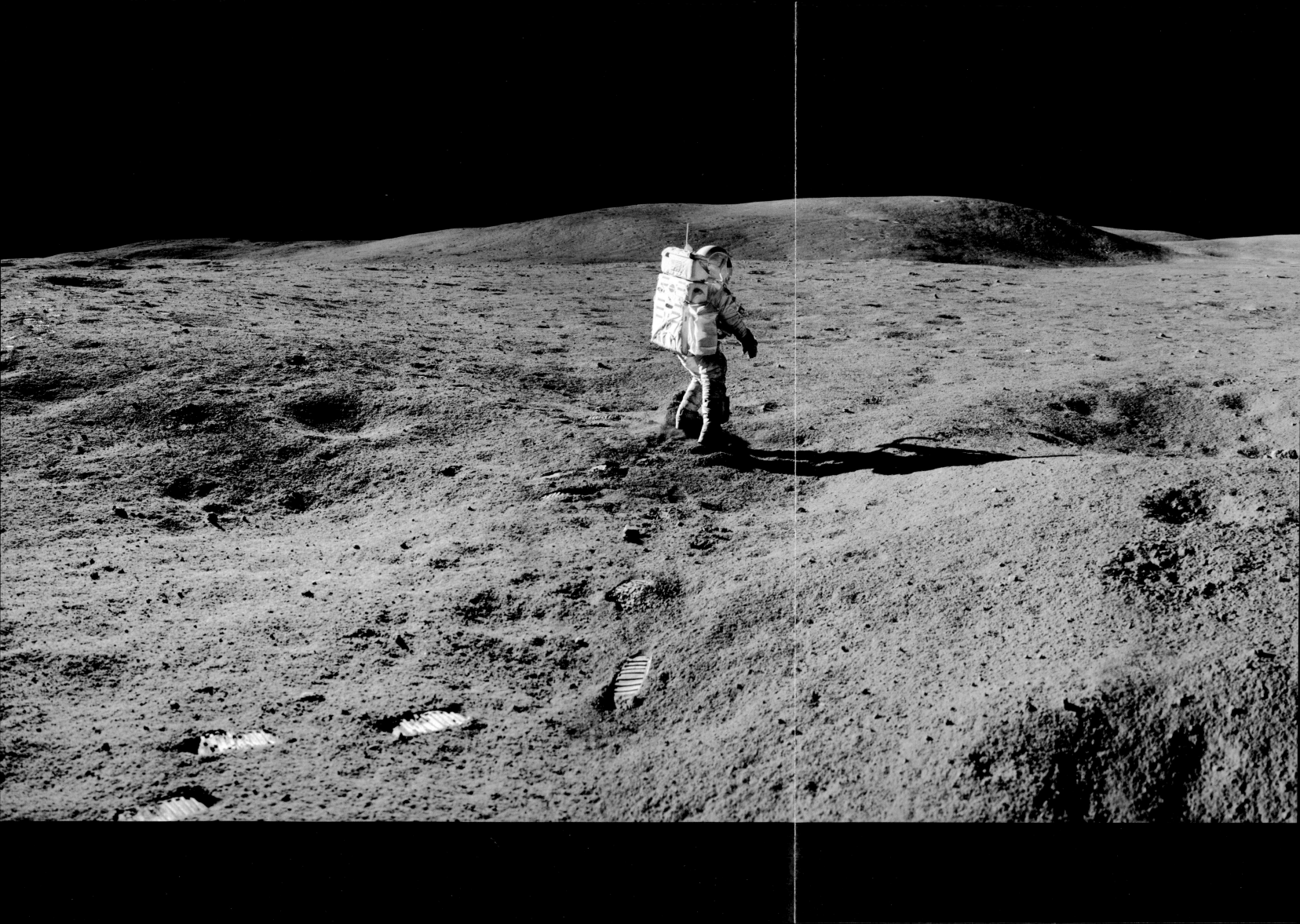

April 21, 1972 EVA-1 HASSELBLAD 70MM. LENS 60MM F/5.6 | BY JOHN YOUNG NASA ID: AS16-114-18426 TO 18430

Duke kicks up some dust as he steps to his left and is greeted with this vista across the Descartes plain. The bright white streaks in the distance are ejecta from South Ray crater. Duke told me: "I recall moving away from Plumb and toward South Ray. I was going to collect a sample, but what hit me was the views of Stone Mountain and South Ray crater – both magnificent!" *(Panorama, fiducial mark removal, EL: 3/5)*

April 21, 1972 EVA-1 11 FRAMES OF 16MM FILM, STACKED AND PROCESSED NASA ID: **APOLLO 16 MAG 1286-P**

Duke: "Okay, John. We need to stop out here for the Grand Prix." Toward the end of the seven-hour EVA, Young put the LRV through its paces on the rough terrain, as Duke filmed with the 16mm DAC. Duke to Mission Control: "He's got about two wheels on the ground. There's a big rooster tail out of all four wheels . . . Okay, when he hits the craters and starts bouncing is when he gets his rooster tail . . . The suspension system on that thing is fantastic!"

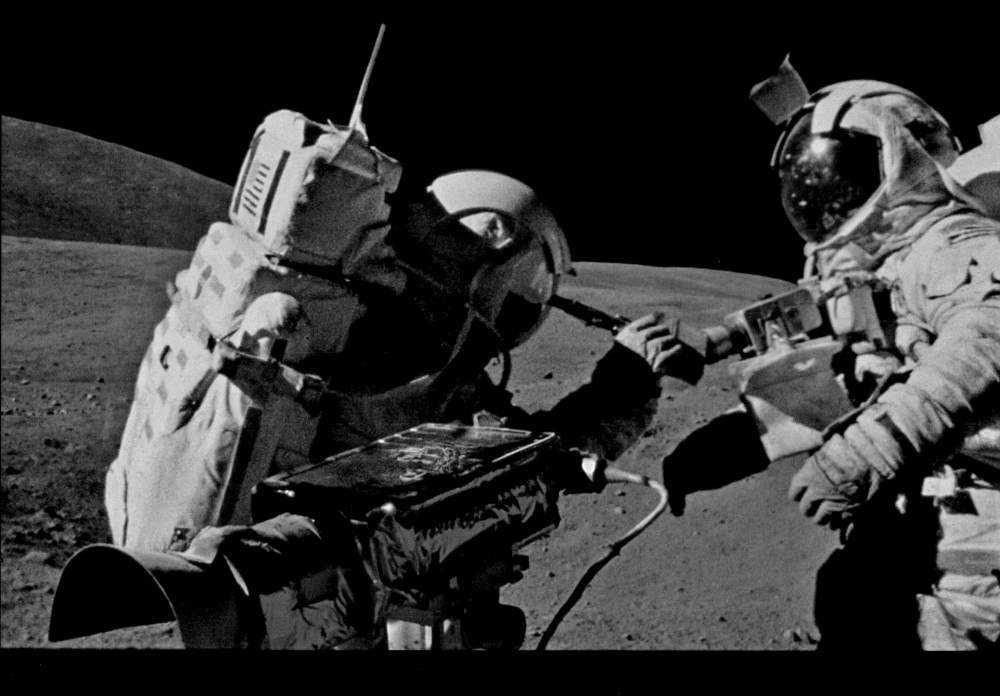

April 21, 1972 **EVA-2** 8 FRAMES OF 16MM FILM, STACKED AND PROCESSED NASA ID: **APOLLO 16 MAG 1290-R**

Duke: "John, before I do this [pan], how about checking my lens? . . . Man, those battery covers are filthy." Dust is a significant problem during EVAs on the Moon, but particularly when driving the LRV. It covered electrical components and radiators, which could lead to overheating, as well as the lenses of the Hasselblads, 16mm DAC and the TV camera. Regular stops were made to brush down lenses, as can be seen here, a little later on EVA-2.

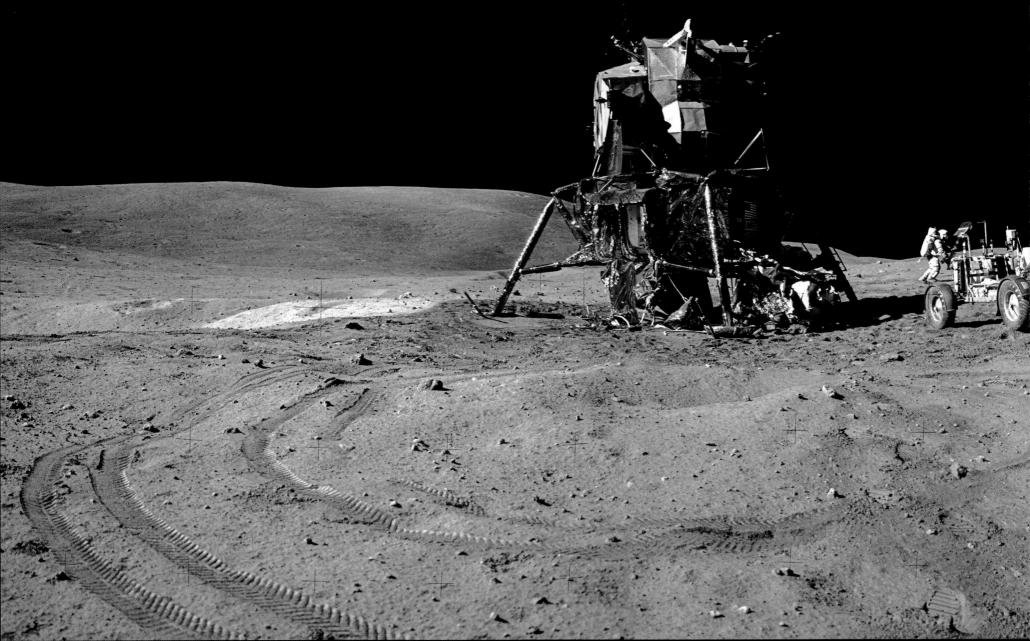

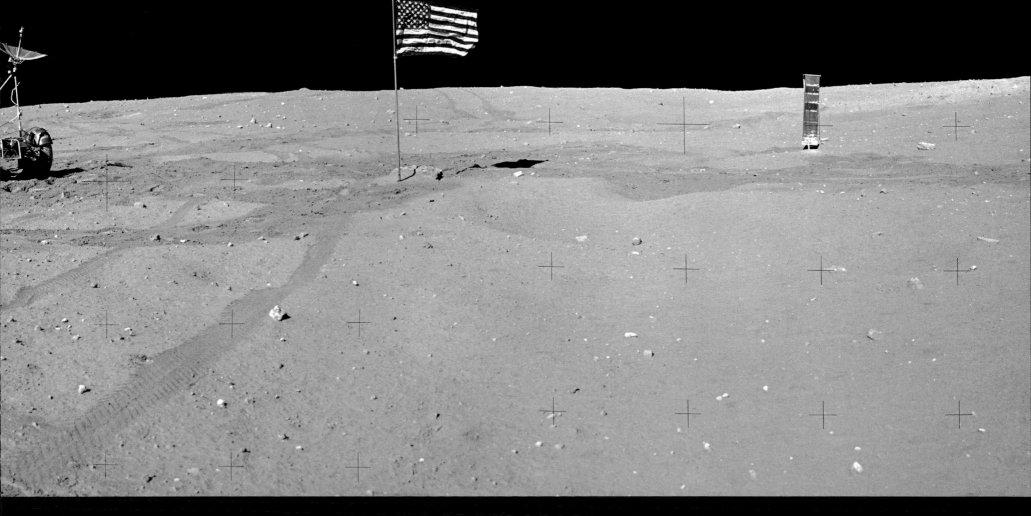

April 22, 1972 EVA-2 HASSELBLAD 70MM. LENS 60MM F/5.6 | BY CHARLIE DUKE NASA ID: AS16-107-17433 TO 17440

Duke: "I hate to tell you, but I need your camera . . . Here, take mine with the black-and-white and let me have yours for the pan." Duke took this color sequence at the start of EVA-2, showing the area around *Orion's* landing site. It shows the LM, LRV, flag and solar-wind experiment, and Young is in the background collecting samples. It also shows how close the LM came to landing in the crater, far left. *(Panorama, EL: 2/5)*

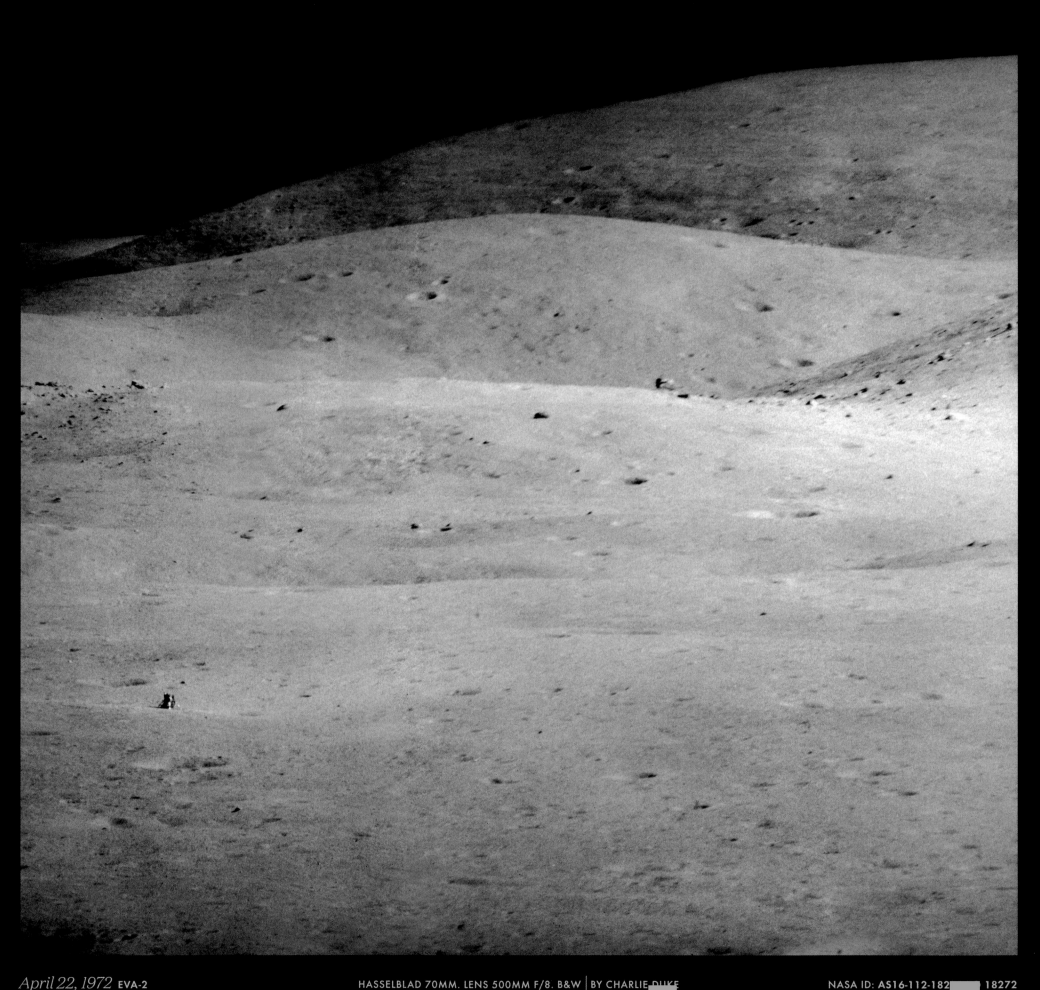

April 22, 1972 EVA-2 HASSELBLAD 70MM. LENS 500MM F/8. B&W │ BY CHARLIE DUKE NASA ID: AS16-112-182░░ 18272

The crew drove to Station 4, at the Cinco craters up on the slopes of Stone Mountain. Duke to Mission Control: "I'm around ░░ the 500 [camera/lens]. Tony, you just can't believe th░░ You just can't believe this view! You can see the Lunar Module, you can see North Ray . . . There's one huge boulder [House Rock] that's going to be just great!" The LM is 2.7 miles away on the Descartes plain, 460 feet below. House Rock is 5 miles away. *(Panorama, fiducial mark removal, EL: 5/5)*

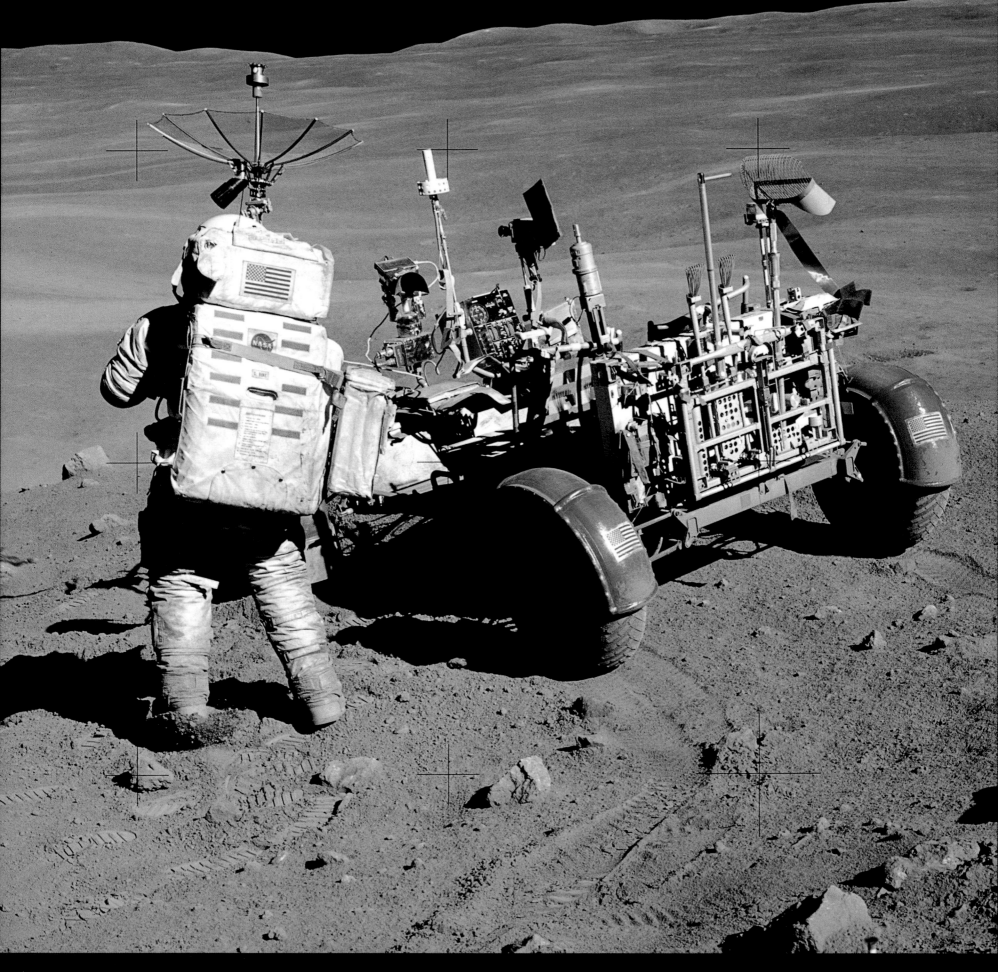

April 22, 1972 EVA-2 HASSELBLAD 70MM. LENS 60MM F/5.6 | BY JOHN YOUNG NASA ID: AS16-107-17446

Duke: "Wow! What a place! What a view, isn't it John?" Young: "It's absolutely unreal!" Duke has just taken his 500mm shots and is at the LRV as Young takes this photograph to document the sample location. It's a great shot of the rover, including its dashboard and the geology tools at the rear. The 16mm DAC camera and TV camera are pointing forward, down onto the plain. *(Cropped, EL: 2/5)*

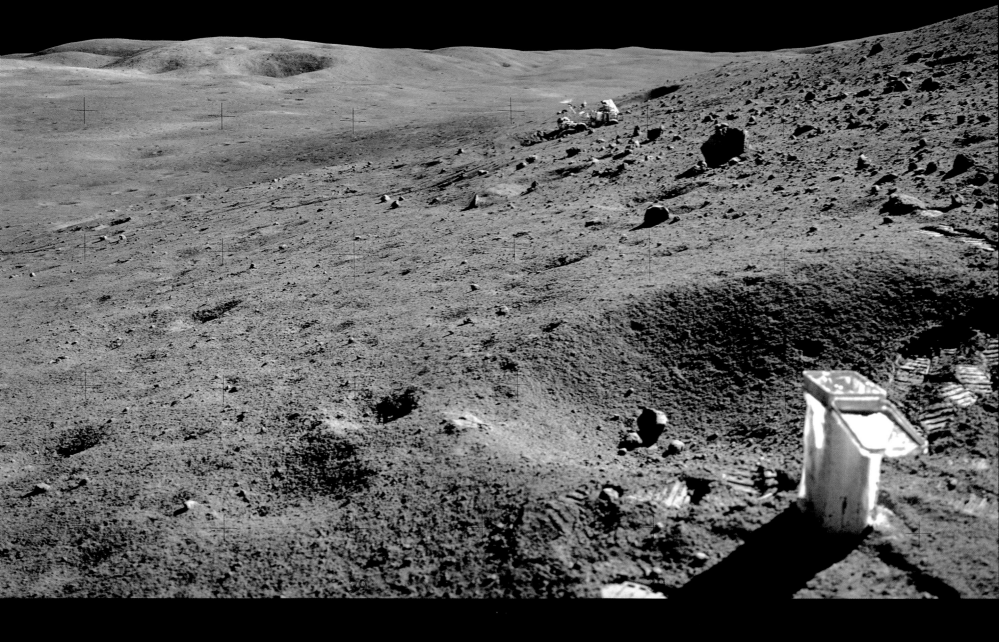

April 22, 1972 EVA-2 HASSELBLAD 70MM. LENS 60MM F/5.6 | BY JOHN YOUNG NASA ID: AS16-107-17472 TO 17473

Still at Station 4 on Stone Mountain, Young's sample collection bag is in the foreground as he takes this series of photographs. Duke is at the back of the LRV and the deep crater beyond, on Smoky Mountain, is Ravine. LM *Orion* is the tiny dot upper left of the top left fiducial cross mark. Duke: "It's just spectacular. Gosh, I have never seen . . . All I can say is "spectacular," and I know y'all are sick of that word, but my vocabulary is so limited." *(Panorama, EL: 3/5)*

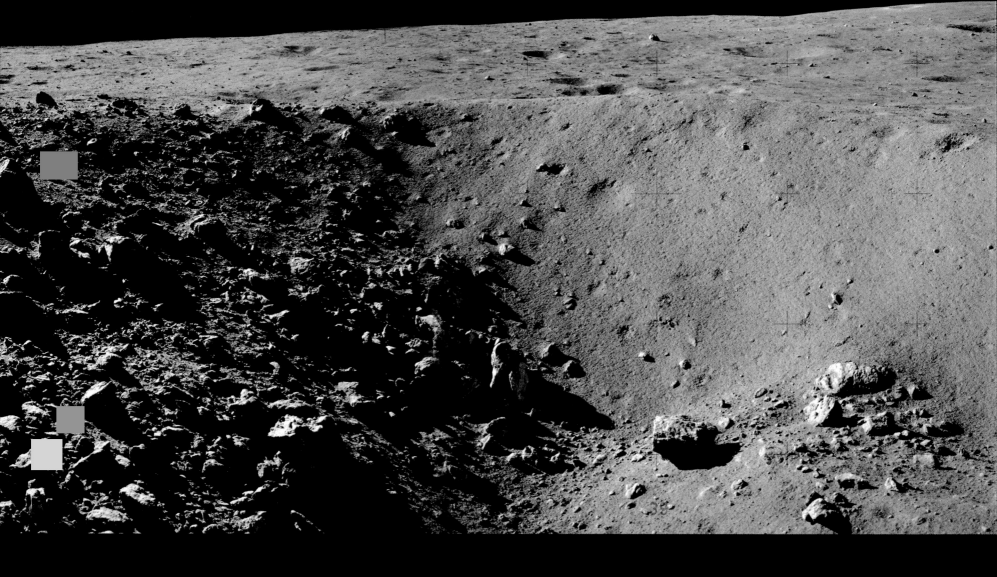

April 2 ___ *2* **EVA-2** HASSELBLAD 70MM. LENS 60MM F/5.6 | BY JOHN YOUNG NASA ID: AS16-107-17477 TO 17478

The anatomy of a crater. Immediately to the right of the previous photograph at Station 4; Young: "Okay, Houston. Here's some blocky-rimmed secondary . . . Do you think all the blocks on the up-slope side were the secondary that made it? Don't you reckon, if it's from South Ray?" A secondary crater is made by the material ejected during the impact of a primary crater, in this case South Ray. (Panorama, EL: 4/5)

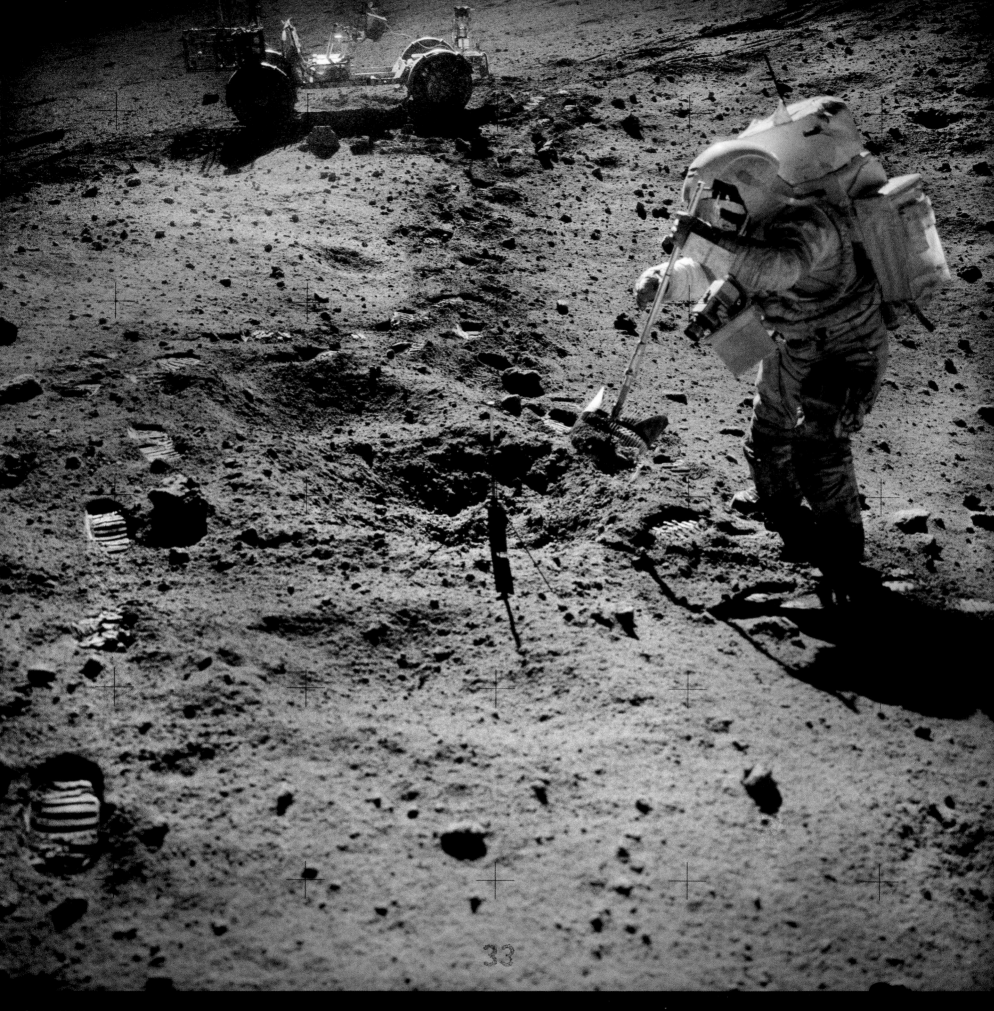

33

April 22, 1972 **EVA-2** HASSELBLAD 70MM LENS 60MM F/5.6. B&W | BY CHARLIE DUKE NASA ID: **AS16-110-18020**

Young and Duke retraced their rover tracks to reach Station 5, on a topographic bench down the slope of Stone Mountain. They parked the LRV on the edge of a 50-foot crater, then decided to pick it up (handles were provided) and place it on flatter ground. Duke: "That rake is sure a great way to get a lot of rocks in a hurry . . . Okay f/11 and 11 [foot focus]." *(EL: 5/5)*

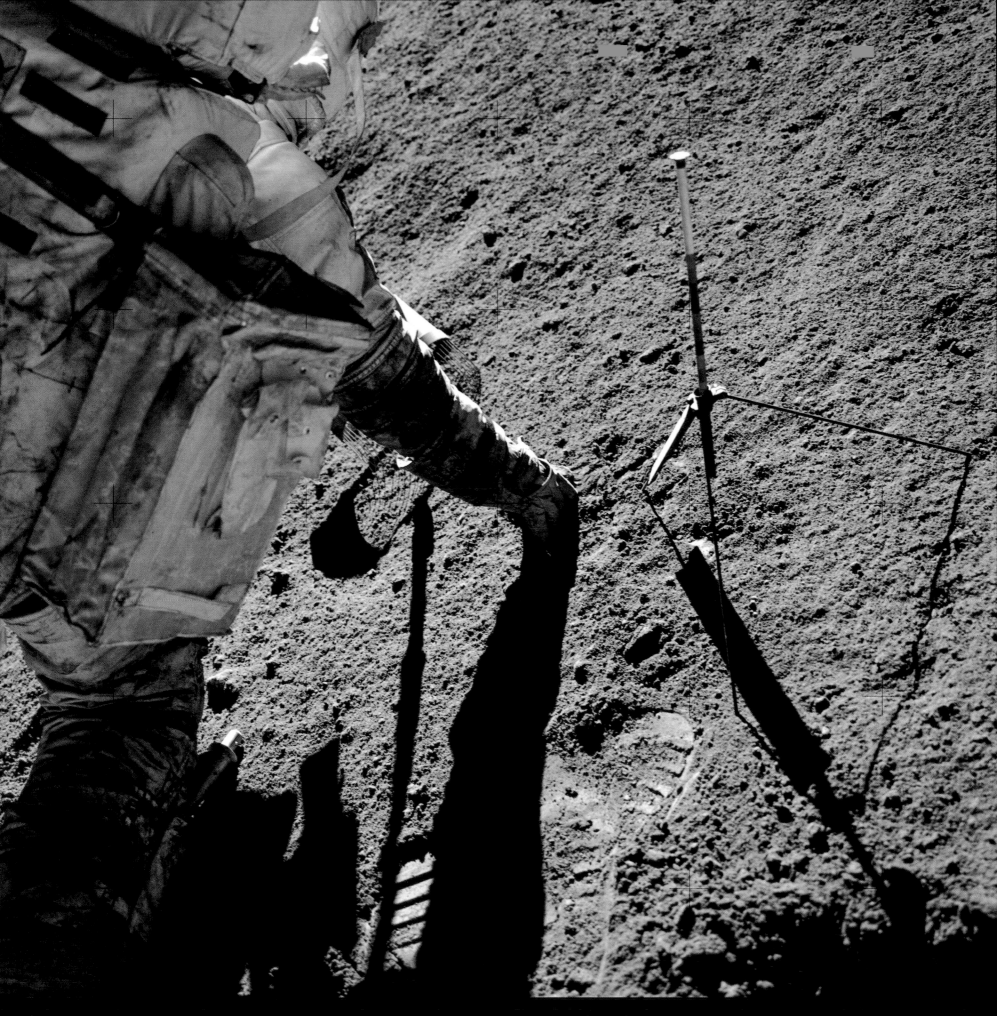

April 22, 1972 **EVA-2** HASSELBLAD 70MM. LENS 60MM F/5.6 | BY JOHN YOUNG NASA ID: AS16-107-17503

Duke: "Here's an old, old rounded rock that's fractured, badly beat up. Let's get that one." Young: "I'll shoot these at f/5.6, Houston." Duke kneels against the slope to pick up the rock sample he identified. His sample collection bag is strapped to his PLSS. The gnomon was difficult to position on the steep slopes. Young: ". . . was an old rock, wasn't it?" Duke: "It was; it crumbled to pieces." (EL: 3/5)

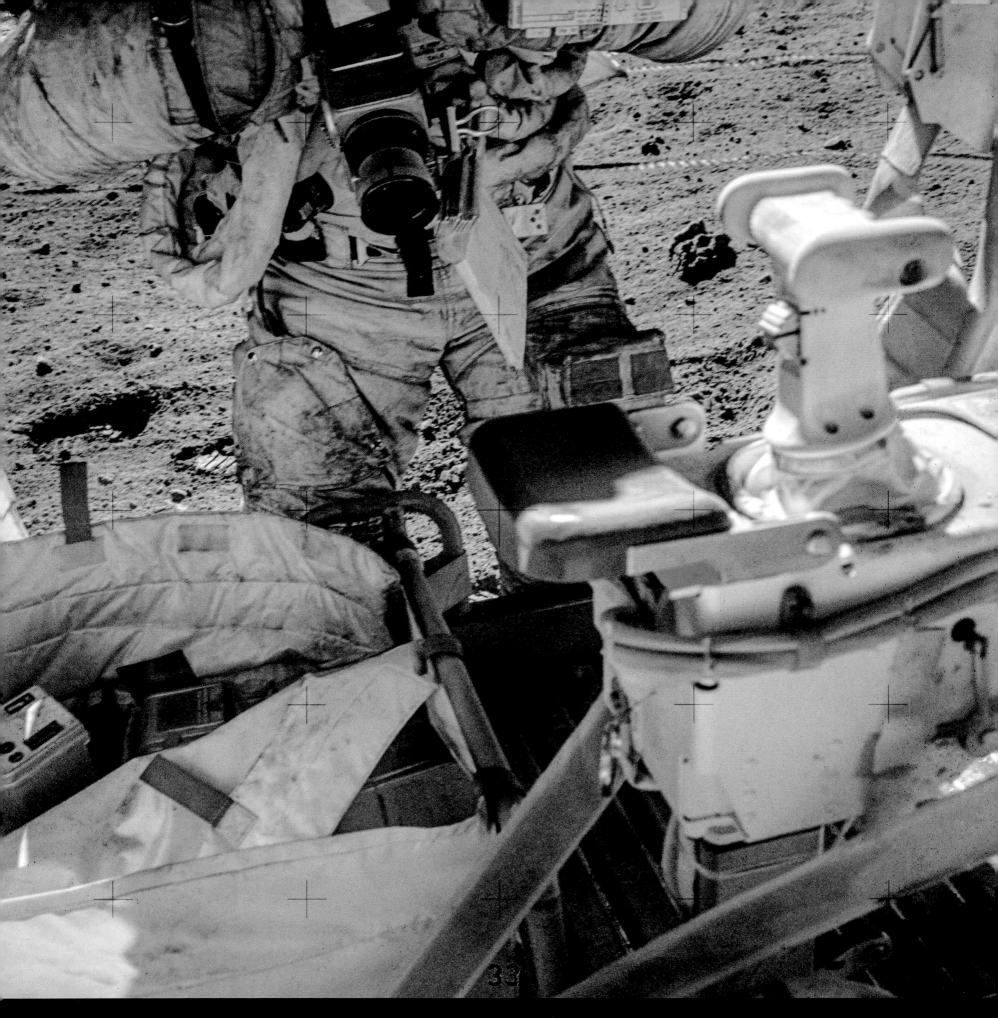

April 22, 1972 **EVA-2** HASSELBLAD 70MM. LENS 60MM F/5.6 | BY CHARLIE DUKE NASA ID: AS16-115-18472

Before leaving Station 9, six hours into the 7-hour-23-minute EVA, Young and Duke both changed their Hasselblad magazines. Duke: "Got to hold it back and then pop it. There you go. Hold
bat; then pop her loose." Young is pictured removing magazine 107/C from the back of his camera. Spare magazines can be seen in the seat pan under the Commander's seat. (FL: 5/5)

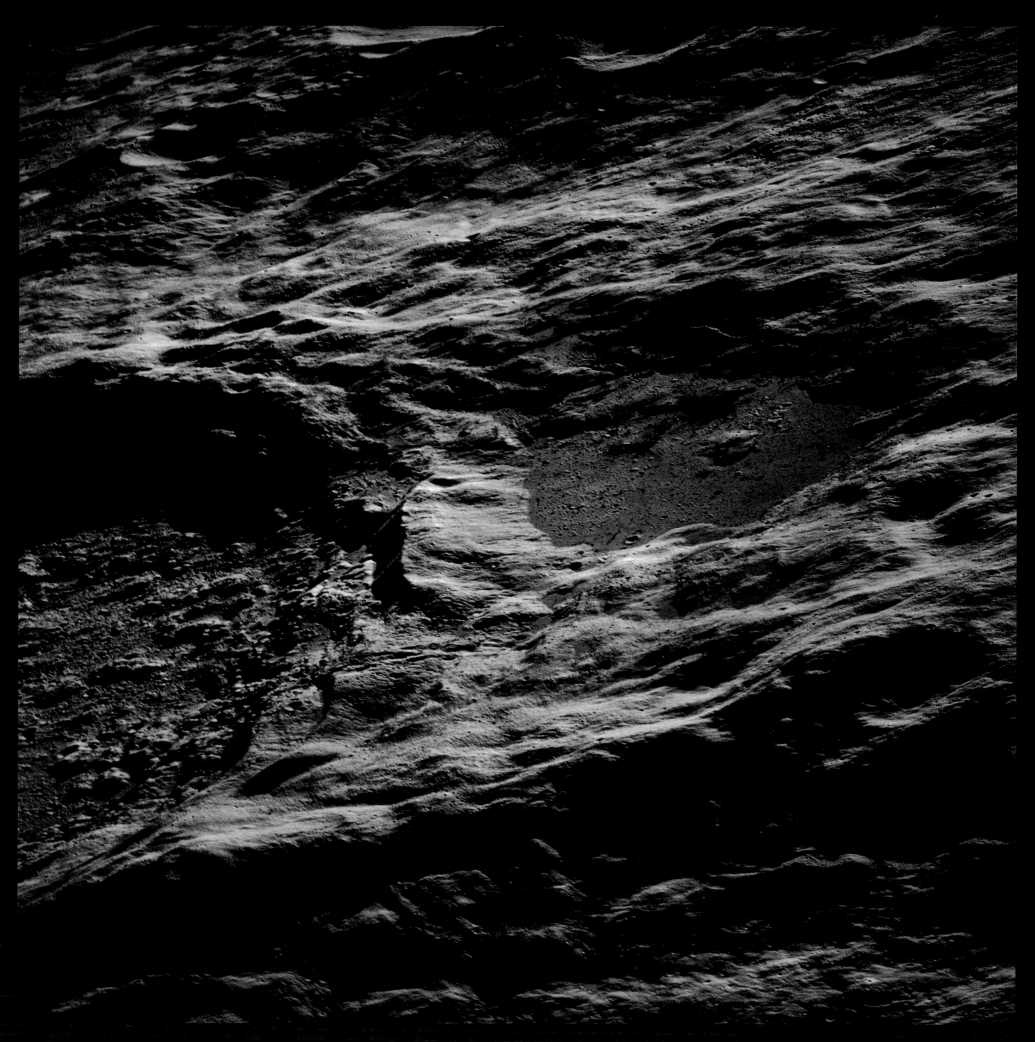

April 20–24, 1972 HASSELBLAD 70MM. LENS 250MM F/5.6 | BY UNKNOWN NASA ID: **AS16-120-19266**

As Young and Duke continued their lunar surface activities, Mattingly orbited overhead in Casper, undertaking observations, experiments and photography. He would later tell his crewmates: "I saw a glint off the LM once, and I saw a glint off the rover when you were over on Stone Mountain – with the binoculars." This image, taken later in the mission, is an oblique showing the inner terraced walls of King crater on the farside of the Moon. *(Rotated, EL: 3/5)*

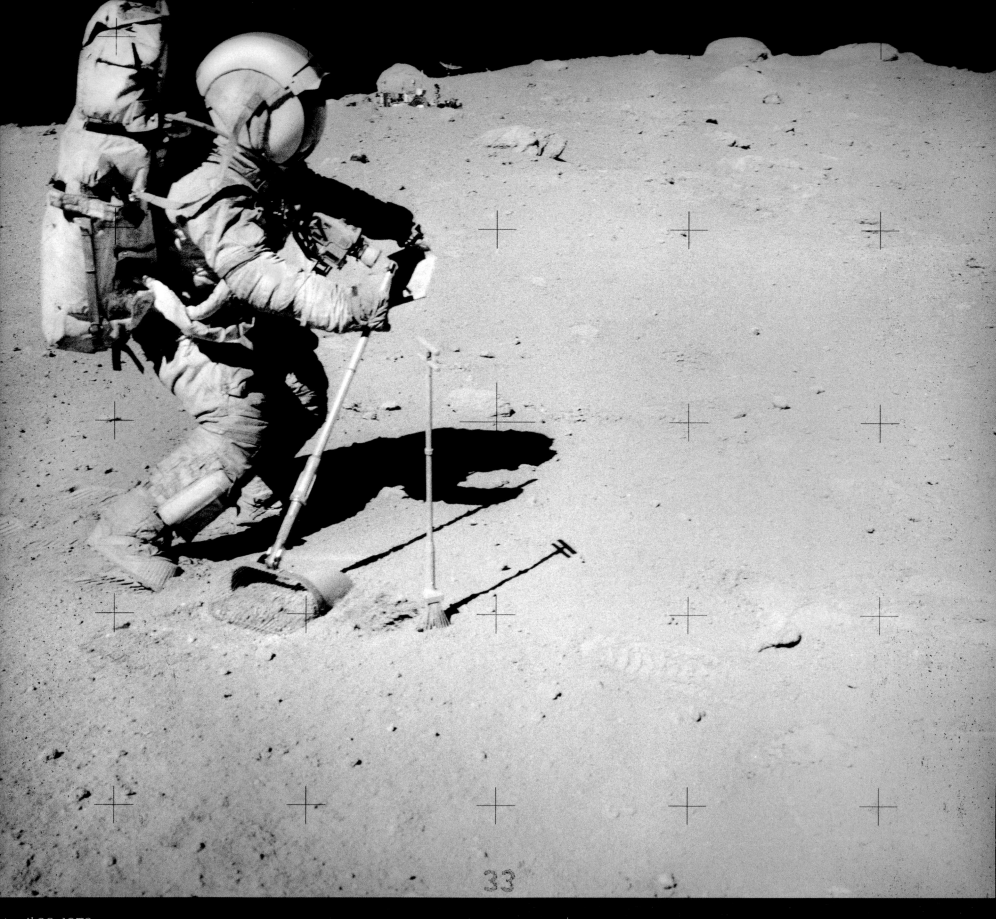

33

April 23, 1972 EVA-3 HASSELBLAD 70MM. LENS 60MM F/5.6. B&W │ BY CHARLIE DUKE NASA ID: AS16-106-17340

Young: "Look at the size of that biggie [House Rock] . . . It may be further away than we think because . . ." The absence of an atmospheric haze and any known reference objects makes the judgement of size and distance on the Moon extremely difficult. Duke: "Okay. We'll stop about halfway down here and do another rake." Young takes a sample halfway down from the rover's parking spot (seen up on the horizon) and House Rock. *(EL: 5/5)*

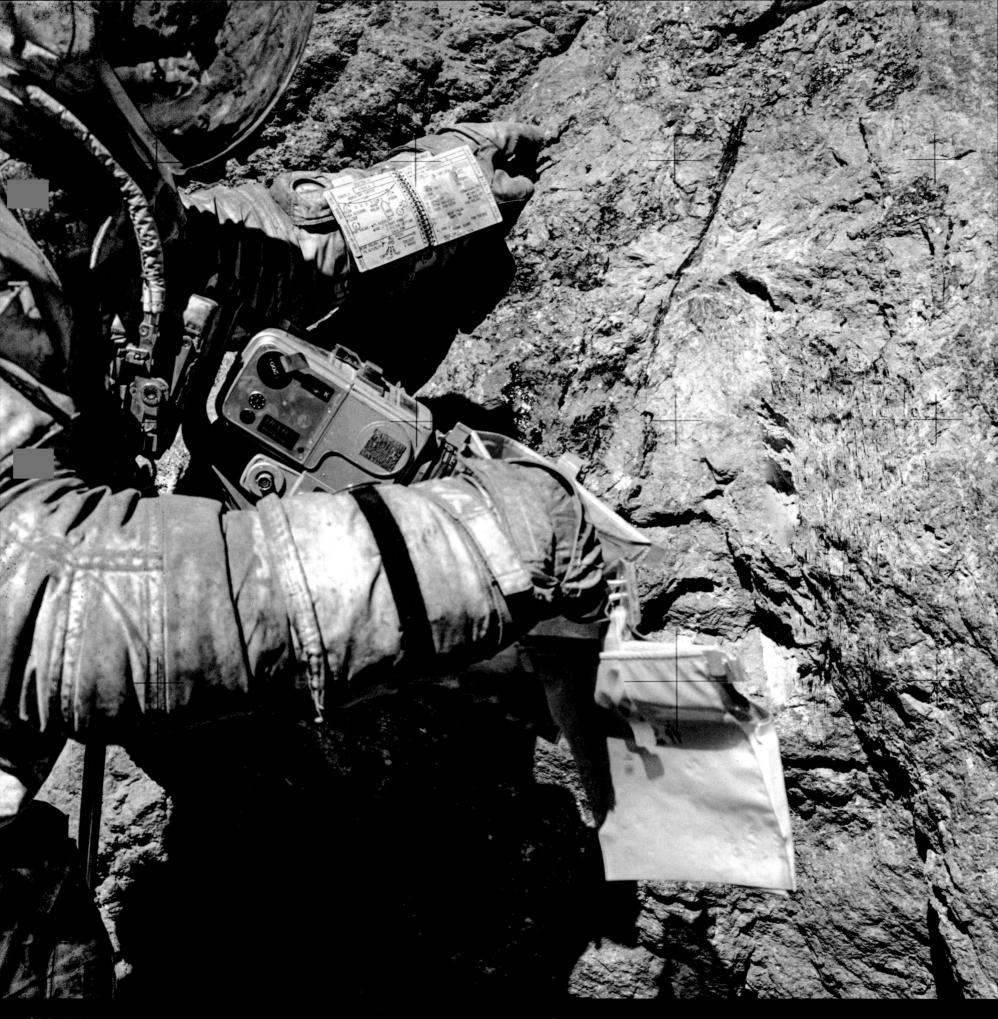

April 23, 1972 EVA-3 HASSELBLAD 70MM. LENS 60MM F/5.6 | BY JOHN YOUNG NASA ID: **AS16-116-18649**

Outhouse Rock is a separate, 10-foot section of the main rock. Duke: "Look at that. See, it's glass-coated, and this is just fractured off . . . and it's got a bluish tint to it . . . How about stepping back and as I point to it." Young: "Okay, I'll take a picture." The glass (right of the camera) and bluish hue can be seen in this pin-sharp image, which also shows great detail in Duke's Hasselblad and Remote Control Unit. (Cropped, EL: 2/5)

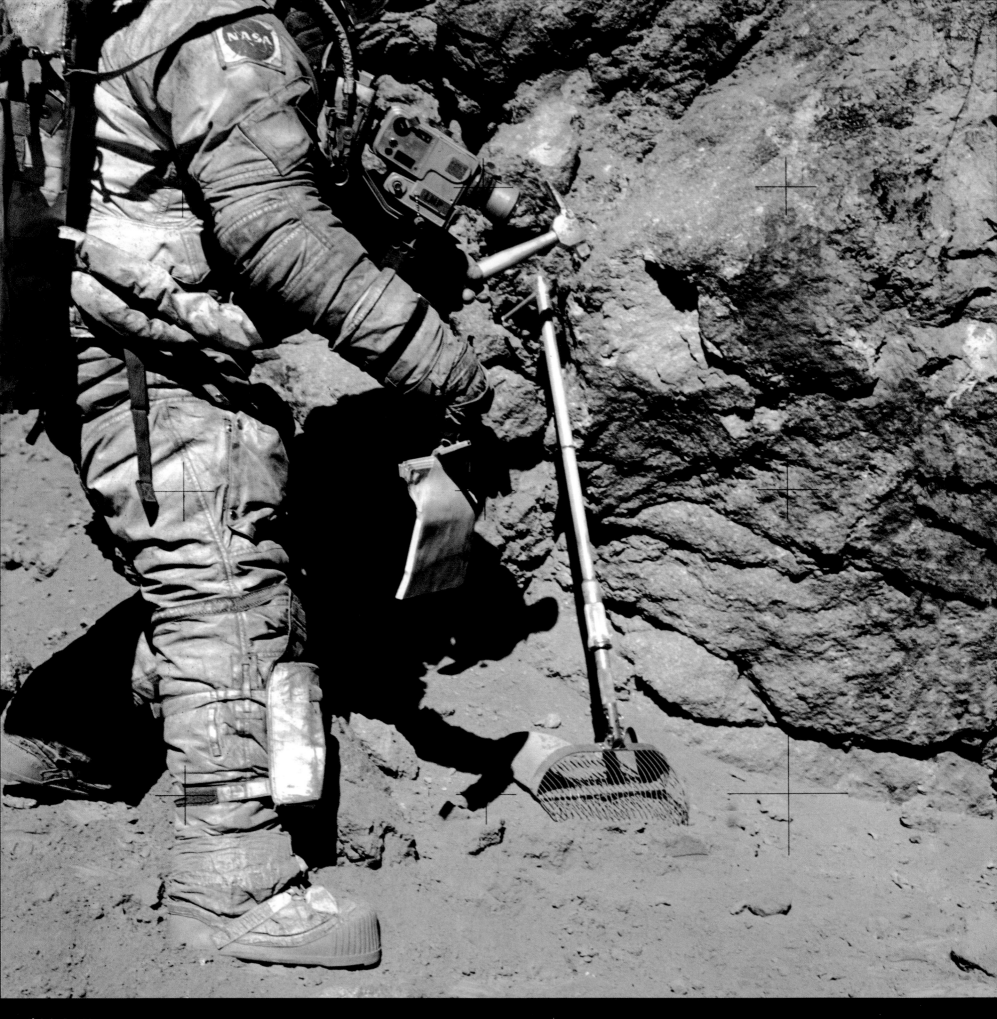

April 23, 1972 **EVA-3** HASSELBLAD 70MM. LENS 60MM F/5.6 | BY JOHN YOUNG NASA ID: **AS16-116-18653**

Duke: "It's a clast in a black rock. Look here. How about that? John, we'll whack off another . . . Could you get a picture of this where the hammer is? Let me get some of the unshocked . . . the white stuff." Another great shot shows Duke as he strikes the rock with his geology hammer. Details in Duke's suit and the color variances in the rock can be seen. Duke is carrying the sample bags on his little finger. (Cropped, EL: 3/5)

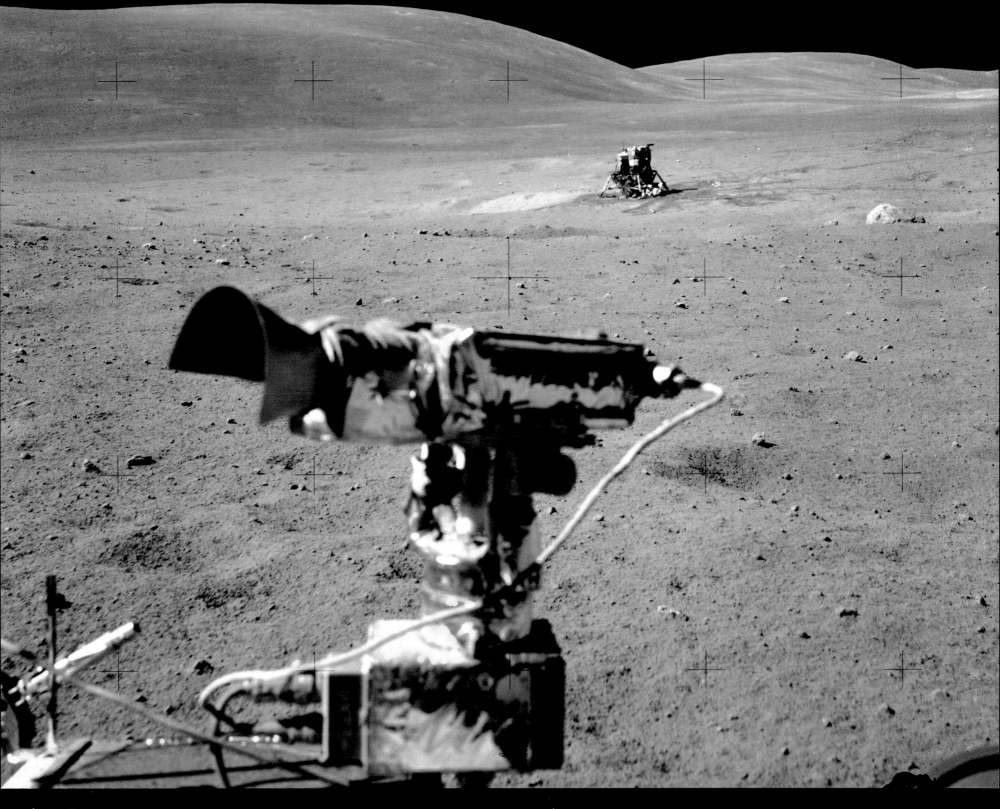

April 23, 1972 EVA-3 HASSELBLAD 70MM. LENS 60MM F/5.6 | BY CHARLIE DUKE NASA ID: **AS16-117-18797**

Duke: "We ought to see the old beauty [*Orion*] when we top the rise here . . . There she is, John! . . . And that Nav system has us pointed right at the Lunar Module!" After covering 7.2 miles during the EVA, the LM was a welcome sight. Duke: "Let me get a picture of that. That is beautiful . . . Home again, home again! Jiggety-jig!" The LRV's TV camera is also prominent in the foreground. Note the LM's proximity to the steep crater to the left. *(EL: 2/5)*

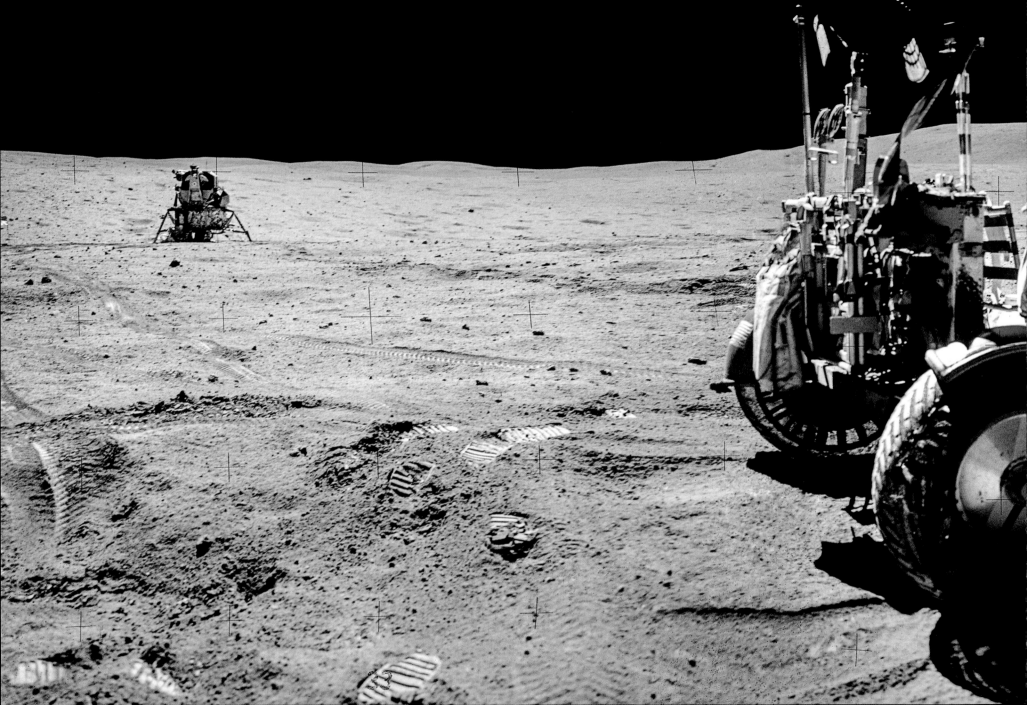

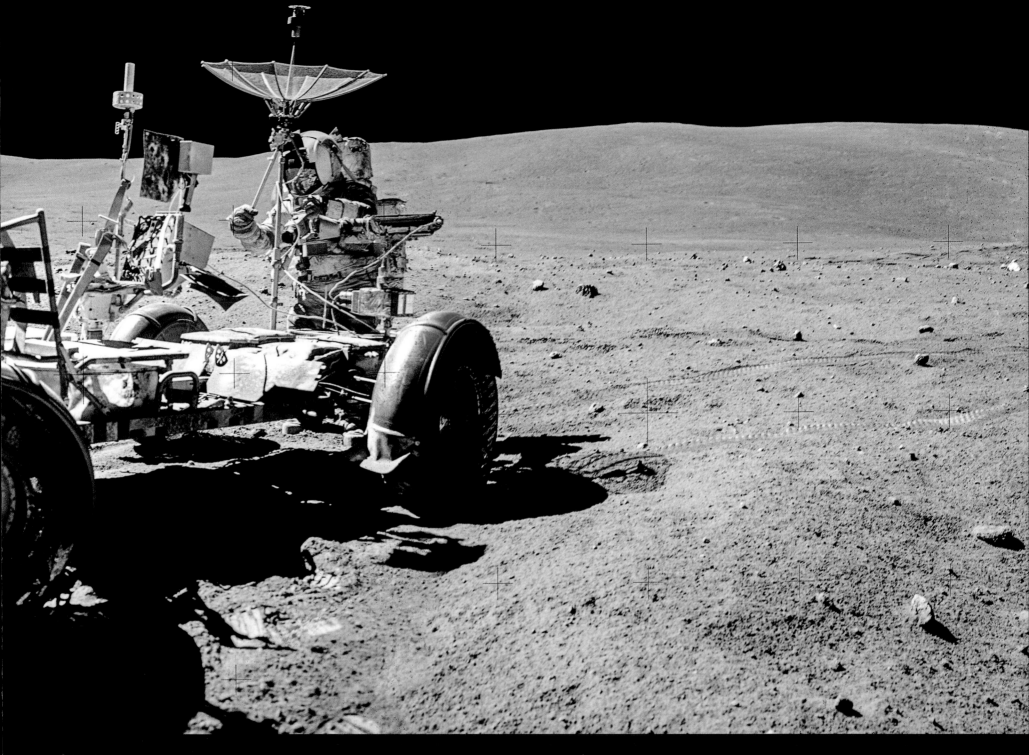

April 23, 1972 EVA-3 HASSELBLAD 70MM. LENS 60MM F/5.6 | BY CHARLIE DUKE NASA ID: AS16-117-18816 TO 18819

Duke's Station 10 panoramic series. The LM can be seen, left, and Young is aligning the high-gain antenna on the LRV to point at Earth in order to transmit the live TV pictures. Young: "Charlie, where is the Earth? Should be right straight up." Duke: "No, you've got to go right some . . . See it in the sight?" Young struggled to use the antenna's alignment sight. The planet Venus was also captured (though not visible in this image) above the horizon in this series. *(Panorama, EL: 4/5)*

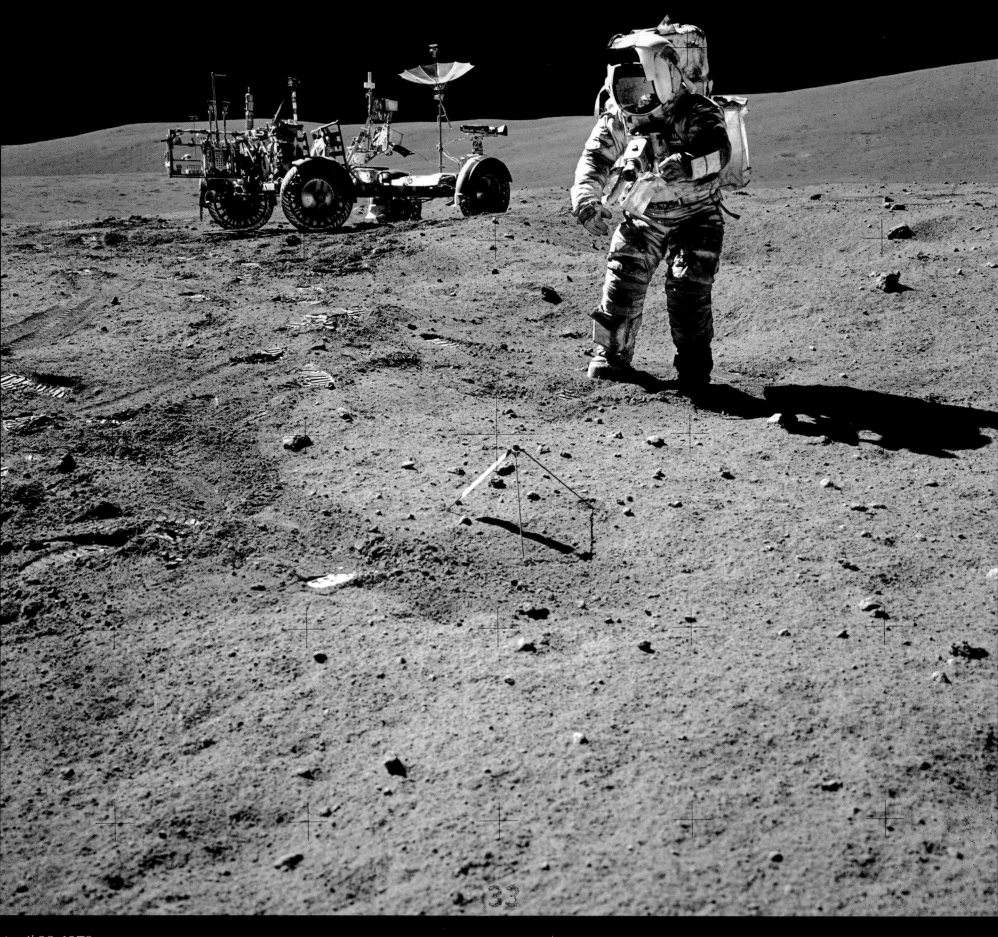

33

April 23, 1972 **EVA-3**　　　　HASSELBLAD 70MM. LENS 60MM F/5.6 | BY CHARLIE DUKE　　　　NASA ID: **AS16-117-18825**

Before this photograph, Duke takes a down-Sun version of this site as a "locator" for the upcoming sample. Duke: "Boy, I just can't see anything when I get this camera in my shadow." The decals and settings on the Hasselblad were difficult to read in the shadows, particularly when re-adjusting from looking at the super-bright lunar surface. This "locator" photograph is also a great portrait of Young. *(EL: 3/5)*

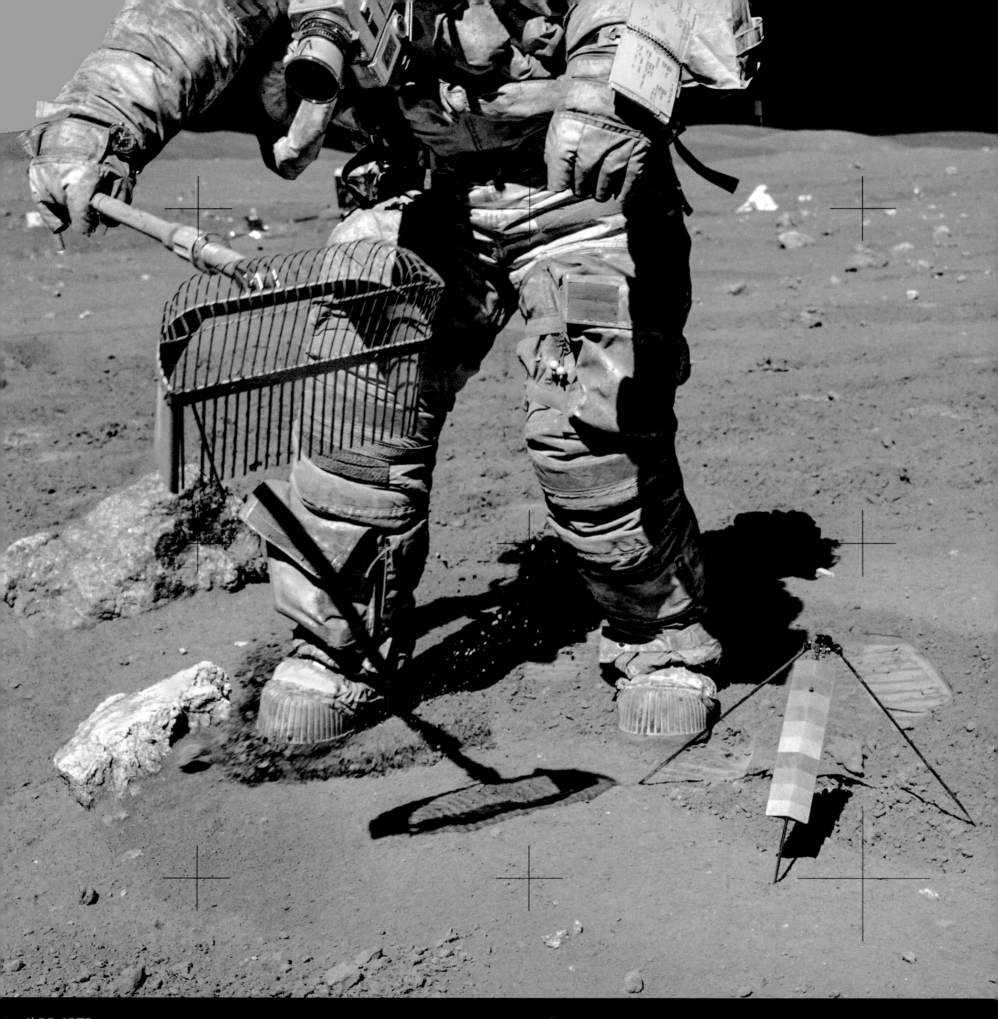

April 23, 1972 **EVA-3** HASSELBLAD 70MM. LENS 60MM F/5.6 | BY CHARLIE DUKE NASA ID: AS16-117-18826

Young, covered in Moon dust, is about to use the rake to collect a sample. From all the Apollo flight film, this photograph shows some of the finest suit detail. Young's Omega Speedmaster watch

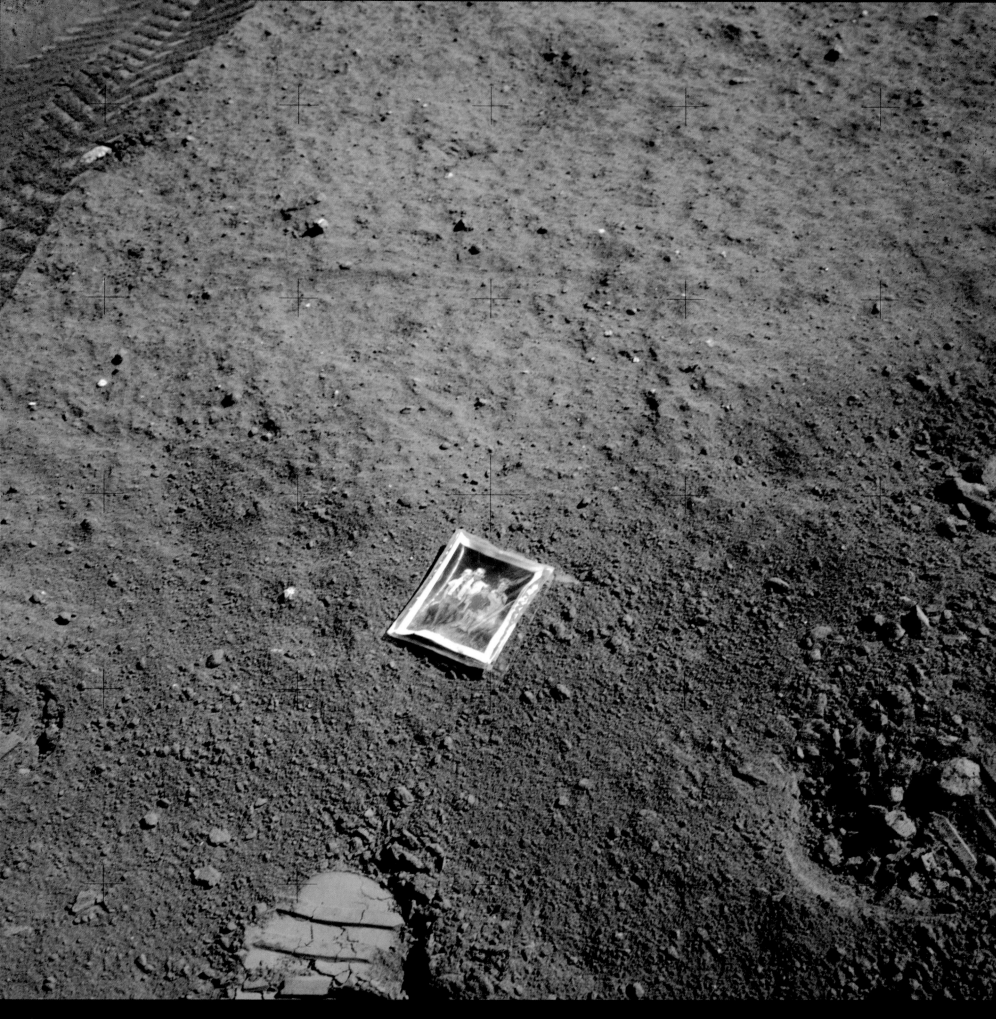

April 23, 1972 EVA-3 HASSELBLAD 70MM. LENS 60MM F/5.6 │ BY CHARLIE DUKE NASA ID: **AS16-117-18841**

Duke told me: "Leaving the photo of the family on the surface was an emotional moment." During EVA close-out, with only an hour of surface time left on the mission, Duke found an appropriate area close to the LM. The photograph was taken in the backyard of the family home and shows Charlie, wife Dotty and children Charles and Tom, then seven and five. On the back was written: This is the family of Astronaut Duke from Planet Earth. Landed on the Moon, April 1972." *(EL: 2/5)*

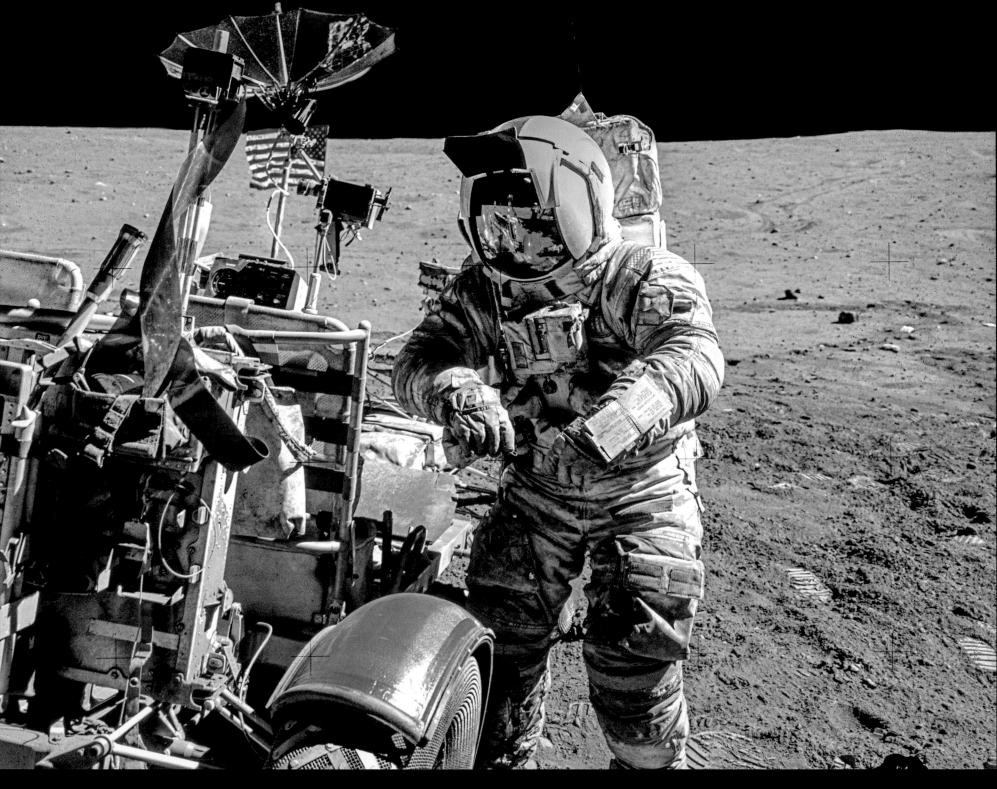

April 23, 1972 EVA-3 HASSELBLAD 70MM. LENS 60MM F/5.6 | BY CHARLIE DUKE NASA ID: AS16-117-18852

Duke: "Hey, John." Young: "Yeah." Duke: "Take a look [at the camera]." One of the last shots on the magazine, as the crew collected up everything needed for LM ingress and the journey home. This frame was badly damaged by sunlight as it was removed from the camera, but is shown restored. (EL: 5/5)

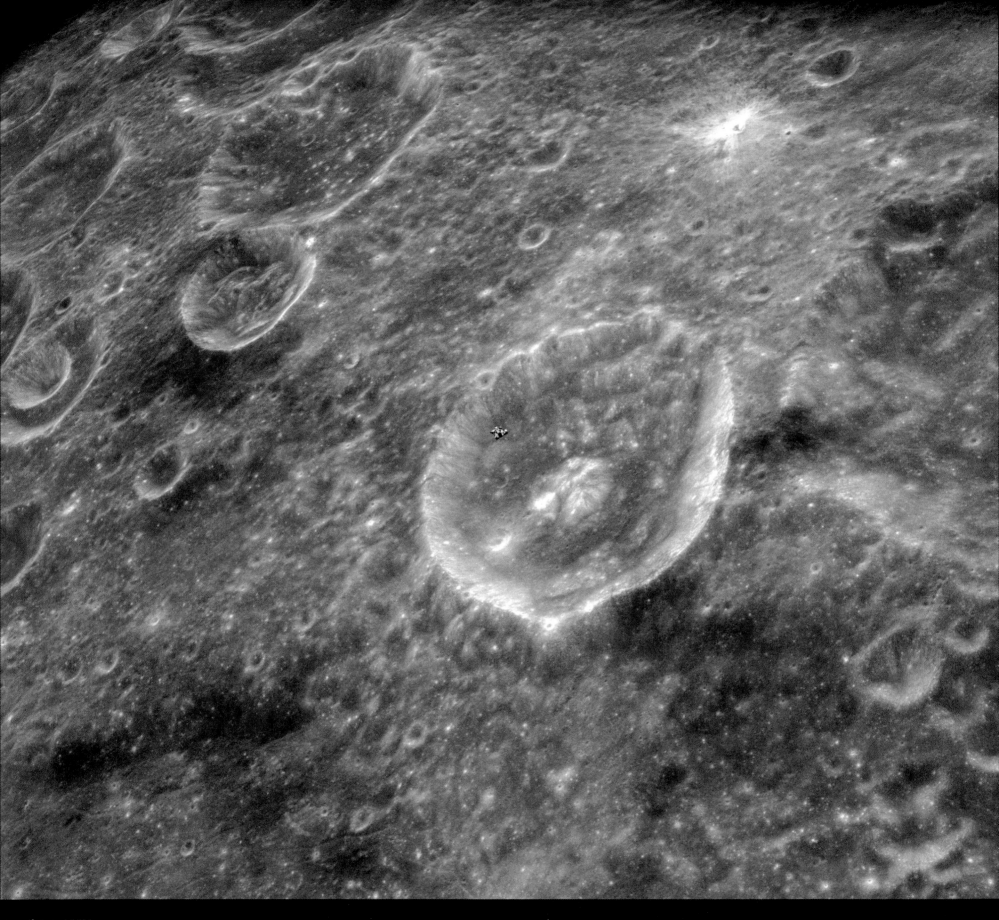

April 24, 1972 HASSELBLAD 70MM. LENS 80MM F/2.8 │ BY KEN MATTINGLY NASA ID: AS16-122-19527

Duke: "Lift-off. There we go! . . . What a ride! What a ride!" After three days on the lunar surface, the LM, carrying Young and Duke, fired its ascent engine to rejoin Mattingly in the CSM in lunar orbit. Mattingly: "You really look pretty against the lunar surface." The LM can be seen over Schubert B (Back) crater on the western edge of Mare Smythii. Duke: "Man, Ken, we got a load of rocks!" (Rotated, EL: 2/5)

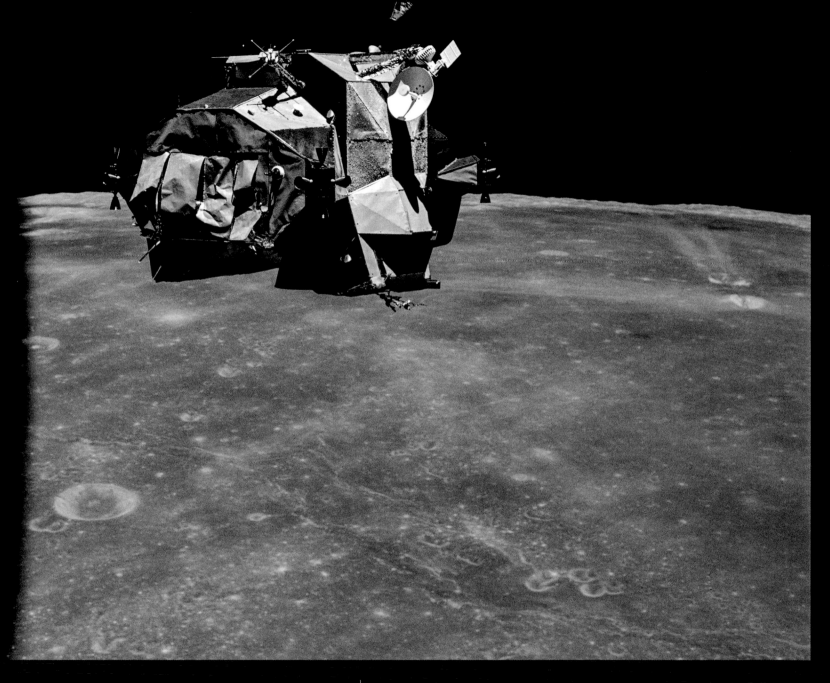

April 24, 1972　　　　HASSELBLAD 70MM. LENS 80MM F/2.8 | BY KEN MATTINGLY　　　　NASA ID: AS16-122-19533

Mission Control noticed that parts of the LM seemed to come loose due to the forces exerted at lift-off. It was requested that Mattingly undertake a visual inspection and photograph any damage observed. Mattingly: "Okay. Everything on the plus-Y side looks clean – just the surface is a little flaky with paint . . . Looks like some of the thermal blanket . . . on the back end there is pretty badly chewed up . . . A couple of panels are torn off." *(Rotated, EL: 3/5)*

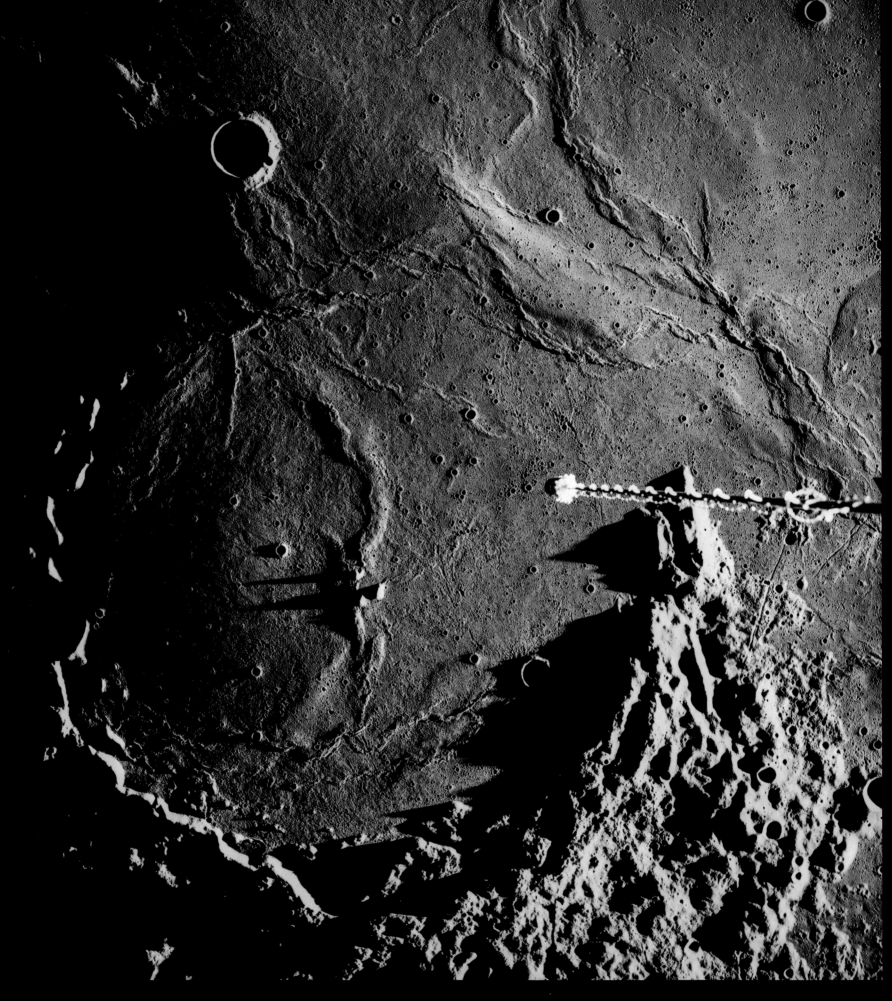

April 24, 1972

METRIC MAPPING CAMERA 115MM. LENS 76MM F/4.5. B&W

NASA ID: **AS16-M-2842**

Long shadows across the crescent "bay" of Letronne crater, at the terminator on the Moon's nearside. Taken prior to LM jettison, by the Metric Mapping camera located in the SIM bay. The mission was shortened by a day to allow time in the plan, in the event of further issues with the CSM's SPS engine, but Duke told me: "While we were joined back together our thoughts were on preparing the CM for TEI [trans-Earth injection] and reviewing emergency procedures. We had confidence in success." *(EL: 3/5)*

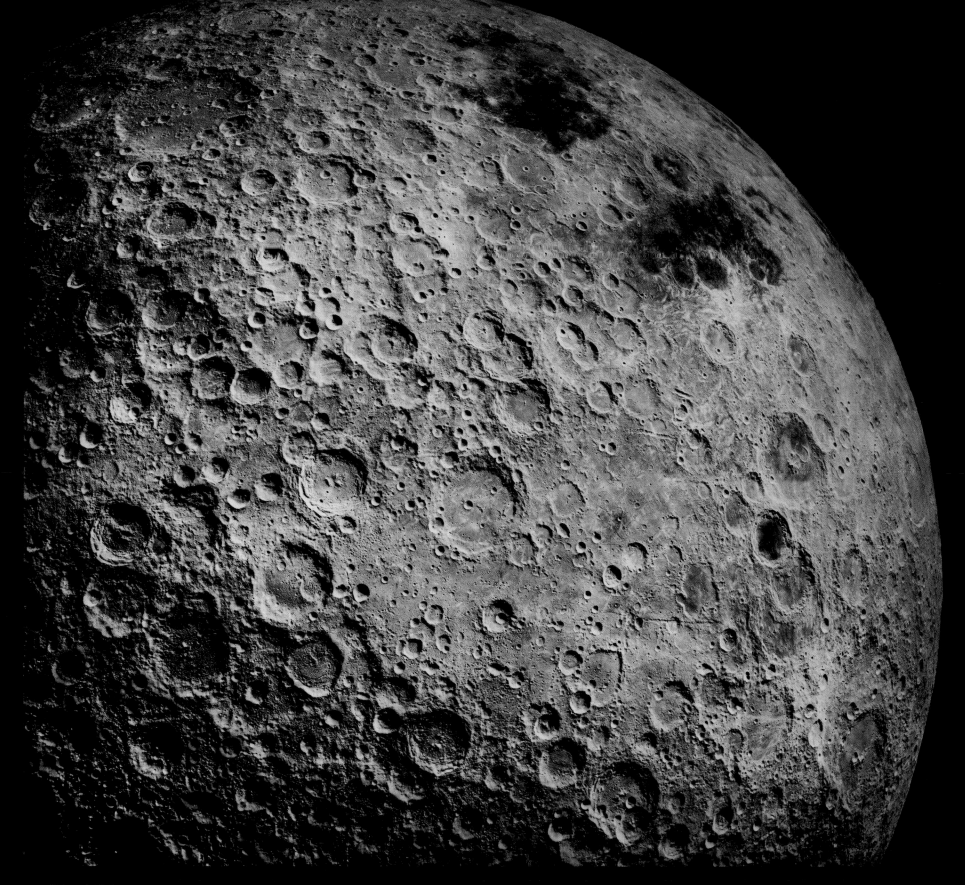

April 25, 1972

METRIC MAPPING CAMERA 115MM. LENS 76MM F/4.5. B&W

NASA ID: **AS16-M-3012**

Despite the concerns among some, Casper's SPS engine performed perfectly to put Apollo 16 on a course for home. This photograph of the lunar farside was captured after trans-Earth injection. An area of the Moon's nearside can also be seen – the darkened areas of Mare Smythii and Mare Marginis prominent, upper right. *(EL: 4/5)*

THE DETAILS

ROCKET	LAUNCH	DURATION	SPLASHDOWN
Saturn V (SA-512)	12:53 GMT, December 7, 1972, Pad 39A	12 days, 13 hours, 52 minutes	19:25 GMT, December 19, 1972, Pacific Ocean
COMMAND AND SERVICE MODULE *America* (CM-114)	LANDING SITE Taurus-Littrow	SURFACE TIME 75 hours	
LUNAR MODULE *Challenger* (LM-12)	DISTANCE 1,484,934 miles	LUNAR ORBITS 75	RECOVERY SHIP USS *Ticonderoga*

THE CREW

Eugene A. Cernan
COMMANDER (CDR)

Born March 14, 1934. An ex-fighter pilot, Cernan joined NASA with the third group of astronauts in 1963. He was Pilot of Gemini IX-A, performing a two-hour EVA, and Lunar Module Pilot on Apollo 10. To date, he is the last man to walk on the Moon and one of only three men to have flown to the Moon twice.

Ronald E. Evans
COMMAND MODULE PILOT (CMP)

Born November 10, 1933. An ex-naval officer and fighter pilot in the Vietnam War, Evans joined NASA in 1966. He was back-up Command Module Pilot of Apollo 14, but this would be his first and only spaceflight. One of only three men to perform a deep-space EVA, he retired in 1977.

Harrison H. "Jack" Schmitt
LUNAR MODULE PILOT (LMP)

Born July 3, 1935. Schmitt was back-up LMP on Apollo 15, which would have put him on the prime crew of Apollo 18. He was influential in the community of geologists supporting Apollo and when Apollo 18 was canceled, he was moved to Apollo 17, becoming the twelfth man and only professional scientist to walk on the Moon.

December 7–19, 1972

APOLLO 17

THE MISSION

Apollo 17 was the final lunar mission of the highly successful program. It broke many records during the course of its 12-day voyage, including the longest stay on the surface (75 hours), the longest total time on EVAs (22 hours), the largest sample return (243lbs) and the most lunar orbits (75). Not to mention setting the land speed record on another celestial body of a blistering 11.2 mph in the LRV while also traversing the greatest distance on the surface (19.3 miles).

It was the last time the Saturn V roared from the launch pad with a crew on board, maintaining its 100 percent success record and treating the 500,000 people who attended to a spectacular night launch. The launch helped put Apollo 17 on course for its pinpoint landing in the Taurus-Littrow valley – a site selected for its possible volcanic activity and potential to yield both older and younger rocks than those returned from previous missions. Surely the greatest possible field trip for the only professional geologist to visit the Moon, LMP Jack Schmitt.

Schmitt only made the crew when his Apollo 18 mission, and the rest of the program, was canceled, and the scientific community pressed for the inclusion of at least one scientist-astronaut.

Lunar orbit insertion was accomplished at 19:47 GMT on December 10, placing the spacecraft into an orbit of 170 by 53 nautical miles. At 14:35 GMT on December 11, Cernan and Schmitt entered LM *Challenger* to prepare for descent to the lunar surface. They touched down in the Taurus-Littrow valley at 19:54:57 GMT.

EVA-1 commenced with the planting of a U.S. flag with a rather unique history, having been carried to the Moon and back on Apollo 11, and then prominently displayed on the wall in Mission Control throughout the rest of the Apollo program. All three grueling, seven-hour, science-packed EVAs were considered successes. The clear highlight, however, came at the end of EVA-2: running low on oxygen, the crew made the incredible discovery of orange soil, throwing the crew and scientists in Mission Control into an excitable frenzy. Schmitt compared the color to the decal on his Hasselblad camera; the soil was later discovered to be tiny spheres of volcanic glass, created as lava erupted from the Moon's interior, 3.64 billion years ago. In 2011 it was also discovered that this sample contained the same proportion of water as rocks in Earth's interior – adding to the evidence that the rocks of Earth and the Moon came from the same place.

On EVA-2, the rover was driven to Station 2 (Nansen crater), an impressive 4.7 miles away from the relative safety of the LM. This was the outer envelope of their "walk back" limit should the LRV fail.

EVA-3 concluded at 05:40:56 GMT on December 14, 1972. Alone on the surface, Commander Cernan spoke the final words from the Moon; a poignant reminder that we have yet to return:

"As I take man's last step from the surface, back home for some time to come – but we believe not too long into the future – I'd like to just [say] what I believe history will record. That America's challenge of today has forged man's destiny of tomorrow. And, as we leave the Moon at Taurus-Littrow, we leave as we came and, God willing, as we shall return, with peace and hope for all mankind. Godspeed the crew of Apollo 17."

THE PHOTOGRAPHY

The sheer quality and quantity of incredible images from this mission has made shortlisting the 2,200+ surface images for this book a near-impossible task.

The most requested photograph from NASA's archives is the "Blue Marble." Said to be the most reproduced photograph of all time; almost every image of the full Earth ever seen is derived from this one photograph. Other highlights include the multi-colored lunar surface and, with significant enhancement, the faces of Schmitt; through his visor at the LRV, and Commander Cernan through the window of the LM – at the helm as he pilots the last spacecraft from the Moon. The whole scene during transposition and docking, encompassing the S-IVB, the LM and a limb-to-limb view of Earth can now also be appreciated via the 16mm stacked footage, as can detailed views of the interiors of the Lunar Module and Command Module.

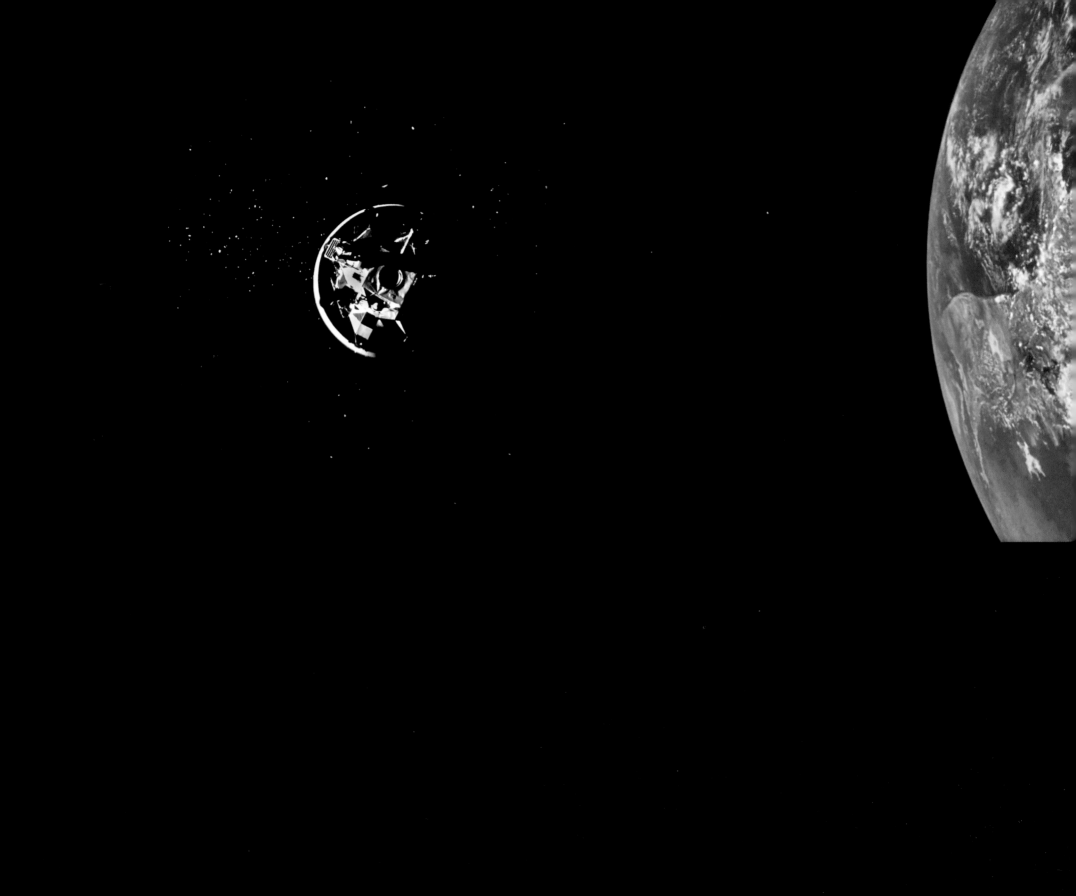

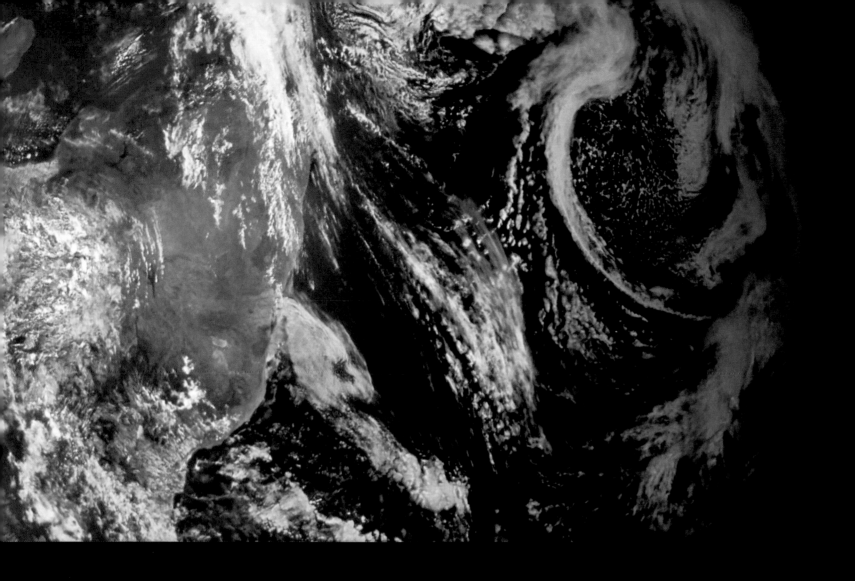

December 7, 1972 482 FRAMES OF 16MM FILM, STACKED, PROCESSED AND STITCHED NASA ID: **APOLLO 17 MAG 1341-AA**

Schmitt: "It looks like the Fourth of July out of Ron's window!" 5,300 nautical miles from Earth, the 16mm film is rolling to capture the CSM, docking with LM *Challenger*. Cernan: "We've got the booster, and is she pretty! *Challenger's* just sitting in her nest." Surrounded by debris caused by separation from the third stage of the Saturn V, the panned "movie" footage from the CM's window has enabled the creation of this panoramic image, to better comprehend the extraordinary scene.

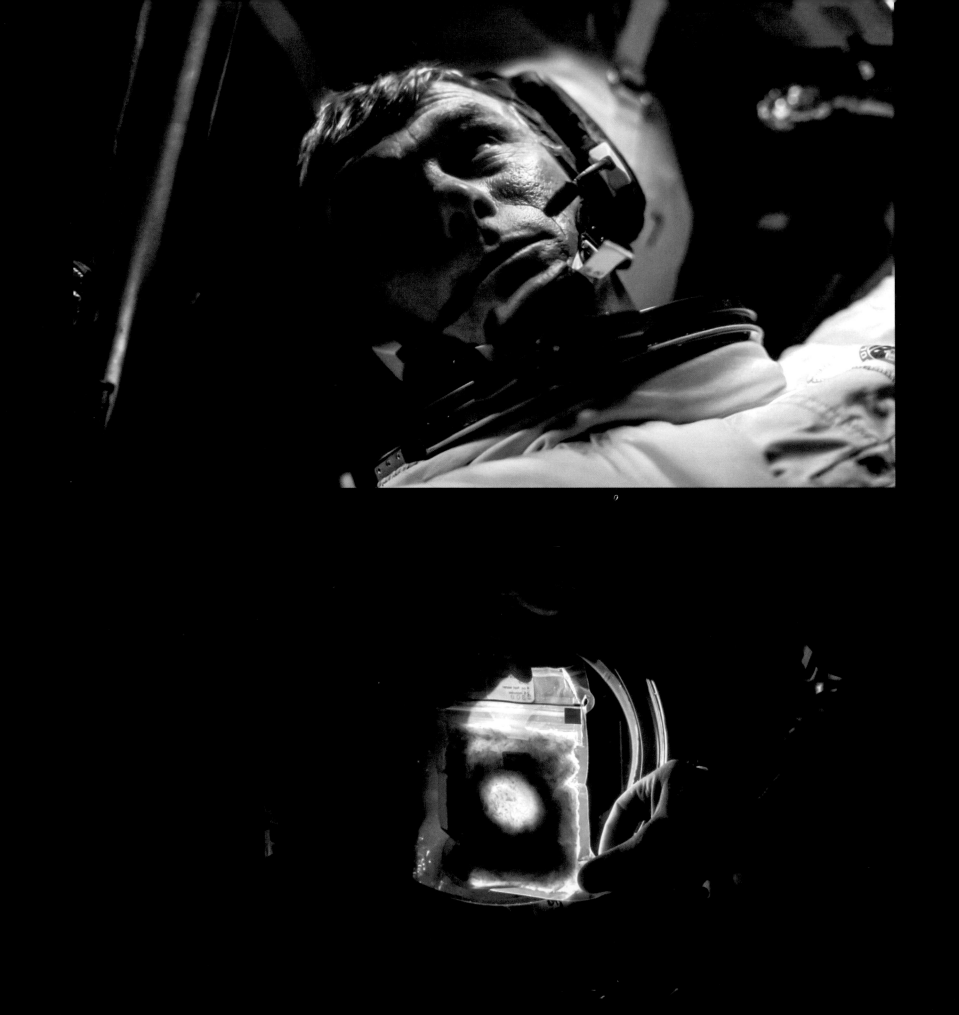

December 7, 1972

NIKON F 35MM. LENS 55 MM F/1.2 | BY UNKNOWN

NASA ID: **AS17-162-24035 & AS17-162-24086**

After docking with the LM, Apollo 17 continued its 3.5-day coast to the Moon. TOP: Commander Cernan, still in his pressure suit early in the flight; they would take the bulky suits off six hours after launch. BOTTOM: Time for the crew's first lunch; the chicken and rice soup pouch is held up to the hatch window. It was accompanied by meatballs and sauce, fruit cake, lemon pudding and an orange-pineapple drink. *(EL: 2/5)*

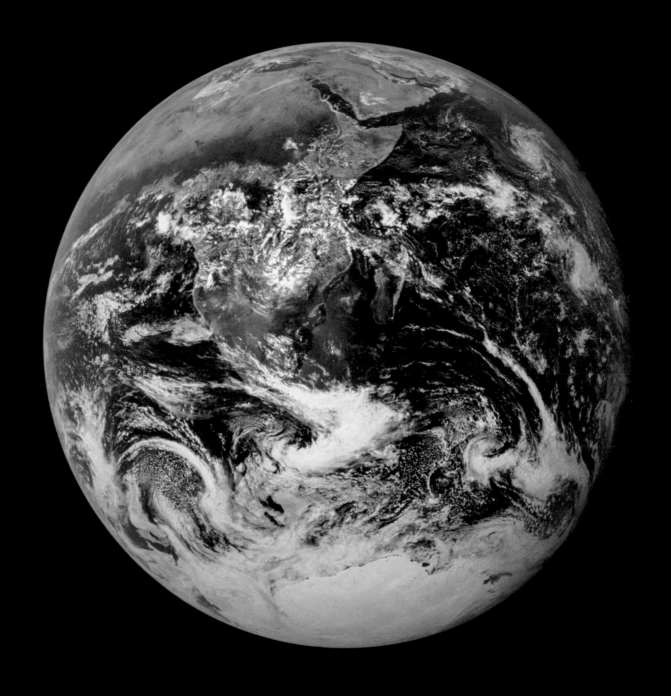

December 7, 1972 HASSELBLAD 70MM. LENS 80MM F/2.8 │ PROBABLY BY JACK SCHMITT NASA ID: **AS17-148-22727**

"The Blue Marble." Said to be the most reproduced photograph of all time, it depicts the whole, illuminated Earth from around 18,000 nautical miles. Evans: "The Earth just fills up window 5 . . . What a beauty! . . . Madagascar and Africa . . . Hey, there's Antarctica!" Cernan: "It's these kinds of views that stick with you forever." Schmitt: "I'll tell you, if there ever was a fragile-appearing piece of blue in space, it's the Earth right now." The photograph became a major catalyst for the environmental movement. *(Cropped, EL: 2/5)*

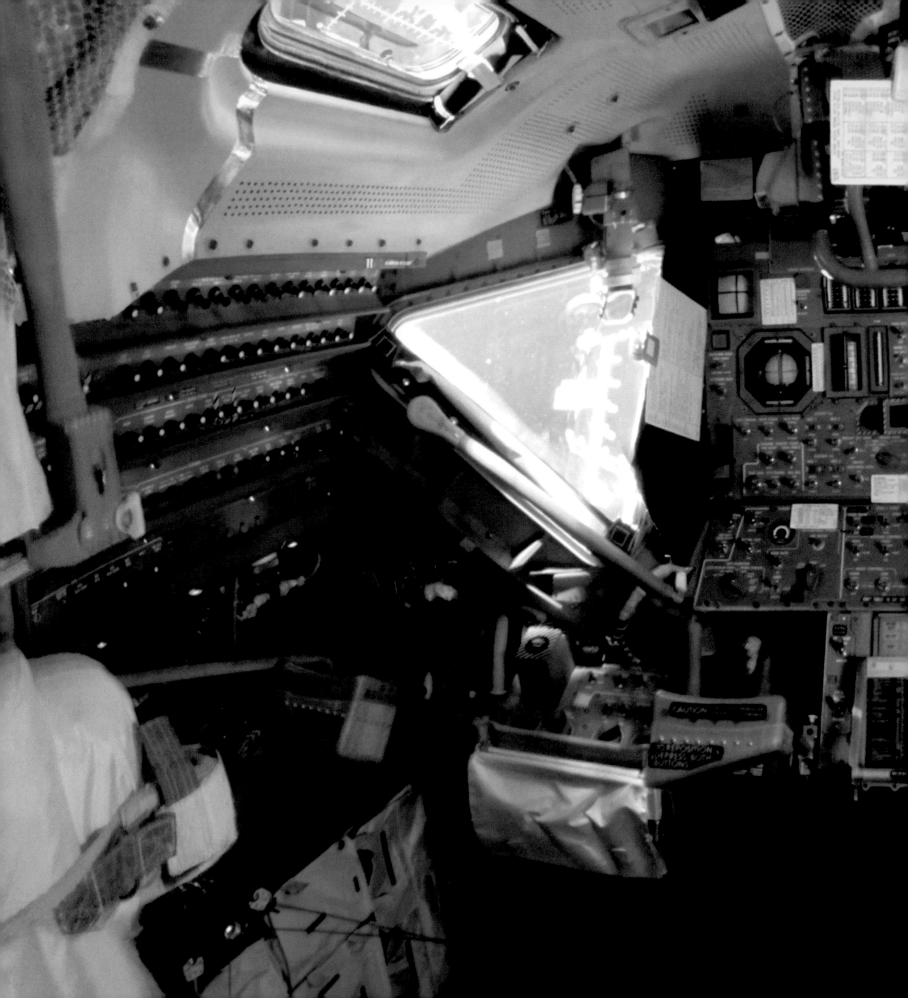

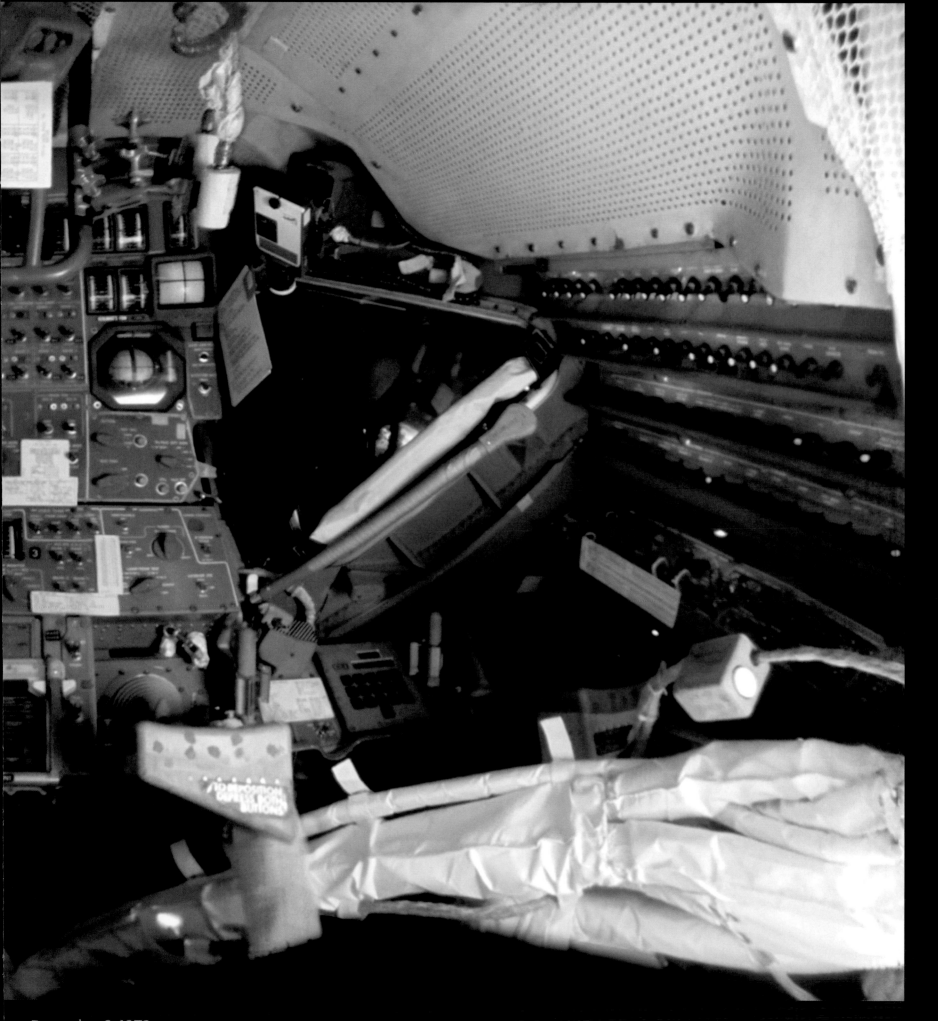

December 9, 1972 461 FRAMES OF 16MM FILM, STACKED, PROCESSED AND STITCHED NASA ID: **APOLLO 17 1350-II**

Cernan: "We're going up to take another look at *Challenger*." 54,000 miles from the Moon, the crew performed a checkout of the LM. Evans: "And Houston, is [the 16mm DAC] magazine 'II a good one to use for . . . interior?" An apparently conscious, strategic pan of the interior of the last spacecraft to land humans on the Moon has enabled probably the most complete, detailed view inside a Lunar Module in flight. Commander Cernan's station is to the left, LMP Schmitt's on the right.

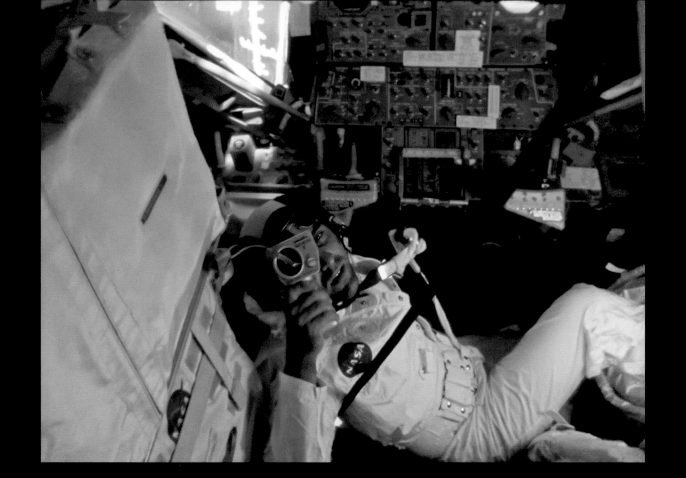

December 9, 1972 41 AND 16 FRAMES OF 16MM FILM, STACKED AND PROCESSED NASA ID: **APOLLO 17 1350-II**

TOP LEFT AND TOP RIGHT: Schmitt, dressed in his coveralls, has floated through the tunnel, into the LM for its checkout. He is pointing the Minolta Space Meter (to assess the lighting for the camera settings) back at Evans, who is in the tunnel. Cernan's PLSS backpack is near his right elbow. Schmitt: "The cleanliness of these two spacecraft is certainly a tribute to all the people at Grumman and Downey and at the Cape, who worked so hard to put them that way."

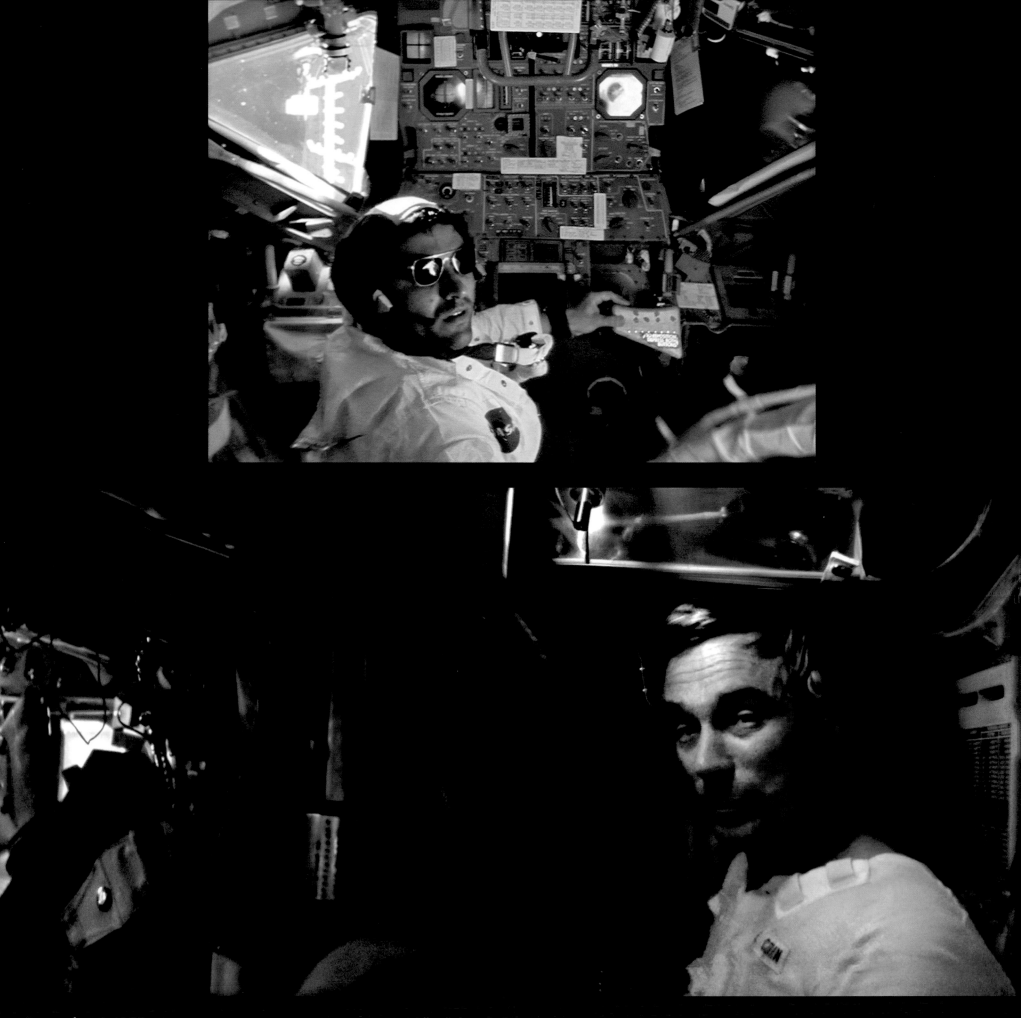

December 9, 1972 403 FRAMES OF 16MM FILM, STACKED, PROCESSED AND STITCHED NASA ID: **APOLLO 17 1350-II**

BOTTOM: Meanwhile "down" in the Command Module *America,* Cernan is in the lower equipment bay. The tunnel to the LM is above him and the displaced hatch can be seen left, beyond his floating coveralls. A Hasselblad with the 250mm telephoto lens attached is also upper left. The CM appears roomier than in reality due to the approximately 120-degree view.

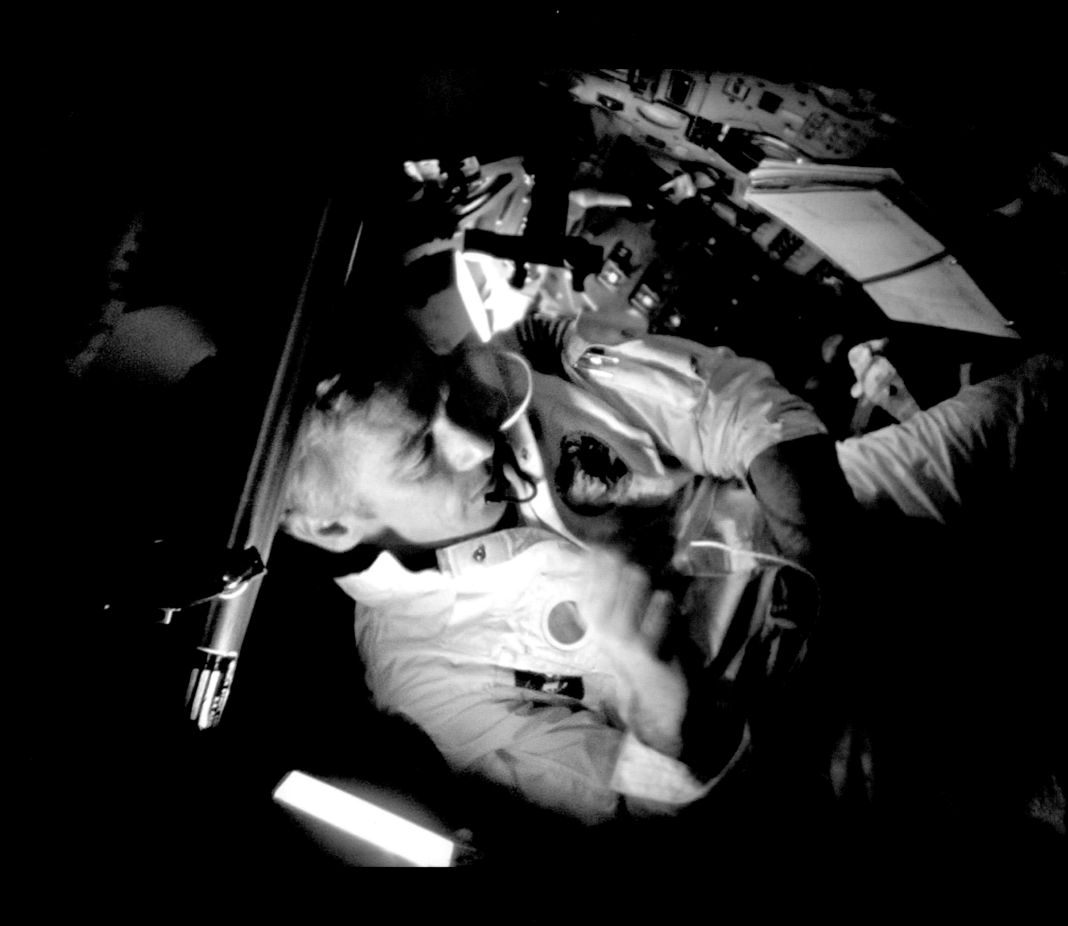

December 9, 1972 58 FRAMES OF 16MM FILM, STACKED, PROCESSED AND STITCHED NASA ID: **APOLLO 17 1350-II**

Life on board *America* as Apollo 17 nears the Moon. Cernan (left) plays a popular zero-gravity game of throwing food (probably a cereal cube) into the mouth of a crewmate, Evans, who is down in the lower equipment bay. Three meals per day totaling 2,800 calories were provided, much of which required re-hydrating.

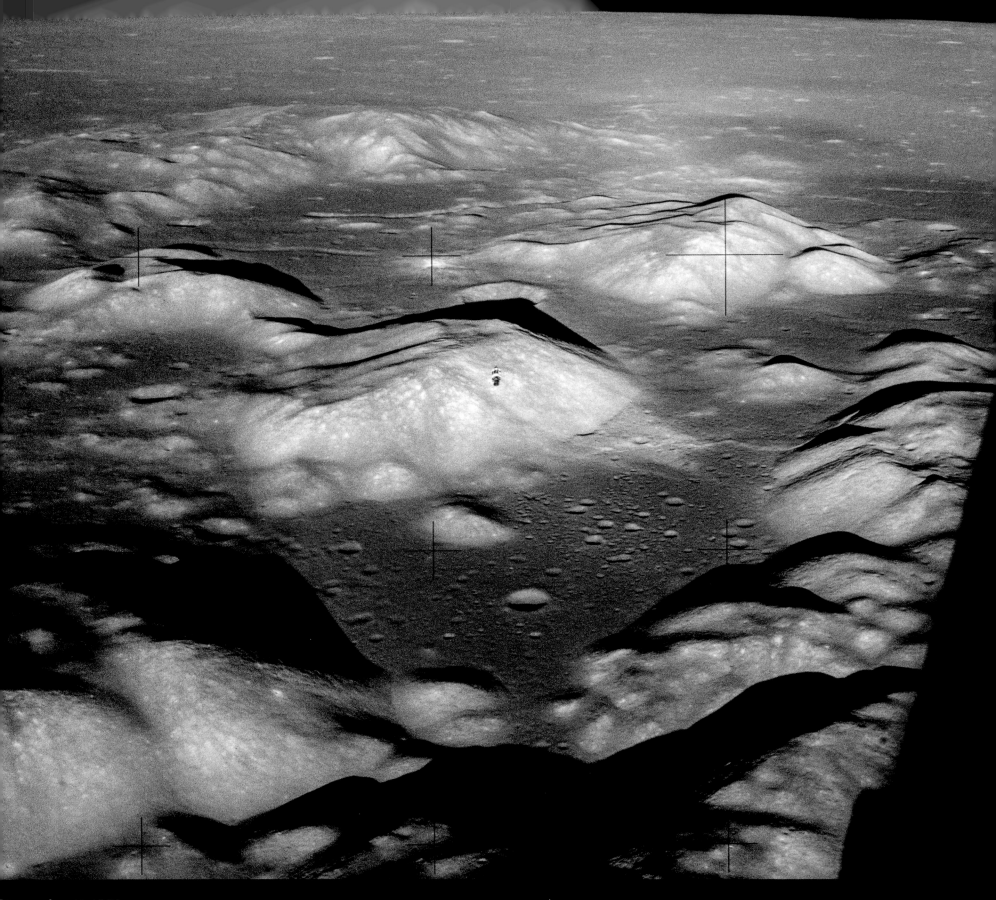

December 11, 1972 HASSELBLAD 70MM. LENS 80MM F/2.8 | BY GENE CERNAN NASA ID: **AS17-147-22466**

Cernan: "It is absolutely spectacular looking at that Command Module, *America*, down there coming across the surface. We're just tracking him at about a 30-degree dive angle." This amazing photograph was taken from the LM as the CSM passed directly over the Taurus-Littrow landing site. "We got the landing site! We're coming right over the front of it . . . We'll get a picture of America coming right across it." Schmitt: "Super targeting." Cernan: "I can even see Poppie [crater], right where we're going to set this baby down!" (Cropped, *FL: 3/5*)

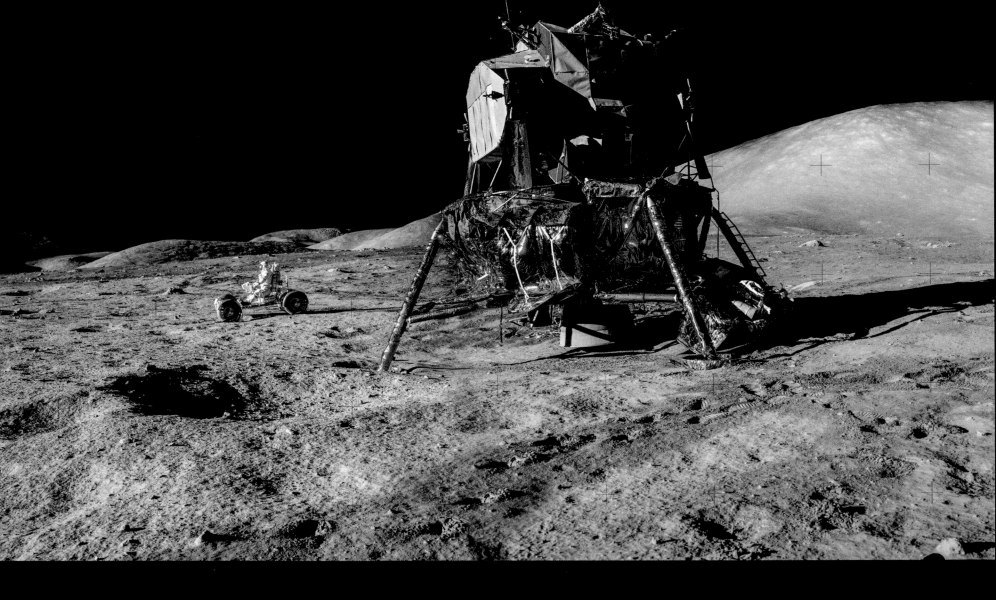

December 12, 1972 EVA-1　　　HASSELBLAD 70MM. LENS 60MM F/5.6 | BY JACK SCHMITT　　　NASA ID: AS17-147-22517 TO 22521

Challenger touched down hard, but safely. Cernan: "Boy, when you said shut down, I shut down and we dropped, didn't we?" Schmitt: "Yes, sir! But we is [sic] here." Cernan made his way out first: "God, that LM is a pretty sight!" It then took only 20 minutes to deploy the LRV. Schmitt, the geologist, was commenting on the rocks below his feet even while assisting deployment: "I never thought I'd do geology this way!" *(Panorama, EL: 4/5)*

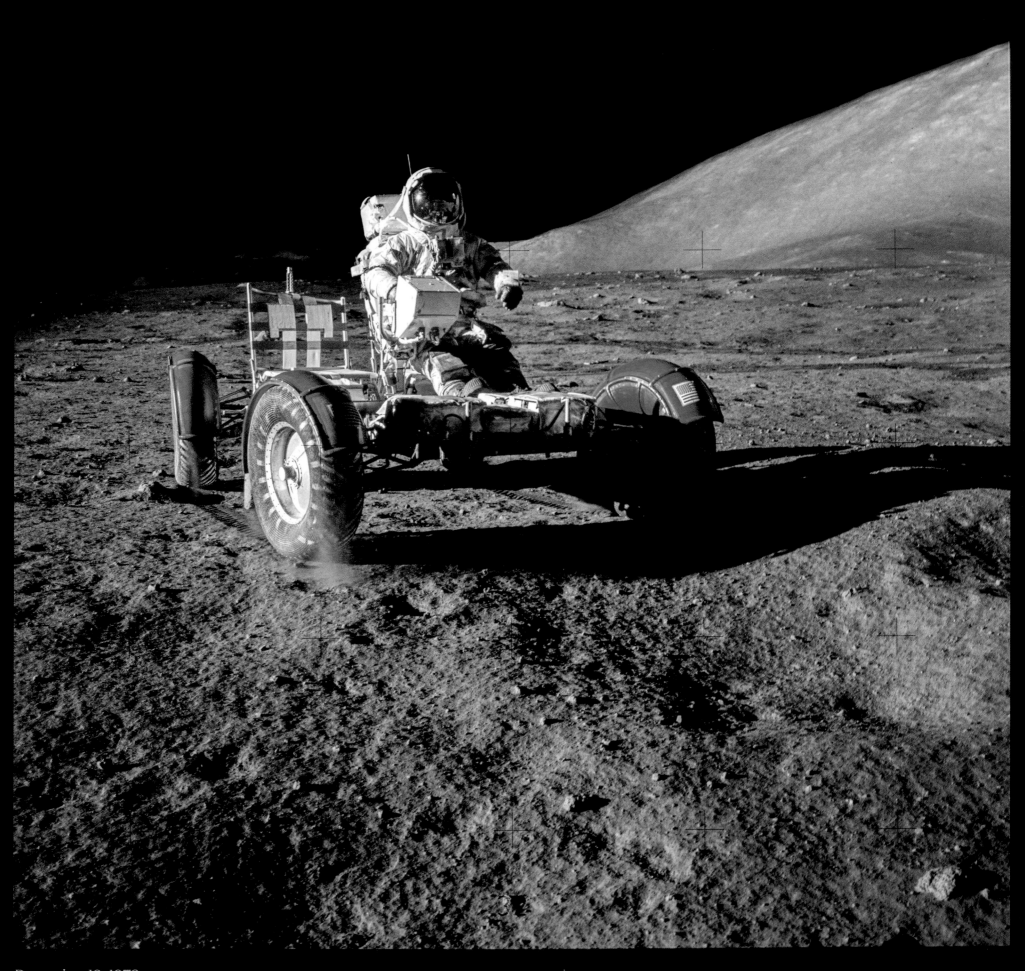

December 12, 1972 EVA-1 HASSELBLAD 70MM. LENS 60MM F/5.6 | BY JACK SCHMITT NASA ID: **AS17-147-22526**

Cernan: "Let's see if there is any life in this here baby . . . and judging from the way it's handling, I think the rear wheels are steering too . . . What do you see, Jack?" Cernan tests the LRV and steering – each pair of wheels could turn in opposite directions to improve maneuverability. Schmitt: "Come toward me, baby! Looks like it's moving . . . Don't run over me!" Over Cernan's right shoulder is Bear Mountain, and 4.5 miles in the distance, to the right, is South Massif. *(EL: 4/5)*

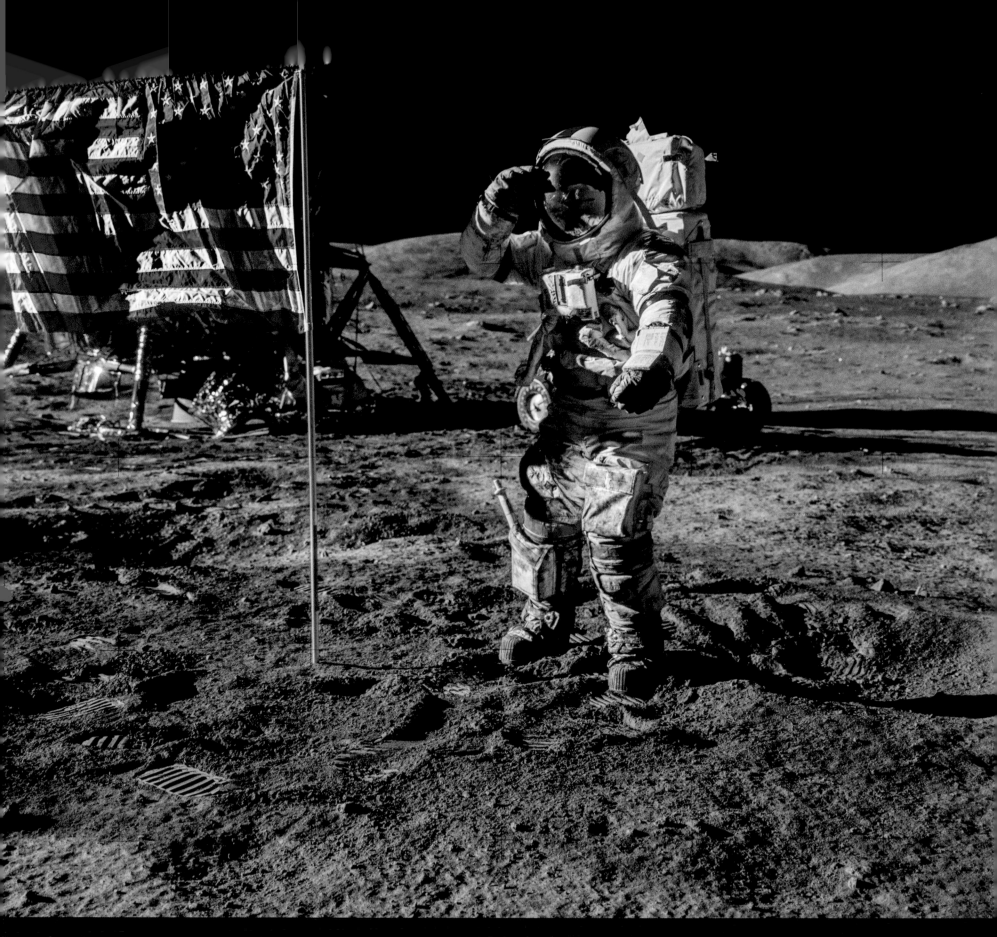

December 12, 1972 EVA-1 HASSELBLAD 70MM. LENS 60MM F/5.6 │ BY JACK SCHMITT NASA ID: AS17-134-2038C

After loading the LRV, the U.S. flag was planted. This exact flag had made the return trip on Apollo 11, then hung in Mission Control throughout the Apollo program, until finding its final resting place here. Cernan: "We can get the rover in the background." Schmitt: "Yeah and the LM . . . That's beautiful." Cernan attempts a John Young-style jump salute (see **AS16-113-18339**). *(FL: 4/5*

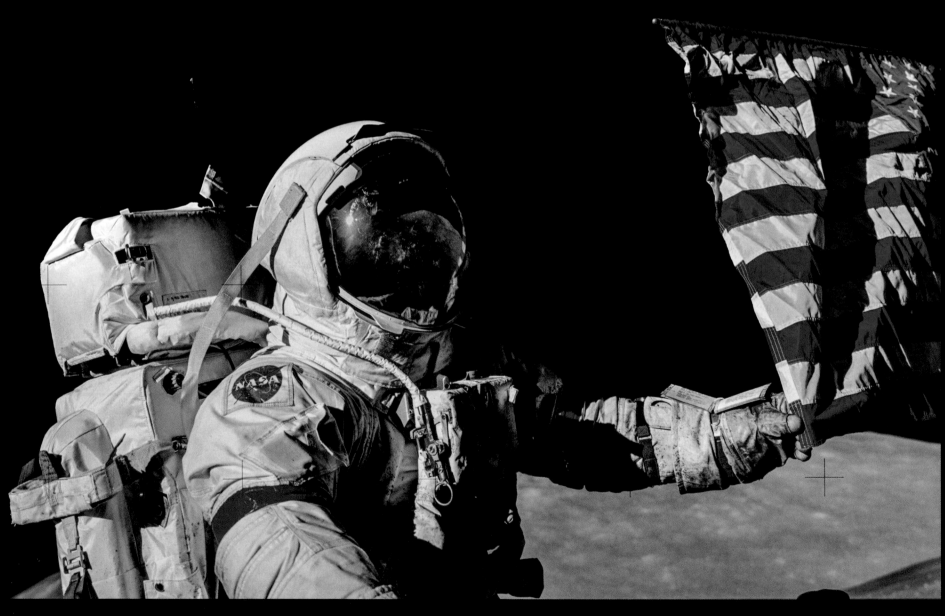

December 12, 1972 EVA-1 HASSELBLAD 70MM. LENS 60MM F/5.6 | BY JACK SCHMITT NASA ID: AS17-134-20387

Cernan: "I want to get the Earth . . . Try that one time, then we'll give up and get to work . . . Point it up a little, yeah?" Schmitt: "I don't know, Gene-o . . . Let me get over here closer to you . . . Okay, that might have got it." Schmitt absolutely got it, resulting in this image of Cernan, the flag and Earth. Note, Schmitt can be seen in the reflection, on his knees in his efforts to get the right angle. Cernan is also just visible through his visor. *(EL: 2/5)*

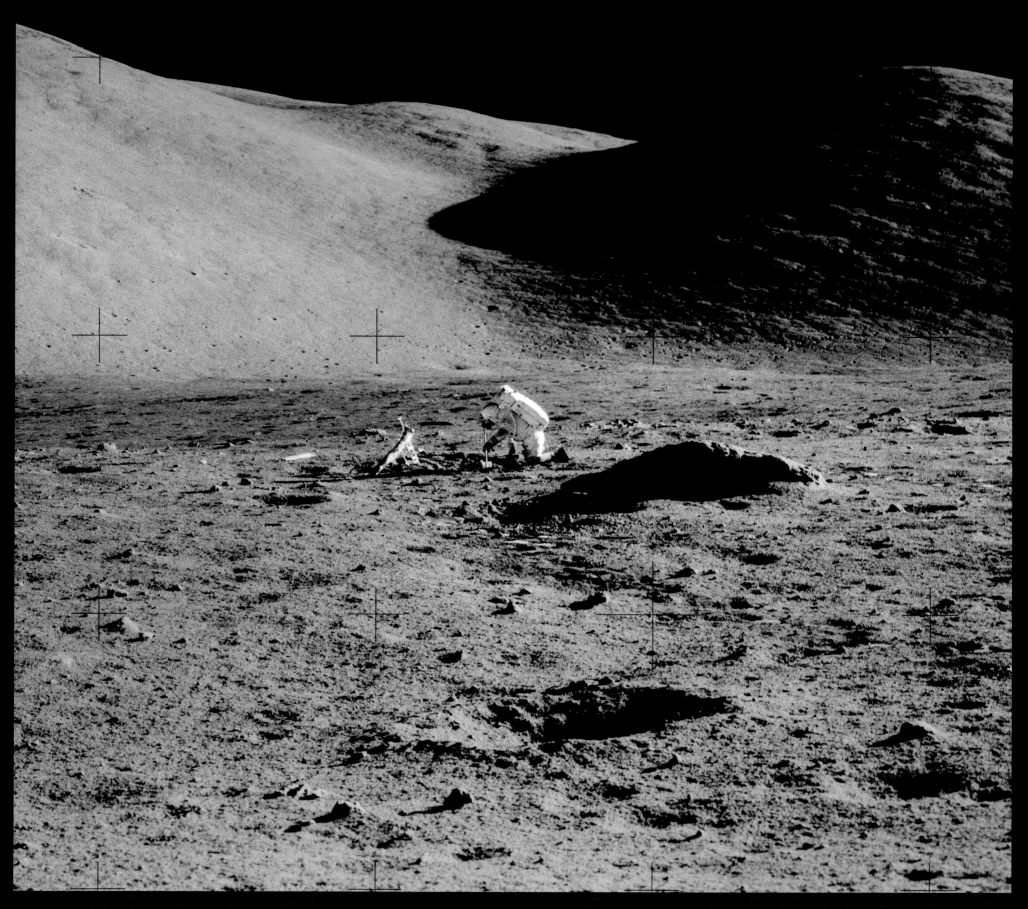

December 12, 1972 **EVA-1** HASSELBLAD 70MM. LENS 60MM F/5.6. B&W | BY JACK SCHMITT NASA ID: **AS17-136-20695**

After deploying the ALSEP, Cernan is on his knees trying to jack the 10-foot deep-core sample out – a continuous section of the lunar regolith. Cernan switched his suit to maximum cooling and Mission Control requested regular breaks as his heart rate was running at 150bpm. "That's what you call getting down into your work!" Schmitt: "I guess I take ALSEP photos . . . I know what you want, you want color . . . but I got Hotel [black and white magazine 'H'] on." *(Cropped, EL: 3/5)*

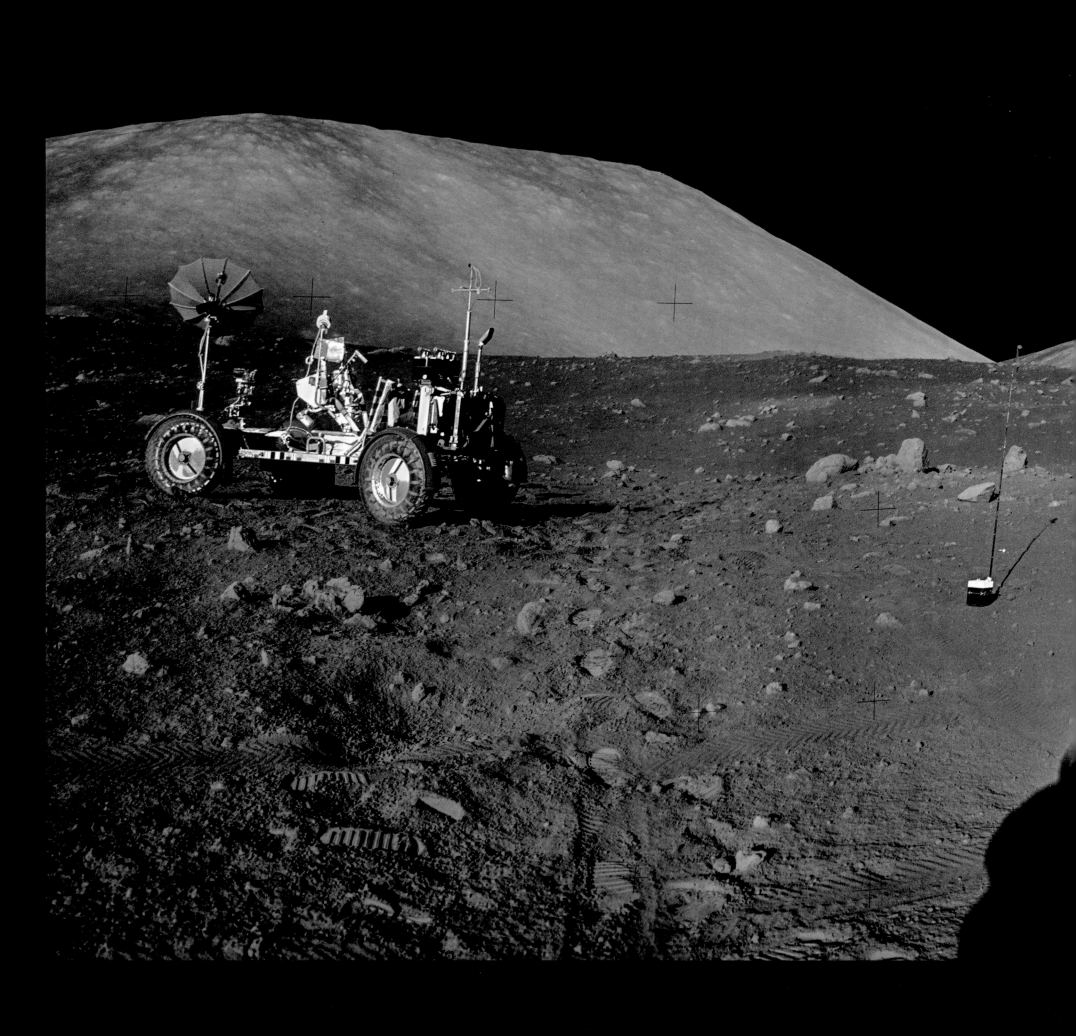

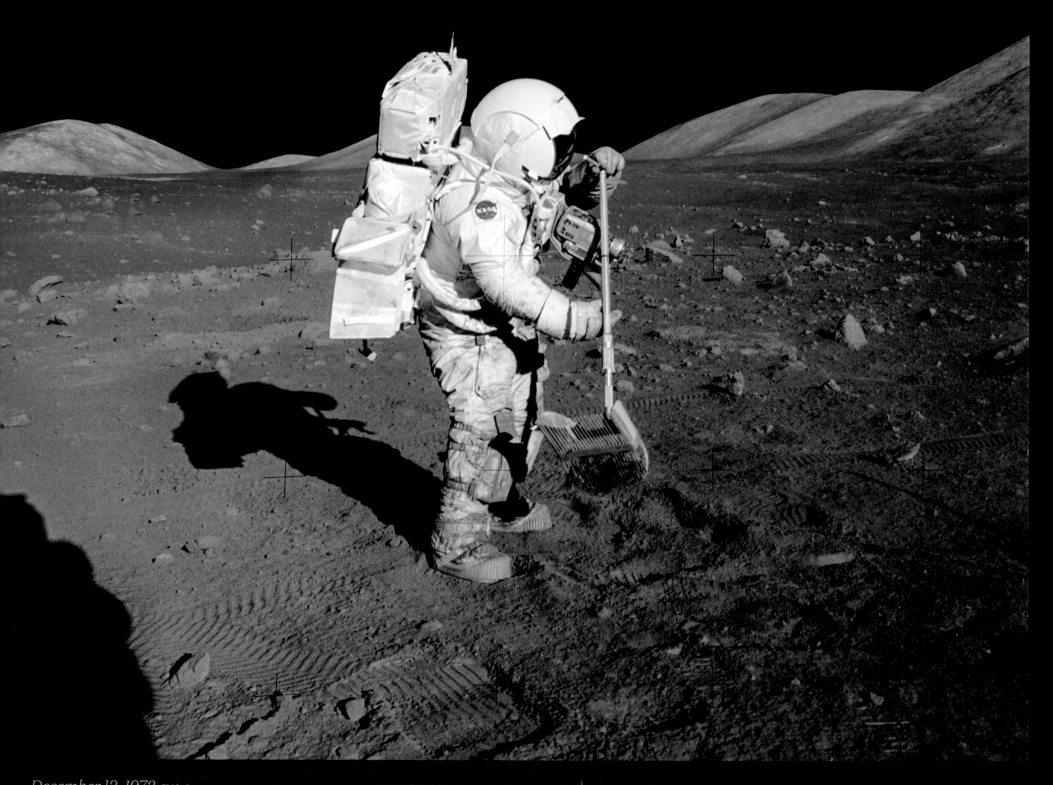

December 12, 1972 EVA-1　　　　　　　　HASSELBLAD 70MM. LENS 60MM F/5.6 | BY GENE CERNAN　　　　　　　　NASA ID: AS17-134-20421 TO 20425

Cernan: "Okay, you got your camera. My camera is in the floor pan." The crew board the LRV for their first traverse, to Station 1, at Steno crater. Mission Control: "Number-one priority will be some block samples . . . Second priority is a rake soil sample . . . Then, also in there, the pans [panoramas], of course." This image, from Cernan's pan, shows Schmitt taking a rake soil sample. Schmitt: "I'm really only penetrating about . . . 3 centimeters into this area with the rake. I've picked up a very good sample." *(Panorama, EL: 2/5)*

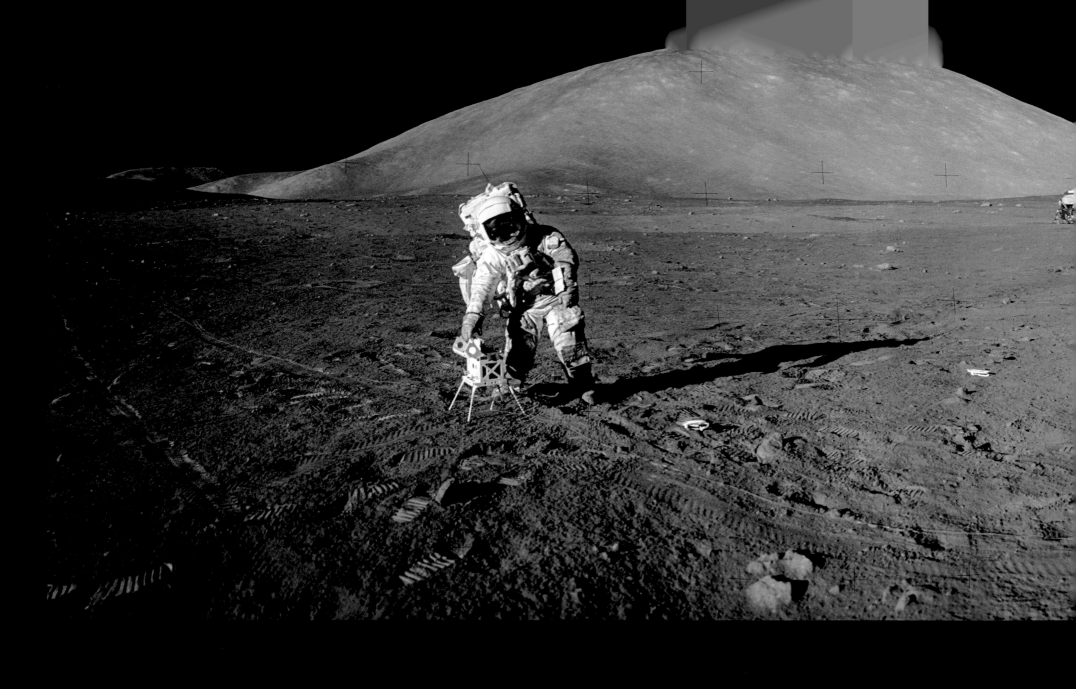

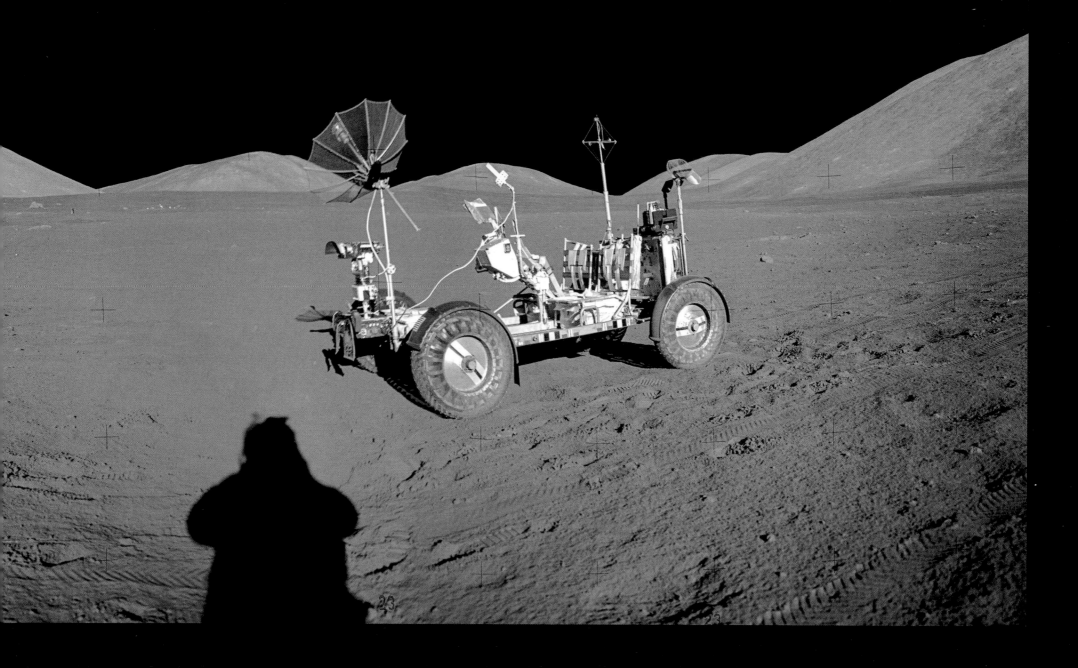

December 12, 1972 **EVA-1** HASSELBLAD 70MM. LENS 60MM F/5.6 | BY GENE CERNAN NASA ID: AS17-134-20438 TO 20444

Back at the LM (500 feet away), Schmitt is unfolding the solar panels on the SEP (Surface Electrical Properties) transmitter. A crossed-dipole antenna was laid out with four 115-foot-long wires on a cross pattern of rover tracks that Cernan purposely made. Cernan consults his cuff checklist: "Okay, it says, 'Take locator photo to LM.'" Coming to the end of the EVA, Cernan: "You want to walk back or ride?" Schmitt: "Oh, I'll walk back." *(Panorama, EL: 2/5)*

December 13, 1972 EVA-2 HASSELBLAD 70MM. LENS 60MM F/5.6 | BY GENE CERNAN NASA ID: **AS17-137-20961**

Mission Control: "We'll give you the full eight hours [of sleep] tonight, Gene-o." Schmitt woke only occasionally to hear the "comforting sound of fans and pumps," until Wagner's rousing "Ride of the Valkyries" wake-up music was pumped through to the LM. Later, they traversed a record 4.7 miles from the relative safety and comfort of their temporary home. Their permanent home, Earth, significantly further away, was photographed over a head-height boulder at Nansen crater, at the foot of South Massif. *(Rotated, EL: 2/5)*

December 13, 1972 EVA-2 HASSELBLAD 70MM. LENS 60MM F/5.6 | BY GENE CERNAN NASA ID: **AS17-137-20968**

Mission Control: "Do you see any more different blocks up there that are worth sampling?" Schmitt: "Here are two rocks side by side, a meter or two in diameter." Cernan used his hammer to chip off samples. Note the varying colors in the rock, as Cernan used his tongs to ensure perfect focus distance. Mostly containing a greenish mineral known as olivine, this dunite clast turned out to be the oldest Moon rock ever sampled, dating back 4.6 billion years to the birth of the solar system. *(EL: 2/5)*

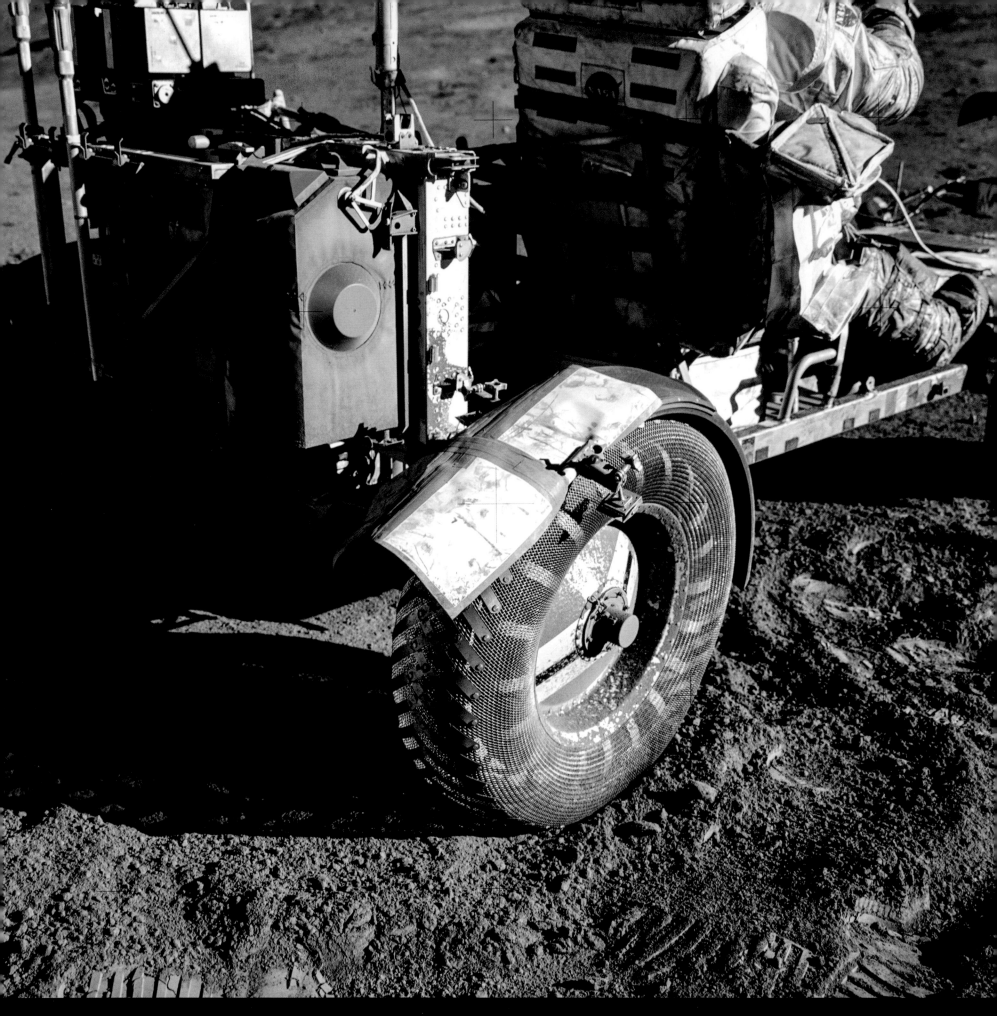

December 13, 1972 **EVA-2** HASSELBLAD 70MM. LENS 60MM F/5.6 | BY GENE CERNAN NASA ID: **AS17-137-2097**

During EVA-1, Cernan's hammer caught the rear fender: "Oh, you won't believe it . . . No!! There goes a fender." A huge rooster tail of dust could be extremely hazardous, including potentially leading to overheating of the LRV. A temporary fix didn't last long. Cernan: "Good old-fashioned American gray tape doesn't stick to lunar-dust-covered fenders." This more permanent fix was worked up by Duke and Young in Houston overnight and utilized four taped lunar maps, clamped to the fender with AOT clamps (see top center in the LM interior panorama, APOLLO 17 MAG 1350-III *(FL 25*

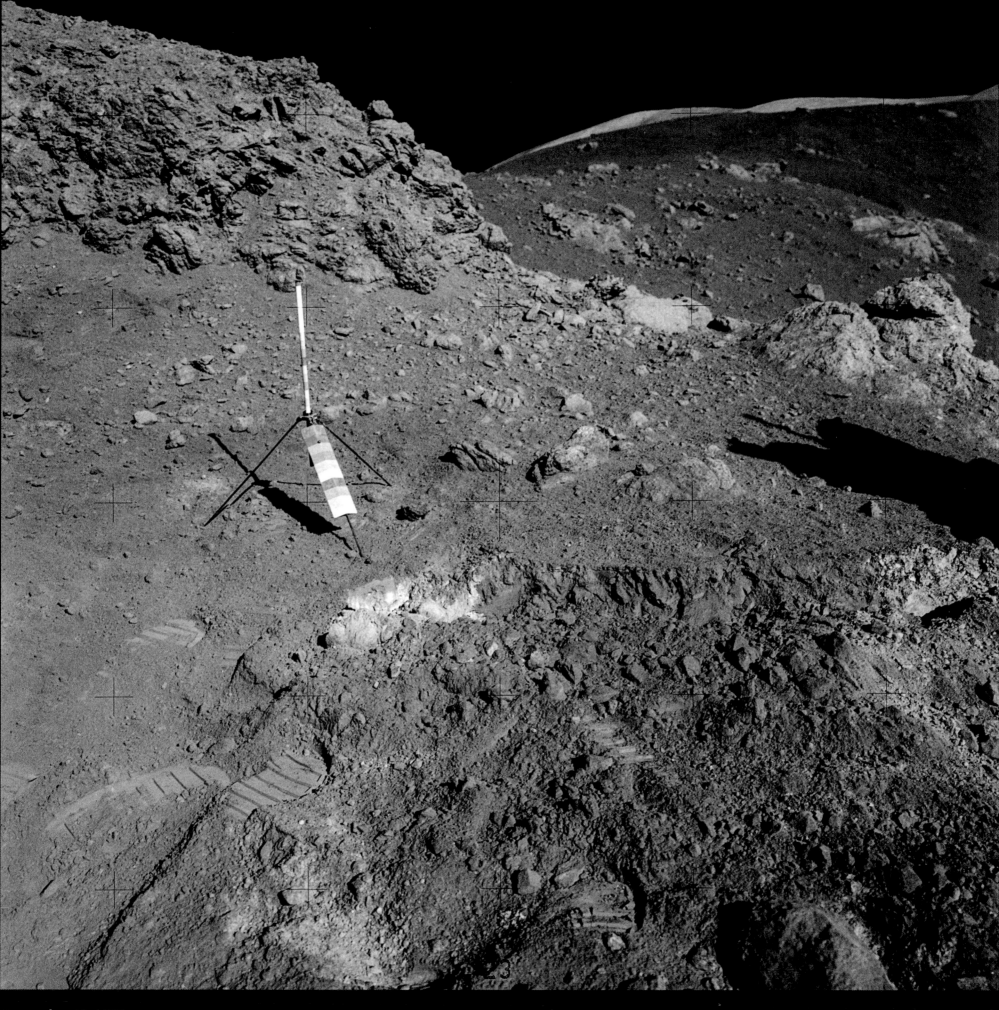

December 13, 1972 **EVA-2** HASSELBLAD 70MM. LENS 60MM F/5.6 | BY GENE CERNAN NASA ID: **AS17-137-20990**

The crew pulled up at Station 4, Shorty crater. Schmitt: "Okay, we've got a large boulder of very intensely fractured rock, right on the rim, right near the rover . . . Wait a minute . . . There is orange soil!! It's all over!! Orange!!!" Cernan: "Wait a minute, let me put my visor up . . . How can there be orange soil on the Moon!?" This was later discovered to be tiny spheres of volcanic glass, created as lava erupted from the Moon's interior, 3.64 billion years ago. *(EL: 2/5)*

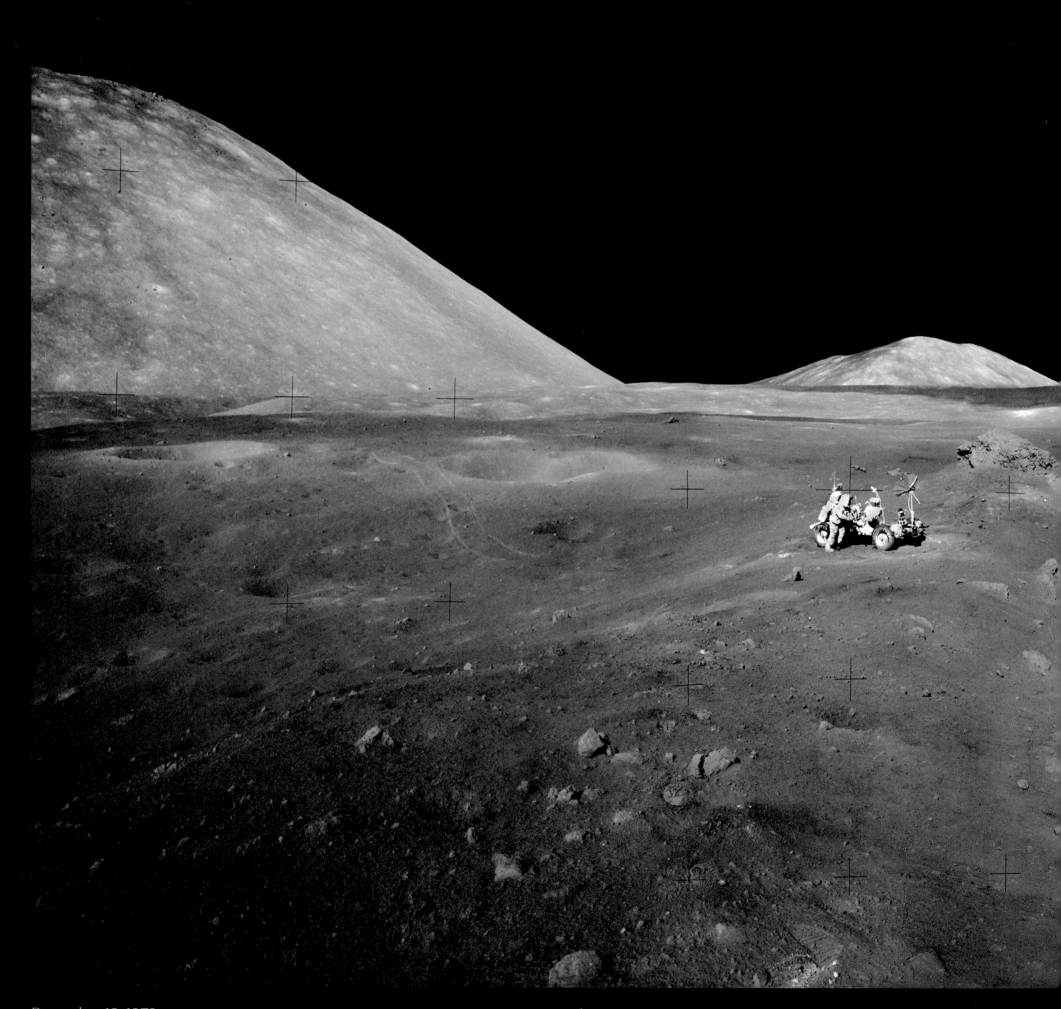

December 13, 1972 EVA-2 HASSELBLAD 70MM. LENS 60MM F/5.6 | BY GENE CERNAN NASA ID: AS17-137-21004 TO 21013

Schmitt peers over the edge of the 330-foot-wide, 45-foot-deep crater. The boulder and the orange soil (see previous image) are beyond him. The rover tracks up to the rim are visible, as is the orange and, according to Cernan, "very dark bluish" material. Cernan: "From where I am, about 100 meters around the west side of the rim . . . there's a lot of orange stuff that goes down – radially down – into the pit of the crater." *(Panorama, EL: 4/5)*

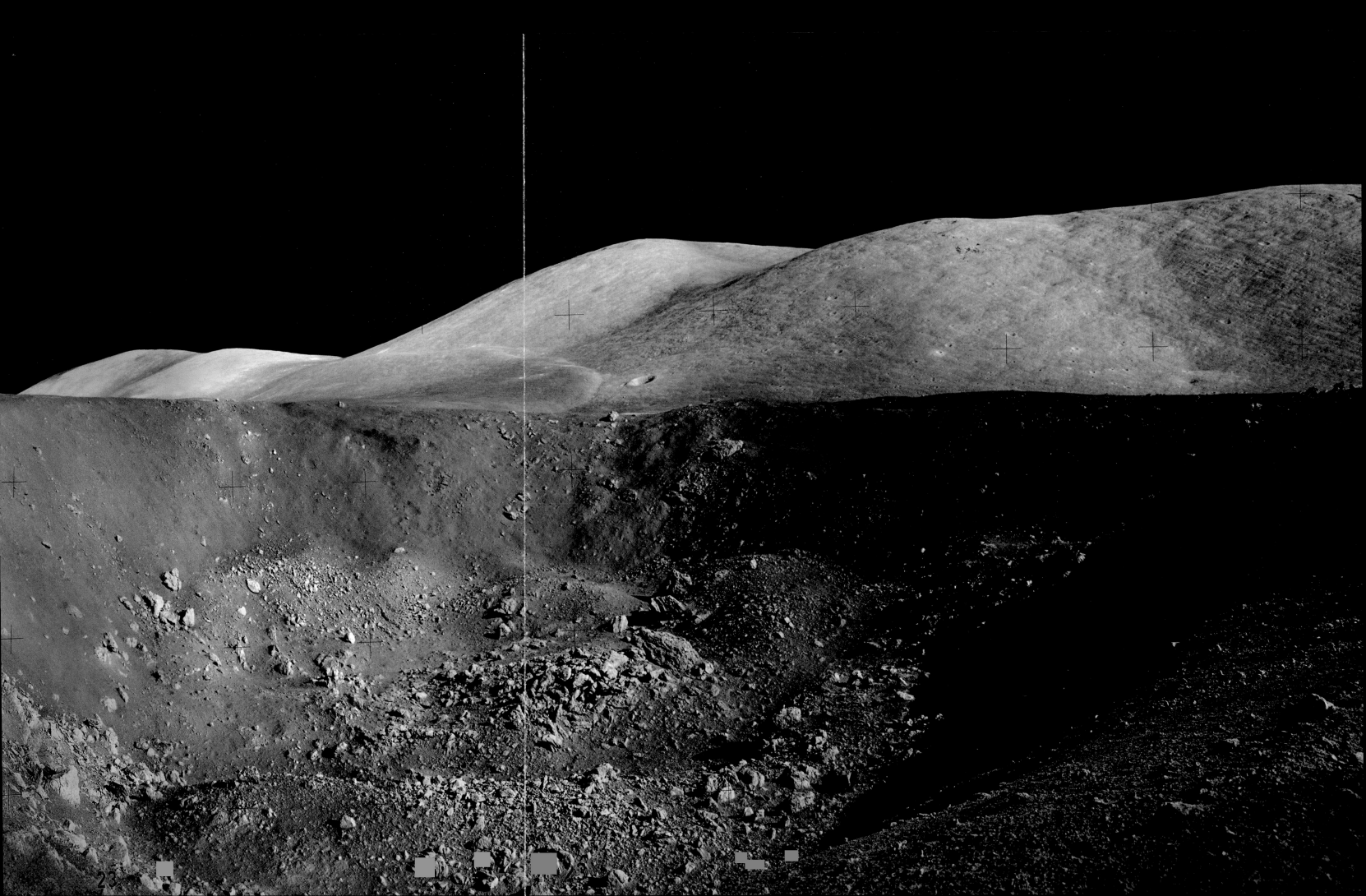

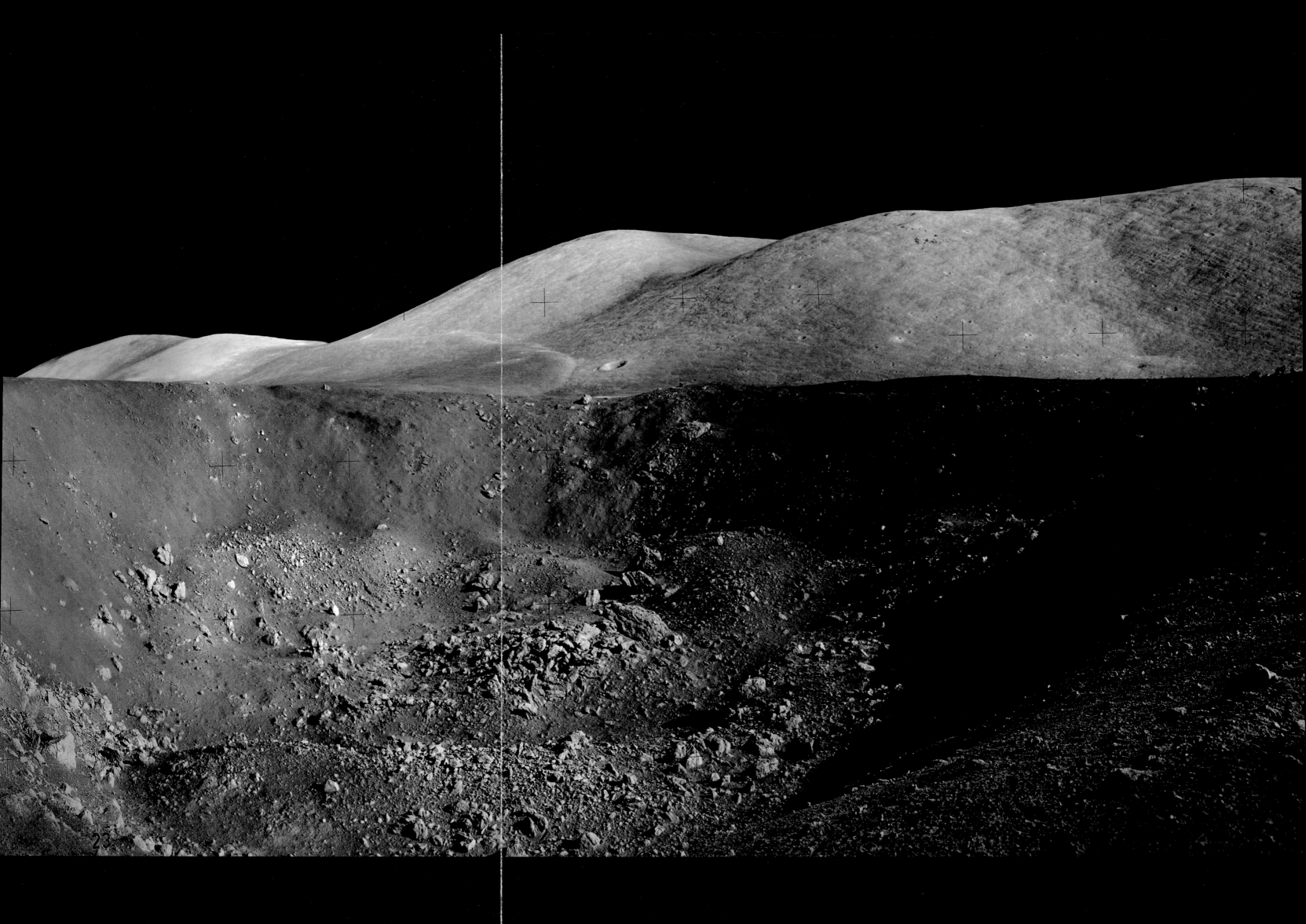

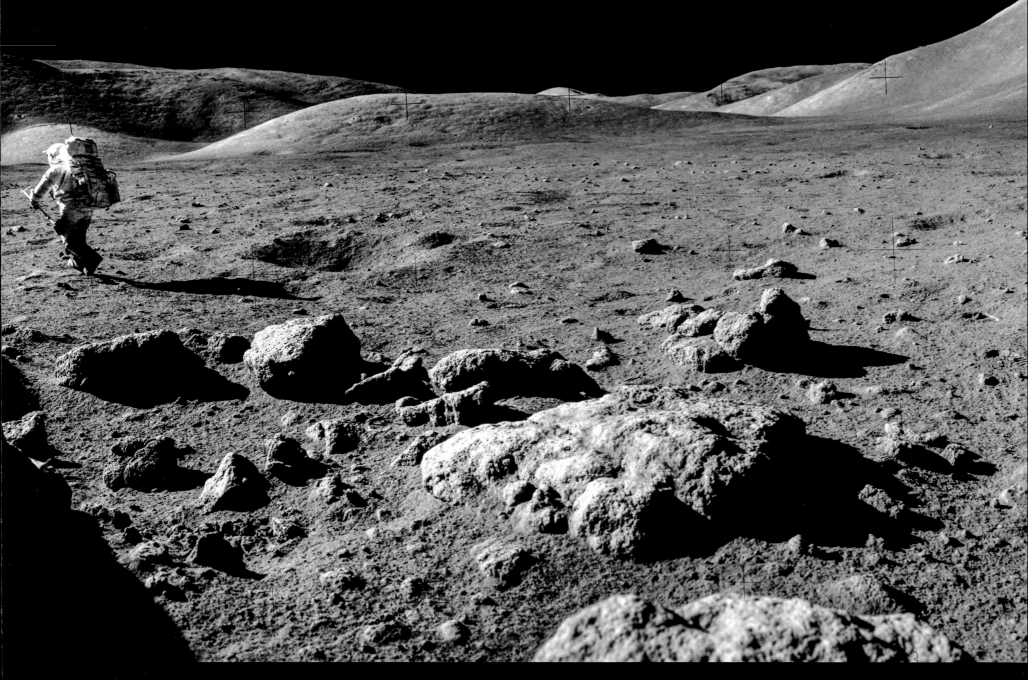

December 13, 1972 **EVA-2** HASSELBLAD 70MM. LENS 60MM F/5.6 | BY GENE CERNAN NASA ID: **AS17-145-22159 TO 22171**

Schmitt: "Are you getting a pan? . . . I'll go over near the rover and get one [too]." This superb sequence shows the boulder field at Camelot crater. Schmitt is bounding back to the parked rover. The 6,000-foot peak of East Massif is above him, 11 miles distant, leading to the Sculptured Hills in the center and on to North Massif far left, Camelot crater beneath. Mission Control: "Hello, 17 . . . We'd like you to leave immediately, if not sooner!" *(Panorama, EL: 4/5)*

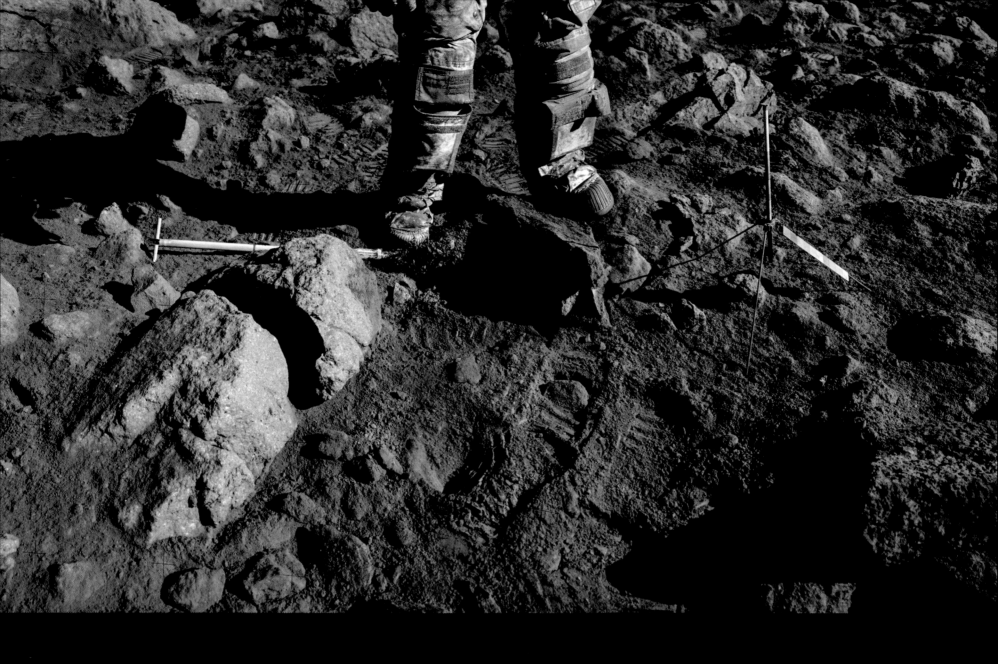

December 13, 1972 **EVA-2** HASSELBLAD 70MM. LENS 60MM F/5.6 | BY GENE CERNAN NASA ID: **AS17-145-22139** TO **22140**

Boots on the Moon. At Camelot crater, Cernan: "Talk about a block field!" Schmitt: "Here I am, folks, in the middle of a boulder field. Just minding my own business." The crew had to take extreme care hopping between the boulders. Schmitt: "I have the impression that these blocks are buried up here, that the mantle does exist, even on Camelot. The big ones seem to be projecting out of the mantle." Excellent surface detail is visible, as Schmitt drops his sampling scoop. *(Panorama, EL: 2/5)*

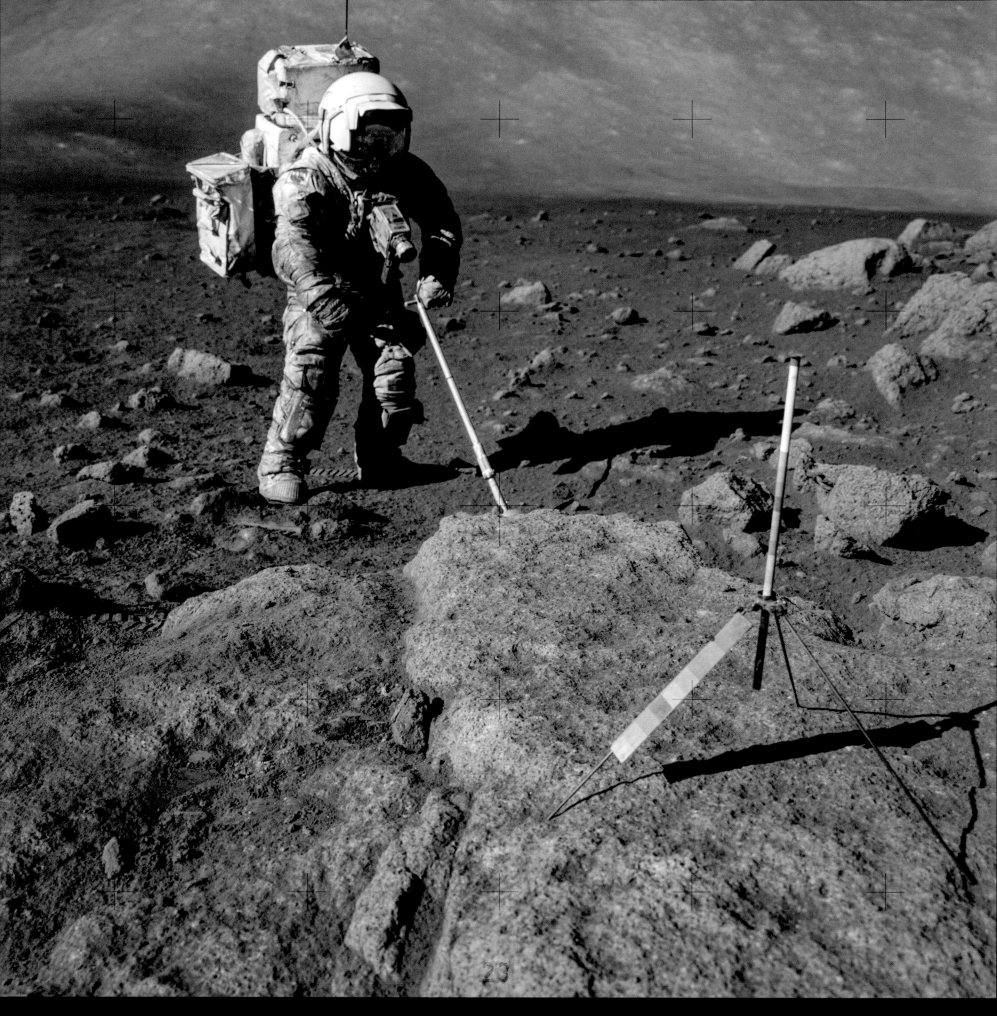

December 13, 1972 **EVA-2** HASSELBLAD 70MM. LENS 60MM F/5.6 | BY GENE CERNAN NASA ID: **AS17-145-22157**

A truly filthy-looking geologist, Schmitt: "There are a few blocks that are lying out on the . . . looks like they're lying more or less on the surface." Mission Control: "We'd just like to get the kilogram of soil somewhere between the boulders." Schmitt: "Let's do it right here. Okay, Houston, we sampled about three meters southwest of the gnomon that was set up for the top-of boulder soil sample." *(EL: 2/5)*

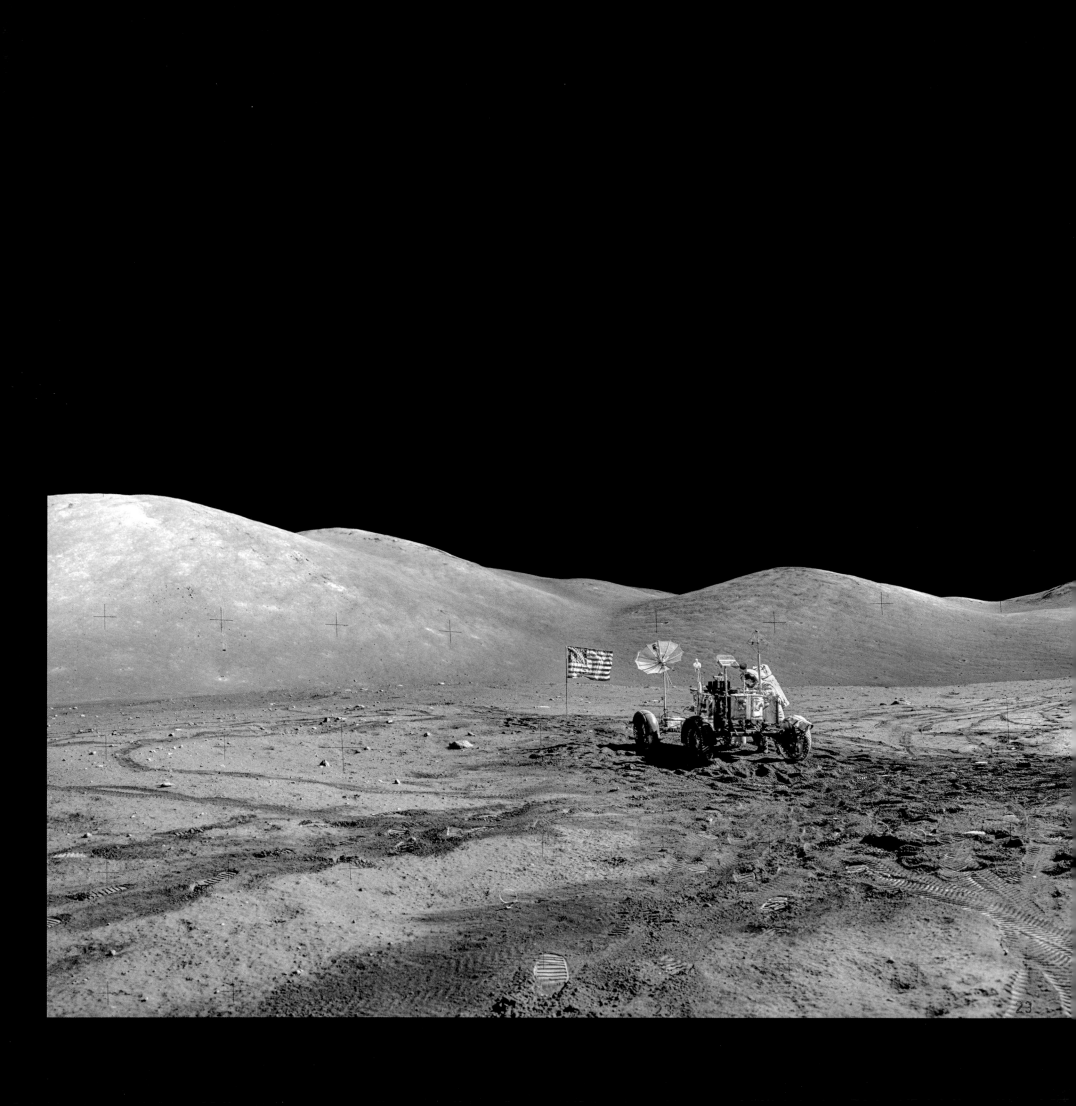

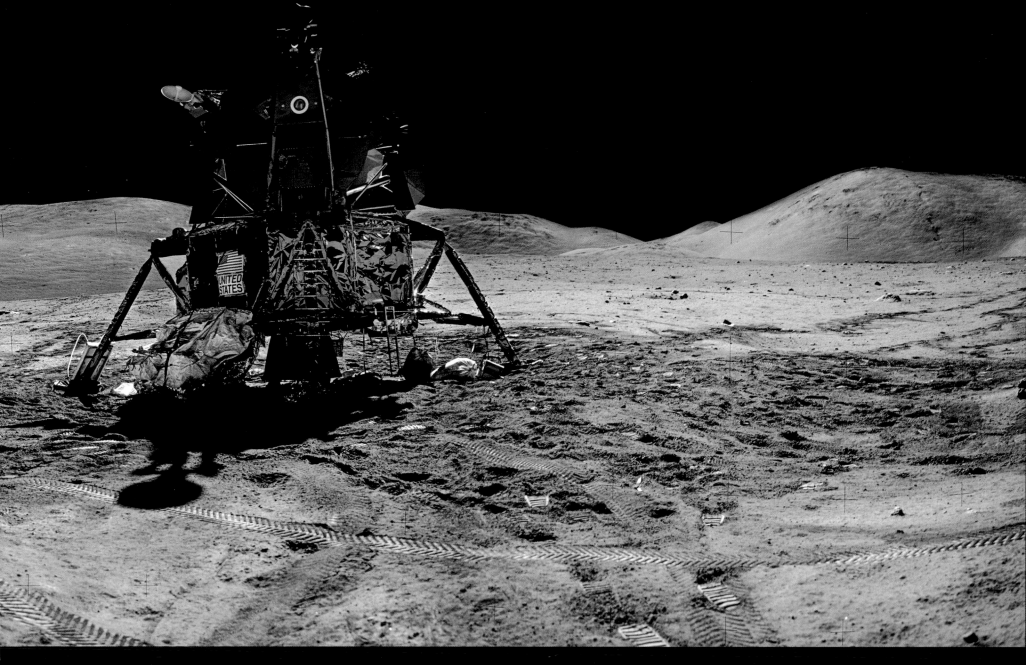

December 13, 1972 EVA-3 HASSELBLAD 70MM. LENS 60MM F/5.6 | BY JACK SCHMITT NASA ID: AS17-140-21366 TO 21373

A good rest was required after the longest Apollo EVA on record. Mission Control: "Looking forward to that third EVA tomorrow. It's going to be the last one on the lunar surface for some time."
Cernan: "Somewhere, someday, someone will be here to disturb those tracks . . ." Upon waking, Cernan looked for weather patterns on Earth: "Well, it's sunny and pleasant in the valley of Taurus-
Littrow!" Here, he's preparing the LRV for the traverse to North Massif. *(Panorama, EL: 5/5)*

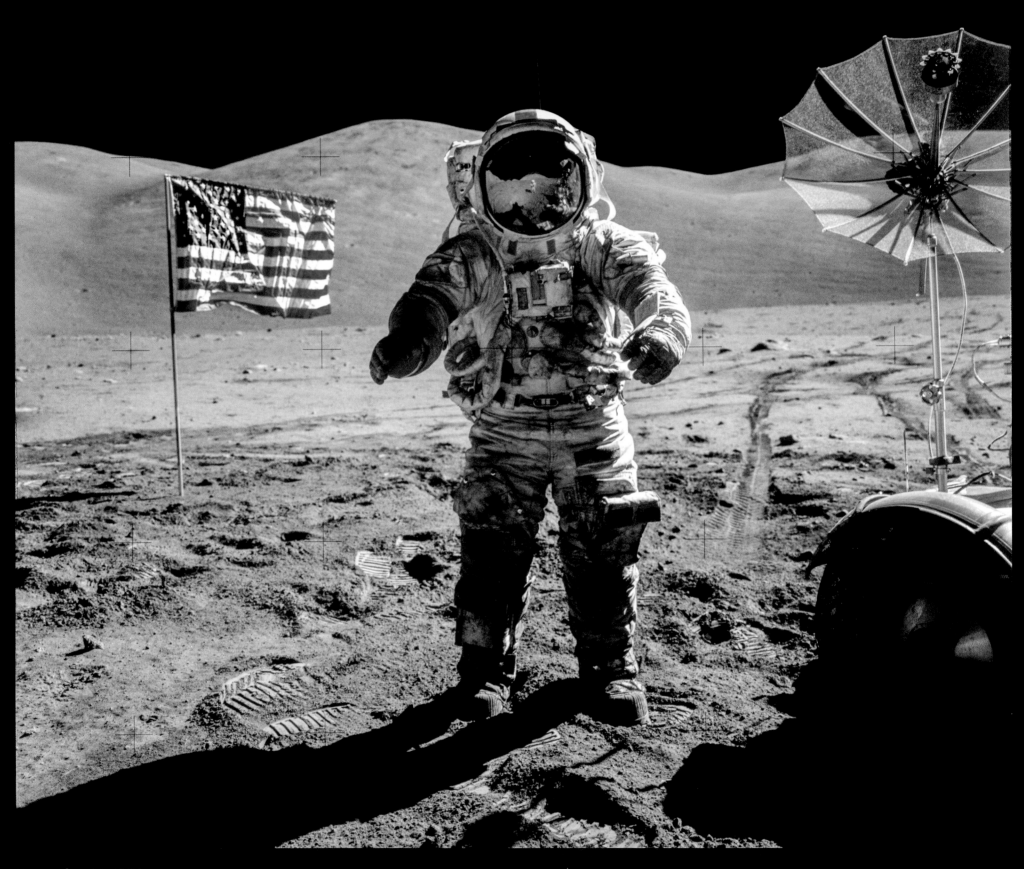

December 14, 1972 EVA-3 HASSELBLAD 70MM. LENS 60MM F/5.6 │ BY JACK SCHMITT NASA ID: **AS17-140-21391**

Cernan: "Wait a minute . . . You got a second? Just come over here by the left front whee ▮ Ah, that's good . . . Can you do that likewise? . . . And you might want to take a couple . . ." The reflection in Cernan's visor s ▮ Schmitt taking the photograph, next to the LRV, with South Massif behind him and Earth, hanging in the blackness over his shoulder. Note the antenna also points to Earth. *(EL: 4/5)*

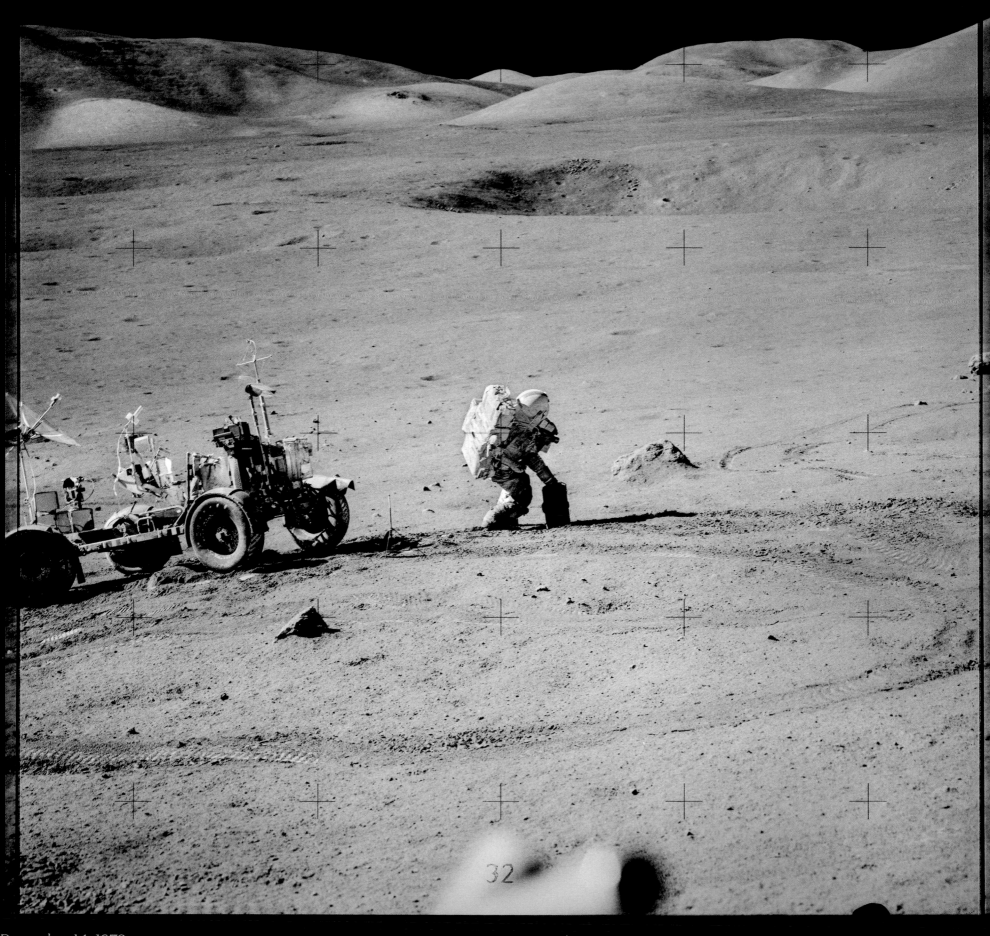

32

December 14, 1972 EVA-3　　　　　HASSELBLAD 70MM. LENS 60MM F/5.6. B&W │ BY JACK SCHMITT　　　　　NASA ID: AS17-141-2159

At Station 6 Cernan is placing the Tranverse Gravimeter Experiment on the ground. Unique to Apollo 17, its purpose was to measure the relative gravity across a number of sites and a accurate measurement compared to Earth. This was one of 26 locations in which it was used during the EVAs. The LM is just visible as a tiny speck almost two miles away, beyond the larg crater, upper right. *(EL: 3/5)*

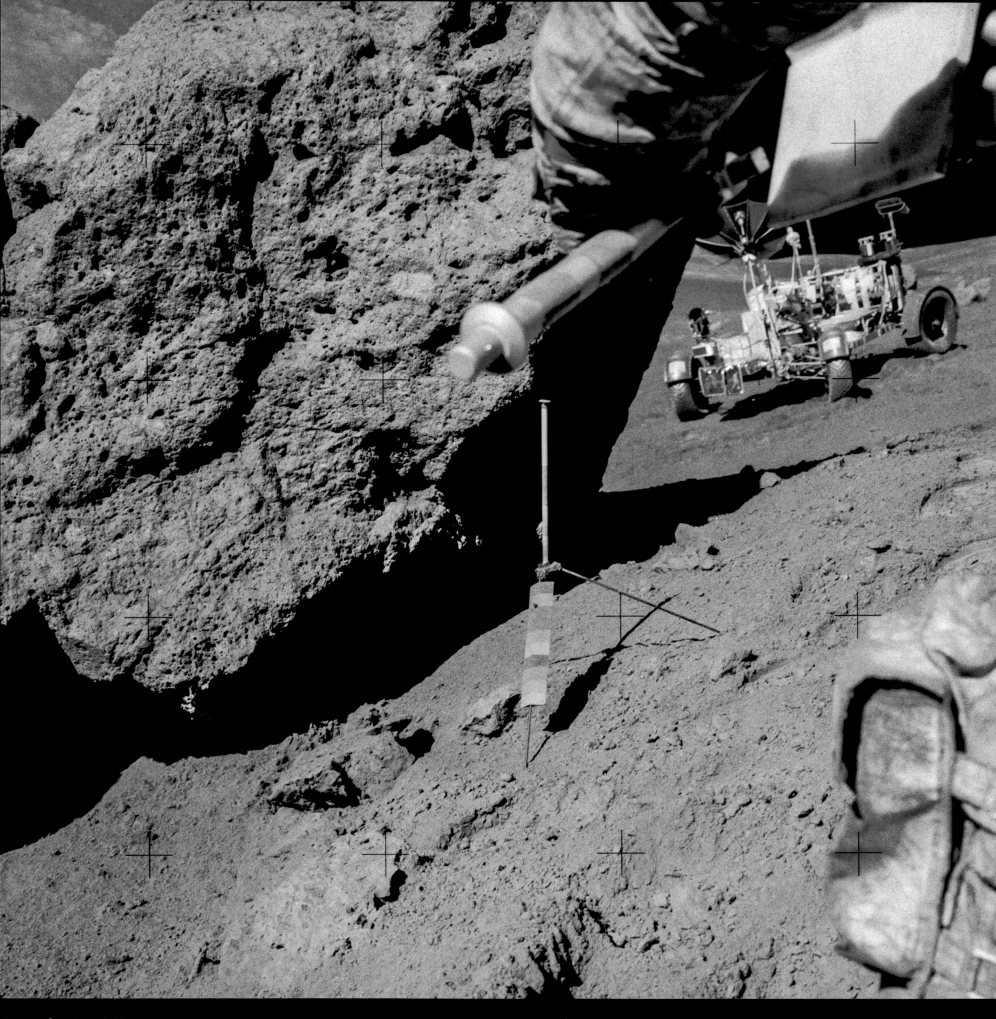

December 14, 1972 **EVA-3** HASSELBLAD 70MM. LENS 60MM F/5.6. B&W | BY JACK SCHMITT NASA ID: **AS17-141-21607**

Cernan: "Oh, man, I tell you, are we parked on a slope!" When the crew arrived at the Station 6 boulder (actually five fragments of boulder that had rolled down North Massif at some point in the Moon's history), they struggled to dismount the rover due to the slope, seen here beyond Cernan's hammer and the boulder. *(EL: 4/5)*

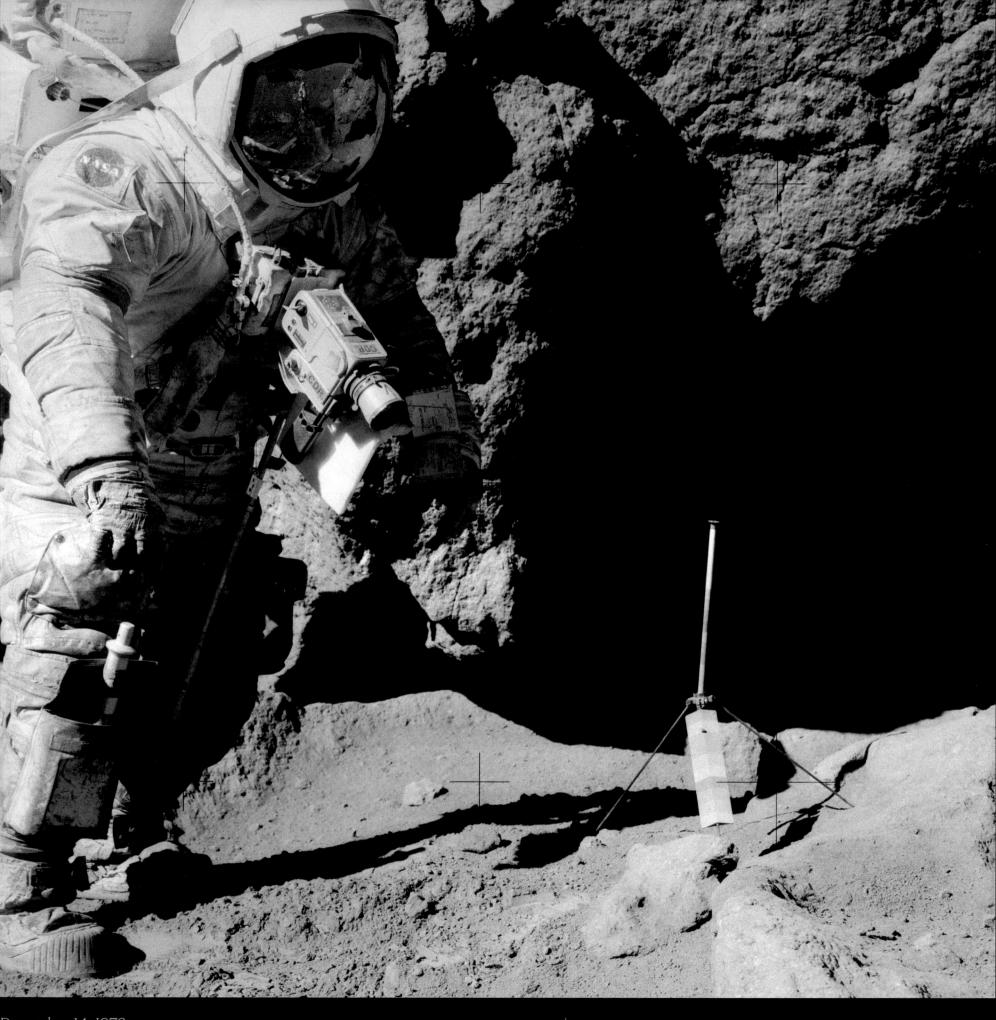

December 14, 1972 **EVA-3** HASSELBLAD 70MM. LENS 60MM F/5.6. B&W │ BY JACK SCHMITT NASA ID: **AS17-141-21608**

Schmitt: "It's a beautiful east-west split rock. It's even got a north overhang that we can work with." Cernan: "Okay, we need some of the soil outside the shadow here." A great, if unintentional portrait of Cernan at the split between the two main fragments of rock. Note his cuff checklist and "CDR" (Commander) sticker on his Hasselblad. Schmitt: "This block looks different . . . It's a big blue-gray rock, itself is crystalline, I believe." (Cropped, EL: 3/5)

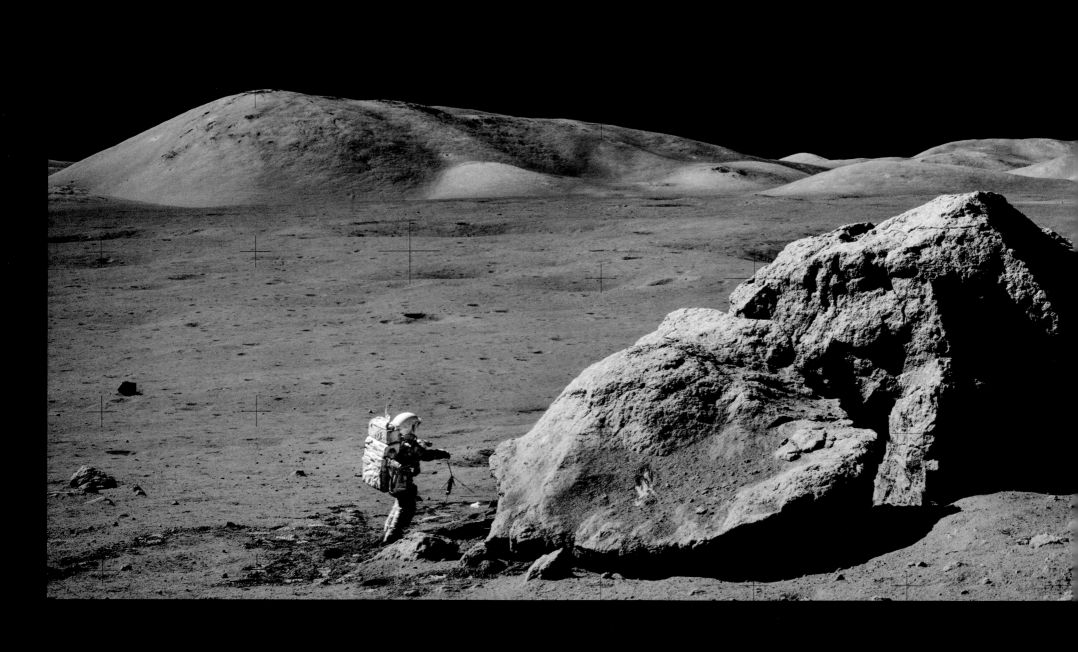

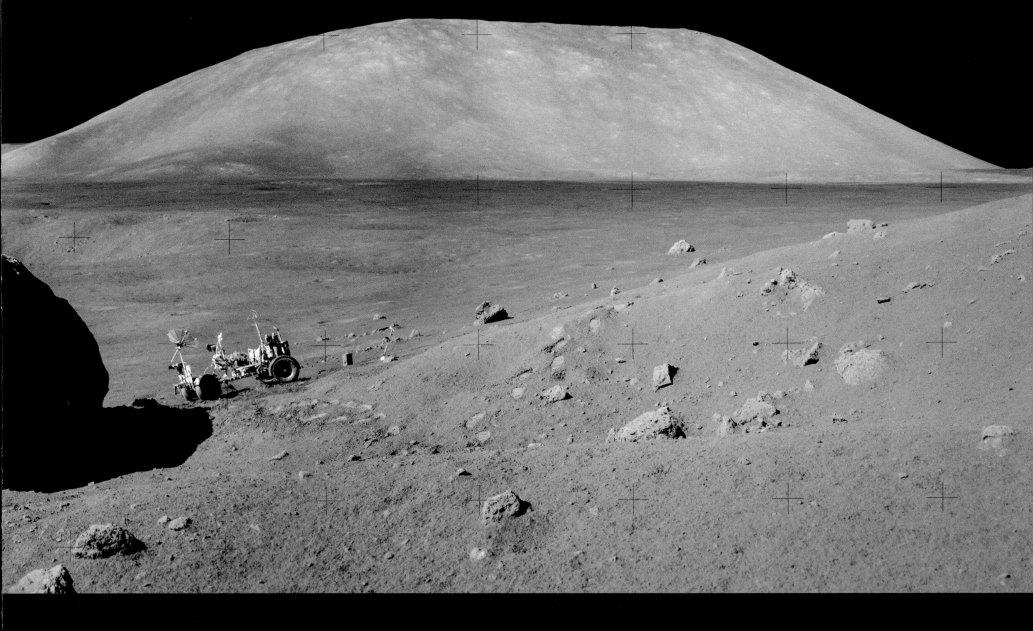

December 14, 1972 **EVA-3** **HASSELBLAD 70MM. LENS 60MM F/5.6** | **BY GENE CERNAN** **NASA ID: AS17-140-21491 TO 21499**

Cernan: "Just got to get a place I can get a pan from . . . Hope my lens is clean." This extraordinary panorama over the valley, toward South Massif, shows the boulders as Schmitt heads back to the rover. Note the different colors and Cernan's handprints on the near face, "Oh, and there's *Challenger*! (right of the boulder's peak). Holy Smoley! You know, Jack, when we finish with Station 8, we will have covered this whole valley from corner to corner!" *(Panorama, EL: 3/5)*

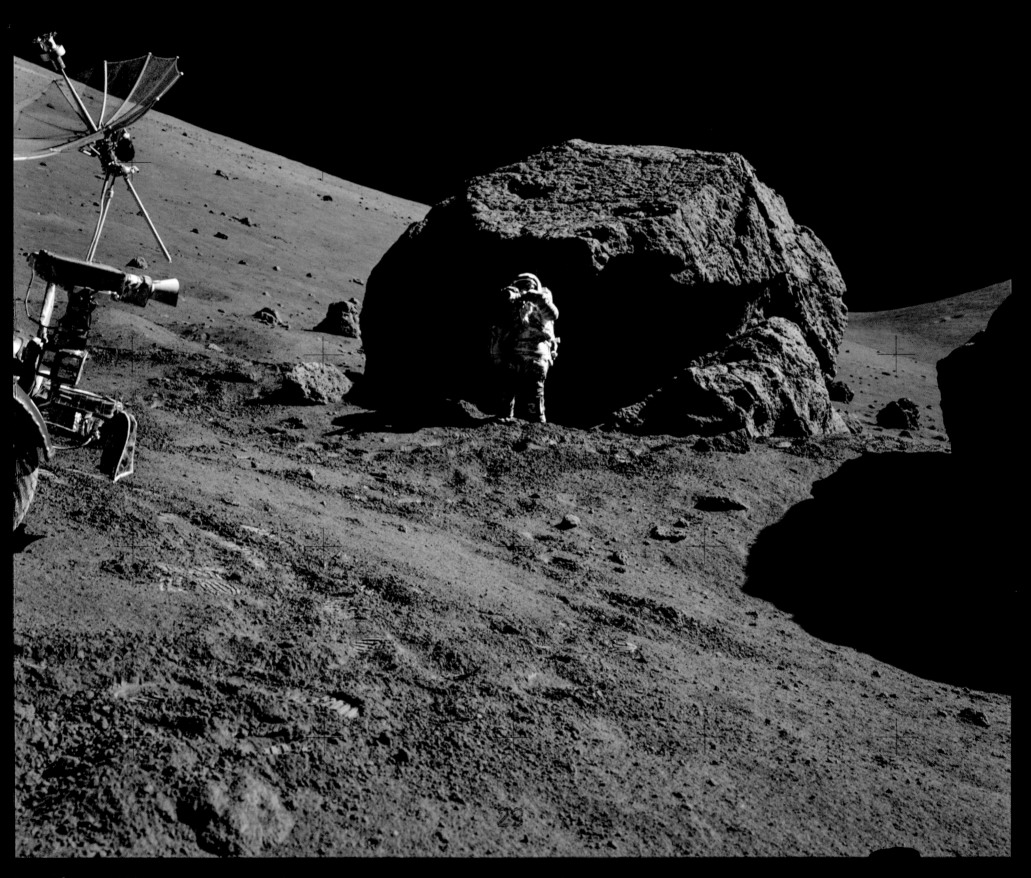

December 14, 1972 **EVA-3** HASSELBLAD 70MM. LENS 60MM F/5.6 | BY GENE CERNAN NASA ID: **AS17-146-22293**

Still at Station 6, Schmitt is struggling on the slope with the Hasselblad and large 500mm lens: "How am I going to see up there to shoot this thing?" Cernan: "Well, why don't you lean against the rock?" Schmitt followed the advice and Mission Control informed him that LM *Challenger* was a prime target (see opposite page). *(EL: 4/5)*

December 14, 1972 EVA-3 HASSELBLAD 70MM. LENS 500MM F/8. B&W | BY JACK SCHMITT NASA ID: AS17-139-21204 TO 21205

Cernan: "Can you get the LM from there?" Schmitt: "Yep." The tiny *Challenger* on the Taurus-Littrow valley floor, a little under 2 miles away, dwarfed by the rugged lunar landscape. The flank of South Massif is coming in from the right and East Massif is over 20 miles in the distance. (Panorama, fiducial mark removal. EL: 3/5)

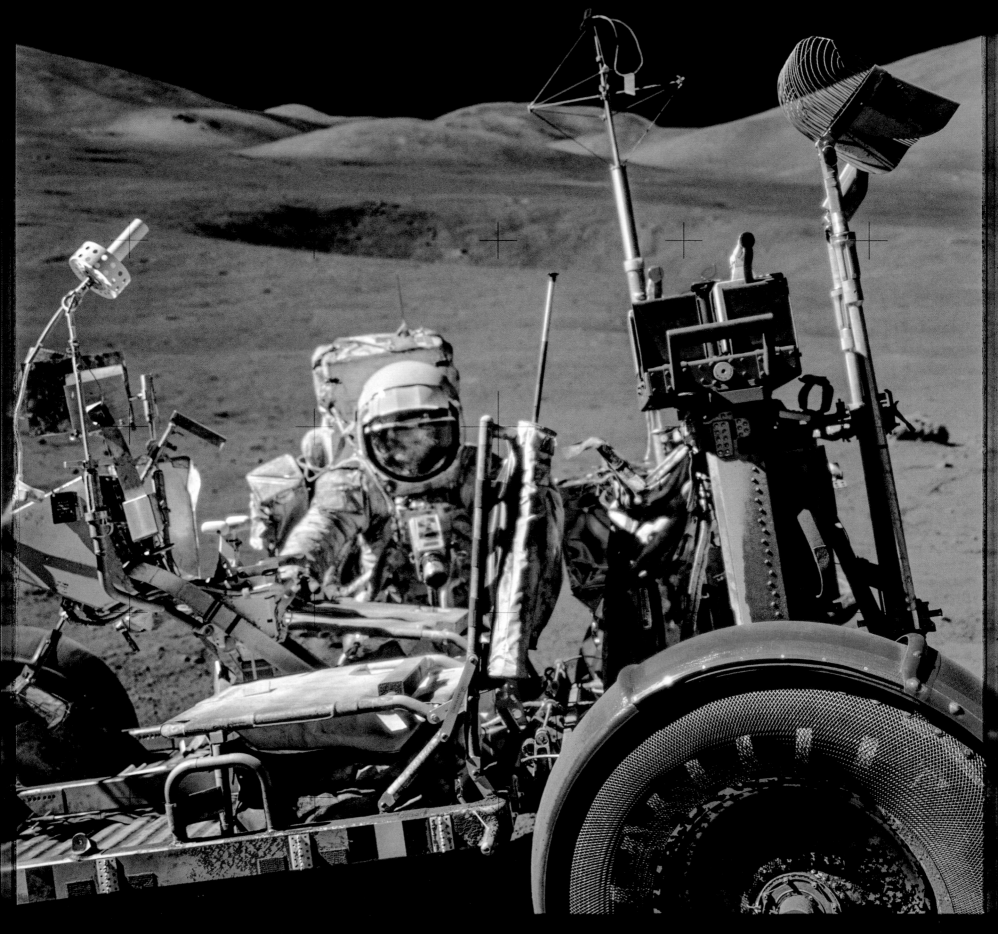

December 14, 1972 **EVA-3** HASSELBLAD 70MM. LENS 60MM F/5.6 | BY GENE CERNAN NASA ID: **AS17-146-22296**

Mission Control: "Hey, Jack. And we see your gold visor is up. You may want to put it down out here in the Sun." Schmitt: "Well . . . I can't see with it down; it's scratched!" Before moving on from Station 6, Schmitt lifts his seat of the LRV to store the collected samples. Although a little out of focus, this is probably the clearest known photograph of any astronaut's face on the Moon. The mesh construction of the LRV wheels can also be seen in sharp focus. *(EL: 4/5)*

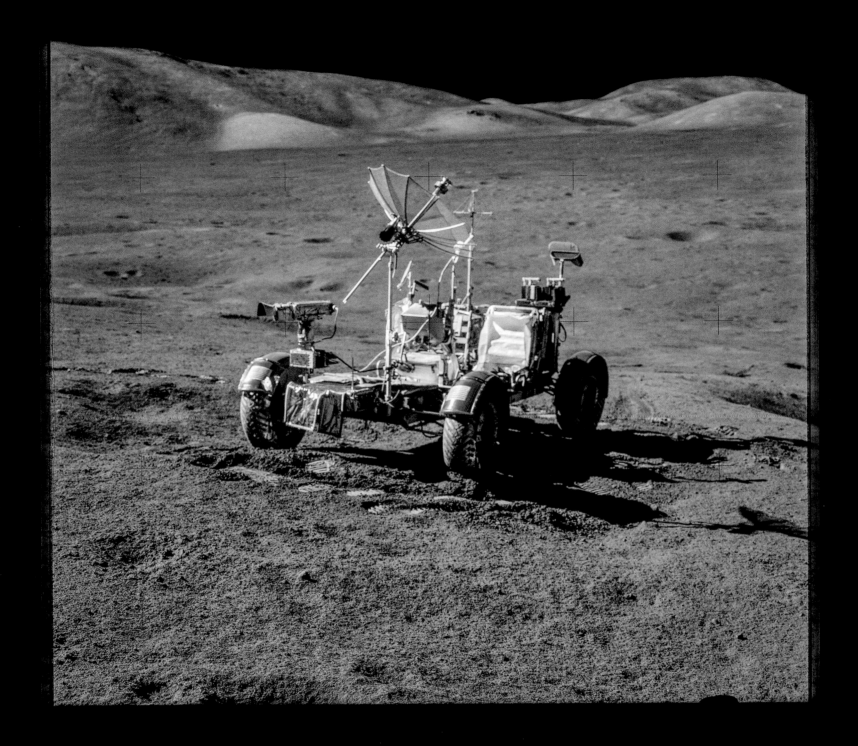

December 14, 1972 **EVA-3** HASSELBLAD 70MM. LENS 60MM F/5.6 | BY GENE CERNAN NASA ID: **AS17-146-22367**

A perfect portrait of the LRV in its operating environment. Its antenna is pointing back to Earth over South Massif. The four-wheel-drive battery-powered "Moon buggy" weighed in at around 440lbs and was folded and transported to the Moon in the LM's Quadrant 1 bay. A Moon land-speed record of 11.2mph was achieved on the mission. The whole scan of the film frame, including sprocket holes for film advance has been shown in this example. *(EL: 3/5)*

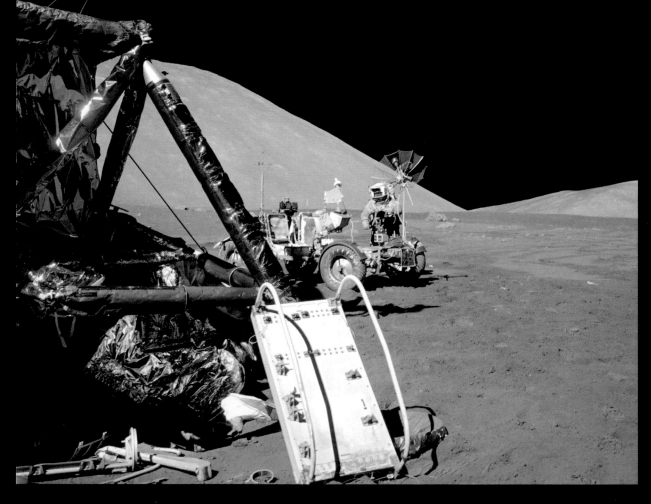

December 14, 1972 EVA-3 HASSELBLAD 70MM. LENS 60MM F/5.6 | BY GENE CERNAN NASA ID: **AS17-134-20461** TO **20462**

As the end of the final EVA nears, Schmitt is packing up camera magazines, samples and experiments to bring back to the LM for the journey home. From the very start of the mission the crew tried, with limited success, to capture Earth above them in their photographs. Here, and on the following page, panoramas have helped produce the awe-inspiring view the crew had, and intended to capture. *(Panorama, EL: 3/5)*

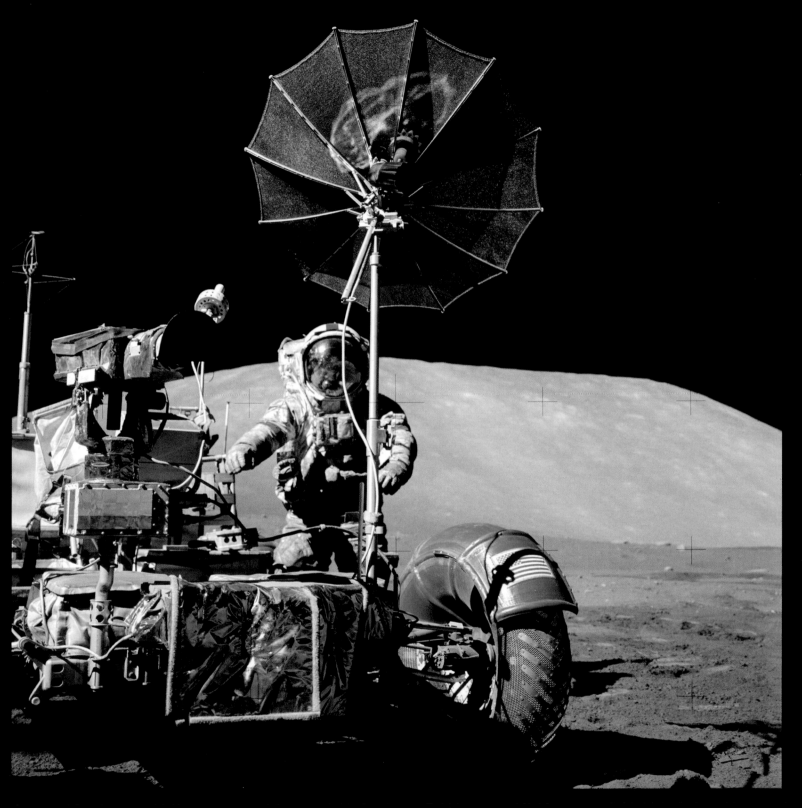

December 14, 1972 **EVA-3** HASSELBLAD 70MM. LENS 60MM F/5.6 | BY JACK SCHMITT NASA ID: **AS17-134-20473 TO 20475**

With film to spare at the end of the stay on the surface, Cernan: "That's color [the magazine]. Why don't you see if you can grab a couple [of 'tourist' pictures]?" Schmitt: "Boy, are you dirty! . . Let's see. I don't know whether I can get you . . . [presumably with Earth]." Cernan: "Yeah, you can." Schmitt: "Let me get a little different focus. That looks good . . . Try one more over here; have your pick . . . One more." *(Panorama, EL: 3/5)*

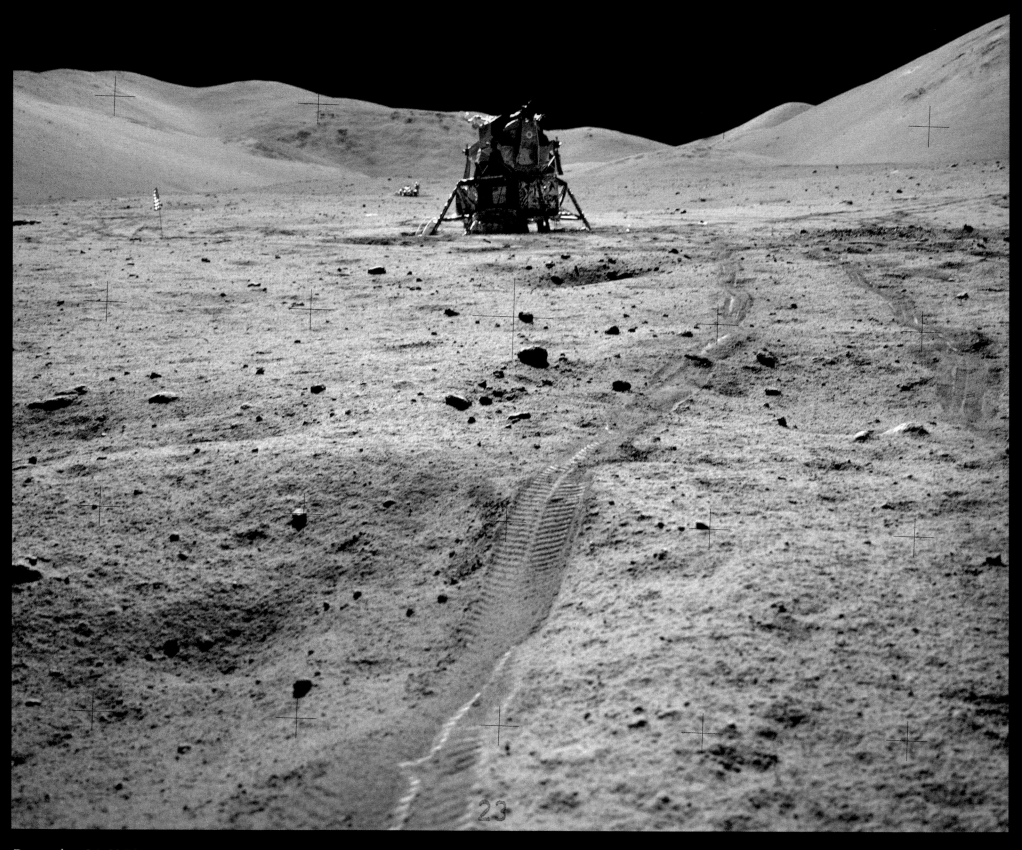

23

December 14, 1972 EVA-3 HASSELBLAD 70MM. LENS 60MM F/5.6 | BY JACK SCHMITT NASA ID: AS17-134-20506

Cernan (in the far distance) drove the rover to a suitable spot for the live TV camera to capture their launch from the surface. Schmitt has gone to photograph and make final checks at the ALSEP site. Cernan: "One of the finest running little machines I've ever had the pleasure to ▮▮▮▮" Mission Control: "Gene, we're ready for you and your ▮▮▮▮ brush to hasten back to the LM and dust each other and climb in." A parting shot of the last spacecraft on the Moon. *(EL: 3/5)*

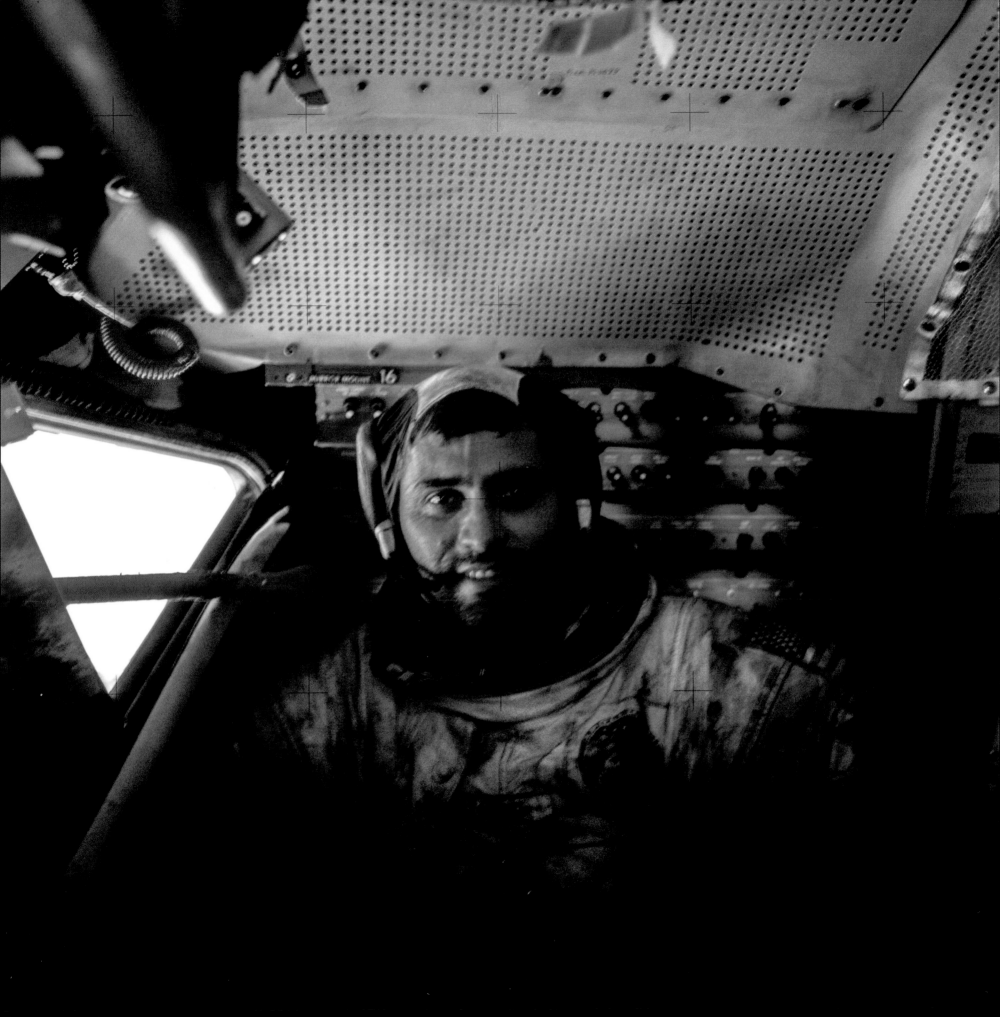

December 14, 1972 HASSELBLAD 70MM. LENS 60MM F/5.6 │ BY GENE CERNAN NASA ID: **AS17-145-22228**

Cernan: "Let me look at that hatch once more . . . Does it look good to you?" Schmitt: "There is a little bit of dust but . . . I don't think the seal's affected." Cernan: "Hatch is closed." Back in the relative safety of the LM, Cernan and Schmitt took portraits of each other. Here's an understandably exhausted, but content-looking Jack Schmitt, still in his suit, covered in Moon dust. Altered blood flow in low gravity causes the astronaut's prominent forehead vein. *(EL: 5/5)*

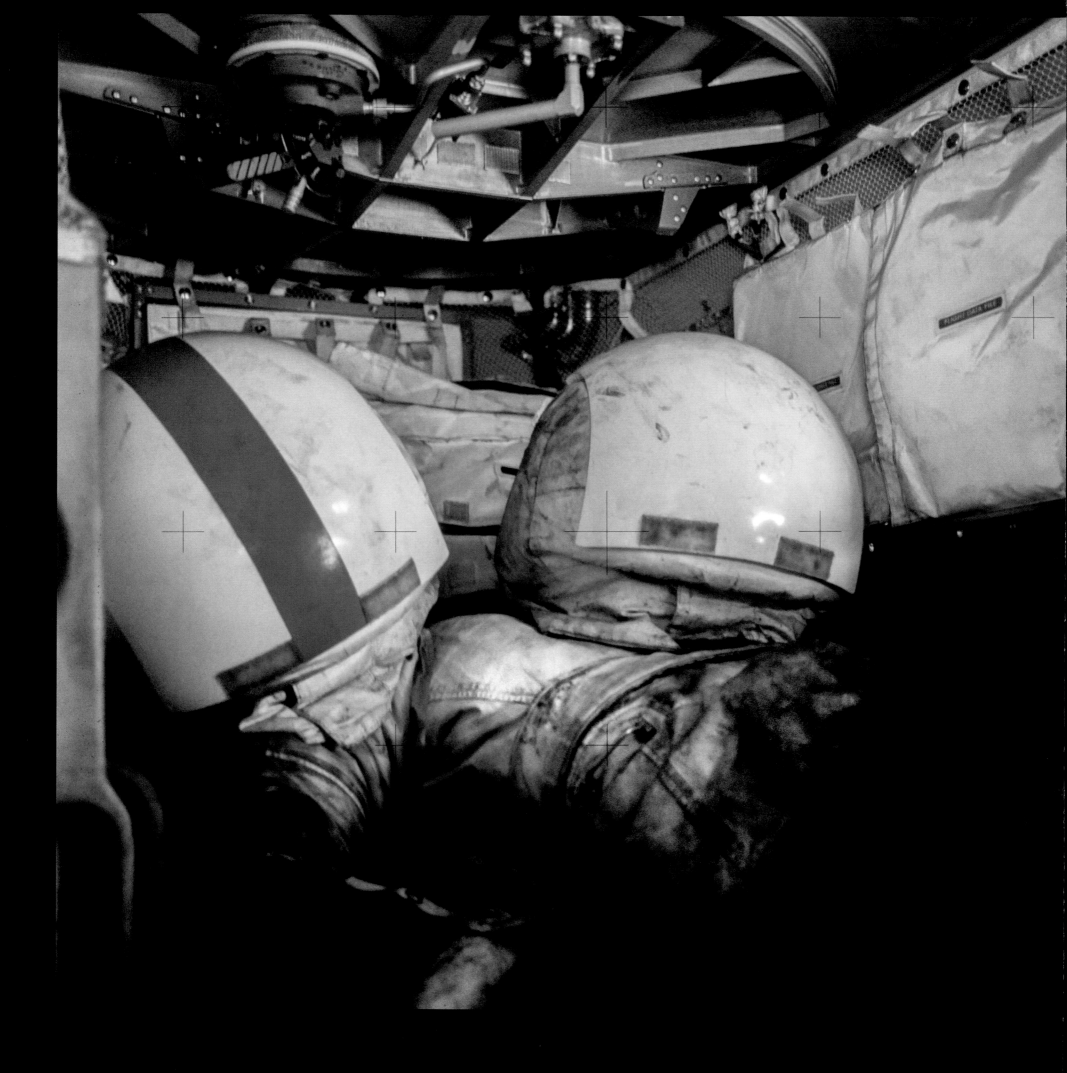

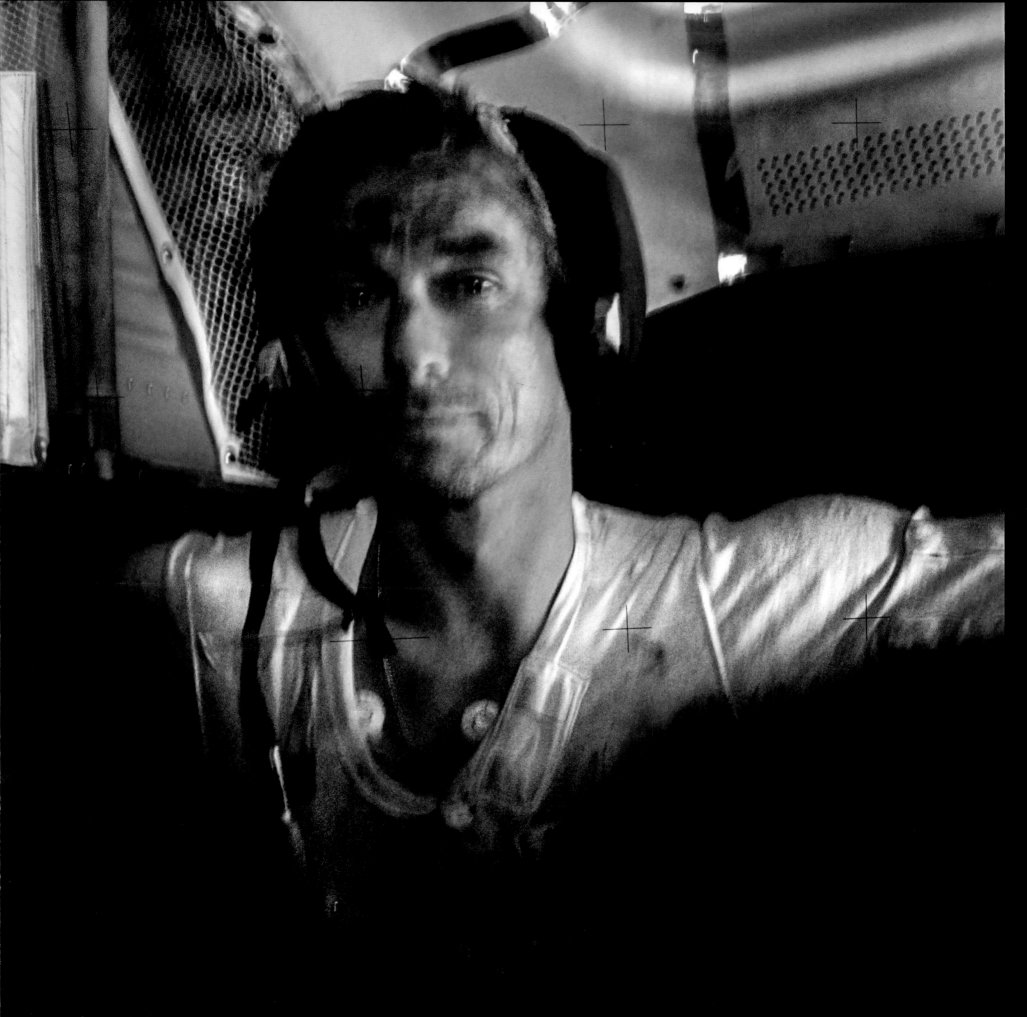

December 14, 1972 HASSELBLAD 70MM. LENS 60MM F/5.6 | BY JACK SCHMITT NASA ID: AS17-134-20522 & 20524

Schmitt and Cernan removed their suits and set up their hammocks for an eight-hour rest period, their last before joining Evans in lunar orbit. Cernan: "I have never seen so much dirt and dust in my whole life. Ever. Ron's not going to be able to see out of either one of these helmet visors [for his deep-space EVA]." The tired Commander's biomedical sensors are visible under his liquid cooling garment. Helmets and suits are stowed on the ascent engine cover, and the hatch is visible above. *(Panorama, EL: 5/5)*

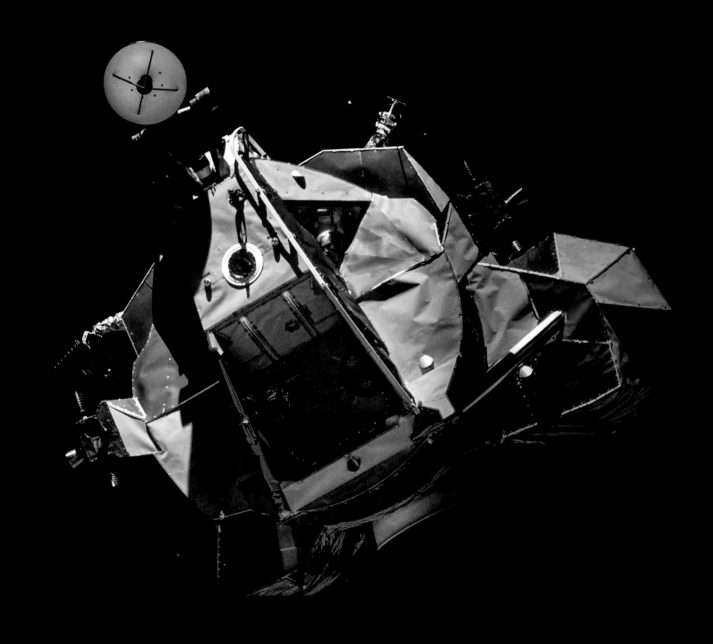

December 14, 1972 HASSELBLAD 70MM. LENS 80MM F/2.8 | BY RON EVANS NASA ID: **AS17-149-22859**

Schmitt: "Ignition!" Cernan: "We're on our way, Houston!" Evans: "Good to have you all back up here . . . Man, that *Challenger's* a beautiful vehicle! . . . Oh, I got to get a picture here!" The angular, awkward-looking Lunar Module in the blackness of space. With some enhancement, Commander Cernan is now clearly visible through the window – at the helm, piloting the Moonship from the lunar surface for the last time. Cernan: "Can you see me?" Evans: "Yes, I can see you right in there!" *(EL: 5/5)*

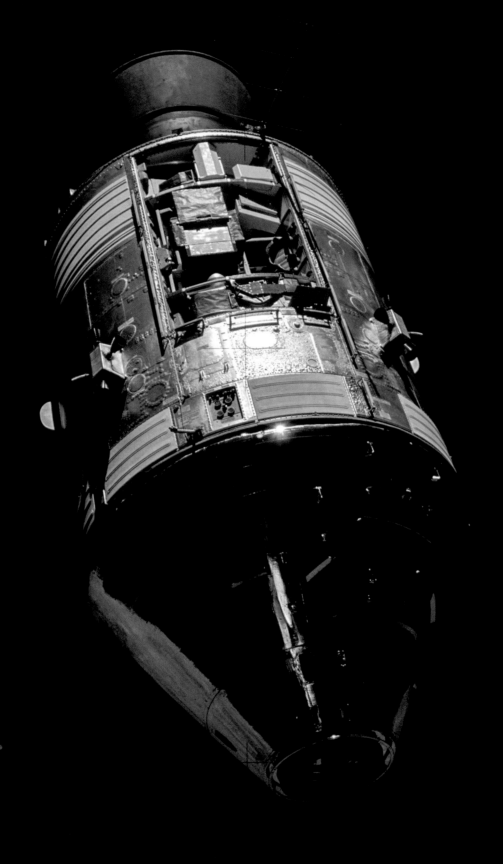

December 14, 1972 HASSELBLAD 70MM. LENS 60MM F/5.6 | BY JACK SCHMITT NASA ID: AS17-145-22248

Prior to docking, visual inspections were made of each spacecraft . . . Cernan: "God you look pretty . . . going to go out and take a peek at your SIM bay." Evans: "How does the Mapping camera look?". Cernan: "Sun's shining right on it . . . There's one door open, Ron. If you were standing in the shoes [footholds], it's at the . . . bottom left-hand side of the SIM bay." Evans: "Okay. Yes, that's the one that the camera pushes open by itself . . . Let's get in a docking attitude." *(EL: 3/5)*

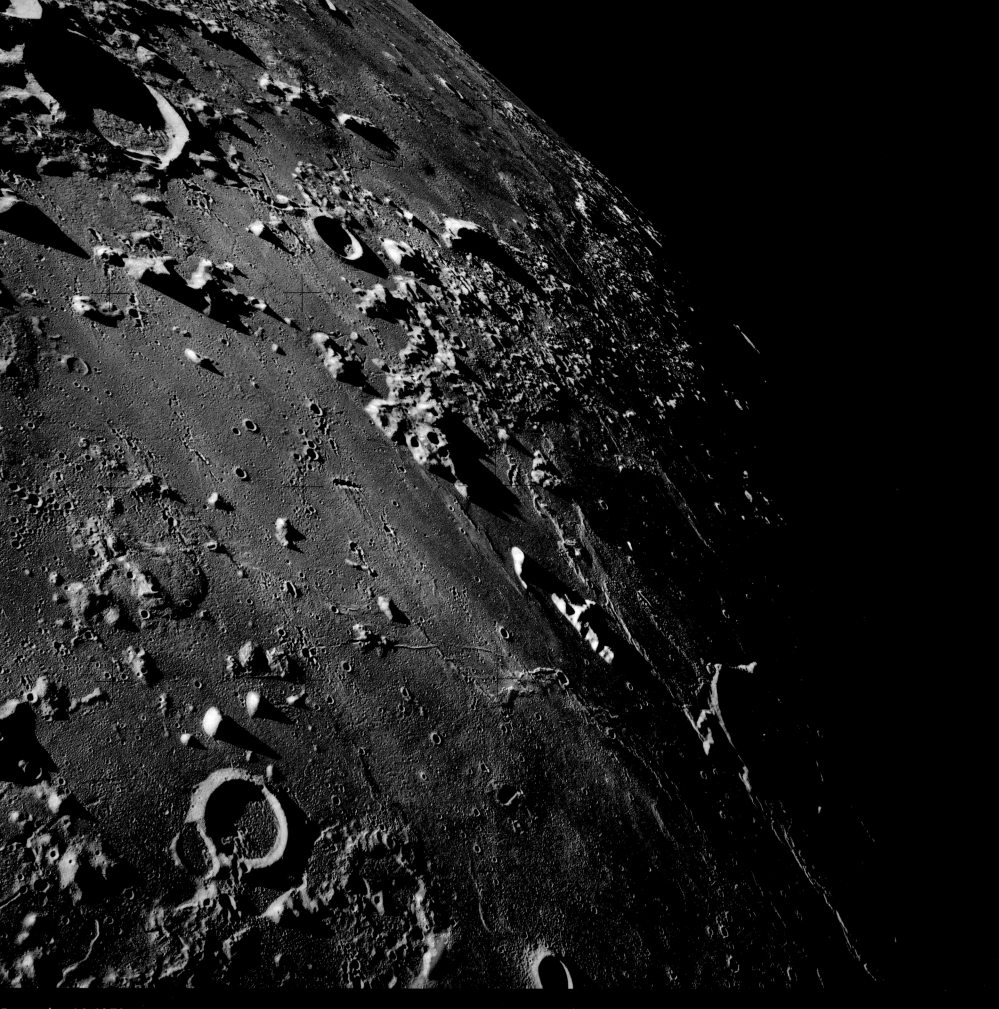

December 16, 1972

HASSELBLAD 70MM. LENS 60MM F/5.6. B&W │ BY UNKNOWN

NASA ID: **AS17-139-21295**

After docking, the crew spent the next two days orbiting the Moon in the CSM a further 21 times. They undertook photography and geological observations from the window, relaying information to Mission Control. Terminator photography here shows the area around the Tobias Mayer crater on the Moon's nearside from 71.5 miles above the surface. The area contains lunar domes – caused by lava erupting from vents and undergoing relatively slow cooling. *(Rotated, EL: 4/5)*

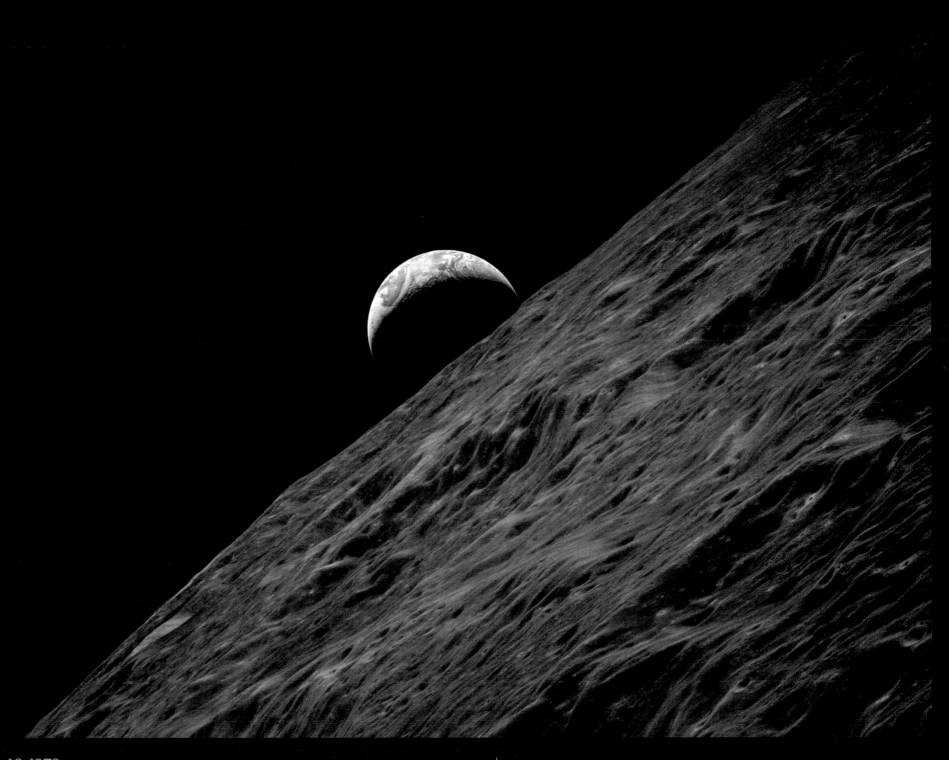

December 16, 1972 HASSELBLAD 70MM. LENS 250MM F/5.6 | BY UNKNOWN NASA ID: **AS17-152-23275**

Upon acquisition of signal, on the 66th orbit, the crew were treated to a spectacular crescent Earthrise. Evans: "Houston, *America*. Looks like we're with you again . . . In fact, we know we are, we've been taking [your] picture just as we came up!" The photograph was taken near Ritz, an impact crater just beyond the eastern limb of the Moon as viewed from Earth. The wake-up music for the final day in orbit was The Doors' "Light My Fire," appropriate for the upcoming trans-Earth injection burn. *(Rotated, EL: 3/5)*

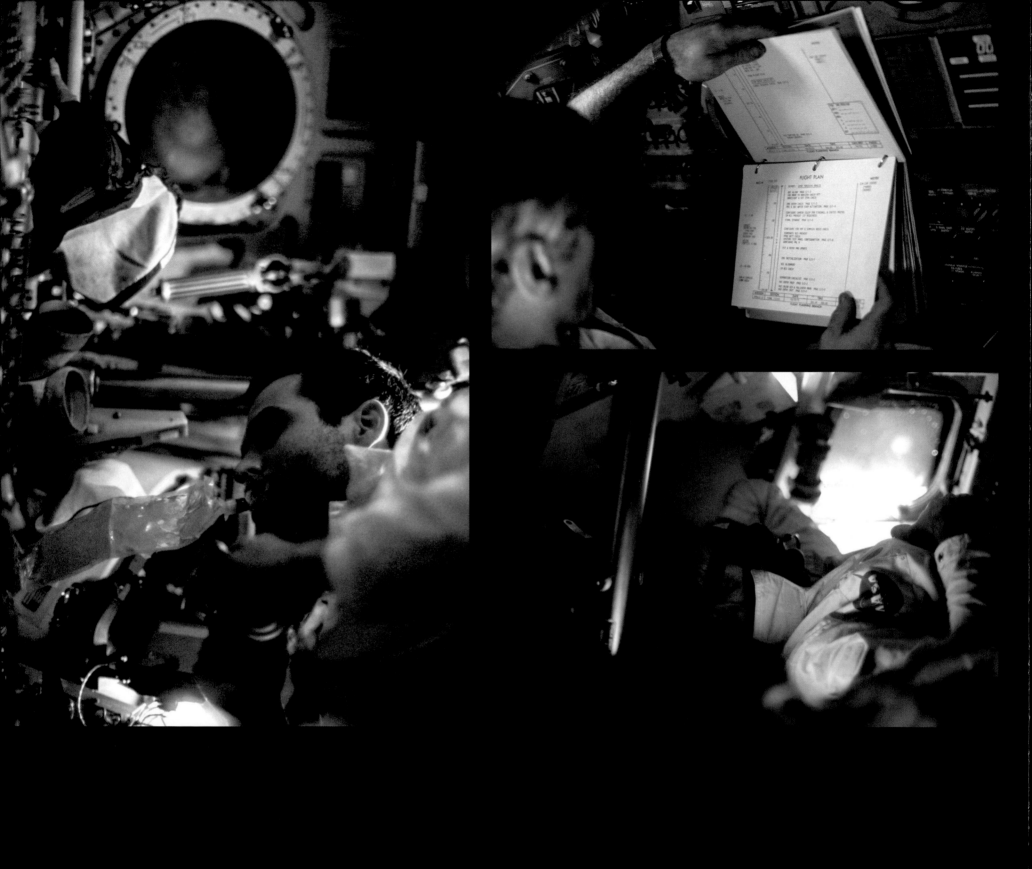

December 16–19, 1972 NIKON F 35MM. LENS 55 MM F/1.2 NASA ID: **AS17-163-24134, AS17-163-24155 & AS17-163-24117**

Life on board *America* during the long journey home. LEFT: Schmitt is drinking from a drinks pouch at meal time; his "Snoopy" cap is against the control panel and the circular hatch window is above (by Ron Evans). UPPER RIGHT: Cernan checks the latter stages of the flight plan (by unknown). LOWER RIGHT: Cernan takes a well-earned nap (by Jack Schmitt). *(EL: 3/5)*

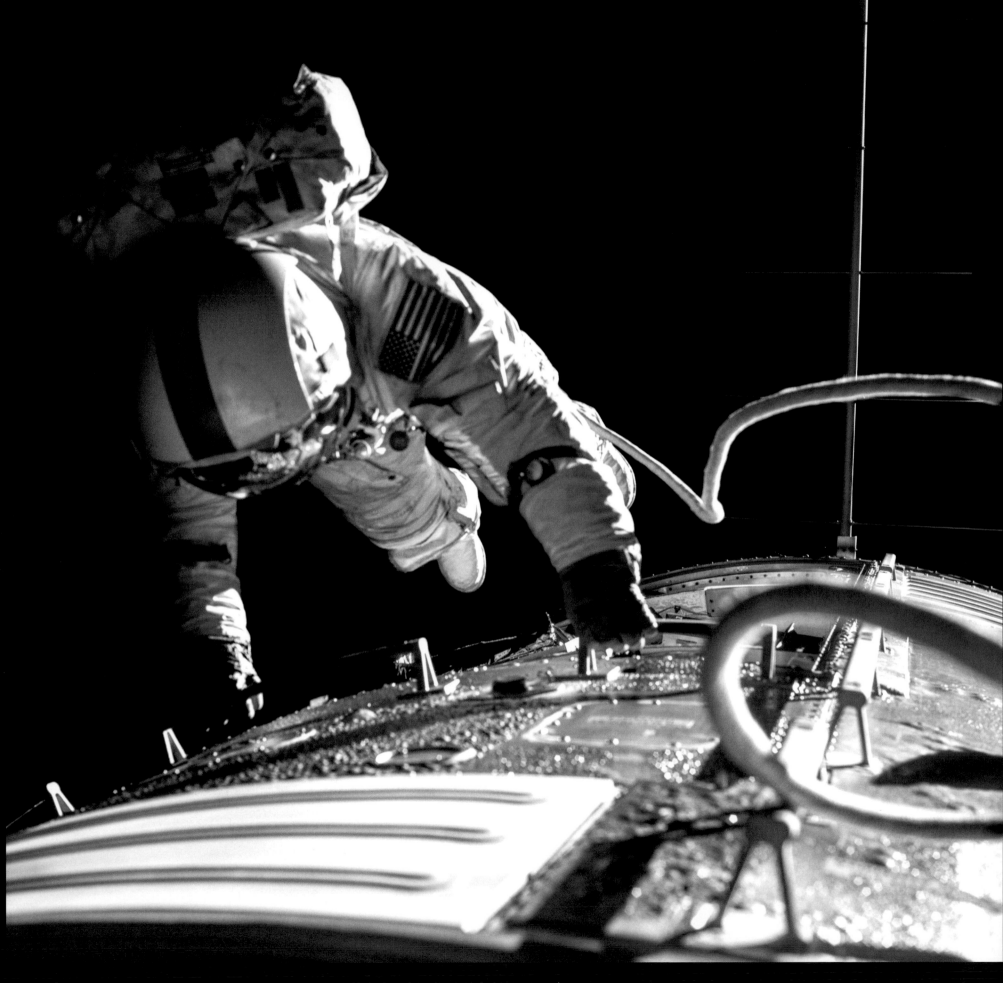

December 17, 1972 HASSELBLAD 70MM. LENS 80MM F/2.8 | BY JACK SCHMITT NASA ID: AS17-152-23374

Evans utilizes the handholds on the CSM during his 67-minute, deep-space EVA to retrieve the film from the cameras in the SIM bay. "I can see the Moon back behind me! Beautiful! . . . And off to the left . . . is a crescent Earth . . . I see what Charlie Duke meant – *Man*, it's dark out here. It is *really* dark!" Note the blistered aluminum paint on the CSM, caused by the temperature extremes in space. Evans is wearing Cernan's red-striped, used, lunar surface helmet, which afforded protection from micrometeorites and the Sun. *(EL: 4/5)*

December 17, 1972 HASSELBLAD 70MM. LENS 80MM F/2.8 | BY JACK SCHMITT NASA ID: **AS17-152-23375**

Farewell, Moon. Over 50,000 miles away, the full Moon disappears over Evans' shoulder on the voyage back to Earth. Apollo 17 completed our first program of missions to the Moon – humankind's greatest adventure. Splashdown signified the end of an era of extraordinary exploration and arguably the most important moments and photographs in our history. It would be over 50 years until the first woman, and the next man, embark upon the incredible voyage from the Earth to the Moon, and take the next, small step. *(Cropped, EL: 2/5)*

THE DEVELOPMENT OF SPACE PHOTOGRAPHY

"With Mercury, space photography was born. With Gemini it struggled toward maturity, so that Apollo space photography would give you and me, indeed the whole world, an opportunity to reach out and practically touch the Moon"

RICHARD W. UNDERWOOD, NASA CHIEF OF PHOTOGRAPHY, MERCURY, GEMINI AND APOLLO

PROJECT MERCURY
The Birth of Space Photography

The first human spaceflights were conducted in very small capsules, with extremely stringent weight considerations. They were, by their very nature, groundbreaking, bold, complex missions which tested the capability of the new vehicles, and of the cosmonaut or astronaut. There was little appetite to include a large camera or to engage in hand-held photography.

Cosmonaut Yuri Gagarin became the first human in space on the Soviet Vostok 1 mission in April, 1961. Although a camera, pointed at Gagarin, beamed live TV footage back to the ground, no film camera was included to capture his dazzling unique view of Earth. Weeks later, on the second human spaceflight – America's first – a Maurer 220G 70mm camera configured to automatically capture one frame every six seconds was mounted and pointed, via a mirror, through a small porthole window in the capsule. It captured the first-ever views of Earth from a human spaceflight (see image: MR-3-13012-039).

GLENN'S ADAPTED 35MM CAMERA AT THE NASM

Vostok 2, in August 1961 carried the first "movie" camera and cosmonaut Gherman Titov used the 35mm Konvas-Avtomat to film short sequences out of his capsule window. No still camera was carried. When NASA confirmed that Mercury-Atlas 6 would be its first orbital space mission, astronaut John Glenn took it upon himself to purchase a $40 Ansco Autoset (Minolta) 35mm camera from a drugstore in Cocoa Beach, close to NASA's Florida launch complex.

Glenn worked with technicians to make the camera easier to use with gloved hands and in the tight confines of the Mercury capsule, adding a pistol grip for shutter release. On two rolls of film, ultrasonically spliced together, he captured never-before-seen views of Earth, including spectacular arcs of colored light, bent by the atmosphere during sunrise and sunset (see image: MA-6-40452-023).

All Project Mercury flights also included 16mm "Pilot Observer" cameras built into the equipment panels, though their purpose was to simply record the astronaut and his interaction with the spacecraft's controls for post-flight analysis. Longer Mercury missions would afford more time for experimentation with hand-held photography, but with a single astronaut responsible for flight, NASA still felt this could be a diversion from their important core work.

Mercury-Atlas 8's Wally Schirra was a keen photographer and appealed for better camera equipment on his mission. Schirra was well acquainted with famous photographers of the day, from *Life* magazine and *National Geographic*, and sought their recommendations. The Hasselblad 500C was a clear frontrunner; its larger-format 70mm film more suitable than 35mm film to reliably capture the detail and quality required.

According to NASA's Chief of Photography Richard Underwood, Schirra, a tough ex-naval aviator and test pilot, practically broke down in tears during a meeting, when told the Hasselblad wouldn't be suitable due to the significant adaptations that would be needed to make it spaceworthy. Schirra then worked closely with technicians and camera modifications were made by Pan Am Laboratory in Cape Canaveral. The adapted Hasselblad made it onto his flight.

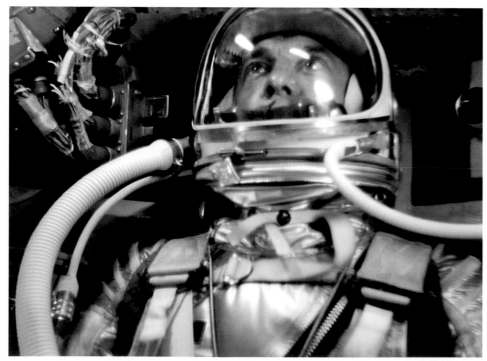

INSIDE SHEPARD'S TINY MERCURY CAPSULE. 16MM PILOT CAMERA FILM, STACKED AND PROCESSED

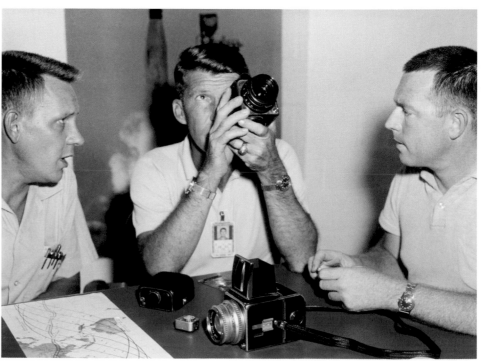

SCHIRRA ASSESSES THE ADAPTED HASSELBLAD 500C

PROJECT GEMINI
Toward Maturity

It was the longer-duration Gemini missions, incorporating a two-man crew and improved mobility in the larger capsule, that led to the most significant development of hand-held space photography. There was increasing demand from various departments, such as the Weather Bureau, the Bureau of Commercial Fisheries and Earth Sciences studies, requiring quality photographic work for improved mapping.

Gemini IV incorporated America's first spacewalk, and Jim McDivitt's breathtaking photographs of Ed White floating in the void against the backdrop of Earth proved to be a turning point in NASA's appreciation for the intrinsic value of space photography.

Underwood convinced Bob Gilruth and other NASA managers of the public relations value, as well as the scientific value, of stunning imagery: "We're looking at things no human being has seen before!" Given the reliance on taxpayers' dollars, more cameras, resources and better training could help NASA deliver images that carried a message and provide some visual substance to their rhetoric, mesmerizing the public and bolstering financial support.

The time allotted to photographic work on Gemini V increased signifi-

WHITE (LEFT) AND MCDIVITT (RIGHT) INSIDE THEIR GEMINI IV CAPSULE BEFORE LAUNCH

cantly, yielding over 400 photographs. Having made its first flight on Gemini IV, a predecessor of the Maurer 16mm DAC "movie" camera was also utilized on the flight, and every mission thereafter.

Astronauts continued to show a passion for photography throughout Gemini and, by the time of the final mission, Gemini XII, they had some freedom to capture general interest photographs and "targets of opportunity" in addition to their more technical photographic work. Buzz Aldrin even captured a series of himself during his EVA – the first selfies in space. Astronauts were now more than recorders of events, they were space-faring photographers.

PROJECT APOLLO
Touching the Moon

From the first Apollo missions, the primary focus of photography remained the technical documentation of operations and the new flight hardware tests for engineering assessment. Among the first to see the images upon return were those planning and designing the next missions. In a world before computer simulations, those on the ground, including in Mission Control, found an element of comfort in being able to visualize exactly how things operated out in space. Photography was clearly a vital tool in helping humans reach the Moon.

It was inconceivable to fly to the Moon with anything less than the best photographic equipment. A camera capable of operating reliably in the airless lunar environment, with its extreme temperature fluctuations, would need to be developed.

Lunar surface photography during the landing missions evolved over time, in part due to the relative needs of the various audiences. According to a letter to spaceflight researcher Keith Wilson, shared by Mr. Wilson with me, NASA's Head of Public Affairs, Brian Duff, endured constant battles with his friend and Director of Flight Crew Operations Deke Slayton and the engineers. There was clear "creative tension" between parties. In Duff's view, the reticence toward the importance of public affairs photography was in part due to the "right stuff" image. Only highlighting the need for "continued Congressional support" helped to sway opinion.

When it came to Apollo 11, Duff also stated that only black-and-white film was originally allocated for the lunar surface. He had to demand the inclusion of color film and, not until NASA was asked if it could accept a monochrome photograph of the first man on the Moon on the cover of *Life* magazine, was any ground conceded. As it transpired, there would be no "public affairs worthy" photograph of the first man on the Moon at all. It was during the scrambled, frantic search for an image of Armstrong, among all the returned images that were spread out in long strips on light tables in the Johnson Space Center photo lab, that Duff suggested a means to more easily identify

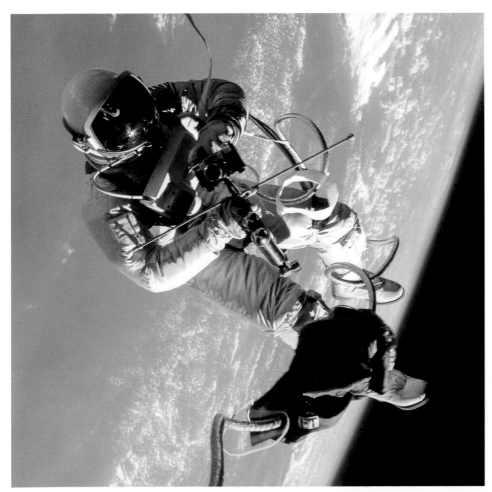

A TURNING POINT IN SPACEFLIGHT PHOTOGRAPHY – ED WHITE FLOATS ABOVE THE EARTH, JUNE 1965

one suited astronaut from the other. The inclusion of red stripes on the Commander's helmet and suit would be too late for Apollo 12 but was a feature of all future missions. Initially referred to as the "Public Affairs Stripes," they were renamed the "Commander's Stripes."

Inexplicably, only a single Hasselblad camera and magazine were taken onto the lunar surface to record one of the most important events in our history. A 16mm DAC camera also recorded some low-frame-rate footage from the window of the Lunar Module, but it wasn't until later Apollo missions that a multitude of cameras and magazines would expose huge volumes of film to record these voyages. From Apollo 15, the Panoramic and Metric Mapping cameras were added to the Service Module to complement lunar orbit photography. The crew of Apollo 15 also fought hard for the inclusion of additional lenses for their cameras, even at the expense of abort fuel. Despite these obvious weight constraints, it could also be argued that the ultra-thin photographic film had a very high scientific return per unit of weight.

By the time of Apollo 17, our final voyage to the Moon, four Hasselblad 70mm cameras, a 35mm Nikon camera, two 16mm DAC "movie" cameras with all associated lenses, two live TV cameras, a Panoramic camera and a Mapping camera made the trip. The still cameras exposed 3,999 photographs on 31 separate magazines. The Metric and Panoramic cameras captured a further 4,878 images from orbit, and 13 magazines for the 16mm DAC camera were exposed. A far cry from Glenn's $40 consumer camera from the early years of Project Mercury.

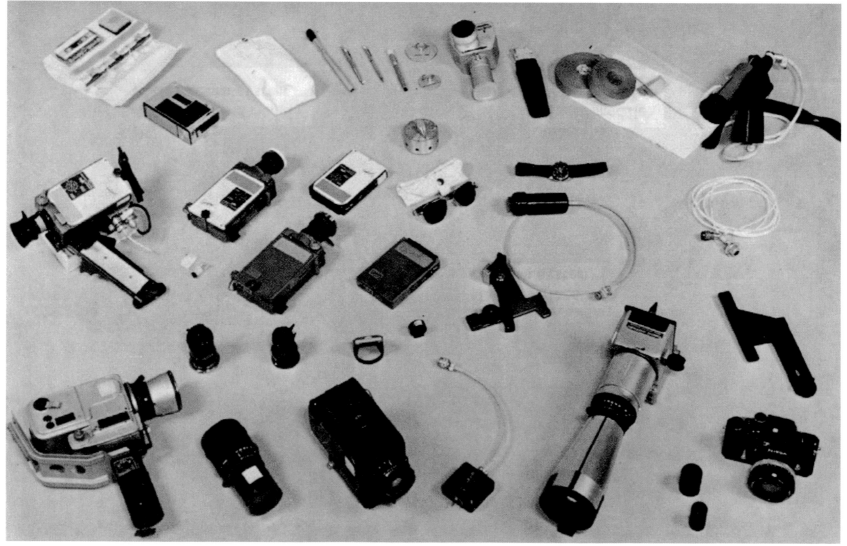

AN ARRAY OF SOME OF THE PHOTOGRAPHIC EQUIPMENT ON APOLLO 16

PHOTOGRAPHIC EQUIPMENT AND OPERATION

The development of NASA's photographic hardware was an iterative process from the early years of Glenn's rudimentary adaptations of his 35mm automatic camera. Growing expectations and appreciation for mission photography from various quarters led to the need for a system technically capable of functioning reliably in the space environment, producing detailed, accurate images suited to a range of audiences, and flexible enough to be operated effectively during the rigors of spaceflight. A camera to accommodate larger 70mm film and interchangeable lenses and magazines to afford the use of different film types was required. If accurate, Hasselblad's own promotion of its camera's "modularity, versatility and reliability" was worthy of attention.

HASSELBLAD 500C

First used on Schirra's MA-8 mission, the modified Hasselblad 500C was then employed on every spaceflight through to Gemini IX-A, and again on Apollo 7 and Apollo 9. The leather coverings and adhesives of the consumer camera had to be removed as they could off-gas onto the optics. Underneath the leather covering, however, was a shiny stainless-steel casing. Unfiltered sunlight beaming through the capsule window and bouncing off the casing could blind the astronaut. The metal surfaces were given a black finish, which had the added benefit of making the camera less visible in reflections when shooting through the capsule windows.

Given that a helmeted astronaut in the cramped cabin would find it impossible to aim the camera while looking through the existing top-mounted viewfinder of the consumer model, the focussing hood, screen, auxiliary shutter and reflex mirror assembly were removed. A rudimentary method of aiming the camera via the side-mounted "cold-shoe" was utilized where necessary. This also reduced the potential hazard of these glass elements being smashed and floating around in the cabin, and saved on weight too. Every gram of weight saved in spaceflight leads to a commensurate and significant reduction in fuel required.

To avoid the astronaut accidentally decoupling the magazine from the camera, the magazine release was ground flat. Later models would use a specially developed locking mechanism to allow the changing of magazines in flight. The 500C was further refined by Cine Mechanics of Los Angeles, which also included a modified magazine to accommodate 70 exposures on 70mm film versus the standard 12. The lubricants used in the commercial 500C were eliminated or replaced, as they would boil off or solidify in the vacuum and extreme temperatures of space, eventually rendering them useless or hazing up the optics.

HASSELBLAD ELECTRIC CAMERA (HEC)

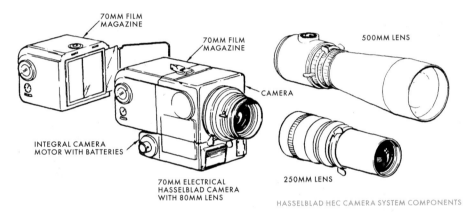

HASSELBLAD HEC CAMERA SYSTEM COMPONENTS

The HEC was used from Apollo 8 onward (except Apollo 9). Designed for use in the space environment and in the Command Module and the Lunar Module, it captured the iconic "Earthrise" photograph on its very first outing.

NASA's relationship with various photographic equipment providers such as Hasselblad had broadened after the spectacular Gemini IV images. The mutual benefit of collaboration between Hasselblad and NASA was clear and Victor Hasselblad made it his personal mission to help modify the cameras for use in space and ultimately on the Moon.

The HEC was based on the consumer Hasselblad 500EL, and the key improvement over the 500C was the inclusion of an electric motor which would automatically advance the film and prime the shutter. This would allow more photographs, and sequences of photographs, to be taken more easily by the astronauts in such difficult conditions. The standard 500EL also underwent similar modifications to the 500C to ensure space worthiness.

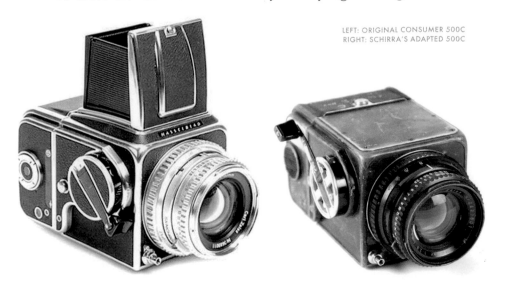

LEFT: ORIGINAL CONSUMER 500C
RIGHT: SCHIRRA'S ADAPTED 500C

APOLLO 11 HASSELBLAD HEC WITH 80MM LENS

The astronauts' interaction with the camera in pressurized suits and gloves was made easier with the introduction of larger buttons and switches. Notably, the small shutter-release button was replaced with a one-inch square adaption. An improved locking mechanism for the magazines would reduce the chance of accidental decoupling but also allow them to be easily changed with gloved hands.

After the devastating Apollo 1 fire which killed astronauts Gus Grissom, Ed White and Roger Chaffee, a program to maximize safety across all spacecraft equipment was initiated. Adaptations to the camera's electric motor were made and other components redesigned.

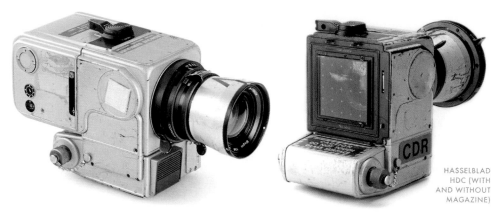

HASSELBLAD HDC (WITH AND WITHOUT MAGAZINE)

HASSELBLAD ELECTRIC DATA CAMERA (HDC)

NASA requested that Hasselblad further adapt the HEC for use specifically on the lunar surface. By September 1968, only ten months before the first landing, the specifications for such a camera were finalized. The most obvious external difference in the end product is the silver finish. The camera had to operate effectively in an environment with huge temperature fluctuations of –186° Centigrade to +114° Centigrade (-302° to +237° Fahrenheit) for long periods and the aluminum paint finish minimized the absorption of thermal radiation.

The other significant modification is apparent when viewing the images it captured. Small cross-hairs (fiducial markers) were exposed on every film frame. They were generated by a transparent 4mm-thick glass Réseau plate (register glass) positioned at the back of the camera body, immediately in front of the film plane, with the pattern of markers precision-engraved onto the glass. The markings were calibrated with the lens to a tolerance of 0.002mm and were used to aid photogrammetry – measuring sizes and distances of lunar features, in the absence of known references in the frame. Any distortion of the photographic film caused during exposure or processing could also be identified from the markings.

With the film guided by the edges of the plate, and in the absence of a humid atmosphere, a static charge could build up between the poorly conducting glass and the film, which could create sparks. To conduct this away, the plate was coated with a fine transparent conductive layer, and two silver deposits at its edge (seen on many of the photographs) connected to the metallic parts of the camera body via two contact springs. The Réseau plates on Apollo 15 onward (excluding the 500mm-lens HDCs) included the last two digits of the camera's serial number at the bottom and are seen in many images from these missions.

A bracket and handle with built-in trigger assembly, to release the shutter, were attached to the bottom of the camera with a thumb-wheel screw. The bracket was used to mount the camera onto the astronaut's life support system Remote Control Unit (RCU) on his chest. It was Neil Armstrong who suggested the idea of chest-mounting the Hasselblad as a means of the astronauts keeping their hands free to undertake other work. Without the benefit of a viewfinder, a significant element of the astronauts' photography training was to learn to aim the camera in this configuration, by moving and positioning their body. The HDC with 60mm lens, a full magazine and handle/trigger assembly weighed in at 6.9lbs (about the weight of this book).

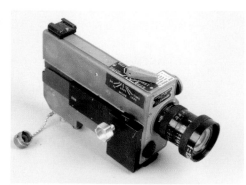

MAURER 16MM DATA ACQUISITION CAMERA (DAC)

With an early model used to record America's first spacewalk, the 16mm DAC accompanied every U.S. spaceflight from Gemini IV through to Apollo 17 (and beyond). Engineering-based photography on missions tended to require sequences of images rather than stills in order to assess processes that change over time. The DAC could be used hand-held or mounted to the spacecraft to film through the windows, often via a mirror.

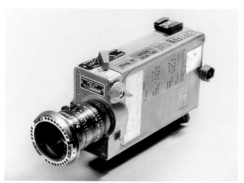

TOP: THE 16MM DAC THAT FILMED ARMSTRONG'S FIRST STEPS ON THE MOON. BOTTOM: APOLLO 11 COMMAND MODULE 16MM DAC WITH MAGAZINE

CLOSE-UP OF THE HDC'S RÉSEAU PLATE

SHEPARD'S HDC CAMERA WITH TRIGGER ASSEMBLY (POST FLIGHT)

A multitude of lenses were available, ranging from a wide-angle 5mm for inside the cabin, through to 180mm for distant-object photography. A lunar surface model, incorporating a nickel cadmium battery pack was also used outside the spacecraft.

The DAC had adjustable frame rates and shutter speeds which were independent of each other. The shutter speeds were manually selectable and ranged from 1/60th through to 1/1000th. Frame rates were lower than standard "movie" cameras to maximize the usage of film while still acquiring the required data. Frame rates of 1fps, 6fps, 12fps and 24fps could be selected via the selector on top of the camera. Combined with magazines containing 140 feet of thin-based film, this would yield 93 minutes of footage at 1fps, down to 4 minutes at 24fps.

OTHER CAMERAS

NASA experimented with various other camera systems leading up to the lunar landing missions. The 70mm Maurer Space Camera and 220G took some excellent photographs throughout Gemini, and of Earth during the uncrewed Apollo 4 test flight (see image: AS04-01-0532). Concerns over its reliability for scientific work, however, led to NASA adopting the Hasselblads for still photography.

The Hasselblad Super Wide Camera (SWC) was used extensively during the latter stages of Project Gemini and again on Apollo 9. The quality of images from this camera and lens were evidently the finest of the early space program. However, the 500EL-based HDC was ultimately selected for lunar landing missions, despite being larger and heavier. A Réseau plate couldn't be accommodated with the SWC's 38mm lens and was therefore unsuitable for photogrammetry. Also, the auto-advance feature of the 500EL-based HDC had already been developed and effectively tested in the HEC. Motorizing the SWC would have left little time to fully develop and test the system before the lunar landing missions.

On the latter Apollo missions, NASA requested that Nikon develop a 35mm camera to supplement the 70mm Hasselblads and provide a more portable camera system for active, dynamic shooting in low-light conditions.

On Apollo 11 to Apollo 14, the 35mm Apollo Lunar Surface Close-up Camera, designed by Eastman Kodak, took stereoscopic images of the lunar surface. It

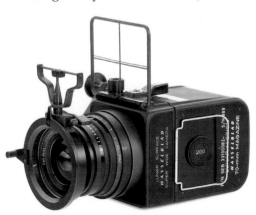

is also referred to as the "Gold" camera, after British astronomer Thomas Gold. Capturing a color stereoscopic shot of a 72mm x 83mm section of the surface gave geologists a unique insight, but the astronauts were not particularly keen on its inclusion. During an interview with Apollo Lunar Surface Journal (ALSJ), Armstrong said: "Professor Gold got his camera placed on the manifest very late and over crew objections. He hoped to support his

erroneous theory of a 'cotton candy' surface. We had little enthusiasm for the intruder." The Fairchild Metric Mapping camera and ITEK Panoramic camera were introduced from Apollo 15. Housed in the Service Module's Scientific Instrument Module (SIM) bay, the cameras provided data for geological study and to produce detailed topographic maps. The Metric Mapping camera operated in conjunction with a laser altimeter and Stellar camera. The Stellar camera photographed star fields to determine the spacecraft's exact orientation to improve the accuracy of the Metric camera's images. The Panoramic camera was based on a reconnaissance camera used by the U.S. Air Force and captured 13.5-mile by 211-mile strips of the lunar surface along the spacecraft's ground track, down to a resolution of one meter. The Command Module Pilot would need to retrieve the large cassettes of 127mm film from the SIM bay on his deep-space EVA, during the return journey from the Moon.

Although not film cameras, from the first crewed mission of Apollo 7, live TV pictures transmitted to Earth contributed significantly to the imagery from Apollo, and the TV cameras completed the photographic equipment taken on these incredible voyages. The live TV broadcasts would become the most watched events in history.

LENSES

German manufacturer Carl Zeiss made significant contributions toward the development of space photography, creating eight lens models used throughout the program. Most were space-modified versions of their commercial equivalents, incorporating adapted Synchro Compur shutters, optimized for use in a vacuum, and utilizing lubricants that would not evaporate onto the lenses. Using the lenses in thick gloves was made easier by the addition of oversized paddle levers to the exposure and focus rings. To aid photogrammetry, all lenses naturally had to exhibit minimal tangential and radial distortion across the image field.

The Zeiss Biogon 60mm f/5.6 was custom-designed for use on the lunar surface with the Hasselblad HDC and was calibrated specifically to the Réseau plate in the camera. The lens hood was given a silver coating to help minimize

temperature fluctuations and black marks on the top indicated the field-of-view. A linear polarizing filter was also available for this lens.

From Apollo 15, after significant lobbying from the crew and geologists, a large Zeiss Tele-Tessar 500mm f/8 telephoto lens was also carried, for use on the lunar surface with the HDC. Calibrated to the Réseau plate, it stayed attached to a dedicated camera.

The Hasselblad HEC was mostly used inside the spacecraft and didn't incorporate a Réseau plate. Specific lenses for this camera included a Zeiss Planar 80mm f/2.8 for general use, and a Zeiss Sonnar 250mm f/5.6 telephoto lens for more distant shots of Earth or the lunar surface.

SCOTT'S 500MM LENS FROM APOLLO 15

FILM

As early as 1964, Eastman Kodak was working with NASA to assess the effects of light reflection off the lunar surface on different types of film. NASA requested that Kodak develop very thin polyester bases for their emulsions. This thin-based film afforded a greater number of exposures per magazine and reduced weight. The film was dark-room loaded, spool to spool, to eliminate the need for the standard film cassette and, combined with a physically larger magazine, increased capacity to 160 color or 200 black-and-white frames on 38- to 42-foot-long double perforated rolls.

For black-and-white photography, Kodak Panatomic-X and Plus-X aerial negative film were generally used. Previously developed for aerial reconnaissance and mapping applications, its high dynamic range, fine film grain and high resolution (170 lines/mm) was often preferred over color (80 lines/mm),

particularly by engineering and scientific audiences. Medium-speed (ASA 80) films were typically used, although very high-speed versions (up to ASA 16,000) were available for astronomical photographic experiments.

For color photography, Kodak Ektachrome reversal film (slide film) was preferred over negative film. With reversal film, a positive working image is generated on the film itself after undergoing a chemical process in the lab. With no color references in space or on the Moon, lab technicians would not know how to correctly render true colors during the processing of

MAGAZINE "S" – CAPTURED EVERY LUNAR
SURFACE PHOTOGRAPH ON APOLLO 11

negative film. The positive image on reversal film negated this variable. Reversal film also had greater resolution and produced more vibrant colors, leading to its selection for space photography.

Previous experience indicated that there was no significant disturbance caused by using film in a vacuum, and as such the magazines would not be fully sealed. To avoid damaging the Réseau plate on the HDC lunar surface camera, the metal dark slide could not be inserted or removed with the magazine attached. Velcro strips were attached to the magazines to aid storage in the spacecraft, and stickers on the top included recommended aperture settings for different shooting situations as a prompt for the astronaut.

Handling And Processing: The flight films were refrigerated until the week before launch. They were then thawed, spooled and a test shot exposed at the start of each roll, comprising a gray card and color chart. To ensure optimum developing upon return, sensitometric control strips were taken and

Film Type	Color / B&W / Resolution	Speed	Application
Kodak Ektachrome SO-368 medium speed	Color Reversal (80 lines/mm)	ASA (ISO) 64	Earth and sunlit lunar photography from orbit. General photography
Kodak Ektachrome SO-168 EF high speed	Color Reversal (80 lines/mm)	ASA (ISO) 160	Lunar surface use in the HDC camera and low light levels (eg. interior)
Kodak Ektachrome 3400 Panatomic-X Aerial	Black & White Negative (170 lines/mm)	ASA (ISO) 80	High-resolution lunar photography from orbit
Kodak 3401 Plus-X Aerial medium-speed	Black & White Negative (170 lines/mm)	ASA (ISO) 64	High-resolution lunar surface use in the HDC camera

7.49mm (0.295")

10.26mm (0.413")

LEFT: A DUPLICATE, CUT 70MM COLOR
FRAME FROM UNDERWOOD'S COLLECTION.
ABOVE: A DUPLICATE 16MM DAC FRAME

held in sealed film cans in Houston. Comparison with the returned flight film could be made in order to determine the effects of the space environment on the film, and processing adjusted accordingly.

On the first lunar landing missions, the films (as with the precious rock samples) were split and flown in two separate aircraft back to Houston in humidity- and temperature-controlled cases. Everything, including the astronauts, went into quarantine upon arrival so that all lunar debris was contained in a controlled environment due to concern over potential "Moon bugs." The film magazines were expedited by decontaminating them with ethylene oxide.

Processing by hand, rather than machine, was slow but allowed for an instant intervention should anything go wrong. The very thin-based film was also difficult to handle. As MSC photo lab technician Terry Slezak explained in his NASA Oral History interview: "Imagine trying to handle something that's about as thin as a roll of toilet paper. It was almost impossible to even load the stuff on the reels . . ."

Once processed, a master duplicate was immediately made to avoid further handling of the invaluable original flight film, which went into temperature-controlled storage. The master duplicate frames were numbered and any copies made from this for distribution were at least third generation.

CAMERA OPERATION

The only automatic feature on the Hasselblad cameras was the advancement of the film after each shot. The lack of a viewfinder meant that, on the lunar surface, with the camera chest-mounted, the astronaut had to compose the photograph by pointing his body toward the subject and release the shutter by squeezing the trigger on the handle. Armstrong, who first suggested chest-mounting the Hasselblad, described the astronaut's body and legs as a "bipod" for the camera. Black lines on top of the lens hood indicated the field-of-view to aid in composition.

With the huge 500mm lens attached, it was necessary to lift the camera up

to eye level and aim through the ring sight and along the top of the long lens. Apollo 15 Commander Dave Scott used his helmet shield to steady the lens but Apollo 16's Charlie Duke told me: "The hardest task for me was using the 500mm lens camera. It was very difficult to hold steady and to point."

The shutter speeds available ranged from 1 second to 1/500th (and a "bulb" setting), but were almost always maintained at 1/250th. The astronaut was then left to set the f-stop and focus distance on the lens using the oversized levers. On the 60mm Biogon, apertures ranged from f/5.6 to f/45, with detents (easy-to-find click-stops) at every half stop. From Apollo 15 the f-stop was limited to f/16 and detents were only every full stop, with the aim

TOP: HDC TOP STICKER. BOTTOM: HEC TOP STICKER

of improving aperture repeatability. In reality, the apertures actually used tended to be limited to f/5.6, f/8 or f/11 (with exposure bracketing on important subjects) and stickers on top of the magazines indicated which of these three settings were recommended for different subjects and lighting conditions.

Focussing was a matter of estimating the distance to the subject and was made easier on the lunar surface due to the adoption of "zone focussing" – the wide-angled lens and relatively high f-stop effected a large depth-of-field (the total distance that would remain in focus). The focus ring on the 60mm Biogon was marked with 3, 3.5, 4, 5, 6, 8, 10, 15, 50 feet and infinity, but had detents at 5.3, 15, 74 feet and infinity. The detents were particularly useful on later missions when the markings were difficult to see as the camera became covered in moondust. The marks and detents were slightly different from Apollo 15, but on all missions, focussing could potentially be broken down into simply "near," "medium" and "far," with each depth-of-field overlapping the next. An indicator in front of the focus ring also confirmed acceptable depth-of-field for the f-stop/focus combination. For more accurate close-up focussing, astronauts often used their hand tools (tongs and scoops) held to the subject as a calibrated reference distance.

Even without the pressure suit,

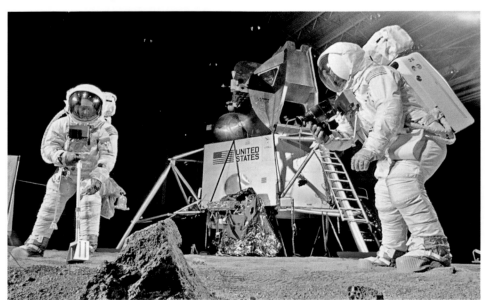

gloves and helmet to contend with, using the Hasselblad HEC in the Command Module presented its own challenges – remaining still in zero gravity while composing the shot through small windows in a cramped capsule was no mean feat. The "cold-shoe" or ring-sight could be used to aim the camera in the absence of a viewfinder, particularly when using the 250mm telephoto lens. However, Apollo 9's Rusty Schweickart told me: "You're never exactly sure that you're pointing in the right direction – you're eyeballing the edge of the camera, pointing it the way you want . . . You're mainly just hoping that the picture turns out."

Training: In August 1967, Deke Slayton made the first formal request for photography to be integrated into the astronauts' training. This included a lecture course and self-study, with astronauts given a Hasselblad to use at home, on vacation and in their T-38 training jets, with their pictures extensively assessed by experts. Apollo 15 CMP Al Worden practiced low-light photography in dark places such as parking lots at night and was relieved the police never asked him to explain his unusual behavior, given the rather far-fetched reality.

The crews were trained to shoot the way they saw things, as events developed, so that those analyzing the photographs upon return could better understand what was happening. The goal was a transparent, accurate filmic trace of events and their surroundings, rather than a personal interpretation of them.

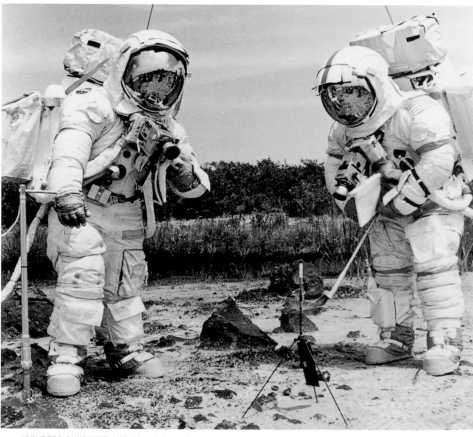

BUZZ ALDRIN HONES HIS PHOTOGRAPHY SKILLS DURING A GEOLOGY FIELD TRIP IN TEXAS, FEBRUARY 1969

ABOVE TOP: DUKE (LEFT) AND YOUNG (RIGHT) COMPLETE WITH HDCS DURING GEOLOGY TRAINING IN ONTARIO, JULY 1971
ABOVE: SCHMITT (LEFT) ADJUSTS HIS CAMERA SETTINGS DURING SAMPLE DOCUMENTATION TRAINING AT THE CAPE, AUGUST 1972

PHOTOGRAPHIC OBJECTIVES AND EXECUTION

In the early years, astronauts often struggled to sleep during their rest periods; the incredible view of Earth was too great a distraction. Richard Underwood would hide a little piece of paper in the spacecraft titled "Photography for insomniacs" detailing additional photographic targets of interest over and above those in the flight plan. By the start of the Apollo program a more formal control document was required.

The Photographic and Television Procedures Document defined the photographic objectives, astronaut procedures, camera equipment, film use, time-line integration, and even exposure settings.

With these well-defined procedures and camera settings laid out in the pre-mission documentation, simulated in training sessions, and included in the flight plan documents and on cuff checklists, the astronauts were well prepared to carry out their photographic duties. Schweickart told me, "We took pictures all the time, in the T-38s flying back and forth, I mean frankly pre-flight you got tired of taking pictures, we were just taking them *all* the time." Despite the preparations however, mission photography was not without its significant challenges and the astronauts didn't always stick rigidly to the plan. Neil Armstrong's first task after his first steps on the Moon was to collect a contingency sample, but in the moment, he decided that capturing photographs was important too and undertook this task first (see image: AS11-40-5850).

Time and location didn't always allow for a well composed, perfectly exposed shot. Real-time, unpredicted events on such complex missions often knocked photographic tasks down the priority list. Velcro on the camera equipment was designed to keep it easily accessible at all times. This wasn't always successful, however, made apparent in the Apollo 8 transcripts as the crew scrambled around looking for a color magazine to capture the famous "Earthrise" photograph, fearing the moment was lost. Simply holding on to a camera in zero-G during complex activities could be a challenge – Michael Collins lost control of his Hasselblad during his EVA on Gemini X and it tumbled away into space.

The following exchange from the mission transcripts, prior to the Apollo 9 EVA, exemplifies the emphasis on extensively capturing key events for evaluation back on Earth, and the complexities in doing so: McDivitt (in the LM), to Schweickart (outside the spacecraft), "I'll take a couple of pictures and pass you the Hasselblad. You take a couple and pass it back. I'll hand you the movie camera, and I'll take some more pictures with the Hasselblad." Meanwhile, Scott, in the Command Module was also taking still photographs and 16mm film in the other direction. Despite this apparent complexity, mission Commander McDivitt told me that he never considered the photographic work as an annoyance that interfered with the mission, and that the crew were well trained for their photographic tasks.

Although the camera hardware performed exceptionally well throughout the program, particularly in such a challenging environment, there were also some difficulties

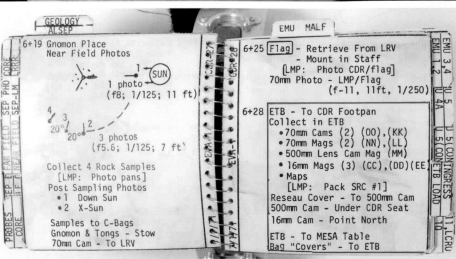

ABOVE: DAVE SCOTT PHOTOGRAPHS A SAMPLE DURING GEOLOGY TRAINING IN HAWAII, DECEMBER 1970

ABOVE: DUKE TRAINING WITH THE 500MM IN NEW MEXICO, SEPTEMBER 1971

ABOVE TOP: BUZZ ALDRIN'S STITCHED-ON CUFF CHECKLIST FROM APOLLO 11
ABOVE: DAVE SCOTT'S CUFF CHECKLIST FROM APOLLO 15, EVA-1

posed by the equipment. On Apollo 10, having fought hard to have cameras included in the LM for their low pass over the surface, the crew had recurrent issues with the film binding in the magazine, leading to complete camera failure just before passing over the planned Apollo 11 landing site. During debrief, the crew also expressed difficulty changing the magazines. Even by the time of Apollo 16, Charlie Duke concurred; expressing to me that changing magazines was difficult. In the Apollo 15 Technical Debrief, Irwin suggested the cameras being caked in Moon dust contributed to the difficulty in removing them and Scott added that the camera settings became impossible to see.

On Apollo 12, both Hasselblad camera trigger/handle assemblies came loose, leading to misfires on Conrad's (hence losing those intended shots) and rendering Bean's

FOULED CM WINDOW WITH CONDENSATION, APOLLO 12

inoperable. The ensuing confusion in switching magazines ultimately led to a color magazine being left on the Moon. Shepard encountered similar problems with the handle/trigger assembly on Apollo 14, and in a similar mix-up, a 16mm DAC magazine was accidentally left behind, still attached to the camera (seen in image: AS14-66-9336 to 9343). Jim Irwin's Hasselblad on Apollo 15 intermittently failed to advance the film and five of the eight lunar surface 16mm DAC magazines jammed, two were not used, with just one operating to completion. Charlie Duke, on the next mission, told me, "The only worry we had was with the 16mm Maurer, but it worked great."

On one occasion, during Apollo 9, camera equipment failure was considered a blessing, when Dave Scott's difficulties with a 16mm magazine gave Schweickart five minutes of relative peace during his EVA to simply hold on to the LM and observe the Earth. Schweickart told me, "... if it hadn't been for the photography getting in the way at that point I would not have had that five minutes, and that was a very special time, so thank heaven!"

In the main, the camera equipment performed superbly, capturing thousands of exceptional images. The actual photographic tasks varied by mission stage:

Earth Orbit: Up to and including the early Apollo missions, much of the photography was understandably focused on Earth. There were certain hard restrictions for such photography. With an orbit taking just 90 minutes, there is only a 45-minute window of light per revolution and typically over 50% cloud cover. The orbit inclination culminated in a ground track that only reached, on Apollo 7 for example, 31.6 degrees north and south of the equator, and this ground track shifted 22.5 degrees longitudinally every orbit. This highlights the limited Earth coverage, and importance of planning, to ensure targets were not missed.

Given that photographs through the Command Module windows should be limited to 30 degrees from vertical

S-IVB STAGE SEPARATION DURING APOLLO 17

due to the effect of Earth's atmosphere, a window would need to be oriented correctly to get the shot and fuel was budgeted for attitude control specifically for this purpose. On Apollo 7 three of the five windows fogged up due to off-gassing of sealant, two had soot deposits from the escape tower jettison and another two had condensation. Beyond these hard restrictions, the astronaut then had to ensure they were prepared, at the right time, had the correct lens attached, selected the correct settings, oriented themselves in zero-G and effectively composed the shot before releasing the shutter.

Trans-lunar/Trans-Earth Coast: Important engineering and operational photography at this stage of lunar missions included documenting the separation from the S-IVB stage and the "transposition and docking" maneuver shortly after TLI.

The long coast offered the opportunity for more experimental photography. Apollo 11 captured the solar corona as the Sun passed behind the Moon and the Apollo 12 crew were treated to a stunning total eclipse of the Sun by Earth, during trans-Earth coast. On Apollo 15, a special window was installed in the Command Module to facilitate UV photography of Earth and its atmospheric envelope.

The 250mm lens was typically employed for distant shots of the Moon and Earth. It was during trans-lunar coast that the "Blue Marble" photograph of the whole sun-lit Earth was taken. Conversely, it was the early stages of leaving lunar orbit, during trans-Earth coast, that provided the best opportunities to photograph the whole Moon.

On board the spacecraft during coast periods, the crews filmed their mobility in zero-G, hand-held with the 16mm DAC. With the increased internal spacecraft volume, the Apollo missions were the first real opportunity to assess human maneuverability in a weightless environment.

Lunar Orbit: Photography from lunar orbit was focused on mapping large sections of the surface, assessing future landing sites (and their approach) and capturing geological "targets of opportunity." The targets of opportunity lay along the flight path and were to be taken if time and circumstances permitted. They included specific features of scientific interest or wider views of areas not covered adequately by satellite photography. Photography near the terminator (the shadow line between "day" and "night") afforded great detail to be captured due to the relief offered by the longer shadows.

For mapping purposes, long strips of the surface, including terminator to terminator, could be captured by the Hasselblad HEC and 80mm lens mounted in the Command Module window. The camera was connected via its accessory socket at the rear of the body, to an intervalometer – a remote control device for taking

sequential pictures automatically at 20-second intervals. A 60% overlap of each image provided stereoscopic images, from which it was possible to determine the elevation as well as the geographical position of lunar features.

From Apollo 15, mapping photography was undertaken specifically by the Metric Mapping and Panoramic cameras in the SIM bay, which were activated at predetermined times from the Command Module.

Operational photography during this phase included the undocking, separation and visual inspection of the Lunar Module prior to its descent to the surface. The 16mm DAC then captured dramatic footage from the Lunar Module Pilot's window, of powered descent right through to touching down on the lunar surface.

Lunar Surface: The operational and engineering-based photographic tasks on the lunar surface included documentation of the condition, performance and location of hardware and equipment.

The mobility and performance of the astronauts in the new environment and 1/6th-G was also a focus for documentation, particularly during the early missions. The first moments descending the ladder and setting foot on the surface were filmed with the 16mm DAC, mounted in the Lunar Module Pilot's (LMP) window and, on Apollo 11, continued to record much of the EVA at a low frame rate. On later missions the 16mm DAC was used out on the surface during EVAs, predominantly capturing the traverses on the LRV. The LMP would also take still photographs at regular intervals from the LRV in motion, to help in reconstructing the traverses from the images.

The footpads of the LM and the area around the engine bell and landing site were extensively photographed to better understand surface mechanical properties and the LM's landing performance. Lunar soil mechanics were

THE 16MM DAC MOUNTED IN ALDRIN'S WINDOW ON APOLLO 11

also assessed via experiments such as Aldrin's famous boot print photographs – a photographic task specified on his cuff checklist. Photographic documentation of the deployment of the ALSEP experiments package, and its condition and location, was another area of significant operational photographic work.

The majority of photographs taken on the surface, however, particularly on later missions were those of a geological or scientific nature. Documenting the rock and soil samples in their undisturbed condition before collection, and recording their location was a fundamental part of the procedure for geologic sampling. This would consist of a down-Sun photograph for photometric study and a cross-Sun stereo pair – here the astronaut would take a photograph, then make a side step, then take the next photograph to produce the stereoscopic image, used for topographical analysis. Their immediate and wider vicinity was also captured to determine the location of the sample and to provide context, illustrating any relationship to surrounding features which may provide clues as to their origin. A photograph with the LRV in frame, whose position was known, would help in determining the exact sampling location within the station area.

Where time permitted, a gnomon was placed in the field-of-view for the sample documentary photographs. The gnomon consisted of a central rod that could swing

18 MAY 1969 LAUNCH DATE
Target of Opportunity Flight Chart
SKB 32100097-301

PHOTOGRAPHY LEGEND

○ 80 mm Single Frame B & W

△ 250 mm Single Frame B&W

10 Number of Frames

(20 sec) Interval Between Frames

120 Target Number

B&W FILM EXPOSURE SETTINGS
f4, 1/250
 Terminator/Terminator Vertical Strip
 Descent Strip to Highlands Site
 Targets of Opportunity - 80 mm Lens
f5.6, 1/250
 Targets of Opportunity - 250 mm Lens
f4, 1/125
 Obliques to LS-2 and LS-3
 Descent Strip to LS-3

SYMBOL LEGEND

⊕ Subsolar Point 🎯 Subearth Point

── Horizon Limits

□ Transient Event Area

LANDMARK DATA

◁ Checkpoint ◁ Initial Point

⬭ Landing Site □ Surveyor Location

MERCATOR PROJECTION
Approximate Scale 1:7,500,000 at the Equator

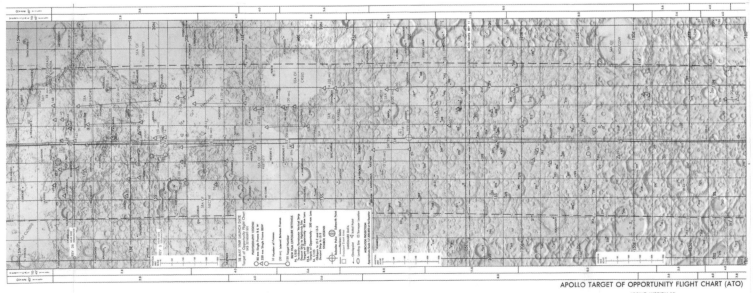

APOLLO TARGET OF OPPORTUNITY FLIGHT CHART (ATO)
APOLLO MISSION 10
18 May 1969 LAUNCH DATE

ABOVE: PHOTOGRAPHIC TARGET OF OPPORTUNITY CHART FOR APOLLO 10, SHOWING ITS GROUND TRACK OVER THE SEA OF TRANQUILITY. ABOVE RIGHT: A CLOSE-UP OF THE CHART LEGEND

freely and indicate the local vertical. One of its three legs contained a photometrically calibrated painted gray-scale and color chart to aid in assessing the sample colors in the shot. The known dimensions of the gnomon could be used to determine the size of objects in the frame, and the shadow cast by its central staff indicated Sun direction.

Panoramic sequences of photographs were predetermined and indicated on the astronaut's cuff checklists. They were taken to show wider areas around sample sites, or to determine the exact LM landing location, or simply the broader context of topographical and geological features, supplementing the astronaut's observations. A panoramic sequence was taken upon arrival at the geological stations, and another before leaving, from a different location. The second panorama showed footprints and rocks that were missing from the first, which aided retracing the activity and identifying the locations of samples within the station area.

Full panoramas consisted of 15 to 20 photographs and covered 360 degrees. With the focus maintained in the 74-foot detent, the astronaut would turn approximately 20 degrees between each shot and adjust the aperture as they turned, based on the Sun position. The overlap of each image provided stereo pairs to aid topographical analysis of objects in the near-field. According to NASA geologist trainer Bill Muehlberger, it was Apollo 17's Harrison Schmitt who suggested introducing a side step between each photograph in the panorama, to extend the useful range of the stereoscopic effect.

Operational photography at the end of lunar surface operations included recording the take-off and ascent to lunar orbit. This was filmed with the 16mm DAC, mounted in the LMP's window. The experiments packages, the U.S. flag, and tracks made by the astronauts and the rover are often visible in these sequences.

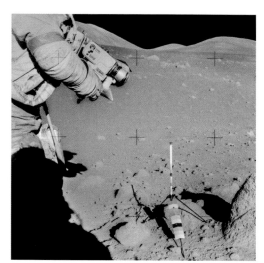

CERNAN ADJUSTS HIS CAMERA SETTINGS AS HE PHOTOGRAPHS A SAMPLE LOCATION WITH GNOMON ON APOLLO 17

ALDRIN PRACTICES A PANORAMIC SEQUENCE DURING TRAINING FOR APOLLO 11

ABOUT THE SCANS, IMAGE PROCESSING AND RESTORATION

Immediately after the exposed photographic film was returned and processed, master duplicates were made. The irreplaceable original film then entered a secure archive vault in Building 8 at Johnson Space Center (JSC). The vault was maintained at 12.8°C (55°F) and 50% relative humidity, until a new vault was built in 1982, with the film canisters maintained at -18°C (0°F) and 20% relative humidity, to better maintain their condition. Color film degrades and fades over time, and freezing the film slows down the offending chemical processes. The life expectancy of the film in this protected state is 500+ years. Duplicates are also maintained in a similar vault at a NASA test facility in White Sands, New Mexico.

From approximately 2008 to 2018, JSC and Arizona State University (ASU) embarked upon a significant project to carefully remove all of the original flight film from the freezer, and digitally scan the film using some of the best, specially adapted digital scanners available. The scanning process involved moving the sealed film canisters from the -18°C freezer environment into a 13°C refrigerator to gradually thaw. After a further 24 hours at room temperature, the film was removed from the canisters and inspected for damage or debris, and cleaned if necessary before scanning.

Using a specially modified Leica DSW700 photogrammetric scanner, the Apollo film was scanned at a resolution of 5 microns (200 pixels per mm) – beyond the resolution of the original film grain. Due to the capability of the original film to capture the high contrast subject matter, the bit depth of the scanner was extended from 12-bit A/D to 14-bit A/D, capturing 16,384 shades of gray, to preserve as much film content and detail as possible. The output, for a 70mm Hasselblad frame, is a 1.3GB raw, 16-bit TIFF file. At approximately 11,000 pixels square, a single image would require a 12-foot x 12-foot computer monitor to display the whole image at standard resolution. It is these high resolution scanned frames that are the source of the still photographs in this book.

The new scans require a significant amount of careful processing to tease out the detail and produce a well-balanced image. The transparencies were developed for an analog world, not for digital scanning – they originally required light to penetrate the "slides" to present the image correctly on light-sensitive paper or via projection. As a result, the raw scans typically show an apparently significantly underexposed image, often resembling an almost fully black frame, particularly if the original shot was also underexposed. Only after digitally enhancing the output files

THE FREEZER IN BUILDING 8, JSC, HOUSTON

THE LEICA DSW700 SCANNER

can it be determined if there is usable data; a not insignificant task given their file size, and that they number approximately 35,000.

For this book, I have inspected every image in the archive, consisting of approximately 20,000 Hasselblad transparencies, 10,153 Metric camera images, 4,612 Panoramic frames and 620 frames from the 35mm camera. I recovered images potentially revealing new detail, or those that appear difficult to process, using digital processing techniques. I then made a final selection from all the resulting imagery, and meticulously processed each frame to produce the final image.

How far to push the digital processing of any image is a difficult balance between the general aesthetic and ability to reveal detail on one hand, while maintaining a well-balanced, authentic image that accurately reflects reality and respects the historical context, on the other. The aim is to sympathetically remaster and restore these important images and present them in the highest clarity possible. Some images have required a significantly higher level of processing in order to reveal specific detail. The level of enhancement is stated in the caption for each image.

The level of processing applied has been considered on an image-by-image basis, with certain key principles in mind. No AI (machine learning) software has been utilized. Absolutely no artistic or lens effects, such as those which may indicate a different depth-of-field have been added to any image. The processing should not be pushed too far, yet far enough to represent what are, in reality, other-worldly scenes. Guidance and testimony from the astronauts who were there indeed describe almost unreal vistas. The lighting conditions in space are not like on Earth. Can we truly comprehend the stunning bright colors of Earth set against the blackest, ink black sky, illuminated by the super-

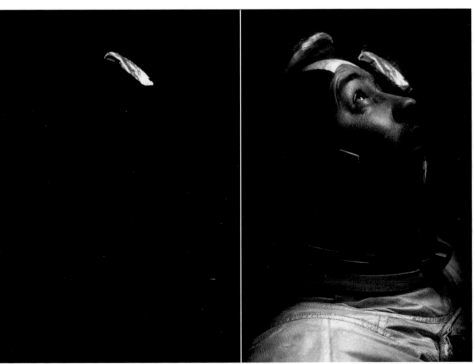

A SIGNIFICANTLY UNDEREXPOSED ORIGINAL (LEFT) AND THE REMASTERED IMAGE (RIGHT)

bright white unfiltered sunlight? The result is enormous contrast. On the lunar surface, as in space, the lack of atmosphere means that near-field objects, through to the far horizon, are unaffected by atmospheric haze, resulting in crystal clear vistas. Duke stressed to me that "the far horizon was *incredibly* sharp and well defined." In 2004, Apollo 15 CDR Scott told ALSJ, "Some of the IMAX stuff is pretty good. It's getting there. It's not there, but I'm sure people will get there [technologically] . . . I think with the improvement in optics and computers and enhancement, things that are going on now – I think people will get pretty close to being able to clear out all of the 'glue' [lack of clarity] that's in front of you. But this visual thing is pretty spectacular on the Moon." The source of reflected light is another important consideration for each scene, as is color.

Some may question whether any digital enhancement should be applied to these images at all. Yet digital enhancements are simply a more powerful, effective, convenient method for achieving what has always been undertaken in the dark room, including by NASA. Terry Slezak, MSC Photographic Technician said in his NASA Oral History interview, "I was absolutely the best re-toucher in the Photo Division, but the way I learned this at school was the old-fashioned manual way . . . Retouching color photos is a whole lot more difficult than black-and-white because you have the density and you have the color to deal with too. Now I do all kinds of photo restoration on the computer and it is just wonderful . . . it would have been quite different in the mid 60s to have had that type of technology."

Most importantly, the objective is to produce the most accurate representation of what the astronauts actually witnessed. To this end, some of the select few humans, the Apollo astronauts, who were there and actually took the photographs, have graciously contributed to this book. Walter Cunningham (Apollo 7), Rusty Schweickart (Apollo 9), Fred Haise (Apollo 13) and Charlie

Duke (Apollo 16) have checked over and critiqued the images prior to print to ensure they are as accurate as possible and represent what they witnessed during their missions.

SPECIFIC PROCESSING APPLIED

Exposure / Levels / Contrast: The scans are first adjusted for exposure. The significant gain/levels increase required on the underexposed frames introduces a host of unwanted effects,

UNWANTED EFFECTS WHEN PROCESSING UNDEREXPOSED SCANS

including film glare and sporadic areas of lower contrast. Localized contrast and exposure adjustments are made to balance the whole frame, maintaining the wide dynamic range experienced by the astronauts.

The many photographs taken through the double-paned glass of the spacecraft windows (plus an additional 0.7-inch-thick heat shield pane in the CM) exhibit less contrast and require greater adjustment, as do some of the faster films that display some radiation-induced fogging. Although the astronauts regularly dusted off their lenses during EVAs, fine coverings of lunar dust are often evident around brighter objects or against the black sky at some Sun angles, and have been subdued via contrast adjustments.

Further localized levels adjustments, or "dodging and burning," have been applied in some images to improve details. For example, on a handful of images this has been used to reduce the glare on the astronauts' visors to better reveal their face. Lens flares from the super-bright Sun often add to the context, but in others they have been subdued.

Noise Reduction: Noise reduction is generally not necessary due to the resolution of the film and digital scans. The exception is on images requiring significant levels and exposure adjustment.

Color Correction: The most difficult, yet important aspect to get right in the processing is color. The color reversal film was selected over color negatives by NASA in order to take out any guesswork and variances caused by decisions made by those in the lab during processing. Much of the film contains color casts (perhaps the first signs of aging), but the specific color and intensity varies from mission to mission, and even magazine to magazine. Photographs through the Command Module

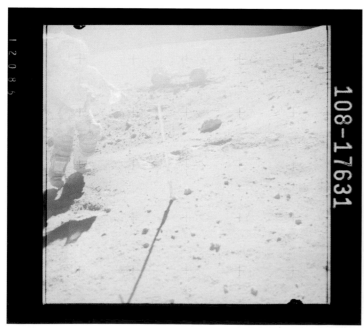
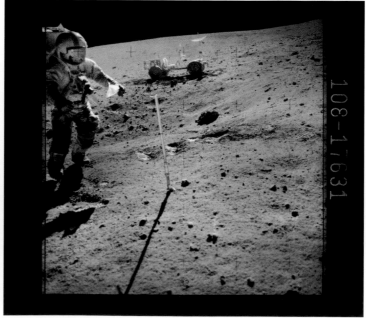

A HEAVILY OVEREXPOSED ORIGINAL FRAME (ABOVE LEFT) AND THE REMASTERED IMAGE (ABOVE RIGHT). ALSO NOTE THE SOLDER MARKS AND OUTER EDGES OF THE RÉSEAU PLATE.

windows also exhibit a marginally different color cast to those through the Lunar Module windows due to their different make-up and coatings.

A disappointing characteristic exhibited by many existing representations of the Apollo images, particularly online, is a severely desaturated shot – the result of an apparently lazy default processing technique driven by the misguided presumption that the Moon simply must be gray and the spacesuits perfectly white. This is best demonstrated in representations of the "Man on the Moon" photograph of Buzz Aldrin, taken by Neil Armstrong (see image: AS11-40-5903). As Aldrin is effectively backlit by the Sun, his front right side is in shadow, lit almost entirely by reflected light. We can see that much of this light is reflected from his front left, off the shiny gold surfaces of the Lunar Module. This bathes Aldrin in a wonderful orange/yellow light, sadly wiped out in most versions of what is one of the most iconic images of all time. Similarly, the super-crisp images taken with the Hasselblad SWC, of Rusty Schweickart during his EVA on Apollo 9 (e.g. image: AS09-20-3094) are beautifully lit. This is predominantly reflected light from Earth, and as such the blue-green tones on his white suit are a wonderful element of the visual storytelling.

The color of the Moon itself was of great interest, and a source of significant debate during the missions. From Earth, and at first glance from orbit, or on the surface, the Moon unsurprisingly looks gray. However, the Moon does have color; a little blue-green, but mostly a tan-brown hue. The intensity of the colors depends on the region, the viewing direction and the Sun angle. Reflections off glass particles containing iron contribute to the tan-brown color. Distinctly orange soil was found on Apollo 17 (see image: AS17-137-20990) caused by volcanic glass, and the prevalence of the mineral olivine can give a definite blue-green tint to the regolith. Down-Sun (as bright as Sun-lit snow) and up-Sun views exhibited browner shades, and cross-Sun views are more gray, occasionally highlighting the blue-green tint.

Identifying the very subtle color tints within the gray can also depend on the observer. Straight talking test pilots such as Pete Conrad on Apollo 12, said during orbit, "If I wanted to look at something that I thought was about the same color as the Moon, I'd go out and look at my driveway." Crewmate Alan Bean, who later became an accomplished artist, ensured the blues, greens and browns he observed were reflected in his superb paintings. In a 25-minute exchange on board Apollo 10, in which the crew were describing the Moon, the word "tan" was mentioned 15 times, "brown" 12, "white" 12 and "gray" once. The crew of Apollo 11 concurred upon entering lunar orbit, Aldrin exclaiming, "Well, I have to vote with the 10 crew, that thing is brown!... but when I first saw it, at the other Sun angle... it really looked gray." Walking on the surface, Aldrin added, "The blue color of my boots has completely disappeared now into this... still don't know exactly what color to describe this, other than [a] grayish-cocoa color."

The post Mission Report for the first human voyage to the Moon, Apollo 8, also concluded that some color was captured in the photographs too, stating, "The color photographs show a gray surface modified by weak-to-strong overtones of green, brown, or blue. The human eye readily detects intense hues but commonly does not recognize faint hues present in a dark gray surface unless color standards are available for direct comparison." These hints of color are typically edited out of many Apollo photographs, but in processing the digital scans of the original film for this book, where these hues are detected, they are not desaturated to gray, unless identified as a color cast from the spacecraft windows, or the film itself. Of course this is still, to some extent, a subjective process, aided by the input from the astronauts who were there.

Sharpness: Presenting the super-crisp vistas in the atmosphere-free environment is a critical element to presenting the images. However, the original photographs and scans are inherently extremely sharp, thanks to the quality of the lenses and other camera equipment. The 1/250th second shutter speed also generally minimized any motion blur. Very little sharpening is required. Only a mild high-pass filter is applied to some images.

Film Artifact Removal: In most cases the film acquired microscopic foreign material during use, in post processing, or as a result of further handling. Material remaining adhered to the film after its pre-scan cleaning has been removed using a spot healing technique. The two silver deposits that conduct static away from the Réseau plate manifest as a small dark mark in the upper left and lower right of photographs taken with the Hasselblad HDC. As the marks are part of the visual record of the camera system, they have typically been left in place. On images where the marks are of significant distraction however, and given that they occupy only a minute spot on the extreme edge of the frame, they have been cropped out, spot healed or subdued. Other linear

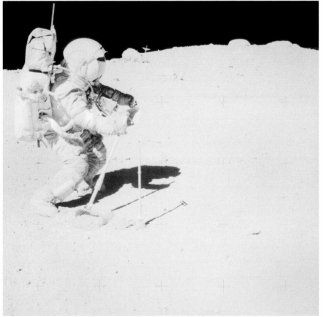 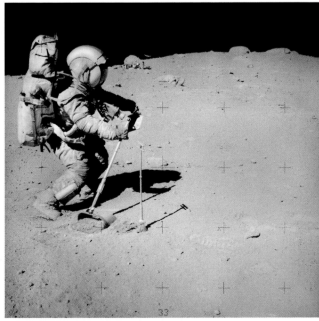

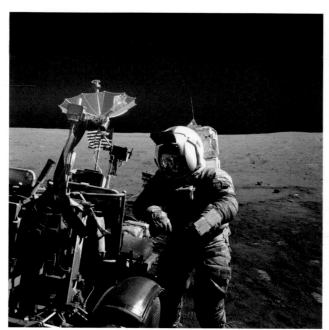

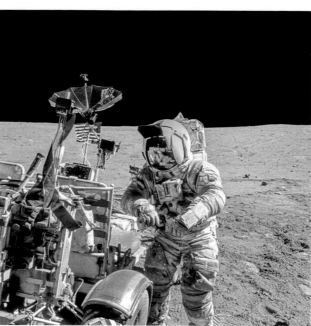

lunar landscape, alongside the perfect blue Earth from where these alien spacecraft and life-forms originated. Charlie Duke confirmed to me that it was he who took the picture, "I took this photo. Mission Control had just informed us to rendezvous, so John [Young]was busy with that. It was such a unique opportunity I could not pass up."

As with cropping, image rotation is undertaken sparingly. Rotations in 90 degree increments are rather easy to justify. In space there is no up or down, and the astronaut may have held the camera in any orientation, as he floated, perhaps sideways, while framing and capturing the shot. This is born out in the Apollo 11 transcripts, just after LM separation in preparation for descent to the surface; CMP Collins got his first look at the LM. "I think you've got a fine looking flying machine there, *Eagle*, despite the fact you're upside down." "*Somebody's* upside down," replied Armstrong.

marks that were evident from the processing or scanning process have also been spot healed.

Frames that were sunstruck and badly damaged as light entered the magazine, required a more extensive restoration, in addition to significant contrast and color corrections. Moon dust entered the camera system and contaminated the Réseau plate on some missions. Thousands of small black dots, and even some streaking as the film advanced, is evident on these images, particularly those from Apollo 16. These have been significantly reduced but not entirely removed.

Crop/Orientation: In the absence of a viewfinder, and with no zoom lens or ability to quickly and spontaneously change lenses, the astronaut photographers typically did an extraordinary job of aiming and framing the subject. Often, however, it was less than optimal. It would be extremely unusual for any photographer, given such limitations, not to crop and rotate their images in order to better frame the shot after the event. As the original images were intended as a scientific record, and such imperfections are part of the visual storytelling, almost all are left without any significant crop. In a few circumstances however, where an image has significantly benefited from re-framing, it has been cropped; and this is clearly stated in the caption. It is worth noting that NASA also re-framed their release of the "Man On The Moon" image (AS11-40-5903), prior to release.

One extraordinary image in particular, a clear highlight in this collection, has benefited enormously from the extent of cropping applied; only recently made possible due to the huge resolution of the new scans (image AS16-113-18288 from Apollo 16), it depicts an almost unfathomable scene. Two humans from Earth are in a spacecraft orbiting the Moon; one of them takes this photograph of another Earth-built spacecraft, also orbiting the Moon, containing another human. The spacecraft is seen above the hostile, rugged

Images that have been rotated are clearly stated as such in the caption.

Photographs taken with the 60mm lens on the HDC camera captured the edge of the Réseau plate down the left and right sides of the frame. Where they make some contribution to the final image they are included; in others they are a distraction and are cropped out. The recent scanning process also captured the whole film width, including the sprocket holes used to advance the film. In some images they have been left in as they add a unique 3D effect to the image and are a reminder that the photographs in this book are direct scans of the actual film that was exposed in the cameras during these extraordinary voyages.

Panoramas: The requirement for panoramic sequences and how they were captured on the lunar surface is outlined on page 436. Despite the original scientific rationale, however, they now provide us with an opportunity to view the stunning lunar landscape in all its glory. It must be stated that significantly more liberties are taken in order to assemble and present the panoramic images. Perspective changes, as the astronaut and lens turned through the sequence, necessitate some manipulation and distortion in order to align and "manually" stitch the overlapping frames. Where necessary, black infill has been added to an already perfectly black sky to complete the image. A very small gray infill has also been added to the Apollo 13 image AS13-60-8607. In the difficult balance of presenting an image effectively, while taking care not to portray anything that is not historically correct, this "fill" has been

considered acceptable. This is particularly in light of the fact that NASA themselves added black sky above Aldrin's PLSS (in my view justifiably) in the most iconic image from Apollo 11 ("A Man on the Moon," image: AS11-40-5903), before public release.

The fiducial markers (cross hairs) on the Réseau plate are an absolutely fundamental element of the Hasselblad HDC lunar surface photographs and one of the attributes and key visual clues that define Apollo imagery. Any decision to remove them goes against the principles associated with presenting an authentic record of the image. The perspective changes and distortion exhibited in some of the panoramic sequences however have necessitated their removal. Réseau mark removal is stated in the caption for the few images to which this applies.

16mm DAC Film Image Stacking: The original 16mm flight films were brought out of the frozen archive vault in Houston in 2006. Telecine transfers of the film were made to HDCAM (a high-definition digital videotape format). These HDCAM tapes were then digitized by Archive Producer and NASA/JSC Consultant, Stephen Slater who generously supplied me with the digital master files for all missions. They are the highest quality digital transfers currently available of the 16mm flight films, and were used to produce the stacked, processed images in this book.

Before applying similar processing techniques used on the Hasselblad scans to the 16mm footage, a rather complex image stacking process was applied. The technique has been adopted as a means of abating the comparatively higher noise levels and reduced detail inherent in the smaller format film. It is a technique often utilized in modern digital astrophotography to reveal detail in distant astronomical objects, and works on the principle that every image contains a signal and noise. The noise present in the footage may be caused by the grain structure of the film medium, in addition to digital noise introduced in the film transfers, but unlike the signal, noise is truly random. By aligning and stacking multiple image samples of the same subject, individual values for each aligned feature in the stack can be averaged out, thus reducing noise, while maintaining signal. The more sample images, the better the averaging, with the improvement in the signal/noise ratio equal to the square root of the number of stacked images. The result is less noise, more detail, and a more photo-like quality. The output of this stacking process has then undergone wavelet processing, before applying similar processing techniques outlined above for the Hasselblad stills.

I first applied this technique to footage of Neil Armstrong's Apollo 11 EVA. It was made possible as the 16mm DAC was "locked-off", mounted to the window, and Armstrong remained almost motionless for long enough to lift several, almost identical frames – a prerequisite in order to easily align the signal in each frame.

THE STACKING PRINCIPLE APPLIED TO 16MM DAC FOOTAGE

Interestingly, a similar analog process was adopted by MSC photo lab technician Terry Slezak (perhaps most famous for becoming the first human to be "contaminated" by lunar dust in processing the Apollo 11 film). He explained in his NASA Oral History, "I wanted to tell you about (an invention that I had)....a grain interruption device used for printing good quality 8 x 10 pictures from 16-millimeter film....If you take one frame of 16-millimeter – it's so small – and project it, the grains are big as baseballs. But if you can interrupt this grain pattern, it looks all nice and smooth....you come out with a fairly nice-looking print. Didn't work on moving objects or anything, it had limited use, but it was a neat thing."

The key issue with much of the Apollo footage, however, even with the camera mounted, the subject moves within the frame. Worse still, for internal footage, the DAC was handheld as the astronaut operator often panned across the scene while floating in zero-G, leading to constant movement of the

A SINGLE 16MM DAC MOVIE FRAME (ABOVE LEFT) AND 80 STACKED AND REMASTERED FRAMES (ABOVE RIGHT)

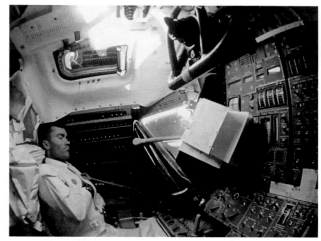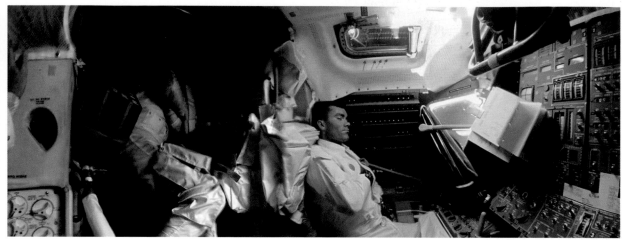

A SINGLE 16MM FRAME (ABOVE LEFT) AND A PANORAMIC VIEW RESULTING FROM STACKED, PROCESSED AND STITCHED FRAMES AS THE CAMERA PANS LEFT (ABOVE RIGHT)

camera. In addition, due to the distortion of the wide angle (fish-eye) lens which was required for internal footage, the movement of subjects at the outer areas of the lens, compared to the center areas of the lens, are non-linear.

Due to the complexities of perfectly aligning multiple frames of a moving subject, within the frame of a moving camera, with a distorted lens; I developed a new process specifically to produce the stacked 16mm images in this book. Re-stacking multiple frames in multiple locations results in images containing over 1,000 samples. The process also allows for the production of the panoramic still representations of the panned "movie" footage, while still benefiting from the signal/noise quality improvements from the stacking process.

About the Captions: Every effort has been made to present the images in chronological order, so that the story of each mission, indeed the whole program, may be followed through the medium of the flight film. Pertinent quotes from the astronauts captured on the onboard tape recordings, and with Mission Control during air-to-ground communications, at the time each photograph was taken, are included to further contribute to our ability to vicariously experience these historic moments.

The dates stated are based on GMT (with the exception of the Apollo 11 landing date) and the captions include the original NASA reference – typically made up of the mission ID, magazine number and frame number. It is not possible to use the frame number alone to determine chronology, however, due to the simultaneous use of multiple cameras and the exposure of numerous magazines.

The mission transcripts of air-to-ground communications and onboard voice tape recordings have been used, in addition to studying the content of the photographs and 16mm footage, to help complete the picture. Known mission events and timings can be cross-referenced with the transcripts and clues within the footage gleaned. These included the relative sizes of the Moon and Earth given the lens used, whether particular equipment had been deployed on the lunar surface, the location of the LRV and its tracks, and the relative positions of the spacecraft during rendezvous or stationkeeping.

Sequences inside the spacecraft during trans-Earth and trans-lunar coast required more subtle observations. The presence of the CO_2 scrubber, for example on Apollo 13, or Scott's bruised fingernails on Apollo 15, identifying the open page of the mission plans or glimpsing the Command Module's mission timer. Not to mention an interesting conversation with Rusty Schweickart, as we pored over the details assessing the relative beard growth of McDivitt versus Scott.

The captions also specify the lens used and, where known, a credit to the astronaut who took the photograph. To determine the lens; post-mission photographic reports were used and cross-referenced with information provided with the ASU scans. These often differed and occasionally were evidently incorrect based on the field-of-view observed, the transcripts, or more broadly, the use of the Hasselblad SWC on Apollo 9 and the presence of Réseau marks on Apollo 13 images (indicating the 60mm lens on the HDC).

Since each camera was accessible to all crew members, the transcripts were studied and clues gleaned from image content to determine the photographer. For example, the angle of photographs and objects within the frame can help determine the seat position within the spacecraft from which the photograph was taken, and therefore the astronaut occupying that seat position or LM station. The 50-year-old memories of the astronauts who were actually there, also helped complete missing information in the captions that inform these iconic images.

If the image is significantly cropped, rotated or is a stitched panorama, this is specified in the caption and an indication of the level of enhancement required/applied is also included on a scale from 1 (little enhancement) to 5 (significant enhancement).

ACKNOWLEDGMENTS

The decision to undertake such a huge, time-consuming project was not taken lightly. What began with evenings, through to the early hours and weekends, slowly morphed into incorporating the weekdays too and it became clear this would be a project measured in years rather than months. All other work and business commitments were put on hold indefinitely. This would not have been possible if it were not for the support from my wife Fernanda and children Ben and Luna. Thank you Fernanda for coping with everything our daily life necessitated and Ben and Luna for your patience when frustrated with losing Dad to his office to do "those flipping photographs!" Without your support this book would not have been possible. Thank you also to my parents for always telling me I could do anything and encouraging me to pursue a wide range of interests.

It would be remiss not to thank NASA and all the early astronauts and space pioneers who helped us reach the Moon; risking all and pushing the boundaries for the greater good and to enhance our understanding of our place in the universe, and more importantly, our home planet. Thank you in particular to those Apollo astronauts who generously contributed to this book: Walter Cunningham, Charlie Duke, Fred Haise and Rusty Schweickart. Your time is precious and I enjoyed and was honored by every second of every phone call, Zoom session, email or text; discussing image selection, color accuracy, image content, photographic technique, image chronology and more. Thank you also to Jim McDivitt for your encouragement and, to all of you – your continued engagement, enthusiasm, not to mention memory, after all these years is an inspiration.

NASA's open source policy; making the information and images available to all, helps anyone with the interest to undertake this kind of work, which in turn can often make some contribution to keeping the history alive. Thank you in particular to all those at Johnson Space Center and Arizona State University for undertaking such an important project – scanning all of the original flight film, making it accessible, and helping preserve these incredible moments. And thank you to acting NASA chief historian, Brian Odom, for your continued encouragement and for helping me navigate the enormous machine that is NASA. Thank you to Stephen Slater (archive producer of the Emmy Award-winning Apollo 11 movie) for the generous provision of the highest-quality digital transfers available of the 16mm DAC footage. Your tireless and brilliant archival work is so important in preserving and showcasing these historic events.

On another archival note, thank you to every contributor to two of the most in-depth Apollo resources available – the Apollo Lunar Surface Journal and Apollo Flight Journal, overseen by Eric Jones and David Woods respectively. I can't even comprehend how much work has gone into these over the years.

They are such valuable resources for any researcher: I would encourage anyone with a further interest to please check them out online. It is via ALSJ that I managed to track down Keith Wilson, a British spaceflight researcher. Thank you Keith for your past research and for sharing with me your personal correspondence with key people from back in the day. Your encouragement and kind words have also been a great motivator throughout this long process.

The concept to turn the project into a book was thanks to too many people to mention, many of whom followed my work from the very early days on social media. Thank you so much to all of you – you know who you are. Thank you to my agent Jeff Sheve for recognizing the potential in the book and guiding me through every step of the process – I categorically couldn't have done this without you. Thank you for putting up with so many, likely irrelevant questions from someone who had zero experience of the publishing world.

Thank you to all those at Penguin Random House UK who actually turned the concept into reality. To my editor Casiana Ionita for your guidance, of course, but also for your enthusiasm right from the first second – this was so important to me in the early stages. To art director Jim Stoddart for managing to so brilliantly organize and present the hundreds of photographs thrown at you, and incorporate the more technical text seamlessly into the design. Thank you to Imogen Scott who then turned the wonderful design into this beautiful object. I really appreciate your patience with me in the pursuit of the perfect print, and your shared desire to accomplish this. Thank you also to Edward Kirke, Samantha Johnson, Rebecca Lee, Fiona Livesey, Julie Woon, Thi Dinh, Claire Péligry, Catherine Wood, Mark Williams and Mike McKay. And at Hachette Book Group USA; Becky Koh, Betsy Hulsebosch, Lillian Sun and Kara Thornton.

To Sarah Knapton, science editor at the *Daily Telegraph*, thank you for recognizing the significance of my Neil Armstrong image, which really started everything. Thank you to Chris Cooze at Hasselblad, and the Hasselblad Foundation for your help during research, to the brilliant science communication photographer Max Alexander for your wonderful guidance, and to James Adam at Cunning Plan for your digital presence advice and help.

A big thank you to all those who supported my work, often before the book became a reality, and who helped with research advice, guidance, networking and encouragement, including Andrew Chaikin, Keith Haviland, the Smithsonian Institute – in particular Teasel Muir-Harmony, Jennifer Levasseur and Kathrin Halpern, Carl Walker (ESA), Mark McCaughrean (ESA), Paolo Attivissimo, Nicholas Booth, Julie McDermott (Space Lectures), George Leopold, Ben Feist, Andrew Luck-Baker (BBC), Robert Pearlman, Ángel Gómez Roldán, Francis French, Dave Shayler, Dave Schlom, Cole Rise (Space Camera Co.), and finally to the family members of the Apollo astronauts and to the curators and researchers at many museums and institutions who also offered their encouragement.

LIST OF ACRONYMS

ALSEP: Apollo Lunar Surface Experiments Package
AOS: Acquisition of Signal
AOT: Alignment Optical Telescope
ASE: Active Seismic Experiment
CAPCOM: Capsule Communicator
CDR: Commander
CM: Command Module
CMP: Command Module Pilot
COAS: Crewman Optical Alignment Sight
CSM: Command and Service Module
DOI: Descent Orbit Insertion
EASEP: Early Apollo Scientific Experiments Package
EVA: Extravehicular Activity
EVVA: Extravehicular Visor Assembly
HTC: Hand Tool Carrier
IU: Instrument Unit
LEVA: Lunar Excursion Visor Assembly
LM: Lunar Module
LMP: Lunar Module Pilot
LPD: Landing Point Designator
LRV: Lunar Roving Vehicle
MECO: Main Engine Cutoff
MESA: Modular Equipment Stowage Assembly
MET: Modular Equipment Transporter
OPS: Oxygen Purge System
PDI: Powered Descent Initiation
PLSS: Portable Life Support System
PSE: Passive Seismic Experiment
RCS: Reaction Control System
RCU: Remote Control Unit
RTG: Radioisotope Thermoelectric Generator
SEP: Surface Electrical Properties
SIM: Scientific Instrument Module
SLA: Spacecraft Lunar Module Adaptor
SPS: Service Propulsion System
TEI: Trans-Earth injection
TLI: Trans-lunar injection
VAB: Vehicle Assembly Building

PHOTO CREDITS

All images are courtesy of The National Aeronautics and Space Administration (NASA) and image processing by Andy Saunders, unless stated below. Additional digitization credit to Johnson Space Center and Arizona State University for 70mm film and Stephen Slater for 16mm DAC footage.

Page 424, John Glenn's camera
Courtesy of Smithsonian National Air And Space Museum
Page 427, Wally Schirra's adapted 500C
Courtesy of RR Auctions
Page 427, Apollo 11 HEC
Courtesy of Smithsonian National Air And Space Museum
Page 428, Hasselblad HDC Camera With Magazine
Courtesy of Leitz Photographica Auction
Page 428, Hasselblad HDC Camera Without Magazine
Courtesy of Marco Nietlisbach
Page 428, Close-up of Réseau
Courtesy of Marco Nietlisbach
Page 428, Apollo 11 16mm DAC Cameras
Courtesy of Smithsonian National Air And Space Museum
Page 429, 60mm Biogon Lens
Courtesy of Marco Nietlisbach
Page 429, 80mm Lens
Courtesy of Smithsonian National Air And Space Museum
Page 429, Hasselblad Super Wide Camera
Courtesy of Leitz Photographica Auction
Page 429, Scott's 500mm Lens
Courtesy of RR Auctions
Page 430, Magazine "S"
Courtesy of Smithsonian National Air And Space Museum
Page 430, Underwood's 70mm Film Frame
Photo by Andy Saunders
Page 433, Scott's Cuff Checklist
Courtesy of RR Auctions
Page 435, Target Of Opportunity Chart
Courtesy of the U.S. National Archives
Page 437, Building 8 Freezer and Leica Scanner
Courtesy of Johnson Space Center (Via Arizona State University)
Page 440, Underwood's 70mm Film Frame
Photo by Andy Saunders

NASA DOCUMENTS AND PUBLICATIONS

70-Millimeter Photography and NASA Earth Resources (Apollo 7), 1969

Photogrammetric Calibration of Apollo Film Cameras, W. T. Borgeson and
 R. M. Batson, 1969

Analysis of Apollo 8 Photography and Visual Observations, 1969

Apollo 10 Photo Debriefing, Bellcomm Inc., 1969

Apollo 11 Lunar Photography, 1970

Analysis of Apollo 10 Photography and Visual Observations, 1971

Apollo 15 30-Day Failure and Anomaly Listing Report, 1971

Analysis of Surveyor 3 Material and Photographs Returned by Apollo 12, 1972

Photography Equipment and Techniques – A Survey of NASA Developments,
 Albert J. Derr, 1972

Apollo Experience Report – Photographic Equipment and Operations During
 Manned Missions, Helmut A. Kuehnel, 1972

Handbook of Pilot Operational Equipment for Manned Space Flight, 1973

Apollo Experience Report – Spacecraft Structural Windows, Orvis E. Pigg and
 Stanley P. Weiss, 1973

Apollo by the Numbers, Richard W. Orloff (NASA History Division), 2004

Science Training History of the Apollo Astronauts, William C. Phinney, 2015

Photographic and TV Operations Plans (mission specific)

Mission Reports and Preliminary Science Reports (mission specific)

OTHER ARTICLES AND PUBLICATIONS

U.S. Geological Survey, Photometric Calibration Report,
 Apollo 16 Gnomon, 1972

U.S. Geological Survey, The Geologic Investigation of the
 Taurus-Littrow Valley: Apollo 17 Landing Site, 1981

Neil Armstrong Interview, Buffini & Company MasterMind Summit, 2002

James R. Hansen, *First Man* (Simon & Schuster, 2005)

Andrew Chaikin, "Who Took the Legendary Earthrise Photo From Apollo 8?",
 Smithsonian Magazine, July 2018

American Cinematographer, "Photographing Apollo 11," 2019

Jennifer K. Levasseur, *Through Astronaut Eyes – Photographing Early Human
 Spaceflight* (Smithsonian Institution, 2020)

WEBSITES

Apollo Flight Journal (NASA History Division, David Woods et al.):
 https://history.nasa.gov/afj/

Apollo Lunar Surface Journal (NASA History Division, Eric M. Jones et al.):
 https://www.hq.nasa.gov/alsj/

Apollo 17 Audio Transmissions (Ben Feist et al.):
 https://apolloinrealtime.org/17/

Hasselblad History:
 https://www.hasselblad.com/inspiration/history/hasselblad-in-space/

Johnson Space Center / Arizona State University Digital Repository:
 https://tothemoon.ser.asu.edu/

Lunar and Planetary Institute (mission specific):
 https://www.lpi.usra.edu/lunar/missions/apollo

NASA Apollo Mission Reports (mission specific):
 https://history.nasa.gov/

NASA Oral Histories (astronaut, management
 and photographic personnel interviews):
 https://historycollection.jsc.nasa.gov/JSCHistoryPortal/history
 /oral_histories/oral_histories.htm

NASA Science (Earth's Moon):
 https://moon.nasa.gov/

NASA Technical Reports Server:
 https://ntrs.nasa.gov/

Project Apollo Archive:
 https://apolloarchive.com

U.S. National Archives:
 https://nara.getarchive.net/

"You know, when you get back, you're going to be a national hero, but those photographs, if you get great photos, they'll live forever . . ."

RICHARD W. UNDERWOOD
NASA CHIEF OF PHOTOGRAPHY, MERCURY, GEMINI, AND APOLLO

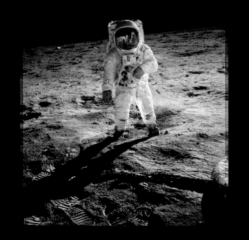